ART IN THE WORLD

ART IN THE WORLD

Fourth Edition

STELLA PANDELL RUSSELL

HARCOURT BRACE JOVANOVICH COLLEGE PUBLISHERS

FORT WORTH PHILADELPHIA SAN DIEGO NEW YORK ORLANDO AUSTIN SAN ANTONIO
TORONTO MONTREAL LONDON SYDNEY TOKYO

Publisher Ted Buchholz
Acquisitions Editor Janet Wilhite
Developmental Editor Terri House
Project Editor Laura J. Hanna
Senior Production Manager Kathleen Ferguson
Book Designer Diana Jean Parks
Photo Editor Peggy Cooper
Composition and Color York Graphic Services
Printing and Binding R. R. Donnelley & Sons Company

Cover Image: Pat Steir. *The Brueghel Series (A Vanitas of Style).*
1982–84. 8 × 8′ grid, polychromes 64 panels, each
25-1/4 × 21-1/2″. Robert Miller Gallery, New York.

Address for Editorial Correspondence
Harcourt Brace Jovanovich College Publishers,
301 Commerce Street,
Suite 3700, Fort Worth, TX 76102

Address for Orders
Harcourt Brace Jovanovich College Publishers,
6277 Sea Harbor Drive,
Orlando, FL 32887
1-800-782-4479, or 1-800-433-0001 (in Florida)

Photographic credits appear on pages 515 and 516.

Printed in the United States of America

Library of Congress Catalogue Number 92-70938

ISBN 0-03-276543-6

2 3 4 5 6 7 8 9 0 1 048 9 8 7 6 5 4 3 2 1

For Janna,
Jonathan,
Loriann,
and their father,
George

SUSAN ROTHENBERG *ORANGE BREAK*, 1989–90 OIL ON CANVAS 79 3/4 × 95 IN. (203 × 241 CM.)
COURTESY SPERONE WESTWATER, NY.

Preface

The fourth edition of *Art In the World* is a foundation text in art for college and other interested students—offering a broad introduction to concepts, media, vocabulary, and history of art. Through examples from the distant past up to the present from many cultures, the universal qualities in human aesthetic responses, as well as the special differences that distinguish societies, become clear.

Many of these goals have been addressed in other fine books, of course. The aim of this edition is to retain clarity and coverage within the major areas and with expanded cultures—all in a manageable volume. I believe we have succeeded.

Beyond fulfilling these needs, *Art In the World* features areas often slighted in other texts:

1. **Contemporary art** For many students, the art of our own time is difficult to understand, much less appreciate. For this reason, an entire section of *Art In the World* is devoted to twentieth-century art and its roots in the arts of the historical Age of Revolution. Whenever possible, modern works have been related in contrast or comparison with art of the past.

2. **Spectrum of the arts** A feature of this book through every edition has been to treat all the arts with respect. Along with the fine arts of painting, sculpture, and architecture, the graphic arts, for example, are presented with equal coverage, just as is the art found in objects designed to make daily living—where all of us have the most contact with art, after all—more satisfying.

3. **Non-Western, minority, and Third World arts**
Present in every edition of *Art In the World*, but currently expanded, the less familiar arts have all been chronologically integrated, and correlations between cultures clarified. Our focus remains on the Western world with which we have the most experience, but our legacy from parallel civilizations and the diffusion of contributions from them have been noted with appreciation.

4. **Art Talk** A feature in each chapter, essays on issues and people allied with the art world, explore the contributions of art patrons, art critics, art restorers, art historians, and art dealers. Some of the issues examined highlight research in art technology and art processes that lead to an understanding and appreciation of art.

5. **Artist Sketch** Brief yet insightful summaries of the life contributions of artists, past and present, in double the numbers of the third edition, help to make the artists "come alive." More men than women have had opportunities, it seems, to develop greater stature in the past, but, wherever possible, women have made significant contributions, and these are appropriately noted.

Structure of the Book

Art is inspired by living. In the years since *Art In the World* was first published, living artists with their unique ability to invent images that illuminate our world have continued to add to the body of art. The evolution of the contemporary visual arts has required substantial adjustments to the text and illustrations from the third edition. Parts I, II, and III, preceded by an Introduction, are still organized into two- and three-dimensional arts, but changes have been made within their arrangement.

The world of art is defined in the Introduction, while the processes of creativity and the artist's language remain a preamble to the comprehensive survey of media. Beginning with guidelines for evaluating art in Chapter 1, Chapter 2 explores all the elements that govern a work of art. Chapter 3, Drawing, Painting, and Mixed Media, and Chapter 4, Printmaking, have been updated. In Chapter 5, Arts of the Lens have been expanded to include a new section on computer graphics, carefully defined, diagrammed, and illustrated. Chapter 6 begins our exploration of the three-dimensional arts with a fresh overview of sculpture. Architectural and Environmental Design are covered in Chapter 7, while Design for Living incorporates a whole new view of the applied arts, including the impact of the computer as a design tool. Wholly new is Chapter 9, dealing with the increasing importance of Performance Art, traced from its origins in the Bible to its appearance in religious street festivals. Controversial issues, no longer strangers to the art world, conclude the chapter and cover the important areas of Public Art, the Art Market, Art Preservation, and the new role of the Art Museum.

Parts IV and V, expanded broadly to include all significant minority and non-Western art, provide a chronological history of art beginning with the Stone Age and proceeding to the most recent styles of the 1990s. These main divisions, Part I through Part V, may be taken in any order.

Illustrations, Biographies and Art Essays

Art In the World, fourth edition, has been printed entirely on a four-color press, thus allowing the placement of the color reproductions alongside their textual references. Many more illustrations, with close to half in color and larger than ever before, reproduce works by women and men from the earliest societies up to the world of tomorrow. While the art of our own time is featured, as in prior editions, perhaps because it touches us most deeply, the expanded scope of world art is covered thoroughly. No art is discussed without an illustration.

The lives of artists continue to intrigue us all. With self-portraits wherever possible, the number of biographies (The Artist Sketch) has been doubled, while art people and issues that exert influence in the art world (Art Talk) are a new feature to this edition and supplement every chapter. The book is printed on higher quality paper to achieve greater clarity of detail and a fuller range of values than ever before.

Pedagogy

To foster comprehension of complex subject matter, important terms, highlighted in boldface, are defined the first time they appear in the text and again in the Glossary. Each chapter ends with several art activities and research exercises that can provide deeper learning opportunities to interested students. Concluding the book are a Glossary of terms to clarify the specialized vocabulary of the visual arts and an annotated Bibliography, arranged by chapters, to help students to pursue topics of interest in greater depth. Each of the historical chapters in Parts IV and V begins with a Timeline that relates cultural happenings that occurred concurrent with the creation of art. These, coupled with maps, provide the broader base of time and space correlations, essential to understanding and appreciation of the visual arts.

I hope that *Art In the World,* fourth edition, will prove to be a valuable guide to the world of art, that the reader will find stimulation to continue experiencing art in the outside world, and will learn through it to understand and appreciate art in whatever form it appears.

Acknowledgements

The author wishes to thank the numerous reviewers who read various drafts of the manuscript and made useful suggestions. The research involved for this edition was no less comprehensive than for each of the earlier texts. In particular, the reference staff of the local library was, as always, invaluable, and especially, Dorothy Moore. Special thanks go to the highly professional team at Harcourt Brace Jovanovich Publishers who helped make this book a reality: Ted Buchholz, Publisher; Bill McLane, Executive Editor; Diana Jean Parks, Designer; Laura Hanna, Project Editor; and Kathleen Ferguson, Production Manager. The Acquisitions Editor, Janet Wilhite, was a constant inspiration; Peggy Cooper, Photo Editor, was always patient; and Terri House, Developmental Editor, held my hand throughout to support the process.

Stella Russell
Oyster Bay

Contents

• • •

Part One
The Creative Impulse

• • •

Part Two
Two-Dimensional Media and Techniques

• • •

Part Three
Three-Dimensional Media and Techniques

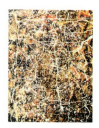

• • •

Part Four
Art In Society

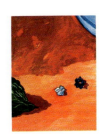

• • •

Part Five
The Modern Age

ART IN THE WORLD

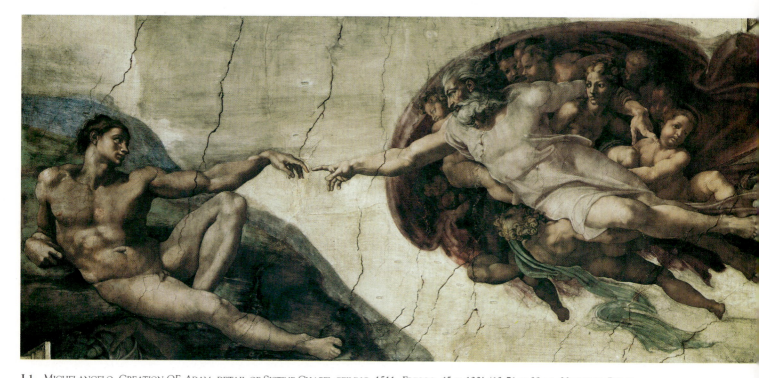

I.1 MICHELANGELO. *CREATION OF ADAM*, DETAIL OF SISTINE CHAPEL CEILING. 1511. FRESCO, 45 × 130′ (13.71 × 39 M). VATICAN, ROME.

Introduction

THE WORLD OF ART

WHAT IS ART?

It is certainly easier to ask what art is than to answer the question simply. Defined as a creative act, activity, or product of a human being, **art** means different things to different people. President John F. Kennedy believed that "art establishes the basic human truths which must serve as the touchstone of our judgment." The great mime Charlie Chaplin went even further: "There are more valid facts and details in works of art than there are in history books." Perhaps the poet Robert Browning said it best: "Art remains the one way possible of speaking truth." Exploring what and how and why artists create art can be a way to extend our own awareness beyond the ordinary and thus permit art to enhance our lives.

We expect to find great art when we visit world-renowned museums of painting and sculpture. But the term *art* is also applied to such fields as literature, theater, dance, and music—areas all considered branches of the humanities, as apart from the sciences. Yet, it is possible to find some forms of art even in everyday living, as close to us perhaps as the cartoons that make us smile.

One element common to all of the arts is the demonstration of skill. When we speak of the arts, however, we usually mean much more than skillful technique. We expect great art to provide us with unique experiences that affect our senses in special ways. Art may convey a message that moves us deeply or awakens us to new insights. Art also reminds us of feelings all people share but few seem to express as clearly as the artist. The most soul-stirring art may stretch our awareness of how special we are or can become. For instance, while we all marvel at the creation of life, how many of us could have imagined the act of

creation with the impact achieved by Michelangelo (1475–1564) in his **fresco*** *The Creation of Adam* on the ceiling of the Sistine Chapel in Rome [I.1]?

We cannot hope to discuss every area of art in this book. We will not be concerned with the art of literature, which depends on words, nor with the performing arts, which are primarily fleeting experiences of music, dance, and drama designed to be heard or seen as sequential events. Although dance and drama have visual elements, their foundation is the human body; they leave nothing material behind but costumes and stage props. We must confine ourselves to the visual arts, which consist of works created both to be seen and, more or less, to endure.

No matter what the level of art, none is ever entirely simple. A painting, a sculpture, a church, or a piece of pottery are all phenomena of varying complexities evolving from the artist's world, in his or her own time and place. Only a very special painting, sculpture, church, or unusual piece of pottery, something we call a masterpiece like Michelangelo's *Adam*, is able to rise above that original setting to speak as powerfully to a new audience, different from its intended patrons. Some artworks can also be useful at the same time that they may represent beauty to us— that which gives aesthetic pleasure as we view it. Most of us believe that beauty in art constitutes the highest form of appreciation in our lives, fulfilling the ultimate human joy, close to exultation of the human spirit. For many, art also represents the maximum cultural attainment, social status,

* See the Glossary at the end of the book for the definitions of many terms, including most of the terms in bold type in the text.

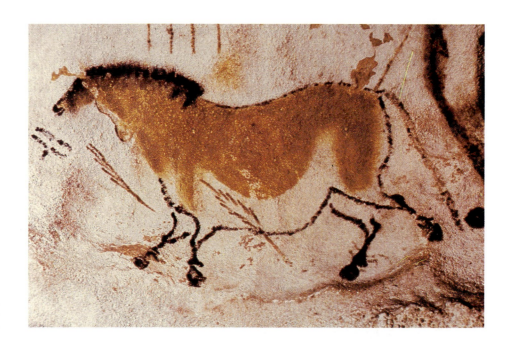

I.2 *PALEOLITHIC CAVE PAINTING.* C.
15,000–10,000 B.C. APPROXIMATELY LIFE-
SIZE. LASCAUX (DORDOGNE), FRANCE.

and even financial investment. For all these reasons, society has supported the visual arts from the beginning of recorded time.

From the first stick figures hesitantly drawn in sand and the earliest animals painted and carved on stone [I.2] until today, people have reacted to their physical, psychological, and religious worlds by making images. The vitality of many of these images has far outlasted the societies in which they were created and first enjoyed. We might say that art is a gift our ancestors left behind from which we all benefit. The ancient Romans called these visual images *arti*, a word they defined as "skills." Artists were trained to be skilled in painting, carving, building, pottery making, and other crafts. Today when we look at ancient works of art, we are respectful of the skills involved in their creation, but we are moved most deeply by their beauty. Such works show us in the days before Columbus [I.4] the functions that art served in their culture. With the legacy of art, which remains long after civilizations have flourished and disappeared, we can see what was important to the societies that preceded us. Art remains our best link with the past, while our own arts will become our gift to our descendants [I.3].

FUNCTIONS OF ART

Throughout the history of civilization, many kinds of art have enriched our lives in some way.

Art and Religion

Our first works of art seem to have been responses to universal human needs to address the mysteries of life or to soothe powerful forces held in fear. The cave paintings [I.2], for instance, have been interpreted as an attempt to

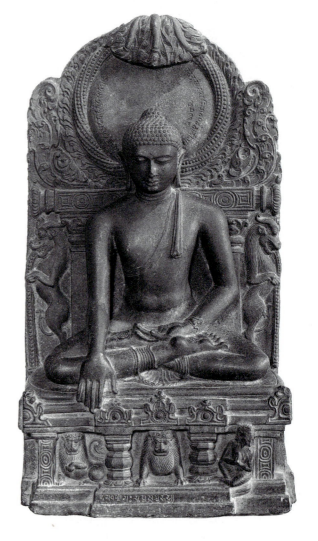

I.4 *BUDDHA AS CONQUEROR OF MARA.* BIHAR, INDIA; PÁLA PERIOD, 8TH CENTURY A.D. CHLORITE; 33 × 17-1/2" (84 × 44 CM). ASIAN ART MUSEUM OF SAN FRANCISCO. THE AVERY BRUNDAGE COLLECTION.

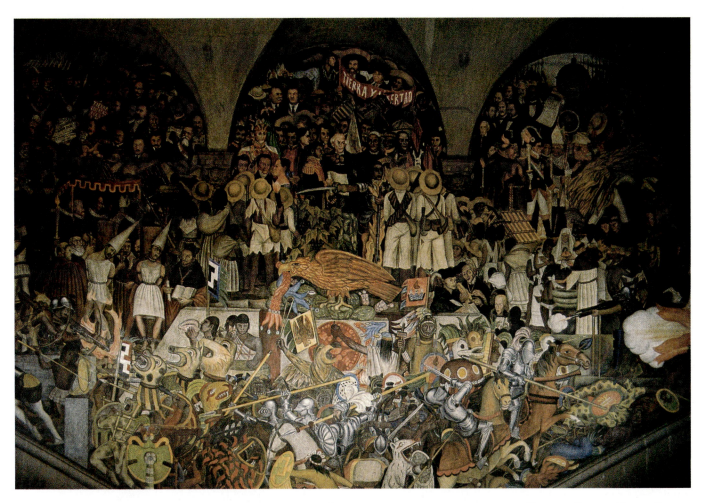

I.3 DIEGO RIVERA. 1950. FRESCO. *HISTORY OF MEXICO, THE WAR OF INDEPENDENCE,* ONE OF A SERIES OF MURALS, NATIONAL PALACE, MEXICO CITY.

gain magical control over the animals on which the Stone Age culture depended, by painting animal images and, later, ritually "killing" the paintings. Works of art have sometimes permitted us to visualize the deities of various religions. We can learn something about people as far away from us as the Chinese when we compare the way they represent God and how differently Christianity shows the deity. (Neither Judaism nor the Islam faith ever pictures God, believing that the second of the Ten Commandments forbids graven images.) Native Americans in Mexico presented a frightening God (Coatlicue) who would destroy them if they misbehaved. Coatlicue's image makes this clear enough [I.20]. However, most Eastern [I.4] and Western religions show God (and the Christian saints) in a spiritual state of peace, far above ordinary human feelings. The pagan classical gods and goddesses were represented in similar ways. In fact, all these images seem to reflect a universal concern for the world beyond everyday living. In addition to enhancing religious ritual, the structure and decoration of churches promote an atmosphere of mystery that encourages feelings of the sublime and of the unknown essential to the religious experience. Works of art can bring to life the eternal truths of religion.

There is a tradition, dating at least from the Renaissance, that identifies the inspiration leading to the highest forms of art as a God-given gift. Many also believe that the spark of the divine considered to be present in artistic genius is in turn imparted to the art as well. Fra Angelico (d. 1455) is said to have sunk to his knees in tearful adoration of the Madonna image he had just finished painting on the walls of a monk's cell! In some Asian societies, an artist is also seen as a medium between this world and the state beyond human life. In our more secular twentieth century, the artist Vasily Kandinsky (1866–1944) [15.8] also believed that art was a product of the human spirit, far beyond manual skill or external vision, and wrote a book about it, *Concerning the Spiritual in Art.* In whatever other ways religion has depended on art, the church has been one of its greatest patrons.

Art and Politics

Art has served to strengthen the power of the ruling forces in societies. Perhaps evolving from the magical properties that early peoples associated with art, the impact of works of art has been recognized by leaders in every era, who have

always used art to their advantage. Like the church, government has provided support for artists who could glorify their patrons (whether individuals or a state) in idealized portraits. Today, our television arts provide an arena for political candidates, as do other mass media, and the most successful politicians are those who understand and use these media to best effect.

Art has also served to register social protest, as in the work of Corita Kent (1918–1986) **[I.5]**, a former nun who chose mass-media formats—posters, and then billboards—for her work. The billboard became the perfect medium in her hands for protest. Artists have often stood outside the social order, either as critics or as pioneers of a new movement. In turn, their work has sometimes provoked censorship (Chapter 9), for governments understand only too well that ideas in visual form have a particular potency.

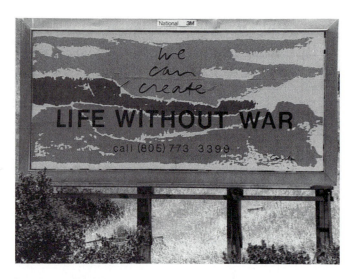

I.5 CORITA KENT. *LIFE WITHOUT WAR.* 1984. BILLBOARD ON HIGHWAY 1, MORRO BAY, CALIFORNIA.

Art and Communication

All over the world, every age and every civilization has recognized that by celebrating significant events with art it became possible to document the past, as in works such

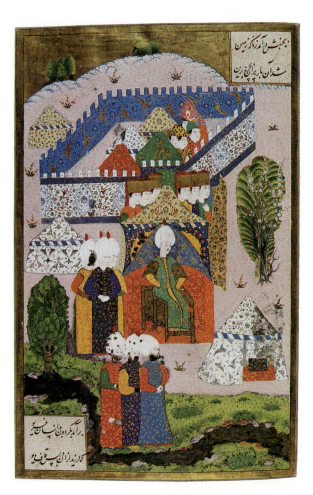

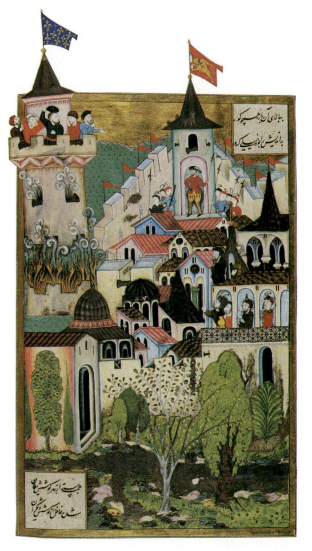

I.6A&B ANONYMOUS. *"SIEGE OF BELGRADE," FROM SÜLEYMANNAME OF ARIFI*, FOLS. 108B–109A. TRANSCRIBED 1558. MINIATURE ILLUMINATION. TOPKAPI PALACE MUSEUM, ISTANBUL.

as the *Süleymanname*, the illuminated manuscript biography of Sultan Süleyman the Magnificent, a sixteenth-century Ottoman ruler [I.6]. It also became apparent that artists could create images of experiences they had never seen, and, probably even more valuable to a leader, that artists could create *illusions* of events that never happened! Artists, like historians, have thus served as society's chroniclers. Since today's technology permits unrivaled accuracy in the ability to record external data, the artist has been freed to assume a role beyond mere recorder of events. In a very real way artists interpret the current scene for us and for future peoples as well.

Art and Commerce

The appreciation of art for itself, for its collectibility, is hardly new. More than two thousand years ago, Attalus of Pergamum and his successors (third to second centuries B.C.) collected masterpieces from the great eras of Greek art. Greek pottery has been found in third-century Ptolemaic Egyptian tombs, and Greek art and artists were imported to Rome and its provinces. There also is a collection of beautiful Asian objects contributed as valuable gifts to the Emperor Shōmu by his countrymen and later stored by Shōmu's daughter in the Shōsōin at Nara, Japan, in A.D. 756 (Chapter 9). In the sixteenth century, the Medici in Florence amassed large collections of classical and contemporary work. Works of art fetch huge prices at art auctions today as an outgrowth of these traditions of collecting. At the same time, art pervades the marketplace—it is used to

sell products, services, and institutions by means of advertising art and illustration; it is used to create and enhance products by means of fashion design, industrial and architectural design, and other related design areas. In a consumer culture, the role of art, either as a valuable commodity or means of promoting sales, takes on increasing importance, as is attested, for example, by the very successful Absolut vodka campaign that features the art of Carole Jeane Feuerman [I.7]. Appearing on the cover of *Forbes* 1989 (international magazine of business) and in *Art* (1990 Japanese publication), and later at Sotheby's Auction House as the freshest marketing strategy ever, Feuerman's sculptures have helped to give Absolut the edge in the business world (Chapter 8).

Art and Aesthetics

Not the least function of art is its ability to enrich the surfaces it adorns and the space it occupies while giving pleasure to the observer. Art is almost universally associated with beauty and an appeal to the senses. These characteristics, noted at least as early as the ancient Greeks, were formalized in 1820 by the German philosopher Hegel into a theory of **aesthetics** generally accepted today. The sensations and emotions inspired by art are for many its most important role, and they accommodate the artist's need for self-expression and satisfaction in the successful execution of his or her visual goals. For example, Gustav Klimt's (1862–1918) brilliantly colored decorative paintings produce a sensuous richness hardly equaled in the history of

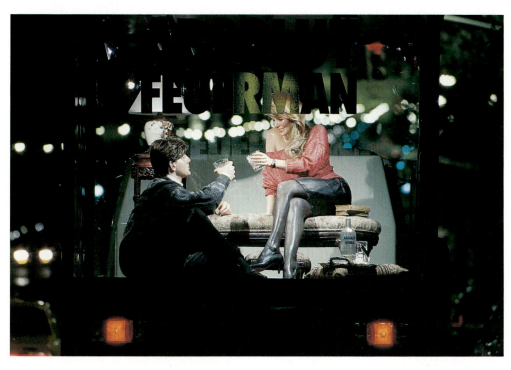

I.7 CAROLE FEUERMAN'S ROLLING TABLEAU. ABSOLUT VODKA AD CAMPAIGN. 1989.

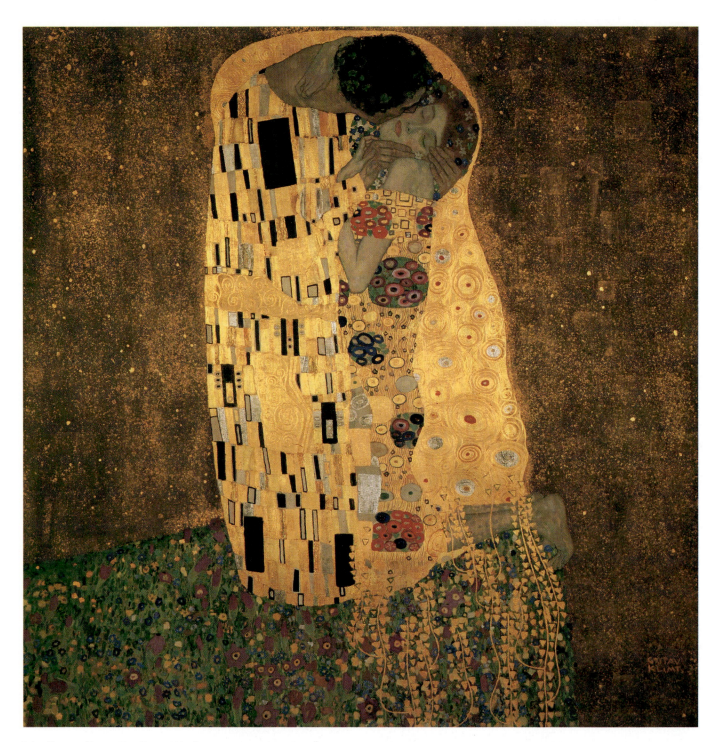

I.8 GUSTAV KLIMT. *THE KISS*. 1908. OIL ON CANVAS, 71 × 71″. ÖSTERRICHISCHE GALERIE, VIENNA.

modern art [I.8]. Arising from this point of view—that is, the aesthetic appeal of art—is the concept of "art for art's sake" to be enjoyed for itself rather than for any of the functions we have already described. No theory of art can be complete that does not encompass our deepest level of awareness, our feelings rather than our intellects. What we view as beautiful or sublime awakens senses that increase our faculty for the enjoyment of life itself.

MEANING

Before the nineteenth century, the basic goals of art were rarely satisfied with the achievement of beauty. More often, art conveyed meaning and expressed important ideas and feelings through arresting images. As Pablo Picasso (1881–1973) once remarked, "Art is not for interior decoration."

There are many kinds of meaning in art. They reflect the fact that art is an expression of thought or emotion and also a response to the world that nurtured the artist. One kind of meaning is the practical role art often plays in society, as discussed above. The purpose it serves and the form it takes reflect the values and concepts of beauty in different times and places.

Another kind of meaning, sometimes closely related to the practical purpose of art, is symbolism. If we are aware of the meaning of religious, political, or other symbols, we will better understand and enjoy a work of art. We may need to study Islamic art to know that Islamic artists often incorporated Arabic sayings from the Koran into their designs, as in the border of this nineteenth-century Persian prayer rug [I.9]. Symbols used in much twentieth-century art may be easier for us to follow because they derive chiefly from contemporary society, but some symbols are so personal to the artist that they remain baffling. Knowing what a car means to many Americans, we are able to decipher some of the messages conveyed in James Rosenquist's (b. 1933) *I Love You with My Ford* [I.10]. Through advertising, we have been persuaded that success in love and possession of "wheels" are closely allied. In the Islamic rug, symbolism was used to strengthen the believer's faith. In the Rosenquist work, symbolism is a means of commenting on a society in which advertising shapes popular tastes, perhaps softening values, like soft, canned spaghetti.

On a more personal level, meaning in art is to be found in the individual approach of the artist. Because everyone observes the world differently, each work of art is unique—a reflection of the artist's perceptions, insights, and experience. For instance, a favorite theme of artists, most of them men, has been women. An artist's approach to that theme reflects both the role of women in the period and the artist's feelings about women. Consider the art

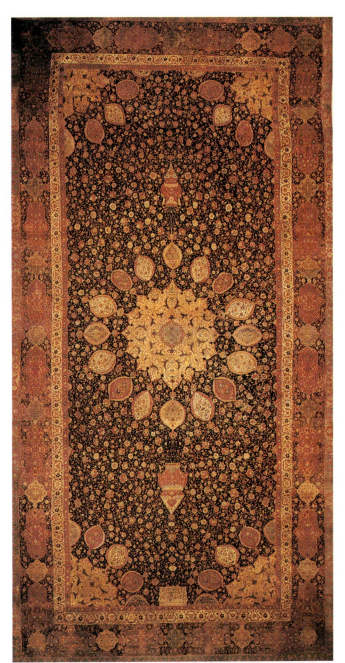

I.9 *Prayer rug.* Maksud of Kashan, Ardabil rug detail (Tabriz, Iran). 1539–1540. Silk warp and weft, wool, 36'6" × 17'6" (11.1 × 5.3 m). Victoria and Albert Museum, London. Bequest of Isaac D. Fletcher, 1917.

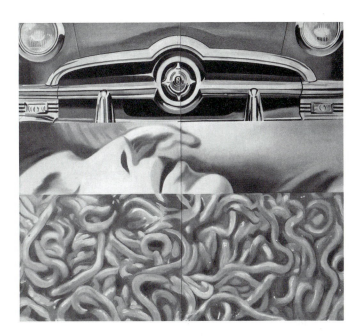

I.10 James Rosenquist. *I Love You with My Ford.* 1961. Oil on canvas, 7'1/4" × 7'11-5/8" (2.14 × 2.43 m). Moderna Museet, Stockholm.

I.11 LEONARDO DA VINCI. *LA GIOCONDA (MONA LISA)*. C. 1503–1505.
OIL ON PANEL, 30-1/4 × 21″ (77 × 53 CM). LOUVRE, PARIS.

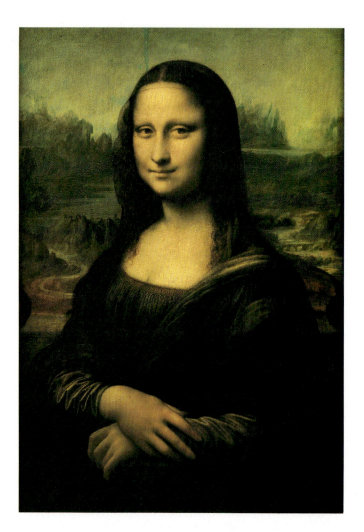

world's most familiar and perhaps endearing Renaissance portrait, Leonardo da Vinci's (1452–1519) *Mona Lisa* [I.11], and Picasso's fractured, cubistic portrait *Ma Jolie* [I.12], rendered in the style he introduced to the twentieth century. A quite different treatment of the theme of womanhood is Marie Guillemine Benoist's (1763–1826) *Portrait of a Negress* [I.13]. All three images record women, but how different was each artist's goal! Although Benoist sensitively records her subject's graceful form, long neck, and full breasts, she emphasizes not bodily features but her subject's quiet dignity and reserve. Benoist was perhaps ahead of her time in her sympathetic portrayal of a black woman.

To express an individual approach, an artist consciously selects certain aspects of the world and eliminates others, adds some items and exaggerates others. In addition to choosing the subject, the artist also adopts materials, colors, and shapes to communicate a particular perception, shaping an image into a full artistic statement. Were it possible to clone nature limitlessly and without change, the result would not be art. It is the artist's choice and approach to the subject or materials that produce significant work.

FORM AND CONTENT

Everyone knows that the same story can be told in many ways. When we retell an anecdote, we consciously select some details and omit others, depending on our audience. In a work of art, the theme or story is the content and the structural way it is told is the form. When Picasso was preparing to paint his great mural *Guernica* to protest man's

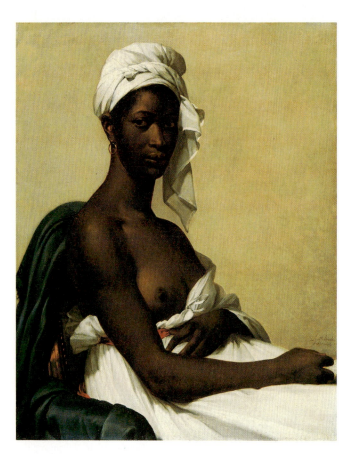

I.13 MARIE GUILLEMINE BENOIST. *PORTRAIT OF A NEGRESS*. 1800.
OIL ON CANVAS. 31-5/8 × 25-3/4″ (81 × 65 CM). LOUVRE, PARIS.

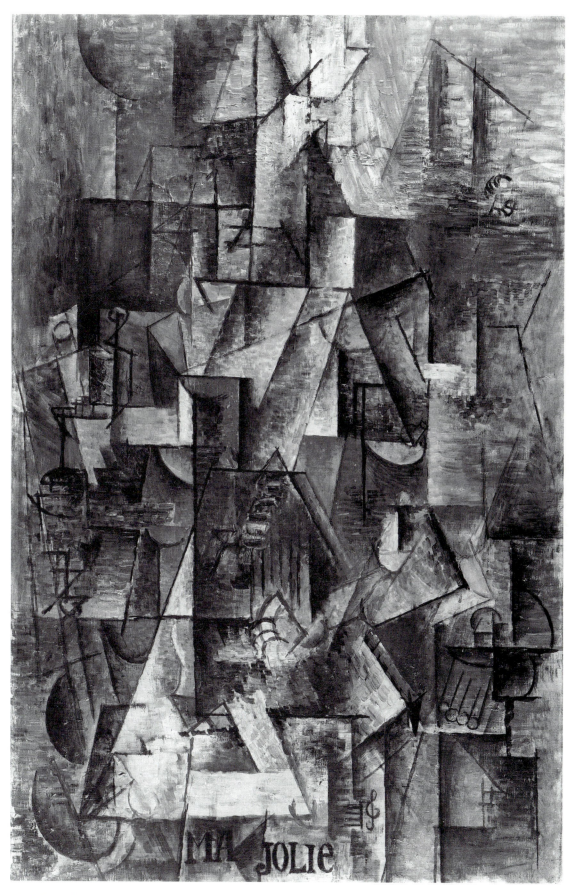

I.12. PABLO PICASSO. *MA JOLIE*. 1911–1912. OIL ON CANVAS. 39-3/8 × 25-3/4″ (100 × 65 CM). COLLECTION, THE MUSEUM OF MODERN ART, NEW YORK. ACQUIRED THROUGH THE LILLIE P. BLISS BEQUEST.

I.14 PABLO PICASSO. STUDY FOR *GUERNICA*. 1937. PENCIL ON GESSO ON WOOD, 25-3/8 × 21-1/16" (65 × 54 CM). MUSEO DEL PRADO, MADRID.

inhumanity to man by showing the bombing of a town during the Spanish Civil War, his preliminary drawings of the bull **[I.14]** took many forms; the content was somewhat altered in the final work **[I.15]**. The bull is probably the oldest subject of art in Western civilization. Appearing even earlier than images of human beings, the bull can be traced from Paleolithic times in the Lascaux caves in France **[I.2]** to a dominant culmination in *Guernica*. The bull of the mural is perhaps a symbol of persecuted innocence or of unfeeling, brute force. Its massive form is balanced by the figure in the burning building on the right. Although Picasso seems to relate the bull and the victims of

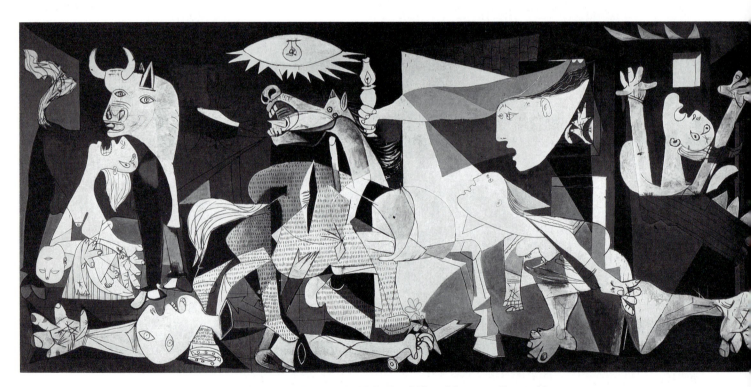

I.15 PABLO PICASSO. *GUERNICA*. 1937. OIL ON CANVAS, 11'5-1/2" × 25'5-3/4" (3.49 × 7.77 M). MUSEO DEL PRADO, MADRID.

the destroyed town of Guernica to the misery of war-torn Spain, he never gave us an explanation of the painting, maintaining that art tells its own story. His studies for the bull, the only stable element of the composition, reveal many changes in form from a **Classical** image to its finished state, quietly dominating the composition with enigmatic countenance. The horror of Guernica's story remained the same throughout the many changes in Picasso's presentation.

Sometimes an artist must be adventurous and creative to lead us into his or her vision. Sometimes artists present us with visual statements based on the familiar world but presented in new, often disturbing ways. It takes courage to depart from tradition and to upset visual conventions; but by tossing away preconceptions, the artist can often bring us a new reality with new symbols and a fresh point of view.

In *The State Hospital* **[I.16]**, Edward Kienholz (b. 1927) has assumed the mantle of social concern worn in the eighteenth century by William Hogarth (1697–1764). Both artists force us to confront an unpleasant scene behind the facade of a public institution. Hogarth's print of

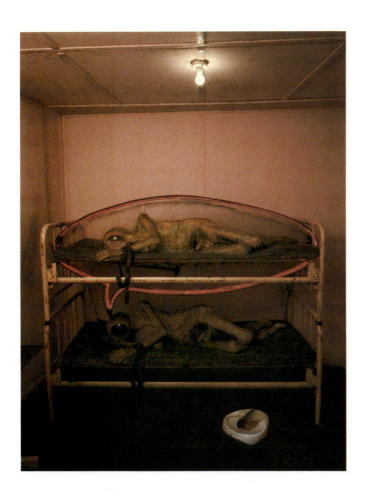

I.16. EDWARD KIENHOLZ. *THE STATE HOSPITAL*, DETAIL. 1966. MIXED MEDIA, 8 × 12 × 10′ (2.44 × 3.66 × 3.05 M). MODERNA MUSEET, STOCKHOLM © EDWARD KIENHOLZ.

Bedlam, London's insane asylum [I.17], clearly reveals the degeneration of a nobleman, straitjacketed after a night of indulgences, a fitting end, in Hogarth's opinion, to the evils of excess in food, sex, and drink. Kienholz's representation of a cell block is perhaps more indirect. At first, we view the tableau with curiosity, until we realize the old man is chained to his cot. Details of horror appear in this victim of modern civilization, a living skeleton with mottled, leathery skin stretched over it. The duplicate upper figure, set off in cartoon style by neon tubing, may represent the old man's imagined self, lit up like a fish for all to see. The head of the lower figure has been replaced by a bowl in which a live fish darts fitfully. *The State Hospital* suggests loss of personal status. Kienholz dramatizes the plight of the elderly and the infirm who struggle for self-worth within a public institution that deprives people of all individuality and pride. Contrast the different structural forms of these two works, both portraying weaknesses of society. Is today's artist more powerful because the approach to art has changed to satisfy a new age? Surely, both works achieve the artists' intentions of arousing strong responses from their viewers.

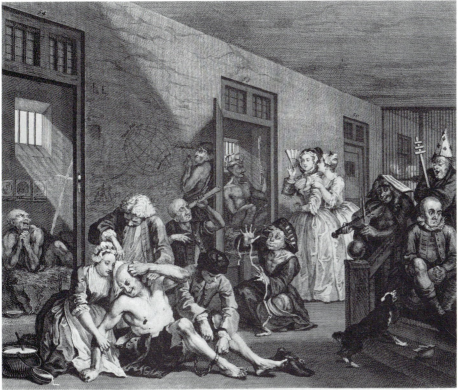

I.17 WILLIAM HOGARTH. *IN BEDLAM*, FROM *THE RAKE'S PROGRESS*. C. 1734. INTAGLIO, 15-1/8 × 12-1/4″. THE METROPOLITAN MUSEUM OF ART, HARRIS BRISBANE DICK FUND, 1932.

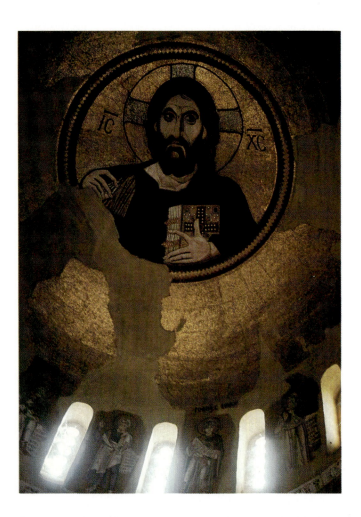

I.18 *Christ as Pantocrator.* c. 1080. Mosaic. Dome of the Church of the Domition, Daphni, Greece

ICONOGRAPHY

Closely allied with form and content is **iconography**, the traditional images in a work of art, especially religious, that have symbolic meanings for everyone. For instance, conventional iconographic images of the Buddha **[I.4]** or Christ **[I.18]** do not need to be labeled for identification by the devout. Many major works in Eastern and Western art history make religious, historical, or literary associations that are familiar to most and explain the differences of people's beliefs about the deity depending upon the cultures from which they came.

To avoid persecution during early periods of Christianity, artists translated religious themes into symbols that were clear only to those initiated to the faith. We still use the wedding ring as a sign of eternity—there is no beginning and no end—just as the circle promised everlasting life to the first Christians. The vocabulary of these symbols became so elaborate during the next twelve hundred years that when the Master of Flémalle (probably Robert Campin, c. 1378–1444) in precise detail painted the richly colored *Mérode Altarpiece* **[I.19]**, practically every object in the picture bore some religious significance, represented by a method known as disguised symbolism. The central *Annunciation* scene depicts the Virgin as a middle-class Flem-

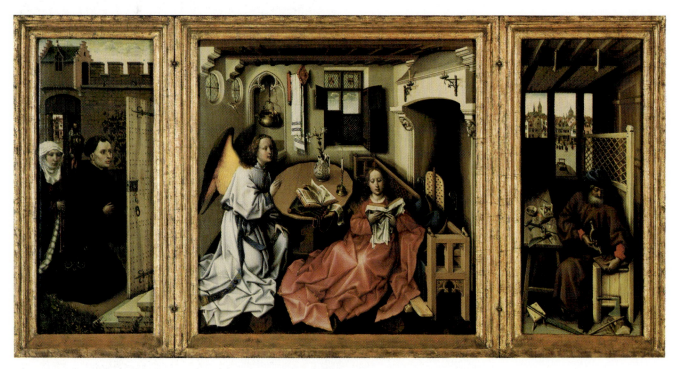

I.19 Robert Campin. *Triptych of the Annunciation.* c. 1426. Central panel, *The Annunciation;* left wing, *Kneeling Donors;* right wing, *Joseph in His Workshop.* Oil on wood; center panel, 25-1/4 × 24-7/8″ (64.1 × 63.2 cm); wings, 25-3/8 × 10-3/4″ (64.5 × 27.3 cm). The Metropolitan Museum of Art, The Cloisters Collection, 1956.

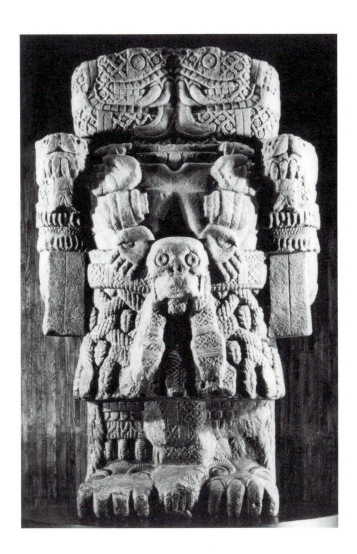

I.20 *COATLIQUE (GODDESS OF EARTH AND DEATH). AZTEC, 15TH CENTURY. BASALT, HEIGHT 8'3" (2.51 M). NATIONAL MUSEUM OF ANTHROPOLOGY, MEXICO CITY.*

an iconography that we can partly understand despite its unfamiliarity [I.20]. Reflecting the warlike Aztec belief in the need for human sacrifice to satisfy the sun god, human skulls, a universal symbol for death, decorate the sculpture. Coatlicue's head consists of two serpents facing each other whose eyes, viewed frontally, dominate a formidable force! She wears a necklace of hands and hearts with a pendant skull and a skirt made of intertwined skulls and serpents. Where harmless snakes are benign and so common in the Americas, their appearance as deities may also represent forces for good. Quetzalcoatl, for instance, represented in any of three images (bird-serpent-god effigy) [I.21] is considered a savior by the Toltec Indians. As we can see, no symbolism that is strange to us can be really understood or fully appreciated without knowledge of its iconography.

Important images in any culture are sometimes called **icons**; in such cases the image itself stands for what it represents. For example, in the Greek or Russian Orthodox religion, a two-dimensional image of Christ [I.18] may be considered sacred and treated with veneration; similarly,

ish woman, virgin-pure as attested by the spotless room, the vase of lilies, and the immaculate bronze kettle hanging on the back wall. Seven rays of light stream through the window pane toward the Virgin's ear, through which she was believed to have conceived the infant Jesus. The wooden table and bench and the partition isolate her from all other physical contacts. A tiny child bearing a cross, harbinger of future events, hovers in the "divine light" over the angel Gabriel's head. The gray-haired Joseph, the carpenter, fashions mousetraps, symbols of the trap for Satan, with the birth of Jesus expected to serve as the bait. Gabriel's counterpart, an earthly messenger, stands respectfully just outside the flower garden, another reference to Mary. There are many other symbols within the *Mérode Altarpiece*; they are less significant, perhaps, and in any case require further specialized knowledge of Renaissance iconography to understand.

From a different culture and with a fearsome view of God, but in the same millennium, came a figure of the ferocious Coatlicue (Aztec deity of earth and death) with

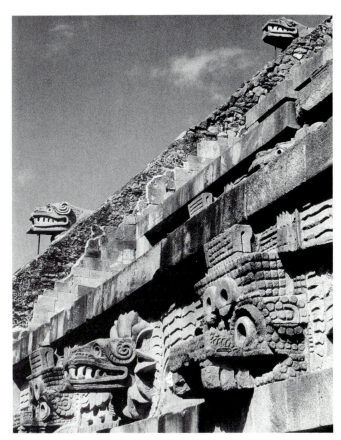

I.21 *TEMPLE OF QUETZALCOATL, TEOTIHUACAN, NEAR MEXICO CITY. 300–700 A.D.*

the familiar image of the American flag is seen by some to exemplify patriotism. Jasper Johns (b. 1930) devoted a whole series of works to the flag theme, questioning the role of the patriot. Many of those who viewed Johns' work thought it was radical and inflammatory. Yet these **Pop Art** paintings of the late 1950s and 1960s would have had no meaning to observers unfamiliar with the iconographic symbol of a modified American flag painted in unusual colors [I.22]. Therefore, understanding of the iconography and the culture that produced a work of art can greatly enhance our appreciation of it—or at least our ability to react to it.

STYLE AND SUBJECT

Closely related to form, content, and iconography are style and subject. Most people look at a work of art for what is shown, such as a landscape or a portrait. Although the theme may be considered the most obvious element of the work, full appreciation demands much more than recogni-

tion of images. The viewer must go past the obvious subject to consider form and style. Style is the individual approach an artist takes in his or her art. Artists consciously and subconsciously choose to work in a certain way according to what they wish to express and in doing so reveal different personal styles. Thus the work of well-known artists can often be identified as easily as the FBI distinguishes fingerprints. Art experts can even quickly recognize an artist's works that they have never seen before, if they are familiar with the artist's style.

As an example of personal style, consider Rosa Bonheur (1822–1899), whose forceful approach projected the artistic strength she needed to compete in the nineteenth-century art world dominated by men. She chose active subjects in energy-charged compositions, painting them carefully with the technical precision required for exhibition at the French Academy. *The Horse Fair* [I.23] typifies her style: vitality in the poses of her subjects, skill in rendering texture and color, and, above all, sure knowledge of complex composition, involving rhythmic inter-

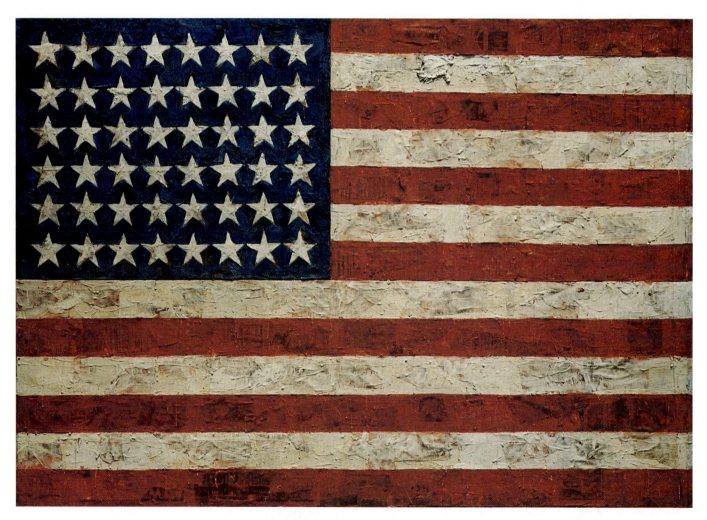

I.22 JASPER JOHNS. FLAG. 1954. ENCAUSTIC, OIL AND COLLAGE ON FABRIC MOUNTED ON PLYWOOD; 3′6-1/4″ × 5′5/8″ (107.3 × 153.8 CM). COLLECTION, THE MUSEUM OF MODERN ART, NEW YORK. GIFT OF PHILIP JOHNSON IN HONOR OF ALFRED H. BARR, JR.

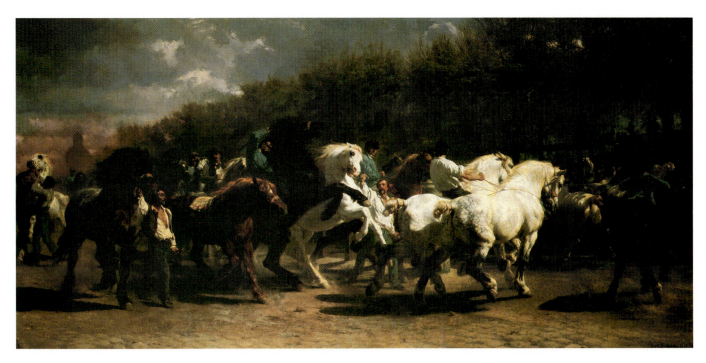

I.23 ROSA BONHEUR. *THE HORSE FAIR.* 1853–5. OIL ON CANVAS. 96-1/4 × 199-1/2″ (244.5 × 506.8 CM.) THE METROPOLITAN MUSEUM OF ART. GIFT OF CORNELIUS VANDERBILT, 1887.

penetration of space. Romare Bearden (1914–1988), in contrast, developed his use of **photo montage** in a uniquely personal style. His work characteristically involved assembled pieces of photographs and paint arranged in **Cubist**-inspired compositions of urban blacks. The vitality of his art is based on the contrasting shapes and textures of his figures and their unexpected sizes, which are rarely faithful to reality [**I.24**]. An impossible seascape may be glimpsed through a bedroom window, while utensils and other objects within violate gravity, floating in the orderly disorder of a room that cannot quite be believed.

Style is also, however, more than a personal approach. It is a way of treating a subject that may be shared by many artists who belong to a particular historical period or cultural region or who have a similar point of view. Thus, subject matter may be representational, abstract, or nonobjective, depending on how faithful the artist is to the appearances of the real world.

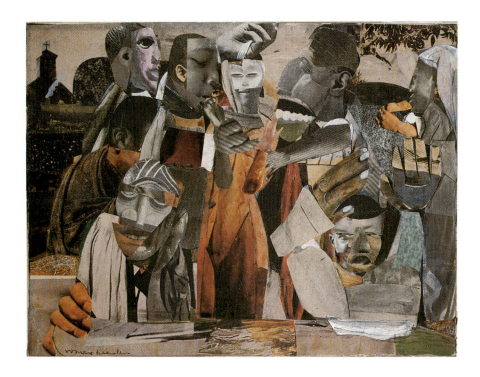

I.24 ROMARE BEARDEN. *PREVALENCE OF RITUAL: THE BAPTISM.* 1964. PHOTOCHEMICAL REPRODUCTION, SYNTHETIC POLYMER AND PENCIL ON PAPERBOARD. 9-1/8 × 12″ (23.2 × 30.5 CM). HIRSHHORN MUSEUM AND SCULPTURE GARDEN, SMITHSONIAN INSTITUTION. GIFT OF JOSEPH H. HIRSHHORN, 1966.

I.26 DETAIL OF I.25

Representational art reproduces the world we know with minimal change from the appearance of things in everyday experiences. Clearly, Piet Mondrian's (1877–1944) early landscape painting of 1906 was dominated by a large tree hanging over an isolated farmhouse **[I.25]**. The style is representational and direct. Yet, as we examine enlarged details, we note the artist's early concern with the pattern created by the tree's branches and his emphasis on the horizontal and vertical divisions of the shingles.

Abstract art alters the view of a real world, retaining only the essence of a thing or an idea, while freely

changing qualities of the original. Mondrian's first interest in the tree he undertook to paint appears to have been gradually expanded to focus on the spaces trapped by the tree's branches, which primarily form a horizontal and vertical pattern **[I.26]**. The detail of branches seems to have been an early step that led to his eventual total concentration on the whole tree and then on horizontal and vertical design.

Nonobjective art [I.27], also called nonrepresentational or nonfigurative art, depicts no recognizable object or clear reference to the real world. Had we not studied

I.25 PIET MONDRIAN. *LANDSCAPE.* 1906. OIL ON CANVAS. 34 × 42-3/4″ (56 × 109 CM). PHILADELPHIA MUSEUM OF ART: PRIVATE COLLECTION.

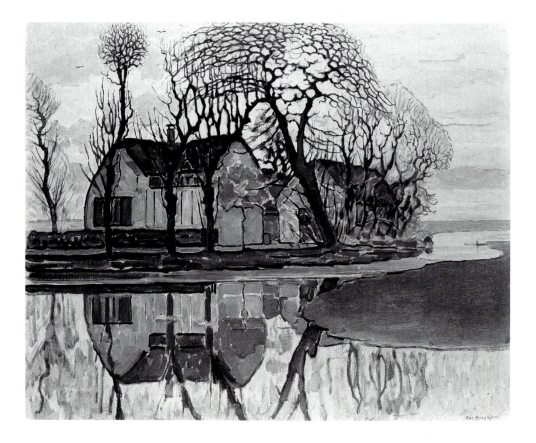

I.27 PIET MONDRIAN. *COMPOSITION V.* 1914. OIL ON CANVAS, 21-5/8 × 33-5/8″ (54.8 × 85.3 CM). COLLECTION, THE MUSEUM OF MODERN ART, NEW YORK. THE SIDNEY AND HARRIET JANIS COLLECTION.

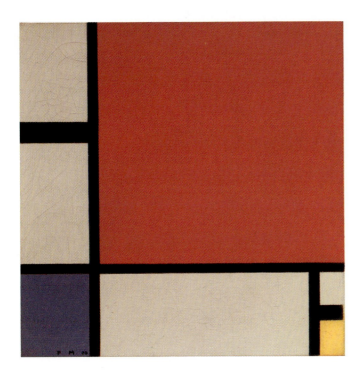

Mondrian's early work, tracing the evolution of his nonobjective compositions, we would be unaware that what became his lifelong preoccupation **[I.28]**, the "essential plastic means of art"—line and color free from any particular subject—may have been originally inspired by a farmhouse, a tree, and its branches.

In this book we will review the different areas of the visual arts and the history of the arts of various peoples. As a preliminary to our study, we will consider creativity and our responses to it. We will also explore the basic elements common to all the visual arts, such as line and color; and the principles of composition, such as unity, balance, rhythm, and proportion. Throughout, we will examine how current technology and the skill required to master it interact with works of art past and present.

I.28 PIET MONDRIAN. *COMPOSITION WITH RED, YELLOW AND BLUE.* 1930. PRIVATE COLLECTION, ZURICH.

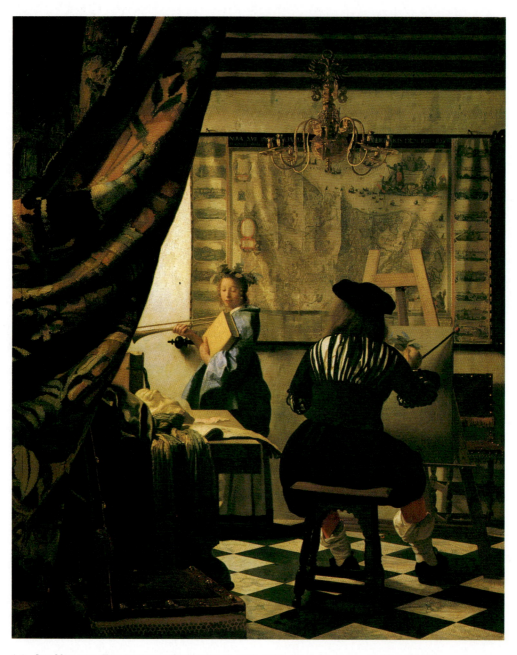

1.1 Jan Vermeer. *The Artist in His Studio.* c. 1665–1670. Oil on canvas. 47-1/4 × 39-3/8″ (120 × 100 cm). Kunsthistorisches Museum, Vienna.

Part One
The Creative Impulse

Art has become a part of human existence, as necessary in our lives as the other languages we use to communicate with each other.

Think about it for a while, and perhaps you will agree that art is really a kind of visual language. Those of us who make art and those who can only admire it find that art also helps us to understand each other and to identify our feelings about the world around us. The images that express our ideas go a long way toward explaining life itself.

Our ability to experience images as art grows with our capacity to view it, to understand it, and appreciate its creativity. Because all of us have the potential to be creative, a good place to begin expanding human awareness is by examining creativity in art. The studies of psychologist Erich Fromm in 1959 in *Creativity and Cultivation* in 1959 may guide our explorations:

> . . .What is creativity? The best general answer I can give is that creativity is the ability to see (or to be aware) and to respond.

Creation and Response

"*T*he making of a work of art may be a treasure hunt in which the seeker understands what he is looking for only when the job is done. The essence of creation lies in the recognition of beauty when it occurs. Picasso said, "I do not seek, I find. . ." I believe that the way to learn about where one is as a creative person is to be involved with life. . ."

—LIPPOLD, SCULPTOR, 1973

• • •

"*T*o draw lines and mix colors does not qualify one as an artist, but as a simple craftsman; it is a purely mechanical activity—whereas painting concerns the mind."

—FÉLIBIEN, ARTIST, 1667

• • •

"*I*n painting ... there are no longer any masters, since there are no longer any pupils. There are only artists without certitude who submit themselves to uncertain influences."

—APOLLINAIRE, PHILOSOPHER/WRITER, C. 1910

Experiencing art can provide great joy; sometimes surprising us about ourselves, our society, and, above all, our relationship to our world. Many people find art enjoyable and fascinating; yet others find it bewildering, or unskillful. Its variety echoes the complexity of the world and the broad differences in artists' reactions to it—as far apart as our own responses to art. In many situations, what the artist is revealing about our society and ourselves may not be welcome. But if we shut our eyes to everything that seems unpleasant or difficult to understand, if we refuse to expand our horizons or to look at art with a sense of adventure, we will surely lose the opportunity to profit from an artist's message. Certainly, pioneering artists will suffer, but the greater loss is likely to be our own.

Today some form of art enters most aspects of our lives—in our homes, on the job, and at play. It speaks to the conscious and subconscious, to our intelligence and to our emotional being. Yet we tend to think of art as something so mysterious or complex that only an artist, scholar, or critic can fully understand it. The creative process, in fact, *is* as complex as life itself [1.2]; but as we observe it closely, we find that we, too, can better understand it and perhaps foster it in ourselves, as well as enjoy it with each work of art we view.

CREATIVITY

In the West we have a tradition of attributing creativity to something we call the imagination. The "imagining" of an idea—some call it visualization—may take place in one's mind long before any actual images are formed. Perhaps this is the route that most artists take, that is, creating art

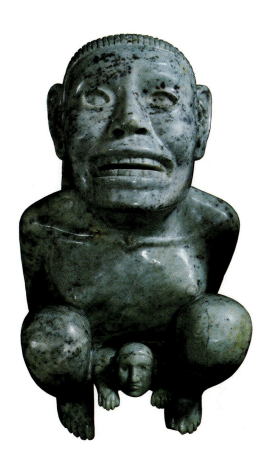

1.2 AZTEC. *GODDESS TLAZOLTEOTL IN THE ACT OF CHILDBIRTH.* APLITE WITH GARNET INCLUSIONS, 8 × 4-3/4 × 5-7/8". DUMBARTON OAKS PRE-COLUMBIAN STUDIES, WASHINGTON, D.C.

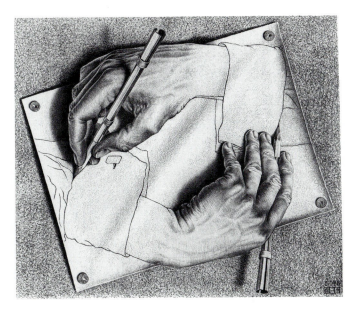

1.3 M.C. ESCHER. *DRAWING HANDS.* 1948. LITHOGRAPH, 11-1/4 × 13-3/8" (29 × 34 CM). © 1948 M.C. ESCHER/CORDON ART-BAARN, HOLLAND. COLLECTION HAAGS GEMEENTEMUSEUM, THE HAGUE.

by following a mind's-eye view and realizing it in art materials. Of course, other ideas may feed into the creative process as the work of art evolves; but the seed of that initial concept has usually determined the intensity of the work.

Universal Expressions of Creativity

Everyone can share in the impulse to create, although we are not all creative to the same degree. If you ever held an audience spellbound while telling a story or produced ideas you really cannot remember seeing anywhere, you have been close to inspiration—and to the exhilaration that comes from creating something where nothing existed before. The Dutch artist M. C. Escher's (1898–1972) print *Drawing Hands* reflects creativity endlessly [1.3]. Exactly how the creative process begins is hard to pinpoint, but we do have some theories.

Left vs. Right Brain Creative Functions

Scientific research has been helpful in mapping the human brain according to its areas of specialized functions and in so doing has helped us to better understand the mechanics of creativity. It is now widely accepted that the two halves of the brain, the right and left hemispheres, have specialized and complementary modes of functioning. In most people, the left hemisphere dominates, controlling verbal, logical, and motor skills; the right hemisphere seems superior at perceiving and remembering visual patterns, at processing emotional responses, and at monitoring one's actions. This left-brain domination coincides with right-handedness, which is by far more widespread than left-handedness.

According to British psychologist Marian Annett, more than twice as many artists, musicians, mathematicians, and engineers are left-handed than would occur by chance. Both Michelangelo and Leonardo da Vinci were left-handed. The inclination of the right hemisphere toward superior perception in visual patterns and memory also suggests the importance of the right hemisphere in artistic creativity, a theory that psychologist Dr. Betty Edwards has substantiated with exercises that call upon the right side of the brain. Basically, however, despite what split-brain research has discovered about their specialized functions, the two halves of the brain do operate as one unit. It is likely that creativity in everyone fluctuates from left to right cortex, with the degree of dependency on either side determining how we make our choices.

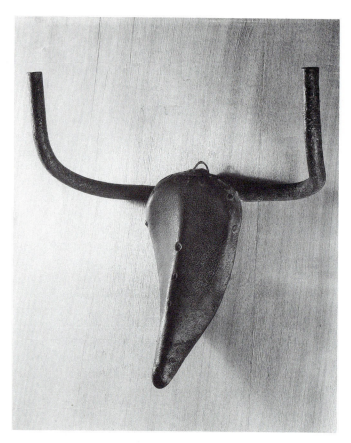

1.4 PABLO PICASSO. *BULL'S HEAD.* 1943. BRONZE, HEIGHT 16″ (41 CM). MUSEE PICASSO, PARIS.

Creativity Through Inspiration

Most artists call the process of creativity simply inspiration. Scientists have defined four stages. Probably we all explore this process at one time or another.

1. Observation: intake of data, examination of tools and materials, unformed ideas, curiosity

2. Gestation: conscious and subconscious realignment of disorganized insights, time out

3. Inspiration: flashes of intuition and intimation of solutions, excitement

4. Verification: conscious, organized evolution and culmination of project

Artistic experiment for its own sake is simply not enough, and rarely is invention itself the goal of any artist. The process of creativity with inspiration often leads to significant contributions, but no artist can count on a masterpiece at the end of the road. Television and the film industry often portray artists as if they were driven by creative urges when, in fact, few arise with the conviction that they will produce a work of art before the day is out. Most artists are committed to spending time in the studio, sometimes on a scheduled basis,

where ideas, perhaps perceived at another time and place, can be reworked into art. The laboratory for art has always been the artist's studio, a favored subject for the artist since the time of Jan Vermeer [1.1].

Picasso explained the process simply when he said, "I do not seek, I find." His *Bull's Head* probably evolved from an idle observation of a discarded bicycle. With a flash of inspiration, Picasso quickly repositioned the elements into a witty sculptural expression of a primal motif in Western art—the bull. We in turn are delighted by the unexpected origin of the new form [1.4].

Human beings seem to have a need for clarity and order. Artists in particular search for understanding and ultimate truth about the world, often with the diligence we associate only with scientists. Why do you suppose that Renaissance artist Leonardo da Vinci recorded thousands of exploratory details of anatomy, botany, and mechanics? His notions of ballistics certainly predated modern projectiles. He also examined human physiology by studying such things as bone formations and the human head.

Usually, however, the artist's purpose is to know nature well enough to comment about the world through art. Artistic inspiration transforms the world we know

through skilled use of shape and mass; line, light and shade; values, color, and texture. The artist may abstract from nature and reinterpret it to give us heightened aesthetic experiences, just as Henri Matisse's (1869–1954) *Seated Woman* [1.5] may have been derived from a similar, rather uninspired pose of this model [1.6].

Creativity in Children

What we admire most in creative people—freshness of viewpoint, unique kinds of self-expression, and new approaches to everyday living—appears quite naturally in children. Certainly the child who dresses in her mother's clothes plays out a creative fantasy. This creative impulse is born in the child and is frequently stifled by demands from the adult world. By examining how a child develops artistically, springing from a universal urge to share ideas, we gain a notion of how the power of expression grows. Such insights may tap our own wellsprings of creativity or, at the least, aid us in the appreciation of others'.

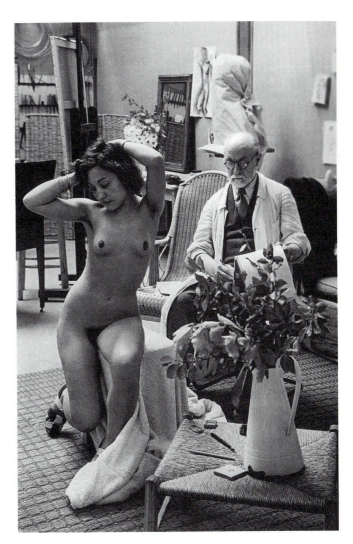

1.6 Brassai. *Henri Matisse Drawing a Nude Model.* 1939. Silver print. 18 × 24 cm. © Gilberte Brassai.

1.5 Henri Matisse. *Seated Woman Seen from the Back.* 1940. Pen drawing

Probably most children are born with creative aptitude. Children reach out to their environment, continuing to investigate the world until they are stopped or discouraged. In those early stages, few are able to withstand outside intervention. Psychological tests confirm that youngsters are very vulnerable to positive or negative reinforcement from those they respect the most—parents and teachers.

Born imitators of what they see, children learn to cope with an adult world by copying everything around them. Such imitation is expressed as much through art as through anything else. By age two, with some visual-motor control, children begin to draw swinging-arc scribbles that some psychologists see as most significant, representing centeredness in the child. Children begin a slow departure from the circular form around age three, moving to rectilinear shapes at four and back to complex circles by five.

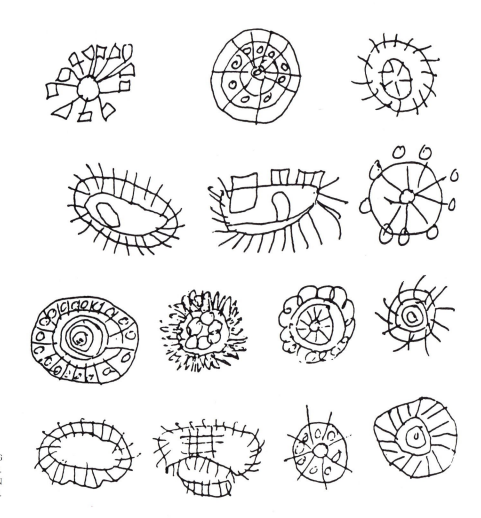

1.7 Children's sun-like figures during three-year-old's mandala phase. Identified by Rhoda Kellog, specialist in children's drawings.

1.8 Janna Russell. The American Museum of Natural History. 1962. 13 × 17-1/2" (33 × 44.5 cm).

These sunlike figures [1.7], noted child authority Rhoda Kellog believes, represent the self to a child. Children's early drawings rarely show the same thing very long. Soon they become interested in differentiating the people they draw. With age, their repertoire increases. At this point, we may say that the child has entered the "golden age" of self-expression, when an innate sense of design prevails.

Much of children's art becomes involved with storytelling, both from their own worlds and from the books they are learning to read. At age seven, a child's figures are more controlled; though the choice of colors is limited by what is available, the production of textures is inventive, with the resultant image full of life [1.8].

There is a universal quality in the artwork of all children. Inventiveness tends to persist if individual self-expression is encouraged. On the other hand, children soon lose the urge to produce unique images when they are provided with coloring books and other "charted" art materials. How much the evolution of an artist is dependent on encouragement, imitation, or inherited abilities has yet to be determined. Yet children's creativity assures us that creativity exists in all of us and may enrich our lives at any point if we let it happen.

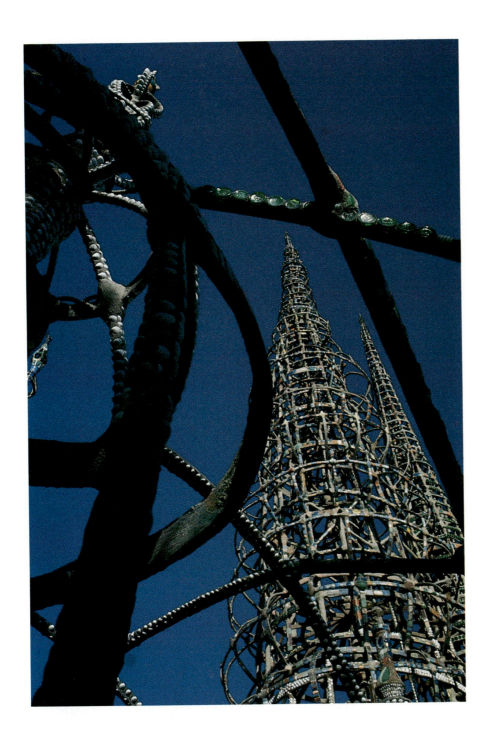

1.9 SIMON RODIA. *WATTS TOWERS*, LOS ANGELES. C. 1921–1954. NOW BEING RESTORED AND STABILIZED.

Everyman as a Creative Artist

Working with the unhampered spirit of invention we have seen in children, an uneducated immigrant tile-setter, Simon Rodia, tried to express his gratitude to his adopted new land by meticulously building fantasy towers to God in his own tiny backyard in the Watts section of Los Angeles. Laboring for thirty-three years, using materials discarded from a lifetime's employment on small jobs [1.9], Rodia maintained a modesty in dramatic contrast to the fierce devotion many give to the "Watts Towers," as they are commonly known today, saying

I no have anybody help me out...
I never had a single helper.
...Some of the people...
think I was crazy
and some people said...
I wanted to do something
for the United States
because I was raised here
you understand?...
because there are nice
people in this country.

Sabatino "Simon" Rodia

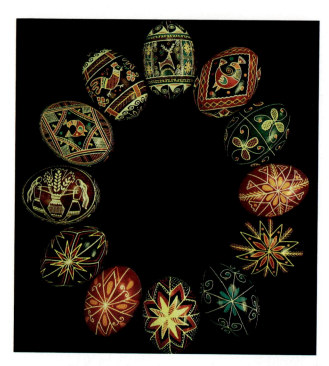

1.11 UKRAINIAN EGGS. PHOTO COURTESY UKRAINIAN GIFT SHOP, INC. MINNEAPOLIS.

Embellishing a severly disadvantaged area, Rodia's artwork enriches and distinguishes the life of the community and its inhabitants, many of whom have little other reason to feel special.

Perhaps graffiti on subway cars and other public places indirectly derive from the same universal need for self-expression and recognition. Our acceptance of these and the many wall paintings that spring up on abandoned buildings as expressions of art depends on the degree of skill they demonstrate and their conformity with the vocabulary and language of art that most of us are familiar with and respect. To many in the city, these anonymous works brighten an otherwise dreary cityscape. In turn, the vitality and social criticism of graffiti have influenced such trained artists as Keith Haring (1958–1990), who used unoccupied subway advertising sites for his work [1.10].

Creative Folk Art

The term **folk art** is applied by many to any art or craft by untrained artists, such as Simon Rodia. More precisely defined, however, folk art describes work stemming from long-standing traditions outside the mainstream of academic teachings. Craftwork by the Amish, for instance, is readily identified by the decorative patterns that have been repeated for generations. The wonderful and delicate craft of Ukrainian egg painting has been famous for hundreds of years [1.11]. Yugoslav glass painting is distinguished by the brightness of its colors and the constant vitality of its forms. In fact, almost all folk art has the same decorative goals— that is, making something wonderful of simple materials and sparing no amount of time to do so.

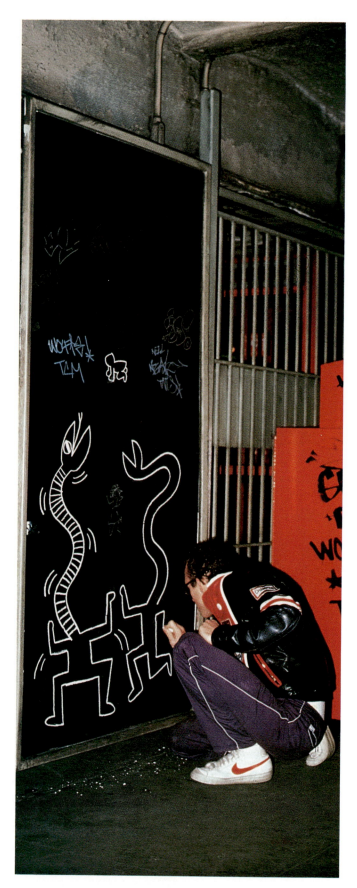

1.10 KEITH HARING. SUBWAY DRAWING. 1982. CHALK ON BLACK PAPER, DESTROYED. PHOTOGRAPH BY TSENG KWONG CHI. © MUNA TSENG DANCE PROJECTS INC.

Art Talk

Vincent van Gogh's letters to his younger brother, Theo, confirm a closeness between brothers that existed unto death. But in the beginning, when the bond was formed, Vincent was the care giver.

The third child, Theo [1.12] was honored with the name of his father, the pastor in their hometown, Zundert, Holland. As the village pastor, Theodorus van Gogh had no special gifts, but he and his pious wife were unusually progressive in many ways. The cost of educating the children, including the girls, was half their total annual income. Military conscription was a fact of life in Holland, and Father van Gogh made additional financial sacrifices to relieve his sons of military service.

An early influence on the boys was three of the pastor's brothers, who served as art dealers. Uncle Vincent later became a partner in the internationally famous Goupil & Co. in a suburb of Paris, so it's not surprising that at almost sixteen years of age, both boys—first Vincent, then Theo—chose art dealership as their professions. Each served first at Brussels, Belgium, and then at The Hague. But unlike Vincent, Theo was quickly successful, even moving to his employer's home as early as 1873.

Yet Theo's letters reveal a melancholy unusual in one so young—a matter of concern to Vincent who wrote (Letter 40) in 1875: "...I am writing again, for I know that there are sometimes hard, barren stretches in life's path. Keep courage, lad, sunshine follows after rain." In the next years, although Theo's life became more secure, it became clear that an unhappy love affair continued to depress him. Vincent's letters to Theo offer support, encouragement and guidance, and reveal the remarkable bond that deepened with each passing year. Yet as Theo's life stabilized, Vincent became more and more spiritual with the fervor that marks evangelism.

Before moving to the south of France, Vincent stayed with his brother in Paris. Describing their time together, Johanna van Gogh-Bonger (Theo's wife who, after their deaths, arduously, yet lovingly, assembled The Complete Letters of Vincent van Gogh, 1958 edition, a collection of the brothers' correspondence) writes: "Of all that Theo did for his brother, perhaps nothing entailed a greater sacrifice than his having endured living with him for two years."

Yet, they soon made peace and, until their deaths, were never closer. Theo wrote to his youngest sister in 1888, "...Vincent left Sunday for the South... When he came here two years ago, I did not think we should become so attached to each other . . . but a person like Vincent is hard to replace . . . I am sure that he will make a name for himself while he still has certain number of years to live . . ."

Theo devoted those years fully to his brother's career, which was not too easy with Vincent's enormous mood swings and hospital bouts. But he considered Vincent close to genius and his mission in life was to sustain him. A brief interlude of distress between the

1.12 THEO VAN GOGH.

brothers followed Theo's marriage to Johanna, but, with the birth of the son they named for Vincent, the rift was healed.

In July 1890, the following year, in the sun-drenched fields in southern France that Vincent loved so well and where he had once hoped to form an artist's colony, he killed himself in a momemt of despair. Within six months, Theo also was gone, not able to accept his brother's death. The brothers are buried side by side at Auvers-sur-Oise.

ART PATRON AND ARTIST'S AGENT THEO VAN GOGH (1857-1891)

Creativity in the Trained Artist

The role of the imagination in the complex activity of creation was mentioned earlier. There are also theories, such as those put forward by psychiatrist Sigmund Freud, that artistic creativity is the result of neuroses and is therefore a form of therapy for the artist. The unhappy life of Dutch painter Vincent van Gogh (1853–1890) is cited to prove that art reflects high emotion or stress. Vincent's brother, Theo, tells us what it was like to live with such a tortured personality.

It is true that some artists produce their work under of severe personal demand, while others do best when the mood strikes them. But just as many work well during scheduled hours in the studio. For example, contemporary New York artist Robert Longo says: "I want to be able to tell the world what it's like being an artist. It's not like cutting off your ear or hanging out in bars and drawing pictures of barmaids. It's a very sophisticated thing, very much like being a lawyer or a doctor."[1]

There is still another point of view, revealed by many creative artists who believe they work intuitively from observations made earlier, letting the work of art take its own direction. The artist Jackson Pollock (1912–1956) said: "Art has a life of its own. I let a painting live!" In our century, using this method of creation, a whole movement of art developed from such paintings as Pollock's *Number 1, 1948* [1.13]. However, trained artists like Pollock create by drawing on all three techniques without being aware of how much they owe to any one of them. Perhaps that is also the way all of us use some of our potential skill in creativity.

Innovation is often a characteristic of the creative temperament. For instance, in the twentieth century many artists, searching for unique expression, have tried to free themselves creatively from the confines of traditional forms of art. Robert Smithson (1938–1973) rejected the long-held belief that sculpture can only be produced in the artist's studio from metal, wood, or clay. Like the Japanese, whose carefully sculptured gardens are living, changing, natural designs, the elements of land and water appear in Smithson's startling earth sculpture, *Spiral Jetty* [1.15]. An

[1] Tony Godfrey, *The New Image: Painting in the 1980s* (New York: Abbeville Press, 1986), p. 119.

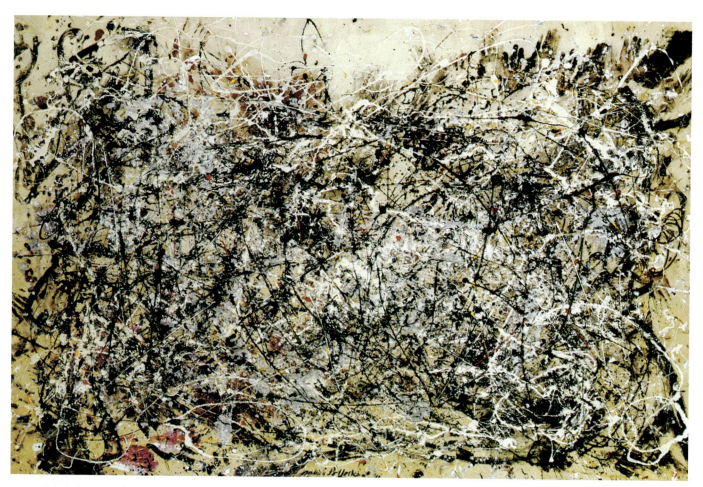

1.13 Jackson Pollock. *Number 1, 1948.* 1948. Oil and enamel on unprimed canvas. 5′8″ × 8′8″ (172.7 × 264.2 cm). Collection, The Museum of Modern Art, New York. Purchase.

The Artist Sketch

Born on the Watkins Ranch in Cody, Wyoming, Paul Jackson Pollock was the youngest in a family of five boys. Nothing in his family background would have suggested the ground-breaking role of his art or the brief but tumultuous lifestyle he later pursued in New York. Yet, it may well have been Pollock's contribution to painting that made America the leader in world art for one glorious decade at midcentury.

As a teenage student of Thomas Hart Benton's mural class at the Art Students League in New York City, Pollock [1.14] formed associations that would last his whole life. By the time he was 21, Benton had moved to Indiana where he undertook a major mural commission and Pollock studied the figure in John Sloan's [16.2] Life Drawing Class. During that summer, he watched Diego Rivera paint murals at the New Workers' School, later producing a number of experimental works himself. By fall 1934, his brother Sanford had joined him in looking for work. Both finally accepted ill-paying jobs as janitors at City and Country School and noted that they still had to steal fuel and food from pushcarts in order to survive those Depression days.

Jackson's luck seemed to turn in 1935 when he signed with the newly created Federal Art Project of the Works Progress Administration (WPA) and submitted, through 1943, some fifty paintings of which only two are known to be extant. Like many other artists of this period, survival in the world of art depended entirely on finding work through governmental agencies and living off the monthly checks. The stress, perhaps, led to an alcohol dependency. Two years later, Pollock began psychiatric treatment for alcoholism, a problem that plagued him to his death. While in treatment, he was remanded to draft deferment status by the military. At the same time, he was befriended by a promising young art student, Lee Krasner, whom he had met in class and later married.

By 1943, his work was favorably reviewed in the national publication *ARTnews*, and he was commissioned by Peggy Guggenheim to paint a mural for the entrance hall of her 61st Street town house. Her patronage permitted Pollock to quit his custodial job. In his application for a Guggenheim Fellowship, he formulated the foundation for his art:

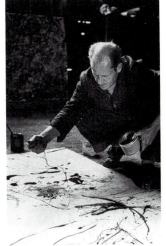

1.14 POLLOCK AT WORK.

I believe the easel picture to be a dying form, and the tendency of modern feeling is towards the wall picture or mural…

One of the leading art critics of the day, Clement Greenberg (Chapter 16) encouraged him further with his November 1943 review in the *Nation*:

There are both surprise and fulfillment in Jackson Pollock's not-so-abstract abstractions. He is the first painter I know of to have got something positive from the muddiness of color that characterizes a great deal of American painting…

During summer 1943, Pollock and Krasner rented a studio together in Provincetown and by the next year were married. His mural-size painting *Number 1* [1.13] had been exhibited in New York City at MoMA (Museum of Modern Art) in a show that made a tour of universities and museums throughout the country.

His career was rising rapidly and meeting surprising success in between alcoholic bouts. By September 1953, he began intensive biochemical treatment for alcoholism while his paintings traveled to galleries worldwide. He had said in 1947 that the source of his art was the unconscious, but something was surely happening to him in 1954 and 1955, and the sources of his creativity seemed to be drying up. In panic, he questioned whether he would ever be productive again. Meanwhile, his earlier works continued to gather awards as they toured. In July 1956, Lee Krasner Pollock sailed for a vacation in Europe, while Jackson remained in analysis and lapsed in and out of periods of substance abuse. At 10:15 p.m. on August 11, 1956, while going north on Fireplace Road in East Hampton, New York, Pollock's car crashed into a clump of trees and overturned. He was killed instantly. He was only 44. An earlier *TIME* magazine review on February 20, 1956, had described Pollock as "Jack the Dripper," echoing much of the public's negative reactions to his art. While Pollock's work had always been viewed by the popular press as if it might have been produced by a drip or spatter gun, in the final analysis, America lost an important visionary with his death.

JACKSON POLLOCK (1912-1956)

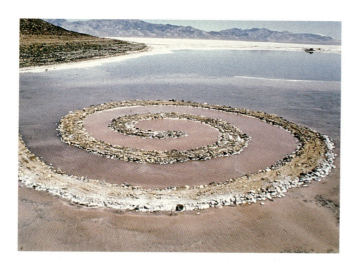

1.15 ROBERT SMITHSON. *SPIRAL JETTY*.
1970. BLACK ROCK, SALT CRYSTALS,
EARTH, AND RED WATER (ALGAE); COIL
1500' (457.2 M) LONG, 15' (4.57 M) WIDE.
GREAT SALT LAKE, UTAH.

important feature of this large-scale public sculpture was change through erosion; the action of the water eventually left nothing of the work, and now we have only a photographic record of it. When we can be open to experiencing art without trying to establish a traditional category for it, or when we can accept art that derives from everyday living or unfamiliar aspects of nature, we are more likely to enjoy creativity in places we never expected.

For instance, the sky, which all of us see and usually take for granted, is shown creatively and quite individually by three artists. The heavens become a means of emotional and aesthetic release for Vincent van Gogh. His excited perception is communicated to us by his exaggerated swirling shapes, tense brush strokes, and brilliantly contrasting colors [1.16]. The tiny village sleeps beneath the turbulence of nature, unaware that both the sun and

the moon have joined the stars to illuminate the heavens. As observers, we are filled with awe at the extraordinary event. Vincent van Gogh's innovative style, very different from what he had been taught in school, can also be noted in the way he applied thick paints in heavy strokes and strong outlines.

Almost three hundred years earlier, another great artist, Domenico Theotocopoulis, known as El Greco (c. 1548–1614), just as creatively rendered a night sky, overlooking the city of Toledo, Spain. As far as we know, his painting may have been one of the first to record the light of an impending storm. His view of the city, treated quite differently from the village in *The Starry Night*, is no less innovative. Were we to stand on the plains looking at the distant city, we would see how El Greco distorted the landscape in order to echo the energized clouds he painted overhead [1.17]. Still, a later artist—Scandinavian Edvard Munch [4.12], known for his pessimistic views of humanity, rendered the sky as if it were reflecting the anguish of his central figure, and through the work we can almost sense his own pain. Each of these views creatively demonstrates a similar theme but with historic differences.

1.16 VINCENT VAN GOGH. *THE STARRY NIGHT*. 1889. OIL ON CANVAS. 29 × 36-1/4″ (73.3 × 92.1 CM). COLLECTION, THE MUSEUM OF MODERN ART, NEW YORK. ACQUIRED THROUGH THE LILLIE P. BLISS BEQUEST.

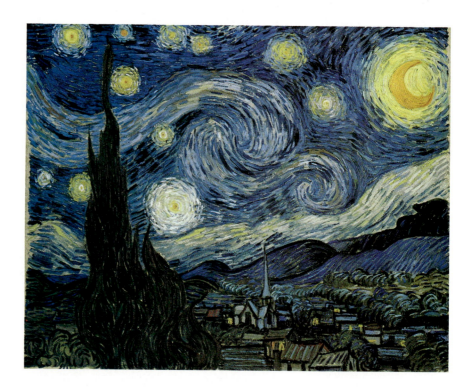

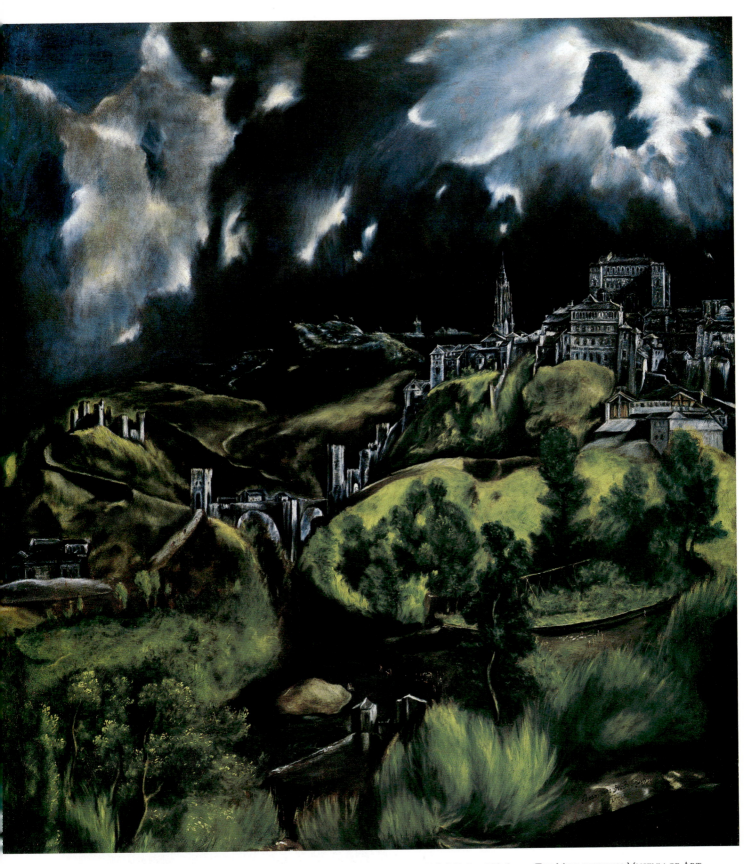

1.17 El Greco. *View of Toledo*. c. 1604–1614. Oil on canvas. 47-3/4 × 42-3/4″ (121.3 × 108.6 cm). The Metropolitan Museum of Art, Bequest of Mrs. H.O. Havemeyer, 1929. The H.O. Havemeyer Collection.

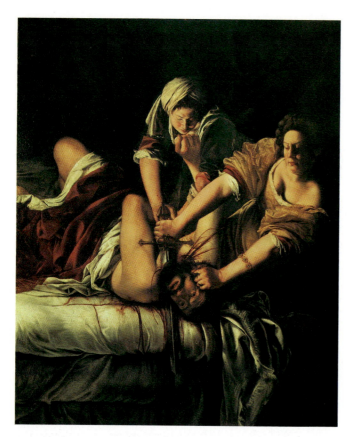

1.18 Artemesia Gentileschi. *Judith Beheading Holofernes.* c. 1620. Oil on canvas. 5'11" × 5'8" (1.80 × 1.72 m). Uffizi, Florence.

dinner and be only subconsciously aware of the design of the porcelain, silver, and crystal. We may take pleasure in the appealing groupings of furniture and subtle relationships of colors and textures in a palatial home. These reactions, while probably not as intense as those inspired by the paintings we discussed earlier, are also emotional responses to some form of artistic expression.

In developing an appreciation of art, such reactions are important because they lead to sensitivity. Whether we love or hate a work of art initially is really less important than trying to understand it. It takes little effort to react pleasurably to paintings of colorful flowers or brilliant sunsets, yet many of us find difficulty in appreciating other works of art. Many viewers are confused by art that does not seem to record nature. Could it be that such works deal with selected aspects of today's complex society? For example, try to see and experience fully the interwoven web of colors and shapes created by Jackson Pollock. His great paintings may serve like Japanese gardens designed not for a stroll but for visual delight. By mentally following the multicolored paths, we are distracted from worldly connections. Pollock's infatuation with color and his delight in the overlay of pulsations of paint can become our own avenues of sensation.

THE OBSERVER'S RESPONSE

There is more to art appreciation than simply identifying and enjoying the artist's theme in a work of art. Responsiveness on the part of the observer is also necessary. Without it, the artwork might as well not exist. Responses can be of several different kinds.

Emotional Response

We can respond on an emotional level. Art can shock, disturb, or horrify us as well as soothe, delight, or excite us. For example, we may stand in a great cathedral and be overwhelmed with religious exaltation. Or we may be shocked, as we are by Artemesia Gentileschi's (c. 1597–c. 1652) depiction in pitiless detail of Judith's ferocious beheading of Holofernes [1.18]. The work is unique in the violence of the killing, the fury of the artist, and the horror we feel observing the scene.

All forms of art, however, need not demand intense responses to vibrant artwork to satisfy an audience. We may open a magazine and enjoy the illustrations created by graphic artists and the pleasing display type without being conscious of the page design. We may savor a fine

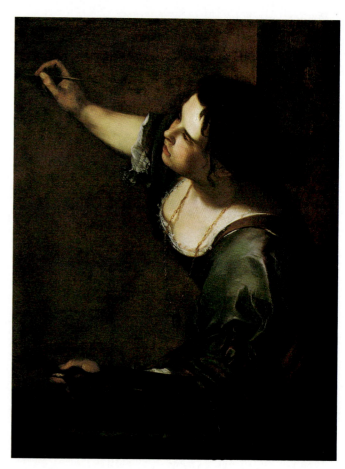

1.19 Artemesia Gentileschi. *Self-portrait.* Royal Collection, St. James's Palace. © Her Majesty Queen Elizabeth II.

Artist's Sketch

Achieving the rank of foremost woman painter of the Baroque period was not an honor easily won by Artemesia Gentileschi. She lived a tempestuous life that was, at least in part, echoed in her paintings.

Born in Naples, Italy, with artistic talent that was recognized early, Gentileschi was brought up with the advantage of familiarity with an artist's tools by her father Orazio, one of the four best-known painters of Bologna. Orazio Gentileschi happened to work in the popular, new style of Caravaggio, an avant-garde painter of his time. It is natural, perhaps, that Artemesia absorbed in adolescence the spirit of pioneering art. Her world was further expanded by Agostino Tassi, a successful fresco artist of Roman palaces, who was retained by Orazio to teach the young girl drawing and perspective. A man of dubious morals, he also seduced and raped the maiden. For this, he was brought to a lengthy and notorious public trial by Orazio Gentileschi. The verdict of guilty and subsequent brief imprisonment hardly damaged Tassi's professional career, but the humiliation suffered by Artemesia hung like a cloud over the rest of her life. Torture by thumb-screws, the seventeenth century lie-detector that was to establish her virtue, Artemesia noted in the record, was a poor substitute for the marriage contract she had been promised.

Eager to quit the scene, she married the Florentine Stiattesi within a month of the trial and by age twenty-three was made a member of the Florence Academy. They had at least one daughter, Palerma, who also became a painter. While the marriage was not to endure, Artemesia's ensuing professional career supported her and her children for many years. In fact, her painting skills placed her among the leading artists of her generation who worked in the style of Caravaggio. Based upon the experiences of her youth and early married life, it is perhaps not surprising that Artemesia preoccupied herself with biblical themes of women's courage combatting a difficult world. But there was apparently a considerable market for that work. Most of her life, she pursued the style she had learned early from her father, even assisting him with a brief commission at the court of Charles I in London just before he died.

The most notable characteristic of Artemesia's art may be her constant demonstration of skill in rendering the female form, gained in part from observation of models in her childhood home, by using a servant or her own body. She invented new compositions and uncovered new layers of meaning for painting in her time. In *Self-Portrait As the Allegory of Painting* [1.19], she wears the mask of imitation from a gold chain suspended from her neck as she works, since art imitates life. Other iconographic symbols appear in her piled-up hair that represents the fervor of creation, while her multicolored dress echoes her broad-based talents. She is poised, summoning inspiration to commit her energies.

Perhaps, Artemesia's final legacy lay in her determination to control her own life to the extent permitted in the seventeenth century. She found the market for those avant-garde creative skills she discovered while yet a student in her father's studio, and she bypassed the themes her society considered appropriate for a woman of her time.

ARTEMESIA GENTILESCHI (1597–C. 1652)

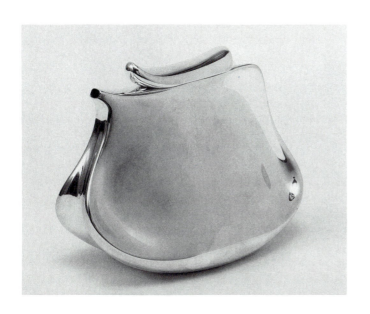

Aesthetic Response

The aesthetic satisfactions that our eyes, bodies, or hands receive from formal components of the art object itself also expand our appreciation. These responses may range from the beauty we perceive in the organization of colors in a painting to the exhilaration we experience passing through an impressive building or the tactile satisfaction we feel in handling a well-designed piece of silver [1.20]. In each of these situations, the aesthetic response comes from an interaction between the art object and the observer.

1.20 CHUNGI CHOO. *DECANTER*. 1980. SILVER-PLATED COPPER. 5-7/8 × 7-3/4 × 4-1/4" (14.9 × 19.7 × 10.8 CM). COLLECTION, THE MUSEUM OF MODERN ART, NEW YORK. MRS. JOHN D. ROCKEFELLER 3RD PURCHASE FUND.

Surprisingly, what seems beautiful to us, that which gives pleasure to the senses and may exalt the mind or spirit, is determined not so much by what we instinctively feel as what is commonly accepted by the culture in which we live. Thus, we must make an effort to put ourselves into the world of the artist. If we know something about what people felt, thought, and experienced during a particular historical period, we can better understand their aesthetic aims.

Some experiences—particularly birth, love, and death—are universal. When art deals with these themes, we usually have less trouble responding to it. But even these emotions are experienced differently in certain cultures, so some knowledge of social and religious attitudes can heighten our aesthetic responses. For example, prehistoric peoples were deeply concerned with survival through perpetuation of the race. The *Venus of Willendorf* [1.21] may have been considered beautiful 22,000 years ago, but it is more likely that she was revered as a fertility symbol. Her enormous breasts and swollen belly reinforce her role as Earth Mother; her generous proportions outweigh her tiny measurements.

Concepts of beauty continue to fluctuate from culture to culture and throughout history. Not so long ago, an African woman from Zaire evoked an aesthetic response from her community not so much for her body, but because it considered the intricate scarification decorating her back a mark of beauty [1.22]. If we did not know of her willingness to bear pain to be made "beautiful," we would have only a superficial appreciation of her scarification designs and those seen on many African sculptures as well [1.23].

Quite different is our own concept of ideal beauty. The blonde film actress Marilyn Monroe has surely been a favorite symbol of femininity in the United States and possibly in much of the world for more than three decades. If a single image of Marilyn Monroe was created to please, then consider the fifty identical pictures of her [1.24] presented in one work by Andy Warhol (1930–1987) in the year of Monroe's death. Warhol focused our attention on the mass media, which use multiple imagery and tantalizing packaging to promote a product, person, or point of view. By using the title *Diptych*, the word for a two-paneled work such as a medieval altarpiece, Warhol suggests that advertising values have replaced the religious orientation of other ages. We contrast Marilyn Monroe with other portraits of women in this text to note further the changing concepts of feminine beauty in Western culture.

Perceptual Awareness

Some understanding of the way the human eye and brain react to visual stimuli may also help us achieve enriched responses. The twentieth-century British author Aldous Huxley defined the art of seeing as three processes, occurring almost simultaneously: sensing, selecting, and perceiving.

Sensing is an instinctual response of the eyes and the nervous system. As the eye scans a crowd of people, it

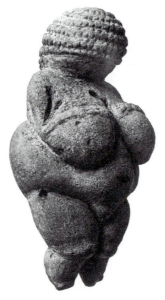

1.21 *VENUS OF WILLENDORF*. LOWER AUSTRIA. C. 30,000–25,000 B.C. LIMESTONE, HEIGHT 4-3/8" (11 CM). KUNSTHISTORISCHES MUSEUM, VIENNA.

1.22 *MAIPIMBE SCARIFICATION*. BOMA, ZAIRE.

1.23 *MENDICANT FIGURE*. BALUBA, ZAIRE. 19TH CENTURY. WOOD, HEIGHT 22" (56 CM). COLLECTION OF THE AUTHOR.

1.24 ANDY WARHOL. *MARILYN DIPTYCH.* 1962. ACRYLIC SCREEN PRINT ON CANVAS. 6′9″ × 9′6″ (2.06 × 2.90 M); TWO PANELS, EACH 6′9″ × 4′9″ (2.06 × 1.45 M). TATE GALLERY, LONDON. REPRODUCED BY COURTESY OF THE TRUSTEES.

receives details of shape and color, light and dark. The physiological process takes care of sending these impulses to the brain.

Selecting is the process of focusing intensely on one part of the total visual field. From the huge number of stimuli the eye takes in, the brain chooses those that have meaning for the brain.

Perceiving gives meaning and significance to the whole act of seeing. Our perceptions are influenced by experiences, knowledge, emotions, and expectations. What we finally say we "see" is the result of the combination of these influences.

Experiences affect our perceptions to a greater extent than we realize. We may see what our observations have led us to expect rather than what is really there. Psychiatry informs us that we often project our inner emotions onto people and objects around us. *The Starry Night* depicts a wildly charged firmament, brilliant in color and steeped in emotion **[1.16]**. This fervent perception of nature appears to have been rendered by Van Gogh in a frenzy of excitement.

Intelligent appreciation of art, then, requires an understanding of its meaning, a response to the artist's vision or emotion, and sensitivity to the work's aesthetic in its historical context.

EVALUATION AND CRITICISM

Historic Role of Criticism

The practice of art criticism goes back at least to the Greeks, such as Plato. The process seems to be twofold, combining a sense of art history with a trust in intuitive judgment. Permanent and undisputed critical viewpoints on art do not exist, since our opinions are affected by changing attitudes in changing societies. Something like a consensus, however, may become evident over a period of time about the value of individual works or a body of work. There is also a procedure for making critical judgments that came out of the Renaissance.

Giorgio Vasari began to grasp the importance of understanding artistic personality in evaluating a body of work. His *Lives of the Artists* (1550, 1568) contended that there had been a steady progress in art since the fourteenth century, culminating, Vasari believed, in Michelangelo and Raphael in the sixteenth century. Not till the Renaissance were the arts raised above the crafts, an attitude, however, that has come under siege in the twentieth century. Based on this distinction between artist and craftsperson, the visual arts have been divided into two categories. The **fine arts**, or major arts, comprised drawing, painting, printmaking, sculpture, and architecture. The **decorative arts**, or minor arts, included ceramics, textiles, furniture, jewelry, metalwork, and the like.

In 1759 Denis Diderot, editor of the vast project known as the *Encyclopédie*, wrote the first critical reviews of exhibitions of the French Salon. A view of the Salon of 1785 [1.25] shows us how academic formulas had dictated the making and judging of art. Aside from distinguishing between fine and decorative arts, hierarchies within the arts were established. For instance, paintings were rated and exhibited according to the subject matter they treated. Historical subjects were most important and hung closer to the audience; **genre** (daily life) themes were distant. "Cold exactitude is not art; ingenious artifice, when it pleases or when it expresses, is art itself", Diderot stressed, c. 1765.

This rigid, official academic formula in France was in sharp contrast to the new work by such later revolutionary artists as the nineteenth century **Romantics**: Delacroix, Courbet, and Manet, for example. It was only then that the notion o of the **avant-garde** was born and the growing gulf between the public and the more innovative artists began. Art critics who came to appreciate these artists respected their claim to originality in defiance of a tradition-laden past or present (the status quo).

Current Criticism

Modern art criticism has become ever more important, branching into several roles—the journalist who writes about art, the teacher who critically seeks to advance the level of his or her students' works, the scholar who comes closest to the critical methods of the past, and the majority of the public, which has minimal claims to expertise. Philosophical modes of art criticism include iconology, a system elaborated by Erwin Panofsky (1925) that "is a method of interpretation which arises from synthesis rather than analysis," a search for the intrinsic meaning of a work of art based on its content; phenomenology, a system concerned only with the characteristics of an art experience itself without extraneous reference or inference; and contextual criticism (evaluation based on the relationship of art to life, past or present). For our purposes today, while the criteria for judging art change from time to time, formal criticism still plays a major role in the dynamics of cultural art life, with its main goal aesthetic, paring away everything except

color, shape, technique and composition. Hilton Kramer, editor in chief of *The New Criterion*, a monthly cultural journal he founded in 1982, and former art critic of the *New York Times*, described his job quite simply in the first issue of his journal:

> The first task of the critic is to see the object for what it is, and to describe its qualities and attributes as clearly and concretely as possible. This is the task of elucidation. … Another important function of criticism is evaluation … best performed as frankly as possible with reasoned arguments and detailed examples and comparisons.

The key to the entire process for us, of course, is "to see the object."

Six Steps in Judging Art

While we may be helped in looking at art by drawing on the experience and insights of professionals, we should remember that critics often come from specialized educational backgrounds, steeped in art history. Understanding how these professionals approach critical assignments can permit us to ask the same questions when confronting unfamiliar works.

1. How does this work fit into the history of art? Are there connections between this piece and those that preceded it? For instance, if a twentieth-century work imitates a masterpiece produced 100 years earlier, its value as a unique contribution is questionable.

2. Is there anything known about this artist that might influence our responses to the work? For example, is this the work of a beginner or of a famous artist whose earlier works have instant market value?

3. When and where was this work created? What was the context that inspired the work? You might ask, for instance, "What induced Artemesia Gentileschi to create *Judith Beheading Holofernes*?" and learn it evolved from her lifelong preoccupation with themes of heroic womanhood, mainly culled from biblical references [1.18].

4. Has the artist used the medium with an understanding of and sensitivity to its inherent physical properties? Does a watercolor, for instance, reveal freshness of hues and, perhaps, transparent layers of colors? Or does the wood grain of a block enrich a woodcut?

5. How has the artist's vocabulary—form, techniques, and composition—contributed to the total effect? Does

Coup d'œil exact de l'arrangement des Peintures au Salon du Louvre, en 1785.
Gravé de mémoire, et terminé durant le temps de l'exposition.

A Paris, chez Bornet, Peintre en miniature, Rue Guénégaud N° 24.

the work evoke feelings and memories that you may associate with the artist's inspiration, like Van Gogh's *The Starry Night* [1.16]?

6. Does the content and context of the work reveal the artist's goal in creating the piece? Why did Andy Warhol choose the diptych format to highlight a Hollywood goddess [1.24]?

Armed with only these six steps in judging art—(1) art history, (2) the artist, (3) the art era, (4) the art medium, (5) the language of art, and (6) the content and context, if the theme is vital to the work—almost anyone should be able to look at art with an informed, critical eye. Whether we view art on a neighbor's walls or in the greatest museums of the world, we will find our critical abilities growing with our exposure. One day, when we are experienced in the history of art, we may come across a work that we know is a special case—that moves us almost as much as it might move a critic or historian. A seventh criterion in art criticism, in fact, might deal with uniqueness of art vision. Has the artist reported even a familiar fact of life with such

remarkable insight that the old becomes as if new? Not many artworks are so timeless as to become historically significant, affecting the art that follows, such as the portrait by Leonardo da Vinci of *Mona Lisa* [I.11]. In this work, Leonardo has not only focused attention upon the head as was traditional, but also included his subject's arms and hands and the torso down to the hips, a practice followed by most later portrait artists of the Renaissance. *The Artist in His Studio* by Vermeer [1.1] quickly became a popular theme of artists and is as popular today as when it was first introduced. There are, however, relatively few works in comparison to all the art in our world—past and present—that form important links in the chain of art history.

The Role of the Critic in Determining Merit in Art

The question of establishing worth in art is a complex issue. We are accustomed to making judgments all the time—we make choices of size, color, style, or quantity; what to eat, what to wear, where to vacation. Aesthetic judgments originate from similar demands; they involve a process quite

1.26 Camille Pissarro. *Boulevard des Italiens, Morning, Sunlight.* 1897. Oil on linen, 28-7/8 × 36-1/4″ (73 × 92 cm). National Gallery of Art, Washington. Chester Dale Collection.

distinct from, yet linked to, art appreciation. They are not simply determining what we like. While there are no absolute standards for deciding if a work of art is beautiful or for appraising its market value, every evaluation depends on the experience and education of the judge, not only on his or her instincts. The influence of art criticism upon many of today's artists cannot be underestimated. Trends in art can be affected and even created by art critics and galleries.

The livelihood of an artist is shaky at best. Encouragement in competition, presentation in a gallery, recognition by a critic, and finally purchase by an art collector can make the difference between bare survival and success. The whole circle of activities that revolves around the actual creation of art is also affected by art criticism. Collectors, patrons, galleries and museums, art periodicals and newspapers, and reproduction services, to name a few, depend on the professional critic for objective opinions. The current

controversies evaluating (and censoring) art mainly derive from a few nonprofessional opinions influencing the many. The issue is important enough to demand its own section for discussion in Chapter 9.

Many artists quite naturally believe they are the best qualified to evaluate art since their direct involvement with the process has expanded their awareness of problems and solutions. Professional art critics, however, argue that detachment is more important. Critics have usually studied art history in depth, are familiar with materials and processes, and have demonstrated informed skill in reviewing a wide range of art.

A critic's viewpoint is helpful when it provides a fresh interpretation of a work of art. Some art is so startling that we are unable to accept the work as art without the critic's help. The critic clarifies the artist's message, helping us to look at unfamiliar images with more tolerant

vision. Critics, however, are not infallible. Some have been known to change their minds, while others are unwilling to accept new ideas. For example, today we are pleased by *Boulevard des Italiens* [1.26], painted by Camille Pissarro (1830–1903). Nothing about it disturbs or surprises us, for we have seen many similar views of city streets. But when it was created in 1897, most critics condemned Pissarro for his lack of sensitivity to what they termed real painterly concerns. They complained that the painting was like a "slice of life" without redeeming creative contributions from the artist. Even the perspective, such as a bird might see from a lofty studio window, was considered a weakness by many critics.

Perhaps evaluation requires more professional knowledge than most of us have; however, all of us can develop appreciation, given time and a willingness to be involved. A critic's comments should never serve as the only criteria for evaluation or our appreciation of art. Our own exposure to art will lead us to value judgments like those of professionals. As with all skills, the trip that leads to informed judgments and deep appreciation must be taken alone by an individual who is sensitive to the work of art and the spirit that produced it. Ultimately, the most important effect of art is what the artist says directly to each observer.

Our encounter with art can be made more satisfying if we learn how the artist creates by exploring the simple activities and materials that follow—noting basic elements, like line or color, and art principles, such as unity and balance.

EXERCISES AND ACTIVITIES

Exercises for Research and Discussion

1. Attend an art exhibit in a local gallery or museum. Write a one-page review, explaining why you do or do not like certain pieces of art. How has the artist individualized his or her personal art statement, that is, created a work that is memorable for you?

2. If possible, locate an art critic's review of the same exhibit. What appear to be the criteria the critic has used on which to base his or her comments? Write your own review.

3. What psychological, emotional, and aesthetic factors do you feel are involved in the appreciation of art? Can you explain, using the six criteria of art evaluation, why some masterpieces seem to have universal appeal?

4. Picasso's *Ma Jolie* [I.12] and Leonardo's *Mona Lisa* [I.11] are both portraits of women and masterworks. Discuss, perhaps in class, how they differ and cite some historical factors that may explain these differences.

5. Find five artworks in this book that have been inspired at least in part by the natural environment. Which appear to be duplications of nature? Which works reinterpret details from nature? These last three exercises can be discussed within class groupings, each devoted to a single question. Conclusions from this chapter, and all that follow, can then be shared with the whole class.

Studio or Homework Activities

1. Note the cage-like form painted near the leaping antelope, illustrated in the introduction [I.3]. Since no one knows what it means, design another linear symbol that has meaning you can explain to take its place.

2. Find a piece of slate to use as a base for your version of a prehistoric painting. With colored chalks or paints, draw a "stone age" animal in action. Try to make use of any cracks, changes in surface level of the slate, or color irregularities to enrich your design.

3. Form a photo montage (a composite image made by assembling parts of two or more photographs) dealing with materialism like Rosenquist's *I Love You with My Ford* [I.10].

4. Using clay instead of stone, shape your own version of the *Venus of Willendorf* [1.21] celebrating fertility.

5. Observe a child's drawing. Express the same theme using the same medium and materials. Try to maintain the vigor of the child's concept. You may need heavier lines, brighter colors, or stronger textures to keep the same impact, because children's art often flows more freely than more repressed adults can imitate.

2

Exploring the Artist's Language

"Art is human intelligence playing over the natural scene, ingeniously affecting it toward the fulfillment of human purposes."

—ARISTOTLE

• • •

"It took me close to thirty years to comprehend why Cézanne was the father of modern art.
... For hundreds of years, they had worked to capture the sheen and texture, the hairs, the dust, the flickering motes of light on the surface of a drape. ... Did a painter work a canvas properly? Then one could cut out a square inch of canvas, show it to an unfamiliar eye, and the response would be that it was a piece of lace, or a square of velvet, for the canvas had been painted to look exactly like a lace or velvet.
Cézanne, however, had looked to destroy the surface. A tablecloth in any one of his still lifes, taken inch by square inch, resembled the snowfields of mountains. ... and one could not know, looking at a detail, whether he was representing the inside of a flower or the inside of a tent."

—NORMAN MAILER,
OF A FIRE ON THE MOON, 1957

• • •

"Allow me to repeat what I was saying to you here; treat nature in terms of the cylinder, the sphere and the cone, all put in perspective, so that each side of an object, of a plane, moves towards a central point. Lines parallel to the horizon give the breadth. ... Lines perpendicular to the horizon give the depth. ..."

—PAUL CÉZANNE, CORRESPONDENCE
(B. GRASSET, PARIS), 1937,
EXTRACT FROM A LETTER TO EMILE BERNARD

The Artist Sketch

Seen today as one of the most important contributions to the art of the twentieth century, the work of Paul Klee has gathered ever-increasing recognition since his death half a century ago. Klee's influence on modern art is perhaps best understood by examining his paintings and drawings. What he experienced within himself, especially in his later years, emerges in the work. One of the most prolific artists of the modern era, Klee produced close to nine thousand works of art—most, if not all, of which give a sense of newness from work to work that is extraordinary [2.1].

Born of a Swiss mother and German father, who taught music at a local school, Klee had the early advantage of a collegiate cultural atmosphere to which he was oriented all his life. He chose a career of art, eventually studying painting and drawing at the Art Academy in Munich. A year of travel in Italy, spent mostly in Rome, broadened his experiences further while expanding his career. In 1920, he joined the faculty of the Bauhaus School of Design in Germany, a school whose reputation gradually extended worldwide. Its innovative philosophy of study—student with professional artist, designer, and teacher, together exploring work projects—profoundly affected art education and inspired Klee's *Pedagogical Sketchbook*, produced in his third year on the Bauhaus staff.

2.1 PAUL KLEE. *ABSORPTION (SELF-PORTRAIT)*. 1919. LITHOGRAPH, 9-1/4 × 6-1/4" (23.6 × 16 CM). PAUL KLEE FOUNDATION, KUNSTMUSEUM, BERN.

As a young man, Klee had developed a drawing technique of continuous cobweb-thin lines that he used all his life. After a trip to Tunisia, where he learned to paint in **water colors [2.2]**, he added the brilliance of pure color to his unique approach to line, producing the style of fresh ingenuity that appeared in all his work. He shared his creative credo with his students, but his artistic discoveries proved inspiring to many artists who never met him. "Whether they knew it or not," the art critic Clement Greenberg once commented, "everyone was learning from Paul Klee"—from his style and his philosophic base.

Klee's creative life was derived from his painting and music but was founded upon nature, his observation of cycles of change and his respect for cosmic forces. Yet, for all of Klee's symbolic ties to nature, his work reveals the mysterious course of civilization. Paul Klee did not experience a dramatic or adventurous life by almost any standard. Professional recognition came slowly, though it accelerated with his appointment to the Bauhaus School. The refined subtleties of his imagination were such that *New York Times* art critic John Russell called Klee "as civilized a man as the history of art has to show."

But Klee saw himself in 1923 as a child of nature: "the artist is human; himself nature, part of nature within natural space."

PAUL KLEE (1879–1940)

Our search for knowledge has pulled us high above the earth, far below its crust, and deep beneath the sea. From the dawn of human awareness on earth, we have reacted to this world in conscious and unconscious ways, some of which are termed art. Observations of the natural environment and of human experiences within it have been the inspiration for most art for thousands of years. Artists select, summarize, and then interpret what they have perceived. In reworking their own responses, they transform ideas into art. Commenting on the artist's role, Paul Klee (1879–1940) observed that the artist is like "the trunk of the tree, gathering vitality from the soil, from the depth (the unconscious), and transmitting it to the crown of the tree, which is beauty."

Artists use certain basic artistic devices both consciously and unconsciously to develop a work fully. Though these elements are fundamental to all the visual arts and other arts as well, the manner in which each artist organizes them is unique. For the most part, over thousands of years, art has presented aesthetic designs that have involved point, line, color, value, shape, and texture, some of the visual elements we will examine next.

THE VISUAL ELEMENTS

An ancient Greek vase and a contemporary painting may seem worlds apart in their inspiration, function, and composition, yet, surprisingly perhaps, they share the same basic components of art. The Greek vase [2.3], an early grave marker from the Dipylon cemetery in Athens, has

2.2. PAUL KLEE. *HAMMAMET WITH ITS MOSQUE.* 1914. WATERCOLOR AND PENCIL ON TWO SHEETS OF LAID PAPER MOUNTED ON LIGHT CARDBOARD. 8-1/8 × 7-5/8″ (20.6 × 19.4 CM). THE METROPOLITAN MUSEUM OF ART, THE BERGGRUEN KLEE COLLECTION, 1984.

2.3 DIPYLON VASE, WITH FUNERAL SCENES. ATTIC, 8TH CENTURY B.C. TERRACOTTA, HEIGHT 42-5/8″ (108.2 CM). THE METROPOLITAN MUSEUM OF ART, ROGERS FUND, 1914.

been decorated with an orderly composition of horizontal lines that confines tiny figural and geometric motifs. The overall design is flat and makes no reference to three-dimensional space. The small figures, rhythmically repeated, form a textural pattern of evenly balanced dark and light values. The decoration painted on the red clay is geometric and similar to many other examples of early pottery. The popular key or fret design located at the lip of the vase, however, identifies Greece as its country of origin.

In contrast, Pavel Tchelitchew's (1898–1957) fanciful mid-twentieth-century painting *Hide-and-Seek* **[2.4]** is made up of brilliant, highly imaginative figurative images, typical of the artist's style, with color the only additional element to those noted on the vase. The vivid reds and yellows advance from the cold blues of the background. A multiplicity of lines in this work suggests a vast, pulsating circulatory system as the basic texture. The irregular foreground shapes, varying in size, are massed around the small child almost hidden in the dark shadows at the center. Indistinct human forms emerge mysteriously from the

2.4 PAVEL TCHELITCHEW. *HIDE-AND-SEEK* (*CACHE-CACHE*). 1940–1942. OIL ON CANVAS, 6′6-1/2″ × 7′3/4″ (199.3 × 215.3 CM). COLLECTION, THE MUSEUM OF MODERN ART, NEW YORK. MRS. SIMON GUGGENHEIM FUND.

depths of the painting. In the game of "hide and seek," perhaps the child is imagining her terrors of the unknown. The children's heads that surround her small figure, all the more vulnerable as she faces the dark unprotected, may represent herself at varied stages of her life—since a baby can be seen at the left—but more likely those faces are the tormentors whom she fears. In both the vase and the painting, line, shape, value, texture (and color), the visual elements, have been organized to provide powerful aesthetic experiences.

Point

The tiniest element of design is a point, the smallest visible attention-getter, although rarely used alone. By its position in relation to the outside edges, a single dot on a surface may determine the impact of a design. It may become the central focus or exist as a single point of emphasis in a total composition or may even be the design in itself.

For instance, every location on an artist's computer screen can be precisely pinpointed, even when thousands of points may be involved in a total composition. With the magnification possibilities of computer design, it

2.5 *DIGITIZED MONA LISA.* 1987. AT&T TRUEVISION IMAGE PROCESSING SYSTEM. COURTESY ROBERT F. TINNEY.

2.6 ELAINE DE KOONING. *BASKETBALL PLAYERS.* 1979–1980. CHARCOAL, 28 × 22″ (71.1 × 55.9 CM).

becomes feasible to view any of these points, called a **pixel** or picture element, on demand (Chapter 5). Like a single sound in a quiet room, or the central element in a target, any point can be made to be the important focus of attention [**2.5**], as shown in the computerized detail of the *Mona Lisa.*

Line

We may begin to communicate what we see through **line**, the basis of most drawing and much painting. A speeding arrow and the light of a moving flashlight [**3.11**] demonstrate lines formed by connecting points in space. Line may consist of actual marks, drawn with pencil, pen, or brush, or it can refer to an outline—the outside of a shape. In paintings, lines often occur by contrast; lines may be drawn, but also the edges formed by contrasts of light and shadow, or of different colors and shapes, may suggest lines. Whether it can actually be seen or is only implied, line undoubtedly is one of the artist's most eloquent tools, enclosing space, suggesting mass or volume, and creating a feeling of movement. Where light falls on the contours of an object, the outlines may be lightly drawn. Where the shadow is deepest, thicker lines can suggest and provide emphasis, while grouped lines create illusions of volume and shadow.

Quality of Line Line may also convey emotion and, thereby, is one of the artist's most valuable tools. Line may be drawn forcefully (with strong, thick strokes) to

focus a directional thrust, as to the apex of Elaine de Kooning's (b. 1920) [**2.6**] composition, or nervously (with uneven, broken strokes), or smoothly (with stable, consistent strokes) to create a mood. In contrast, Ben Shahn (1898–1969) in *Silent Music* [**2.7**] uses a modified action line. This method may be derived from the games children play in making a drawing while hardly lifting the tool from the paper to assure continuity of line and the communication of a sense of action.

2.7 BEN SHAHN. *SILENT MUSIC.* 1950. SERIGRAPH, PRINTED IN BLACK, COMPOSITION: 17-1/8 × 35-1/8″. COLLECTION, THE MUSEUM OF MODERN ART, NEW YORK. PURCHASE.

The Machine Line We have depended on machines and provided systems for instructing them at least since the Industrial Revolution. Mechanical lines do not vary in thickness or value, but when machines such as computers are programmed to change their direction at random intervals, the design appears progressively more disorganized. The machine line has a special new character [2.8], very different from the artist's variable line with its potential for thick and thin, dark and light, straight or free-form. That "machine" look, hardly yet explored, now serves as a fine counterpoint to the artist's line.

Calligraphy Line is basic not only to drawing and most painting but also to **calligraphy**, the art of decorative line, as in fine handwriting. Calligraphy has existed for centuries in the Far East and the Middle East, where calligraphy and painting are closely interrelated. Highly respected for its vitality and grace, calligraphy is produced

2.9 FRANCISCO GOYA. *EXECUTION OF THE MADRILEÑOS ON MAY 3, 1808*. 1814. OIL ON CANVAS, 8'8-3/4" × 11'3-3/4" (2.66 × 3.45 M). MUSEO DEL PRADO, MADRID.

2.10 DIAGRAM OF FIGURE 2.9

2.8 WILLIAM J. KOLOMYJEC. *BOXES I*. 1980.

with the same brushes and similar brush strokes as painting and often may be found in the very same work of art. Close examination of the *Siege of Belgrade* by an unknown artist of the Middle Eastern Ottoman Empire in 1558 [I.6] discloses little difference in the quality of line between the calligraphic painted message and the linear landscape details. Finally, we note the point at which calligraphy may have had its beginnings. Each person's legal signature possesses a unique quality of line that may be faltering or vigorous, but is surely always identifiable.

Line as Direction and Emphasis Another kind of line is seen in the painting *Execution of the Madrileños on May 3, 1808* [2.9], also known as *The Third of May, 1808*, by Francisco Goya (1746–1828). Here the contours of various shapes imply lines that serve to guide the viewer to the

2.11 THE SPHINX (C. 2540–2514 B.C.) AND THE
PYRAMID OF CHEFREN (C. 2590–2568 B.C.)

central theme: the brutal execution of hostages, randomly chosen by the French troops of Napoleon occupying Madrid, in reprisal for the uprising of an unruly Spanish mob the day before. The directional lines are so strong that we can diagram them [2.10]. The contour of the hill leads us down through the body of the principal soldier, then up through the saber at his waist to the rifles pointing at the light-toned civilian whose arms are outstretched—as if on an invisible cross. You may find many other contour lines that reinforce this movement to focus our attention on the drama. Although the linear element is rarely so easy to see, it exists in most works of art.

Linear Perception of Shape and Mass Line can be also followed in three-dimensional works of art as suggested by the silhouette of a figure, the upward thrust of a vault, or the long horizontal edge of a building. For example, the clear-cut shapes of the Great Pyramids [2.11] present a strong, simple geometry of linear planes, shapes that dominate the Egyptian desert and are visible for many miles. They perhaps represent the most familiar triangular silhouettes of all time.

In contrast, recent advances in our knowledge of optical laws have led to the complex use of line in which images seem to shift as the viewer moves. In the hands of an artist such as Bridget Riley (b. 1931), repetitious lines of precisely equal weight, equally spaced, can create visual illusions that appear to advance and retreat as we observe the work [2.12].

Shape and Mass

In painting, in drawing, and sometimes in sculpture, any area enclosed by a line is usually perceived as a whole entity or **shape**, set apart from its surroundings. Shape can also be made to stand out through the use of strong contrasts in color, value, or texture. Shapes can be geometric or organic, symmetrical or asymmetrical, related to known objects or nonobjective. Artists may use shape, like line, to express different moods. The playful shapes in the whimsical **mobile [2.13]** by Alexander Calder (1898–1979) create a lively mood, reminding us of a school of fish in formation. A truly original artist, Calder created highly intellectual and controlled works that delight us with the variety of

movements of the abstract shapes as they interplay when the entire piece is set in motion.

To the novice in art, shape is always easy to see. Few beginners, however, take the time really to look at the space around the shapes, which is generally ignored as mere background. Many times, however, these same areas, called **negative space,** are as important to the artwork as the positive shapes we see first. Artists manipulate relationships of the figure to its ground to increase visual excitement and to take advantage of the different ways all of us

2.12 BRIDGET RILEY. *CURRENT.* 1964. SYNTHETIC POLYMER PAINT ON COMPOSITION BOARD, 58-3/8 × 58-7/8". COLLECTION, THE MUSEUM OF MODERN ART, NEW YORK. PHILIP JOHNSON FUND.

2.13 ALEXANDER CALDER. *BIG RED.* 1959. SHEET METAL AND STEEL WIRE. 74 × 114". COLLECTION OF WHITNEY MUSEUM OF AMERICAN ART, NEW YORK. PURCHASE, WITH FUNDS FROM THE FRIENDS OF THE WHITNEY MUSEUM OF AMERICAN ART, AND EXCHANGE.

2.14 M.C. ESCHER. *STUDY OF REGULAR DIVISION OF THE PLANE WITH HORSEMEN.* 1946. INDIA INK AND WATERCOLOR, 12 × 9″ (30 × 23 CM). COLLECTION HAAGS GEMEETEMUSEUM, THE HAGUE.

perceive shapes in space. M. C. Escher is well-known for his rather remarkable ability to manipulate negative-positive spaces into visually provocative new relationships [2.14].

Converting Shape to Mass The term shape usually refers to defined areas in a painting or drawing, while **mass** is used more often in discussions of sculpture and architecture. However, the term mass may also occasionally be applied to paintings where the artist has concentrated upon the illusion of mass. During the Renaissance, many artists tested the newly discovered principles of geometry and linear perspective and produced more solid-looking forms on a two-dimensional surface than had been seen for a thousand years. In addition, many artists used heavy shadows in their paintings to exaggerate the appearance of three-dimensional weight.

For example, the draperies massed in shadow on the left in the painting *The Artist in His Studio* [1.1] by Jan Vermeer (1632–1675) form a strong contrast to the artist's model positioned in the bright central area. The woman creates a focal point, which ties together the geometric shapes of the furniture and the room. More recently, however, some Pop artists like Tom Wesselmann, in his long series of *Great American Nudes* [2.15], almost always diminishes and may even eliminate the feeling of mass in his figures. This nude, for instance, seems like a caricature of the Greek and Roman shapely Goddess of Love who has inspired her form. In fact, his women appear as lifeless as supermarket commodities, offering no more sexuality than a cellophane-wrapped doll, despite the literal details of their bodies.

2.15 TOM WESSELMAN. *GREAT AMERICAN NUDE, #99.* OIL ON CANVAS. 1968. 60 × 81″. COURTESY SIDNEY JANIS GALLERY, NY. COLLECTION: MORTON G. NEUMANN, CHICAGO.

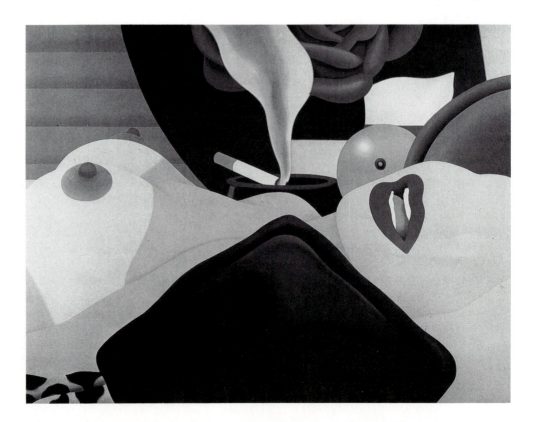

2.16 INTERIOR, ABBEY CHURCH OF ST. DENIS, PARIS, 1144.

2.17 ANTOINE PEVSNER. *DEVELOPABLE COLUMN*. 1942. BRASS AND OXIDIZED BRONZE, HEIGHT 20-3/4″, BASE 19-3/8″ DIAMETER. COLLECTION, THE MUSEUM OF MODERN ART, NEW YORK. PURCHASE.

2.18 GASTON LACHAISE. *TORSO*. 1932. BRONZE, HEIGHT 9-1/2″ (24 CM). COURTESY OF THE SALANDER-O'REILLY GALLERIES, NEW YORK.

The sense of real three-dimensional mass can be intentionally emphasized, as in the pyramids of Egypt, which were built to ensure a comfortable immortality for the pharaohs. On the other hand, the sense of mass may be reduced or denied altogether by creating perforations, or openings, in a structure. A **Gothic** church like St. Denis [2.16], an expression of spiritual aspirations toward heaven, appears light and fragile. Glass windows fill the spaces between structural supports, and the cathedral's strong vertical lines, just like those of the *Developable Column* [2.17] by Antoine Pevsner (1886–1962), imply a weight light enough to rise into the air. Pevsner's column was designed to simulate an upward twisting force. Gaston Lachaise (1882–1935) [2.18] utilized the partial-figure concept in the creation of frankly erotic sculptures. Recalling the prehistoric Willendorf Venus [1.21], the exaggerated proportions of the reproductive female zones are emphasized in the fractioned figure.

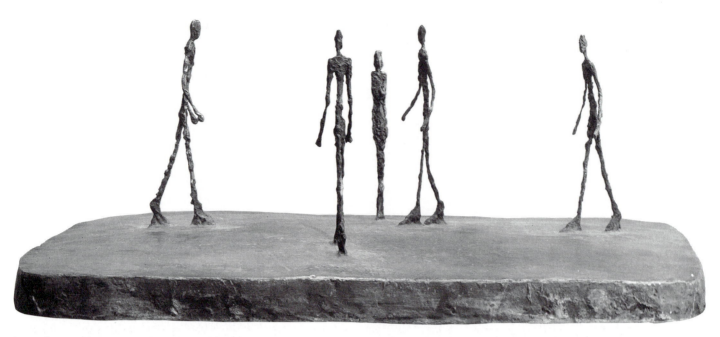

2.19 ALBERTO GIACOMETTI. *CITY SQUARE*. 1949. BRONZE; BASE 25 × 17″ (64 × 43 CM), HEIGHT OF TALLEST FIGURE 8″ (20 CM). PIERRE MATISSE GALLERY, NEW YORK.

2.20 NADAR (GASPARD FELIX TOURNACHON). *SARAH BERNHARDT*. 1859. PHOTOGRAPH. BIBLIOTÈQUE NATIONALE, PARIS.

2.21 GEORGES SEURAT. *CAFE CONCERT*. CONTÉ CRAYON. 12 × 9″. MUSEUM OF ART, RHODE ISLAND SCHOOL OF DESIGN, PROVIDENCE. GIFT OF MRS. MURRAY S. DANFORTH.

Paradoxically, the long, open figures by Alberto Giacometti (1901–1966) in *City Square* [2.19] utilize so little solid material that we become more aware of the negative spaces the figures occupy than the small mass of matter that forms them. Giacometti is known for his attenuated figures—thin masses corroded by time. The indistinctness of the details and their apparent lack of weight suggest a spiritual isolation that projects loneliness.

Value

The degree of lightness or darkness of a surface is referred to as its **value**. In the visual arts, value can range from the darkest to the very palest tones or from pure black through shades of gray to pure white. Variations and contrasts in values can be effective whether the artist is working with colors or black and white. For example, a photographic portrait of Sarah Bernhardt [2.20] shows a full range of values, from white through grays to black; the strongest contrasts of tone (the lightest and the darkest elements) are placed near the center of the photograph for dramatic emphasis. On the other hand, in the conté crayon drawing of *Cafe Concert* [2.21] by Georges Seurat (1851–1891), we find a somewhat different treatment of tones. Although pure white and intense black values exist together in this work, the total effect is generally soft, because most of the picture is made up of delicate gradations of medium to dark tones.

However, Edouard Manet's (1832–1883) *The Execution of the Emperor Maximilian* [2.22] is strident and harsh. The contrasts in this work, concentrated black-and-white tones, have been reserved for the execution, while

2.22 EDOUARD MANET. *THE EXECUTION OF THE EMPEROR MAXIMILIAN.* 1867. OIL ON CANVAS, 8'3" × 10' (2.52 × 3.05 M). STÄDTISCHE KUNSTHALLE, MANNHEIM.

Art Talk

In contrast to working methods in painting common at least since the Renaissance, Edouard Manet rarely prepared preliminary drawings. His etchings sometimes served as sketches. Then he worked directly in oils on canvas. He said to his friend Antonin Proust: "There's just one real thing. To get down what one sees at the first shot. When it's there, it's there. When it's not there, one starts over. Everything else is nonsense." X-ray analysis of his paintings in combination with historical records show us how difficult it was for Manet to get it right the first time and how he on occasion reworked his canvases after they had gone on public view.

According to the press of the time, *Episode in a Bull Ring* showed several figures—one lying dead and others in the ring with tiers of spectators above. Manet seemed to demonstrate no understanding of perspective and the painting was therefore widely mocked. *Episode in a Bull Ring* disappeared afterward and does not exist today. One art historian has been able to prove through x-ray and laboratory analysis that two paintings, *The Dead Toreador* [2.23] (National Gallery of Art, Washington) and *The Bullfight* (Frick Collection, New York), which share the same border of the same canvas, were once segments of the same painting. Manet apparently

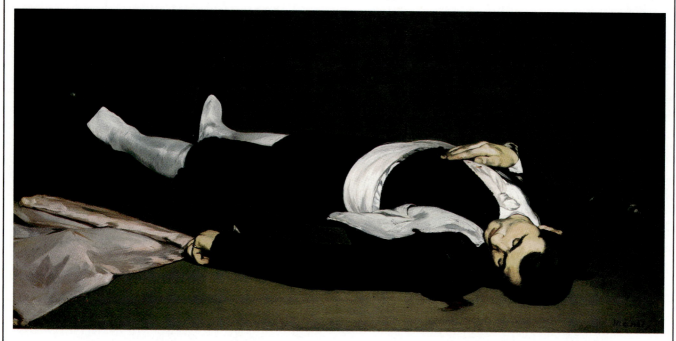

2.23 EDOUARD MANET. *THE DEAD TOREADOR*. PROBABLY 1864. OIL ON CANVAS. 29-7/8 × 60-3/8″ (.759 × 1.533 M). NATIONAL GALLERY OF ART, WASHINGTON. WIDENER COLLECTION.

Anyone who experienced the frustration of sitting for a portrait by Manet saw one canvas after another discarded in the artist's attempt to capture what he envisioned. Manet would also scrape the pigment off the canvas when certain passages bothered him, as x-ray analysis shows us in several of his paintings. Sometimes he added strips of canvas to a painting to change the composition; at other times he cut one work into several, as was the case with his *Episode in a Bull Ring* exhibited in 1864.

cut and reworked the original painting into at least these two independent paintings. Further x-ray analysis shows that originally there was a bull in what is now *The Dead Toreador*, which, incidentally, was exhibited not long after the storm over *The Episode in a Bull Ring* and has since been hailed as one of Manet's masterpieces. We now know how hard Manet struggled to gain the appearance of spontaneity—a discovery that was made possible only through the use of modern technology.

RADIOGRAPHY: CLUES TO THE PAST

the mid-range values serve only as backdrop for the main event. This important painting by Manet may be compared with Goya's *The Third of May, 1808* [2.9], a work with a similar theme and one that undoubtedly served as a reference for Manet; like Goya, he closely followed newspaper accounts and photographs. Both of these works dealing with execution reinforce their message by portraying machinelike executioners set against strong contrasts in value.

Gradation Scale A value-gradation scale helps us to understand how we perceive tones [2.24]. Even when tones are identical in value, they may appear quite different when the value of their surrounding tone is changed. The phenomenon is evident not only with black, white and gray tones, but also with colors.

Variations in values can be used like line to guide the viewer's eye or to give a sense of movement. For example, an area of sharp contrast in a painting will attract our attention. Three or four such areas, if related in a balanced composition, may cause our eye to travel from one to another, giving a sense of movement. Values are often used to create an emotional response. Sharply contrasting colors or blacks and whites can express dramatic tension or excitement. The portrait of the *Mona Lisa* by Leonardo [I.11] produces a dramatic emotional impact not only because the range of values is wide, but also because the artist has effectively used lighting to focus on our center of interest. However, the areas of dark shadows in Leonardo's paintings are equally important. They are never voids of darkness but instead suggest details that our imaginations can enlarge upon. Light-toned values with few contrasts, on the other hand, can give a hazy or mystic feeling to a composition.

Only with illumination, either by natural or artificial light, which creates highlights and shadows is it possible to represent form. As light changes, the entire character of the subject may be revealed or concealed. Whether portraying geometric shapes of a cylinder, sphere, and cube or the human figure, the artist can emphasize shape and mass by manipulating tones of value.

The use of light and dark in a painting to represent the effect of light and shadow in nature is called **chiaroscuro**, an Italian word meaning "light and dark." This method of using light and shadow to reveal the modeling of three-dimensional forms was common to Western painting from the Renaissance to the nineteenth century. Leonardo developed a smokelike haze called **sfumato** to envelop his forms, resulting in transitions from light to dark so gradual as to be imperceptible. In this technique, light seems to come from a source within the painting, creating soft contours.

Though Western painters have used value relationships for many effects, since the Renaissance they have been preoccupied with how contrasting values and light patterns play over solid objects to create an illusion of three-dimensional form on a flat surface. The patterns formed by light and dark shapes can evoke moods and emotions. Artworks exe-cuted with limited gradations of tones, as in the flat, decorative style of Turkish paintings [I.6], are keyed to values that tend to heighten mood. Images limited to light shades are termed **high key**; they are associated with areas of intense light such as beach scenes or scrubbed-clean places like hospitals. **Low-key** locales shown in dark shades typically include night views of streets and intimate bars.

2.24 THE GRAY SCALE.

Color

Perhaps the most effective of all available art elements is **color**, which is what we perceive when our eyes sense light reflected from an object. Artists have used color since prehistoric times, generally reproducing the natural (local) color they saw. The science of color has developed more slowly. Although the Greeks as early as 400 B.C. realized that the apparent color of an object changes with the color of light that falls on it, it was not until the mid-seventeenth century that the English mathematician Sir Isaac Newton discovered that white light passing through a prism is broken into a whole spectrum of colors [2.25].

Newton deduced from this discovery that white is actually a mixture of all colors. The prism fragments the light, breaking it into component color rays. When we see a rainbow with violet at one edge, moving step by step through the spectrum to red at the other, we are seeing an example of the same phenomenon. In this situation, however, instead of being fragmented by a prism, the sunlight is broken apart as it passes through raindrops. Furthermore, Newton discovered that when various quantities of red, blue, and green light rays are projected onto a single area, they combine to form white light. These three colors of light—red, blue, and green—are therefore known as the **additive primary colors**. Conversely, when white light is projected through the **subtractive primary colors**—cyan (blue), magenta, and yellow—onto a single surface, all color is subtracted from the white light, resulting in black [2.26].

Hue, Value, Intensity The colors, or **hues**, of the **spectrum** are produced by light rays, while artists' colors come from substances called **pigments**. Pigments absorb certain light rays and reflect others. Blue pigment, for example, absorbs almost all but the blue rays; blue paint

2.25 A RAY OF WHITE LIGHT PROJECTED THROUGH A PRISM SEPARATES INTO THE HUES OF THE RAINBOW.

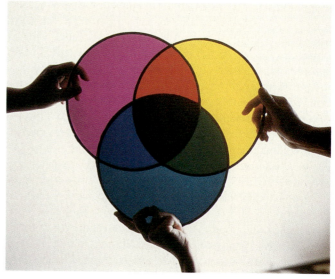

2.26 ADDITIVE COLOR MIXTURES (LEFT) AND SUBTRACTIVE COLOR MIXTURES (RIGHT).

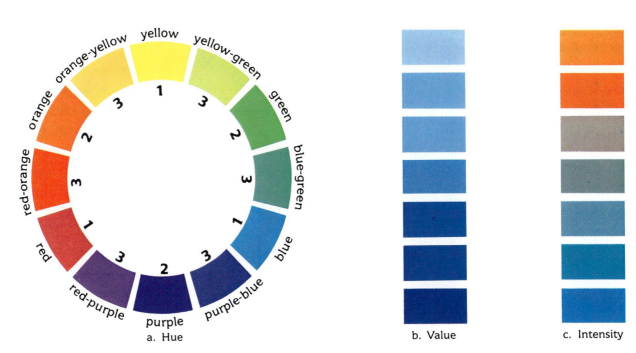

2.27 THE MAJOR ELEMENTS OF COLOR: HUE (AS EXPRESSED IN THE COLOR WHEEL), VALUE, AND INTENSITY.

therefore reflects the blue waves and we see blue. No pigment can produce as pure a color as the prism, so no paints have ever achieved the brilliance of light rays. Similar hues may reproduce differently. For example, one pure alizarin crimson (deep red) pigment may reflect more yellow rays than another red pigment, and colors look different under different kinds of illumination.

For convenient display of colors and all their attributes, colors are usually laid out in a circle, instead of a spectral band or other more complex configurations. The **color wheel** is composed of the major colors in the spectrum plus other colors achieved by mixing the main colors. The twelve colors on the wheel [2.27] can be divided into three groups: **primary**—blue, yellow, and red—those colors that cannot be produced by mixing other hues; **secondary,** combinations of primaries; and **tertiary**, or intermediaries. The artist can use mixtures of the three primary colors to create all other colors on the color wheel. When two primary hues are mixed, ideally, secondary hues are produced, although the proportions of each may vary with the pigments. The three secondary colors are created in this way: blue mixed with yellow yields green; blue mixed with red becomes purple; and red mixed with yellow makes orange. There are six tertiary colors, each a result of mixing a primary color with a nearby secondary color. Thus, red and orange make red-orange, orange and yellow produce orange-yellow, and purple and blue yield purple-blue, and so on.

Complementary colors are those that appear opposite each other on the color wheel. For example, blue and orange are complementary colors; so are red and green. Adjacent colors on the color wheel, such as blue and blue-green, are called **analogous** colors.

Each color varies in **value**, which ranges from light to dark, just as uncolored values may range from white through a series of grays to black [2.24]. A very light blue, for example, is high on the value scale and is called a **tint**, while a dark, low value of blue is called **shade** [2.27]. We may note that color values and hues may appear quite different depending on the local values and hues around them.

Intensity, or saturation, refers to the purity of a color. A pure blue, as it appears in the color wheel and as near the spectrum blue as possible, is said to have full intensity. Color complements neutralize the intensity of each other when they are combined in varied amounts; when mixed in equal amounts they create a neutral gray, but pigment impurities often make this gray difficult to achieve. The addition of shades of gray will also neutralize color intensity.

The three major elements of color may be summarized as follows:

1. Hue: an identifiable color on the color wheel and the spectrum; a specified wavelength of spectrum color
 a. primary hues: red, yellow, blue
 b. secondary hues: green, orange, purple
 c. tertiary hues: yellow-green, blue-purple, and so on

2. Value: the degree of lightness or darkness of a color

3. Intensity or saturation: the degree of purity of a hue; ideally, a pure hue reflects no other color rays

Artists achieve infinite color variations by mixing colored pigments with one another and with black and white. Even more vibrant colors than pigment mixtures seem to occur when dots of pure analogous color are placed next to one another, with the result that from some

2.28 GEORGES SEURAT. *A SUNDAY ON LA GRANDE JATTE.* 1884–1886. OIL ON CANVAS. 6'9-3/4" × 10'1-1/4" (2.08 × 3.08 M). THE ART INSTITUTE OF CHICAGO. HELEN BIRCH BARTLETT MEMORIAL COLLECTION, 1926.224.

distance they appear to the viewer to be blended. This practice of optical color mixture was introduced by **Impressionists** in the nineteenth century. **Postimpressionist** Georges Seurat advanced these techniques further when he restricted his **palette**—the pigments he chose to use—mainly to the color primaries, applying tiny dots of color in a method he called **Pointillism**. Examination of a detail of *La Grande Jatte* [**2.28**] reveals a dot pattern very similar to the pattern shown in modern four-color printing—significant because it shows how artists often foreshadow technology. Even for shadows, Seurat used no black [**2.29**].

Artists make use of color schemes, or arrangements of certain colors, to produce special effects. In a color scheme where complementary colors are used next to each other, the effect will be one of strong contrast and emotional excitement. An analogous scheme made up of colors close to one another on the wheel has a subdued physical or emotional effect. Schemes with light colors, or tints, evoke different emotional responses from those with dark colors.

Such reactions appear to be almost universal—some colors depress us while others lighten our spirits. There is a sense of joy in *Vir Heroicus Sublimis* [**2.30**] by Barnett Newman (1905–1970) with its variations of reds. Psychologists believe that the satisfactions most of us associate with these hot colors ultimately go back to the pleasure given to us by the warmth of a fire on a wintry night or by the sun itself.

Color can be used symbolically as well as emotionally. The Virgin Mary, Queen of Heaven, is traditionally shown in a blue cloak because the color has come to symbolize heaven. Unlike emotional responses to color, however, symbolic color varies from culture to culture. For example, a particular color may symbolize mourning in one

2.29 GEORGES SEURAT. *A SUNDAY ON LA GRANDE JATTE* (DETAIL: VIEW #29). THE ART INSTITUTE OF CHICAGO. HELEN BIRCH BARTLETT MEMORIAL COLLECTION, 1926.224.

culture and joy in another. When complementary colors or colors of equal value are placed side by side, they seem to intensify one another's hue, a phenomenon known as **simultaneous contrast**. If, however, a neutral gray shape is placed on a yellow background, the gray appears violet, a phenomenon called **successive contrast**. There are many other optical effects like these that we have come to recognize, but none so familiar as rubbing our eyes and seeing flashes of color. No one is entirely sure why these phenomena occur, only that our view of color is linked to the retina of the human eye as well as to the effects of the light.

Impressionist and Postimpressionist painters often tried to duplicate the effect of sunlight by placing small brush strokes of contrasting colors next to each other [2.28]. Vibrations in the eye from these painted colors heightened the effect of dancing light. Artists today use light itself as a medium, trapped in neon sculptures, or in works to be viewed under changing light. While colors are almost always dependent on existent light to create hues, under certain other conditions, special color effects can occur. For instance, after staring at the red shapes in *Vir Heroicus Sublimis* [2.30], when you shift your eyes to a white surface, the complementary color to red, a definite green, will appear. This visual phenomenon is called **afterimage**.

Reducing color to its elemental characteristics [I.28], Mondrian generally simplified his paintings to the primary hues. Working in this way, he used colors at full intensity. The density and weight of his colors also affect the apparent balance. Large areas appear closer, small ones farther away. Warm colors—red and yellow, colors we associate with the sun—are dominant, tending to move forward toward the eye. Cool colors—such as blue, like icy water—tend to recede from the viewer. It sometimes surprises a beginner studying art to realize that Mondrian often spent months determining slight differences in color areas. His works are so orchestrated that one cannot imagine any alteration to one area that would not have to be matched with balancing changes in the others.

Because of the great number of visual effects that can be achieved through color and because of its effect on our emotions, and well-being, color is an expressive device of endless excitement and visual variety. Although we think of color as a major concern of the painter, it is also important to designers in other areas of art such as interiors, fashion, advertising, and theater.

Texture

The surface quality of an object, or its **texture**, attracts our senses of both touch and sight. Nature is lavish with appealing surfaces, which artists sometimes try to duplicate or even exaggerate in their work. Artists' textures, however, are not real—they are only simulated. An example of an actual texture is an orange skin that, with a closer look, reveals true hills and valleys, which can compare with the surface of the moon. Paint may be applied to suggest the smoothness of human skin or of a river-polished rock. The sculptor grinds and polishes stone to simulate the sheen of satin. Rough and smooth, shiny and dull, hard and soft textures are contrasted to increase the expressiveness of shapes and to avoid monotony. Infatuation with texture and with the tactile quality of oil paint has driven some artists to pile on pigment, creating frenzied surfaces, as in Van Gogh's *The Starry Night* [1.16]. Often painters achieve a desired effect through the addition of actual

2.30 Barnett Newman. *Vir Heroicus Sublimis.* 1950–1951. Oil on canvas. 7'11-3/8" × 17'9-1/4" (2.42 × 5.14 m). Collection, The Museum of Modern Art, New York. Gift of Mr. and Mrs. Ben Heller.

2.31 GEORGES BRAQUE. *LE COURRIER*. 1913. COLLAGE, 20 × 22-1/2″ (51 × 57 CM). PHILADELPHIA MUSEUM OF ART. A.E. GALLATIN COLLECTION.

textures like newspaper cutouts and pasted-on surfaces, that is, **collage**, a medium invented in the twentieth century. (See *Le Courrier* by Georges Braque (1882–1963) **[2.31]**.)

Many artists have forsaken traditional uses of brush and paint to create new tactile effects. **Abstract Expressionists** earlier in this century worked with heavy, irregular strokes as they became involved with the physical process of painting, following the lead of Pollock, who poured paint from the can directly onto prepared but unstretched canvas. The preparation of canvas (or wood, or other surface) is a coating of **gesso** (thinned plasterlike composition) primer in the technique traditional since the Renaissance. Helen Frankenthaler (b. 1928), in contrast, has chosen to work on unstretched canvas surfaces that are not prepared. Therefore, her paints sink into the unprimed canvas, creating pools of deep color. The variations in dyed surfaces of *Formation* **[2.32]** were achieved by sponging thinned acrylic dyes onto her large canvas areas. Such textures are fresh to our century.

Since the period of the Impressionists, sculptors also have been moving away from the traditional smooth surfaces of well-worked materials. Auguste Rodin

2.32 HELEN FRANKENTHALER. *FORMATION*. 1963 (4?). ACRYLIC ON CANVAS 6′4″ × 5′5″ (1.93 × 1.65 M). PRIVATE COLLECTION. COURTESY ANDRÉ EMMERICH GALLERY, NEW YORK.

2.33 MILAN CATHEDRAL. BEGUN 1368.

(1840–1917) [6.5] was said to have worked by the light of a flickering candle, with which an apprentice slowly illumined his models from head to foot in order to simulate the effect of broken light desired by the Impressionists. In the twentieth century, Giacometti's roughened sculptural surfaces intrigue us, perhaps because they suggest the relentless corrosion of time [2.19].

Architecture is also dependent on textures, produced by the glass, stone, and wood from which buildings are made. The huge Gothic cathedral of Milan [2.33], one of the largest in the world, was carved with details that create pockets of shadows and highlights to add textural interest to what might otherwise have been a monotonous area. The various setbacks of structural parts and the open stonework on the façade of the cathedral are typical of the Gothic style, as are the sculpture in high niches and the carved decoration over the roof, which can be seen only by the birds or, perhaps, God.

Space

A sense of space depends entirely upon what occupies it. The layperson sees space as emptiness. The artist regards space as a challenging arena in which to arrange forms and colors. The visual arts are often known as **spatial arts** because their elements are arranged in space. In contrast, the arts of theater, dance, music, and poetry are **temporal arts**, comprehended in sequences of time.

Dealing with Real Space Every civilization has dealt with real space differently. For example, in ancient Egypt great horizontal expanses of desert were blocked by huge temple complexes approached by vast walkways. In order to cover the immense areas of needed interior space, Egyptian architects used forests of mammoth columns to support flat stone roofs. Later in medieval Europe, the cathedral was at the heart of the medieval city and often built on high ground, where it dominated the living and working

spaces clustered on three sides. Subsequent Gothic builders used fewer columns, strengthened, as we shall see, by buttresses, to support vaulted roofs over huge interior spaces. Contrast the sense of the slivers of space between columns in the hypostyle hall of the Temple of Amun at Karnak [2.34] with the soaring interior space of St. Denis [2.16].

Compare these uses of space with the concentrated space of many major cities today, crowding boxlike skyscrapers together in a comparatively small area. Interior space is divided into numerous floors or stories, each further subdivided into tiny cubicles.

Like architecture, sculpture and other three-dimensional arts are designed in relationship to the space they occupy. Since ancient times, sculpture has always been a solid form dominating space from a central position. Many contemporary sculptors, however, have emphasized space by incorporating it within the design of their work. Giacometti's *City Square* [2.19] appears to focus on the alienation of people in today's society by isolating his figures in a space that seems too large for their elongated bodies. As a result, they are lost in an urban environment that discourages human contacts.

Three-dimensional Space Space in our daily lives is also important. A respect for personal space is a fairly new concept. With the population explosion, especially in third world countries, crushing demands on the actual

2.34 GREAT TEMPLE OF AMUN AT KARNAK. 1350–1205 B.C.

space our bodies occupy make us more aware that the immediate area around us is not to be invaded without specific invitation. A packed subway car at the peak of rush hour or the experience of an over-filled elevator leave most of us uncomfortable.

Architecture and sculpture only exist in three-dimensional space, taking their character from the way space has been shaped within them as well as outside their forms. It almost requires professional experience in the fields of architecture or sculpture to be able to visualize from a two-dimensional floor plan of a building or a sketch of a sculpture exactly how those masses will appear when they occupy real space. Today's computer graphics help designers solve visualization problems by programming the dimensions of a given mass into a computer, then by observing on a monitor screen (much like a television set) the simulation and turning of a design in space (Chapter 5).

Two-dimensional Space The space within any kind of flat art is confined to two dimensions—the height and width that work of art may occupy in any given area. The appearance of visual depth is an illusion accomplished by variations in size and placement of the art elements and the laws of perspective that we will examine next.

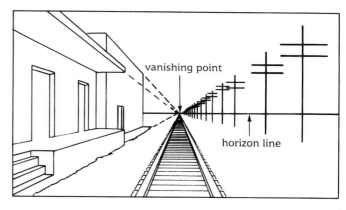

2.35 ONE POINT PERSPECTIVE.

Perspective

In two-dimensional art forms, such as drawing, painting, prints, and photography, the artist often wishes to create an illusion of three-dimensional space, or depth. Images are rendered on a two-dimensional surface, through the device of **perspective**, to make them appear to vary in distance from the viewer. When we think of the term perspective

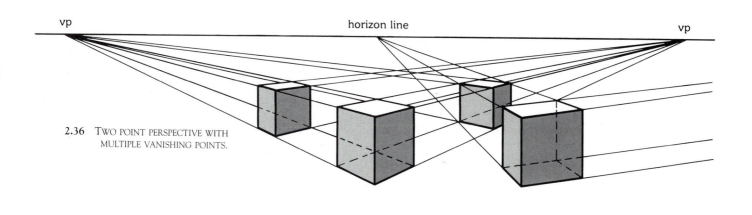

2.36 TWO POINT PERSPECTIVE WITH MULTIPLE VANISHING POINTS.

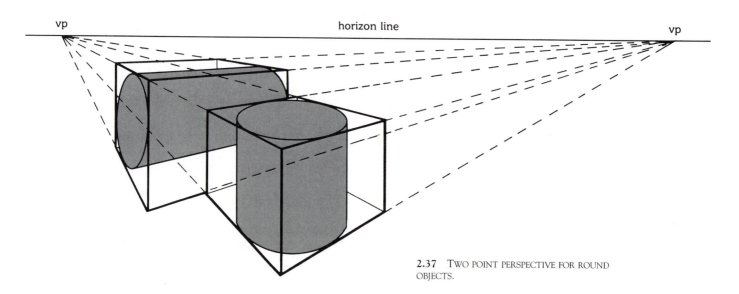

2.37 TWO POINT PERSPECTIVE FOR ROUND OBJECTS.

Artist Sketch

Born in 1452 in the small Tuscan town of Vinci near Florence, Leonardo was a love child—the product of a brief and illicit tryst between a young lawyer and a neighborhood girl. From this beginning came a man who is acknowledged to be an extraordinary figure in the history of civilization [2.40].

Although he was one of the world's greatest artists, few of his paintings have survived. He was neither a teacher nor a writer, and he published no consistent body of research. Instead he left behind thousands of pages of notes, teeming with observations that stretched from art, science, and philosophy to problems in engineering.

That he hoped one day to collect his notebooks into discourses for the general public is implicit in a passage dated March 22, 1508: "This is a collection without order, drawn from many papers that I have copied, hoping later to put them in their right order, according to the subjects which they treat." One senses a consistent thread through the pages of a teacher expounding his views to the reader. In any case, Leonardo never did arrange his notebooks, and they were lost and all but forgotten for many years after his death.

Leonardo spent his earliest years with his mother,

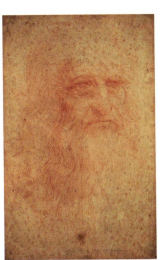

2.40 LEONARDO DA VINCI. *SELF-PORTRAIT.* C. 1514. RED CHALK, 13-1/8 × 8-3/8" (33.3 × 21.3 CM). BIBLIOTECA REALE, TURIN.

and later joined his father, never fully absorbed into a complete family circle. During much of his life, he was in financial straits. Though known as a painter of supreme ability and associated with a succession of distinguished men of his time, something in his personality failed to make for leadership and success. At age twenty, Leonardo was enrolled as a member of the painters' guild, while still apprenticed to Verrocchio, the noted Renaissance sculptor. In later phases of his career, Leonardo developed friendships with other great philosophers of his day. But his most fruitful association in his final years was with the gifted young anatomist Marc Antonio della Torre, a former student in medicine at the University of Padua. From Della Torre, Leonardo learned the practice of dissection, which, coupled with a natural ability to sketch anatomical detail, led to Leonardo's vivid anatomical drawings, many still accepted for their accuracy today.

Inheriting traditions of Renaissance humanism that encouraged human potential, Leonardo seems to have epitomized the hopes and achievements of his time. Intensive study of his recovered notebooks discloses the genius of his brilliant intellect, one of the select personalities in world history.

LEONARDO DA VINCI (1452–1519)

we usually mean **linear perspective**, said to be a discovery of the Italian Renaissance architect Brunelleschi during his work on Florence Cathedral, influencing our way of creating and looking at art for centuries. In linear perspective the artist uses lines, either implied or actual, to give an illusion of great depth on a flat surface. The main rules of linear perspective follow:

1. All objects appear to grow smaller the farther away from the viewer they are.

2. Parallel lines receding into the distance appear to converge. The point at which they seem to meet is called the **vanishing point**. Horizontal parallel lines cannot converge.

3. In **one-point perspective** the viewer appears to be looking at the object from directly in front of it, and all nonfrontal sets of parallel lines, if extended, meet at one vanishing point [2.35].

4. In **two-point perspective** the viewer appears to be looking at the object from an angle so that no side is frontal; this must involve two vanishing points, one for each set of parallel lines receding in space. Objects viewed at different angles have their own vanishing points, which result in multiple vanishing points on the horizon line [2.36].

5. Vanishing points are positioned along an imaginary line called the **horizon line**—generally, our eye level from level ground. Parallel lines above the horizon appear to converge down toward it. Parallel lines below the horizon appear to converge up toward it.

6. The horizon line may be arbitrarily raised or lowered by the artist to make the objects appear below (a bird's-eye view) or above (a worm's-eye view) the viewer's eye.

7. Round and irregularly shaped forms that do not have parallel sides are viewed in perspective as if enclosed in regularly shaped blocks [2.37].

Leonardo's *The Last Supper* [2.38] is often regarded as a **classic** example of one-point perspective [2.39]. The painting occupies the upper end wall of a long room. The lines of the walls, ceiling, and table in the painting continue the lines of that room and converge from above and below the imaginary horizon line toward a single point behind the frontal figure of Christ. His divine calm at the center of the painting thus becomes its focal point, in dramatic contrast with the writhing, agitated forms of the disciples to his left and right.

Many contemporary artists choose to ignore linear perspective or may combine it with other methods of producing spatial effects. The Cubists, for instance, rejected the rules of linear perspective altogether to create a different kind of space. In *Three Musicians* [2.41], Picasso used several vantage points and aspects of each figure, assembled with flat, overlapping shapes. He was not concerned with creating a three-dimensional illusion any more than were Egyptian painters, who combined front, top, and side views in order to show the clearest views of an object [2.42]. The most important figures

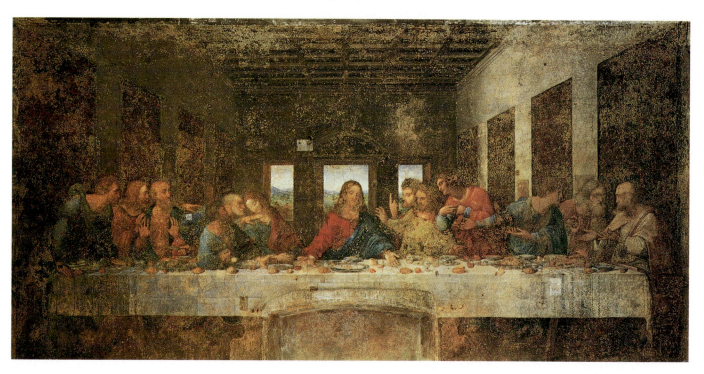

2.38 LEONARDO DA VINCI. *THE LAST SUPPER*. 1495–1498. FRESCO. 14′5″ × 28′-1/4″ (4.39 × 8.61 M). REFECTORY, STA. MARIA DELLE GRAZIE, MILAN.

2.39 DIAGRAM OF FIGURE 2.38, SHOWING ONE-POINT PERSPECTIVE.

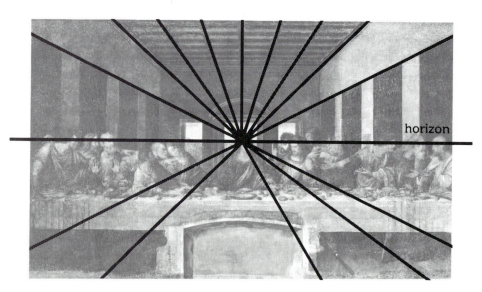

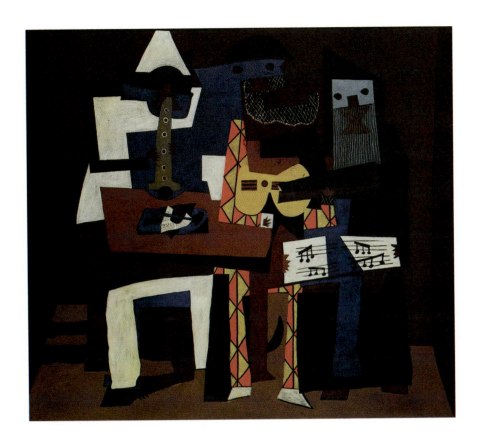

2.41 PABLO PICASSO. *THREE MUSICIANS*. 1921.
OIL ON CANVAS, 6'7" × 7'3-3/4". COLLECTION,
THE MUSEUM OF MODERN ART, NEW YORK. MRS.
SIMON GUGGENHEIM FUND.

were shown very large, while wives, servants, and children were much reduced. This tradition developed from the dominance of the pharoah in Egyptian society, not from any lack of artists' abilities to place figures in space. Different experiences of space can be found in many other cultures where art is not concerned with three-dimensional representations of the real world. We may note the Middle Eastern approach to spatial representation [I.6].

Time and Motion

Artists have always recognized that paintings are illusionistic splinters of time. Some artists, however, have been interested in implying the passage of time in a single work.

When the Florentine painter Masaccio (1401–1428) told the story of *The Tribute Money* [2.43], he created an illusion of passing time by repeating the life-size figure of St. Peter three times to illustrate the three-part event that was painted at the viewer's eye level. First, we see St. Peter with the tax collector (right); then we observe him extracting a coin from a fish's mouth (left); finally we can see the payment of the tribute (center). Despite its sequential arrangement, *The Tribute Money* appears unified because of its clearly organized composition and its repeated colors and figures, standing out from their backgrounds of complementary colors.

The photographic advances of Eadweard Muybridge (1830–1904), which inspired the invention of the

2.42 FOWLING SCENE, COPY IN
TEMPERA OF WALL PAINTINGS FROM
THE TOMB OF KHUM-HOTPE. BENI
HASAN, XII DYNASTY. C. 1900 B.C.
THE METROPOLITAN MUSEUM OF
ART.

2.43 MASACCIO. *THE TRIBUTE MONEY.* C. 1427. FRESCO, 8'4" × 19'8" (2.54 × 5.9 M). BRANCACCI CHAPEL, CHURCH OF STA. MARIA DEL CARMINE, FLORENCE.

motion picture camera, involved a series of twenty-four frames to be projected at speed, producing an illusion of time through motion **[2.44]**. In fact, we will learn how the marvel of the motion picture can manipulate time, contracting, for instance, a safari across a continent into a few minutes of film or expanding a timed experience with a slow-motion recording. Now, television has made it possible to transmit images as they occur in the real world. The

video synthesizer, a mechanical network with levers manipulated by an operator in the television control room, can, among other things, mix recorded events with real-time happenings in order to create a desired psychological and educational effect.

Motion has always fascinated people. Accordingly, there have been many allusions to motion in the static images of two-dimensional painting and drawing. Even the

2.44 EADWEARD MUYBRIDGE. *WOMAN KICKING, PLATE 367 FROM ANIMAL LOCOMOTION.* 1887. COLOTYPE, 7-1/2 × 20-1/4". INTERNATIONAL MUSEUM OF PHOTOGRAPHY AT GEORGE EASTMAN HOUSE.

2.45 DETAIL OF *BAYEUX TAPESTRY*. C. 1073–1088. WOOL EMBROIDERY ON LINEN; HT, 1′8″ (0.51 M), ENTIRE LENGTH 231′ (70.41 M). TOWN HALL, BAYEUX, FRANCE.

prehistoric representation of the leaping antelope on a wall in the Lascaux cave **[I.2]** shows the animal with front and rear legs spaced for the forward plunge into space. Later artists have attempted whole battle scenes, depicting men and animals in violent motion, as in the *Bayeux Tapestry*

2.46 MARCEL DUCHAMP. *NUDE DESCENDING A STAIRCASE, NO. 2.* 1912. OIL ON CANVAS, 4′10″ × 2′11″ (1.47 × 0.89 M). PHILADELPHIA MUSEUM OF ART. LOUISE AND WALTER ARENSBERG COLLECTION.

(c. 1080), which immortalized the Battle of Hastings **[2.45]**. In order to portray the correct sequence of events, the artists decorated a very long strip of linen with thousands of carefully embroidered soldiers, horses, and other figures. The features of the major characters are repeated to permit us to follow the action. In the twentieth century, concurrent with the invention of cinematography, many artists combined multiple images to demonstrate the changes in position of a moving object.

Few illusionistic works, however, have ever created the furor of *Nude Descending a Staircase (No. 2)* **[2.46]** by Marcel Duchamp (1887–1968). In the vast 1913 Armory Show in New York made up of 1100 pieces of art, this painting of a technological Venus figure in motion is said to have moved former President Theodore Roosevelt to comment, "Explosion in a shingle factory!" More recent styles in art have approached the illusion of movement by means of nonobjective designs. Some works, such as Bridget Riley's *Current* **[2.12]**, produce the effects of changing images as the position of the viewer is altered. Many optical paintings are simple, repetitive patterns of distinct, often geometric shapes, but after prolonged scrutiny, hard edges blur and colors vibrate, appearing to ripple before our eyes.

Perhaps inspired by the earth's rotation, the sway of branches in the wind, or the turbulence of waves breaking on a beach, Leonardo demonstrated an early preoccupation with motion in the 1400s, designing ballistic missiles such as cannons and other inventions that moved. The same life forces may also account for Alexander Calder's first notions of mobile art, an invention of the twentieth century **[2.13]**. His kinetic works appear simple, but actually, many of the elements of a single sculpture may rotate on separate axes, designed to coordinate with the larger movements of the whole sculpture.

Today, numbers of artists are exploring other time-motion dimensions of the visual arts. The hypnotic effect of moving bodies of water accounts for our delight in fountains. In some cases, computers coordinate musically activated changes of light with changes in the flow of the water. Jean Tinguely (b. 1925) has designed many works that actually move, some through audience manipulation of levers **[17.20]**. A few Tinguely designs with violent movements may even self-destruct before our eyes! In essence, motion in art is an echo of motion in life and is just as important to us.

PRINCIPLES OF DESIGN

Composition

The order of the universe has given us a basic appreciation of design and a tendency to appreciate an orderly, harmonious existence. Natural designs like a beaver's dam or a beehive have inspired us to create designs. The visual arts consist of elements organized into aesthetic combinations. These arrangements, whether spontaneous or planned, are termed **composition**. Up to this point, we have been discussing the technical language of the artist dealing with those areas of concern unique to the visual arts. We are now ready to examine the language the artist uses in regard to composition, which is common to all the arts, visual and performing. Many of the terms—unity and variety; rhythm; balance; proportion and scale; and thrust, dominance, and subordination—are basic not only to most of the arts but also to many other of life's experiences.

Unity and Variety

Visual **unity** (oneness) occurs through the interrelationship of all parts of an artwork so that they fit together in a recognizable order. This order may be simple or highly complex. A composition can be related and unified by repeating and echoing certain shapes, masses, colors, or lines, as, for example, the curved lines repeated in Riley's *Current* [2.12] and the processions of columns in the Temple of Amun at Karnak [2.34]. In these works, the repetition and interrelations of the parts give pleasure and satisfaction by creating unity.

Sometimes a work of art may appear to the inexperienced eye to have little unity, as in *Carnival of Harlequin* [2.47] by Joan Miró (1893–1983). The apparent disorganization adds to its sense of fantasy, yet the repetition of somewhat similar shapes, bright colors, and lines produces a unified composition that holds together. The differences between the elements themselves provide interesting variety within the basic unity.

2.47 JOAN MIRÓ. *CARNIVAL OF HARLEQUIN.* 1924–1925. OIL ON CANVAS. 26 × 36-5/8″. ALBRIGHT-KNOX ART GALLERY. BUFFALO, NEW YORK. ROOM OF CONTEMPORARY ART FUND, 1940.

2.48 José Clemente Orozco. *Zapatistas.* 1931. Oil on canvas. 45 × 55" (114.3 × 139.7 cm). Collection, The Museum of Modern Art, New York. Given anonymously.

Rhythm

A basic element of life is **rhythm**. It is created through the regular repetition of natural phenomena, such as waves pounding on a shore or a heart beating in a regular pattern that can be seen on a cardiogram. The natural rhythms of the tides, the phases of the moon, and the turning of the earth all suggest the rhythm of regular repetition. In the visual arts, rhythm is produced by the regular repetition of similar lines, shapes, colors, or textures. Our eyes quite naturally follow the pattern of repeats. Marcel Duchamp created a sense of flowing rhythm in *Nude Descending a Staircase (No. 2)* [2.46] by repeating shapes of the body as it moves down the stairs. The female form has been reduced to machined parts, reflecting the technological interest of many early twentieth-century artists, but it has rarely been expressed more dramatically. Even the colors, muted grays and browns, remind us of the machine.

Rhythm appears similarly in the repeated forms of the Temple of Amun at Karnak [2.34], and we are comfortable with their regularity. These are obvious examples of rhythm in art. A more subtle design appears in Michelangelo's *The Creation of Adam* [I.1], in which the lines of Adam's listless, still lifeless body are echoed but not exactly repeated in the vital, life-giving lines of God's figure. In a similar way, in José Clemente Orozco's *Zapatistas*, the repetition of diagonals in the standing figures (with their hats) direct a march to the left that is strengthened by the large hats above [2.48].

Balance

There is a desire for **balance** in all of us; we are disturbed when our equilibrium is threatened. A teetering tightrope walker creates extremes of tension in the audience. In the same way, although the Leaning Tower of Pisa is famous for its imbalance, few of us are comfortable when actually climbing its ascending ramp. When we experience works of art, that same need for balance is involved.

Balance results from the unified relationship of two opposing forces. When almost equal shapes or masses are evenly distributed in a work of art, it is said to have formal balance. An example of informal balance may be seen in Miró's painting [2.47]. Exhibiting yet another kind of balance, Calder's mobiles fascinate us with their ever-changing but totally balanced relationships. His subtle organic shapes move animatedly through space to create a vital rhythm [2.13].

Proportion and Scale

In art, as in mathematics, science, or even cooking, **proportion** refers to how parts relate to each other and to the whole. Human proportions affect architecture and furniture design. In contemporary design, the **module**, or core unit, is based on dimensions and ratios derived from the human body. Similarities in proportions within groups of people have permitted fashion designers to standardize clothing. Modern mass-produced plywood or plastic

2.49 THE GOLDEN SECTION.

furnishings are also designed to suit average proportions. The scale of a building in relation to the size of the human figure has much to do with its emotional impact. For example, the immense size of many churches and public buildings dwarfs the individual's sense of importance. When the artist tampers with predictable proportions in order to create a desired effect, the viewer experiences a discomfort that often gives way to fascination [2.4].

Greek civilization was particularly concerned with proportion, both in life and in art—noted by the subtle relationships incorporated in every work of Greek art; each small part was affected by every other part. One aspect of this refined sense of proportion was called the **Golden Section**, a principle that the Greeks applied to their temples and most other artworks [2.49], as can be seen in the spacing of parts of the Dipylon vase [2.3].

According to this rule, a small part relates to a larger part as that larger part relates to the whole; that is, A : B = B : A + B. This ratio was likely derived unconsciously from natural laws we have only recently understood. Science has verified that this year's growth of a mollusk (or indeed of any living form) relates to last year's increase as that amount relates to the whole.

Scale, on the other hand, refers to size, that is, to the relative measurements of the viewer and the work. For instance, when we consider miniatures, which are small paintings or objects, we anticipate works that can be held in the hand. Most paintings and wall hangings are perhaps two to five feet (61 to 152 centimeters) wide, enough to serve as a focal point of decoration in the average building. Artists of the **New York School** of the 1950s overwhelmed their viewers with monumental works, planned essentially

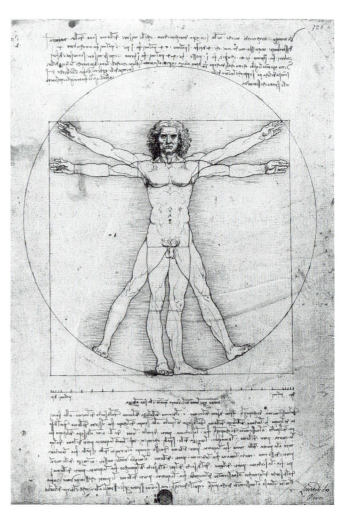

2.50 LEONARDO DA VINCI. *STUDY OF HUMAN PROPORTIONS ACCORDING TO VITRUVIUS.* C. 1485–1490. PEN AND INK, 13-1/2″ × 9-3/4″ (34 × 25 CM). AECADEMIA, VENICE.

to surround their viewers with painted environments. Consider that Jackson Pollock's *Number 1, 1948* **[1.13]** is about 5'2" x 8'8" (1.73 by 2.64 meters)—as large as a whole wall in many homes and a decidedly oversize scale for most.

People have often been concerned with the relationships of the parts of the body; the Greeks developed an idealized scale that served as a criterion of beauty for a thousand years. Classical Greek sculptures adhered to the scale set forth by Polykleitos in a set of standards—a canon. The Greek figure considered ideal measured seven-and-one-half head lengths. Scale also intrigued Leonardo, who declared: "Man is the measure of all things." He placed the human figure as a unit of measurement in the center of the most perfect geometric shapes recognized by his day, the circle and the square **[2.50]**.

Some rules can be set with considerable accuracy. A child's head is always larger in relation to the rest of the body than an adult's. However, sometimes artists disregard the rules for expressive purposes. In teaching figure drawing, an instructor may suggest that students measure a figure's length in relation to the head. The average adult is about seven to eight head-lengths tall, but the fashion artist may draw a figure whose height measures twelve heads, while a painter may elongate figures to suggest spirituality. Unlike the Greeks, contemporary artists feel free to alter conventional proportions and to manipulate scale to create special effects.

Thrust, Dominance, and Subordination

Directional, linear forces are created in the basic structure of a work of art, as seen in de Kooning's drawing **[2.6]**. Vertical and horizontal lines suggest growth and repose, respectively, because they refer to natural states of life that fall into vertical or horizontal positions. Diagonal lines repeat the direction of driving snow or rain and consequently suggest lines of action to us. **Thrust** is created by the most dominant linear force within the work of art and is usually directed to the focal point of the work—the emphasis of the composition. For example, in order to direct attention to his model in *The Artist in His Studio* **[1.1]**, Vermeer places the greatest contrasts in light and dark and the largest shapes near her figure. The lines of the draperies echo her pose and help to frame her effectively. By subordinating almost everything else in size and value, Vermeer assures that the model will dominate the composition.

We have seen that sensitivity to design, inspired by the natural world, is as old as humanity. The veining of a leaf and the pattern of annual growth of a tree suggest designs of variety and complexity. Similar curved, spiral, wavelike, and animal designs based on nature are found everywhere in the world. Whether we view the decoration on a clay pot or analyze the complex plan of a building, we note a universal awareness of structure and order.

In our further studies of the visual arts, we will try to identify the devices used by all artists to achieve satisfying designs.

EXERCISES AND ACTIVITIES

Exercises for Research and Discussion

1. Select two artworks reproduced in this book to analyze on the basis of the artists' use of the following terms: line, shape, mass, value, color, texture. Find works that illustrate unity and variety; rhythm; and thrust, dominance, and subordination.

2. Study William Hogarth's two series dealing with eighteenth-century morals, that is, *The Rake's Progress* and *The Harlot's Progress*. How many works were involved, which media, and what was Hogarth's purpose in these series? Contrast the similarities and differences between his works and those of Edward Kienholz.

3. The pre-Columbian Aztec pantheon includes other deities as ferocious as Coatlicue and a few quite peaceable. Who were they and what powers did they represent?

4. Why is Francisco Goya's painting, *The Execution of the Madrileños on May 3, 1808*, considered a milestone in modern art?

5. What moved Jasper Johns away from target paintings into flag icons (Introduction)? What was his goal with these works?

Studio or Homework Activities

1. Cover a sheet of paper with lines, using pencil, chalk, charcoal, pen and ink, and paint. Vary the thickness, length, direction, and spacing of the lines. Notice how the lines produce different effects.

2. Inside small squares draw groups of lines that express joy, sorrow, excitement, humor, confusion, tension, or other emotions. Analyze which kinds of lines express each emotion best.

3. Linear perspective has been used by painters to create the effect of three dimensions on a two-dimensional surface. To understand how artists use this method, place some solid objects, such as books, on a table. Try to see where the horizon line and vanishing points lie and make a simple drawing of the objects in perspective.

4. The traditional color wheel places the primary, secondary, and tertiary colors in a certain relationship. Using poster paints, mix the secondary and tertiary colors, painting all the colors on pieces of paper. Paste them in the order shown on the color wheel.

5. Take two complementary colors and mix them, producing a series of equal steps from one color to the other. Mix as neutral a gray in the middle as is possible.

3.1 FAITH RINGGOLD. *STREET STORY QUILT*. THREE PANELS: *THE ACCIDENT*, *THE FIRE*, AND *THE HOMECOMING* (DETAIL OF *THE HOMECOMING*). OIL, FELT-TIPPED PEN, DYED FABRIC, AND SEQUINS SEWN ON CANVAS, SEWN TO QUILTED FABRIC. 90″ × 144″ (228.6 × 365.8 CM). THE METROPOLITAN MUSEUM OF ART, PURCHASE, ARTHUR HOPPOCK HEARN FUND AND FUNDS FROM VARIOUS DONORS, 1990.

Part Two
Two-Dimensional Media and Techniques

All visual arts communicate some level of human experience that can be expressed through a wide range of media, materials, and techniques. In the next few chapters we will examine the many routes artists have used during the last several thousand years in their creation of art. For the most part, the original methods still work, but other techniques have been added through the centuries. Western tradition has designated the fine arts (*beaux arts*), such as painting and sculpture, for visual enjoyment, philosophical enrichment or intellectual stimulation, whereas the applied arts have been primarily concerned with functional goals. All of the arts can offer beauty and aesthetic satisfaction. However, for the most part, the crafts are no longer restricted in their utility. For instance, Faith Ringgold's *The Street Story Quilt* [3.1], was surely never designed to cover a bed, but rather to be enjoyed for its aesthetic contribution while social issues were raised by its content. On the other hand, much fine art has often assigned a lesser role to beauty than, perhaps, to bring about philosophical change in nontraditional ways. We will proceed to study all of the two-dimensional arts and such media as painting, drawing, and printmaking, as well as xerography and computer graphics. Part 3 will focus on the three-dimensional media, moving from sculpture through architecture and environmental art, and the design disciplines for everyday living, concluding with the expanding role of Performance Art.

All these media depend on the same visual elements and principles of design that we have explored in Chapter 2, but each has unique characteristics and potential depending on the materials used. These include traditional materials such as stone, wood, clay, and paper and new materials developed in the twentieth century, such as polyresins, gases, color film, and electric light. Some artists work in only one medium; others, like Picasso, try many. The traditional distinctions among media, materials, and techniques are being eroded by many twentieth-century artists, who use several (mixed) media in one work. By examining each medium in turn, we will be prepared to understand and enjoy art wherever we find it.

Drawing, Painting, and Mixed Media

"*It is not enough for a painter to be a clever craftsman; he must love to "caress" his canvas, too.*"

—PIERRE AUGUSTE RENOIR

• • •

"*I want to paint men and women with that something of the eternal which the halo used to symbolize, and which we seek to convey by the actual radiance and vibration of our coloring.*"

—VINCENT VAN GOGH

• • •

"*I have always tried to hide my own efforts and wished my works to have the lightness and joyousness of a springtime which never lets anyone suspect the labors it has cost. So I am afraid that the young, seeing in my work only the apparent facility and negligence in the drawing, will use this as an excuse for dispensing with certain efforts which I believe necessary. … I believe study by means of drawing is most essential. If drawing is of the Spirit and color of the Senses, you must draw first, to cultivate the spirit and to be able to lead color into spiritual paths.*"

—HENRI MATISSE

Drawing, painting, and mixed media—each technique, so basic to artists, has its particular characteristics, yet all share similarities. What related skills do they require?

Traditionally, the creation of an image on a flat surface through the application of some kind of coloring material has been the common element in all these art forms. Whether they are produced by drawing on parchment or on paper or by painting on plaster walls, wood, or canvas panels, these images have all appeared on flat surfaces. Artists have translated individual visions to a working surface by using brushes, pens, and assorted graphic tools. New techniques and materials, however, have changed the visual forms of these arts, for the changing world has led artists to search for new methods to express their ideas.

When we investigate the contemporary art world, we will discover that while some artists continue with familiar methods and materials, many are experimenting with industrially developed techniques and surprising new ways of creating images on two-dimensional surfaces.

Still others are rejecting the limitations of flat surfaces altogether. Such trends confirm that clear demarcations between the arts have broken down. Sculptured forms appear on paintings; paint is used on sculpture; and some graphic expressions are three-dimensional. Time and sound enter into many art experiences, and the viewer often becomes a participant in a staged environment. We will examine these newer concepts of art in greater detail later.

DRAWING

Of all art skills, drawing is the most basic. As children, we learned drawing was fun. We drew whatever caught our eye. Most of us began long before we learned to write. We drew in the sand at the beach and may have decorated the walls of our room before we began to doodle at the telephone or at the desk. However, when we learn to draw from observed form rather than from hazy recollection, we discover that most of us need to see more perceptively.

While a fine drawing may appear deceptively simple, the basic drawing skills that provide the underlying structure of many painted works may require years of patient observation to become effective. The lively images painted on the walls and ceilings of prehistoric caves also depend on the contour of drawn lines to express the action of the charging animals [I.2]. Earth pigments were used to fill the spaces between the lines with shaded color. Many scenes on the walls of Egyptian tombs were first drawn with heavy outlines and then filled in with flat color [2.42]. Thousands of pottery jugs and drinking vessels throughout the Greek world were decorated with brush drawings outlining flat areas. The monks who decorated early medieval manuscripts usually outlined the complex, intertwined designs with a pen or brush before filling them in with color. A page from the *Lindisfarne Gospels* [3.2] is a complex lin-

3.2 CROSS PAGE FROM THE *LINDISFARNE GOSPELS*. LATE 7TH CENTURY. MANUSCRIPT ILLUMINATION, 13 × 9-1/2″ (33 × 24 CM). THE MANUSCRIPT COLLECTIONS, THE BRITISH LIBRARY, LONDON.

ear delight, revealing fantastic monsters whose birdlike heads and clawed feet interlace with snakelike bodies.

Drawings also exist independently, falling into two groups: (1) drawings that serve as plans or studies for other works, and (2) drawings intended as completed artworks. The first (larger) category are notes or sketches for the artist's information and may include studies for paintings, prints, sculptures, architecture, decorative arts, and industrial arts. Artists and designers make rough sketches for their final works much as writers jot down ideas and notes.

Drawings used as studies through which artists try out ideas in pencil, conté crayon, or pen can give us insight into how a final image evolved. They were probably intended only for personal use and were sometimes stored in artists' sketchbooks, such as the well-known folios by Leonardo. In them, he included his verbal observations, writing from right to left, perhaps in order to keep his discoveries somewhat secret. When Michelangelo was commissioned to paint the ceiling of the Sistine Chapel, he also doubtless prepared for that complicated project with considerable thought before he ever put chalk to paper. Actually, few of his drawings are still extant, but each is a record of search and discovery. Michelangelo's sketches for

the *Libyan Sibyl* reveal careful observation and concern for accurate rendering of anatomy [3.3]. Those parts of the human form that presented problems to him, such as the big toe of the left foot, he drew three times, observing it from three different viewpoints. While he must have anticipated that the ceiling would receive considerable attention from Pope Julius II, who had commissioned it and others, Michelangelo would have been much surprised at the affection the world has since given those very private, preliminary drawings.

Working from sketchbook notations, an artist, especially in the Renaissance, often created a preparatory full-scale drawing of the intended work, called a **cartoon**. Once approved, the cartoon guided the artist in creating a wall painting or **mural** or other planned work.

Architects and designers also use preliminary drawings to develop their ideas and communicate them to clients. Plans for buildings, sketches from furniture to clothes, rough layouts for books and advertisements—all depend on drawing in one form or another.

3.3 MICHELANGELO. STUDIES FOR THE *LIBYAN SIBYL*. RED CHALK ON PAPER. 11-3/8 × 8-3/8″ THE METROPOLITAN MUSEUM OF ART, PURCHASE, 1924. JOSEPH PULITZER BEQUEST.

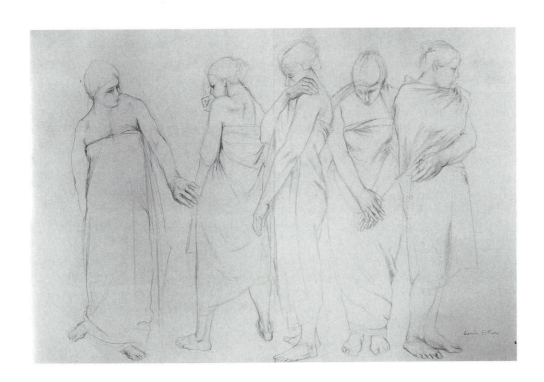

3.4 Leonda Finke. *Survivors, Study for a Frieze.* 1980. Silverpoint, 36 × 24″ (91 × 61 cm). Private Collection.

Dry Media

Pencil Before the lead pencil was invented, artists used silver-tipped tools to draw delicate lines on paper coated with white or tinted pigment. Through oxidation, as the **silverpoint** slowly travels over the surface, the line tarnishes, darkening in time to a delicate gray-brown. Such lines cannot be erased. Modulated tones are developed from many individual parallel strokes. Silverpoint drawings are rare today, but such drawings as those by Leonda Finke (b. 1922) may result in works of refinement and sensitivity. In her study for a frieze, *Survivors* [3.4], the line has a remarkable sensitivity to form and suggests light and dark in small areas. The small cross-hatchings lend some solidity to the figures while they define their contours.

The earliest pencils were lead points in a holder, but by the eighteenth century, the graphite pencil had widely replaced lead. Its wood-encased point creates lines that can be thin and hard or smudgy and soft. Today, pencils remain a prime medium. They range in grades from the soft 6B to the hard, fine 9H. Pencil does not smear as readily as chalk or charcoal. Though it is particularly suitable for small sketches and detailed drawings, it can serve for larger drawings, provided the artist has unlimited time and patience to work on that scale. Pencil is particularly effective in the hands of Robert Carter (b. 1938). His themes are generally concerned with African-American culture; lovingly handled, they are based on recollections or uniquely imagined forms like *I Dreams Too* [3.5]. The delicacy of the tones is applied and slowly built up with so long and fine a point that any excess pressure would instantly destroy it. Often, when further developed with

3.5 Robert Carter. *I Dreams Too.* 1990. Mixed media, neon. 35 × 60″.

rubbed-on graphite shavings, huge areas of ground are effectively covered. His delicate drawings are sometimes six feet (1.8 meters) high! A counterpoint, in this case of neon lights, suggests the colorful tastes of his subject.

Chalk Chalk, suspended in a binding medium such as gum arabic and pressed into sticks, became a popular drawing material in the Renaissance. It was available in black, white, and in shades of red and brown. Then, as now, it was a versatile material. It can be sharpened to a reasonably fine point, can be used bluntly, or can be rubbed on its side across the paper to cover large areas. Chalk can be used strongly and vigorously or lightly and delicately. Many chalk drawings by the greatest artists of the Renaissance still exist. In them we can see, for example,

how Leonardo studied a series of heads or how Michelangelo worked out the twist of a body or, as seen earlier, the detail of a foot [3.3]. Although this drawing was rendered on a sheet of paper small enough to fit into a modern typewriter, the study was large enough to lead Michelangelo to the life-size figure we know so well. We are brought very close to the creative inspiration of these great Renaissance masters when we view the studies they made for their major works.

Charcoal Charcoal has come a long way from the crumbled pieces our distant ancestors salvaged from ashes of a fire to the present convenient, prepared stick made from hard, close-grained wood. Artists find charcoal an easy material with which to work, because they can quickly develop with it a wide range of different tones. It is especially useful in drawing large areas of light and shade. If sharpened with sandpaper, charcoal may be used for linear drawings or, if smudged and rubbed into the paper, it can create soft, hazy effects. Traditionally, a popular way to use charcoal was to draw with it on gray-textured paper, adding white chalk highlights. Charcoal is limited because it smears easily. Consequently, charcoal drawings must be protected with a sprayed fixative to protect them from dam-

3.7 MARK ARENDS. MOTORCYCLE MARKER RENDERING. 1977. FELT TIP MARKER. 14 × 17″. PHOTOGRAPH COURTESY THE ARTIST.

age. Jim Dine (b. 1935), in an untitled series for a special exhibition of drawings for the Museum of Modern Art, rendered seven tools [3.6], using a combination of charcoal and graphite pencil (described earlier) to produce extraordinary drawings. The blurred, rubbed tones of the charcoal serve as a soft contrast to his impeccable pencil detail.

Crayon Wax crayons have an advantage over charcoal in that they do not smear or rub off paper so easily. Oil pastels known by the trade name Craypas are useful for drawing large colored areas of light and shade. With the somewhat softer lithographic crayon, the artist can create rich, shining darks or, if handled lightly, soft mid-values as well. Conté crayon, available in shades of red, brown, and black, were perhaps more popular in the past than now. Often applied upon a precoated plaster gesso surface that provides some "tooth," conté is a highly compressed pigment with binder that can be used like chalk, producing velvety shadows in contrast with brilliant whites. When conté is applied to a gesso surface, variations of tones are almost unlimited if the artist has patience to build up values slowly, with painstaking effort. Drawings by Georges Seurat in conté [2.21] upon a rough surface are starkly realistic and, as black-and-white studies, minutely render reflections of the artist's interests. The *Café Concert* demonstrates his concern with organized space.

Colored Pencils, Markers In conclusion, colored pencils and markers designed to dry on contact, the latter most popular with illustrators especially since midcentury, provide a broad range of colors and are convenient. In the hands of a professional illustrator, a marker rendering [3.7] provides the appearance of an instantly created work yet may comprise the full range of textures and tones that in previous decades would have been laboriously built up with the painterly media of watercolor and **gouache**.

3.6 JIM DINE. *UNTITLED* (5 BLADED SAW) FROM SERIES OF SEVEN TOOL DRAWINGS. 1973. CHARCOAL AND GRAPHITE, 25-5/8 × 19-7/8″. COLLECTION, THE MUSEUM OF MODERN ART, NEW YORK. PURCHASE.

Liquid Media

Ink, Wash The artist's basic fluid drawing medium, ink, has been in use for thousands of years. The Egyptians drew on papyrus with carbon ink, the ancient Chinese used ink on silk scrolls, and Western manuscript illuminators drew with ink on vellum made from animal skins. Paper is believed to have been developed in China around A.D. 100 and brought to Europe with the spread of Islamic culture. By the fifteenth century, paper was manu-

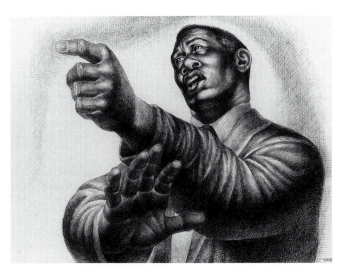

3.9 CHARLES WHITE. *PREACHER.* 1952. INK ON CARDBOARD. 21-3/8 × 29-3/8″. COLLECTION OF WHITNEY MUSEUM OF AMERICAN ART, NEW YORK. PURCHASE 52.25.

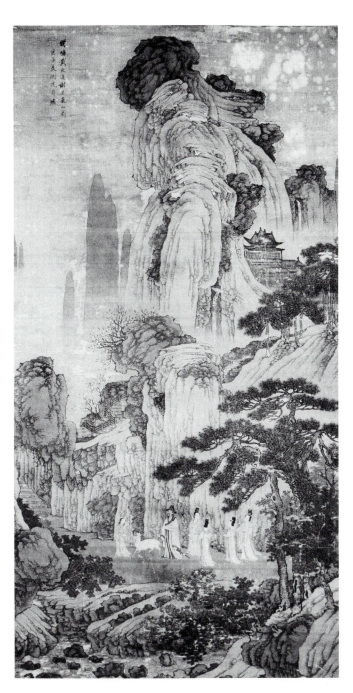

3.8 SHEN ZHOU. *XIE AN IN THE DONGSHAN MOUNTAINS.* 1480. HANGING SCROLL, COLOR PAINTING ON SILK; 67-1/4 × 35-3/8″ (170.8 × 90 CM). COLLECTION OF WAN-GO H.C. WENG.

factured in Europe, offering a wider choice of drawing surfaces and techniques. Ink was brushed onto the paper with hair brushes or stroked on with a bamboo or quill pen. Depending on the materials and techniques used, artists could produce a wide variety of effects, ranging from broad brushstrokes to delicate pen lines.

Inks that are diluted to produce various tones are termed **washes.** The variety of tones possible with wash is well demonstrated in a Chinese landscape [3.8]. Also common to many Chinese and Japanese paintings is the vertical composition depicting an imagined idyllic landscape. While our eyes journey upward from the base of the work, delicate details of shrubs lead us to the mountain at the top. These tones are particularly characteristic of Oriental drawings, which are washed onto silk or paper with subtle value gradations. Here again, we find an instance where the distinction between drawing and painting disappears.

Pure (undiluted) ink is used when the artist wishes to make a strong statement that can be quickly understood. The classic pen drawing by Ben Shahn, *Silent Music* [2.7], was commissioned by CBS during a musicians' strike and commanded half a page in the *New York Times.* Shahn's brilliant use of line captivates our eyes while we follow the path he has laid out for us, threading our way through the orchestra pit. CBS resolved its differences with the musicians almost immediately, but Shahn's drawing remains as a classic illustration of line.

Tones of gray can also be achieved by building up fine, usually parallel lines in pencil, ink, or chalk in a process known as **hatching.** By crossing the parallel lines in another direction, **cross-hatching** produces deeper and solid values, as in the powerful *Preacher* [3.9] by Charles White (1918–1979). The white highlight areas and light

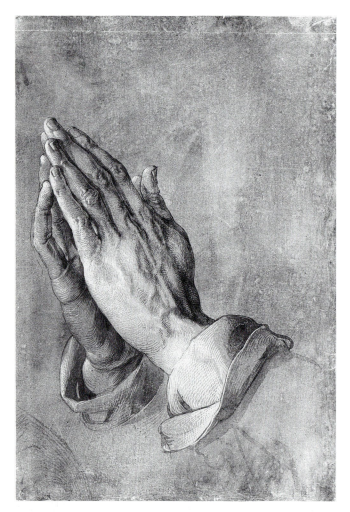

3.10 ALBRECHT DÜRER. *PRAYING HANDS*, STUDY FOR DETAIL OF *THE ASSUMPTION*. 1508. WASH DRAWING WITH OPAQUE HIGHLIGHT, 11-1/2 × 7-3/4″ (29 × 20 CM). GRAPHISCHE SAMMLUNG ALBERTINA, VIENNA.

grays are almost devoid of inked lines. The enlarged left arm and foreshortened right arm emphasize the preacher's dramatic and dynamic arm positions while he exhorts his congregation.

Chinese White Though many of us are familiar with the detailed study of Albrecht Dürer's (1471–1528) *Praying Hands* [3.10], we are less aware that it was intended to be only a preliminary drawing for a much larger work, *The Assumption*, which few of us know. Artists, it seems, cannot always predict what will attract the public's fancy. The study of reverent hands is meticulously rendered in a technique quite common in the Renaissance but rarely used today. Dürer used blue paper as the base for the drawing; then he slowly built up highlights with opaque Chinese white paint, while at the same time, he applied dilutions of ink (wash) for the shaded areas and pure ink for the deepest tones. The beauty of the drawing has commended it for

study through the years both as inspiration for worship and as a model for imitations.

Combinations of Techniques

Today many drawing methods are used in untraditional ways to produce varied effects. Ink and chalk drawings may have bits of photographs or magazine reproductions pasted on them. Pencil drawings may be combined with commercial overlays of printed dot patterns just like the screen used to reproduce photographs and artwork for books, magazines, and newspapers. Some artists blow fine mists of paint and ink onto paper with **airbrushes**; many others draw with the same brushes with which they paint. It is difficult to say at which point drawing ceases and painting begins. These new methods have given artists freedom to express new ideas, so that drawing continues to serve as a base for all who work in the visual arts.

Perhaps the most innovational medium of our time for drawing is the use of light, as seen in Picasso's final experiments with a new technique [3.11]—there is scarcely a medium he did not explore—portended as early as his 1949 rendering of the outline of a mythological centaur. Many artists of today have turned to the computer to

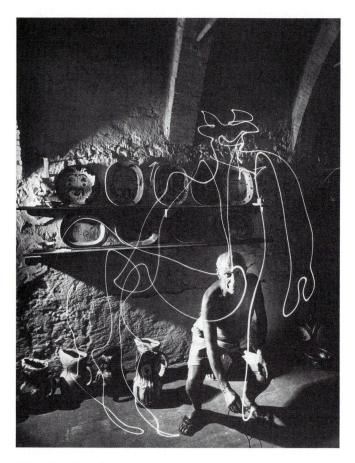

3.11 GJON MILI. *A CENTAUR DRAWN WITH LIGHT*. 1949. PABLO PICASSO AT THE MODOURA POTTERY, VALLAURIS, FRANCE.

work with electronic light. Keith Haring, already involved with politically controversial themes set up in public places such as the subway [1.10.], experimented with computer-generated light images. *Messages to the Public* opened a new environment for his art, translating original line drawings instantly into light art in the enormous proportions that few artists ever dream of achieving [3.12].

PAINTING

The most honored, perhaps, of all the art media, painting, by its very nature, offers the artist possibilities for visual images that cannot be accomplished in any other way. In painting, the first consideration is usually color, basic to most painted works. Drawings are sometimes colored, but paintings hardly exist without differentiation of color as the avenue for developing all the other elements. As we have learned, a painting need not be concerned with beauty to be aesthetically moving. The subject matter or emotional content may produce sensations of horror, while the composition and other elements of design are well organized.

Paint consists of **pigment** (dry coloring material) suspended in a mixing agent, which is a liquid made up of a **binder** (a sticky material) and a solvent (thinner). Various kinds of paint—oil, tempera, watercolor, and the paint used in fresco—differ in the mixing agent, the surface to be covered, and the technique of application.

Pigments are made from both organic and inorganic substances. Traditional organic sources for pigments that occur naturally include charcoal (black), a kind of beetle (red), the urine of cows fed on mango leaves (yel-low), and a vast variety of plants (indigo blue). In recent times, coal tars have become an important synthetic organic source. Among other organic pigment sources are earth, which produces yellow ocher and raw and burnt umber, and minerals such as zinc (white), cadmiums (yellow, orange, red), and cobalt (blue). In the Middle Ages, ground *lapis lazuli*, a semiprecious stone, produced a beautiful blue, which was so costly that it was often reserved for images of sacred figures, such as the Virgin Mary's cloak. Today many inorganic pigments are artificially made.

In the past, artists ground their own pigments and mixed them with the appropriate vehicle. Paleolithic painters mixed charcoal and earth colors with animal fat to paint the walls of caves [I.2]. In the ancient and medieval world, artists mixed pigments with such binders as gum arabic, egg, beeswax, or lime and water to paint the walls of tombs and houses or the pages of books. The dryness of the Egyptian climate and the sealing of the tombs have combined to keep Egyptian paintings fresh after thousands of years [2.42]. Most twentieth-century artists use commercially prepared paints in which the pigment is suspended in the mixing solution. Dry pigments are still available, however, for artists who wish to mix their own paints.

Fresco

The Italian term **fresco**, meaning "fresh," in general refers to the technique of painting on freshly plastered walls. The artist usually prepares a full-size drawing, or cartoon, and transfers the outline to the wet-plastered wall surface. Then he or she quickly brushes on pigments mixed with water. As the wall dries, the pigments form a permanent, strong,

3.13 *Bull Leaping*, fresco in the Palace of Minos, Knossos, Crete. c. 1500 b.c. 34 × 63″ (86 × 160 cm).

3.14 Fresco from Bonampak. c. 790–800 a.d. Life-size. Bonampak, Chiapas, Mexico. Watercolor reproduction by Antonio Tejeda. 1948. Peabody Museum, Harvard University. © 1988 President and Fellows of Harvard College. All Rights Reserved.

3.15 MICHELANGELO. CEILING, *SISTINE CHAPEL*. 1508–1512. FRESCO, 44 × 128′ (13.41 × 39.01 M). VATICAN, ROME.

extremely durable surface, impervious to moisture. Indeed, the colors quite literally become part of the wall.

Because the pigment should be brushed on when the plaster is wet, only enough plaster is applied to cover an area that can be painted in one day of work. If you look closely at a frescoed wall, you can often see lines where one day's plastering stopped and the next began. Usually the artist tries to conceal these lines by planning them to fall along the edges of the shapes in the painting.

This technique applied to wet plaster is specifically called **buon fresco** ("true fresco") to distinguish it from **fresco secco** ("dry fresco"), in which pigments mixed with a binder are applied to plaster that has already dried. Fresco secco is less durable and less brilliant than buon fresco.

Fresco secco was used by many early peoples to make murals. As far as we know, the earliest true frescoes were painted on the walls of the famous palace of King Minos in Knossos on the island of Crete. The representation of figures leaping over a bull for sport [3.13] formed the basis for the later Greek legend of the menacing bull-monster, the Minotaur. Crete's slender-waisted athletes dominate a fun-loving way of life, unique among frescoes in the ancient world, though the whole series inspired later murals on the Greek mainland.

Fresco was an important technique in Europe, in the Greek, Roman, medieval, and Renaissance periods. Concurrent with the early European Middle Ages, however, native Americans in Middle America also discovered buon fresco. As far back as the seventh century and since, temples and palaces were decorated with colorful wall paintings. The fresco series from Bonampak in Yucatán about A.D. 700 are particularly fine examples [3.14]. Still later, at the height of the Renaissance, the Sistine Chapel ceiling painted by Michelangelo achieved the world renown that has been maintained ever since [3.15].

The preliminary work that is required for preparing and plastering the wall affects the durability of a fresco. Because Leonardo da Vinci worked slowly, with great de-

liberation, he experimented with new, slow-drying mixtures of paint. Consequently, his famous work *The Last Supper* [2.38], generally identified as fresco secco since not all his paints were applied to a wet plaster surface on the monastery refectory of Sta. Maria delle Grazie in Milan, began flaking off the wall even during his lifetime.

A little-used technique in succeeding centuries, fresco was revived in the early twentieth century by Mexican painters responsive to their native American heritage. Revolutionary figures in *The Modern Migration of the Spirit* by José Clemente Orozco (1883–1949) were painted in the same basic technique used by their forebears [3.17]. Fresco can still be found, chiefly for murals in public buildings.

Tempera

When you hear the term **tempera**, you probably think of the jars of poster paint you used in grade school. Probably these paints were gouache, or opaque watercolor paint bound with gum or glue, not true egg temperas, which depend on an egg yolk binder. Occasionally, egg white and, less frequently, casein (which is derived from milk) may be used as the binding material. Applied to a properly prepared surface called a **ground**, egg tempera is very durable. The most suitable surface is wood, coated with a ground of **gesso**, a mixture of white pigment (chalk, plaster, or white clay) and animal glue. Perfect preparation of the gesso is important—an incorrect mix can cause cracks to develop all over the painting. After the ground is prepared, dry pigments are mixed with egg yolks and water and then applied to the absorbent gesso. Sometimes the egg yolks are mixed with oil and varnishes to create an emulsion. During the Middle Ages, this method of painting with egg tempera was widely used for household and church altar paintings on wood called **polyptychs** if many-paneled and **diptychs** if double-paneled. Later painters used tempera on canvas, which proved to be far less durable.

Art Talk

A team of experts is well into a twelve-year project to restore Michelangelo's ceiling frescoes in the Sistine Chapel—a process that has provoked questions and controversy.

The vast panorama of hundreds of frescoes of biblical prophets, mythological figures, and Old Testament scenes was commissioned by Pope Julius II in 1508; through the centuries it has been viewed by hordes of visitors.

The scaffold designed by the master, erected some 60 feet (18 meters) above the floor, has been regarded

cleaning in a few areas seems apparent, there is by no means universal agreement as to how to go about it and when to stop. Since the paint thickness of the frescoes varies dramatically from 3/8 to 3/4 inches (1 to 2 centimeters), a uniform removal of the topmost layer is not practicable. Finally, questions arise as to how best to protect the frescoes during and after the cleaning process, when the usual 6000 to 18,000 daily visitors return to view them.

Chemical analyses from this Sistine project have confirmed what was suspected. Earlier water seepage

 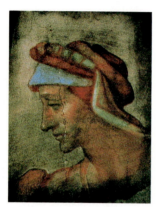 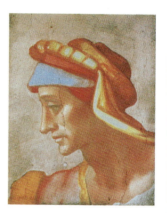

3.16 DETAIL OF THE LEFT SIDE OF THE AZOR-SADOCH LUNETTE SHOWING THE RESTORATION PROCESS. © NIPPON TELEVISION CORPORATION.

with awe by engineers, especially since a modern scaffold had to be built. The original scaffold, strong enough to support Michelangelo and his helpers, plus plaster and other assorted items, was occupied for about four years without interruptions. The current cleaning program began when the new scaffold, built to repair water seepage, put Vatican conservators within reach of the frescoes.

In the nearly half a millennium since the works were completed, the frescoes have accumulated some mold on the lunettes (semicircular areas) and dust and grime from the smoky stoves first used to heat the chapel and from airborne pollutants tracked in by tourists and worshippers. Though the need for some

had been repaired and cosmetic varnishing added. The procedures used in the restoration process are designed to prevent any loss of original paint. The protective patina covering the base (al fresco) layer is never touched. "A secco" areas (places where paints were applied "dry") are microscopically examined to determine if the pigments predate the sixteenth century and, if so, only the darkened varnishes are removed. Vatican officials are considering some form of climate control. All agree that a technological solution to the multiple concerns of temperature, humidity, and pollutants in the Sistine Chapel is needed now. Just what course that will take is less certain [3.16].

RESTORATION AND CONSERVATION OF THE SISTINE CEILING

Tempera paintings can be built up by painting layer over layer. Early artists slowly built up dark and light values over the usual underpainting of umber pigment, although other colors also have been noted in a few regions. Brilliance and crispness are characteristic of tempera paintings. Colors dry quickly with high gloss, and repainting

over underpainted layers, when the artist wishes to alter the original concept, is simple. Although the technique fell into disuse when painting with oils was introduced, many contemporary illustrators continue to use tempera. A few painters, such as Andrew Wyeth (b. 1917), choose tempera because of the opportunities it offers for precision. By

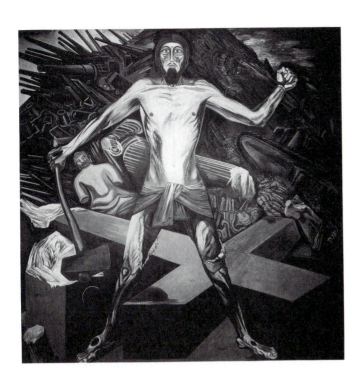

3.17 JOSÉ CLEMENTE OROZCO. *THE EPIC OF AMERICAN CIVILIZATION: MODERN MIGRATION OF THE SPIRIT, PANEL 21.* 1932–1934. FRESCO, 10'5" × 10' (3.18 × 3.05 M). COMMISSIONED BY THE TRUSTEES OF DARTMOUTH COLLEGE, HANOVER, NH.

overpainting several layers of varying tones, for instance, Wyeth retains our interest in the broad foreground area of *Christina's World* **[3.18]**. By selectively etching with a knife blade various surface pigments, he achieves finely detailed blades of grass. The expanse of grass is particularly important in this work because it emphasizes Christina's physical limitations in reaching her distant house.

Watercolor, Gouache

Watercolor paints are made of pigments and binder such as glue, egg white, or gum arabic, which can be diluted with water. Washed over a white surface, which shows through

3.18 ANDREW WYETH. *CHRISTINA'S WORLD.* 1948. TEMPERA ON GESSO PANEL. 32-1/4 × 47-3/4". COLLECTION, THE MUSEUM OF MODERN ART, NEW YORK. PURCHASE.

3.19 Joseph Mallord William Turner. *San Giorgio from the Dogana, Venice: Sunrise*. 1819. Watercolor, 8-13/16 × 11-15/16″ (22.6 × 30.4 cm). Tate Gallery, London. Reproduced by courtesy of the Trustees.

the pigments, watercolors produce paintings of distinctive freshness, clarity, and transparency—qualities that can be easily lost if the painting becomes overworked. Watercolor has been used in the West since Classical times, and almost all medieval manuscripts were executed with watercolor or gouache. The *Lindisfarne Gospels* [3.2] demonstrate the delicacy and fine detail possible with watercolor.

Watercolor paintings using nonfading pigments on good-quality paper or silk are remarkably permanent, as can be judged from examination of many Chinese works, treasured for centuries. The landscape [3.8], revealing the Eastern love of nature, demonstrates the endurance of watercolor despite a lifespan of five hundred years. The basic pigment used is lampblack mixed with glue, although many Chinese artists also used some colored pigments. Years of training prepared the artist to use the brush skillfully and expressively. Unlike most Western painting, color was rarely used to give an illusion of reality. Eastern traditions generally required paintings to be quickly executed so that both the theme and calligraphic identification were not only handled with the same tools and materials but fulfilled the artist's original concept in minimal time. Suggestion, therefore, has always been more desirable than faithfully detailed representation.

In the West, for some time after oils became popular, watercolor was restricted primarily to sketches. It is a quick, spontaneous technique, which lends itself well to the notes an artist might make as the study for an oil painting. In the eighteenth century, watercolor was revived as

an important art medium. Joseph Mallord William Turner (1775–1851) created misty paintings in watercolor that were forerunners of later Impressionist works. His view of Venice [3.19] at sunrise is certainly very close to nineteenth-century Impressionism. Even though the variety of effects possible with watercolor does not measure up to the potential of oils, artists have used the medium in different ways to serve their purposes. Thinly diluted watercolor is also used in wash drawings to provide a wide range of tones. Wash works well with line drawing.

Gouache, watercolors bound with gum or glue, is opaque, and therefore light is not reflected from the white paper beneath the paint. Because of its opacity, gouache can be reworked more than watercolor. Gouache paintings are usually started with thin washes and brushstrokes, close to the color or tone of the surface used. Because gouache dries quickly, additional painting can be built up without delay. Many artists apply the first layers of paint in the consistency of watercolors, reworking while wet, or blotting to further lighten results. The paint may later be applied opaque for finished effects. Morris Graves' *Owl of the Inner Eye* [3.20], a gentle image of a bird as typically mysterious as all of Graves' bird imagery, is rendered with fine lines, and broad textured strokes.

Oil

Oil paints consist of a mixture of dry pigments with oil and sometimes varnishes diluted with turpentine. Developed in

3.20 MORRIS GRAVES. *OWL OF THE INNER EYE.* 1941. TEMPERA ON TRACING PAPER, 20-3/4 × 36-5/8″. COLLECTION, THE MUSEUM OF MODERN ART, NEW YORK. PURCHASE.

Flanders in the fifteenth century and gradually refined, oil painting was an outgrowth of the commercial developments of that period. Trade with many parts of the world brought new materials to Europe, including those from which oils and varnishes could be extracted. The transition from tempera to oil was slow. Oil paint was first used for transparent glazes—mixtures of oil, thinner, and varnish—over a tempera underpainting on gesso-covered wood panels; solid form was modeled with tempera, and the final painting was completed with thin oil glazes. The Renaissance practice of layering thin, semitransparent glazes of warm and cool colors on top of each other produced a rich glow and depth to the painting. Demonstrating unusual artistry at an early age, in his *Self-Portrait* Parmigianino (Francesco Mazzola) showed gifted skill in capturing human expression and great technical brilliance in rendering details of clothing and the textures of fabrics. The surfaces glowed like enamel [3.21] and thereby succeeded in launching his professional career.

By the sixteenth century in Italy, linen canvas had gradually replaced wooden panels as the preferred surface for oil paint, since fabric was light in weight, less costly, and easy to prime with gesso or with glue, white pigment, and oil. Although oil paint on canvas is not as durable as fresco or tempera on wood, other advantages led to oil becoming the major choice of artists in the Western world for centuries. Oil dries slowly and can be reworked for a long time. It can be applied in thin glazes over underpainting, or it can be put on in thick layers with a brush or palette knife. Oil allows a wide range of shades and easy blending of colors. Thin, transparent, dark shadows can be contrasted with thickly applied highlights, a combination that was unattainable with earlier methods of painting.

Rembrandt van Rijn (1606–1669) made full use of this quality of oil paint in his contrast of deep, mysterious shadows and concentrated brilliant light areas, particularly evident in *The Night Watch* [13.43]. Oil paint in the hands of a master like Frans Hals (1580–1666) can also be used to suggest spontaneity. Like all of Hals' work, the underdrawing of *The Bohemian Girl* [3.22] is precise and carefully painted; only in finishing it did Hals apply fluid fine strokes that make the portrait appear deceptively casual, just as if his subject were caught by a candid camera.

Later painters, instead of using underpainting and glazes, applied the paint directly to canvas with free brush-

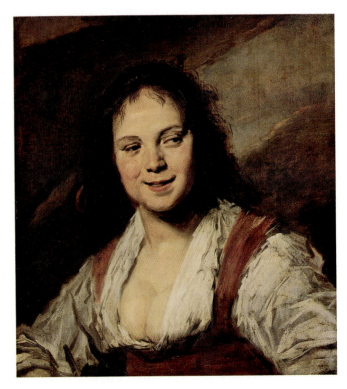

3.22 FRANS HALS. *THE BOHEMIAN GIRL.* 1628–1630. OIL ON CANVAS, 22-7/8 × 20-1/2″ (58 × 52 CM). LOUVRE, PARIS.

The Artist Sketch

In 1524 at age twenty-one, while preparing a small portfolio of his work with which to meet the great Renaissance master artists Raphael and Michelangelo in Rome, Francesco Mazzola, called Parmigianino, completed a small work destined perhaps to become the most startling portrait of his time. Fascinated by his own reflection in a barber's convex mirror, Parmigianino determined to reproduce it exactly. Sawing off a portion of a wooden sphere to use as the base, he painted himself as he was, looking outward and, as sixteenth century historian Vasari has stated, "so handsome, with the face of an angel rather than a man, his reflection in this ball appeared divine." His head was not distorted but the mirror from which he worked showed his hand and sleeve enormously enlarged. The sloping skylight of his studio, as well as the opposite wall, are curved to encircle the portrait, reflections, shadows, and lights. The finished work was greatly admired in Parma, where the young Parmigianino was born, and was well received in Rome, even by Pope Clement, who was amazed by the youth

3.21 FRANCESCO MAZZOLA (PARMIGIANINO). *SELF-PORTRAIT IN A CONVEX MIRROR.* C. 1523. OIL (?) ON WOOD SPHERE. 15-3/8″ (29 CM) DIAMETER. KUNSTHISTORISCHES MUSEUM, VIENNA.

of the artist.

As his professional skills expanded, he began to compete for commissions with the somewhat older, better known Correggio. In a brief twenty years or less, the two established new canons of European taste. Parmigianino's work was so highly regarded by many of his contemporaries that the noted poet and satirist of his day, Annibale Caro, declared that Parmigianino was the sum of all possible elegance and artifice and that "excess is an honest thing. Painters give to their things a measure beyond the natural," an outlook later associated with **Mannerism**.

Parmigianino's mature style culminated with his work in Parma, particularly in the *Madonna of the Long Neck* [13.20] demonstrating an otherworldly grandeur. In 1539, he fled to Casalmaggiore to avoid imprisonment for breach of contract, where he died at only thirty-seven years of age. He had promoted a new kind of beauty and a fresh way of seeing oneself and the world that might have been foretold by his first self-portrait.

FRANCESCO PARMIGIANINO (1503–1540)

strokes. For example, the Impressionists created an effect of vibrant light by placing small, thick strokes of complementary colors next to one another, a practice continued by Postimpressionists Seurat [2.29] and Paul Cézanne (1839–1906). Cézanne's *Still Life* [3.23] is a careful attempt to direct the viewer's conscious attention to the changing volumes of the fruit and cloth by shifting tones, plane to plane, instead of portraying a literal photographic view. This deliberate counterbalancing of changing tones to suggest mass led directly to Cubism in the early twentieth century.

Oil paint can also be applied heavily as **impasto**, a technique preferred by some painters, Van Gogh in particular, who used a palette knife to spread the thick paint. Observing a Van Gogh oil painting [1.16] becomes almost a tactile experience.

With this change to direct techniques, painters generally became less concerned with the precise craft of painting than with the immediate effect produced. Thus many carelessly painted works from the eighteenth and

nineteenth centuries are cracking. Very heavy paint is likely to crack when it is not properly applied, and some colors will darken and bleed into each other. Many artists, including Rembrandt, applied so many layers, resulting in such thick paint, that the solid, substantial-looking images become crisscrossed with countless fine cracks [13.43]. Despite these problems, oil makes possible such a variety of styles and techniques that it remains very popular.

Pastels

In their present form—pure pigment compressed into sticks with a minimum of gum binder—**pastels** date back about two hundred years. Sometimes classified as a drawing technique, but more often as painting, pastels depend rather on broad areas of color for their effects than on drawn outlines. Because the colors are not mixed with egg or oil, they do not suffer from darkening or from other effects of age. When these nonfading colors are used on high-grade paper, the result is one of the most permanent types of painting.

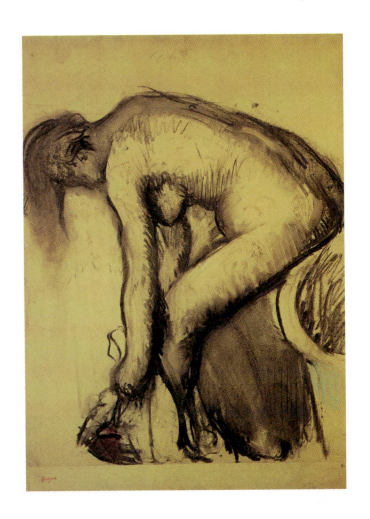

The colors do rub off, however, unless protected by glass or by a fixative spray. Because of its brilliant color and freshness of application, pastel appealed to Impressionist painters, who sought to capture momentary effects. During the latter part of his life, Edgar Degas (1834–1917) confined most of his painting to pastels, for the ease of achieving broad tones with them as well as for their effect of spontaneity. Many of his studies, such as *After the Bath* [3.24], are intimate glimpses of women at work or at ease.

Acrylics and Other New Materials

In their search for new ways to respond to inner emotions and the outer world and to achieve permanent color effects, many artists investigate new materials and techniques. Sometimes restricted access to traditional materials leads an artist to new materials with which he or she may develop an original approach to art. For example, Jackson Pollock [1.13] used oil-based house paints and metallic enamels for his canvases, he admitted, because he could

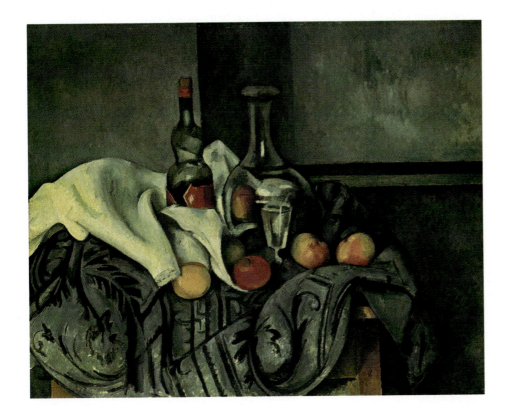

3.23 PAUL CÉZANNE. *STILL LIFE WITH PEPPERMINT BOTTLE.* C. 1894. OIL ON CANVAS, 26 × 32-3/8" (55 × 82 CM). NATIONAL GALLERY OF ART, WASHINGTON. CHESTER DALE COLLECTION.

3.25 MORRIS LOUIS. *SARABAND.*
1959. ACRYLIC RESIN ON CANVAS.
101-1/8 × 149″ (257 × 378.5 CM).
SOLOMON R. GUGGENHEIM
MUSEUM, NEW YORK.

3.26 DON EDDY. *GOREVIC SILVER.* 1975–1976. ACRYLIC ON CANVAS. 4′2″ × 5′10″ (1.27 × 1.78 M). PRIVATE COLLECTION. COURTESY OF NANCY
HOFFMAN GALLERY, NEW YORK.

not afford artists' oils. The fluidity of inexpensive paints from the hardware store, however, led him to experiment, first by dipping his brush into the paint, then by pouring, dribbling, and flinging his paints onto canvas laid out on the floor. Such a process would have been impossible with oils from tubes brushed onto a canvas set on an easel. Unfortunately, however, because the quality of housepaints scarcely compares with artist-quality oils or acrylics, some of Pollock's early work, as well as that of other somewhat impoverished pioneer Abstract Expressionists, is already deteriorating. (See: Conservation, Chapter 9.)

New synthetic polymers probably have given artists the greatest shift in materials and techniques since the evolution of oils five hundred years ago. The most popular synthetic paints today are the **acrylic** and pyroxylin paints in which pigments are suspended in a polymer vehicle, producing opaque or transparent films. These paints have greater durability than oils and can be used on a wide range of surfaces. They are thinned with water, yet are resistant to water once dry. As synthetics, these paints are inert and will not change color or affect the surface on which they are applied.

In addition, acrylics are brilliant, and they can be used as transparent glazes or built up in thick impasto surfaces. Thinly glazed areas can be contrasted with heavily painted textures. Since acrylic dries rapidly, it can be worked over in a matter of minutes, and many layers of paint can be built up. The viscosity of acrylics permits them to be laid directly on canvas that has not been primed, thereby permitting the paints to sink into the fibers of the cloth in highly personalized ways. While Morris Louis (1912–1962) never described his methods, it is apparent that he poured on his colors and then, setting the canvas on end, let gravity pull the paint down, as in *Saraband*

[3.25]. Helen Frankenthaler has demonstrated the luminosity of acrylics when applied as dyes on the canvas. Laying her unprimed canvas on the floor, she sponged her colors onto the surfaces, pulling the colors into shapes that pleased her. The huge areas involved literally surround the viewer with color [2.32].

The brilliance and vividness of synthetic paints account for their popularity in **Optical Art**. With further thinning, acrylics can be used in an airbrush. This small tool, barely larger than a ballpoint pen, is a refined, small-scale paint sprayer, capable of producing effects ranging from fine lines to broad sprays. Intended for the commercial world of photo retouching and illustration, the airbrush has become a favorite of many artists who, influenced by **Pop Art**, rework images from advertising art. Many of the **Photo-Realists** of the 1970s also took advantage of the airbrush to create detailed acrylic works, frequently derived in some way from original photographs. For many of these artists, the camera takes the place of sketches that more traditional artists still use as reference for finished works. Don Eddy (b. 1944), youngest of the Photo-Realists, sprays small dots of color, a technique particularly evident in the series depicting showcases of silverware, a tribute to our taste for material display. He chooses to work only from black-and-white photographic images, preferring to invent an original color system for every painting he completes [3.26].

The fast-drying properties of acrylic paints make them the medium of choice for **Street Art**, in particular for projects that involve several artists. *Ascension* [3.27], a community mural in a predominantly black area in Athens, Georgia, was designed by Wadsworth Jarrell with the assistance of Elissa Melaragno, Elizabeth Furbush, and a whole team of young artists. While the painting style is culled

3.27 COMMUNITY MURAL. *ASCENSION.* WADSWORTH JARRELL AND TEAM. ATHENS, GA. 1979. ACRYLIC LATEX AND HYPLAR SCALER ON WALL. 32 × 52′.

The Artist Sketch

"I work out of a response and need to redefine the image of man in the terms of the Negro experience I know best." [3.28].

Black artists today, thousands of them, are making statements like Bearden's, perhaps without even knowing that he said it first, many, many years ago.

Born in Charlotte, North Carolina, Bearden, like other Southern blacks, looked for educational (and other) opportunities in New York City. He graduated from New York University with a science degree in mathematics, trusting to a conservative career, but, enjoying the arts more, he was also the cartoonist for the school paper and for *AfroAmerican*, a news weekly. Firmly choosing the art career, he went on after college to the Art Students' League. He studied with twentieth-century German **Expressionist** artist George Grosz and from him learned about the social commentary artists Kollwitz (Chapter 15) and Daumier [14.8].

Like Aaron Douglas [16.9], who served as the first president of the *Harlem Artists Guild*, and Jacob Lawrence [16.11], Bearden also became closely associated the "306" Harlem-based group of artists. In fact, his studio on 125th Street in Harlem, New York City, was on the floor above Jacob Lawrence and next to that of the poet and novelist Claude McKay, with whom he occasionally collaborated. Bearden's work appeared in several exhibitions and one of his paintings was reproduced in *Fortune* magazine just before he was drafted into the army in 1942.

He served in World War II in the segregated 372nd Infantry Battalion. With the General Issue (GI) bill paying his way, Bearden went to Paris where he came upon the medium that has served him so well, namely collage. Faces dominate his work; some are masked, others reported in a fractured Cubist mode, but all seem to be experiencing some torment. We can sense in his frequent figures with guitars the musical base

3.28 ROMARE HOWARD BEARDEN.

that supported Bearden's skills in songwriting; he was a member of the American Society of Composers, Authors, and Publishers (ASCAP). Echoing the stringed instruments that can be found even in ancient cultures, the music of the new jazz, with its assonances and dissonances, appears again and again in the distortions of Bearden's forms.

Solo shows of his art were held not only in New York but also at Fairleigh Dickinson University, New Jersey; the Corcoran Gallery in Washington; the Carnegie Institute in Pittsburg; and in Michigan, Massachusetts and Iowa. He was commissioned by *Fortune* to design a cover and later by the *New York Times Magazine*, among many other publications.

Interviewed for *The Prevalence of Ritual*, a weighty, oversized book devoted to his art, Romare Bearden confided that it was "not his aim to paint about the Negro in America in terms of propaganda," but much as Brueghel [10.19] or Bosch [13.31] illuminated the everyday life of Flemish people of their day. And, like Brueghel who illustrated many of the time-honored proverbs that were repeated for centuries before the Renaissance in Flanders, Bearden concentrated upon the legacy of ritual. A number of his collages and paintings are titled rituals and usually depict the rites of passage, the historical inspiration of almost all African art. His themes sometimes include the humdrum details that fill most of our lives. Some of his focus is urban; some is rural.

Yet his art reaches beyond its ethnic roots. His images communicate profound feelings—sometimes haunting, more often disturbing, but almost always inspiring in that they celebrate the human spirit. While Bearden's medium involves montage and collage in a style that echoes African sculpture, it is his unique, sophisticated technique and the disquieting manipulation of scale and proportion, most obvious in the heads of his figures, that makes his work so compelling.

ROMARE BEARDEN (1914–1988)

from African traditions, perhaps by way of Picasso, and reinterpreted for a neighborhood audience, there is no ambiguity in the message. The mural calls for pride in all of the black contributions to American culture as the first step toward maximizing life's potential for every viewer of

Ascension. The dominance of geometric abstract designs, echoing Mali motifs from West Africa [14.12], creates a mood of vitality, while also suggesting in stylized details contributions of blacks to sports, women's achievements, construction trades, jazz, and education.

MIXED MEDIA

In addition to experimenting with new paints and techniques, artists in the twentieth century have also incorporated new kinds of materials into their paintings. Before 1920, Cubist painters in Paris such as Picasso and Braque [2.31] were pasting scraps of printed paper and fabric onto their painted canvases. By mid-century, Bearden was creating whole works, made up almost entirely of cutout pieces of magazine illustrations. All these works were called **collages**, from the French word for "paste" or "glue." Many artists today combine a variety of materials—metal, fabric, wood, sand, string, and words or images photoprinted on paper, plastic, or canvas—with the painted surface to make **assemblages**, from the French word for "gathering together." The English term is **combine art**. These materials, along with three-dimensional, **ready-made** objects, are glued, stapled, nailed, or even welded onto paintings. Sometimes the shadows cast by the solid objects are painted onto the canvas to push further the **trompe l'oeil** ("trick the eye") effect. This technique, so popular in the late 1600s, has become a favorite twentieth-century device to point up the issue: what is real and what is illusion? Other artists use three-dimensional canvases. Lee Bontecou (b. 1931), for example, experiments with canvas stretched over three-dimensional armatures [3.29]. In her fascination with hollows and openings she brings actual space into the painting, instead of creating an illusion of space with paint.

On the other hand, Robert Rauschenberg's (b. 1925) *Rodeo Palace* [3.30] has joined actual three-dimensional objects to a two-dimensional painted and collaged surface. This large work also succeeds in combining actual,

3.29 LEE BONTECOU. *UNTITLED*. 1964. MIXED MEDIA, 72 × 80″. HONOLULU ACADEMY OF ARTS. PURCHASE 1968 (HAA 3545.1).

3.30 ROBERT RAUSCHENBERG. *RODEO PALACE*. 1976. COMBINE PAINTING, 12 × 16′.

3.31 FRANK STELLA. *THRUXTON 3X.*
1982. MIXED MEDIA ON ETCHED
ALUMINUM, 6'3" × 7'1" × 1'3"
(1.90 × 2.16 × .38 M). THE SHIDLER
COLLECTION, HONOLULU, HI.

functioning doorways to the total configuration and is, per-
haps, the earliest environment of this type to be created by
an artist in this way. Frank Stella's (b. 1936) recent relief
constructions, made of brightly painted aluminum thrust
boldly into space [3.31], extend the concept of **combine**
still further. In their three-dimensionality, they also con-
tribute to the breakdown of the demarcation lines separat-
ing painting and sculpture. However, their emphasis is
strongly pictorial, and they are not meant to be seen from
all sides. Stella says of his art that he is attempting to infuse
new life into abstraction by sustaining its pictorial energy.

Are these works sculptures or paintings? The fre-
quently used term in today's art world is **mixed media**, a
convenient way to get around the problem of how to clas-
sify so much of contemporary art. Beyond painting and
sculpture, there is a host of new art forms. The mixed-
media story quilts of Faith Ringgold (b. 1934) seem to have
broken new ground, reinforcing possibilities of story and
art. While Pop Artist Roy Lichtenstein had used captions
in his "comic strip" paintings [17.27] and Robert Indiana
had used stencils in his 1960s imagery [17.29], Ringgold
introduced long narratives and integrated traditional wom-
en's handcrafts into her works of fine art. Albeit she was

trained academically, she found that the conventional
practices of painting limited the vigor of the political state-
ments she felt induced to make. Drawing upon a variety of
her skills, her works reflect the many influences in her life.
The dominance of the media, blunt newspaper headlines
amplified by columns of narrative, and powerful poster im-
agery, combined with her childhood delight in the decora-
tive stitchery with which her mother had supported the
family, led Ringgold finally to her quilts. Her work further
addresses what it is like to grow up black and poor in an
unfeeling white society [3.1].

Synthetic paints, new techniques, and mixed
media have not replaced traditional materials and tech-
niques; rather, they have enormously expanded the artist's
possibilities for expression. The great diversity that results
is also a product of the changing concepts of subject matter,
approach, and role of the artist that have identified art
since the late nineteenth century (Chapter 16), freeing it
from many traditional limitations. Yet does not this diver-
sity also reflect an ambiguity in our society? Artists echo
the boundless options of our world as much by their free
choices of materials and media as by the themes they
explore.

EXERCISES AND ACTIVITIES

Exercises for Research and Discussion

1. Powerful visual forces produced by drawing and/or painting techniques can evoke drama in a work of art. Using an example from this chapter, explain how such an effect was achieved.

2. Compare any three drawing techniques in regard to the medium and the expressive opportunities each offers. Use specific examples of artworks to clarify your statements.

3. In the same way, compare any three painting techniques.

4. Basing your conclusions on your understanding of the different approaches an artist may use from preliminary drawing to finished masterwork, trace the evolution of *Guernica* (Introduction).

5. Explain any difference you see from the initial concept of *Guernica* to the finished work.

Studio and Homework Activities

1. Since different drawing materials vary in flexibility, use several media, such as pencil, pen and ink, crayon, and poster paints, to create a full range of values from black to white. Arrange them in small squares in nine equal steps to determine the differences in effect and the difficulty of creating tone with some media.

2. Each drawing medium is capable of producing distinctive textures which may be expressively manipulated by the artist. Divide a large sheet of drawing paper into rectangles. Find a texture in your environment that pleases you and try to copy it in pencil, crayon, ink, or paint. Using the same media, create new textures.

3. Colors make a direct appeal to the emotions and have come to be associated with various feelings. Select a black-and-white photograph or reproduction that conveys a specific mood to you. Using any medium, make a simple composition based on the photograph, using a color scheme that expresses the mood.

4. The color of a subject may be modified by the artist in many different ways in order to express a personal feeling or emotion. Set up a still life and draw it in simple outline form. Fill in the outlines, using any three contrasting colors at full intensity, widely separated on the color wheel. Repeat the same grouping in an analogous color scheme and note the difference in effect.

5. Create a mixed-media composition using a combination of at least three techniques and materials.

Printmaking

"One man may sketch something with his pen on half a sheet of paper in one day, or may cut it into a tiny piece of wood with his little iron, and it turns out to be better and more artistic than another's big work at which its author labors with the utmost diligence for a whole year. And this gift is miraculous."

—ALBRECHT DÜRER, 1523

• • •

"It is not easy to retain the imagination's immediate, transitory intention and harmony of the first execution. … I have made observations for which ordinarily there is no place in commissioned works and in which imagination has been given full rein."

—FRANCISCO GOYA, C. 1790

• • •

"I make prints because in using the metal, the wood, and all other materials available, I can express things that I cannot express by any other means. In other words, I am interested in printmaking, not as a means of reproduction, but as an original, creative medium. Even if I could pull only one print from each of my plates, I would still make them."

—GABOR PETERDI, 1960

• • •

"[When making a print], you are performing on a stage. You can be heavy, you can be light— an accent here, an accent there. What you do alone today, thousands of people will see tomorrow."

—TATYANA GROSMAN, 1980

In our multimedia world, we are bombarded daily with thousands of images—printed, photographic, and electronic. From the moment we open the morning paper to the last page of a book we read before turning the lights out at bedtime, we have probably made our way past more printed images in a day than our ancestors faced in a lifetime. Messages once written by hand, before carbon copies, can today be duplicated almost endlessly by machine. Words and pictures are printed on countless packages, posters, cans, and magazines. Even works of art, once unique objects viewed by a handful or reproduced in a limited number of original prints, can today be duplicated millions of times through mechanized techniques. Andy Warhol's use of repeated images of bottles of Coca-Cola or the face of Marilyn Monroe reflects our involvement with multiple images [1.24]. It makes sense to try to understand and differentiate among the kinds of printed images we see.

Though the dependency of our society on the printed image is a recent phenomenon, the process of printing is ancient. **Printing** may be defined as transferring an inked image from a "master" surface to another surface, a method by which we can reproduce the same image many times. Printing has existed since early times in Egypt, China, and India. A process that was first developed to repeat textile designs on fabric, printing was much later applied to paper.

PAPERMAKING

Early surfaces for writing were papyrus scrolls in Egypt, clay tablets in Mesopotamia, and vellum scrolls and sheets in the West. All of these were less convenient than scrolls and sheets of paper made by the Chinese about A.D. 100. The Chinese adapted to papermaking the skills they had already developed in forming felt cloth. A hand-beaten mash of plant and rag fibers and water was put through a sieve, called a **mold**. As the water drained off, a sheet of vegetal felt was deposited in the mold. Such sheets, dried and sized with fish glue or soft rice paste to prevent fibers from absorbing ink, were translucent when held up to the light, like most modern book paper.

These sheets were of two kinds. **Wove paper**, possibly so called from the cloth that covered the first molds, revealed virtually no pattern when held to the light. **Laid paper** was thick and thin as a result of fibers lodging unevenly in the strips and spaces of the bamboo grid that formed later molds. Against the light it revealed a pattern of closely spaced horizontal lines and widely spaced verticals corresponding to the structure of the grid. The textural variations in laid papers enriched illustrations, but proved less satisfactory as a base for type, wherein the clarity of a letter is essential to printed communication. These basic differences in paper have been continued in the wove and laid papers of today. The tough, smooth, cheap sheets of paper produced by the Chinese provided ideal printing surfaces.

When papermaking spread from China to Spain by about 1150, European printers of cloth extended their skills to papermaking. Italians used animal glue for sizing and substituted water-powered hammers for hand beating. About 1300 they made the first watermarks, simple crosses pressed into the damp paper to identify the kind or the paper mill. Increased stocks of paper stimulated the use of printing, which in turn created a market for more paper. Eventually papermaking became a large-scale industry.

In the twentieth century, papermaking by hand, like other skills lost since preindustrial times, has been restored as a handcraft that can reach the level of art. Douglass Morse Howell (b. 1906) has dedicated a lifetime to papermaking and achieved a reputation that spans continents. His papers are works of art in themselves, and his workshop is a showplace of inventive art with paper. Howell's work with other pioneers has spawned a new generation of papermakers such as Coco Gordon (b. 1938) [4.18], who enjoys the challenge of working with textural, handmade papers. Many find that beautiful papers themselves are their goal, without embellishment by printing. Other twentieth-century pioneering printmakers like Michael Ponce de Leon find that the quality of handmade papers becomes an inspiration that always determines his art. In fact, *Tell It Like It Is* evolved from a Howell original paper, the only kind on which Ponce de Leon works [4.1].

The numbers of well-known contemporary artists using handmade papers today as a primary medium continues to grow, such as Robert Rauschenberg (b. 1925)[4.20], David Hockney (b. 1937) [5.19], and Chuck Close (b. 1940) [18.17]. From the Museum of Modern Art's "7 Master

4.1 MICHAEL PONCE DE LEON. *TELL IT LIKE IT IS.* 1969. KINETIC PRINT, LITHO AND INTAGLIO, 11-3/4 × 11". PHOTO COURTESY PIONEER-MOSS, INC.

Art Talk

"The making of paper for the elite in the art world is a joy forever," said Howell.

The acknowledged master of papermaking, Douglass Morse Howell [4.2] is the quintessential artist-scholar, maintaining after 45 years the same high level of craftsmanship with which he began. A philosopher in every sense of the word, his own work, his interests and correspondence with government leaders, teachers, and artists throughout the world has led to a resurgence of papermaking by hand and the appreciation of it by those honored while honoring his paper with their art.

Although born in New York City, his early years were spent in Florence, Italy, where a family friend and director of the Laurentian Library took him to see the frescoes in San Marco, Fiesole, by the devout Fra Angelico. At the Uffizi Gallery he was introduced to the fine quality of handmade papers of the cinquecento (1500s) never equalled because, as Howell says, "standardization always makes for a leveling down."

Howell pursues the purest of methods involving only the fibers, water, and the thousands of hours he has logged experimenting. His papers "allow the eye," as he says, "to see the limitless colors of nature" never possible with machine manufacture. A visit to Howell's studio becomes an excursion to a treasure chamber. The range of papers viewed at close hand begins to defy definition as surfaces rise and sink disclosing strands of colored paths floating past, some with hidden watermarks.

He was first visited in 1951 by Lee Krasner and Jackson Pollock, both of whom often used his papers for ink and watercolor works. By 1953, his handmade paper lamps were exhibited at America House, the same year that Georges Rouault [15.11] and Universal Limited Art Editions workshop first used his handmade papers. The recipient of a Ford Foundation Grant in 1961, he set up a model papermaking laboratory with perfectly controlled heat and humidity utilizing heavily insulated walls. Amongst the many visitors attracted to the site was the head of Cranbrook Academy's Printmaking Division, who became, like others of Howell's students, a missionary in the service of handmade paper.

Douglass Howell was able to create extremely large sheets of paper by using a hybrid of Western and Eastern techniques, providing the oversize surfaces that characterized the Postpainterly Abstract art style of the late 1950s and 1960s. In the 1970s, Howell served

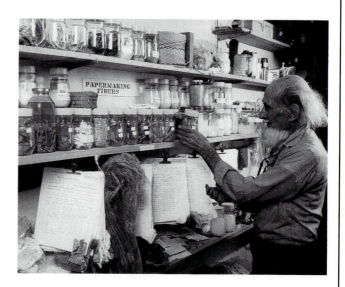

4.2 DOUGLASS MORSE HOWELL.

as Artist In Residence successively in Europe, Canada, and finally the United States, at the Nassau County Museum of Fine Arts in Roslyn, New York. By 1980, his papermaking laboratory was set up on the Alfred Ossario Estate on the east end of Long Island, funded by grants.

In spite of all his achievements, he never relaxed his standards. When asked how paper made only with vegetable fiber and water was able to hang together, Douglass Morse Howell responded with a smile, "Ask the paper."

PAPERMAKER DOUGLASS MORSE HOWELL (B. 1906)

Printmakers," Summer 1991, most of the printmakers used handmade paper, including Rauschenberg with his brilliantly colored series of large abstract handmade paper compositions. Every print from his *Trilogy from the Bellini Series* [4.3] was made of three sheets of handmade paper, each 60 inches × 38 inches, and like much of his work, printed at Universal Limited Art Editions Workshop.

PRINTING TECHNIQUES

The ancestor of printing was the early practice of stamping carved seals in the form of clay cylinders or rings into damp clay. Babylonians stamped the names of their kings on bricks, and Roman wine dealers stamped their names

on wine jars. The Chinese cut pictures and characters in relief on wood blocks, which they inked and stamped, or printed, first on fabric and then on paper in multiple copies. Anticipating modern commerce, they used copper plates to print bank notes, which were provided with inserts for changing the denomination.

In fifteenth-century Europe, **woodcuts**, made from wood blocks carved in relief, were used to print religious souvenirs and cheap playing cards. As paper became generally available and printing with movable metal type spread from Germany through Europe, handwritten, handpainted books gave way to printed books, some of them illustrated with woodcuts. By the seventeenth century, illustrations were usually made by copperplate **engraving**. Playing cards for the wealthy were engraved, while princes commissioned painted and gilded one-of-a-kind masterpieces.

In the centuries that followed, as commercial printing techniques for mass production developed, the art

of printmaking gradually evolved. Artists later adapted some artisans' techniques for their own use, often after these were discarded commercially as too costly and too slow. Many artists today, however, still use the traditional printing techniques; some artists continue to print their own work, but others prefer to have their designs reproduced by master printers.

In the past an artist might devote a whole lifetime to mastering a single technique, such as **aquatint**. Since the 1960s, cross-fertilization of ideas and techniques between artists in the atmosphere of printers' workshops have permitted major artists to freely share their printing innovations. Run by highly skilled and trained master printers, workshops provide techniques that few artists in isolation could ever hope to learn.

The Edition

Since printmaking makes use of drawing skills, it is frequently difficult for the beginner to determine whether a particular work is a drawing, a print, or a photographic reproduction. However, a familiarity with some of the most common printing techniques used by artists may be helpful in identifying prints. As part of the printmaking process, single proofs, which are sample prints, are **pulled** (printed) at various stages, or states, to determine how the image—on the broad surface (sometimes called **flatbed**) of the block, plate, or screen—is progressing. When the image is finished to the artist's satisfaction, a series is run off called **artist's proofs**. A print labeled artist's proof is retained by the artist for personal record and comparison. After inks are properly distributed on the printing surface to the artist's satisfaction, a **printer's proof** is pulled, labeled *bon à tirer* ("good to pull"), which becomes the standard by which the **edition** is judged. The entire edition is numbered. For example, the figure 20/100 at the lower left of the print indicates that it is the twentieth print pulled in an edition of one hundred. The artist's signature in pencil verifies its authenticity and his or her approval of its quality. After completing the edition, the artist may deliberately deface the block, plate, or screen and pull a print called a **cancellation proof** to guarantee that the edition is limited.

Printmaking was originally intended to provide thousands of copies for a mass market, but the modern trend has led to limited editions. Many painters also work in graphics to provide fine prints for those who cannot afford their paintings; they may limit their editions to fifty prints or less, each carefully signed and numbered.

Relief Printing

Woodcuts The oldest method of reproducing images is **relief** printing. The most common print types are **woodcuts**, wood **engravings**, and **lineoleum cuts**. The artist first transfers a design to a block. Then, using sharp gouges, he or she cuts away all unwanted areas of wood or

4.3 ROBERT RAUSCHENBERG. *BELLINI #1.* 1986. COLOR ETCHING, EDITION OF 36. 58-1/4 × 38-1/4″. PRIVATE COLLECTION.

linoleum, leaving elevated only the design area that is to be printed [4.4]. Ink is then spread over the block and paper is laid upon it. The ink is transferred from the relief surface to the paper by means of pressure, usually by a press, produc-

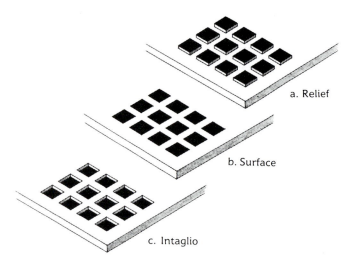

a. Relief

b. Surface

c. Intaglio

4.4 FLAT-BED PRINTING PROCESSES.

ing a "mirrored" printed image of the original design. The technique is characterized by bold lines and strong tonal contrasts between the inked images and the paper.

In the Orient, woodcuts have been a significant art form for centuries, fulfilling a need for inexpensive art for those who could not afford hand-painted scrolls. Many Oriental woodcuts were printed with black outlines and later colored by hand. Other woodcuts were produced by cutting a separate block for each color. Each block was carefully inked, registered over the image left by the preceding block, and printed.

The woodcut of Fuji [4.5], also known as *The Great Wave*, is one of a series of different views of the mountain executed by Katsushika Hokusai (1760–1849). In this engaging print we scarcely perceive the tiny fishermen's boats desperately trying to escape from the towering wave. The striking asymmetrical composition, in which the wave almost encircles the remote mountain peak, seems very different from the symmetrical work of Renaissance printmakers like Dürer.

Japanese woodcuts reached Europe after Japan was opened to world trade in the nineteenth century, when

4.5 KATSUSHIKA HOKUSAI. *THE GREAT WAVE OFF KANAGAWA.* FROM THE SERIES *THE THIRTY-SIX VIEWS OF FUJI.* 1823–1829. WOODBLOCK PRINT. 10-1/8 × 14-15/16″. THE METROPOLITAN MUSEUM OF ART, BEQUEST OF MRS. H.O. HAVEMEYER, 1929. THE H.O. HAVEMEYER COLLECTION.

4.6 Utagawa (Ando) Hiroshige. *Maple Leaves at the Tekona Shrine, Mamma.* 1857. Color woodcut, 13-3/4 × 9-3/8" (35 × 24 cm). Courtesy of the Trustees of the British Museum, London.

One of the most remarkable examples of Renaissance woodcuts is the mammoth *Triumphal Arch of Maximilian I* [4.7] by Dürer. Including the beautifully lettered explanation at the bottom, it measures about 11 1/2 feet by 9 3/4 feet (3.5 by 2.97 meters) and is reputed to be the largest print ever commissioned before the twentieth century. The work was printed from 192 separate blocks, required four printing shops and more than two years to complete, and it was printed in five editions, three posthumously. The iconography, or meaning, of the images of this fantastic design involves many means of glorification, from the simple recording of historical events to cryptic emblems. The structure can be read like a book or decoded like a cryptogram. Yet, at the same time, it can be enjoyed like a collection of quaint and brilliant jewelry. The fine detail was possible because the design was probably cut on closely textured wood, such as cherry. The work is also remarkable in that the entire configuration is a product of Dürer's imagination. For the scenic representations, he furnished slight sketches and supervised their execution. When the work of his assistants left too much to be desired, he supplied actual working drawings. When motifs had to be repeated symmetrically, he furnished only the designs for half of the woodcut, leaving it to his assistants to reverse them, change minor details, and, of course, the shadows, as needed.

they inspired Western artists in new directions. Hokusai, Utagawa Hiroshige (1797–1858) [4.6], and Kitagawa Utamaro (1753–1806), somewhat later, were especially influential. As a result, many Western artists adapted Japanese asymmetry to their painting and some revived woodblock printing.

In Western Europe, woodcuts were important in the fifteenth and sixteenth centuries, when religious pictures were printed in editions of thousands and sold at popular prices. People believed that because of their holy subjects the woodcuts would protect the purchaser from sickness. Woodcut taroc, or tarocci, playing cards were also widely popular. These ancestors of today's playing cards and of tarot cards, associated by some with fortune-telling and esoteric cults, came in standard packs of 62, 78, or 97. Venetian sets copied the four Islamic suits of cup, coin, sword, and polo stick. Twenty of Albrecht Dürer's pen-and-ink drawings of taroc or tarocci cards, copied from a set in the Venetian style of 1462, still exist, as testament to the widespread interest in these cards.

4.7 Albrecht Dürer. *The Triumphal Arch of Maximilian I.* 1515–1517. Woodcut (192 blocks), approximately 10′ × 9′4″ (3.05 × 2.85 m) without inscription. National Library of Austria, Vienna.

The Artist Sketch

Perhaps the most prolific printmaker of all time, Albrecht Dürer was born in the south German city of Nuremberg, one of eighteen children of a not particularly prosperous goldsmith, also named Albrecht. As an early apprentice to his father, he acquired a thorough familiarity with the tools and materials of engraving, especially the jeweler's graver or **burin**, a tool unknown for printing before him. The young Dürer was brought up in the tradition of Jan van Eyck and Rogier van der Weyden, with whom his father had studied in the Netherlands. At fifteen, he was apprenticed to the foremost painter of the region, Michael Wolgemut, from whom he learned to handle the pen and brush, to copy and draw from life, and to work in other media—gouache, watercolor, and oils. The greatest publisher in Germany was his godfather, so Dürer became familiar early with the graphic processes that occupied him for the rest of his life. His prints set a new standard of perfection for more than a century and inspired countless other works in Italy, France, Russia,

4.8 ALBRECHT DÜRER. *SELF-PORTRAIT.* 1500. PANEL, 25-5/8 × 18-7/8" (67 × 49 CM). BAYERISCHE STAATSGEMÄLDESAMMLUNGEN.

Spain, and even Persia. In 1494, Dürer visited Italy, enjoying huge success, artistically, socially, and financially. In 1515, he was appointed court painter to Maximilian I, a position he retained even with the emperor's successor.

Dürer's most famous *Self-Portrait* of 1500 is the only one in which his figure is rigidly frontal in a vertical format [4.8]. This hieratic arrangement was traditionally reserved for images of Christ, with whom Dürer intended to demonstrate some resemblance. It seems certain that he also deliberately idealized his own features, softening his nose and cheekbones, while enlarging the size and shape of his eyes. The self-glorification of Dürer in the portrait implies a mystical relationship of the creative artist with God.

The last years of Dürer's life were devoted more toward building up his scholarship in books and treatises and less in the continued production of art. As a Renaissance artist, he was attracted to perfection and an ideal beauty, believing in the genius of the artist whose hands and mind were, in effect, a gift of God.

ALBRECHT DÜRER (1471–1528)

4.9 ANTONIO POLLAIUOLO. *BATTLE OF TEN NAKED MEN.* 15TH CENTURY. ENGRAVING. THE METROPOLITAN MUSEUM OF ART, PURCHASE, 1917, JOSEPH PULITZER BEQUEST.

Woodcuts were commercially discarded in the West in favor of copper and steel engravings, but they continued to be used in cheap books and to illustrate political handbills, particularly during the French Revolution in the eighteenth century and the Mexican Revolution in the twentieth. Woodcuts were revived in the late nineteenth century as a result of Japanese influence and continue to be used by today's artists.

Wood Engraving The technique of **wood engraving** differs considerably from woodcuts. Many thin layers of wood are laminated together to yield a hard, nondirectional surface. Very fine lines can then be incised or engraved with such tools as a burin that permit razor-sharp strokes capable of fine gradations and precise details. A well-known early engraving by the Florentine Antonio Pollaiuolo [4.9] of ten fighting figures demonstrates their exaggerated musculature and dramatic poses achieved with meticulously engraved lines, nearly parallel. The deeper lines hold more ink and therefore reproduce the darkest.

Intaglio Printing

The opposite of relief printing is **intaglio** (in-'tal-yo) printing, a term derived from the Italian word *intagliare* meaning "to cut in." In the intaglio processes of etching and engraving, the ink is forced into grooves in a metal plate with a felt-covered dauber [4.4] so that it lies below the surface. When damp paper is pressed onto the plate by a press, it picks up ink from the grooves, in contrast to woodcut, where the ink lies on the wood that has been left raised.

The differences between etching and engraving lie in the different means used to cut the image into the metal plate. In **etching**, the plate is first coated with a waxy, acid-resistant substance, called a **ground**. The artist draws an image on the coated plate by scratching through the ground with a fine needle. When the plate is placed in an acid bath, the acid cannot reach the metal where it is covered, but along the lines where the ground has been removed, it can bite, or etch, them into the bare metal. The remaining ground is then removed, the plate is inked and wiped off, leaving ink in the grooves, the paper is positioned, and then the print is pulled from the plate. In **engraving**, the grooves in the plate are made by cutting directly into the metal with special tools. Lines are rarely as fine as those achieved by etching, but they are sharper and clearer.

In both etching and engraving, the artist builds up areas of darks by placing many lines close together. In both processes, the ink is lifted out of the grooves by the pressure of the press, forcing the ink to stand out on the surface of the paper. The ink can be felt as a raised edge when you run your finger over it. These processes yield sharply defined images. In other methods called **mezzotint** and aquatint, large areas of the plate can be roughened so that the ink adheres to a whole area and is printed as a flat tone. In **drypoint**, a needle is used to scratch lines (furrows) into a

plate surface. The ridge of metal at the furrows, called a "burr," catches and holds some ink, softening the lines of a drypoint etching. In the drypoint etching *Woman Bathing* [4.10] by Mary Cassatt (1845–1926), both line and aquatint are combined to create dramatic images marked by intense light and shade. Compare this work with Hogarth's engraving from *The Rake's Progress* [I.17], which reveals infinite gradations and clarity in all details. Although both prints demonstrate careful draftsmanship and love of detail, the etching is far softer and is well suited to Cassatt's preoccupation with intimate themes.

Engraving on copper was first developed as a popular commercial process in the first half of the fifteenth century and was later used for illustration by artists such as Dürer, who designed many prints—more than one hundred engravings, etchings, and drypoints and more than three hundred woodcuts. Editions of thousands of his prints were not uncommon. Much finer detail is possible in the engraving process than in the woodcut, which may have accounted for the greater popularity of his engravings.

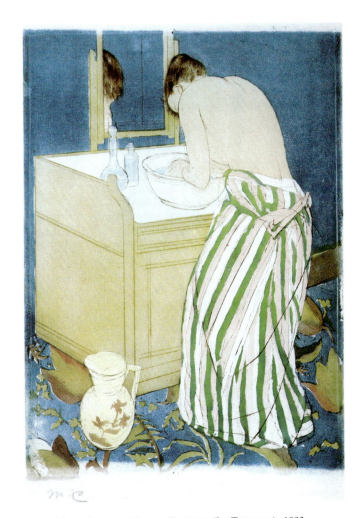

4.10 MARY CASSATT. *WOMAN BATHING (LA TOILETTE)*. 1890–1891. DRYPOINT, AND AQUATINT IN COLOR, 14-1/2 × 10-1/8″. COURTESY, MUSEUM OF FINE ARTS, BOSTON. GIFT OF WILLIAM EMERSON & PURCHASE FROM THE CHARLES HENRY HAYDEN FUND.

4.11 SUSAN ROTHENBERG. *UNTITLED (MAY #3)*. 1979. ETCHING: SUGAR LIFT, SPIT BITE, SOFT GROUND AND BURNISHING FROM 2 STEEL-FACED COPPER PLATES ON FABRIANO PAPER; 29-5/8 × 22″ (75.2 × 55.9 CM). PUBLISHED BY PARASOL PRESS LTD. COURTESY BARBARA KRAKOW GALLERY.

limestone slabs or metal plates are used as drawing surfaces [4.4]. The artist draws with greasy lithographic crayon or with a special ink called **tusche**. Next a nitric-acid solution is applied to the stone or plate to make the sections that have not been drawn on resistant to the printing ink. The stone is kept wet with water during the entire printing process. The greasy printing ink adheres only to the crayon image and is repelled by the wet areas of the stone. When the stone and paper are run through a press, the paper picks up the ink from the drawn image, reproducing the artist's work. If the stone is not kept wet, the paper will be printed solid black as beginning printmakers soon learn.

The direct drawing methods in lithography allow the artist considerable spontaneity and variety. Drawing crayons are made in varying degrees of hardness and when stroked onto the grainy surface of the stone, they can create tones ranging from soft grays to rich, heavy darks. Crayons

Later, engravings were used for reproductions of artworks. Steel engravings of sentimental scenes were popular in Victorian homes. Few artists today, however, are as concerned with the sharp detail achieved by engraving; most prefer the versatility of etching. Many artists, past and present, have illustrated books with etchings and have produced limited editions of individual etchings. An edition by Susan Rothenberg (b. 1945) rarely exceeds sixty, including one *bon à tirer* print that confirms the even distribution of inks, a printer's proof, and artist's proofs. Emblematic images of a single horse looming forward established her reputation. Their stark iconic quality suggest ghostly hallucinations. The tension between figure and ground that persists in her paintings is, if anything, intensified in the print by the expressionistic quality of her lines [4.11]. The equine silhouette projects the totemic look of a cave painting and, perhaps, isolation like an Edvard Munch figure [4.12].

Surface Printing

Lithography The third printing process is planographic, or surface, printing. **Lithography** is a planographic process that depends on the natural antipathy of oil or grease to water for the transfer of ink to paper. Sensitized

4.12 EDVARD MUNCH. *THE CRY*. 1895. LITHOGRAPH ON PINK PAPER. 14-1/2 × 9-7/8″ (37 × 25 CM). COURTESY, MUSEUM OF FINE ART, BOSTON. WILLIAM FRANCIS WARDEN FUND.

The Artist Sketch

There are not many living American artists whose latest exhibitions attract the leading artists and art critics. Susan Rothenberg can claim that distinction.

Her work first appeared in the mid-1970s when, except for the **Superrealists**, painters and sculptors treated even traditional themes with photographic precision, figurative art was still a rarity, and images of horses nonexistent. The look of her work seems far more symbolic than representational. She held on to minimal references to the human figure, presenting the body in fragments reaching across space in a state one critic described as "terminal anxiety."

Rothenberg made her reputation with the review of her very first show at Willard Gallery in New York City. Her ghostly, painterly images of pounding horses established the artist in the leading **New Image** style yet to be defined at that time. Hilton Kramer, then the art critic of the *New York Times* wrote of the exhibition in 1976:

> ...it is the quality [of the painting] that is so impressive—the authority with which a highly simplified image is transformed into a pictorial experience of great sensitivity and even grandeur.

She soon had a waiting list of eager buyers. Even William Rubin, then the director of painting and sculpture at the Museum of Modern Art, bought two of her paintings. She was shocked by her success, having been certain that no one was going to accept an image of a horse.

Since the early 1980s, Rothenberg has been grappling with several problems. The horse image that had occupied her for six years suddenly was exhausted for her, and she felt that the fragments of her figures seemed to need to make better contact with each other. There was also the problem of how to deal with color, having worked in a monochrome structure for so long. She feared that she could not meet the challenges while maintaining the distinctive art quality expected of her. She had never been a natural colorist and worried that her struggles would be obvious.

For the last decade, her works have breathed light and air, but every square inch of their surfaces still shivers with doubt. Most of her forms are recorded in rapid movement. None are done from life, and yet they show an essence of truth, as if rendered through a flicker of impressionistic haze, like specters that flash for an instant and are gone. Having come to artistic maturity under the influence of Eva Hesse [18.8] and Bruce Nauman, now her husband, Rothenberg is sensitive to problems of the process of making art. We see images of forms spinning on their axes, describing arcs through space like the sweep of a brush across canvas. Movement is part of what her art is now about. Some of this new focus must come from the trip she and Nauman experienced, pulling up roots after more than twenty years of working in New York City to move to New Mexico. The expansive terrain, sheltered by mountains, was certainly a strong influence on such artists as Georgia O'Keeffe. Rothenberg is sure to also respond pictorially.

SUSAN ROTHENBERG (B. 1945)

can be held on their edges to produce large areas of gray, while details can be drawn in with a pointed crayon or a pen dipped in tusche. In color lithography, as in color woodcuts, each color requires a separate drawing, which is printed in sequence on one sheet, faithfully following registration marks. In **offset** lithography, a more involved process, impressions are transferred via a rubber blanket, rather than directly from stone or plates.

The lithograph by Edvard Munch (1863–1944) [4.12] is one of a series on a single theme which occupied him on and off for much of his life. The anguish of the abandoned central figure is echoed by the land, sea, and sky, graphically demonstrated by the heavy, strident lines. The bridge on which the figures stand may represent the passage of time. Hands held to the ears, with the mouth open, the image is filled with anxiety and despair, while the torment reverberates even unto the land, the sky, and the sea. The face seems to exude death, while the distant passersby suggest a world indifferent to private tragedy. Munch's lines are summary, yet express in their economical strokes the anguish of existence. Munch once said, "I paint the scream in nature."

When lithography was invented in 1798, the technique quickly became popular for illustrations in newspapers and magazines because it is much easier to draw with crayons on a stone slab than to engrave lines into a metal plate. Honoré Daumier (1808–1879), for example, used the lithographic process on stone regularly for political and social comments. Many of Daumier's drawings and paintings [14.8] also carry on the social caricatures of Goya and presage political and social works by Käthe Kollwitz (1867–1945) [15.16] and George Grosz (1893–1959), whose pen, brush, and ink drawing [15.17] reveals his skill at political satire. Moving away from these black-and-white expressions into strident color to depict insanity and murder, the theme of the opera *Wozzeck* by Alban Berg, Jan Lenica

(b. 1928) makes use of strong color by contrasting a dominant red-orange with discordant bits of red-purple in the offset lithography medium [4.13]. The poster also suggests the composer's atonal, untraditional musical harmony.

A legend even in his own time, Henri de Toulouse-Lautrec (1864–1901) evolved from an illustrator (of horses) to perhaps the most perceptive satirist of the café scene. His poster design for *Le Divan Japonais* [4.14] demonstrates graphic clarity, influenced by the late nineteenth-century exposure to the linear quality of Japanese prints, which avoid most illusions of depth provided by linear perspective. His forms are flattened, the viewpoint is unusual, and the memorable imagery is designed to be quickly seen and understood, for posters are rarely given long study. The lines are economically drawn, revealing the skill of an artist who successfully produced single paintings as well as multiple works for an unlimited audience.

A very different orientation to design can be seen in the lithographs of M. C. Escher. His highly imaginative works, which border on the surrealistic, also demonstrate a delight in detail and an eye for illusions of perspective. In

Drawing Hands [1.3] we experience a new dimension produced through the physical and optical impossibilities which he has created.

Many artists print their own lithographs. Some alter the initial images, as early proofs suggest, while others draw the image clearly at the start and maintain their original concept from beginning to end. As with other forms of printmaking, many artists entrust their works to master printers whom they carefully supervise.

Serigraphy **Serigraphy** is a planographic process that uses a stencil placed on a screen of fine silk. The term is the fine-arts equivalent of the twentieth-century commercial printing process called **silkscreen**. Many contemporary artists adopt serigraphy because it permits more variations in the material to be printed on than other printing processes. Used commercially, silkscreen can print images onto soft fabrics such as T-shirts or hard surfaces such as glasses, yielding almost unlimited possibilities. Used for fine art, silkscreen can produce prints (serigraphs) that incorporate complex images in multiple colors, which are particularly effective in large, flat areas on posters.

4.13 JAN LENICA. *ALBAN BERG WOZZECK.* 1964. OFFSET LITHOGRAPH, PRINTED IN COLOR, 38-1/8 × 26-1/2″. COLLECTION, THE MUSEUM OF MODERN ART, NEW YORK. ANONYMOUS GIFT.

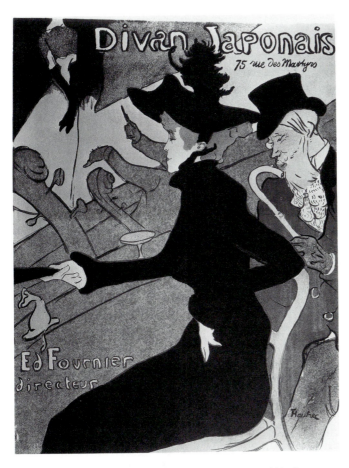

4.14 HENRI DE TOULOUSE-LAUTREC. *DIVAN JAPONAIS*. 1892. COLOR LITHOGRAPH, 31-5/8 × 23-7/8″. COLLECTION, THE MUSEUM OF MODERN ART, NEW YORK. ABBY ALDRICH ROCKEFELLER FUND.

Silkscreen, however, can also be used to achieve rich, subtle colors and varying textures.

The artist cuts a stencil from a special film, which is then fixed to the screen of silk stretched on a frame. Alternatively, the stencil may be painted directly on the silk with glue, mascoid cement, or shellac. The stencil prevents the paint from seeping through the screen onto the paper beneath. Thus any area not covered by the stencil is printed. If the stencil is brushed on with glue, a loose, free-flowing image can result. With a firm stencil, the images are hard and sharp. The paint, which can be thick and opaque or thin and transparent, is dragged across the silk with a wide rubber squeegee and directly transmitted through to the paper. To produce multiple-color prints, the artist uses several stencils, printing each separately, one over the other. The colors may be adjacent or built up in transparent layers, depending on the stencils.

Photography has become increasingly important since mid-century as an aid in the precise production of stencils for silkscreen. The coating of a screen with a photographic emulsion and the subsequent processing of the screen like any photographic print permits an almost instant screen reproduction of photography, a process we will examine in the following chapter. With the advent of Pop

Art introducing Andy Warhol's images of endless duplications [1.24] and the avant-garde movement of **concept art**, which we have yet to examine, photography also has been used to critique the way we create art imagery. Barbara Kruger believes that advertising sets the value systems around which many of us orient our lives. Our society seems drawn to the material products and services that we observe in advertisements. It is no accident that she has chosen vinyl as the ground or base upon which her photographic stencil is screened [4.15]. Like the comment made by Claes Oldenburg's giant 5 foot fan [6.23], Kruger's art reflects the fact that we often seem to prefer a plastic world to the real thing. *Worth Every Penny* further suggests the "buy-buy-buy" demands put upon consumers.

Blue to Red Portal [4.16], a screened color print by Richard Anuszkiewicz (b. 1930), shows a complex geometry of concentric rectangles and straight lines, yielding warm and subtle gradations of color and movement. This print, from the artist's series based only on straight lines,

4.15 BARBARA KRUGER. *UNTITLED (WORTH EVERY PENNY)*. 1987. PHOTOGRAPHIC SILKSCREEN/VINYL, 182-1/4″ × 110-1/2″. COURTESY, MARY BOONE GALLERY, NEW YORK.

creates a visual excitement that demands perfect registration of the several superimposed stencils (and printings) involved—no easy task to satisfy, but well worth the effort.

Monotype

It is perhaps fitting to round out our discussion of printmaking with media that may involve other processes as well. The "monotype" is defined as a single image—a unique work of art, produced from a drawing or painting applied to a nonabsorbent plate surface of any material. Fine detail is achieved by scratching paint off the plate, using a sharp implement. If the image is transferred to paper by rolling it

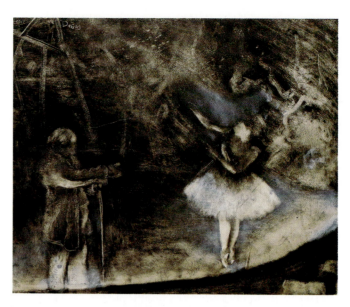

4.17 EDGAR DEGAS. *THE BALLET MASTER (LE MAITRE DE BALLET).* C. 1874. MONOTYPE (BLACK INK) TOUCHED WITH WHITE (GOUACHE?). NATIONAL GALLERY OF ART, WASHINGTON. ROSENWALD COLLECTION.

through a press, some printmakers identify the work as a monoprint. Others term all singular works of this kind, even those in which transfer of matrix to paper is accomplished by handrubbing, as monotypes. The edition is customarily numbered 1/1. A monotype by Edgar Degas [4.17] demonstrates the freshness possible in a drawing combined with the rich and varied textures typical of painting.

Expanded Techniques

Prints, like paintings, can make use of mixed media. Collages made of various materials glued onto metal or wooden panels can be inked and run through a press to produce unusual textures. This new and freer way of printing is called **collography**. The potential for this technique has barely been approached and is limited only by the inventiveness of the artist.

Collography can be combined with other printing methods. To achieve varied effects, prints can be given raised surfaces by printing damp papers under strong pressure onto carved wooden blocks to which textured materials such as metal scraps, screening, or heavy twine have been glued. Silkscreen and lithography have been used to print flat cutouts, many complete with slots and tabs, which can later be assembled into three-dimensional objects. Thus the artist, instead of trying to produce an illusion of solidity through the flat image of a print, may create a printed image that will become a three-dimensional object itself. Coco Gordon, a contemporary artist-poet who also produces her own paper, emphasizes wit as well as aesthetics in her work. Many of her pieces move through

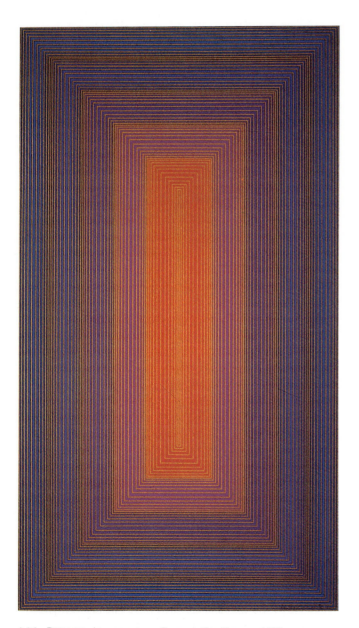

4.16 RICHARD ANUSZKIEWICZ. *BLUE TO RED PORTAL.* 1977. SCREENED ON MASONITE, 7 × 4′ (2.1 × 1.2 M). COLLECTION THE ARTIST.

two- and three-dimensional space concurrently, while others are intellectual exercises, as significant for their creative concept as for the lasting work that is produced [4.18].

Photoprinting and other techniques have revolutionized printmaking in the second half of the twentieth century. Artists are working in ways that make classification of their art impossible. For example, photographs printed on cloth may be cut out, stuffed, and sewn, becoming sculptural forms, while prints on Styrofoam produce three-dimensional objects.

Printmaking, perhaps even more than the other visual arts, is characterized by almost unlimited experimentation. A host of new processes that artists have used with great success—photolithography, for example—creates an atmosphere of experiment and great vitality. Clearly, technology is the focus. The three-dimensional print *Gertrude* [4.19] was printed in six colors from two aluminum plates by Red Grooms (b. 1937). The prints were die-cut, folded, and glued together in an amusing sculptural spoof of Gertrude Stein.

4.19 RED GROOMS. *GERTRUDE.* 1975. COLOR LITHOGRAPH, CUT-OUT, GLUED AND MOUNTED IN PLEXIGLASS BOX; EDITION OF 46; 19-1/4 × 22 × 10″ (49 × 56 × 25 CM). CO-PUBLISHED BY BROOKE ALEXANDER, INC. AND MARLBOROUGH GRAPHICS, INC., NEW YORK. PHOTO COURTESY OF BROOKE ALEXANDER EDITIONS, NEW YORK.

4.18 COCO GORDON. *HUM.* 1979. COLLOGRAPH AND ELECTRIC ENGRAVING ON PLEXIGLASS (FACE), SOFT-GROUND AND BRUSHED AQUATINT (COLLAR), ON OWN METHOD TWO-PULP LINEN HANDMADE SHAPED PAPER; 12 × 18″ (31 × 46 CM).

The technical processes required in making prints have become for many printmakers the focus of much if not most of their attention in the latter half of the twentieth century. This interest in process appeared first at the turn of the century when some artists began to turn away from traditional procedures in favor of experimenting with technique. Lithography is the graphic medium closest to drawing, where most artists begin, so it is not surprising that the lithograph has become the most popular arena for technological expression. As is apparent from *The Cry* [4.12], lithography provides a range of tones from the deepest, richest blacks to the pure white of the paper. The vigor of this drawing is exceptional, produced with thickened brush strokes using liquid tusche, like black ink with a brush.

Toulouse-Lautrec's lithograph *Le Divan Japonais* [4.14] was achieved by departing further from conventional lithographic procedures. Important in the history of printmaking, Lautrec enlarged the scope of a somewhat limited technique of drawing on stone to the rank of a flexible art form. For instance, after painting a few areas of the stone with tusche, he alternately covered other areas with pieces of paper, laid like stencils over the rest of the stone, then painted flat tones, echoing Japanese traditions.

In recent years, the medium of lithography has evolved still further, expanding from a ground base of stone to other surfaces, such as zinc plates now used in the artist's studio and in commercial printing. Metal plates made by a

4.21 LARRY RIVERS AND FRANK O'HARA WORKING ON *STONES*. 1958. © HANS NAMUTH 1991.

photomechanical process are curved around rollers that can quickly transfer images from one roller to another and then to paper in the printing method called **offset**. Lithography has thus become with all its many variations the most popular print process today.

When Robert Rauschenberg was commissioned to produce a poster that would commemorate the hundredth anniversary of the Metropolitan Museum of Art [4.20], he made use of these and other commercial innovations. Employing two stones and two aluminum plates in red, yellow, blue, and brown, he superimposed photographs on art reproductions transparently, adding signatures of museum officials and museum goals at the center. Rauschenberg has gone on to transfer selected newspaper and magazine impressions of advertisements and editorial comments onto a single lithograph, less concerned with the content of the rub-ons than to critique the media in our culture. The technology has surely become the artist's focus.

THE PRINT WORKSHOP

The atmosphere of today's print workshops with their invigorating smells of turpentine and ink is probably not much different from that in Renaissance shops like Dürer's. There is still an extraordinary interest in the print process in busy art centers worldwide. There has been a shift away from the traditional notion of a solitary individual plying his or her craft to a community where insights and skills are shared. The practice approaches the ideal of William Morris (1834–1896) a century ago (see Chapters 6 and 14); he and others so feared the loss of craftsmanship in the burgeoning industrial age that they encouraged artists to unite their skills in the common interest. Today print workshops are flourishing. Master printers' studios are visited by artists who are eager to experiment with new techniques and larger sizes not seen since Dürer's *Triumphal Arch* [4.7]. In the United States major artists have taken to the printmaker's craft. The following list, though incomplete, suggests how good workshops have proliferated.

A pioneer in the workshop movement was Tatyana Grosman (1904–1982), a spiritual catalyst to many of the great artists of our time. The quotation that opens this

4.20 ROBERT RAUSCHENBERG. *CENTENNIAL CERTIFICATE, MMA*. 1969. COLOR LITHOGRAPH, 35-7/8 × 25″ (91.2 × 63.5 CM). THE METROPOLITAN MUSEUM OF ART, FLORENCE AND JOSEPH SINGER COLLECTION, 1969.

chapter and the following remarks are based on the author's meeting with Mrs. Grosman in West Islip, New York, in the spring of 1980. Realizing that limestone slabs no longer used in construction on their property would be fine surfaces for lithography, she and her husband, Maurice, a painter and sculptor, set up a workshop for printing on stone in limited editions. With the registration of their **logo,** Universal Limited Art Editions, in 1956, the **atelier,** or workshop, was born. Younger artists were invited to share the facilities. The philosophy of the workshop went far beyond merely furnishing the necessary tools and presses. Work with stone was to be a revelation. Their first undertaking was with Robert Blackburn (b. 1920), an early apprentice chosen to print a work produced by a pioneering partnership **[4.21]** of a painter, Larry Rivers (b. 1923), and a poet, Frank O'Hara (1926–1966). As creative novices in printing on stone, they even incorporated the outlined edge of the limestone slab into their design—a practice never approved by traditional printmakers, which made their work a unique blend of art, literature, and graphic experiment.

Everything was visual. Mrs. Grosman's personal philosophy of "glorifying existence" by inspiring artists "to do something extraordinary" brought to her door such well-known painters as Robert Rauschenberg, Jasper Johns, Barnett Newman, and Helen Frankenthaler, and sculptor Lee Bontecou. She established a personal level of communication with each artist, involving them all in printmaking, encouraging them each time to surpass their previous work, yet allowing artists the private use of the premises and the master printers. Each print is made by hand and strives to capture the spirit of the artist's design drawn the day before. It is easy to see why some artists work best with particular printers in such a milieu.

The first master print shops on the West Coast were Gemini G.E.L. and the Tamarind Lithography workshop, founded by June Wayne (b. 1918). These and later master print shops provided facilities for famous artists of the 1960s. Wayne's skilled technicians created a whole new chemistry. The prints that emerged were often of a size, complexity, and degree of innovation that craftspeople with limited financial means could never otherwise have achieved. The impetus for these American workshops doubtless came from the English artist Stanley William Hayter (1901–1988), who in the 1930s established Atelier 17 in Paris as a center of experimental printmaking. In the

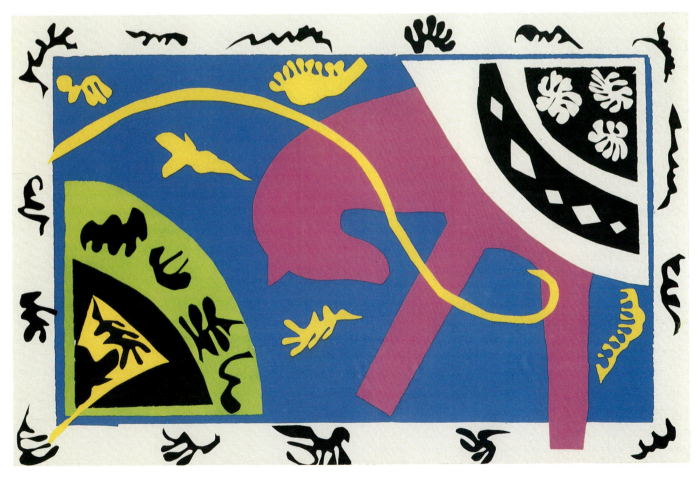

4.22 HENRI MATISSE. HORSE, RIDER AND CLOWN. PLATE 5 FROM JAZZ. 1947. POCHOIR, PRINTED IN COLOR COMPOSITION, 16-1/2 × 25-3/4' (41.9 × 65.4 CM). COLLECTION, THE MUSEUM OF MODERN ART, NEW YORK. THE LOUIS E. STERN COLLECTION.

4.23 Barbara Fahrner with John Cage. *Nods*. 1991. 13-1/2 × 6-1/2″. The text is printed letterpress; the drawings are pen & ink with watercolor. They are hand-applied in each book. Edition of 45. Typography and printing by Philip Gallo, drawings by Barbara Fahrner, binding by Daniel E. Kelm. Each book is signed by the four collaborators. Published by Granary Books.

1940s, during World War II, Hayter brought his ideas to New York, providing inspiration to American artists.

As a result of such workshops, there has been a resurgence of printmaking all over the United States—a renaissance brought about not, as might have been expected, through the efforts of printmakers or their students, but through the finished works, which have inspired broad public interest. Current achievements in the graphic arts, particularly in these print shops, which aim not for mass output but for creative production, are bound to be a major influence on art for many years to come.

The Artist's Book

The artist's book, a folio of prints, often hand-assembled into the format of a book, is based on the concept that the spaces enclosed within the covers of a book provide a legitimate area for artistic expression. Just as two-dimensional space is explored by the painter and graphic designer, three-dimensional space manipulated by the sculptor, and environmental space controlled by the architect, a growing number of artists are attracted to the artist's book. During his declining years, Henri Matisse created, with an assistant's help, such a book, called *Jazz*. Matisse supervised the cutouts of various brightly colored forms, which were later displayed on the wall in an exhibition at the Museum of Modern Art in New York. Some of these designs were assembled (reduced) within the pages of *Jazz*, alternating with pages of text that incorporated ideas Matisse had expressed in his informal writings some years earlier. The original collated book is in a private collection, but *Jazz* was also offered by the museum in soft and hard cover editions, printed by offset **[4.22]**.

Variants of Matisse's procedures can be found today. There are at least three different kinds of books currently produced by artists:

1. A one-of-a-kind book may be created by drawing, painting, printing, and assembling elements through collage, with or without hand-lettered text.

2. The artist may design a book of limited edition, encompassing prints, type, or drawings reproduced by offset.

3. The printmaker may produce lithographs, etchings, and silkscreened prints, hand-stitch them together, and manually bind them into a book format as an original.

Most of the books made by German artist Barbara Fahrner (b. 1940) are handmade one-of-a-kind works. She draws and paints her books, having worked since 1979 with book forms, which then tend to be a blend of word and image. The texts are a mixture primarily of literary and philosophical sources including the artist's own writing. Her drawings, unique books and edition books have been exhibited extensively through Europe and only recently introduced here to America. In collaboration with composer John Cage, typographer/printer Philip Gallo and binder Daniel E. Kelm, the work *Nods* was produced [4.23]. The text was printed letterpress from handset type. There are about twenty original drawings in each book of an edition of forty-five, dated 1991. Explaining her work, she wrote for her first New York exhibition in 1991:

About my work

The world is a book
The world is a mystery. Day and night things send out messages
which keep my curiosity ablaze. I constantly encounter limits
I want to pass and doors I want to push open.
Defiance and a longing not to shut up
in this world any longer drive me continuously to investigate,
examine, connect, assort, arrange, collect...

The handmade book of course is intended to address the existence of multiples which, no matter how few, suggest that the special mystique of the original may be shared by many. When we look at a Hogarth engraving [I.17], we are viewing work intended to be seen by many. The artist's book, by the diverse nature of various examples, is the newest arena for the printmaker's creativity in the United States, though the ambiguities of terminology and valuation—original v. multiple printings—remain an open-ended issue, yet to be resolved.

Photomechanical processes that developed from the 1850s to the 1880s have deeply affected printmaking in the twentieth century, particularly with the advent and involvement of photography. Therefore, the arts of the lens are the basis of our next group of studies. Where the new vision will lead, no one knows, but, clearly, art will be changed radically.

EXERCISES AND ACTIVITIES

Exercises for Research and Discussion

1. Trace the origins of paper, distinguishing between "wove" and "laid."

2. Why is handmade paper important to many printmakers today?

3. Each category of printing—woodcut, etching, engraving, stencil, lithograph, or collograph—offers a different potential for creative expression. Explain the differences between these types of printing. How does engraving differ from etching both in method and final effect?

4. Select from the prints reproduced in this book three works that appeal to you and explain your reasons for choosing them.

5. Divide the class into two groups, selecting printmaking or painting as the medium that most closely satisfies human needs for art. Discuss the advantages of each medium.

Studio or Homework Activities

1. Transpose the black and white of Edvard Munch's *The Cry* into colors, using, perhaps, pastels. Does the work lose impact?

2. Eliminate linear perspective in *The Cry* to alter the spatial effect.

3. Design your own monogram and transfer it to a printing surface from which you can make a relief image. Use linoleum, Styrofoam, or even a potato as a printing surface, being careful to cut a "mirrored" image so that the printed monogram can be read normally.

4. As a class project, select one wall for a temporary display of all the students' monogram prints. Critique the work using the six criteria listed in Chapter 1.

5. Design personal note paper for limited circulation, perhaps making use of a seasonal motif, using a relief process. Do not concentrate on lines but focus instead on flat areas, which are easier to carve and then to print.

5

Arts of the Lens

"To me, photography is the simultaneous recognition, in a fraction of a second, of the significance of an event."

—HENRI CARTIER-BRESSON,
PHOTOGRAPHER

• • •

"Photography is more than a medium for factual communication of ideas; it is an exalted profession and a creative art. ... The picture we make is never made for us alone; it is, and should be, a communication—to reach as many people as possible without dilution of quality or intensity."

—ANSEL ADAMS, PHOTOGRAPHER

• • •

"I have treated the cathode ray tube [CRT or TV screen] as a canvas, and proved that it can be a superior canvas. From now on, I will treat the CRT as a paper and pen. If Joyce lived today, surely he would have written Finnegan's Wake on videotape, because of the vast possibility of manipulation in magnetic information storage."

—NAM JUNE PAIK, VIDEO ARTIST

• • •

"I am able to mystify, and I have at my disposal the most precious and the most astounding device [the motion picture camera] that has ever, since history began, been put into the hands of the juggler."

—INGMAR BERGMAN, FILMMAKER

The camera, as used in still photography, films, television, and the media, has shaped our lives in the twentieth century perhaps more than any other single invention. Through the photographic image we have all been exposed to people, places, and ideas that we would never otherwise have witnessed. For instance, the recognition of our involvement in a conflict few of us had stomach for became inescapable when we were forced to view the execution of a Vietcong officer by a Vietnamese police chief [5.1]. Much of our understanding of the world in which we live has come to us through the camera lens. In fact, we are so completely surrounded and seduced by photographic images that few will question Canadian communication specialist Marshall McLuhan's view that "the medium is the message."

By examining how the camera lens records images on film, as well as how it transmits images to the television tube, we can perhaps better appreciate the aesthetics of still photography and cinematic film, as well as the electronic medium of television. For many people these media are the dominant visual arts of our time. Photography is both a complex science and an evermore important art form. As a science, it depends on laws of physics involving the passage of light through a lens and laws of chemistry involving sensitivity to light. Light transfers the image "seen" by the lens onto chemically sensitized film, and this image is then made visible and permanent by further chemical action.

The photographic image is a product of scientific laws, but it can also be a work of art whose impact is limited only by the creativity and imagination of the photographer. Though it is true that a camera more or less accurately records what it is focused on, the same subject can be interpreted in as many ways as the many visions of each photographer—or many photographers. Like all other artists, the

5.1 EDDIE ADAMS. *EXECUTION OF A VIETCONG.* 1968. PHOTOGRAPH.

photographer chooses what to portray, how to emphasize or eliminate various aspects, and what viewpoint would be most expressive.

An unusual vantage point permitted Margaret Bourke-White (1904–1971) to observe the face of nature given a new identity through indomitable human spirit [5.2]. The large shape that dominates *Contour Plowing* is made of striated furrow lines that course rhythmically throughout. Bourke-White's "message" may have been that, with determination, the human units of force (at the plow) can metamorphose the earth. Without a doubt, photographic creativity like Bourke-White's is able to transform the mechanical process of photography into fine art, separating the myriad snapshots and conventional photographs that surround us from the few truly expressive images.

Historical Roles of the Camera

Photography can be described as the most popular art form of this century—certainly the most widespread. The arts that depend on the lens dominate our visual environment, providing as many services to society as were once furnished by the more traditional medium of painting. Indeed the areas of photographic specialization we shall examine,

5.4 RAY K. METZKER. *TROLLEY STOP* (DETAIL). 1966. GELATIN-SILVER PRINT; WORK IN ITS ENTIRETY 40-1/2 × 35" (103 × 89 CM). COLLECTION, THE MUSEUM OF MODERN ART, NEW YORK. PURCHASE.

in their historic sequence, evolved from roles formerly the exclusive domain of painters; that is, from photography as fine art with portraiture and nature studies as its major preoccupation; through the documenting of social problems, photojournalism and editorial photography; and on to fashion and advertising photography, relatively new fields that began in the twentieth century. Within the broad range of camera arts that have developed since photography first became accessible to the public 150 or so years ago, its contribution to the fine arts has been consistent and perhaps still remains the focus of most photography today.

Documentary Still Photography

In still photography, the camera assures the photographer some success by assuming part of the process of recording the subject. The ease with which we can trip a camera shutter may make photography seem like a push-button art; with luck, we can expect some positive results almost from the start. To exploit the creative potentials of photography, however, a photographer must have considerable knowledge and expertise. But, as with any art form, even vast technical knowledge cannot guarantee masterpieces; a work of art in photography, as in all other art forms, is the result of a combination of its creator's personal vision, technical skill, and ability to express meaning in visual

5.2 MARGARET BOURKE-WHITE. *CONTOUR PLOWING*. 1954. PHOTOGRAPH.

The Artist Sketch

Who's Who In America 1940 stated for the record that, "Photographer and one of the world's foremost photojournalists, Margaret Bourke-White made better pictures of working people and industry than most men!"—a remarkable (feminist) statement a half-century ago.

A pioneer news photographer in the 1920s, Bourke-White did not start out behind the camera [5.3]. She began at Cornell University intending to be a biologist like her father Joseph White, taking pictures of college life only to amuse herself. Her father's death forced Kit (as she was known) to find employment quickly, and she began to sell her photographs. An architect's enthusiasm for her photographic style led to a successful career in industrial photography, even sending her on three trips to Russia to record successful five-year plans. By 1933, her first large permanent photomural was installed at NBC Studios in Rockefeller Center in New York. At age 30, she was chosen as one of the ten outstanding women in the country.

5.3 MARGARET BOURKE-WHITE IN 1957.

Late in 1939, while on a LIFE assignment in London, she somehow managed to photograph air-raid blackouts and attracted the attention of the prime minister, whom she later photographed on his birthday. This portrait of Winston Churchill hit the LIFE cover of April 1940, the same year that she was appointed chief photographer for P.M., a short-lived publication. Back at LIFE later that year, she was sent on assignments from Romania to Istanbul, Turkey. It is unclear whether she was arrested by authorities for taking pictures in a (Moslem) mosque or because she served as a photographer in a country where women still are not likely to travel unveiled on the street. In any case, she showed little remorse, for she moved on to Syria where she photographed the commander and learned to ride a military camel. From Syria, she sped on to Egypt, photographing government leaders and heads of state wherever she traveled.

An intense and dedicated woman, Bourke-White pursued a life that most adventurers only dream about. She left no stone unturned in the accomplishment of an assignment, among which her record shot of internees behind the barbed-wire fence at the Nuremberg Trials is probably the most memorable, if not the best-known of her works. Whether the caliber of her art will be judged by the LIFE assignments she fulfilled; by You Have Seen Their Faces, her record of a trip through the eastern United States; or by the sixty-four photographs with which she illustrated husband Erskine Calvert's North of the Danube is not important.

Her work will be remembered as soul-stirring with an ability to bring out the essence of her subject, frequently with breathtaking beauty. She will also be remembered for defying conventions in her quest for the unforgettable photograph!

MARGARET BOURKE-WHITE (1904–1971)

images. For most photographers, a double exposure means two wasted pictures of two events or scenes. Not so for Ray Metzker (b. 1931) in his creative interpretation of a trolley stop [5.4]. His many stills, some recording movement and overlap of images, have produced a memorable configuration that few of us would have imagined was possible. On the other hand, the speed suggested by Track [5.5] has rarely been so convincingly yielded by a single image of blurred colors.

The principle of the camera dates at least as far back as Renaissance Italy, when artistic preoccupation with the creation of an illusion of depth on a flat surface led to the development of a device called camera obscura, literally, "dark room." By reproducing exactly the scenes they wished to portray, artists were helped in rendering three dimensions on a two-dimensional surface. As Leonardo da Vinci described the principle, "Light entering a tiny opening in one wall of a darkened room forms an inverted image of the outside scene on the opposite wall." This view could be traced to provide the correct representation for a painting. Later, artists found that if a lens replaced the pinhole opening, a clearer image could be produced.

It was not until the nineteenth century, however, that a way was found to capture an image on a sensitized surface. Though Thomas Wedgwood (1771–1805) in England had earlier been able to create impermanent solar pictures, the first fixed camera image was probably originated by Joseph Nicéphore Niépce (1765–1833) in France about 1826 and almost concurrently by Louis Jacques Mandé Daguerre (1787–1851) as well. Evolving from those early images that were little more than impressions, Daguerre's pioneering photograph of 1837 remains outstanding in its

artful composition, which demonstrates depth along with a range of textures [5.6].

As the technique of photography improved and permanent images of people and places could be made more easily, many painters decided that in their primary role in society—as recorders of people, places, or events—they had been supplanted by the camera. Photographers began to use the new invention to duplicate art.

Portraits

Photography was officially accepted as an art form in the French Salon by 1859! Early creative photographers all over the world worked mostly in portraiture. People hastened to sit for their portraits by these early photographers, despite the lengthy sittings required to register images on slow photographic emulsions. Although both the sitter and the photographer believed that photographs were to be judged by painterly conventions, they produced some remarkable photographs through expressive use of pose, lighting, background, and point of view, as we have seen [2.21].

5.5 GERRY CRANHAM. *TRACK.* COLOR PHOTOGRAPH.

5.6 LOUIS JACQUES MANDÉ DAGUERRE. *THE ARTIST'S STUDIO.* 1837. DAGUERROTYPE. SOCIÉTÉ FRANÇAISE DE PHOTOGRAPHIE, PARIS.

5.7 JULIA MARGARET CAMERON. *CARLYLE LIKE A ROUGH BLOCK OF MICHELANGELO'S SCULPTURE.* 1867. ALBUMEN PRINT, 13-1/4 × 11″ (33.5 × 28 CM). HERSCHEL ALBUM, NATIONAL MUSEUM OF PHOTOGRAPHY, FILM, AND TELEVISION, BRADFORD, YORKSHIRE, ENGLAND.

The first major female photographer, Julia Margaret Cameron (1815–1879), was almost fifty years old when she encountered the camera. Self-taught in the complexities of photographic processing, she began to exhibit her portraits first in England, then internationally, often preferring "soft-focus" instead of the pinpoint sharpness her critics admired. About her photograph of the great English historian Thomas Carlyle [5.7], Cameron explained: "[My goal was to reveal] Carlyle like a rough block of Michelangelo's sculpture." Cameron was the first to use the close-up vantage point to capture further intimacy with her subject. The dramatic contrasts in light and dark created by her lighting caused her subject's head to seem suspended in darkness and thereby much more than a likeness was captured. A broad range of values, from black through grays to white, engages our attention. However, we return with renewed interest to the intense personality revealed in the face.

Landscapes

Through the technical experiments made by photographers in the mid-nineteenth century, the picture-taking process was shortened, making it possible for photographers to record the horrors of war, which Mathew Brady (1823–1896) and Timothy O'Sullivan (1840–1882) [5.8] did with great expressive power. While photographers were learning how to create photographs that resembled paintings, painters were eagerly looking for techniques that cameras could not duplicate. By the 1860s, French artists were experimenting

5.8 TIMOTHY O'SULLIVAN. *A HARVEST OF DEATH.* GETTYSBURG, 1863. PHOTOGRAPH. THE NEW YORK PUBLIC LIBRARY RARE BOOKS COLLECTION.

5.9 ALFRED STIEGLITZ. *THE TERMINAL.* 1893. PHOTOGRAPH. INTERNATIONAL MUSEUM OF PHOTOGRAPHY AT GEORGE EASTMAN HOUSE, ROCHESTER, NEW YORK.

with changing light and atmosphere in a style the world was soon to label Impressionism. Not much later, however, the camera, in the hands of the American Alfred Stieglitz (1864–1945), was just as successful in capturing steam and smoke in a nostalgic view of a wintry New York horsecar scene called *The Terminal* **[5.9]**. By choosing a camera angle that leads the tracks in a diagonal path, Stieglitz produced an illusion of depth that focused attention on both the horsecar and the steam in the air. Stieglitz was a pioneer in pushing the frontiers of art and, in particular, his chosen field. "My teachers have been life," he said, "— photography is my passion. The search for truth [is] my obsession."

By the end of the nineteenth century, photographers like Stieglitz had become less concerned with imitating painting than with allowing photography to emerge as a new field of art. Many American photographers, rather than viewing photographs as duplications of realistic paintings, discovered that photography could present more expressive views of commonplace scenes. For example, Ansel Adams (1902–1984), the first great landscape photograher, brilliantly demonstrated the artistic potential of photography in his prints, which hint at infinity, deeply extending the range of black-and-white shades. His pictures have always been in some measure a call to arms in defense of the earth and the environment. Time was always a presence in his pictures. His *Moon and Half Dome* **[5.10]** captures a mysterious feeling of vast, yet confined space, illuminated by the moon, hanging in an empty sky, while black, shadowy foreground masses effectively frame and complement the textured stone cliffs.

5.10 ANSEL ADAMS. *MOON AND HALF DOME. YOSEMITE NATIONAL PARK, CALIFORNIA.* 1960. PHOTOGRAPH BY ANSEL ADAMS. © BY THE TRUSTEES OF THE ANSEL ADAMS PUBLISHING RIGHTS TRUST. ALL RIGHTS RESERVED.

Adams found drama in nature by choosing a special station point from which he could observe nature's scale, her infinite variety of textures, the wonderful play of light against dark, and the true flowing sweep of her curves. By using shadowed mountains to frame the clarity of the moon suspended over the lighted expanse of the rock known as Half Dome, Adams captured an arresting image. The brilliant moon, despite its tiny scale in relation to the huge forms below, is a perfect balance and focus for the work. Not many of us could have achieved such a memorable image of a moonlit mountain scene.

This tradition of art photography, like that of Stieglitz and Adams, has been in large part replaced by a new generation of artists who see a different role for photography and a new status in the art world. Robert Mapplethorpe was one of the more old-fashioned of today's successful photographers, whose work was as classically beautiful as Berenice Abbott's and as decorative as Ansel Adams'. He combined photographs with mirrors, used precious woods for frames, and printed his works on linen with inlaid panels of silk. Many of his portraits glamorized sado-masochism, which only daring collectors would hang on their walls. His work attracted a storm of controversy (Chapter 9), but it is likely that he will be remembered as much for the aesthetics of his photographs [18.29] as for anything else.

Social Commentary

By applying high standards of creativity, photographers extended Brady's use of the camera to document moments in history in photojournalism. Dorothea Lange (1895–1965) recorded the desperate hopelessness of a migrant farm worker in the Great Depression of the 1930s in a portrait that has since been recognized as a classic [5.11]. Her field notes describe the futility of the way of life of a migrant worker, trapped by the system: "Camped on the edge of a pea field where the crop has failed in a freeze, the tires had just been sold from the car to buy food. She was 32 years old with seven children."

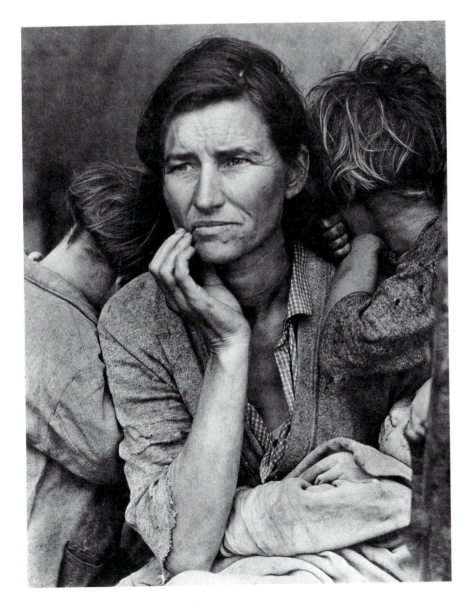

5.11 DOROTHEA LANGE. *MIGRANT MOTHER, NIPOMO, CALIFORNIA*. 1936. GELATIN-SILVER PRINT, 12-1/2 × 9-7/8". COLLECTION, THE MUSEUM OF MODERN ART, NEW YORK. PURCHASE.

5.12 BERENICE ABBOTT. *EXCHANGE PLACE, NEW YORK.* C. 1934.
PHOTOGRAPH. BERENICE ABBOTT/COMMERCE GRAPHICS LTD., INC.

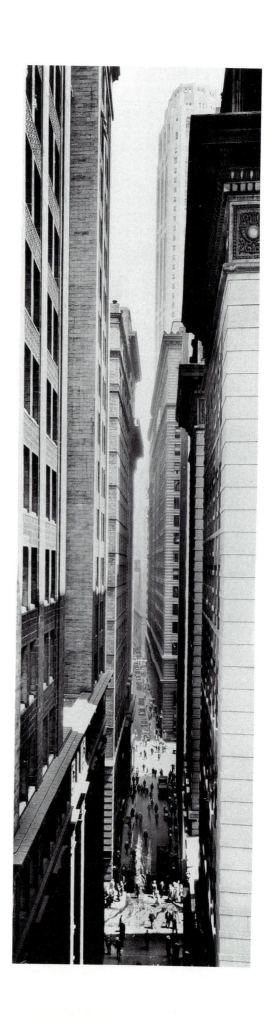

Later, Berenice Abbott (b. 1898) and others earned international reputations as documentary photographers who creatively interpreted the events, people, and places of the world around them as in the memorable view of the lonely man-made canyons of the city [5.12]. The isolation of city dwellers is emphasized by the compartment-like quality of urban life in an office or apartment in these buildings. If Abbott covered a newspaper assignment, her photographs became a creative opportunity to also provide the background of an event as much as the subject. The news photo has now become an important part of our lives through its ability to capture a moment of history as well as to express visually what is often inexpressible in words.

Independent of photography, innovators have explored ways to capture images through noncamera techniques. Shadow pictures called **photograms** or **rayographs** were made by an instructor in the experimental **Bauhaus** school in Germany. László Moholy-Nagy (1895–1946) [5.13] placed an object on light-sensitive material and exposed it to light. Color photograms can be made in the same way, adding color-filter modulators. Other, more specialized noncamera techniques include **holography** and **solarization**.

5.13 LÁSZLÓ MOHOLY-NAGY. PHOTOGRAM. 1926.
© WILLIAM LARSON.

STILL PHOTOGRAPHY TECHNIQUES

Still Cameras

The camera is surprisingly like the human eye, based on principles that are similar to those that enable the human eye to transmit images to the brain.

A simple box camera has a fixed **lens** and a nonadjustable **aperture**, or opening, which admits light rays. The rays are focused on light-sensitized film at the back of the camera. The viewfinder allows the photographer to see what the final image will be. Early photographers used bulky cameras, composing their pictures in large viewfinders that showed images the same size as the intended photographic print. Later, in the 1940s, the development of more sophisticated portable cameras allowed pictures to be taken almost anywhere. The "candid" photography that resulted revolutionized the medium.

Many cameras today can be fitted with changeable lenses of different focal lengths for best use with near, far, or detailed subjects and can be operated by remote control. Many are equipped with photoelectric cells that can control the intake of light and change the shutter speed automatically. There are some cameras capable of processing the film and producing photographs in a matter of seconds. Some cameras are designed to probe unknown space when used in conjunction with telescopes and microscopes.

The lens components are the most valuable part of a camera. Although even a pinhole will produce an image, a good lens concentrates the light, rapidly admitting more light in less time so that even dim moving objects can be photographed. Telephoto lenses permit detailed views of distant objects by magnifying them, while wide-angle lenses enable the photographer to focus on broad subjects at close range. Fish-eye lenses are an extreme form of wide-angle lenses; they distort subjects by magnifying only the central portion of the total image, just as fish tend to see their world. One photographer used a 7.5 mm fish-eye lens positioned directly over the steering wheel of a boat in New York harbor [5.14]. Linear perspective was somewhat sacrificed, since the horizon line follows the curvature of the earth as viewed through the windshield of the boat.

Other important parts of a camera are the shutter and diaphragm, which control the length of time light is admitted to the lens (speed) and the size of the opening (aperture size). Inexpensive nonadjustable cameras have only one shutter speed and one aperture size. The length of time the shutter is open and the size of the opening regulate the amount of light reflected from the subject onto the unexposed film. Different lenses, focal lengths, shutter speeds, and so on, provide flexibility. With more refined cameras, shutter speeds can range from one 4000th of a second to unlimited time exposures. The size of the aperture opening is regulated by the f-stop control dial on the lens—the higher the f-stop number, the smaller the opening.

Film

Black-and-white film is formed from an **emulsion** of light-sensitized crystals (silver-halide particles) embedded in gelatin and laid on a transparent film backing. After exposure to light and processing, the light-sensitized crystals reverse to form the negative from which positive prints can be made.

5.14 Fish-eye view of New York Harbor. Photograph.

5.15 HORST P. HORST. *PALOMA PICASSO*. 1979. PHOTOGRAPH.

Black-and-white films vary in their sensitivity to dark and light values; certain films will produce stronger contrasts than others—often an advantage in fashion photography. This unique art form, developed in the last fifty or so years along with advertising, must create the most effective presentation of the subject. A unique setting and effective lighting can evoke a sense of glamour that most of us could achieve only in dreams. The elegance suggested in the works of one of the leading fashion photographers of our time, Horst P. Horst (b. 1906), might have been seen in one Condé Nast publication or another from 1932 to the present. The drama of brilliant contrasts of dark and light has become Horst's hallmark, casting the face of his subject into shadow so that the garment might be better accented [5.15]. Picasso's daughter Paloma, herself a well-known artist, is here shown wearing a Karl Lagerfeld design.

Film speeds also vary, and the photographer must know which film to select for a particular subject and set of conditions. Moving objects must be recorded at rapid shutter speeds to stop the action and avoid blur; they require, therefore, films that are highly sensitive to light, "fast" films. To convey the essential quality of a dance, Barbara Morgan (b. 1900) chose the full figure of the legendary dancer Martha Graham (1893–1991). The merest suggestion of blur at the hemline and the arresting pose capture in a fraction of a second the emotional thrust of perhaps an entire dance sequence [5.16].

Color films vary. Some produce positive images that become color transparencies or slides; others produce negatives that are used to make color prints. Large photographic prints—whether black and white or color—are desirable for advertising or photojournalistic purposes where corrective photo retouching to clarify detail for reproduction is often necessary. Color films also vary according to their intended use in daylight or artificial light. As in black-and-white photography, the type of film selected is critical to the production of a high-quality final image.

Processing and Printing

Though the processing of black-and-white film is not nearly as complicated as color-film processing, it is not entirely simple. Invisible chemical changes take place when light rays fall on the emulsion surface of film, creat-

ing visual images when the film is put into a developing solution. Rinsing in an acid stop bath prevents further development; then it is permanently fixed in a hypo-alum solution. The more complex procedure involved in developing color films requires highly controlled conditions for both color transparencies and prints. Because film is sensitive to light, heat, and chemicals, photographic developing processes must take place in the controlled conditions of the darkroom, using appropriate color filters.

The printing process requires exposure of photosensitive paper to light that is passed through a negative under darkroom conditions. Contact prints are made the same size as the negative by placing negatives and contact paper together—and exposing both to light. Enlargements of photographs are made by projecting light through the negative and the lens of an enlarger onto sensitized enlarging paper. The distance from the lens to the printing paper controls the size of the enlargement. As in film developing, the invisible images printed on the paper must then undergo the same three baths—developer, stop, and hypofixative—in order to be made permanently visible.

During the enlargement process, the original image may be changed and refined. For instance, by using different kinds of papers, the texture or value contrasts can be increased or diminished. The negative may be masked to emphasize areas of the final print. The image may be darkened or lightened, or parts blocked out altogether. Portions of negatives may be combined into a **montage** by exposing various sections on the same enlargement. The print itself may be cropped or trimmed to change the composition.

As part of an advertising campaign for Safety-Klein, a company that deals in recycling vast numbers of industrial products, Brand Advertising Agency severely cropped a photograph taken by Dick Greene and Arnold Paley. The Statue of Liberty, depicted by a live model standing in a plastic-lined pool, appears to be sinking beneath a sludge-filled harbor. The elimination of all but the upper portion of the body suggests the scale of the statue in a pose certain to attract attention to the antipollution campaign [5.17]. Barbara Kruger satirizes the advertising field by "appropriating" its images and adding her own text that calls into question the insistent focus of our culture upon materialism [4.16].

The variety of photographic technical procedures used with the camera and in the darkroom allows experimentation in a wide range of unusual possibilities, which may increase the expressiveness of the final print. When familiar subjects such as flowers and leaves are

5.16 BARBARA MORGAN. MARTHA GRAHAM: "LETTER TO THE WORLD" (KICK). 1940. PHOTOGRAPH.

Clean up your act, America.

5.17 DICK GREEN AND ARNOLD PALEY. *CLEAN UP YOUR ACT, AMERICA.* PHOTOGRAPH.

photographed in heroic terms, oversized and isolated from their botanical context, they can be explored for their design and structure. The magnolia **[5.18]** reveals a gently expressed sensuous quality. By cropping her image, focusing on the graceful curves of the petals, Imogen Cunningham (1883–1976) brings the viewer into her photograph. Light is diffused through the petals as well as on them so that they become luminous with delicate tones of gray. Such fine variations in tonality are usually rendered best with slower films. A few photographers still insist on "pure" prints made from their original unaltered negatives, but this kind of restraint is rare today.

There can be no question that still photography has fundamentally changed our concepts of the world around us. Certainly, photography has influenced other art forms, particularly painting. And, perhaps even more important, the exploitation of still photography led to the development of the motion picture, as we shall study.

Special Effects and Techniques

Occasionally the camera may be the only way of capturing a record of a special effect; at times, the photographic image may serve only as a starting point in the hands of a creative artist. Artists like David Hockney (b. 1937) echo in their works the fractured nature of communication with mass media. The isolated "stills" from a full-length film, a brief selection from a videotape, feature stories clipped from a newspaper—these represent the nature of modern mass communication with which we are all familiar. Hockney calls his configurations photo mosaics, assembling his works in much the same way as we perceive our world, in

fragmented perceptions, each element a focus on a different aspect. The coherence of the finished artwork is achieved by repetition of similar colors, textures, or themes **[5.19]**. Yet the use of multiple perspectives makes *Celia, Los Angeles* disorienting to the viewer. Thirty-two Polaroid views of the subject, most taken from slightly different station points and scale, remind us of the fragmentation and distortion of reality, perhaps as we perceive it while switching television channels during news broadcasts or by the way the media segment the presentation of news events.

The influence of filmmaking indirectly has induced some artists to create fictional narratives in their work. Cindy Sherman (b. 1954), who combines traditional photographic techniques while calling attention to how the media portray women, produces large-scale (2 feet by 4 feet; .6 meters by 1.2 meters) color photographs that appear to be enlarged frames from films of the 1950s. Sherman eloquently personifies the stereotypical roles assigned to women in Hollywood by depicting passive figures that seem lifeless or, as in this case, express mute, submissive eroticism **[5.20]**. Though Sherman serves as the model in each case, with a variety of wigs and costumes, all of the images and none of them reveal the artist herself— photographer, designer, and actress.

5.18 IMOGEN CUNNINGHAM. *MAGNOLIA BLOSSOM.* 1925. PHOTOGRAPH. © 1974 THE IMOGEN CUNNINGHAM TRUST. ALL RIGHTS RESERVED.

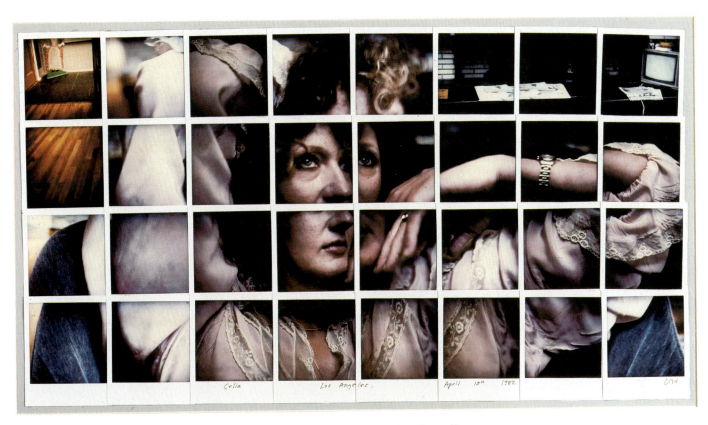

5.19 DAVID HOCKNEY. *CELIA, L.A. APRIL 10, 1982.* COMPOSITE POLAROID. 18 × 40″. © DAVID HOCKNEY.

5.20 CINDY SHERMAN. *UNTITLED.* 1981. COLOR PHOTOGRAPH. 2′ × 4′ (0.61 × 1.22 M). COURTESY OF THE ARTIST AND METRO PICTURES, NEW YORK.

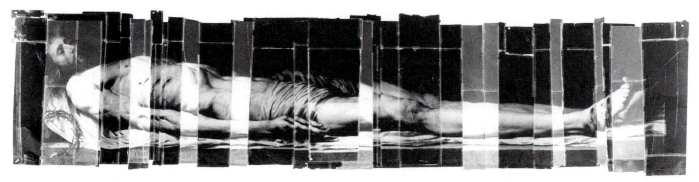

5.21 THE STARN TWINS. *CHRIST (STRETCHED).* 1985–1986. SILVERPRINT WITH TAPE, 28 × 142 × 45″. COURTESY STUX GALLERY, NEW YORK. COLLECTION OF STEFAN AND LINDA STUX.

Images from different negatives can form a single-, double-, or triple-exposure print [5.21]. The Starn twins piece together, like a slapdash mosaic, bits and pieces of photographs with adhesive tape to create one new configuration from many. A few were elaborately framed, but most are simply pushpinned to the wall. What has become their most famous piece is a seventeenth-century painting by Philippe de Champaigne that they rephotographed and "stretched," mounting it horizontally in a glassed, black wooden case. The Starns' rapid rise may reflect photography's changing role in the art world. There are many "purist" photographers who find the Starns and others who work similarly by piecing or segmenting their photographs not lesser artists but questionable photographers. *New York Times* and *ARTnews Magazine* Editor Richard Woodward titled his October 9, 1988, article for the *New York Times Magazine* "IT'S ART BUT IS IT PHOTOGRAPHY? A new generation of artists with cameras is gaining acclaim by blurring the distinction."

Other artists work in a style of fantasy, such as Man Ray (1890–1976), creating special effects involving other experimental photographic techniques. It is now possible to photograph outer space, under the seas, and inside the human body. The artist-photographer is an independent, self-sustaining creative force, unlimited by technology but usually working within the constraints of his or her culture.

CINEMATOGRAPHY

Movement is inherent in all living organisms and has always fascinated people. It is not surprising, then, that the question of how to express motion has concerned artists from the Stone Age to Duchamp and from his *Nude Descending a Staircase* [2.46] painted early in the twentieth century to the most advanced filmmaker today. Our delight in the pattern formed by a drop of splashed milk reveals a preoccupation with even simple movement [5.22]. This pioneering photographic image is now considered a classic

and has even been recreated on a computer screen, element by element. From these beginnings, the invention of the motion picture camera, which made possible the magic of cinema, has resulted in one of the most important and powerful forms of contemporary art.

5.22 HAROLD EDGERTON. *MILK DROP CORONET.* 1957. DYE TRANSFER PRINT. © ESTATE OF HAROLD EDGERTON. COURTESY OF PALM PRESS, INC.

A Brief History

The earliest noteworthy experiments in depicting motion through photography were those of Eadweard Muybridge in California [2.44] during the 1880s. Setting up twenty-four still cameras to capture successive views of motion, Muybridge's sequential photographs led to his invention of a piece of equipment capable of photographing a rapid succession of images. Muybridge also invented a device through which these images could be projected onto a screen. In 1893, an amateur photographer named Alexander Black (1859–1940) had the idea of telling a story through sequential pictures, persuading the president of the United States to be photographed at the White House. The production, called *A Capitol Courtship*, shown with a projector perfected by the American inventor Thomas Edison, was the first practical motion film to win public acceptance as entertainment. With these inventions, film was born in England, France, Russia, Italy, and the United States, first in New York and then, in the 1920s, in Hollywood. For eighty years the film industry has shifted back and forth from the West Coast for most of its studio work, to the East Coast for financial support, "on location sites," and some studio cinematography.

Motion pictures are actually made of thousands of photographic images, which produce an illusion of motion when the photographs, or frames, are projected in a succession of twenty-four frames per second. The human brain is unable to differentiate the individual images or even to see the blank screen flashed between them. This apparently single moving picture occurs because each frame differs only slightly from the one preceding it, and each image projected lingers only briefly as an **afterimage** in the brain.

As soon as the camera was able to record motion believably, cinematographers began to experiment with a variety of space-time illusions. They soon learned that rapid movement over great distances of land or sea can appear to take place, while a brief event can be extended, because the camera is capable of accelerating, slowing down, reversing, or even holding action. A scene can be made to darken, or **fade out**, and a new sequence allowed to **fade in**. A scene can also be made to **dissolve** (merge) directly into another scene. When film scripts call for action that film codes will not permit an audience to view, such devices are invaluable. Filmmakers are thus able to manipulate our perceptions of events and people. Such techniques were fully developed as early as 1915 by D. W. Griffith (1880–1948) in *Birth of a Nation* and continue to be used today.

Cinematographers also discovered that the motion picture camera can be made to imitate the human eye by scanning the overall scene or concentrating on significant details in the distant **long shot**, the closer **medium shot**, and the **close-up**. The close view creates an intense intimacy and can portray unusual views of form and texture, perhaps reminiscent of the vividness of childhood sensations when we first begin to see, feel, and touch the strange new world. Such extreme close-ups in films challenged the social conventions that have always existed regarding appropriate territorial distances between people. When such taboos were broken, the viewer became a participant in screened events, drawn into the film by the intimacy of the images, with a power akin to deities who can "see" everything. The shift in the late 1920s from silent films ("movies") to "talkies" was made possible by the addition of a magnetic sound strip to the film. By this revolutionary invention, the gap between reality and illusion was further reduced, and another dimension was added to the cinema.

The moving picture also controls our perceptions of time. Other visual forms, such as architecture, painting, and sculpture, are restricted to the experience of the here and now. Like live theater, the cinema enjoys the benefits of extended visual experiences, but as an art form it has been most successful when it has rejected theatrical imitation and evolved its own kind of communication.

The earliest films, such as Sergei Eisenstein's (1898–1948) unforgettable, creative shots in *Potemkin* (1925), told a story. The theme of revolution is graphically demonstrated with the slaughter of an innocent populace, the ripped flesh of its citizens, and a runaway baby carriage released from the grasp of a dying mother whose infant remains within and lurches crazily all the way down the Odessa Steps of Moscow [5.23a, b]. Yet, unlike the theater where the art form unfolds through live performance, in filmmaking, editing techniques make it possible for filmmakers to assemble events creatively and suggest rather than spell out an explicit narrative.

Concurrent with these developments in narrative cinema were experimental art films by painters such as Salvador Dalí (1904–1989) and Fernand Léger (1881–1955), who created fanciful, abstract films for small audiences in the 1920s and 1930s. Today, the underground film continues to develop almost as an independent art form, produced by filmmakers who are technically trained and alert to developments in cinema and other arts. Just as many actors and directors such as Woody Allen and Spike Lee have evolved their unique film expressions by drawing upon other media and perspectives, so do the commercial film and the art film echo each other.

A Critic's View of Film

From its beginnings, film—cinematography—was seen as art, enlightenment, and entertainment. The same is true of still photography and other forms of artistic expression. Thus many of the criteria used to evaluate art in general can be applied to film. Nevertheless, feature films—those intended to be shown in theaters—share so many special attributes that they must be reviewed in special ways.

A good starting point for considering a feature film might be the guidelines listed by Dwight Macdonald, former film critic for *Esquire* and *The New Republic*:

1. Are the characters consistent?

5.23 SCENES FROM *POTEMKIN*, DIRECTED BY SERGEI EISENSTEIN. 1925. THE MUSEUM OF MODERN ART/FILM STILLS ARCHIVE.

2. Is it true to life?

3. Is the photography cliché, or is it adapted to the particular film and therefore original?

4. Do the parts go together; do they add up to something; is there a rhythm established so that there is form, shape, climax, building up tension and exploding it?

5. Is there a mind behind it; is there a feeling that a single intelligence has imposed his own view on the material?[1]

 Everyone may not agree with Macdonald's point of view. Some of us expect film to take us "out of this world," while others may look for the essence of "life" and the lessons to be gained from it. All of us seek content that absorbs us. However, many viewers identify the characters of a film with the actors and actresses who play the parts; consistency of characters determines whether or not the film satisfies them. Finally, if a film is consistent and not disjointed, perhaps the director should receive primary credit, even though many of us tend to credit the actors and actresses.
 The ultimate standards for feature films have been well stated by Macdonald in his concluding words:

[1]Dwight Macdonald, *Dwight Macdonald on Movies* (Englewood Cliffs, NJ: Prentice-Hall, 1969), p. ix.

1. Did it change the way you look at things?

2. Did you find more (or less) in it the second, third, nth time? (Also, how did it stand up over the years, after one or more "periods" of cinematic history?)[2]

The Film Script

The creation of a film is a complex communal venture, generally intended to reach vast numbers of viewers yearning to project themselves beyond the confines of their lives. The underlying structure of the film is provided by the script, the written form whose words are translated into an analogous but quite different symbolic representation— images that fill the screen. The filmmaker's effectiveness grows from his or her ability to visualize these images and recreate them as art.
 The script is not a fixed entity but a working outline that charts the long process of filmmaking. It incorporates both the initial conceptualization of the film and the sum total of insights discovered in the process of shooting scenes. For all great filmmakers, a script that begins with one seemingly immutable sequence may evolve through the complex process of filmmaking, requiring thousands of decisions, into a film that begins in a quite different way. At a symposium at the 1966 Cannes Film Festival (the annual

[2]Macdonald, *Macdonald on Movies*, p. xi.

recognition of outstanding achievement in filmmaking), the master French short-story writer Henri Cluzot asked filmmaker Jean-Luc Godard (b. 1930), "You agree that films should have a beginning, a middle, and end?" Godard replied, "Yes, but not necessarily in that order."

Filmmakers handle scripts differently. Ingmar Bergman (b. 1918) may be the foremost director to use the cinema as a medium for sustained philosophical and visionary meditation. In *Wild Strawberries* (1957) and others, he juxtaposes dreamlike sequences that never happened between scenes of past and present events.

Federico Fellini (b. 1920), in the tradition of many Italian directors, develops his films with the skilled support of writers and other experts. His most successful films are said to be autobiographical: *La Dolce Vita* (1960) concentrates on sexual fantasy and sadistic sexual triumph. Eisenstein's *Potemkin* (1925) and *Ivan the Terrible* (1944) offer an inexhaustible source of inspiration for concept and form, including montage techniques; like most of his films, they were created while he filled workbooks with elaborate images and personal notations. Robert Altman's (b. 1925) films have often demonstrated his interest in "offbeat" subject matter and special effects: a sense of dreamlike unreality. Certainly his popular M*A*S*H (1970) is considered an American classic by many. Documentaries evolve differently. Such classics as *Nanook of the North* (1921) through *Woodstock* (1970) may have been developed chronologically and rhythmically in successive sequences. *Gone With the Wind* [5.24], a blockbuster in its time (1939), has achieved a special niche in audience appreciation, because of its rare combination of story line, actors, photography and direction.

Current film imagery seems faster paced and often depends on space-time manipulation and complex technology for its impact. Many films incorporate state-of-the-art special effects with rapid-fire scene changes, exciting imagery, a focus on human emotion and the body beautiful,

5.24 STILL FROM *GONE WITH THE WIND*. © 1939. TURNER ENTERTAINMENT CO. ALL RIGHTS RESERVED.

and more action than dialogue, such as James Cameron's *Terminator 2* [5.25], which is a testament to a formula that works. Other films question history as we know it, such as Oliver Stone's *JFK*, while some directors, notably Martin Scorsese, knowingly take on challenge when they present such a film as *The Last Temptation of Christ*. Although they anticipate some public opposition, they proceed anyway. So motivated by their convictions, they are also resisting censorship (Chapter 9).

Cameras, Films, and Techniques

The motion picture camera is based on many of the same principles as the still camera. The difference between the two lies in the obvious fact that the motion picture camera

5.25 SCENE FROM *TERMINATOR 2: JUDGMENT DAY*.

Art Talk

A view of the world few could have imagined before the twentieth century is now possible through advanced-technology projection. Perhaps inspired by increasing demand for special effects in all media and encouraged by the popular response to unusual visuals that are often offered on television, film technicians developed a new format that has recently appeared in museum auditoriums all over the country as well as in Disneyland, where the process originated [5.26].

Not yet found in conventional theaters, the new technology involves costly large-screen, multiscreen, and 3-D installations capable of accepting much larger than life-size projections of films especially prepared for such viewing. The impact of size and technical brilliance and the creation of an enveloping environment invites the audience to become part of the on-screen event. The eye and the mind are overwhelmed by sheer sensations and a multiplicity of details. In such films as *Nomads of the Deep* the viewer is seduced into an illusion of swimming, swooping, and soaring in the company of sharks and humpback whales off the coast of Hawaii.

Designed to correlate with the new projection techniques are electronic filmmaking processes invented by George Lucas and developed by Francis Ford Coppola in such films as *Captain Eo*, a 3-D spectacle. Featuring Michael Jackson as a latter-day sav-

ior, the film must be viewed through polarized glasses in order to simulate actual space. Along with Jackson's music, a new, total film environment can be experienced. Many will agree that via the dazzling combinations of electronic filmmaking, far larger

5.26 SCENE FROM MACGILLIVRAY-FREEMAN FILMS OMNIMAX PRODUCTION *SPEED*. COURTESY FORT WORTH MUSEUM OF SCIENCE AND HISTORY'S OMNI THEATER.

than life-size screens and specially fitted auditoriums, a fresh means of visual communication has been created to bring filmmaking into the twenty-first century.

NEW FILM ENVIRONMENTS CREATE FRESH WORLDS FOR VIEWERS

is capable of recording a rapid succession of images. The many different specialized needs of cinematography demand varied cameras, films, and modes of operation. Camera sizes include 8 mm, 16 mm, 35 mm, and 70 mm. Generally, the smaller cameras and films are used by amateurs, while the larger, more expensive cameras are used by professionals because they accept large films that can be projected on wide screens for theater audiences.

Lenses control focal length, speed, and depth of field. For example, long-focal-length lenses bring the subject closer by magnifying only a portion of the scene. The zoom lens is generally used to change focal length in a range between the extremes of a wide-angle lens and a telephoto lens, bringing subjects closer, in focus, almost instantly. A smaller lens opening permits sharp focus over a greater depth of field or distance than is possible with a wide-open lens. Moving the camera horizontally (**panning**) or vertically (**tilting**) permits a panoramic view of an area, important when a moving subject must be photographed. By focusing on the subject, the photographer is

able to center in while the remainder of the scene changes, imitating with the camera what we do with our eyes.

The process of editing the literally miles of exposed film (footage) into an artistically coherent work of manageable length is the last creative step in producing a film. The editing is determined by the vision of the filmmaker, usually the director. A work print (positive film) of one or more scenes is run through an editing machine, or viewer, which consists of a lens, screen, and controls for moving the film forward and backward. When the editor decides what changes to make, frames are cut apart in the approximate places with scissors. A splicing machine glues cut frames together. Then the edited print is again run through the viewer. The process is repeated until the editor is satisfied. The sound track, which is recorded on a separate roll of tape, is finally synchronized with the film in the editing machine.

Other cinematographic influences appear in television and video—not surprising, since the newer media almost always begin by imitating their predecessors.

TELEVISION

Television, like cinema, has developed into a major medium for conveying information, artistic expression, and entertainment. It consists of visual images translated into electronic signals beamed through the air to a television receiver, which turns the signals back into images on the television screen. The sources of the images may be film, videotape (magnetic tape with electronic signals), or live action. Television's unique contribution is its instantaneous transmission of events as they happen to our homes. Such live coverage of news and sports events, which gives us a sense of participation in world and national affairs, provides some of television's most successful programming. For instance, much of America was caught up in the Congressional deliberations over Supreme Court Justice Clarence Thomas's nomination to the court. The instant accessibility of television imagery helps relate events on the television screen personally to viewers. Extreme close-ups eliminate the psychological distance between the television image and our emotions, while the immediacy of television provides us with a way to enjoy and identify with dramatic presentations or events. Crowded into large cities, people tend to feel shut off from community living and isolated from others. Yet sometimes, television not only heightens the impact of an event but also helps draw millions of individual viewers together in a shared emotion that brings a kind of national unity.

Television programs range widely and include feature-length drama, situation comedy, musical programs, old motion pictures, interviews and panel discussions, game shows, animated cartoons, news analyses, soap operas, documentaries, and commercials. Some of these presentations are highly creative, others less so. Although panel discussions can rarely rise above the caliber of the guests, a skilled interviewer offers the potential of memorable conversation.

In its attempts to reach the targeted markets for its sponsors, who after all make it possible to present everything we see on the screen, commercial television has been strongly criticized for its tendency to program for the least intelligent or educated and its apparent reluctance to experiment with new ideas. Nevertheless, this is the result of the system. Commercial TV is supported by businesses that buy advertising time and naturally want the largest possible viewing audience for their commercials; therefore, the programs must appeal to the broadest possible audience. Television commercials, incidentally, have become a distinctive art form, frequently showing more creativity and sophistication than the programs they accompany. In any case, the public-supported television stations with no commercials are perhaps freer to show a wider range of programs, as we may determine.

Special Features of Television and Video Art

In commercial television, the possibility of live transmission and the ability to produce instant magnetic videotapes offer several advantages over cinematography that, for viewers, make up for the small size of screens and the monotony of repeated commercials. These advantages are most obvious in the coverage of news events.

An application of videotape that is quite different from the commercial productions for television is video art, which many artists produce as contributions to fine art. Probably its greatest asset is the possibility of instant productions—no long processing delays. Video also offers the

5.27 CHARLOTTE MOORMAN PLAYING A TV CELLO BY NAM JUNE PAIK IN GLOBAL GROOVE BY NAM JUNE PAIK AND JOHN GODFREY. 1973. 30-MINUTE COLOR/SOUND VIDEOTAPE. PRODUCED BY THE TELEVISIONLAB AT WNET/THIRTEEN.

advantage over film of quick electronic procedures like interpolation (added frames), elimination, **splice**, and special effects. The video camera, easily transportable, can accompany a teacher, for example, who demonstrates a particular studio art procedure.

Tape may be edited like film; there is no physical grafting of images, but rather an electronic "grabbing." Finally, the special effects that are rather easily accessible in video have made the medium particularly attractive to musical groups who tap the teenage and early twenties market. Video art for children has tremendous potential as well. The evaluative criteria by which video art may be judged vary with the purpose of a tape. Though the medium is still in its formative stages, cinematographic standards seem to work generally for video, but future possibilities remain an uncharted course.

In a videotape distributed by Castelli-Sonnabend Tapes and Films called *Television Delivers People*, Richard Serra (b. 1939) and Carlota Schoolman (b. 1947) produced a six-minute program focusing on the political import of broadcasting as corporate monopoly and imperialism of the air. The subject of their videotape, notably video-filmed television material, is presented ironically, for their message criticizes commercial television but uses the medium itself to do it. As a parody on the seduction of advertising, Muzak plays while sentences Serra has excerpted from television conferences roll down a blue background in white lettering. For instance, "The product of television, commercial television, is the audience. ... Television delivers people to an advertiser. ... It is the consumer who is consumed."

Noncommercial television obviously is more free to experiment with new expressive forms and creative approaches. Some of these shows, having first won acceptance on public-supported television, have actually been filtered into commercial television. Public and educational television offer many creative possibilities in drama, news coverage, public-information programs, and children's programs. In order to survive, however, and to continue creative broadcasting, public television depends on grants from corporations and foundations and on the financial support of the viewing public—all of us.

Some experimental video art, like film, bases its appeal on the editing process itself. Nam June Paik uses the video synthesizer (Chapter 2) to alter the image on the monitor **[5.27]**. Through electronics, he may distort, blend, and combine images, entertaining us brilliantly with a thousand fluctuating views, including the commercial, even while he reminds us of the insidious pressures exerted by television, which often seduces, persuades, and numbs our sense of values.

It is interesting to speculate on the artistic potential of cable television, with its capacity for almost endless variety in programming. Another exciting innovation is the videotape cassette recorder, increasingly sold for home use. It is not an unlikely projection to anticipate that amateur use of the video camera will soon outdistance its employment by professionals. Just as Eastman Kodak now derives its major income from the amateur market rather than from commercial photographers, this pattern is likely to be repeated with video. Millions of VCRs are now in use; thus tapes of virtually any subject could be made available to vast audiences. Nam June Paik forecasts a not-too-distant time when loss of fossil fuels will eliminate most travel. As he sees it, knowledge will be stored on videotapes, disc-computerized for rapid retrieval, and broadcast to the public.

A relatively recent entry into the video market is the music category **MTV** and **rap music**, with its most vocal performer likely to be *Blonde Ambition* soloist Madonna Ciccone **[5.29]**. One of the most persistent stars promoting females as the center of the video, Madonna makes things happen. The variety of video offerings, however, goes far beyond her, or hard rock music or rap. Some videos create story-line dramas, some are documentary in goal if not in accurate truth, while many music videos have no plot line at all. There are certain stars whose style seems to confuse traditional masculine and feminine signs. We see women taking on the characteristics of power roles that were once played only by men, while still maintaining a measure of femininity, like Paula Abdul. There is an interesting gender confusion. While heavy metal videos have increased in the last decade, the introduction of rap video, primarily male, offers the possibility of harmonizing interracial interests. The common denominator is exciting and

5.29 Madonna. *Blonde Ambition Tour.*

The Artist Sketch

Regarded as a pioneer in the development of video art, Nam June Paik is as well known for his experimental work in music [5.28]. Born in Korea into a manufacturing family, he began his career as a composer and performer of **avant-garde** music, graduating from the University of Tokyo with a thesis on musician Arnold Schönberg and continuing his studies at the University of Munich. Paik's interest in Performance Art probably evolved from the time he spent at the Studio for Electronic Music in Cologne, where one of his 1960 presentations concluded offstage in the audience with a ceremonial cutting of the composer John Cage's tie and shirt. While the demand for his presentations took him all over northern Europe, not until 1963 did his first investment in television—thirteen secondhand TV sets—introduce him to the medium by which he is best known.

The first one-man exhibition of Paik's video art in March 1963 occupied many rooms and included the thirteen altered television sets, three prepared pianos, and Joseph Beuys, an internationally known improvisational artist, who is said to have attacked one of the pianos with an axe. Since then, Paik's explorations, theories, ideas, writings, far-flung performances, and, in particular, his videotapes have shaped the contours of the development of television and video as an art form. He often creates color images on a display terminal that looks like a television screen, sometimes converting black, white

5.28 Nam June Paik. Courtesy Carl Solway Gallery, Cincinnati.

and gray images of reality into any arbitrarily chosen colors.

In an interview of Paik in 1977 by the author, Paik noted the connections between his special use of a video "synthesizer" with the music box invented by Futurist artist Luigi Russolo in the 1920s and with the Cubists' discoveries before that:

> The important point is the time element. My work resembles Cubism in the video weaving of time much like **Synthetic Cubism**. My images may be sequential views fused as you watch them. And also important is that video images cannot decay. We can live forever in video.

Paik's experiments have been supported by the Rockefeller Foundation's art program for video research, permitting him not only the opportunity to participate in numerous programs, but to "play" with the medium in his "voyages" through television. His satire and playfulness underscore his confidence in chance actions. His legacy has been absorbed by the rock-video movement, but his concern with the manipulation of events by the medium brings him much closer to another twentieth-century philosopher, Marshall McLuhan. Both men forecast the power of media. And, indeed, the video camera has invaded the courtroom, the classroom, as well as the operating room. Nam June Paik's vision continues to inform us about ourselves through his videotapes.

NAM JUNE PAIK (B. 1932)

colorful visual imagery that attracts some of our most dedicated and talented video technicians and artists.

We have only to look around us to see some of the technical and social results of the invention of the camera. The new art forms it has produced—photography, cinema, television and video—are now a part of our everyday lives. Their very familiarity should make it easier for us to evaluate just how aesthetically successful and expressive they have become.

Video seems likely to expand its influence on society with every passing year, in aspects that range from news clips to videotaped tutorials, from medical achievements to professional entertainment. More and more filmmakers are incorporating computer-generated video sequences in their films; let us examine next the role of computer graphics.

COMPUTER GRAPHICS

Since mid-century, electronic advances have provided us new media in the graphic arts—arts that literally evolved from 150 years of photography, fairly recently wedded to electronics. No one ever produced computer art before 1960, nor could anyone have done so before this century. This very fact affects in profound ways how people who make, judge, or even look at computer graphics can function. History has demonstrated that the aesthetics of new media are almost always derived from older, established artistic fields. The birth of the earliest digital computers in the 1940s suggested an art style more appropriate to the technology that produced it than to fine art. As a result, computer art departed only slowly from its scientific roots.

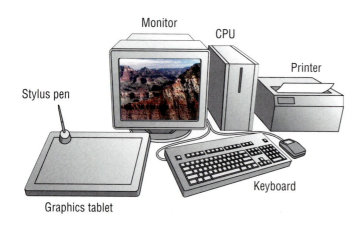

Monitor

CPU

Printer

Stylus pen

Keyboard

Graphics tablet

5.30 DIAGRAM OF COMPUTER HARDWARE.

Art by this machine began as a linear form, closer to optical art than the variety of graphics we see, in particular on television. Andy Warhol remarked (1963): "The reason I'm painting this way is that I want to be a machine, and I feel that whatever I do, and do machinelike, is what I want to do." He must have been thinking of computers. We do know that he was delighted with the endless repeats the computer could easily generate.

Some understanding of the mechanical process that yields computer-generated imagery should help us better appreciate this new art form. A rather complicated design involving electronic beam scanning in the "heart" of a television or computer monitor, called a cathode ray tube, produces the images we see on a computer monitor. If we come very close to the screen, we can usually see some of the individual scan lines, electronically beamed, that make up every image we see on the computer monitor or, for that matter, on the television screen.

Raster scan graphics, now the most common means of creating a video display, makes use of a computer's memory to generate instructions to every spot on the screen. Each picture element, called a pixel, represents a location in the computer's memory. The screen is completely mapped. The size of those elements is determined by the construction of the computer (hardware), and the resolution of a system describes how many pixels can be controlled. High resolution is expensive and difficult to achieve, but the speed of technological advances makes the movement from early graphics (when we could see every pixel) to fine resolution almost in sight for every computer graphic artist today. Software refers to the program on a diskette, as easily changed as a sound cassette in a player and offering the possibilities of visual images as varied as business graphics to fine arts.

In conclusion, the technology we tap to produce computer graphics is exceedingly complex, but our knowledge and understanding of every phase of computer operation need go no further than this overview. Computers, we have seen, can be as valuable to the artist as to the scientist, and all who produce graphics incorporate the following [5.30]:

1. Some kind of input device with a typewriterlike keyboard, a graphic tablet, or a video camera. All are connected electronically to the computer.

2. Central control and informational processing unit, mathematically operated (CPU).

3. Memory device.

5.31 DAVID EM. *TRANSJOVIAN PIPELINE.* 1979. © DAVID EM/REPRESENTED BY ROBERTA SPIECKERMAN ASSOCIATES, S.F.

5.32
RICHARD FELDMANN.
COMPUTER GRAPHIC/
STRUCTURE OF DNA.
© R. FELDMANN/D.
MCCOY.

4. Some kind of output device, such as a display monitor (like the television screen) and/or a printer.

 With some computers, we can change the scale and perspective of a graphic image made on the electronic tablet or a picture put into the computer from a video camera. We can rotate designs and repeat them on command. We can try many, many colors and patterns, changing everything at will.

 In the hands of a gifted artist, the computer is a machine capable of producing images of captivating power and beauty. Its focus can shift from the basketball court on sports television to the internal structure of molecules. Television logos can whirl through space, while computer artists can create worlds more comfortable in outer space than here on earth. A pioneer in using computer technology to create the fine art of astonishing beauty for two decades, David Em has produced a body of work in a unique and distinctive style. Exploiting a broad range of computer-generated colors, the lushness of his computer art pushes the painterly potential of the medium. *Transjovian Pipeline* demonstrates the depth and three-dimensionality possible [5.31] with a two-dimensional image that seems to plunge through an unfamiliar spatial world, complex in pattern and texture. Functionally very different but as significant, molecular biology is clarified for the scientist in this rendering of computer-generated DNA double helix [5.32]. From mind games to the weather report on the evening news, computer graphics may be "the new kid on the block," but as an artistic medium, its future is limited only by the artist at the machine. We will futher examine the computer in Design (Chapter 8).

EXERCISES AND ACTIVITIES

Exercises for Research and Discussion

1. The principle of the camera was first explored in the Renaissance device known as the camera obscura. What was the principle on which it was based? How was it applied to later cameras?

2. Photography is both an art and a science. Explain how it can be both.

3. The operation of a camera is related to the function of the human eye. Define or diagram the relationship between them.

4. Select several photographs from a magazine or from your own collection. Which do you believe qualify as works of art? Explain your reasons for your choices.

5. An illusion of life can be produced through the medium of the motion picture. How did motion picture photography develop out of Eadweard Muybridge's early experiments with multiple photographs? What are the advantages of cinematography and/or television over still photography? Explain the space-time concept involved in cinema and television.

6. Form two class groups; one to discuss the best television programs, the other to analyze the worst. List your reasons; then, share consensus with entire class.

Studio or Homework Activities

1. Cut out magazine photographs that you like. Select those that create different moods and assemble them into a photo montage. Or, if you have many photographs that you have taken, select some of them and assemble them into a photo montage. Perhaps you will find that you can create something that seems better than any of the individual photographs.

2. Select a theme such as the student government association or the college newspaper and create a photo essay on the subject.

3. Create a 15-frame sequence (**storyboard**) for a television commercial publicizing your college. You may sketch your ideas for each frame or take photographs of appropriate images and carefully describe the audio and video changes from frame to frame.

6.1 DUANE HANSON. *TRAVELER WITH SUNBURN*. 1989. BRONZE, OIL PAINT AND MIXED MEDIA. LIFE-SIZE.

Part Three
Three-Dimensional Media and Techniques

The media that occupy space in three dimensions also communicate to some deep level of human need and experience. These art forms perhaps have served human existence for the longest time, from the earliest art objects that remain from the past to our expressive needs for today and, no doubt, tomorrow.

Three-dimensional art visually provides more than the height and width that we see in two-dimensional art. The third dimension—depth—radically alters our perceptions. We experience two dimensions from only one perspective. The multitude of aspects possible in viewing and dealing with works that occupy space often makes each view appear like a totally different configuration. Well-designed three-dimensional work should compel the viewer to move all around it, examining the artwork from many different angles.

Three-dimensional media make use of the same visual elements and principles of design with which we have already become familiar. Every age and society has made its contribution to these arts, such as the use of materials or an approach that is unique to the twentieth century [6.1]. In exploring how artists have used a wide range of materials, we will consider the long evolution from handmade works to today's industry, provoking such questions as: Is "art" made with machines really art? Can real art be produced by industry's machines when they are controlled by artists?

In the chapters to come, we will examine the sculptural arts, architecture and environmental design, and the arts for living, concluding with **Performance Art** and current art issues of concern.

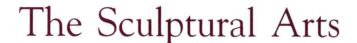

The Sculptural Arts

"When Michelangelo had finished the Moses, there was no other work to be seen, whether ancient or modern, which could rival it ... one might almost believe that the chisel had become a brush."

—GIORGIO VASARI,
RENAISSANCE HISTORIAN

• • •

"I say that the art of sculpture is eight times as great as any other art ... because a statue has eight views and they must all be equally good."

—BENVENUTO CELLINI,
SCULPTOR, C. 1562

• • •

"[Nature], the model, teaches us what we should do ... to model shadow is to bring out the thought. ... Sculpture is the art of the depression and the protuberance ... Nature, by a divine law, tends constantly toward the best."

—AUGUSTE RODIN,
SCULPTOR, C. 1890

• • •

"Sculpture is such a physical thing that you must have manipulative ability—hit a nail with a hammer—cut metal and join metal. The better you know how to make things, the better you are as a sculptor."

—RICHARD STANKIEWICZ,
SCULPTOR, 1973

Sculpture is a three-dimensional art form, probing space somewhat as architecture does. While architectural space, however, is large enough for us to walk-through, most sculpture occupies more limited volume. We are used to looking at statues carved on a building's surface, set into niches, or standing free where we can walk around and enjoy them from every angle. Such forms of sculpture, whether seen only frontally or from all sides, change as the light and our angles of vision vary. The hollow spaces between sculptural masses can often become as important visually as the sculptural forms themselves. Our eyes follow the dominant lines of the work, and frequently our bodies respond as well. Sculpture may be such a powerful art form because it occupies real space just as we do. Perhaps, therefore, we relate to sculpture also because our own bodies identify with three dimensions as is not possible with the two-dimensional arts. The human tactile response is often so strong that our hands often long to touch the sculptural surfaces, to feel the smooth or rough textures. When we cannot touch sculptures, we can usually sense what it would feel like to run our hands over the surfaces. These are all immediate sensual responses, quite separate from any emotional feelings aroused by subject matter.

Through the ages, sculpture has fulfilled many purposes: to reinforce sacred beliefs with statues of religious

6.2 MICHELANGELO. MOSES. 1513–1515. MARBLE. HEIGHT 8'4" (2.54 M). SAN PIETRO IN VINCOLI, ROME.

figures [6.2], to create an emotional atmosphere of worship, and to depict the gods in visual form; to record historical events and to exalt rulers, just as this ivory pendant mask symbolizes the leader of the sacrosanct kingdom of Benin, Africa [6.3]; and to honor the dead, just as these forms celebrate ancestors from New Guinea in Melanesia [6.4]. In contrast, today's sculpture is usually more frequently concerned with communicating the individual artist's inner feelings in response to the outside world.

In addition, new ways of using traditional materials, new technical methods, and new ideas have transformed the nature of sculpture. In fact, the art has changed so radically over the last one hundred years that it is difficult to discuss much contemporary sculpture in conven-

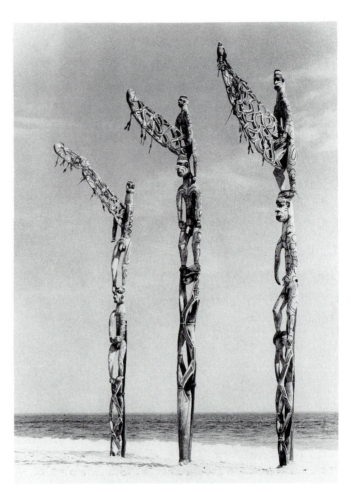

6.4 ASMAT ANCESTOR POLES. OMADESEP VILLAGE, FARETSJ RIVER. WOOD, PAINT, AND FIBER; HEIGHT APPROX. 18′ (5.49 M). THE METROPOLITAN MUSEUM OF ART, THE MICHAEL C. ROCKEFELLER MEMORIAL COLLECTION, GIFT OF NELSON A. ROCKEFELLER AND MRS. MARY C. ROCKEFELLER, 1965.

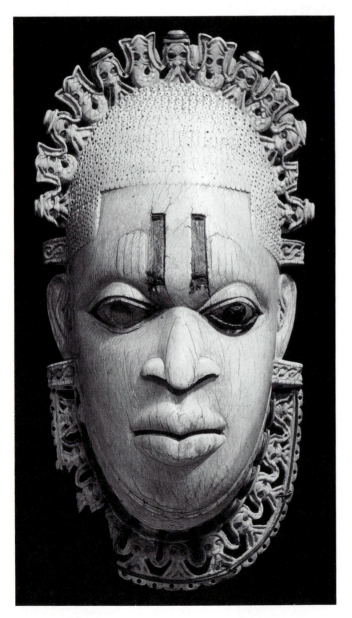

6.3 AFRICAN BELT MASK. NIGERIAN, COURT OF BENIN. 16TH CENTURY. IVORY, HEIGHT 9-3/8″ (24 CM). THE METROPOLITAN MUSEUM OF ART, NEW YORK. THE MICHAEL C. ROCKEFELLER MEMORIAL COLLECTION, GIFT OF NELSON A. ROCKEFELLER, 1972.

tional terms or to classify it in the usual way as carved wood, cast metal, or built-up clay. For example, in what category would you place these examples of present-day sculpture—a stuffed vinyl fan [6.23] or a neon sculpture [6.21]?

As we study the processes by which sculpture is made, we will see how the sculptor often uses complex techniques to create aesthetic sculptural experiences. Since a large part of the process of sculpture is problem solving on a practical level, only after sculptors become technically proficient can they concentrate on expressive aspects of their works.

TRADITIONAL MATERIALS AND PROCESSES

Stone, wood, clay, and metal have been used in sculpture for centuries in an infinite variety of ways, each reflecting different cultural concepts. **Relief** sculptures are close in

appearance to two-dimensional works in that their three-dimensional mass is attached in some degree to a flat surface. In **bas-relief** (low relief), the forms project only slightly off the background. In **haut-relief** (high relief), at least half of the depth of the total form juts off the background. Sculpture in the round, as the name implies, consists of freestanding work. In the past, stone and wood have been carved in what are called direct processes; that is, the sculptor works with the actual material that forms the finished work. As a first step, a small sketch and/or model of the larger work is prepared to serve as a guide. This is then enlarged, either by eye or with a device that measures the original and notes the increased proportions on a block of wood or stone.

Once the material is marked, the sculptor chips away the excess until gradually by this subtractive process the image begins to emerge from the block. Michelangelo used to go to the quarry to pick out the stone he wanted for a particular piece of sculpture. He believed that he could visualize sculptural forms trapped inside the stone, waiting to be released by his carving. Through a similar sense of identification with the source materials of their works, traditional African sculptors beseeched growing trees to give approval to the sculptures to be carved from their wood. Something of that respect for materials exists even today as artists prepare to create an expression of art from the materials around them.

Stone

In the past, stone sculpture has varied from the very small fertility figures such as the *Venus of Willendorf* [1.21] to the enormous bulk of the *Sphinx*, which was made from huge blocks of stone added to the natural rock that was already there [2.11]. Granite, sandstone, marble, onyx, and many other dense stones have been carved by sculptors with tools that have changed little over the centuries. Chisels, heavy-headed mallets, rasps, and hand-finishing tools still in use by sculptors today are basically much the same as those Michelangelo used to carve his *Moses* [6.2], a biblical figure who "came to life" for the Renaissance audience, despite the hard stone from which it was created. But modern sculptors in stone usually also employ power tools to cut away the excess material fairly easily or to add a polish to the finished work. They may use hand tools only for the final carving and shaping, reducing to a fraction the time and effort once required for sculpture. If you were to try to chip off a few pieces of marble with a hand chisel, you would understand the difficulty of the task and the advantage electrically powered equipment has given the sculptor. The skills required, however, while somewhat different from those for hand tools, are just as demanding.

The character of the stone and the nature of the tools with which the sculptor chooses to work determine the appearance of the finished piece. For example, the texture of finished sculpture—highly polished or left rough—will vary depending on the type of surface worked as well as the tool with which unwanted material is eliminated.

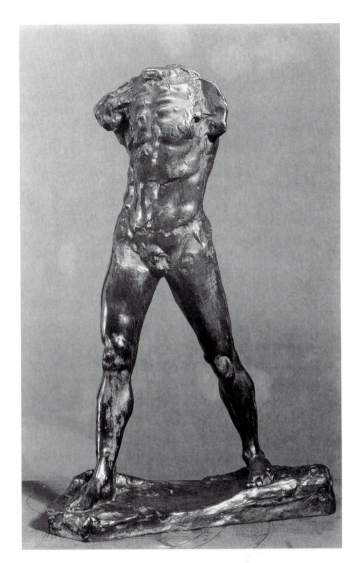

6.5 AUGUSTE RODIN. *THE WALKING MAN.* 1877–1878. BRONZE, 33-1/4 × 16-3/4 × 21-7/8″ (.845 × 0.426 × 0.555). NATIONAL GALLERY OF ART, WASHINGTON. GIFT OF MRS. JOHN W. SIMPSON, 1942.

Many artists, such as Michelangelo and Rodin, have often left a small portion of their sculptures unworked to echo the original surfaces of the natural materials. If you carefully examine Michelangelo's *Moses,* perhaps you can detect the untouched surfaces. In addition, the stone's special qualities, such as the marbled veining, must be respected and used expressively by the sculptor. Finally, because stone, for all its hardness, can break as it is being worked, care must be taken to choose blocks without flaws. While fewer sculptors today use stone as their medium of choice, Rodin seemed as comfortable with stone as the bronze with which he is more closely associated [6.5].

Wood

Wood has played an important role in every phase of human existence. The tombs of the ancient Egyptians were full of wooden utensils and furniture put there to make the dead comfortable in the afterlife. The peoples of Africa,

The Artist Sketch

Whatever Rodin put his hand on exuded an overwhelming power, a force untamed. Until age nine, the young Rodin attended a school run by monks in Paris, where he was born. He was a dull student, but so entranced with art that he was finally permitted to attend the Petite École du Dessin in 1857. "I had a violent longing at first to be a painter. Colour attracted me. I often went ... to admire the Titians and Rembrandts. ... But ... such a passion for sculpture seized me that I could think of nothing else."

Rodin at eighteen was making a name as an artist of uncompromised boldness and originality. Plucked from obscurity and set into a show titled "New Currents," thirty-six of his sculptures joined seventy paintings by Impressionist Claude Monet. No less than the leading critic of his day, Octave Mirbeau, pronounced the show of "two wonderful" artists a colossal success.

As a consequence of a trip Rodin took to Italy, the influence of Michelangelo and ancient sculpture on him was enormous. Like Cézanne, he also came to believe "unfinished" art, that is, fragments of nature or of ancient art, projected extraordinary power—which often, when completed, lost considerable impact. These concepts of the fragment and the

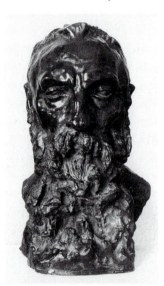

6.6 CAMILLE CLAUDEL. *AUGUSTE RODIN.* 1888. BRONZE, 16 × 10 × 11″ (40.7 × 25.7 × 28 CM). MUSÉE RODIN, PARIS.

bittersweet poignancy of life itself followed Rodin and in fact dominated his art. He may also be credited with a fascination for incorporating free movement into his work, perhaps the first to do so.

Eroticism permeates much of Rodin's art. "People say I think too much about women," he once remarked. "Yet, after all, what is there more important to think about?" After he met Camille Claudel in 1883, she became his assistant and lover, serving also as inspiration for several of his sculptures. She also became a sculptor, pursuing her career with somewhat limited success for many years after her relationship with Rodin [6.6] ended. Although questions linger regarding Rodin's emotional difficulties concerning Claudel's skills as they approached his own in stature, it is perhaps a credit to her art that Rodin's favorite portrait of himself was the bust she had completed of him. Meanwhile, his reputation spread. In 1900, a retrospective exhibition of his work in Paris, launched with a banquet in his honor, was attended by the literary, musical, and artistic leaders at the turn of the century. Rodin's continued appeal to us today may lie with his own identification with the redemptive spirituality that transcends the universal passions of humankind.

AUGUSTE RODIN (1840–1917)

Oceania, and pre-Columbian America used wood for boat decorations, sculpture, furniture, and masks [6.7]. Along the Pacific Northwest Coast whole tree trunks, set near large wooden plank houses, were carved into totemic animal images, such as the grizzly bear or the thunderbird, which might identify the clan crests (following matrilinear lines of descent) of the several families who shared the house. Such totem poles served somewhat like house directories [6.8] of the last century.

Like sculpting in stone, wood carving is a direct technique that involves removing unwanted material until the desired form emerges from the piece of wood. As with stone, the hardness and graining of woods vary. Each kind presents a different technical problem of possible breakage or splitting. Today we value the grain of the wood both from a technical and an aesthetic point of view, since the character of the material chosen by the artist affects the appearance of the final piece of sculpture. In early cul-

tures, however, after a wood sculpture was completed, it was frequently painted or coated with fine sheets of bronze or gold, so that the texture or grain of the wood was masked by the overlying layers. For example, the mummy of the Egyptian Pharaoh Tutankhamen was found in a nest of wood-and-gold coffins, each inner container slightly smaller than the outer. The innermost one, just fitting his body, was solid gold, but was enclosed within an oak coffin almost totally covered by layers of precious gold and inlays of semiprecious stones [6.9].

Medieval cathedrals are treasure houses of carved wooden choir screens, choir stalls, and altars. Inheriting these religious traditions, the Renaissance sculptor Donatello created several works that embodied the piety of the earlier age. The material with which he worked less frequently, namely wood, seems to be particularly appropriate for the *Mary Magdalene*, a sculpture that almost quivers with vibrant religiosity.

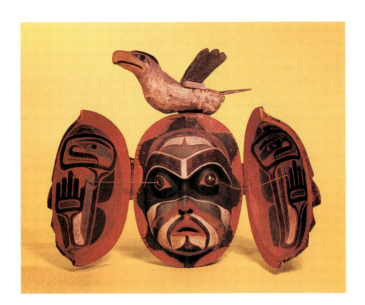

6.7 MOVABLE MASK FROM CAPE MUDGE, BRITISH COLUMBIA. KWAKIUTL. 1850–1900. PAINTED WOOD, HEIGHT 21-1/2″ (55 CM). NATIONAL MUSEUM OF THE AMERICAN INDIAN, SMITHSONIAN INSTITUTION.

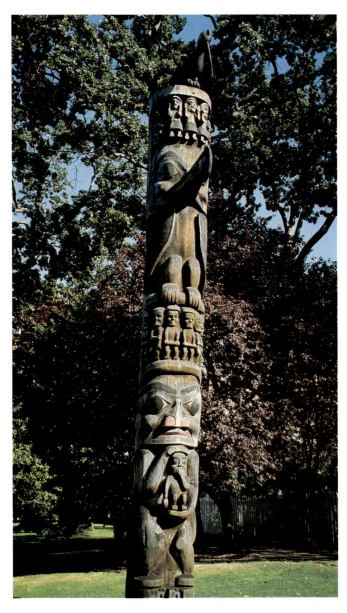

6.8 HAIDA. TOTEM POLE.

6.9 TOMB OF KING TUTANKHAMEN, SECOND COFFIN: LID. EGYPTIAN, XVIII DYNASTY. C. 1365 B.C. 6′8-3/8″ × 2′2-3/4″ × 2′6-7/8″ (2 × .68 × .78 M). PHOTOGRAPHY BY EGYPTIAN EXPEDITION, THE METROPOLITAN MUSEUM OF ART.

Art Talk

A devastating November 1966 storm left Northern Italy covered with several feet of mud and damaged many of its art treasures, but there were a few benefits. In particular, our knowledge was enlarged of one of the greatest sculptors of all time, the fifteenth-century Italian, Donatello (1386–1466). Two of his statues that art historians had attributed to the 1450s, or later, the *St. John the Baptist* in the church of the Frari in Venice and the *St. Mary Magdalene* [6.10] in the Baptistry in Florence, had been dated on stylistic grounds because documentation did not provide strong evidence of when they were made. Both statues, made of wood, came in contact with the flood waters resulting from the 1966 storm, requiring drying and restoration. In the process of restoring both works, it was discovered that a thick layer of brown paint covered the polychrome (colored paints) and gilt that was originally intended to be seen. Further, on the *St. John the Baptist* an authentic signature came to light and the statue's date was uncovered: 1438.

Both sculptures show an intense spirituality and fierce expressiveness that some art historians believe arose out of a mature artist coming to terms with the dissolution of the flesh that accompanies age and the preparation of a religious man for death. Uncovering the date on the *St. John* not only gave a new slant to traditional notions of Donatello's development, but also caused the conventional dating of the *Mary Magdalene* in the 1450s to be reconsidered. The latter statue is now also believed to date from the late 1430s or the 1440s.

Just as modern viewers of classical Greek statuary see it stripped of the coloring that marked it when it was new, so we have come to accept Medieval and Renaissance sculpture without its decorative coloring. We now see the tan of the *Magdalene's* face, arms, and legs setting off the intense blue of her eyes and, even more, the flickering highlights of gold in her hair, which she wears as a garment, contributing to the other-worldly quality which her gaunt, emaciated form expresses. We also know more about Donatello's working methods after the restoration of these two famous wood sculptures. To help overcome some of the restrictions of the subtractive method of carving, Donatello added gesso (a kind of plaster) in some portions of the *Magdalene* to build up areas, unlike earlier sculptors, who used gesso mainly as a ground preparation for polychromy. Thanks to contemporary expertise in and attitudes toward restoration, which favor returning to the object's original appearance when feasible, we can now see and appreciate these two important statues of Donatello's as the sculptor originally intended them.

6.10 DONATELLO. *ST. MARY MAGDALENE.* 1435–1450. POLYCHROMED WOOD, HEIGHT 6'2″ (1.88 M). MUSEO DELL'OPERA DEL DUOMO, FLORENCE.

THE RESTORATION OF DONATELLO'S SCULPTURES

6.11 LOUISE NEVELSON. *ROYAL TIDE II*. 1961–1963. PAINTED WOOD, 94-1/2 × 126-1/2 × 8″ (240 × 321.3 × 20.3 CM). COLLECTION OF THE WHITNEY MUSEUM OF AMERICAN ART, NEW YORK. GIFT OF THE ARTIST 69.161.

Contemporary sculptors often use wood in the traditional manner, carving from solid blocks. But they also use it in new ways, such as the additive process called **assemblage**. Louise Nevelson (1899–1988) collected readymade pieces of wood and combined them into compositions that suggest walls or niches taken from architectural settings. Her works are concerned with the play of light and shade over forms and can be looked at as symbolic spaces for retreat and protection from our plastic, streamlined world. She started by picking up scraps of wood in furniture and pattern shops. After nailing and gluing them together, she painted them all flat black, white, or gold, thus unifying the hundreds of separate pieces. The entire work shown here is large, but each of the small boxes is a self-contained rectangular relief composition, recalling the intricacy of Gothic carving—a cathedral of modern times, touched with poetry and magic [6.11].

Clay

Clay has been shaped into sculpture ever since human beings first discovered this material that covers much of the earth. It is a very motile substance, easy to model, which permits a great deal of spontaneity, especially in small sculptures. Pre-Columbian Indians from the Valley of Mexico, from an ancient settlement at Tlatilco, for example, modeled lively clay figures of humans and animals for religious purposes [6.12]. This little figurine has a simple charm and human quality often lacking in the larger complex clay or stone figures that we normally associate with

6.12 FIGURINE FROM TLATILCO, MEXICO. MIDDLE FORMATIVE PERIOD. 800–300 B.C. CLAY, HEIGHT 3-3/4″ (9.5 CM).

The Artist Sketch

A legend in her own time, Louise Nevelson seemed to enjoy the image that she projected upon the world. During a brief interview by the author in 1983, at the opening reception of a shared exhibition of art by Nevelson and Georgia O'Keeffe—*Independents of the Twentieth Century*—at the Nassau County Museum of Fine Arts on Long Island, Nevelson charmed all around her, especially the author's daughter. Nevelson reached a long, gloved finger to Janna's cheek, whispering almost to herself, "How young, how pretty." The young woman's instant response, "You and I believe in Peter Pan," seemed to please. Such indeed was Nevelson's vanity that she was still dressing with the turban and false eyelashes that had become as much a part of her persona as her abrupt mood swings. From jubilant, to autocratic, to gracious—the potential was always there in her later years.

Nevelson was born in Kiev, Russia, and by the time she was six, her family settled in Rockland, Maine, where she met and married Charles Nevelson. Like other artists of her generation, she joined the Works Progress Administration, serving as a teacher. She was forty-two before she was honored with a solo show and in her 60s before she was elected president of the National Artists Equity, and held her first retrospective show at the Whitney Museum of American Art, New York. The awards began to pile up. Although Nevelson was not a Cubist, she believed that the cube was a key to understanding her work, defining her philosophy as stated in her 1983 show catalog:

> I go to the sculpture and my eye tells me what is right for me ... Sometimes it's the materials that take over, sometimes it's me that takes over ... The very nature of creation is not a performing glory on the outside, it's a painful difficult search within ...

Nevelson's sculptures consist of diverse materials—some left natural, others preformed but used as art materials for which they were never intended—yet, all are essential to the integrity of every work. She has also explored collage, print media, aluminum, steel, and lucite, but it is the wood medium in which Nevelson made her mark and formed her philosophy. As Nevelson stated in 1983, both for the catalog of her show and again for the author as she reaffirmed her beliefs, "Only wood gives a sense of the living, with that inner vitality that gives it another life."

Newly developed processes have given fresh life to wood as a material for sculpture. For example, plywood can be bent and shaped when heated and built up into almost any form; it can then be painted or left with the natural grain and color intact. Nevelson herself is the subject of an assemblage by Marisol (Marisol Escobar, b. 1930), a work formed of plywood, wood block, hair, some plastic, some paint, and other materials [6.13]. Like many of Marisol's works, *Louise Nevelson* is a witty spoof of the mighty figures of our time. It is not known how Nevelson regarded the sculpture.

LOUISE NEVELSON (1899–1988)

Middle American cultures. Clay can also be built up into very large forms by coil and slab methods, provided that care is taken to prevent the shaped clay from collapsing before hardening. These clay sculptures are generally hollow and may be built to a height of several feet. Such was the case with six thousand life-size pieces of pottery that represented an emperor's guardian army. We can only imagine the scores of artisans involved in their production over a period of some years. Buried with the emperor at the time of his death in Xian, China, the sculptures were intended to protect him in the afterlife, just as their prototypes had protected him earlier. Each clay figure is complete and differentiated in regalia, we suspect, like the people they represented. The army of archaeologists who unearthed the figures more than two thousand years later were overwhelmed, as you can imagine, by their find [6.14].

A particular piece of sculpture may be copied one or more times by means of a plaster mold made in sections from the original. Clay is diluted with water until it has a creamy consistency (slip) and is then poured into the mold. When the liquid has hardened, the sectioned molds are removed from the sculpture. The molds can be used over and over again to produce many replicas of the original.

Clay can be baked in **kilns** heated to high temperatures to make it more durable. This firing process, discussed in the section on **pottery** (Chapter 8), causes physical changes to take place in the clay, hardening it and making it nonporous. Fired clay, whether shaped by hand or cast in molds, can be decorated with paint or **glazes**, minerals that, when fired, fuse into a glassy coating. Most Renaissance sculptors glazed their ceramic sculptures, and there is a revival of interest in the technique today. Con-

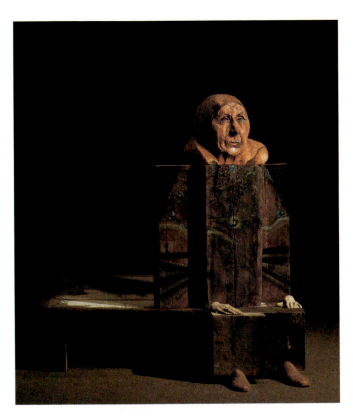

6.13 MARISOL. *PORTRAIT OF LOUISE NEVELSON.* 1981. PENCIL
AND OIL ON WOOD AND PLASTER, 54 × 72-1/4 × 78"
(137.16 × 183.51 × 198.12 CM); BACKBOARD 96 × 108"
(243.84 × 274.32 CM). COURTESY SIDNEY JANIS GALLERY.

temporary artists are producing sculptural pieces using hand-building, casting, or combined techniques. Well-known West Coast ceramic sculptor Robert Arneson (b. 1930) has evolved a career that offers humor as the height of art. In an earthenware work, he sets the cultural hero of our century, Pablo Ruiz Picasso, on a Greek column that recalls sculptures in the Roman Forum that celebrate victorious generals. In this case, he has rendered the artist in an all-too-human pose, stretching to scratch an elusive itch. [6.15].

Finally, in addition to the goal of forming finished sculpture, clay has been used for centuries to make small models of large projected sculptures or to build up full-size sculptures from which metal statues may be cast.

6.15 ROBERT ARNESON. *PABLO RUIZ WITH ITCH.* 1980.
TWO-PART GLAZED CERAMIC SCULPTURE: BUST 29-1/2 × 22 × 22"
(74.9 × 55.9 × 55.9 CM); PEDESTAL 58 × 27 × 15"
(147.3 × 69.8 × 38.1 CM). THE NELSON-ATKINS MUSEUM OF ART,
KANSAS CITY, MISSOURI. (GIFT OF THE FRIENDS OF ART) 82–38 A,B.

6.14 XI'AN, SHENSI, CHINA. IMPERIAL BODYGUARDS FROM THE
TOMB OF EMPEROR QIN SHIHUANG. LIFE-SIZE.

Metal

Until the twentieth century, metal sculpture, usually bronze, was almost always cast. The same lengthy process with few changes has been used for hundreds of years. Metal sculpture cannot be spontaneously produced. It takes careful planning and considerable engineering skill to foresee the problems of casting and to prepare for them.

The sculptor begins the process by creating a full-size original sculpture, usually made from **plasticene**, a plastic clay, surrounding a wooden or metal framework called an **armature**. This is the creative part. Most of the rest of the process is technical. The armature, like a skeleton, keeps the clay from collapsing as it is built up, allowing the sculptor to produce slender forms and extended arms and legs, otherwise impossible with soft clay. After the sculpture is completed, a sectioned plaster or flexible gelatin mold is made from it. Since the sculptor usually wants a hollow metal casting, which is obviously cheaper and lighter than solid metal, he makes a wax model as a hollow shell, usually by brushing melted wax onto the mold until a thin shell is built up, and then filling the middle of the mold with a solid core of heat-resistant material. When the mold is removed, the wax appears as a replica of the original sculpture. Wax rods are attached to the replica to create vents and channels called **gates**; then the replica is placed upside down in a container. A mixture of plaster, silica, and clay is poured around it. This hardens into a fireproof mold that is called an **investiture**.

The investiture is heated in a kiln and the melted wax runs out. For this reason the process is called **lost wax**, or **cire perdue.** What is now left is a hollow space in the shape of the original clay sculpture. Molten bronze is poured into the hot investiture and allowed to harden [6.16]. When the investiture and core are removed, the emerging bronze looks odd with the vents and gates sticking out from it. These must be removed and the surface cleaned and finished according to the sculptor's wishes. A finish, or **patina**, is usually applied to the bronze. Depending on the chemicals used, surfaces range in color from greens to dark brown.

Renaissance sculptors usually cast their own pieces or, like Benvenuto Cellini (1500–1571), directed assistants who did the work.[1] Today most metal sculpture is cast in foundries by trained technicians. Sculptors who produce large cast sculptures may have assistants to help them to build the armatures, enlarge the models, and prepare the sculptures for casting. Henry Moore (1898–1986), a twentieth-century sculptor whose works were often cast in bronze, made small models of his large figures, turning them over to assistants, who built them up to their final size in plaster shaped over armatures. Moore supervised their work throughout the process, refining the final plaster

molten metal is poured here

air escapes here as metal fills the cavity

heat-resistant investiture surrounds the cavity

6.16 THE PROCESS OF MOLDS. BRONZE CASTING.

sculpture himself. He also completed the finishing of the bronze when it came back from the foundry.

Some sculptors today carve the original sculpture from Styrofoam, a material that, like wax, melts when baked in the kiln. Metal sculpture can also be cast with the industrial sand-mold technique. In this method, the sculptor's original model is placed in a sectional metal container, and a special fine, damp sand is packed tightly around it. This sand holds the impression of the original even when the metal sections are removed from the model. These sections are reassembled and clamped firmly together around a sand core suspended inside. Then liquid metal is poured into the hollow space formed between the sand mold and the core. Relief sculpture can also be cast by pouring metal into an impression made in a flat bed of sand.

Through the technique of casting, several metal sculptures can be made from original clay or wax sculpture, each reproducing the original model. Sometimes the sculptor works on the final finishing of all so that each piece can be considered an "original" work. However, molds can also be made from any existing sculpture, so that frequently the duplicates you see are actually reproductions not finished by the artist. Whether the artist casts his or her work or turns it over to a foundry, the final shape in metal exactly

[1] In his autobiography, Cellini included a charming and humorous account of the casting of his great bronze statue, *Perseus* (18 feet, or 5.5 meters, high).

6.17 DALE CHIHULY. *SEA FORM SERIES.* 1984. BLOWN GLASS. 44″ (111.76 CM) WIDE. COURTESY THE ARTIST.

reproduces the handwork of the sculptor. This is particularly evident in the work of Rodin, who intentionally left parts of his works rough or with only suggestions of details. The marks of his fingers or tools in the clay can be seen exactly reproduced in some of his bronze figures [6.5]. Bronze casts are still made, but today most metal sculptors build up their sculpture, using soldering and welding techniques to join and shape the pieces of metal.

Duane Hanson (b. 1925), on the other hand, has discovered that he can simulate a human form so well in whatever material he works that art and reality are indistinguishable. In *Traveler with Sunburn,* Hanson celebrates (as always) a nonheroic figure—the ordinary in most of us [6.1]. Although he often works in plastic, this bronze figure confirms that his skill transcends any material he may use. All his figures so well reproduce their real-life counterparts that almost without exception, wherever they are displayed, pedestrians who pass them frequently apologize if they feel they have brushed by too close, as did the author at the Whitney Museum of American Art. Carefully painted and dressed in real clothes, the sculptures are virtually indistinguishable from the real thing.

Glass

The making of glass, a mixture of silica (sand) and other chemicals, heated and shaped, was well developed by 1500 B.C. and used widely by the Romans after that. Depending on the ingredients, glass can be thick or thin, transparent or opaque, dull or brilliant. Color is produced by adding to the mixture various minerals such as copper, cobalt, or cadmium. When the glass is heated in a furnace to a molten state, it can be blown, poured, pressed into molds, or drawn into threads. It can also be free-blown. In that technique the sculptor working with glass dips a globule of glass from the molten mixture with the end of a blowpipe. As air is blown through the pipe, the molten glass forms a bubble, which is then shaped with a wooden tool, calipers, and shears, the glass being reheated as necessary to keep it pliable.

Glass forms need not be decorated, relying instead upon attractive shape, texture, and brilliance or color. But glass can be ornamented by cutting and faceting; engraving, etching, and sandblasting; or painting, gilding, and enameling. Medieval stained-glass windows relied on color and transparency for their rich, luminous glow and created a level of religiosity that enriched the age of cathedrals during the Gothic period. In the twentieth century many artists are exploring the possibilities of creating new sculptural forms in glass, such as Dale Patrick Chihuly (b. 1941), Seattle-based glass artist and educator [6.17]. His forms are highly complex, depending upon color contrasts and undulant curves for their appeal.

Fibers

Today artists often combine embroidery of various kinds with printing techniques, hand-weaving, and macramé, as we observed with the story quilts of Faith Ringgold [3.1]. **Macramé** is the art of knotting strands of fiber together to produce a variety of openwork patterns. Originally used to make fishing nets, it is used today not only for the belts, handbags, clothing, plant hangers with which most of us are familiar, but also for wall hangings. Using macramé and weaving techniques, artists have created major three-dimensional wrapped wall hangings, freestanding sculpture, and environments large enough to walk into, such as the composition [6.18] by Magda Rena Abakanowicz (b. 1930). For several years, she had been caught up in the tapestry revival in her native Poland, started by Jean Lurçat four years before his death in 1962 at the International Biennial in Lausanne, Switzerland. During successive Biennial exhibitions, Abakanowicz's works gradually gave way to objects that had little to do with those of the traditional weaver. Her many extraordinary works, some totally innocent of the loom, have deep and haunting impact, and could not be conceived in any other period than our own.

In this age where fibers have been introduced as a sculptural art form, we might make note of the Women's Movement that lifted fiber and its woven form, fabric, from the category of women's craft materials to a new position of prominence within the mainstream of sculpture. In non-Western cultures, such as some communities in traditional Africa, fabric art was always the province of men. Other old textile techniques have been revived and are used with great inventiveness. Quilted fabric, in which ornamental

6.18 MAGDALENA ABAKANOWICZ. *BLACK-BROWN COMPOSITION IN SPACE.* 1971–1972. WOVEN FIBERS, 19′8″ × 26′2″ × 11′4″ (6 × 8 × 3.5 M). COURTESY STOCKHOLM COUNTY COUNCIL, SWEDEN.

stitching holds stuffing in place, looped and knotted textiles, and the incorporation of grasses and twigs with woven fibers are some of the techniques contemporary artists use to produce interesting textures. Walter Nottingham (b. 1930) reflects the current interest in soft sculpture in his primeval figure, which uses a variety of fibers and weaving techniques to produce a macabre effect that somehow both intrigues and disturbs us [6.19].

NEW MATERIALS, NEW METHODS, NEW FORMS

Many of today's sculptors reject traditional materials in favor of new ones, but even when they do use stone, metal, wood, and clay, they frequently use them in new ways. Industrial techniques, such as metal welding, lamination of wood, and the casting and vacuum-forming of plastic, are explored by contemporary artists as rapidly as they are invented.

To increase their knowledge of industrial techniques, some contemporary sculptors have spent time in the laboratories and plants of large corporations studying new methods used by engineers and technicians and collaborating with them to apply these techniques to art. Out of this joint experimentation come aesthetic uses of industrial techniques that not only produce works of art but may in turn influence industrial and commercial products.

Sculptors in metal today may weld steel directly or hand-hammer iron, while wood sculptors build up their

pieces using techniques taken from modern furniture production and carpentry. Much sculpture is constructed, built, assembled, or arranged, rather than cast or carved, such as Marisol's *Louise Nevelson* [6.12] or Jacqueline Winsor's (b. 1941) *Bound Square* [6.20], which is wrapped with hemp, embracing the simplest of shapes, extolling the virtues of natural materials expressed with a new emphasis upon confined space. Winsor, an important early contributor to the Women's Movement, only works with fibers for her sculptures, believing that women's involvements with fabric made for a tradition to be perpetuated.

Constructed Sculpture

Picasso may have been the first artist to accommodate whatever objects he found around him—handlebars, bones, a feather duster—into sculptural assemblages [1.4]. Today, many sculptors incorporate bits and pieces found in junkyards or auto graveyards into their work. Constructions of sheet metal, wire, or translucent plastic often replace the traditional sculptural masses with lighter shapes in which space becomes an important element, as with Magdalena

6.19 WALTER NOTTINGHAM. *THE SKINS OF US* (DETAIL). 1972. SCULPTURE IN FIBER: CROCHETED WOOL, RAYON, AND HORSEHAIR MOUNTED ON VELVET PLATFORM WITH PLEXIGLASS, 1′4″ × 5′6″ × 2′6″ (0.41 × 1.68 × 0.75 M). COURTESY THE ARTIST.

6.20 Jacqueline Winsor. *Bound Square.* 1972. Wood and twine, 6'3-1/2 × 6'4" × 14-1/2". Collection, The Museum of Modern Art, New York. Joseph G. and Grace Mayer Fund in honor of Alfred H. Barr, Jr. and James Thrall Soby.

sion in blinking neon gas sculpture, enclosed in simple shapes. With the neon gas, her inventive work comments on today's industrialization, while at the same time it suggests the ever-expanding frontiers of science and technology. Like many of today's experimental artists, Chryssa has explored some aspects of environmental art by combining theatrical and technical elements in an aesthetically exciting spectacle. Her work is reminiscent of the glaringly lighted environment of Times Square in New York City or the Strip in Las Vegas. For example, under the sponsorship of Intermedia 68 and the Museum of Modern Art, she created an electromagnetic environment in which vibrating color and light were designed to envelop the participants.

Plastics

Among the many industrial materials now also popular with sculptors is plastic, which they use in a variety of ways. Cast in solid pieces, formed into sheets, or built up of fiberglass and resin, plastic can achieve seemingly endless effects. Lightweight and colorful, it can be made into tiny forms through which light may filter or it can be built up over wire-mesh supports or cast in solid, brilliantly colored, jewellike forms. Sculptors have found fascinating possibilities for expression in plastic materials and in the industrial

Abakanowicz's work **[6.18]**. With this new use of materials, the sculptor expresses his or her concern with shaping and dividing space rather than filling it.

Alexander Calder used sheet metal to produce flat-painted shapes, some of which were welded or riveted together into metallic sculptures attached to the ground. Whenever it was possible, he placed these **stabiles** in natural settings so that the clouds and sky seen through the openings become active elements of his compositions. A dynamic and inventive artist, Calder created both stable and moving sculptures **[2.13]**. Using electrical motors to create movement in some of his works, Calder early became fascinated with the changing relationships between sections of his sculptures. Some of his later **mobiles,** which depended on air currents to propel them in complex, ever-changing patterns, were even arranged to clank or ring as they moved.

Clearly, twentieth-century sculptors have been fascinated by the machine. Many, such as Marcel Duchamp, Naum Gabo (1890–1977) **[15.36]**, and Calder, made **kinetic sculpture,** propelled by mechanical means. They programmed the parts of the sculpture to move at varying speeds and through changing patterns so that the sculptured object was enriched by a new element of time. The mobile waters of many twentieth century fountains have been programmed by computers to display changing colors as the height of their flow is altered. The Greek sculptor (Varda) Chryssa (b. 1933) accomplished much the same thing in her fragments for *The Gates to Times Square* **[6.21]**. She combines theatrical skill with technical preci-

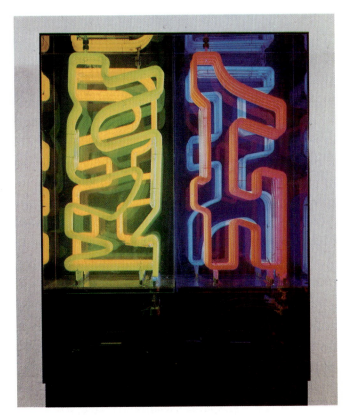

6.21 Chryssa. *Fragment for the Gates to Times Square.* 1966. Neon and plexiglass, 81 × 34-1/2 × 27-1/2" (205.7 × 87.6 × 69.9 cm). Collection of Whitney Museum of American Art. Purchase, with funds from Howard and Jean Lipman 66.135.

6.22 LINDA BENGLIS. *ADHESIVE PRODUCTS.* 1971. NINE INDIVIDUAL CONFIGURATIONS OF IRON OXIDE AND BLACK PIGMENTED POLYURETHANE. 13'5" × 80' × 15' (4.11 × 24.38 × 4.6 M). INSTALLATION WORKS FOR NEW SPACES, WALKER ART CENTER, MINNEAPOLIS, MAY 15–JULY 25, 1991.

techniques used to form them. In *Adhesive Products* [6.22] by Linda Benglis (b. 1941), plastic polyurethane has been effectively pushed and pulled into nine imaginative configurations that conjure up fantastic and somewhat threatening projections that resemble hands which we cannot avoid.

Mixed Media

The new technique of assembling sculpture out of found objects and different materials led to what are called mixed-media combinations or assemblages, such as Kienholz's *The State Hospital* [I.16]. In these works, sculptors use materials that have never been considered sculptural or even aesthetic. Sometimes objects are combined with painted canvases, so that the line between sculpture and painting is at times difficult to define. For example, what kind of art is produced when Rauschenberg attaches a real door to a series of painted and collaged wall canvases (*Rodeo Palace* [3.30])—sculpture or painting? What is it when Picasso draws with light in space [3.11]?

Three-dimensional canvases, constructed on frames and painted in the artist's individual style, are also difficult to classify. Are they dimensional paintings or painted sculptures? Canvases by Lee Bontecou seem to have a resemblance to primitive masks. Her technique, which involves stretching and gluing fabric over a wire-frame skeleton, is similar to early aircraft construction. Using this method, Bontecou has created openings that can be interpreted as eyes, mouths, entrances to caves, or even sexual cavities [3.29].

Familiar materials are often used in unexpected ways. The term **soft sculpture** may seem to be a contradiction, but it describes work created by some contemporary sculptors. For example, many artists make stuffed fabric forms of one kind or another, and some weavers make freestanding or hanging shapes that are sculptural or environmental in form. Claes Oldenburg (b. 1929), a Pop artist, uses vinyl, canvas, and other materials to create his soft, larger-than-life-size sculptures of electric fans [6.23], typewriters, giant lipsticks, clothes pins and other everyday objects. He often uses vinyls to emphasize contemporary

6.23 CLAES OLDENBURG. *GIANT SOFT FAN.* 1966–1967.
CONSTRUCTION OF VINYL FILLED WITH FOAM RUBBER, WOOD, METAL,
AND PLASTIC TUBING, 120″ × 58-7/8″ × 61-7/8″, VARIABLE.
COLLECTION, THE MUSEUM OF MODERN ART, NEW YORK. THE
SIDNEY AND HARRIET JANIS COLLECTION.

materialism and the frequent preference for cheap plastic over natural materials.

In a somewhat playful vein, Scott Burton (1939–1989) has sculpted two ruggedly massive stone hulks that surely make a solid statement about chairs [6.24]. Again, the material of stone is familiar to all of us, but not in this context. Can the work be considered sculpture or are we really looking at furniture? While stone may be no one's choice for living room furnishings, there is no less effort required to work stone for a rock chair than for other more traditional themes.

Kiki Smith (b. 1954) has long been interested in natural history and science. In her most recent work, her interests again center on the human body, especially the female body and bodily functions. Her sculptures usually involve an intermixture of materials and media, many of them combine ordinary mass-produced objects, put to unexpected functions. One work, for instance, consists of eleven oversize glass bottles (perhaps two gallons apiece) each etched with the name of a different bodily fluid, such as blood, urine, and semen. Fortunately, perhaps, the bottles as yet have been exhibited empty. However, viewers have been observed furtively investigating the pieces that are apparently too heavy to lift until a museum guard stops the action. Another singularly controversial sculpture that remains untitled consists of two totally realistic, painted figures, male and female, made of plaster and beeswax

6.24 SCOTT BURTON. *PAIR OF ROCK CHAIRS.* 1980–81. GNEISS, LEFT 49-1/4 × 43-1/2 × 40″; RIGHT 44 × 66 × 42-1/2″. COLLECTION, THE MUSEUM
OF MODERN ART, NEW YORK. ACQUIRED THROUGH THE PHILIP JOHNSON, MR. AND MRS. JOSEPH PULITZER, JR. AND ROBERT ROSENBLUM FUNDS.

[6.25] that are suspended from metal supports. Are they suicide victims, or do they represent wrongdoers who have been hung by their society in punishment for untold crimes? The figures may indeed represent martyrs to a cause we do not understand. The almost life-size, enigmatic figures are certainly intended to be disturbing. In this case, they also succeed in provoking questions, like almost all of Smith's art.

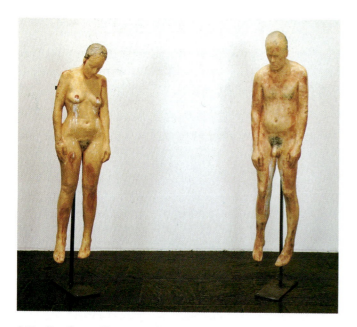

6.25 KIKI SMITH. *UNTITLED.* 1990. BEESWAX AND MICROCRYSTALLINE WAX FIGURES ON METAL STANDS, INSTALLED HEIGHT OF FEMALE FIGURE: 73-1/2″ (186.7 CM); INSTALLED HEIGHT OF MALE FIGURE: 76-15/16″ (195.4 CM). COLLECTION OF WHITNEY MUSEUM OF AMERICAN ART. PURCHASE, WITH FUNDS FROM THE PAINTING AND SCULPTURE COMMITTEE 91.13 A–D.

Sculpture and the Environment

At the same time as technology's surge forward provides artists with new materials and processes to manipulate, some artists continue to try to address such issues as the human's relation to nature and the universe, using the environment as the forum for their discourse. Some contemporary artists such as James Turrell (b. 1943) work on a vast scale [6.26]. His Roden Crater Project involves partially reworking a volcanic crater for viewing astronomical events in an awe-inspiring setting. Such environmental sculptures seem to surround us, much like the original environments from which each sculpture was derived. In 1986, sculptor Carl Andre reviewed the changing functions of sculpture in brief, "The course of development: sculpture as form; sculpture as structure; sculpture as place."

The idea of site-specific sculpture may have stemmed from Robert Smithson's major earth sculptures that could only have been designed for the site they occupied. In fact, *Spiral Jetty* [1.15] was so carefully engineered for the Great Salt Lake in Utah that its lifespan, in concert with the algae of the lake, was but a few short seasons. The beauty of the piece lay in the glowing colors that seemed to change as the composition of the lake was altered by time. The fact that the natural form of the spiral remained intact during that period is of course a credit to Robert Smithson's careful computations. Interviewed by the author in his Greenwich Street, New York City flat shared with his wife, Nancy Holt [17.30], with a measure of pride, he pointed out the large-drawered storage units in which he maintained the hundreds of drawings and diagrams that preceded every one of his projects. Since few of his sculptures were intended for long life, such records may have served as the major archives, along with documentary photographs of the sculptures taken during the time they survived.

6.26 JAMES TURRELL. *RODEN CRATER PROJECT.* CURRENTLY IN PROGRESS; VOLCANIC CRATER NEAR ARIZONA PAINTED DESERT, REWORKED IN PART BY ARTIST FOR PUBLIC VIEWING OF ASTRONOMICAL EVENTS.

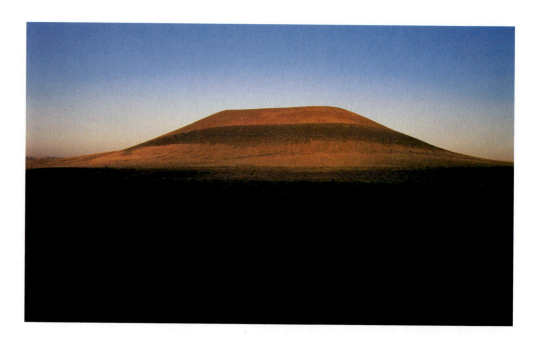

The notion of fitting art to its location is certainly not new. There is a fine, long-standing tradition of designing sculpture for specific sites; the differences here lie in today's notion of providing aesthetic diversion for the poor. A recent trend has developed, aimed at rehabilitating the land through art, that seems very positive indeed. A small rectangular plaza in front of some public buildings was commissioned by the city of Seattle, Washington, to be enlivened by designer Robert Irwin (b. 1928). The space was described by the artist as a "very forlorn, isolated, even hostile plaza surrounded by very grey architecture." His design, 9 *Spaces, 9 Trees* [6.27] is a mazelike garden surrounded by a blue plastic-coated fence. Concrete planters within hold sedum and plum trees that provide a vest-pocket retreat from the otherwise dreary surroundings of the area. Whether such a site might also attract the homeless or undesirables seeking a drug haven remains to be seen.

Wrapping art in its location has become a feature of the art of Christo (b. 1935). In *Surrounded Islands* [6.28], Christo utilized 6.5 million square feet (604,089 square meters) of floating pink fabric to outline eleven islands in Biscayne Bay near Miami, Florida, for two weeks. The project faced tremendous local opposition that gradually dissipated. During the innumerable meetings of the

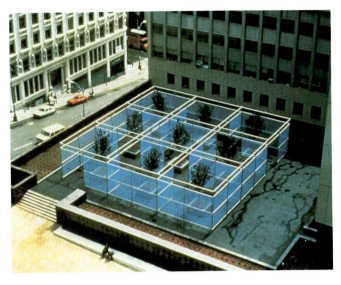

6.27 ROBERT IRWIN. 9 *SPACES, 9 TREES*. 1983. CONCRETE, PLUM TREES, VINYL-CLAD FENCING. FUNDED BY SEATTLE DEPARTMENT OF ADMINISTRATIVE SERVICES. 1 PERCENT FOR ART PROGRAM, WITH SUPPORT FROM THE NATIONAL ENDOWMENT FOR THE ARTS.

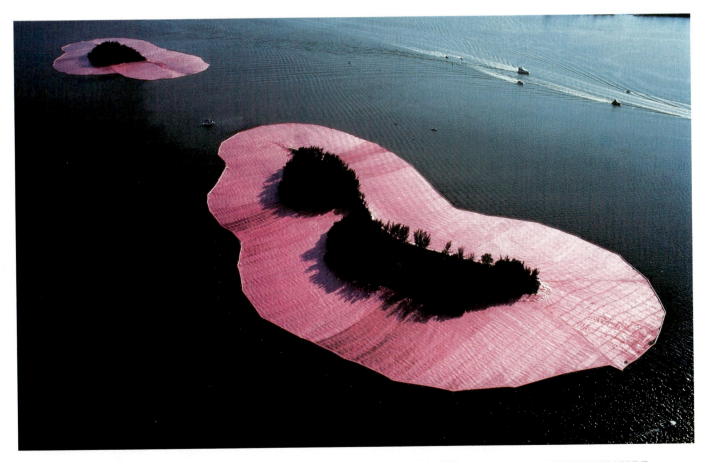

6.28 CHRISTO. *SURROUNDED ISLANDS. BISCAYNE BAY, GREATER MIAMI, FLORIDA*. 1980–1983. 6-1/2 MILLION SQ. FT. OF WOVEN POLYPROPYLENE FABRIC AROUND ELEVEN ISLANDS. © CHRISTO 1983.

6.29 Larry Bell. *The Iceberg and Its Shadow*. 1975. Plate glass coated with quartz and metallic Inconel. 56 sections, varying dimensions. MIT List Visual Arts Center, Cambridge, MA. Gift of the Albert and Vera List Family Collection.

charismatic Christo and his wife, Jeanne Claude, with city councils and the like before the start of any of Christo's projects, often they were able to persuade the opposition. In fact, a testament in their favor has been that many of their most vocal critics frequently join the ranks of their most ardent admirers. With each of his environmental designs, people who might never otherwise be exposed to contemporary art of this kind become devoted supporters of site-specific sculptural works.

The sale of Christo's preliminary drawings has always paid for every project he undertakes, the heavy insurance costs that he always assumes, the materials, and any ensuing construction expenses. It was the author's good fortune at a sculpture convention in Washington, D.C., in 1990 to briefly interview Christo after he described The Umbrellas joint project for Japan and the U.S.A., the upcoming event planned for simultaneous openings in Japan and the United States, possible only because of timeline differences due to the rotation of the Earth. Christo was scheduled to be present at the opening of the huge umbrellas at both sites. Although his plans are always detailed to the last nut and bolt, and every venture is carefully engineered, the Umbrella Project was, as far as we know, the only occasion where tragedy has disrupted an otherwise extraordinary record of success. Two people were killed when umbrellas tore loose in high winds and struck observers. No doubt, his work should and will continue forward.

Light

While all sculpture involves light—natural or artificial—playing over its forms and through its spaces, new lighting techniques have been adapted by sculptors to create spatial environments. Tubing with neon gas inside can be bent and formed into any shape. When lit, such a sculpture makes a visual statement in neon lights. Sculptors familiar with these materials could surely design signs that would be more aesthetically satisfying than most of those we see around us. Plastic rods can also be used to carry light from a light source at one end of the rod; translucent colored resins can be lighted from within to create sculptural objects. In Larry Bell's *The Iceberg and Its Shadow*, ever-changing movement and light seem to dematerialize the surrounding world [6.29]. The sizable, on-the-site work seems to change with the passage of time from morning to late evening, as well as with the vantage point from which the work is viewed. While Bell has been working almost exclusively with glass because of its fine transmittal of light, this was by far the most expansive and, in many ways, the most successful in creating a "magical" environment.

In other sculptures, changing waves of colored light are programmed to play over and through the sculpture. It is apparent that light can be utilized by sculptors in new ways, which represent their individual approaches to sculpture. Some works are highly organic;

others, geometric; still others, mechanical. In further explorations of contemporary technology, many artists have experimented with communications media, building rooms in which we can watch video or film images projected around us, accompanied by electronically synthesized sound. Some artists have directed bulldozers to shape huge earthworks, while still others have created environments intended to surround us. All of these are new sculptural responses to space, form, and light. The creations that have resulted are so varied, there is no single trait common to all.

So we find the artist again often inspired by his or her era, making use of whatever timely techniques are available. Current forms evolve from the methods and materials of today, just as an ancient Greek marble carving grew out of the materials and methods available then. Sculpture, like architecture, has accepted the challenge of new methods to create new concepts within an ancient art, moving from the exploration of interior local and exterior spaces to major forays into the environment.

EXERCISES AND ACTIVITIES

Exercises for Research and Discussion

1. Select five sculptural works from this book that appeal to you and explain why they do.

2. Although sculpture, unlike architecture, usually has no functional purpose, it serves society in other ways. List some of them.

3. Many consider sculpture to have been the earliest medium of art developed by humankind. Explain why this theory may, in fact, be valid.

4. Distinguish between additive and subtractive sculpture.

5. The materials for creating sculpture can be found in any environment. What are the traditional sculptural materials? What materials and processes are unique to twentieth-century sculpture? Discuss how contemporary and ancient sculpture differ in regard to materials. Share group findings with the entire class.

Studio and Homework Activities

1. Using clay, papier-maché, soft wool, or soap, create a sculptural form that re-creates a recognizable natural object. Using any of these same materials and the same subject, create an abstract sculptural form.

2. Using twentieth-century materials, create a three-dimensional form that relates to contemporary technology and also makes a personal artistic statement that expresses your own feelings.

3. Build a direct sculpture, using wood, burlap, and plaster of paris.

4. Create a soft sculpture, perhaps using a plastic sack and filling it with some loose materials.

5. Manipulate a piece of paper and then use it as a mold into which plaster of paris may be poured. When the material has hardened, cut away any unwanted plaster, refining edges as may be required to form a sculpture that pleases you.

7

Architecture and Environmental Design

"Architects, painters, and sculptors must rediscover and understand the many-sided aspects of building both as a whole and in all its parts; only then will their work be informed with an architectonic spirit which was lost in salon art."

—WALTER GROPIUS,
THE BAUHAUS MANIFESTO

• • •

"Architecture is the first manifestation of man creating his own universe...."

—LE CORBUSIER,
TOWARDS A NEW ARCHITECTURE

• • •

"Less is more."

—LUDWIG MIES VAN DER ROHE,
ARCHITECT

• • •

"The modern vernacular can only take you so far ... the role of the architect as civic leader ... has been my contribution."

—I. M. PEI, ARCHITECT

Of all the visual arts, architecture probably impacts us most, for we spend the bulk of our lives within walls. All around us space has been enclosed and walled in. Architecture, the art of building, could as well be called the art of enclosing space in a useful, pleasing way.

What motivates us to build? Clearly, the most basic reason is to provide shelter or protection from the weather or from animals or unfriendly human beings. Imagine living on earth before there were buildings. What to do for shelter? Some would retreat under the branches of a tree, or—if lucky—find a cave to serve as refuge. Eventually, however, we would probably wish to create a permanent home.

After solving the problem of personal shelter, early people everywhere worked in communities to build over the centuries ceremonial temples to gods, fortresses for protection, and palaces and tombs for rulers. The appearance of these structures, then as now, was directly influenced by the climate, available materials, building site, and the needs of the people who used them.

7.1 JAMES STIRLING. NEUE STAATSGALERIE. 1970–83. STUTTGART, GERMANY.

ARCHITECTURAL CONSIDERATIONS AND PLANS

Architectural design involves fundamental concerns that include convenient arrangement and flow of space; illumination from outside and within; protection from the weather and interior climate control at all times; efficient use of fuel, with possible solar alternatives. Roofs, walls, floors, doors, and windows must all be designed to meet these requirements as well as to suit the owner and the location.

In the process of designing a building, the architect makes many drawings, and if the design is complex, a three-dimensional model. An architect's plans may include:

floor plan: structural layout in scale, viewed from above

elevations: front, side, and rear views, in scale, showing all walls and openings

cross sections with details of electrical, heating, cooling, plumbing, and other special installations

perspective renderings: three-dimensional views, including landscaping and locations for sculpture

Architects' designs utilize a variety of materials and types of construction. Some date back thousands of years. Others involve totally new materials and techniques developed during the Industrial Revolution and in the twentieth century. Some architects have tried to maintain the familiar appearance of buildings by using new materials and methods that preserve the "look" of the past, while

others have designed structures that courageously reflect, in architect James Stirling's own disarming words, "a collage of old and new elements ... to evoke an association" with a museum, in this case, of the Neue Staatsgalerie in Stuttgart, Germany [7.1]. The museum is visible from many vantage points, its silhouette tending to dominate the area in the way a cathedral once loomed over a medieval city.

CONSTRUCTION METHODS AND BUILDING TECHNIQUES

Over the centuries, builders have developed a number of methods of construction supporting both the weight of the building materials and the structures. The simplest method is the **bearing wall**, in which the whole length of the wall supports the roof. Its use is limited because the higher the roof, the heavier the wall must be. The second method is **frame construction,** including **post and lintel.** The third is the **arch** and **vault.** The fourth is **cantilever.**

Frame Construction

Post and Lintel More efficient than a bearing wall is a series of upright posts supporting a horizontal beam, or **lintel,** to form a strong rectangular frame [7.2]. Some lintels are placed in walls to span openings for doors and windows. The size of the opening depends on the length and strength of the lintel. Other lintels span interior space and support the roof, which may be flat in hot, dry

7.2 POST AND LINTEL.

7.3 TRIANGULAR TRUSSES.

regions or pitched (gabled) in cold, wet regions to allow snow and rain to run off. There is no limit to the size of the interior space so long as there is no objection to its being interrupted by many posts.

The earliest post-and-lintel buildings were made of heavy tree trunks cut and fitted together, often with wooden pegs. In many ancient civilizations, temples and palaces were of post-and-lintel construction in stone. There are only a few stones large enough to be lintels, however, and no stone can be very long without breaking of its own weight.

Truss Frame construction can span a large space without many interior posts if it uses **trusses**, or cross braces, whose members act together in tension and compression [7.3]. The most common type of truss is triangular. Essentially it consists of two sloping bars fastened at the top and connected at the bottom by a third bar to create a rigid triangle strong enough to support a heavy weight. Triangular trusses of wood were used under the wooden roofs of stone churches in the early Middle Ages. Later, more elaborate forms of wooden trusses developed. In the nineteenth and twentieth centuries, trusses have been made of iron and steel. Truss construction is the basis of modern A-frame buildings and of prefabricated modular systems that provide an ingenious, efficient, and economical way to span space.

Skeleton Frame A more complex form of frame construction is the **skeleton frame**. The parts are lighter than posts and lintels and support one another to make a standing cage. In wooden construction, the parts are made of light pieces of lumber nailed together, and the outside wall is nailed to the frame to increase its strength. A particularly light type called **balloon framing** developed in the nineteenth century when factories made iron nails in quantity and sawmills cut lumber in standard sizes. Most wooden houses today are built with balloon framing [7.4]. The outside walls, which used to be made of board siding, are now often sheets of plywood.

Skeleton frames are also used in iron and steel construction [7.5]. The parts are bolted or riveted together to make a **cage** that is lighter and stronger than wood and able to span large interiors with many fewer posts. The walls are attached to the cage but carry no weight and can therefore be glass or have many large windows. Such **curtain walls**, or **screen walls**, are only thin panels to keep out the weather and enclose the space. Iron- and steel-frame construction developed in the late nineteenth and early twentieth centuries, making use of factory-made parts shipped by rail and assembled at the building site. Today steel-frame construction is all around us, as is very apparent when you observe office and apartment buildings and factories under construction. The Georges Pompidou National Center for Art and Culture in Paris [7.6] is essentially a glass box,

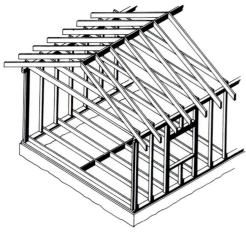

7.4 BALLOON FRAMING.

7.5 STEEL CAGE CONSTRUCTION.

7.6 RENZO PIANO AND RICHARD ROGERS. GEORGES POMPIDOU NATIONAL CENTER FOR ART AND CULTURE (BEAUBOURG), PARIS. 1977.

supported by structural steel. Visible on the exterior are brightly colored heating and air-conditioning ducts, escalators, and elevators, all usually concealed within the lower basements and inner core of a building.

Geodesic Dome A modification of frame construction that uses the principle of the triangular truss is the **geodesic dome** invented by R. Buckminster Fuller (1895–1983) in the 1940s. It is a spherical shape consisting of a spidery framework of short struts forming a three-way grid composed of various arrangements of tetrahedrons (solids with four triangular faces). Drawing on late nineteenth-century discoveries that tetrahedrons are the basic structure

of organic material, Fuller insisted that the tetrahedronal structure was naturally stronger than that of cubes or squares, which tend to collapse if they are not braced. The frame, usually of aluminum or other light material, can withstand pressure because it distributes stress equally among all its parts. It is covered with a skin of plastic or other light substance. Geodesic domes are made in prefabricated, modular units to be easily assembled on the site.

Fuller's golden-hued geodesic dome for the United States Pavilion at Montreal's Expo '67 covered an area 250 feet (76 meters) in diameter [**7.7**]. Considered revolutionary at that time, such domes today come in all sizes and are accepted by most engineers as a strong, efficient, and inexpensive way to enclose large areas quickly. Fuller's designs remain less acceptable to city or village planning boards, which are more resistant to designs that do not easily blend with existing structures. And yet, it was for the ordinary citizen that Fuller was designing homes that he believed all could afford.

Arch, Vault, Dome

Still another way to span a wide opening or other large space without posts is with the **arch**, a curved line of bricks or stones. This method, which developed later than the post-and-lintel system, made possible the evolution of

7.7 R. BUCKMINSTER FULLER. UNITED STATES PAVILION, EXPO '67, MONTREAL. 1967. STEEL AND PLEXIGLASS; THREE-QUARTER SPHERE: HEIGHT 137' (41.97 M), DIAMETER 250' (76.25 M).

The Artist Sketch

Sometimes compared with Leonardo da Vinci in the range and depth of his interests, Buckminster Fuller was first and foremost an architect. But he was also an engineer, a mathematician, a mapping expert, a scientist, a philosopher, an educator, and an inventor. His best-known design was surely the geodesic dome—a brilliant conception of honeycombed triangles that provides considerable strength and space at minimal cost.

Blessed with distinguished ancestors, some of whom arrived in New England in the early 1600s, Fuller attended Harvard University, the family Alma Mater since the 1700s. Uncomfortable with its conservatism, he was not surprised when he was asked to leave in some disgrace after a couple of adolescent exploits in 1913, and he never returned to formal education. A marriage shortly thereafter to the daughter of an architect helped provide some direction to his life. But the many jobs that he tried next ran the gamut from mechanic at a textile mill to naval commander at Newport, Rhode Island. His first two marketable inventions were related to rescue activities at sea, and it seems likely that the variety of his involvements led to the breadth of his skills. He put it this way when he was interviewed for *Current Biographies* in 1960:

7.8 BUCKMINSTER FULLER.

> … My goal was to find ways of doing more with less, to the end that all people—everywhere—can have more and more of everything.

With the death of his four-year-old daughter, and some business reversals, Fuller sank into a deep depression. Intense meditation for about two years was rewarded with a sudden flash of inspiration that led to a series of revolutionary housing designs that could be marketed cheaply. Meeting his life's goal of helping people everywhere, his first design in 1926 was a twelve-decked, hexagonal, 4-D (four-dimensional) luxury apartment house or "living machine," entirely self-sufficient, light enough to be lifted in place by a dirigible, and made at minimum expense by mass production methods. The Dymaxion House, built in 1927, led to construction of other such houses, and the eventual establishment of his company "Dwelling Machines" from 1944–1946.

Among other projects that he designed while employed as chief of the mechanical engineering section for the U.S. Board of Economic Warfare from 1942 to 1944, was a portable emergency shelter used in World War II, probably the basis for his geodesic dome that immediately followed. By the early 1960s, Fuller's geodesic dome was widely recognized as an American architectural achievement and described by *Time* magazine (January 10, 1964) as a "benchmark of the universe, what a seventeenth century mystic … might have called a 'signature of God.'"

International recognition followed him from those years forward, but with it all, he was still unable to convince enough backers to support his next invention: wind-powered generators and world-connected power grids to combat what he saw as the ultimate problem of the century—world energy shortages. He was unable to pursue his theories further, perhaps because no one was willing to invest in such an efficient operation that by its nature might limit profits. His greatest life achievement may lie in his significant book *Synergetics; Explorations in the Geometry of Thinking* (MacMillan, 1975). A reviewer for *Newsweek* on April 7, 1975 called it "a major intellectual achievement about language, thought, and the universe." Our continued dependence on fossil fuels, like coal, oil, and gas—all in danger of running out—proves how right he was.

In the final analysis, as described by another critic, R. Buckminster Fuller was "built like a short fencepost," but his five-foot, two-inch stature may be massive in terms of his achievements. He held more than 2000 patents. The geodesic dome has been used in thousands of structures throughout the world, appropriate indeed for the position he held to his death, World Fellow in Residence at the University City Science Center in Philadelphia.

R. BUCKMINSTER FULLER (1895–1983)

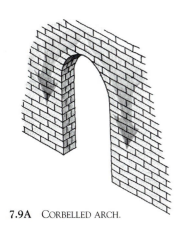

7.9A CORBELLED ARCH.

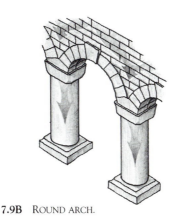

7.9B ROUND ARCH.

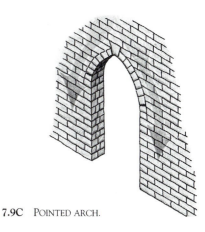

7.9C POINTED ARCH.

architecture from structures made of massed materials to structures with vast, open interior spaces.

The simplest form of arch is the **corbelled arch** **[7.9a]**, in which bricks or stones are built up from two sides, each projecting a little beyond the one below it, until they meet in the middle. These carefully balanced masonry units are held in place by gravity. Corbelled arches were developed in ancient Mesopotamia, where clay for brick was plentiful but there was little wood or stone.

The true arch, later developed in Mesopotamia and refined by the Etruscans and Romans, is an improvement over the corbelled arch because its wedge-shaped masonry units support each other through mutual pressure. In a round (semicircular) arch, such as used by the Romans, stones or bricks, shaped into wedges to fit snugly into the curve of the arch, are built up from the two sides,

shoulders, or **imposts** framing the opening to meet at the **keystone**, the final wedge in the center **[7.9b]**. During construction they are held in place by wooden scaffolding called **centering**, which is removed when the keystone is in place. The wedges are squeezed together, and the weight of the wall or roof they support is sent through the arch outward and down to the ground. The sides are braced by massive **buttresses** to contain the outward pressure. Arches may also be horseshoe-shaped, as in Islamic architecture, or pointed, as in Gothic architecture **[7.9c]**, or may take other shapes.

A row of arches, side by side, forms an **arcade**, used as a wall or to hold an aqueduct, such as the ones that brought water to Roman cities **[7.10]** and provinces. A series of round arches placed one behind the other and connected by a roof produces an arch in depth called a

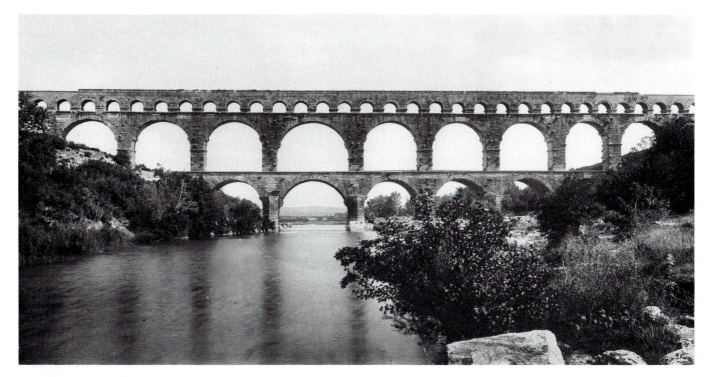

7.10 PONT DU GARD, NÎMES, FRANCE. LATE FIRST CENTURY B.C.

7.11A BARREL VAULT.

7.11B EARLY RIBBED VAULT WITH
ROUND ARCHES COVERING SQUARE.

7.11C GOTHIC RIBBED VAULT
WITH POINTED ARCHES COVERING
RECTANGLE.

7.13 GIOVANNI PAOLO PANNINI.
INTERIOR OF THE PANTHEON, ROME. C.
1750. OIL ON CANVAS, 50-1/2 × 39′
(1.283 × .991 M). NATIONAL GALLERY OF
ART, WASHINGTON. SAMUEL H. KRESS
COLLECTION.

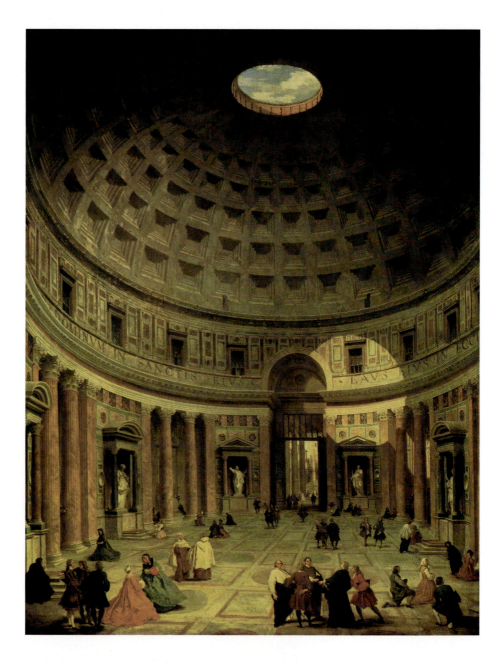

7.12 PENDENTIVES (SHADED AREA)
SUPPORTING A DOME.

barrel vault [7.11a]. A vault is more efficient than a wood lintel, which could burn, or a stone one, which could break. Because it is heavy, however, it must be supported by solid, buttressed walls, which can only have a few small windows.

Two barrel vaults intersecting at right angles make a **cross vault**, or **groin vault**, such as those used in Roman buildings and over the side aisles of Romanesque churches. Because the two vaults support each other, they need buttressing only at the corners; the walls can be lighter and permit larger windows.

A **rib vault** is a groin vault made of thin stone panels supported by a framework of stone ribs that follow the lines of the arches and joints [7.11b]. In Gothic architecture the ribs form pointed arches [7.11c]. The weight of the vaulting is concentrated along the lines of the ribs, which transmit it to the **piers** (supports) at the corners of the **bay** (the area covered by the vault). The piers in turn transfer the lateral pressure from the vaulting to buttresses against the outside walls. Because the weight rests on the stone skeleton formed by the ribs and on the buttressed piers, the bays can be rectilinear, and the wall spaces between the piers can be higher and filled with lighter stone panels or large windows of stained glass. Rib vaulting, pointed arches, piers, and buttressing made possible the lofty, light-filled Gothic cathedrals.

Another form of vaulting is the hemispherical **dome**. A dome, formed by stones or bricks built up in circles of diminishing size, may cover a circular or square space. Various devices such as the **pendentive** (a concave triangle) [7.12] are used to make the transition between the circular dome and the square space below it.

A triumph of Roman engineering is the Pantheon, shown in Pannini's painting of the interior [7.13], a round, brick and concrete temple built in Rome in the second century A.D., which has one of the largest domes ever constructed. The dome of Hagia Sophia [7.14], built as a church in Constantinople (Istanbul) in the sixth century, rests on pendentives. Your city hall or state capitol may have a dome inspired by Roman or Renaissance models.

In the twentieth century, arches, vaults, and domes are often made of reinforced concrete. Examples are

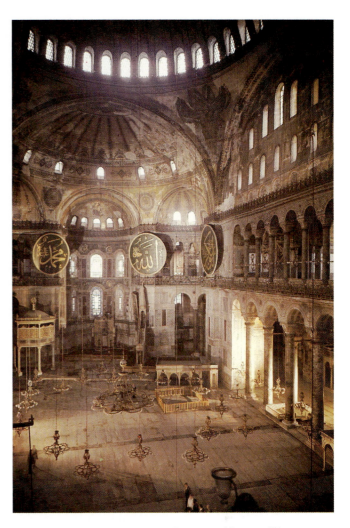

7.14 ANTHEMIUS OF TRALLES AND ISIDORE OF MILETUS. HAGIA SOPHIA, CONSTANTINOPLE (ISTANBUL). 532–537, 553–563.

bridges and the concrete shells in such buildings as Eero Saarinen's TWA terminal at New York's Kennedy Airport [7.26], which was designed appropriately to echo the wings of a bird in flight. Shells can also be made of metal or plywood shaped under stress.

Cantilever

A building technique common in modern architecture is the **cantilever**, a beam or floor slab that juts out from the wall that supports it [7.15]. The wall acts as a fulcrum. The weight of the projecting end of the cantilever needs no posts to support it because it is balanced by the weight of the building on the interior end, much as your weight on one end of a seesaw can be balanced by that of another on the other end. Cantilevers can also support walls, which may be hung from a cantilevered floor. Cantilevers may be wood beams, steel girders, or slabs of reinforced concrete.

Frank Lloyd Wright achieved a breathtaking effect while dramatically cantilevering the Kaufman House over a

7.15 CANTILEVER CONSTRUCTION.

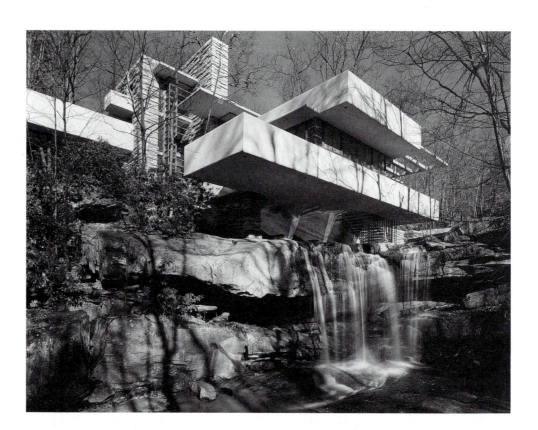

7.16 FRANK LLOYD WRIGHT. "FALLING WATER" (KAUFMAN HOUSE), BEAR RUN, PENNSYLVANIA. 1936–1937.

waterfall in Bear Run, Pennsylvania [7.16]. By making it appear to float over the water, he tied it visually to the natural environment of which it seemed to be an organic part. "A sense of the organic is indispensable to an architect," maintained Wright, whose own term **Organic Architecture** viewed a house as growing out of the site no less than the preexisting trees and plants found there. The tower of Wright's Johnson Wax Building in Racine, Wisconsin, is built around an elevator shaft supporting cantilevered slab floors from which the glass outside walls are hung. Believing that buildings, like trees, should conform to the natural landscape, the Racine Tower is as tall a structure as Wright ever cared to design.

CONSTRUCTION MATERIALS

For centuries, architects built out of wood, stone, and brick, depending on the availability and costs of what they used. The Industrial Revolution introduced new kinds of factory-made building materials, such as iron, steel, and reinforced concrete, which have largely replaced the earlier materials.

Wood

In the forested regions of the world, the most commonly used building material has been wood, which is cheap and easy to work. We know little about early wood structures because wood burns or rots, leaving us nothing to examine. We can, however, guess at their forms by studying the wooden structures built in many rural communities in more recent times. Villagers on lush, tropical Polynesian islands, for example, still use houses made from boards, posts, palm leaves, and other vegetable matter, much like those of their ancestors. In chilly, pine-covered Scandinavia, old farm buildings made of logs with mud and grasses stuffed between them, roofed with bark or sod, are still seen. Such buildings and the log cabins built by American colonists are probably very like the early European wood counterparts. These simple wooden buildings used post-and-lintel construction, which was developed into complex forms in seventh-century Japan. The Japanese built elaborate palaces and temples on stone bases, spanning spaces with wooden posts and beams fitted together in beautifully crafted joints. An outstanding example is the temple at Nara, dating from the seventh century, which is the oldest wooden temple in the world. A five-storied pagoda with up-curving roofs from the Nara temple complex demonstrates how complicated wooden post-and-lintel construction combined with elaborate bracketing can be [7.17].

In medieval Europe, builders experimented with wooden trusses for the roofs of stone churches, as we noted. These were developed into complex arrangements of triangles by such Renaissance architects as Andrea Palladio. The half-timbered houses of sixteenth-century England, using beams and plaster, and the clapboard houses of colonial New England, both still copied by twentieth-century builders, show us how differently wood might be used for

construction. In the late twentieth century, laminated plywood shaped under stress into curved forms is used to make shells that serve as both structure and enclosure.

Stone

Stone is one of the most widely used building materials for permanent structures. The many ancient stone buildings still standing today, such as Egyptian and Roman temples, are evidence of its durability. Stone can support a great deal of weight, but stonework must be carefully designed or its own weight will make it collapse. You may recall that as a child when you tried to build a tower out of blocks you were successful only when you placed them carefully, one on top of the other, and did not pile them too high. The earliest stone buildings were made by placing unshaped stones one above another. The downward thrust of their weight gave the structure stability.

Most early stone building used post-and-lintel construction [7.2]. One of the earliest examples is Stonehenge, a mysterious Neolithic (New Stone Age) monument in southern England. It consists of three con-

centric circles of enormous vertical stones with horizontal stones as lintels [7.18]. How the massive stones were transported miles from the nearest quarry and raised into position is still questioned by archaeologists. The stones were likely dragged over log rollers by hundreds of workers and later precisely arranged for sighting astronomical configurations [10.1].

The Egyptians, who had an abundant supply of stone which they transported down the Nile River on rafts from the quarries to the building sites, built massive stone temples using posts and lintels. In the Temple of Amun at Karnak [2.34], the tops of the posts (capitals) are shaped like lotus plants, probably derived from the shape of carved wooden posts in earlier structures. The immense interior space of the entry hall is filled with a forest of columns, which are necessary to hold up the heavy stone lintels.

The Greeks also built post-and-lintel temples of stone. We can detect evidence of earlier wood architecture in the decorative elements of their stonework. Despite the simplicity of post-and-lintel construction [7.2], the refinements of proportions, workmanship, and detail rank Greek marble temples among the finest of architectural

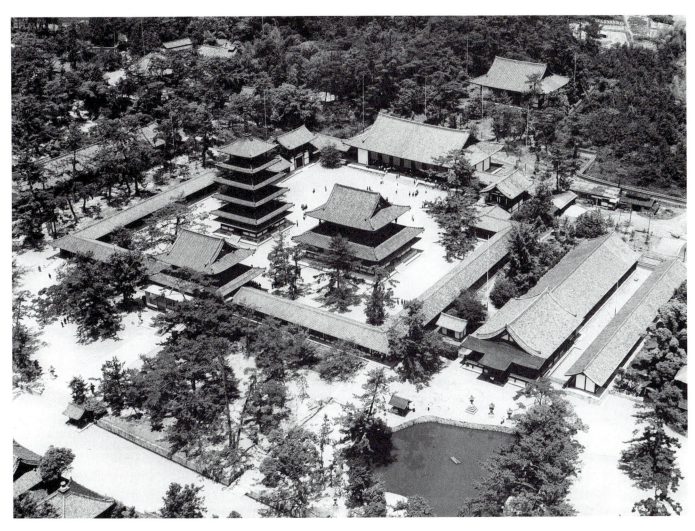

7.17 FIVE-STORIED PAGODA. HORYUJI TEMPLE, NARA, JAPAN. 607 A.D.

7.18 RECONSTRUCTION DRAWING OF STONEHENGE.

achievements. The Romans built early works of stone, using posts and lintels or arches [7.11b] and vaults [7.11a], but later used stone chiefly as a veneer over brick or poured concrete structures.

Most of the great churches and cathedrals of the Middle Ages were built of stone. Massive Romanesque churches had round arches and often barrel vaulting, as we have seen. Gothic churches rose to great heights supported by a cage of ribbed vaulting [12.31], piers, and buttresses [7.11c]. The religious exaltation of the period was expressed in the cathedral of Amiens, France, one of the tallest in the world. The vaulted nave reaches up toward

heaven and is bathed in twilight pierced at intervals by light from brilliant stained-glass windows. You can sense the dynamic quality of the structure of a Gothic cathedral in which each part depends on the counterbalancing weight of every other part. The thrust moves from towers and vaults through ribs and piers out to buttresses and **flying buttresses** (half arches between buttresses and a wall) and so to the ground. Many of these cathedrals took hundreds of years to build, and it is easy to imagine the despair builders experienced while trying to solve the dual problems of weight and thrust. A few cathedrals, in fact, aimed too high. Beauvais Cathedral, France, indeed collapsed

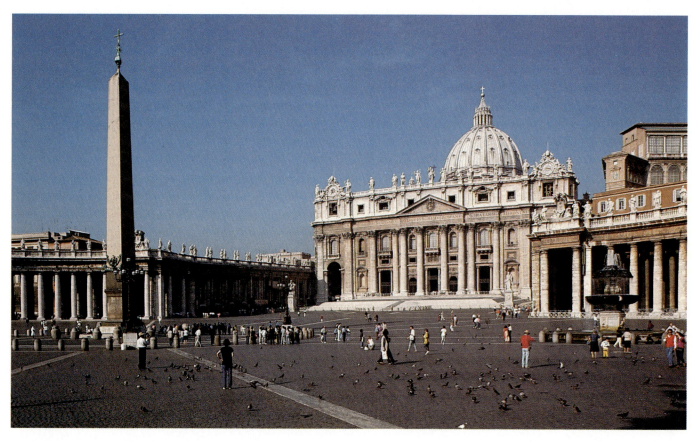

7.19 FAÇADE, ST. PETER'S BASILICA, ROME. 1601–1626.

and was never completed. Most Gothic cathedrals remain, however, as examples of the creativity and the daring of medieval builders.

Many important Renaissance churches and palaces were built of stone, usually adapting the styles of classical Rome. One of the most outstanding structures is St. Peter's Basilica in Rome [7.19]. Succeeding a series of earlier architects, Michelangelo drew plans for an enormous structure that was not finished until after his death. His floor plan of a Greek cross was later modified, but his ribbed stone dome, in a slightly more elongated version, soars above the city. The upward lines of the **pilasters** (flat columnar forms) on the walls of the massive arches that support the dome and the curving ribs reach toward the center in a restless climax. The interior of the church is so large that it is impossible to view the whole interior from any one point within the church. The vast scale may well have been intended by Michelangelo to reflect the greater glory of God, above human perspectives.

Brick

In regions where wood and stone are scarce, the common building material is brick, shaped out of local clay. Early bricks were dried in the heat of the sun but crumbled when exposed to rain or flood waters, as often happened in ancient Mesopotamia. Bricks fired in a kiln are hard enough to prevent such dissolution and are a tremendous advance over sun-dried ones. Bricks can be built into thick-walled houses, roofed with wooden beams, and into huge towers. The adobe brick houses built by some Indians in the American Southwest and Mexico are examples of brick architecture.

The Romans built extensively in brick and concrete, using arches, vaults, and domes to cover large areas and distances. Their basilicas (law courts), theaters, sports arenas, baths, aqueducts, and triumphal arches appeared all over the Roman world. The comfort and well-being of the Romans depended on their engineering feats. Stone or brick-faced concrete aqueducts, for instance, such as the Pont du Gard in Nîmes, France [7.10], brought water from distant mountains to supply Roman city fountains and luxurious baths and villas. Apartments up to five stories high crowded the streets of Rome and Ostia. Structural remains, including stairways, colonnades, light wells, and room layouts, can still be seen in Rome today.

Brick was commonly used in northern Europe after the forests were cleared; in particular, German churches and Dutch houses were built of brick, as were Georgian houses in eighteenth-century England and, later, mansions in America.

Iron

Before the Industrial Revolution, iron was worked by craftsmen and used primarily for nails, dowels, tie rods, and hinges to fasten together parts of wood or stone structures.

7.20 JOSEPH PAXTON. CRYSTAL PALACE, LONDON. 1851. CAST IRON AND GLASS, WIDTH 1851' (564.18 M). OWEN JONES, GREAT EXHIBITION OF 1851. DECORATION OF THE TRANSEPT. BY COURTESY OF THE BOARD OF TRUSTEES OF THE VICTORIA & ALBERT MUSEUM, LONDON.

As a result of mechanized mass production and the development of railroads, it became an important building material, lighter, stronger, and more fire-resistant than wood and easier to work than stone. Iron was especially useful for the large, open, well-lit spaces required by factories. Expanding rail networks created the need for railway stations and bridges, which led to further experimentation with iron frames and trusses.

One of the most dramatic early examples of iron-frame construction was the Crystal Palace, built for the Great Exhibition in London in 1851 [7.20]. Covering seventeen acres (seven hectares), it was the first completely prefabricated building; all its parts were made in factories and shipped to the site, where they were assembled in just six months. The weight-bearing iron frame held the largest panels of plate glass that had ever been produced. They supported no weight but only enclosed space. The enormous open interior with its high, curved glass roof impressed viewers with its remarkable approach to building.

The designer, Joseph Paxton (1801–1865), had been a gardener experienced in building greenhouses,

7.21 LOUIS SULLIVAN. WAINWRIGHT BUILDING, ST. LOUIS. 1891.

rivers led to ever higher structures. With further refinements in steel frames and the invention of the elevator, the high-rise buildings we all know today became a reality.

In the Wainwright Building, built in St. Louis in 1891, Louis Sullivan openly used new methods and materials and designed surface ornament to emphasize the vertical [7.21]. His buildings are the forerunners of modern skyscrapers. Sullivan's vision made possible the modern city, which embodies virtues as well as numerous problems.

Certainly the steel cage [7.5] made it feasible to construct the overwhelming skyscrapers that tend to dehumanize the urban environment. Frank Lloyd Wright was well aware of that potential problem. As we have noted his early resistance to skyscrapers, he later stated in his *Autobiography* (1932):

7.23 WILLIAM VAN ALLEN. CHRYSLER BUILDING. NEW YORK. 1930.

constructed from prefabricated parts. He regarded the structural frame as an organic skeleton, commenting: "Nature was the engineer. Nature has provided the leaf with longitudinal and transverse girders and supports that I, borrowing from it, have adopted in this building." Paxton's creative vision and innovative use of materials produced completely new architectural forms, which critics of the day correctly predicted would revolutionize architecture. A later triumph of iron construction was the 990-foot (300-meter) Eiffel Tower, built in Paris for the exhibition of 1889. Consisting of a cross-braced lattice girder, it too was entirely made of prefabricated parts and surely represented the wave of future construction.

Steel

The lessons builders had learned as they built iron bridges, factories, and other buildings provided the basis for construction in steel. Steel is stronger, lighter, more fire-resistant, and more workable than iron and holds up well under tension, where iron tends to snap. Steel-frame buildings faced in stone or brick were erected in the cities of Europe and North America, especially in New York and Chicago, where, in both cities, the need to use all the space between

The Artist Sketch

Born in Boston and educated at Massachusetts Institute of Technology, Sullivan began his architectural career in Chicago in the office of William Le Baron Jenney, a later pioneer in metal skeletal construction, which was a fore-runner of the first true skyscrapers. After four years in Jenney's office, in 1879 Sullivan joined forces with Dankmar Adler. Their friendship strengthened with their business association, and in 1881 the two set up a firm, Sullivan and Adler, which made its name designing the celebrated Auditorium Building and the great Stock Exchange in Chicago (destroyed by 1976).

Sullivan's tall buildings, like the Wainwright in St. Louis and the Guaranty in Buffalo, were the beginnings of the mature American skyscraper. His philosophy saw ornament as a means to heighten perception of a building's fundamental structure, but his passionate quest was to evolve a fundamental American architecture, not based on any elements of historical European style. In all, the partners designed 120 buildings. One of their outstanding designs was the Transportation Building at the World's Columbian Exposition in Chicago 1893. Very different from the Victorian and classic styles that dominated the fair, this building was plain and bright with color, easily winning international attention.

7.22 LOUIS SULLIVAN.

To Louis Sullivan, ornament could heighten recognition of a building's fundamental structure, and most of the motifs he created presage the Art Nouveau movement that appeared at the turn of the century. Sullivan was soon eclipsed by his later famous student, Frank Lloyd Wright, who served as his chief assistant from 1887 to 1893. Nevertheless, Sullivan is remembered for his own form of genius—the ability to fuse ornament with a new architectural modernity.

Sullivan's declining years were spent alone; his wife abandoned him because of his alcoholism; he received few commissions. In the end he wrote the poetic *Autobiography of an Idea*, published before his death, a fitting legacy for one of the most significant architects America ever produced. [7.22].

LOUIS SULLIVAN (1856–1924)

The tall steel frame may have its aspects of beneficence; but as long as many may say, "I shall do as I please with my own," it presents opposite aspects of social menace and danger. . . . The tall office building loses its validity when the surroundings are uncongenial to its nature; and when such buildings are crowded together upon narrow streets or lanes they become mutually destructive.

To some extent, Wright's prophecy has come true in midtown Manhattan in New York, where megastructures like the IBM and AT&T buildings crowded on narrow streets may have become "mutually destructive." Yet, the period between World War I and World War II witnessed the popular success of the skyscraper. Slowly responding to the new Modernist styles of skyscrapers, architects began to combine **Modernism**, the style of "clean," undecorated structures, with traditional, historic styles to produce eclectic results that some called **Traditionalist Modern**. Ironically, perhaps, as America was descending into the Great Depression, the towering structures of Manhattan were rising and among them, the glittering 77-story Chrysler Building of 1930 and the 102-story Empire State Building the very next year. Automobile giant Walter Chrysler was determined to erect the tallest, most spectacular world structure, and he commissioned William Van Alen for the job. The Chrysler Building [7.23] is an amalgam of such varied influences as the traditional in its vertical thrust (like the Gothic), with the modern **Cubist** breakup of horizontal space, pre-Columbian **motifs**, and an **Art Deco** delight in gaudy colors and shiny materials. Even the drainspouts that copy the 1929 Chrysler hood ornament, and are reminiscent of French Gothic gargoyles, add to the surprising sculptural success of a building that broke away from all the constricting rules of each of the sources that inspired its design.

The **International Style** that we will examine in depth [Chapter 15] is essentially steel-cage construction and was criticized by many for its inorganic boxlike look. Predictably, Frank Lloyd Wright abhorred the style, since skyscrapers ran counter to his conviction that architecture should echo living forms to suit the needs of living people. Yet, after World War II, responding to industrial growth that had been aborted by the war, the multistory corporate headquarters dominated a period of vast urban reconstruction and expansion. Representing giant corporations, many buildings such as the Seagram Building and Lever House of the 1950s were in view of each other. In the hands of a

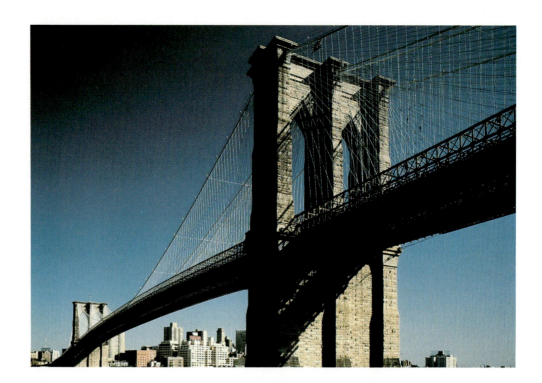

7.24 JOHN AUGUSTUS ROEBLING.
BROOKLYN BRIDGE, NEW YORK.
1869–1883.

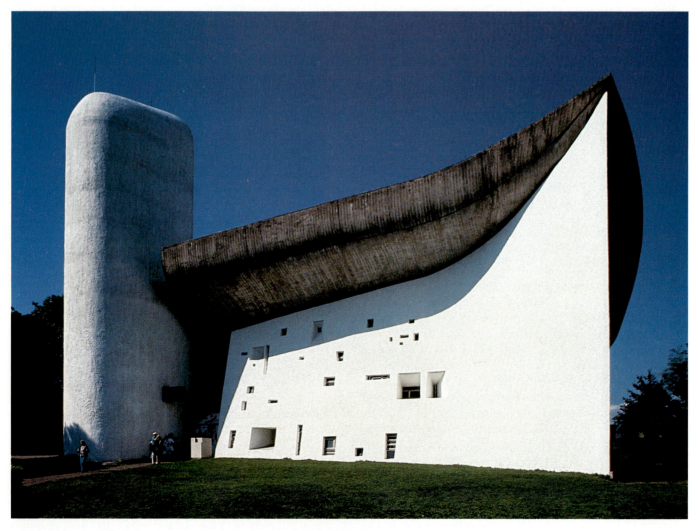

7.25 LE CORBUSIER. NOTRE DAME DU HAUT. RONCHAMP, FRANCE. 1950–1955.

skilled architect like Mies van der Rohe, steel was used to make even the large Seagram Building light and elegant by exposing the steel frame. The ground level, on stiltlike supports, was left without walls or windows to permit pedestrian access to the continuation of exterior space. Across the street, also floating on **pilotis**, Lever House was sheathed in a thin wall of steel and glass, with its lower section supporting a roof garden. Such construction became known as the **curtain wall**, since its exterior wall of glass is no more functional than the curtains that decorate a residence. However, not using all the space allocated to a city lot for the design of building was a courageous new approach to twentieth-century architecture. In particular, the provision of a roof garden for building employees may have been the inspiration for the inclusion of trees and other vegetation in many of the building designs that followed.

Steel is also used to make cables from which bridges are suspended, as in the Brooklyn Bridge in New York [7.24], designed by the engineer John Augustus Roebling (1806–1869). Roebling invented the steel cable, which is made up of many parallel wires, and the machine to attach the cables to the two towers that hold up the bridge. Twentieth-century suspension bridges are still built by his methods. Some of them contain spans almost a mile (1.6 kilometers) long. Not only do the cables support the weight of the spans, but they also permit fluctuations of several feet—caused by wind or load stresses—between the span and the water. Steel cables are also used for buildings. For example, pavilions for fairs and sports events may have the roofs and walls hanging on steel cables attached to central posts.

Reinforced Concrete

Concrete, a mixture of sand, gravel, cement, and water, was used in Roman times for aqueducts and other large structures. Not until the twentieth century, when it was reinforced with metal rods or mesh, was its full potential achieved. Reinforced concrete is a versatile, fire-resistant, durable material that can be molded into columns, beams, slabs, and vaults that can be self-supporting with few or no interior posts. Rule of thumb suggests that almost all buildings whose facades are curved or waved are probably constructed from reinforced concrete.

Builders first used reinforced concrete for utilitarian structures, like factories. As early as 1905, bridge designers in Europe began to use curved reinforced concrete slabs supported on thin vertical members to create graceful arches. Since then, as technical understanding of concrete has increased, engineers have been able to calculate exactly what stresses and loads a structure can support and have experimented more audaciously. At the same time, architects have recognized the aesthetic possibilities. In 1903, the French architect Auguste Perret (1874–1954) built an apartment house in Paris as a rectangular cage of reinforced concrete with walls of glass or thin panels of cast concrete. Perret made no attempt to cover the concrete, believing

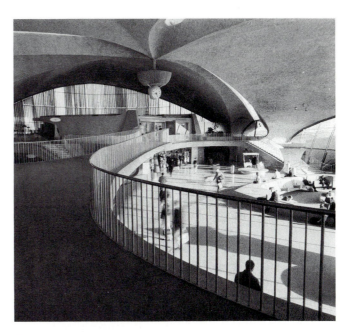

7.26 EERO SAARINEN. TRANS WORLD AIRLINES FLIGHT CENTER. KENNEDY INTERNATIONAL AIRPORT, NEW YORK. 1962.

that decoration frequently hides errors in construction. Inside, the only immovable parts are slim columns and stairs; the rest of the space is left open for flexible arrangement of rooms. In the late twentieth century, the Whitney Museum in New York and the Pompidou Center (Beaubourg) in Paris [7.6] both reveal their structure while permitting considerable modification of interior space for changing art exhibitions.

Architects have used reinforced concrete for sweeping arches and vaults that are thin shells and for sculptural forms such as those in Le Corbusier's (1887–1965) chapel at Ronchamp, France [7.25]. Only with reinforced concrete has it been possible to solve so many architectural goals such as curved wall surfaces. The making of prefabricated, modular sections of shell vaults with curved rib framing, consisting of layers of fine steel mesh sprayed with cement mortar, became a reality with reinforced concrete.

Eero Saarinen's TWA terminal at Kennedy Airport, as we noted, often uses winglike sculptural shapes cast in concrete that are appealing but not overwhelming. They create a large open area broken only by curving staircases, ramps, and balconies. The building, reminiscent of a bird in flight, can accommodate moving groups of people but also allows space for others to sit and watch the crowds while waiting for arrivals and departures. The movement of people increases the visual excitement provided by the architectural forms and the spaces they define, an appropriate quality in an air terminal [7.26]. The building was constructed in a few months with the same number of workers, at any given time, that were involved in building a Gothic cathedral over several centuries!

Challenging our basic perceptions of architecture is the newest concept called **Deconstructivism**, a highly

theoretical approach [7.27]. Much Deconstructivism exists only in the form of models and project plans, perhaps because many of the designs are so bizarre that they are hardly likely to move into a realm of real buildings. If there is any way to summarize this new approach, it might be to state that its supporters do not necessarily accept the architectural conventions that we have been discussing—that is, the floors, walls and other architectural elements of a building—as a given. Deconstructivism claims to be a reaction to conventional form and space that arose from Russian **Constructivism**, a style that reached its fame in the 1920s and was based upon geometrics. In contrast, deconstructivists question whether any kind of order is possible or even desirable in today's world. As remote as these theories may seem now, it is perhaps wise to recall that in the 1930s, when the international style first emerged upon world consciousness—a style that persisted for half a century—public reaction to it was as uncomprehending and probably as unaccepting.

As we trace the evolution of architecture through the following chapters, we must try to recall the vocabulary of construction methods and materials that we have just examined. Look at the buildings around us today to see whether they remain from times past or whether they are recent structures. If we find some that use new materials and techniques to copy traditional appearances and methods, how do they compare with other new and exciting buildings, many of which openly reveal their materials and construction?

ENVIRONMENTAL DESIGN

Harmony with our environment is based on awareness of the interdependence of all life. From a single cell to the billions of cells in every human being to the multitudes of people in our sprawling cities, all are living organisms whose satisfying existence depends on how each element is related. Even the smallest alteration to the ecological balance of our world makes changes we can rarely predict.

People have altered the landscape through the millennia by building farms and cities. Such incursions on the land were all influenced by the natural environment that existed before them. Today, however, that environment, to which our biological rhythms may yet be keyed, has all but disappeared. The vast forest broken by streams and meadows that once covered the eastern United States is gone, and the environment we have put in its place bears little resemblance to it. What has happened to the natural beauty of our country, and how have our communities changed from the human scale of early colonial towns to the overpowering roadscapes and skyscrapers of our time?

With current concern about the environment, perhaps we can adapt age-old solutions to our universal needs for comfort and efficiency in the home, the neighborhood, and the city.

7.27 BERNARD TSCHUMI. PERSPECTIVE OF FOLIE, PARC DE LA VILLETTE, PARIS. 1986.

The Environmentally Designed House

Fundamental to any community design is the plan of each house in relation to its setting. In many eras, people believed that a building should stand apart from its background as a visual reflection of the architect or the client. Many today are turning toward traditions in which a structure is a natural outgrowth of its surroundings.

The Pueblo Indians of the arid Southwest crowded their dwellings together, side by side and one atop another. This compact mass both reduced the area exposed to the sun and provided defense. The few small windows placed high in the walls allowed only late afternoon sun to enter, to be absorbed by the adobe brick walls. This "heat sink" slowly reradiated heat into the dwelling at night. A similar solar design appears in the five-story cliff dwellings called Montezuma Castle, built by the Sinaqua and Anasazi Indians of Arizona in 1100 and now a national monument. The mud, stone, and other indigenous materials served as heat capacitors to absorb solar radiation for later release. In addition, the overhanging mountainside blocked the high summer sun, thus cooling the dwellings naturally [7.28]. Pueblo and colonial houses, using solar radiation, were perhaps intuitive responses to local conditions.

Wright's term "organic architecture" supported such time-honored concepts that are reflected in the work of Luis Barragán (b. 1902). He describes his designs as providing "shelter against the aggressions of the modern world." His major project has been El Pedregal, Mexico, a residential area on a stretch of lava left 2500 years ago. Sensitive to the lava's unearthly shapes and lush vegetation, Barragán transmuted 865 acres (350 hectares) of what was regarded as unusable land into houses and gardens

thick adobe walls

small openings

typical room

Section detail

7.28 Montezuma Castle (cliff dwelling), Arizona. Twelfth century.

[7.29], achieving a modern design that profoundly respects his country's indigenous ways of building and living. Lava walls give privacy and create interior gardens, many imaginatively embellished by regenerative ponds and streams.

Regardless of the region, four elements of climate are critical for energy-efficient heating and cooling systems—solar radiation, air temperature, humidity, and air movement. In addition, a system requires a large collector and storage area of energy that is different from any associated with conventional heating and cooling systems. Although many houses today tap solar and wind resources (and some even incorporate greenhouses for heating and cooling as well as growing food), few are able to be totally self-sufficient.

Neighborhoods

Within a city, or suburb, a neighborhood of 5000 to 10,000 people is generally considered to be ideal for communal life. Such a community should contain the services needed to support everyday life and culture—shops, schools, a health clinic, a library, and a theater or museum. A neighborhood must also be integrated into a larger community, which can provide schools for higher education, fully equipped hospitals, and larger and more extensive commercial and manufacturing facilities. Neighborhoods developed naturally in the past. In newer cities, however, built on a grid pattern and characterized by large apartment houses, widely spaced shopping centers, and streets full of traffic, it is not possible for a comfortably sized neighborhood to develop spontaneously and organically without

segregating people into areas often based on age, ethnic origin, or economic level.

Le Corbusier's master plan for Chandigarh, the capital of the Punjab in India, divides the city into sections that are about the size of a village and that respect the centuries-old living patterns of the inhabitants. Each section has a market, a park, blocks of housing, paths for pedestrians, and roads for slow traffic. Because of the high cost of land, such a plan would not be suitable in more crowded areas. Yet, the advantages of such cluster communities are applicable almost everywhere.

Cities

The pueblo of the American Southwest and an unspoiled New England village share certain qualities—human scale, an ordered relationship of parts to the whole, and above all a sense of identity with a settled place. Old European cities also have these advantages. They are generally lost in the huge, crowded cities of modern America. When did this change take place?

Growth of Cities The metropolis of medieval and Renaissance Europe was relatively small by today's standards and was built to human scale. Many urban houses had gardens with trees and flowers, and fields and forest lay just beyond city walls. Such advantages perhaps offset the dirt, odors, and crowding in the poorer sections. While Venice is not typical, it may offer an urban parable.

7.29 Luis Barragán. Garden in El Pedregal, Mexico City. 1945–1950.

Art Talk

Venice was built on a series of islands in a shallow, marshy lagoon separating the mainland of Italy from the northern shore of the Adriatic Sea. Despite awareness that the city was sinking—in some areas as much as seven inches (eighteen centimeters) between 1908 and 1961—the disastrous effects of the settling only became dramatically apparent after November 3, 1966, when during a windstorm the high tide rose to an all-time peak that did not subside until some 24 hours later [7.30]. The flooding that occurred caused some 6 billion dollars worth of damage and galvanized efforts on an international scale, including such organizations as UNESCO, to clean, repair, and conserve the buildings and monuments that had been damaged.

Located as it is at the basin of the Po River, separated from the Adriatic by a narrow spit of peninsula, Venice—only a few inches above sea level in some areas and at sea level now for about 15 percent of the population—has depended for its survival on a natural balance being preserved in the lagoon. That natural balance has been disturbed, especially since World War II, by the industrial development on the mainland near Venice, requiring the extraction of fresh water from the subsoil under Venice, speeding the process of sinking that has been naturally occurring as the Adriatic rises. Land reclamation has also contributed to upsetting the natural balance. The problem of salt water entering the porous brick out of which most of Venice's buildings are constructed is compounded by the chemicals that industry contributes to that water, resulting in permanent damage and decay.

From around the world, people responded to Venice's plight. These individuals brought expertise in fields as varied as art history, engineering, and conservation, among others. Because the lagoon is the key to preserving Venice, an oceanographer was brought in to study it, with a computer with which he constructed a mathematical model of the lagoon and the surrounding area. The water in the lagoon behaves according to known hydraulic laws. With the computer, it became possible to predict within six hours any flooding about to occur.

Venice remains in peril. Its settling is more seriously threatening than in other cities that do not con-

7.30 AFTERMATH OF FLOODING IN VENICE, ITALY.

sist of islands at sea level. The city's plight is well described by the notice put up at Santa Marie delle Salute in the early days of restoration: "Beware falling angels."

THE SINKING CITY OF VENICE

Venice is still organized in the same way that was possible hundreds of years ago. Each neighborhood has its own piazza, or square, which offers all the vitality and stimulus that local inhabitants need. The trees, fountains, shops, and cafés of the square are reached by streets only for pedestrians. The main arteries of traffic are the canals, where boats transport people and goods without as much noise and exhaust as cars and trucks produce.

City Planning Although most cities grew haphazardly, a few were developed with planning. Inspired by belief in the power of reason and science to solve all problems and by desires for personal glorification, several European rulers ordered vast plans involving public buildings on large squares and the layout of streets on a grid pattern, or, as in Paris, a star pattern of radiating boulevards. Such plans provided for impressive displays of power and

marching troops, but wide, tree-lined boulevards do not encourage neighborhood life any more than twentieth-century freeways.

In the United States, many towns and cities since colonial times have been laid out on the grid system, or, like Washington, D.C., on the star pattern, because the settlers subscribed to the European-derived power of reason and their natural desire to impose human design on the frightening vastness of a new land.

Modern city planning began in the 1890s in Britain, where Ebenezer Howard (1850–1928) and Raymond Unwin (1863–1940) planned garden cities outside industrial areas, where people could live near their work and find the necessary services for daily life. Sunnyside Gardens, a nonsegregated, economically mixed community on Long Island formed models for the many "new towns" built in Britain after World War II.

Cities can be exhilarating but also frustrating and depressing. The individual, lost in a vast area and often monotonous routine, needs to be publicly reminded of people's capacity to experience emotion in large-scale, collective circumstances. Theaters, concert halls, opera houses, sports stadiums, and pedestrian malls, which draw people together for recreation and employment, provide these circumstances, but they also pose special problems for planners. Architects of such buildings must meet the physical needs of crowds, such as traffic flow, and also minimize occasions for confusion, inconvenience, and danger.

An example of a large-scale cultural complex is Lincoln Center in New York [7.31]. It consists of Avery Fisher Hall, the Metropolitan Opera House, and the New York State Theater surrounding three sides of a huge plaza with a round fountain in the center. The austere, grandiose buildings create for some people an anonymous and, for many, overwhelming grouping that has little reference to human scale or familiar, natural details to which people can relate. The impressive architectural scale is carried also to the interior.

Looking Toward the Future

The appearance of cities could change if some of the new, less costly building techniques suggested by creative architects were widely adopted. Buckminster Fuller's geodesic dome [7.7] is one such technique. Modules, or interchangeable sections, such as those used by Paxton in the Crystal Palace [7.20] in the nineteenth century are already used in prefabricated buildings, which can be fitted together quickly and easily at the building site.

The Israeli architect Moishe Safdie (b. 1938) has designed complete housing complexes consisting of modular systems that fit together in a variety of ways, providing

7.31 HARRISON AND ABRAMOWITZ. LINCOLN CENTER, NEW YORK. 1959–1966. METROPOLITAN OPERA HOUSE (CENTER), 1962–1966; AVERY FISHER HALL (RIGHT), 1959–1962. PHILIP JOHNSON. NEW YORK STATE THEATER (LEFT), 1964.

different floor plans for individual units. Safdie's Habitat was a prototype of modular housing built for Expo '67 in Montreal [7.32], human in scale, allowing for privacy and roof-gardens, without monotony—important features for urban dwellers. Safdie also planned pedestrian malls to join the units and provided covered parking underneath. He believes that groups of Habitats could be clustered around city parks and applied this principle to housing developments in Israel and other countries, such as Canada, where the original Habitat is not only in use but still in considerable demand.

Although some people fear that technological progress can result in spiritual impoverishment, others are hopeful about the possibilities that it opens for us. The city of tomorrow would have a few large public buildings to serve "the highest and most significant expression of the new architecture." Indeed, we may note that the Crystal Palace in London, the German Pavilion at the Barcelona World's Fair [8.35], and Habitat in Montreal were all public buildings planned for international events, which provided the opportunity for unprecedented public exposure to avant-garde design.

The newest entry to the horizon of environmental design is a $150 million Biosphere 2 project. In Arizona, eight researchers occupy a miniature world, consisting of 4000 species of plants and animals culled from around the

7.32 MOISHE SAFDIE. HABITAT, MONTREAL. 1967.

7.33 BIOSPHERE II. SONORAN DESERT, ARIZONA. 1991.

planet, living in ecological harmony for two years. Everything—air, water, and human wastes—is recycled. The inhabitants grow their own food. The sealed environment covers 3.1 acres in the Sonoran Desert. A pyramidal section contains the rain forest ecosystem, one of five climates within the structure [7.33]. This human habitat, with its stepped pyramid forms and curved and rounded facades, evokes ancient as well as high-tech sensibilities. Along Biosphere 2 are two white geodesic domes that function as its "lungs," allowing the internal atmosphere to expand and contract as temperatures and pressure changes require. It seems very likely that R. Buckminster Fuller would have approved of this project, especially with its ecological use of the geodesic dome.

EXERCISES AND ACTIVITIES

Exercises for Research and Discussion

1. List several ancient and modern structural methods or building devices. You may also draw simple diagrams of each.

2. What qualities of twentieth-century construction distinguish it from past methods? List examples. Discuss.

3. Locate several buildings in your community that copy historical styles of architecture, such as Gothic or Renaissance. Can you tell if old methods of building were used or if the historical detail is merely applied to the surface?

4. Locate and, if you like, sketch other buildings that appear to use more contemporary structural methods. How do these methods and materials vary from the older methods you have studied?

5. Referring to a text on house construction, learn to read an architectural plan and to understand the symbols for windows, doors, solid walls, closets, steps, etc. Determine how scale is used in a plan.

Studio and Homework Activities

1. Look at house plans in magazines. Pick out one you would like to live in and compare it with one you dislike. What features do you like about it? Are the rooms conveniently placed? What would the traffic flow be like? Change the plan to meet your needs.

2. Draw a plan of an existing school or other public building. Pick out the features you would change to make it more convenient and draw a revised plan showing these changes.

3. Choose a natural setting in your community. Design a structure that could be incorporated into that setting without damage to the natural environment.

4. Sketch the exterior and interior plan of a home to demonstrate the circulation pattern of the occupants and the functions that home must serve.

5. Alter the exterior design of that home to reflect fidelity to a different architectural period. For instance, if you have designed a contemporary home, translate the facade into a neoclassic exterior. How would interior flow or house functions be altered?

Design for Living

"What is needed is not a definition of meaningful imagery, but the development of our perceptive potentialities to accept and utilize the continual enrichment of visual material."

—RICHARD HAMILTON,
FROM THE CATALOG OF
"THIS IS TOMORROW" EXHIBITION,
1956

• • •

"Form follows function."

—LOUIS SULLIVAN, ARCHITECT

• • •

"The book is an extension of the eye ... the extension of any one of our senses alters the way we think and act—the way we perceive the world...."

—MARSHALL MCLUHAN,
WRITER ON MEDIA

• • •

"The roadside strips, the consumer products, the billboards, the fantasy cars, the monster junk piles are all portraits of us, not someone else. There is no "they."

—GEORGE NELSON, DESIGNER

From earliest times, men and women have designed works to meet their daily needs. People have never been content, however, with mere utility. Even when living conditions were difficult they have always found time and energy to refine their designs—whether they be artifacts for telling time or books for record keeping. In the hands of skilled artists, even simple designs for living are made pleasing to see or touch with concern for shape, texture, finish or decoration. In time, every society evolves an aesthetic that produces high quality designs of unquestioned beauty that also "work."

Many call artworks that serve useful purposes and please us aesthetically **functional art** (or **decorative art**). Crafts, textiles, costume, mass-produced furniture, and interior design are some functional works. As we look about us, we see that design or order is basic to life. The incredibly complex forms created by nature inspire artists and appear to have been the basis for the Golden Section [2.49], a principle usually embodied in the art we like best.

The structures of honeycombs, beavers' dams, and birds' nests all express the materials used in them and the purposes they serve. Today many designers and craftspeople believe that any article designed for use—a steel chair, a piece of power machinery, a silver pitcher—or, even a package—must also honestly express its materials and purposes. In addition, the elements of design we have discussed are as important in the functional arts as they are in the fine arts. Rhythm, balance, and proportion are basic to all well-designed art; line, mass, color, and texture are important concerns to functional objects that are also aesthetically satisfying. For instance, the ceremonial wine vessel was designed to fulfill two functions: to please the taste of an emperor [8.1] and to pay homage to the ancestors and the gods.

Millions of printed designs—books, magazines, newspapers, illustrations, corporate signs, symbols, and other materials of communication—dominate the visual landscape of our century. Some are messages that inform; many change our lives; but all are intended to enrich daily living in some way. The specialized artists who provide these printed products and services are known as graphic designers.

GRAPHIC DESIGN

Graphic design refers to the arrangement of words and/or images within a printed format. Arresting visual communications may determine the success of multimillion-dollar ventures. From product trademarks to advertisements, professional designers are indispensable to modern commerce, covering a broad range of fields. The larger divisions include book and magazine production; advertising in newspapers, magazines, television, indoor and outdoor display;

8.1 CHINESE CEREMONIAL COVERED VESSEL OF THE TYPE KUANG. SHANG DYNASTY, MIDDLE AM-YANG. TWELFTH CENTURY B.C. BRONZE, 9-1/4 × 12-3/16" (23.5 × 31 CM). COURTESY OF THE FREER GALLERY OF ART, SMITHSONIAN INSTITUTION, WASHINGTON, D.C.

8.2 SAUL BASS. *THE QUEST*

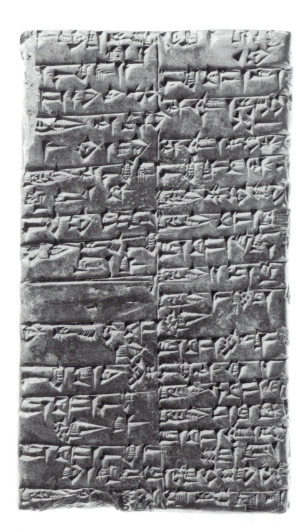

8.3 CUNEIFORM TABLET (DETAIL). SUMERIAN, C. 2050 B.C. BAKED CLAY, ENTIRE TABLET 3-1/8 × 5-1/8″ (8 × 13 CM). BABYLONIAN COLLECTION, YALE UNIVERSITY, NEW HAVEN, CONNECTICUT.

and computer graphics (an open-ended art in itself)[8.2]. The common criterion that binds these arts is their dependency on printed surfaces that are usually two-dimensional; also, they are generally considered to be designed for commercial purposes (and thus distinct from printmaking).

Printing Industry

The printing industry, like cinema, television, and radio, serves mass communication. Printing informs through symbols—recognized images that stand for ideas. The earliest civilizations all developed graphic symbols to communicate ideas. Some symbols remain abstract, such as letters of the alphabet. Sumerian cuneiform characters are some of the earliest sounds and ideas [8.3] that were translated into visual images, numbers, and musical notes. Other symbols are pictorial and almost universal, such as a drawing of a crown to symbolize royalty. Even in ancient times, symbols advertised what was for sale—for instance, a bakery in Pompeii was identified by a painting of bread. Many modern corporations have trademarks that are mainly pictorial symbols, and **logotypes**, which are usually the company's name or initials. Most Americans, for example, recognize AT&T, but forget the letters stand for American Telephone and Telegraph, set with a revolving globe. Decorated with thick and thin lines that connote paths of communication, the modern, squared-off, computer-related style also suggests the accuracy and forward-thinking image that the company wishes to convey [8.4].

So accustomed are we to the printed page, we forget that for thousands of years most words set down in permanent form were written by hand. Each book was in fact a manuscript (from the Latin words for "handwritten"), an

8.4 DESIGNER: SAUL BASS. BASS/YAGER & ASSOC., AT&T TRADEMARK. © 1982 AT&T.

original or a laboriously lettered copy. In China, Japan, and medieval Europe, handwriting developed into the decorative art of **calligraphy** (Chapter 2). A study of the characters painted on a paper handscroll of the Kamakura period reveals the abstract nature of some Japanese calligraphy, which is very close to drawing and painting [8.5].

Printing began in ancient times on fabric in India during the fourth century A.D. By the ninth century the Chinese and Japanese were printing on paper from wooden blocks with characters and pictures cut into them. Movable type made of baked clay dates from A.D. 1041–1049 in China; by the fourteenth century, the Chinese were the first to use movable wooden type. Woodcut illustrations were common in Europe in the fifteenth century, as we saw in Chapter 4, although books were still lettered by hand. In the 1430s and 1440s, Johannes Gutenberg of Mainz, Germany, coordinated into one process all the elements needed to produce printed books in multiple copies—paper, ink, a printing press, and movable metal type. That type consisted of single cast wood letters that could be com-

8.5 FUJIWARA NOBUZANE (?). *LADY KODAI NO KIMI*, FRAGMENT OF *THE THIRTY-SIX IMMORTAL POETS SCROLL (SANJŪROKU KASEN EMAKI)*. EARLY THIRTEENTH CENTURY. COLOR ON PAPER. THE MUSEUM YAMATO BUNKAKAN, NARA, JAPAN.

bined into words, locked into a form, and, after they had been used for printing, reused in other combinations.

Typography The common typefaces used today began with the square capital letters cut with hammer and chisel by ancient Roman stonecutters on monuments and written with chisel-ended pens on parchment by scribes. Such letters have thick and thin strokes ending in **serifs** (short lines set on angle to the stroke). Roman letters might well have been lost during the violence and unrest of the Dark Ages had not the Emperor Charlemagne in the eighth century encouraged a revival of ancient learning in the monasteries.

Over the centuries, Roman letters as copied by Carolingian scribes became modified into the angular, compressed style used in medieval manuscripts of the Gothic period. In the Renaissance, Roman letters were revived by humanist scholars studying ancient manuscripts. Early designers of type were inspired by both styles. Today there are numerous typefaces to meet various requirements. They may be arranged into groups or families: Roman, black letter, script, and sans serif (often called Gothic). Italic is a sloping variant of Roman and sans serif [8.6].

Typesetting In general, type design has changed little since its beginnings, but the process of setting type is drastically altered. For more than four hundred years, metal type was laboriously set by hand, as it still is for special headings. In the nineteenth century, numerous machines

were invented to replace hand assembly and mechanically space the words to **justify** lines, or fill them out to the desired width. Type today is still set by special typewriters or by phototypesetters, which produce photographic images of characters on film or paper. In phototypesetting, varieties of type styles are stored on small discs, film strips, or grids. Computers usually run the systems that convert the type images to the set type and have revolutionized typesetting, radically changing the process and labor force.

Printing Processes Like typesetting, printing (that is, impressing type on paper) has varied through the centuries. Gutenberg and other early printers, using a hand-operated torsion screw to apply pressure on a flat wooden press, were able to turn out a few hundred sheets a day. Today's mechanized rotary presses are power-driven machines that can produce the same number of impressions in a few minutes or even seconds. The upper cylinders carry the paper. The lower ones are the printing plates, which quickly transfer ink to paper.

There are three major printing processes, which correspond to the printmaking methods discussed in Chapter 4. Letterpress is printed from a raised, or relief, surface [8.7a]. Gravure is printed from an intaglio, or depressed, surface [8.7b]. Offset lithography is printed from a level, or plane, surface [8.7c].

Letterpress, evolving from the artist's woodcut, is the oldest and until recently the most common method of printing. Ink is applied to a raised surface and transferred directly to the paper through pressure. The ink rollers touch only the raised areas, not the lower, surrounding spaces. There are several different types of presses, but the basic principle is the same.

In **gravure**, derived from engraving, an image is etched below the surface of a copper plate or cylinder. The etched plate is inked and the excess ink is wiped off the surface. The ink remaining in the depressed areas is directly transferred to the paper by pressure. As with most such printing, the oily ink can be felt on the printed page. Gravure is considered to be the best method of reproducing illustrations, but since the plates are expensive to make, it is only used when a large number of impressions are to be printed. Art books and magazine sections of newspapers are mainly gravure printed.

Old Style Roman
Modern Roman
Modern Italic
Script
Decorative
Sans Serif

8.6 SAMPLE TYPEFACES.

a. Letterpress

b. Gravure

c. Offset

8.7 MECHANIZED ROTARY PRESS PRINTING.

Offset lithography, derived from direct lithography, is the most recent and now the most common of all three printing processes. The two main differences between it and other methods are the use of the same lithographic principles that we noted earlier: grease and water do not mix and the indirect way the images are transferred to paper. After the plate has been dampened by water, the nonimage areas accept water but not ink. Thus when the plate is inked, only image areas are transferred to a rubber roller called a blanket. The images are then transferred from the blanket to the paper (offset to the paper).

Photomechanics The old ways of printing illustrations from handmade woodcuts, steel or copper engravings, or lithographic stones have been replaced by photomechanical processes, which vary somewhat for each of the major printing methods. The oldest, first used in the late nineteenth century, is photoengraving, which makes letterpress plates. The others are photogravure and photolithography. The cheapest and simplest kind of photoengraved plate is the **line plate,** or **line cut,** used to reproduce images made up of solid black-and-white lines or areas with no gray middle tones. Examples of line cuts are some diagrams in this book and pen-and-ink drawings. The artwork is photographed and the resulting image on the negative is transferred to the sensitized plate photographically. An effect of intermediate tones can be produced by drawing the lines close together or by using mechanically prepared screens with dots or cross-hatchings.

Halftone plates are used to reproduce photographs, watercolor drawings, or paintings that require intermediate or continuous tones. When halftones are photographed, a screen, placed between the camera lens and the film, converts the image on the negative into dots. Like line cuts, the halftone plates are also etched in acid, and the dots remain in relief to pick up the ink. The tiny dots of fine reproductions can hardly be seen, but if you look at the pictures in a newspaper, you can see their patterns easily.

This complex process of printing with dots for black-and-white reproductions becomes even more critical when printing in color. The colored illustrations you see in books and magazines, just like fine color prints, are made by printing several colors one on top of another, each with a separate plate for each color. The plates are made by photographing a subject through special filters, which separate the colors of the original. Each color—yellow, magenta (red), cyan (blue), and black—is printed individually from separate plates. Alignment, or registration, is crucial for each printing or the dot patterns will not match up, and the illustration will be fuzzy.

Graphics

What Confucius said is as accurate today as ever—a picture is worth a thousand words. With the international marketing of goods and services, and world tourism, the U.S. Department of Transportation called on The American

8.8 PICTOGRAPHIC IMAGES (ICONS): INTERNATIONAL THEMES. 1982.

Institute of Graphic Arts to evolve what has become a universal language with simple imagery for travelers of any nationality [8.8]. The automobile and airline industries have developed comparable icons for use everywhere in the world and set the standard for other icon designs.

Book and Magazine Design Perhaps the most prestigious assignments in the field of graphic arts are the cover designs of books and magazines. Both are actually package designs of a sort, since they must attract attention, protect the contents within, while at the same time identify the subject. The book jacket for *Horst* [8.9], encompassing the work and world of a noted photographer of fashion [5.15] and society, is a case in point. Designed by Sara Eisenman for Alfred A. Knopf/Random House Publishers, the jacket exemplifies high style. The open-spaced layout and hand-lettered title, a variant of the Roman typeface Carlton, convey the elegance of the world of the rich and famous that this book chronicles. The classic oxford gray of the background is a fine foil for the white lettered title. The 1939 fashion photograph encircled by the letter "O" shows a Mainbocher drawstring corset; Horst tells us that this was "the last photograph I took in Paris before the war … for me, it is the essence of that moment, and … all that I was leaving behind." The back jacket shows an irreverent peacock astride a sculpture in the garden of Maison-Lafitte near Paris.

Package Design The invention of the self-service supermarket indirectly revolutionized the packaging industry. No longer were packages mainly designed to identify and protect goods as they were transported from a warehouse to grocery store shelves. Packages compete for space and attention among the thousands of products in a supermarket. Now, manufacturers aim to distinguish their products as well as to communicate the nature and quality of the

8.9 *Horst: His Life and Work by Valentine Lawford. Jacket design by Sara Eisenman; photo by Horst. 1984. Courtesy Alfred A. Knopf.*

8.10 *Andy Warhol. 200 Campbell's Soup Cans. 1962. Liquitex on canvas, 6' × 8'4" (1.83 × 2.54 m). Collection Kimiko and John Powers, Aspen, Colorado.*

contents of each package. Today's busy consumer chooses a specific product quickly, sometimes in a fraction of a second. The label on a can of soup, Andy Warhol reminded us [8.10], is one package from an assembly line of thousands. Warhol advised us also that packages are the world's most popular art form, since we, as public consumers, purchase the label of every product, as part of the cost of the design, which is added to the price of every item we buy.

New concepts in a package aim to make it different from all others. In identifying the name of the product, the logo must compete with other products [8.4]. The corporate image is generally coordinated to all items produced by the company and must work as well on the sides of their transport trucks as in the supermarket. Furthermore, packaging must identify products on at least front and back, (preferably on all six faces for freezer cartons). Finally, both access and security are critical factors in package design. Consumers are impatient with tricky openings, but in the case of medicines, assurance that containers are tamper-proof and contents unmolested is vital—a fact no designer dares to forget.

8.11 JEFFREY MANGIAT. CUT-AWAY ILLUSTRATION OF AN AUTOMOBILE. 1984.

Advertising Campaigns

For our consumer-oriented society, advertising accounts for the major printed material in our visual environment. Before the Industrial Revolution, however, handbills, posters and shop signs were the only visual means a tradesman could use to publicize merchandise. Today, advertising is a multimillion-dollar industry that measures its impact on commerce in part on the extent of its billings. The largest advertising agencies oversee ad art campaigns for internationally marketed products and services that may be advertised on radio, television, newspapers, and magazines. Large corporations allocate a set portion of their total sales to cover the costs of hiring one or more agencies that will provide such complex services as research, art and layout production, media selection, and public relations.

Credit a Frenchman named Michel Roux for a campaign that has won 60% of the imported market for Absolut vodka in one short decade. Starting as Carillon Importers' first salesman in 1970, he became president by 1982. Under his direction, Absolut has become the vodka of choice among the market segment most desirable today—the young, the affluent, and the trendsetting. Absolut's newest mobile advertising consists of compact glassed-in trucks enclosing people relaxing in casual settings—drinking Absolut vodka. These avant-garde, eye-catching ads are traveling scenarios featuring life-size fiberglas figures by Carole Jeane Feuerman [I.17] that are sculpted and painted to look "real." The high visibility campaign frequently stops pedestrians and vehicles in their tracks. With a $22 million annual marketing budget, and growing, Michel Roux has cultivated a kind of cult following for Absolut ads. He gets stacks of mail with suggestions from Absolut fans proposing advertising ideas. Credit Carole Jeane Feuerman's **Superrealist** sculptures for some of the success of one trendsetting campaign.

The Advertisement Most advertisements are prepared for a specific use, for a limited time and predetermined market. Once the theme of an ad is selected by a client, the artist makes rough "thumbnail" sketches of the layout. These eventually result in a final, carefully prepared assembly of artwork and type called a **pasteup (mechanical)**, which is photographed to make the printing.

Whether working in magazines, books, package design, or advertising design, graphic artists must have a knowledge of lettering, typography, layout, reproduction methods, and printing techniques. Even more important, they must be skilled, creative, and imaginative in using the elements of design—balance, unity, line, color, and shape—that apply to all the visual arts. In the hands of a good designer, the graphic processes can be used creatively and expressively to produce exciting and satisfying designs.

Illustration The artwork for an advertisement consists of photographs or painted or drawn illustrations, which become vital elements in attracting our attention or setting the mood of a story. Clearly dependent upon its broad range of values and precision of details is this **halftone** automobile illustration by Jeffrey Mangiat [8.11]. The interior workings of the car are revealed in a technical **cutaway** view, contrasting nicely with the highly refined exterior surface, rendered in **airbrush**like, smoothly graduated tones.

The popularity of tempera paints, watercolors, and pen and ink for advertisement illustrations has been outmoded somewhat in recent years by photography. The illusion of reality produced by many contemporary

The Artist Sketch

Little known outside his profession, Saul Bass, [8.12] nonetheless, has shaped the face of much of what we see in the international world of print all around us. The designer and developer of numerous corporate identities in Europe, South America, the Far East, and the United States, Bass is in part responsible for the images we conjure up with the mention of AT&T Bell Laboratories, Celanese, Warner Communications, Minolta cameras, United Airlines, Alcoa aluminum, the Girl Scouts, United Way, Exxon-Esso gasoline, and Wesson Oil—to name only a few. Even a U.S. postage stamp—a 1983 stamp commemorating art and industry—bears his imprint.

8.12 SAUL BASS.

He is responsible for the introductory and concluding credit designs for some films that have become minor classics: *Man with a Golden Arm* (1955), the epilogue to *Around the World in Eighty Days* (1956), *Anatomy of a Murder* and *Psycho* (1960), *West Side Story* and *Exodus* (1961), *Spartacus* (1967), and *The Shining* (1980). Bass' own short films are collector's pieces in a giant industry. He and his wife, Elaine, help produce, direct, and supervise the production of art and animation in every film. Bass' latest work was developed from a Ray Bradbury story called *The Quest*. Using computer animation and other special effects, the film is thought-provoking, emphasizing how precious life is [8.2].

Saul Bass was born in New York City; although he only attended Brooklyn College for night courses, he has been awarded several honorary doctorates. His designs are represented in museums on both U.S. coasts. His center, Saul Bass/ Herb Yager & Associates, Inc., in Los Angeles, undertakes total design concepts that may begin with corporate architectural factors (such as Exxon-Esso gasoline stations), continue through trademark and logotype, and then appear in package and poster designs. But, undoubtedly, the average citizen has been most influenced by the Saul Bass film titles and symbols. Bass has received the highest national and international awards for his graphics and for several of his films, recently produced with computerized imagery. The Quest was only the beginning of Bass's experiments with computer graphics. Full potential awaits.

SAUL BASS (B. 1920)

photographs perhaps has caused this shift from the more conventional techniques. A skilled photographer can create drama, elegance, mystery, and special visual effects that persuade us to buy. Saul Bass has remained in the forefront of graphic design for many years, and is skilled in most all graphic media.

COMPUTER GRAPHICS

Virtual Reality Pushing computer technology even further, it now becomes possible to create a "virtual reality" [8.13] that does not really exist. We have reached a point where we can "enter the Land of Oz" without leaving the room. We can stand on a "magic carpet" by putting on a "magic" helmet with goggles, or put our hands into a "magic" glove and find that we are in the world of "virtual reality."

A variety of factors has enabled this to happen. One is our stereoscopic vision that permits us to see a computerized "reality," that we can create and control, in the same three dimensions in which most of us spend our lives. In the real world, depth and distance perceptions are possible because we have two eyes, each one of which sees the world slightly differently. To translate this ability to computerized virtual reality, a mechanism for such perception must be created. Two tiny screens are required and positioned in the "magic" head-mounted device that produces virtual reality. The left and the right screens offer a slightly different view of a subject, guaranteeing that each eye sees only the screen view appropriate to that eye, and together reproduce stereoscopic vision. The virtual reality glove permits us to select what we shall see.

NASA (National Aeronautics and Space Administration) has designed a multi-sensory 3-D interface with which the wearer of a virtual reality helmet or glove can interact, exploring a 360-degree environment. Images appear to surround the viewer. A turn of the head causes an update of the image we see in real time at the same rate that we observe a television-scanned image—thirty images per second. The viewer may interact with the equipment in several ways—tactual, verbal or optical. We can be sure this technology will evolve further, when virtual reality is released from the space program and made available to all of us.

Art Talk

Computers are helping artists create more and more of the graphic images we see every day. Images produced on a computer screen are known as computer graphics, and they in turn pervade television, magazines, newspapers, books, and even museum exhibitions today. The special effects made possible by computers, commonplace in television news and sportscasts, involve innovative techniques—assembling pictures electronically, changing their colors instantly, enlarging and reducing images, and then adding on-screen colors that interact with the more traditional elements of form and shading that we find, for example, in painting and sculpture.

In its unparalleled range of possibilities, the computer has no precedent as a medium for images. Under computer control, television can freeze-frame an image on the basketball court and transform a monochromatic piece into a spectrum of colors. Computers help meet the demands of advertising in television commercials with instant photo montage and other combinations, such as the superposition of titles and backdrops or simulation of flying through surreal space, for instance.

In the field of typography, computers permit integration of type and artwork in a fraction of conventional typesetting time. Hundreds, even thousands, of experimental arrangements can be made, since the computer gives the artist the capacity to rapidly summon images that have been created and stored in computer memory by a layout artist.

With innovative handling, super-computers, the most powerful computers yet devised, can create images that simulate photographs of anything. Appropriate shadows and highlights convince the observer of their authenticity. When portions of the image are blurred to show speed or movement, few viewers can distinguish computer art from a direct photograph. The computer is at the heart of a revolution in image making. Duane Palyka, a pioneer computer artist and scientist who has remained in the vanguard of the medium [18.22], reviewed his lifetime investment in computer graphics: "The creation of paintings and the creation of computer programs are the creation of objects ... constructed of ideas, concepts and craftsmanship ... what kind of artist can get involved with the computer art medium? An artist interested in dealing with algebraic logic as well as ... with aesthetics...."

THE COMPUTER CONNECTION

Ubiquitous Computing The most profound computer technology destined for the twenty-first century may consist of specialized elements of equipment and programs connected by wires, radio waves and infrared waves; so much a part of the environment as to be unnoticeable. Variously known as **embodied virtuality** or **ubiquitous computing**, a centrally located sensor in each room will continuously maintain data banks of information about everything and everyone there. Just how art will flourish in such a controlled environment is unclear.

THE EVOLUTION OF CRAFTS

In the Old Stone Age, men and women shaped weapons and tools from available resources to fit a specific purpose. Even the earliest flintstones were different sizes and shapes to please the eye as well as to fit a specific purpose. Missiles aimed at birds and small animals were small and finely shaped. Harpoons and hand axes intended for heavy animals might weigh as much as 6 pounds (2.72 kilograms).

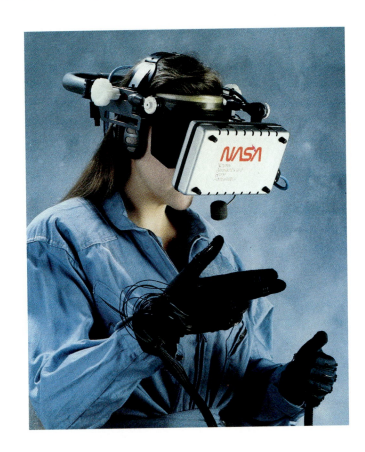

8.13 VIRTUAL REALITY HEAD MOUNT AND GLOVES ENABLES THE USER TO EXPERIENCE A THREE-DIMENSIONAL WORLD.

8.14 LADLE. CANADIAN, NATIVE AMERICAN. 19TH-20TH CENTURY. HORN LENGTH 17-1/4″ (44 CM). THE METROPOLITAN MUSEUM OF ART. THE MICHAEL C. ROCKEFELLER MEMORIAL COLLECTION; BEQUEST OF NELSON A. ROCKEFELLER, 1979.

Ancient flint and ivory tools, baskets, pottery, and weavings fulfilled the same kinds of functions served by the twentieth-century synthetic and natural materials found in our pottery, steel tools, and polyester fabrics. Early on in most societies, the crafts of pottery and weaving were developed to provide containers and clothing. As societies became more complex and sophisticated, the crafts of woodworking and metalworking evolved.

Although handmade and machine-made objects involve the same principles of design, those made by hand fulfill human needs in a more personal way. The most obvious difference lies in the touch of the creator, often visible in handcrafted objects. For example, in an oversized horn ladle [8.14] we can sense the handwork of the Native American of the Northwest Coast who carved it for a village feast. We value the close relationship between the material and the form of the object made from it. A glass vase blown from molten material looks quite different from a clay vase shaped on a wheel from wet clay. The craftsperson uses tools with great care and a personal concern for the object's appearance and durability, its aesthetics and its utility.

Traditionally, a handmade object was both designed and executed by the same person and so could justi-

fiably be called one of a kind. There was also a close tie between designer and consumer that demanded a two-way responsibility. The artisan respected the consumer's needs, while the consumer valued the product and knew and trusted the person who made it. Modern industry does not always reveal this concern for the purchaser of its goods.

With the Industrial Revolution, the fascination for machine-made objects often ignored concern for aesthetic appeal. Almost a hundred years ago, objects were so elaborately burdened with machined decorations that they were made almost unusable. People began to question **industrial design** and looked for a return to more natural materials.

Ceramics

The making of **ceramic** wares, shaped out of damp clay and fired (baked) in a kiln, was one of the earliest crafts to develop. Clay vessels were used in most settled societies for cooking and storage, and became a form of high art in many civilizations.

There are three kinds of ceramics, depending on the kind of clay and the firing temperature. **Earthenware,**

8.15 PETER VOULKOS. *X-NECK.* 1990. ANAGAMA FIRED STONEWARE. 33-1/2 × 21-1/2″ DIAMETER. COLLECTION OF BOB BRADY AND SANDY SIMON. COURTESY BRAUNSTEIN/QUAY GALLERY.

8.16 Earthenware jar with cream and green glaze. T'ang Dynasty, first half 8th century, height 6-7/8" (17.5 cm). The Metropolitan Museum of Art. Lent by Charlotte C. and John C. Weber.

made from coarse, impure clays and fired at low temperatures (about 800° C, or 1470° F), has a soft, porous body suitable for rough pottery vessels and bricks. **Stoneware** is made from finer, purer clays and fired at higher temperatures (about 1300° C, or 2370° F), which fuse the clays into a harder, vitreous (glasslike) body. It is used for sturdy vessels. Responding perhaps to the shapes and design of ancient Greek pots [2.3], Peter Voulkos (b. 1924) makes a bold new statement in his stoneware pot, assembled with layers of clay [8.15]. **Porcelain** is made from the finest white kaolin and other clays and fired at the highest temperatures (from about 1400° C, or 2250° F, to 1613.4° C, or 3000° F). When struck with a hard instrument, its vitreous body produces a clear, resonant sound, and when thin enough, it is translucent. Porcelain makes some of the finest quality vases and tableware, with far harder surfaces than stoneware.

Potters can pat and pinch clay into shape or form it into coils or slabs to build the walls of a vessel, which are then smoothed by hand or with a stone or shell. Native Americans of the Southwest still make pots by these techniques. Using more sophisticated methods, potters shape clay on a rotating potter's wheel, pulling the clay up from the base with the hands, or pouring slip (a creamlike mixture of clay and water) into a mold. The wheel and mold enable them to produce more pots of greater uniformity and smoothness and more ambitious design.

The clay pot must then be dried in the air. If such **greenware**, as it is called, is to be made hard and watertight, it must then be fired to remove all moisture from the clay. Early peoples baked their earthenware pots in the coals of a fire or in covered pits. Since then pottery has been fired in special furnaces, or kilns, such as the multichambered dragon kilns with firing chambers usually stair-stepped up the hillsides of southern China, or in modern electric kilns. The first half of the eighth century witnessed the beginning of aesthetic appreciation of glazed earthenware pottery as an art form. In the abstract simplicity of the cream-colored glazed jar with green splashes, the vigor of the early T'ang Empire in its heyday is reflected in the well-rounded, highly stable and solid form [8.16].

The pot after the first firing is called **bisque**. It may then be decorated with colored stains, or it may be painted with or dipped in **glaze**, a coating of ground chemicals and

8.17 GREEK POTTERY SHAPES.

Hydria

Krater

Amphora

Kylix

Oenochoe

Lekythos

water. A glazed pot is then refired at a higher temperature, which fuses the glaze to the surface of the pot, making it more durable. Glazes range in color from muted earth tones to brilliant primary hues, and they can produce a variety of rough, mat, and shiny textures. Additional glaze decorations can be added in subsequent firings. Each step in firing requires great technical knowledge and skill, whether it is done by an individual or a large factory. Errors can produce drastic changes in glazes or ruin pots completely.

The early Greeks and the Chinese, Koreans, and Japanese produced some of the world's great ceramics, pieces of exceptional beauty in shape, glaze, and ornamentation. Greek potters designed graceful shapes for specific purposes. They made narrow-necked jars and bottles to hold costly wine, oil, and perfume safely and wide-mouthed bowls and cups for mixing and drinking water and wine [8.17]. Heavy jars had three handles to make them easier to move, dip into, or pour from. These vessels were often painted with figural scenes.

Chinese potters developed subtle shapes and a variety of glazes that depended on precise control of the heat and oxygen supply in the kiln. Delicate, creamy white porcelains from northern China were covered with a transparent, almost colorless glaze. Heavier kinds of porcelain, incised or smooth, are covered with celadon (sea-green) glazes in an attempt to give the effect of jade. Chinese porcelains were widely imitated in the West in the seventeenth and eighteenth centuries.

Japanese potters were inspired by sophisticated Chinese and Korean porcelains, but they also developed *raku*, a simpler, coarser earthenware and stoneware, one of several kinds of ware appropriate for use in the tea ceremony, which stressed simplicity and love of nature. Raku, from the Japanese word *raku*, "enjoyment," is modeled by hand, usually in straight-sided bowls and often covered with runny glazes in colors suggesting nature—brown, light orange, dull green, and straw. The calligrapher and painter Koetsu (Hon-ami Koetsu, 1558–1637) made raku tea bowls that are highly prized by connoisseurs [8.18]. Today hand potters make use of traditional methods, some of which were ignored for years because of the Western emphasis on industrialization.

TEXTILE ARTS

One of the most ancient and widespread arts is the process of interlacing horizontal and vertical threads, called **weaving**. To weave cloth, whether by hand or machine, a loom holds taut lengthwise threads, called the **warp**, and a shuttle carries crosswise threads, called the **weft, woof**, or **filling**, in and out between them. Fabrics were traditionally made from natural fibers such as animal hair, cotton, linen, or silk. Today artificial fibers, including rayon, fiberglass, nylon, and polyester, are used alone or in combination with natural fibers.

The fibers used and the types of weaves determine the weight and texture of the cloth produced. There are three basic types of cloth weaves. In **plain weave**, the simplest and strongest, the filling yarn passes over one warp

8.18 Hon'ami Koetsu. *Teabowl named Mino-game.* Japanese, Edo period, early 17th century. Glazed clay, 3-7/16 × 4-15/16" (8.7 × 12.5 cm). Courtesy of the Freer Gallery of Art, Smithsonian Institution, Washington, D.C.

thread and under the next, as in broadcloth, burlap, muslin, or taffeta. In **satin weave**, or **floating-yarn weave**, the filling yarn floats over several warp threads at a time, producing a lustrous surface. In **twill weave**, which is also strong, warp and filling yarns are interlaced in broken diagonal patterns, as in gabardine and denim. Other types of weave include **tapestry weave**, a plain weave in which the weft makes little irregular patches of color, and **pile weave**, in which the weft forms loops, which are cut so as to make a soft, even surface, as in velvet.

By using different kinds of threads, threading the loom in different ways, and varying the way the weft is interwoven, weavers can create an almost infinite variety of fabrics, ranging from rough, sturdy wool cloth for workers' jackets to very delicate cotton muslins and rich, figured silks for the most expensive garments. Egyptian tomb paintings show cloth stamped with designs as early as 2100 B.C. For generations, Native Americans, such as the Mixtec of Monte Albán, Mexico, have woven fabrics on hand looms, perpetuating the ancient geometrical motifs, which seem to accent the horizontal and vertical structure of the weaving [8.19]. African peoples have decorated their textiles for centuries, using many different processes. Adinkera Cloth from Ghana is produced by the Ashanti using various

8.19 Fabric on hand loom. Oaxaca, Mexico. 1971. Wool, 19 × 34" (48 × 86 cm). Collection of the author.

8.20 *KAIN PANJANG (LONG CLOTH)*, CENTRAL JAVA, DETAIL. BATIK, ENTIRE WORK: 3'5-3/4" × 8'6-1/8" (1.06 × 2.62 M). THE TEXTILE MUSEUM, WASHINGTON, D.C., 1977.18.

8.21 ADINKERA CLOTH. ASHANTI, GHANA. PRINTED IN BLACK DYE WITH VARIOUS STAMPS MADE FROM PIECES OF CALABASH. REPRODUCED BY COURTESY OF THE TRUSTEES OF THE BRITISH MUSEUM.

small patterns printed in repeated motifs in black dye with various small stampings cut from pieces of calabash [8.20].

In block printing, the oldest fabric printing process, a design is cut in wood and a colorant applied; the block is then pressed against the fabric, with the raised surface of the block printing the design. Each color requires a separate block and separate printing. Precise registration is important, so designs are usually simple and colors are limited. Both batik and tie-dyeing are old methods of ornamenting fabric that have been revived in recent years and used to create wall hangings as well as fabrics for clothing.

In batik, melted wax, which resists dye, is used to block out areas of the cloth that are to remain white or light colored. Each succeeding dye bath produces deeper colors by dyeing over the lighter colors. Batik dye may also be used for painting directly over wax-blocked areas on fabric, as in the detail of a Javanese long cloth. The impact of the piece comes from the interesting shapes and the use of negative and positive space [8.21]. In tie-dyeing, the parts of the fabric that are to remain light are tied with string to prevent the dye bath from touching them. Renaissance Europe was infatuated with brilliantly colored rich silks and velvets of complex design. In paintings of the

period, such as *The Journey of the Magi* [13.1] by Benozzo Gozzoli (1420–1497), worshippers' garments reveal finely detailed figural weaves that contrast with heavy velvets and edgings of gold or silver thread.

Weavers today combine some of the earliest techniques with others that have been developed over the centuries. Although some of the effects achieved by hand weavers can be attempted on high-speed mechanical looms, machine-made textiles are usually more aesthetically satisfying when the designer has used the machine to produce its own effects rather than trying to duplicate handwoven material. Where precise repetition of pattern is essential, few artists can operate with the speed and efficiency of a machine. Computerized color combinations can be almost instantaneous.

Silkscreen printing is a stencil process, as described in Chapter 4. Originally a hand-printing technique, silkscreen is now electronically controlled and very fast, while continuing to provide richly pigmented printed fabric. When photographically coated, a silkscreen can include today's photographic imagery in textile designs. Textiles that are one of a kind, however, such as those made by batik or tie-dyeing, remain the special province of

craftspeople. Textile designers, familiar with the properties of various fibers and weaves and the history and technique of designing patterned fabrics, may design textiles for furnishing or for clothing, a major field. Clothing design includes two important divisions: fashion and the theater.

FASHION

We usually assume that a basic reason for wearing clothing is protection from the elements, but throughout history, people have also felt a strong impulse to decorate themselves and to be distinguished from (or else made to resemble) everyone else. In the past only the upper classes were privileged to wear clothes for decorative or ceremonial reasons. Today mass production has made it possible for millions to indulge their desires to be fashionable.

The earliest wardrobes included not only protective animal skins but also body paint [9.2], tattoos [9.1], headdresses, masks [9.5], and jewelry. Later, body scarification, bloodstains, and hunting scars probably had as much social significance for the African tribal hunter as makeup had for an Egyptian noblewoman or a laurel wreath for a victorious Greek athlete. Clothing, then, was frequently linked to the wearer's status.

One of the oldest and most constant marks of status has been headgear; even if he wore little else, the early chieftain was distinguished by his crown or headdress; religious leaders in all societies have been set apart by their headdresses and vestments. Other examples of status-giving clothing are the long robes and hoods worn by academics and the wigs worn by British justices. Uniforms provide instant identification for soldiers, nurses, mail carriers, police officers, and Scouts. Modern athletes wear numbers and team uniforms on the field. For many young people, blue jeans have become at the same time a means of conformity and a status symbol, especially with a designer's label attached to a pocket. Foreign designers now also make jeans, once solely an American product, but American jeans still dominate the international market.

Since the purpose of clothing is largely social, fashion in dress has been subject to as many changes as society itself, and clothing styles express the social concerns of each period. Trends often develop from the tastes of a social elite, whether an eighteenth-century French king, as shown in an elegant portrait [8.22] by Hyacinthe Rigaud (1659–1743), or the popular figures in today's entertainment world. Paris has traditionally been the center of high fashion, or **haute couture**, since the time of Louis XIV. European influence, however, is not so dominant in American fashion today as it was thirty years ago. Outstanding Americans have replaced our dependence on elegant imports with new appreciation for American styles.

A common characteristic of contemporary clothing design is that it generally conforms to the shape of the body that wears it. The awkward hoop skirts of the Victorian era are echoed nowhere in today's comfortable, active clothing. The same considerations of color, balance, line, and texture apply to dress as to any other well-designed article. Clothing, like sculpture, is to be seen from all sides, a fact that the designer must always keep in mind. But, in addition, since clothing is seen in action, gathers of cloth should be designed to emphasize the rhythmic flow of the figure.

Did you know that there is no form of clothing worn today (with the possible exception of underwear and jumpsuits) that did not exist a thousand years ago? For example, cloaks, tunics, and sandals date from early peoples before Christ; trousers were worn by ancient Persians, as well as by the barbarians of northern Europe; gloves and long (trunk) hose were medieval creations. Knowledge of the evolution of costume is essential to every fashion designer, partly because it often provides inspiration for contemporary clothing.

In the twentieth century, fashion has been adapted to mass production. The latest creations of top designers, hand-sewn in their workrooms, are usually modified by less exclusive fashion houses and then finally produced in

8.22 HYACINTHE RIGAUD. LOUIS XIV. 1701. OIL ON CANVAS. 9'1/2" × 6'3/4" (2.77 × 1.94 M). LOUVRE, PARIS.

8.23 *The Unicorn in Captivity (The Hunt of the Unicorn, VII).* c. 1500. Franco-Flemish, from the Chateau of Verteuil, France. Silk, wool, silver and silver-gilt threads, 12′1″ × 8′3″ (3.63 × 2.51 m). The Metropolitan Museum of Art. Gift of John D. Rockefeller, Jr., The Cloisters Collection, 1937.

quantity from cheaper materials according to standardized patterns in factories. The ready-to-wear fashion industry is a multimillion-dollar business in the United States, depending on constant changes to provide a renewed market for its products.

Theater

Like the fashion designer, the designer of costumes for the theater must also have a basic knowledge of the history of dress that should not only establish the mood and character of the individual players but also fit the nature of the total production. Theatrical costume designs must be stylized and slightly exaggerated to carry across the footlights to the last row in the house. Often the designer has to find ways to produce historical costumes with present-day fabrics and accessories that may be quite different from the originals. Within budget restrictions the designer must create costumes that satisfy the director, meet the physical needs of the actors, contribute to the mood of the play, and interact successfully with the lighting.

Tapestries

The tapestry-weaving technique, which dates from ancient times, has been used by some civilizations to make tightly woven, figured hangings (**tapestries**) that are considered a major art form. The silk tapestry of China and the wool tapestry made in Europe after the Middle Ages are outstanding. European tapestry weavers, working from a **cartoon** the same size as the intended tapestry, created intricate pictures, using hundreds of colors. These tapestries, which took years to make, illustrated religious scenes and medieval and classical legends. They were used primarily to cover stone walls of chilly medieval castles and later to add richness to royal palaces. The magnificent unicorn tapestry series at The Cloisters of the Metropolitan Museum of Art in New York is still brilliant after five centuries of use. The tapestries depict Christ as the unicorn, a complex symbol [8.23]. In the twentieth century there has been a revival of this ancient art form. Outstanding painters and sculptors design tapestries to be woven by professional hand-weavers, while a few do both—design and weave their own tapestries.

Rugs

Another important textile art is rug making, a process in which short pieces of yarn are knotted around warp threads in various ways and then sheared. For centuries, weavers in the Middle East and China have been making rugs in geometric, floral, and calligraphic designs to serve as hangings, floor coverings, and saddle bags. Persian prayer rugs of the sixteenth century [I.9] were noted for their intricate designs and rich color. Handwoven Oriental rugs have long been highly prized in the West, which has also imitated them by machine.

APPLIED ORNAMENT

Fabrics that do not have designs woven into them may have designs applied by embroidery, block or stencil printing, or by the processes of batik and tie-dyeing. These are all ancient arts that have persisted to the present day, though current materials and machine methods have changed them somewhat. The famous Bayeux Tapestry, discussed earlier [2.45], is not a tapestry but a long strip of carefully embroidered linen, intended to go around the walls of a room in Bayeux Castle. Embroidery was much used on household furnishings and garments in preindustrial Europe and the American colonies.

Enamels and Jewelry Making

In the ancient art of **enameling**, fine particles of colored glass are applied to a metal, glass, or ceramic ground and fused to it by firing. There are many techniques of applying enamel. In **cloisonné**, the design is outlined by cloisons (thin metal strips) that form partitions separating the various colors. Byzantine enamel **reliquaries** were cloisonné on gold. In **champlevé** (raised field) the ground is dug away to leave ridges forming the outlines of the design. Romanesque enamels in medieval France and Germany were

8.24 Bebe Dushey. Wearable jewelry, pendant pin. 1978. Fused, soldered, and oxidized sterling silver with large moss agate and smaller moonstone; 4-1/2 × 2-1/2" (11 × 6 cm). Collection of the artist.

usually champlevé on copper. Enamel may also be painted on metal or other grounds to achieve effects as varied as those produced by oil painting. In the sixteenth century particularly fine enamel was made in Limoges, France.

The desire to enhance the human form with jewelry is universal. Men and women of the Old Stone Age decorated themselves with necklaces and bracelets of stones, shells, feathers, and bones. The jewelry of ancient civilizations involved metalwork, enameling, and cutting and polishing gemstones. Modern tastes in jewelry range from precious gold and diamonds, often regarded as an investment, to costume jewelry in artificial materials and plastic. Jewelry by Bebe Dushey (b. 1927) reflects her obvious love for the materials she uses. Each of Dushey's designs, which balance positive and negative shapes, has also been exhibited as small sculpture [8.24]. Many artists work in enamel today, producing colorful jewelry, plaques, and ritual vessels.

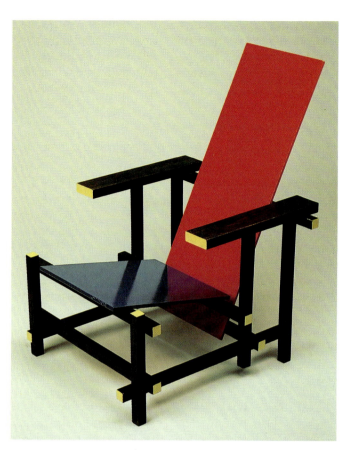

8.26 GERRIT RIETVELD. *RED-BLUE CHAIR*. 1918. PAINTED WOOD, HEIGHT 33-7/8″ (85.1 CM); WIDTH 24-1/4″ (61.6 CM); SEAT HEIGHT 12-1/2″ (31.75 CM). STEDELIJK MUSEUM, AMSTERDAM.

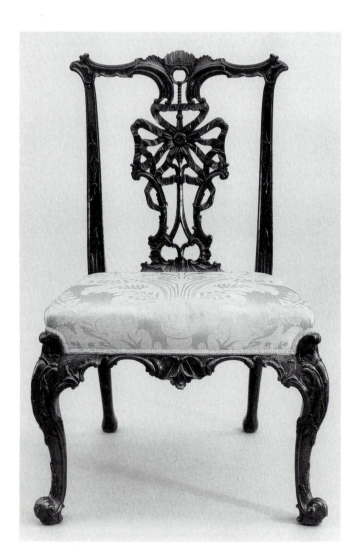

8.25 THOMAS CHIPPENDALE. "RIBBAND" BACK CHAIR. ENGLISH, MID-EIGHTEENTH CENTURY. MAHOGANY, 37-3/8 × 25-1/4″. THE METROPOLITAN MUSEUM OF ART, GIFT OF EDWIN C. VOGEL, 1957.

HOME FURNISHINGS

Wood

Wood has been important to nearly every phase of human existence. For example, in many civilizations, musical instruments, such as the famous Stradivari violins of seventeenth- and eighteenth-century Cremona, Italy, have been made of wood because of the mellow tones it can produce. The great cabinet makers of eighteenth-century Europe created luxurious furniture and floors for the aristocracy in which contrasting wood grains were inlaid in complex floral designs known as **marquetry** and geometric designs known as **parquetry**. Wood has also often been combined with metal or inlaid with ivory or shell. In China and Japan thin wood formed the bases of bowls, boxes, and furniture coated with highly polished, water-resistant **lacquer**. On the American frontier and in the religious Shaker communities of New York State, wooden furniture was simple, functional, and often aesthetically pleasing. The refined, intricate carving of the mahogany chair (with damask seat) by Thomas Chippendale (1718–1779) **[8.25]** combines

delicacy and strength. Such designs often influence contemporary furniture makers.

The reaction to excessive machine-made surface ornament probably accounted for the early twentieth-century style of severe simplicity called **De Stijl**, shown in a chair by the Dutch industrial designer/architect Gerrit Rietveld (1888–1964). An experimental design of elementary colors and cubic forms, the chair offers pioneering rectilinear plywood planes, brightly painted in red, blue, and black; the simply joined structure of the chair is totally revealed [8.26]. Artisans use wood today chiefly for furniture and accessories, such as bowls, trays, and serving implements. Their work generally emphasizes the wood grain and the **patina**, or finish, slowly built up.

The simplification of wooden shapes in a system of **modules** (units) of standardized dimensions that can be produced in a factory has allowed the mass manufacturer to produce a maximum number of coordinated variations in furnishings with minimal effort. Purchasers can rearrange modules in varied space-saving combinations to suit their own needs. Other new industrial versions of wood that have been applied to mass-produced furniture are laminated plywood and wood bent under heat and pressure. Plywoods use thin layers of wood and thus conserve wood—important as natural materials become scarce while the demand for wood products grows. Pioneers in bent plywood furnishings, Ray and Charles Eames are best known for their molded plywood chair [8.27], now considered a classic.

Metal

Metal has been used for jewelry, weapons, ritual objects, and household goods since ancient times. Because metalworking requires more complex technology, it developed later than ceramics and weaving. Each metal, ranging from rare gold and silver to common copper, tin, their alloy bronze, and iron, has different qualities that require different handling, but all are worked by the same techniques—**hammering**, **raising** (hammering a flat shape into a hollow vessel), and **casting** (see Chapter 6). Decorative techniques include **embossing**, or **repoussé** (raised work); **chasing** (depressed work); **engraving**; and **inlay** with other metals, gemstones, or enamel. Metal can also be used to cover other less expensive materials, such as wood. For example, gold hammered into thin sheets was used to plate Tutankhamen's wooden throne [8.28]. Gold and gilded silver inlaid with jewels or enamels were used in the Middle Ages and Renaissance for everything from book covers to

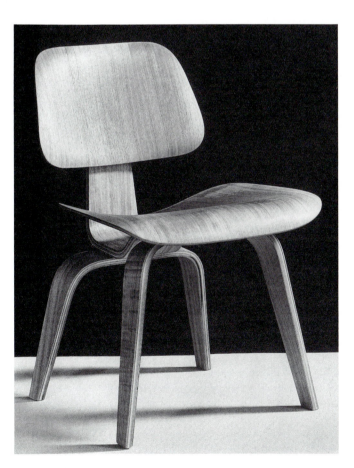

8.27 CHARLES AND RAY EAMES. DINING CHAIR. 1946. MOLDED PLYWOOD, 30 × 16 × 20" (76.2 × 40.6 × 50.8 CM); SEAT HEIGHT 18" (45.7 CM). HERMAN MILLER, INC., ZEELAND, MICHIGAN.

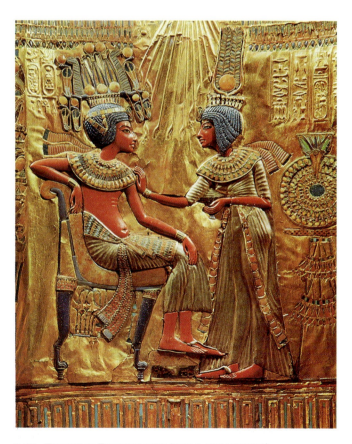

8.28 THRONE OF TUTANKHAMEN (DETAIL OF BACK REST). C. 1365 B.C. WOOD COVERED WITH GOLD LEAF AND COLORED INLAYS OF FAIENCE, GLASS, AND STONE, 41 × 25-3/8 × 20-7/8" (104 × 64.5 × 52 CM). TREASURE OF TUTANKHAMEN, EGYPTIAN MUSEUM, CAIRO.

The Artist Sketch

Internationally famous furniture designer Charles Eames, born in St. Louis in 1907, soon demonstrated the fascination for architecture and design that would occupy him ever after. Influenced by architects Walter Gropius and Ludwig Mies van der Rohe on a trip to Europe, Eames opened his own architectural office in St. Louis. At the same time, in 1936, he accepted a fellowship at Cranbrook Academy in Michigan, where he helped develop an experimental design department that became by mid-century a national center for furniture design. His philosophy led the way: "... the small, obscure, but vital bits of seemingly unrelated information which accumulate in any tradition ... in the end [will be] the details that give the product its life." His collaboration with Eero Saarinen (1910–1961), the son of Eliel, director of Cranbrook, produced for the first time ever a molded plywood chair that echoed the human body and soon became an early prototype for molded chair design.

In 1941, Eames married Ray Kaiser, moving their now joint business to California, where she had been born. While designing equipment for the U.S. Navy during World War II, Charles Eames developed one of the great chair designs of the century—a separate molded plywood back joined to a seat with plywood or

8.29 RAY AND CHARLES EAMES.

metal frames on rubber shock mounts that give the chair resiliency and comfort. The design also used new materials in a new way that could be mass-produced. The sculptural quality of the chair led the Eameses to expand the line with plastic variations that retained an organic shape. In the same year, Eames designed storage cabinets with interchangeable parts—a concept that, along with fiberglass, had never before been used in domestic furniture. The success of these designs, and others, led to thousands of "look-alikes" that serve as testaments to the Eameses' facile creativity. In 1949, the Eameses built their now-famous prefabricated home in Santa Monica. Constructed in just two days, the enclosure provided a lasting maximum space at minimal cost.

Charles' collaboration with Ray was so intensive in all their design undertakings that each one's contribution cannot be isolated. As a student of the abstract painter Hans Hofmann for many years and founding member of the American Abstract Artists, Ray's particular forte was surface design with brilliant colors—projects she continued after Charles' death in 1978. Co-recipient of many awards, the Eameses demonstrated their love of simple form and color with memorable designs that have outlived their creators.

CHARLES EAMES (1907–1978) RAY EAMES (1915–1988)

chalices (cups used for the celebration of Mass) and vessels for wine. Steel armor was often engraved and inlaid with gold. Iron was—and is—hammered into hinges or elaborate grilles and gates.

Ritual Objects Under the patronage of the Indonesian courts, dating back at least to ninth century, their highest cultural expression remains the *wayang kulit* or shadow play. Complex puppets of intricately carved, painted and gilded buffalo parchment [8.30] are manipulated so that their shadows are thrown onto a white cotton screen to act out traditional rituals that include song and poetry [8.31].

Household Objects The Industrial Revolution ushered in machine production of metal household objects in large numbers. Throughout the nineteenth century, industrial production seemed to be unconcerned with aesthetics and good design. With cheap production the

primary goal of most manufacturers, the result was manufactured articles that were often inferior in quality to handcrafted items. Excessive ornamentation, which actually became obsessive, took the place of quality. In reaction, William Morris and other designers in England launched the "arts and crafts" movement, hoping to lead society back to fine handcraftsmanship. Originating as part of the same movement was **Art Nouveau**, a style marked by flowing line, the use of symbolism, and rich ornamentation. There was also a sense of living form, reminiscent of exotic plant life such as appears in the lamp by Louis Comfort Tiffany (1848–1933) [8.32].

Due in large part to the progressive German Bauhaus curriculum of the 1930s, led by Walter Gropius whose philosophy still prevails in the 1990s. He wrote in 1919:

> ... Architects, sculptors, painters, we must all return to the crafts! ...There is no essential difference between the artist and the craftsman...

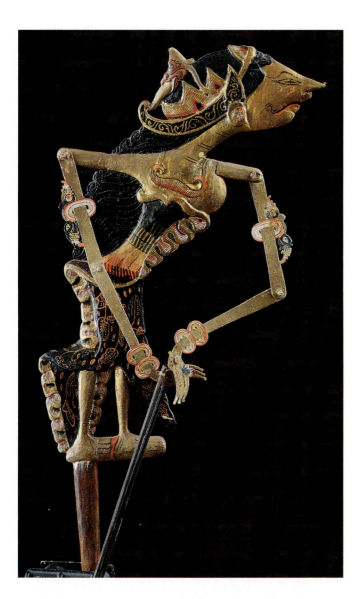

8.30 WAYANG KLITIK, PUYENGAN. CENTRAL
JAVA, 19TH CENTURY. WOOD, LEATHER, PIGMENT,
GOLD LEAF, FISH GLUE MEDIUM, RATTAN
FASTENINGS, 48.4 × 19.5 × 1 CM). COLLECTION
OF ISTANA MANGKUNAGARAN, SURAKARTA.

8.31 WAYANG KULIT PERFORMANCE, KRATON KASEPUHAN,
CIREBON, 1989.

8.32 LOUIS COMFORT TIFFANY. HANGING
"LOTUS" LAMP. C. 1905. FAVRILE GLASS
AND METAL, 31-1/2" DIAMETER OF SHADE.
COLLECTION, THE MUSEUM OF MODERN
ART, NEW YORK. JOSEPH H. HEIL FUND.

Designers for industry were trained to use the machine to create useful objects that are both aesthetically pleasing and would appeal to a broad spectrum of consumers. To the traditional metals of iron and bronze, twentieth-century designers have added aluminum and stainless steel for furniture and utensils; these metals, which can be worked by hand or machine, are particularly adaptable to mass production. An example of modern industrial craftsmanship in metal is the "Barcelona" chair [8.33] by the architect Ludwig Mies van der Rohe (1886–1969). Its fine design and honest use of materials proves again that industrially produced objects often can be as aesthetically pleasing as handcrafted ones.

The Home Today's typical house uses more than four tons of metal, much of it invisible as structural supports. Such furnishings as refrigerators, lighting fixtures, stoves, and, of course, many more rely upon metal's high tensile strength and ability to conduct heat, cold, and electricity. Whatever metal is chosen, metalworkers must consider its special properties, such as its degree of malleability, color and surface, ability to support weight, and susceptibility to corrosion. They must explore all the possibilities of shaping the metal and finishing the surface in order to create an object that serves its function as well as achieving an aesthetic effect.

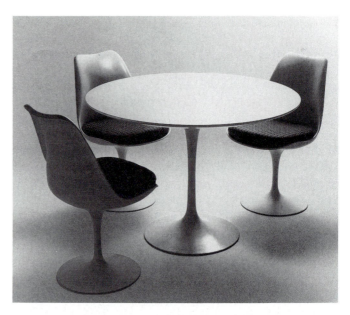

8.34 EERO SAARINEN. TABLE AND CHAIRS. 1956. MOLDED PLASTICS. KNOLL STUDIO, THE KNOLL GROUP.

Synthetics

The invention of synthetic materials has opened new avenues for design and exploration. Probably the most important synthetic products are the acrylic (plastic) resins that make up the various types of lucites and plexiglass used for furniture and other objects. Another group, vinyl resins, are particularly adapted to tools and toys as well as to working surfaces and floors in homes and offices. By using these versatile, synthetic materials, the industrial designer can quickly and economically create handsome designs for mass production, such as furniture with a unipod base [8.34] by the architect Eero Saarinen.

On the other hand, few ways have been discovered to recycle plastic totally, quickly or effectively, and as a result we are rapidly running out of places to put our discarded products. With the population pressures the world faces, artists and designers must consider potential use of products by vast numbers of people, as well as means of disposal, possible depletion of natural resources, and the power sources needed for production. What, indeed, will we leave to future generations if the industrial products we create today destroy the balance and resources of nature tomorrow? Can recycling materials be made to work?

INTERIOR DESIGN

Interiors are as carefully designed as the architectural structures that enclose them. Just as Frank Lloyd Wright believed in organic architecture—his designs evolved from the character of the site selected [7.16] and the occupants' needs for living there—organic interiors are designed for the needs of those who occupy them. Major twentieth-

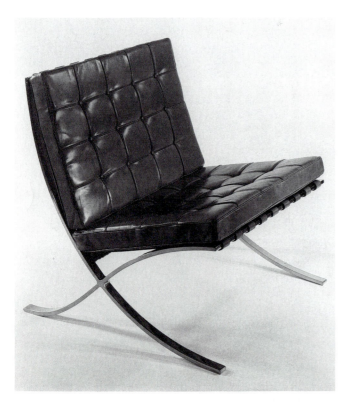

8.33 LUDWIG MIES VAN DER ROHE. "*BARCELONA*" *CHAIR*. 1929. CHROME-PLATED STEEL BARS WITH PIGSKIN CUSHIONS, 29-7/8 × 29-1/2 × 29-5/8". COLLECTION, THE MUSEUM OF MODERN ART, NEW YORK. GIFT OF THE KNOLL GROUP.

century architects are frequently involved in both exterior and interior design. The German Pavilion at the Barcelona World's Fair in 1929 by Mies van der Rohe [8.35] had a profound effect on many later architects, including Philip Johnson (b. 1906). The original source of inspiration for both men was the traditional Japanese house, which, with its sliding screens and walls, continuously modifies interior space in relation to its occupants' needs and the outside world. Incidentally, note the Barcelona chair, which made its first appearance at the fair [8.33].

The main living area of Philip Johnson's home in New Canaan, Connecticut, is a glass box that shields the interior from the weather and makes the structure seem part of the landscape. The colors of the softly polished brick floor and leather furnishings inside harmonize with the grass and trees outside. The house demonstrates clarity of structure, beauty of proportion, and carefully refined details [8.36]. While not designed for ecological balance in severe climate changes, nonetheless the glass walls permit unity and serenity of the house with its surroundings.

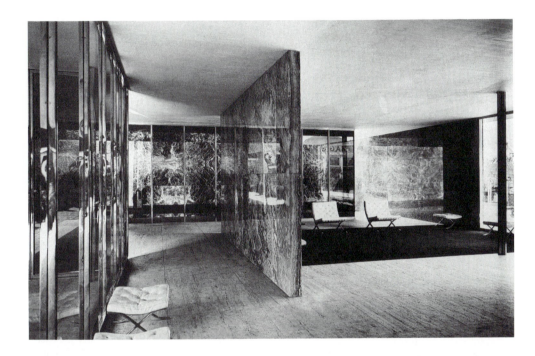

8.35 LUDWIG MIES VAN DER ROHE. GERMAN PAVILION, INTERNATIONAL EXPOSITION. BARCELONA, SPAIN. 1929. PHOTOGRAPH COURTESY, MIES VAN DER ROHE ARCHIVE, THE MUSEUM OF MODERN ART, NEW YORK.

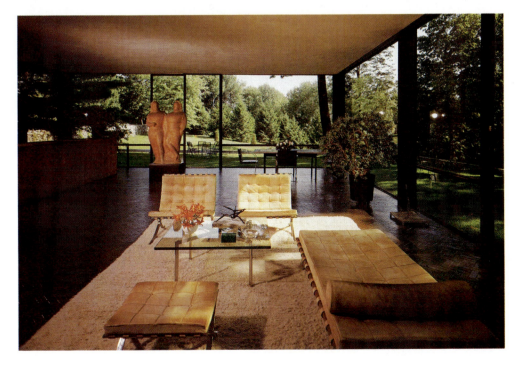

8.36 PHILIP JOHNSON. GLASS HOUSE, INTERIOR. 1949. NEW CANAAN, CONNECTICUT. EZRA STOLLER © ESTO.

Ergometrics

At least since Vitruvius in the first century B.C. wrote the only architectural treatise that survives from antiquity, philosophers have been fascinated with the human body as a source for measurement. It was observed long ago that Euclid's Golden Section—the ideal proportion, to which Renaissance theorists attached almost mystical properties—involves the human body as well as other forms of life. The overall height of a human figure relates to the distance from the floor to the navel in the ratio of 1:618, or fairly close to the Golden Section. Today, the discipline of such engineering, or **ergometrics**, attempts to apply anthropometrics, or the study of human body measurement, to our environment, from the design of consumer products and transportation vehicles to interior spaces, whether the home, office, health facility, or school. Anthropometrics is actually one aspect of the complex discipline of ergometrics, which combines psychology, anthropology, physiology, and medicine with engineering, according to one definition.

Engineering for human factors received a boost during World War II when it became very important to design sophisticated military equipment to be operated at maximum efficiency with the least possible human error. A more recent application has involved the interiors of vehicles traveling to outer space. It has become a question of devising standards of design that ensure a good fit between the individual and the environment in which people live, work, or play. Ergometrics can be called upon to meet single individual needs or the needs of people of differing races, cultures, and ethnic backgrounds. Some of the specific applications can be to determine work-surface heights in a kitchen, office, or home workshop; allowances for seating around a dining or conference table; heights for shelves in an apartment or library; corridor widths in a home or public building—all reflecting the human factor of body size. If we found ourselves squeezed into Tutankhamen's throne **[8.30]** or when we discovered that we had to crouch to enter early American Colonial rooms displayed in a museum, we might have noted that these designs did not consider changing human dimensions. Ergometrics might have foreseen those problems.

Le Corbusier, the noted twentieth-century Swiss-French architect, developed a scale system for modern architecture of the floor-to-ceiling distance based on human proportions that he called the Modulor **[8.37]**. Acceptance of his system has been slow in coming, since people resist change, even when it may be worthwhile. The next generation, however, may be the beneficiary in homes of tomorrow designed through ergometrics.

8.37 Diagram from Le Corbusier's book, *Modulor 2*, 1955. Reprinted by permission of Harvard University Press.

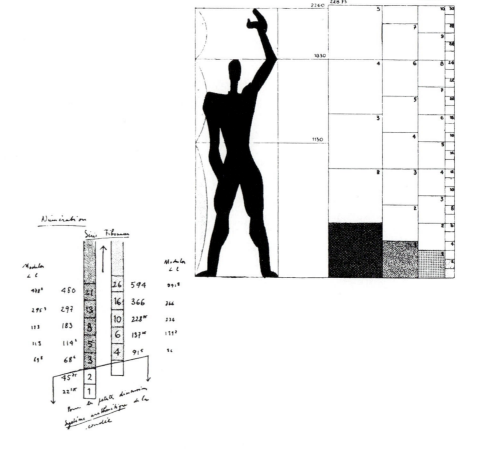

EXERCISES AND ACTIVITIES

Exercises for Research and Discussion

1. How is it possible for early Chinese writing to be pictorial? Explain fully, or demonstrate by drawing Chinese characters.

2. Define computer graphics. How are graphics by computer useful in today's world?

3. Many of the principles of design found in handcrafted products are based on the natural environment. Find examples in this book and elsewhere. Discuss the way these basic principles are applied to one specific piece of functional art.

4. Select from two to five crafts to trace from their earliest beginnings to the present. What differences, if any, do you note in those crafts as practiced today?

5. How may our environment be affected by industrial design? What effects may industrial design have on the ecology of our natural environment? What changes do you think could be made in our attitude toward the functional arts that might improve our environment?

Studio and Homework Activities

1. Design your own logotype. Determine for which kinds of business your design would be suitable.

2. Experiment with a craft you have always admired, perhaps macramé or pottery. Use a reference text on the subject, chosen from the recommended bibliography, as a guide.

3. In a spirit of adventure, investigate a craft that is less familiar to you, such as origami. Attempt some of the earlier projects listed in a book on the subject. You may be surprised at how satisfying it is to work with your hands in a new medium.

4. Using plasticene clay and a rolling pin, roll out two slabs, each about 3/8-inch thick and 8 inches square. Fold over the sides of one slab to form an open box. Smooth the corners. Shape a lid with the second slab.

5. Take a fistful of clay (almost any kind will do) and, using your thumb as you hold the clay lump, shape the piece into a small pinch pot.

Expanding the Boundaries of Art
RECENT ISSUES

"M edia, by altering the environment, evoke in us unique ratios of sense perceptions. The extension of any one sense alters the way we think and act—the way we perceive the world. When these ratios change, men change."

—MARSHALL MCLUHAN,
FROM THE MEDIUM IS THE MASSAGE

• • •

"A ll art aspires to the condition of music."

—WALTER PATER,
NINETEENTH-CENTURY CRITIC

• • •

"I am for art that comes out of a chimney like black hair and scatters in the sky.
...I am for the art of fat truck tires and black eyes.
I am for the Kool-art, Pepsi-art, Sunshine-art, 39 cents art, Vatronal art, Dro-bomb art, Vam art, Menthol art, L & M art, Ex-lax art, Venida art, Heaven Hill art, Pamryl art, San-o-med art, Rx art, 9.99 art, Now art, New art, How art, Fire Sale art, Last Chance art, Only art, Diamond art, Tomorrow art, Franks art, Meat-o-rama art."

—CLAES OLDENBURG, POP ARTIST

The recently identified term Performance Art perhaps presents some questions, especially to newcomers to art. After all, aren't all arts performances of some kind? Of course, they all are. But in our time, the traditional visual arts and the performing arts, which we contrasted as we began our studies of art in the world, are now borrowing features from one another. The dominance of performance in film and television within our culture today has heightened our awareness of the built-in connections between the two forms of art. In fact, those connections may very well go back to the beginnings of art itself, when all art consisted of a performance of some sort. If you took away the artist, the art also disappeared.

EVOLUTION OF PERFORMANCE ART

There is a history of Performance Art with traditions, perhaps, that are thousands of years old. Serving as early performances were the first "magic" rituals that explored some aspect of human life. That these were accompanied by body adornment [9.1] and handmade and decorated objects, some of which still exist today, seems likely, because, in remote areas of today's world, evidences of similar per-

9.2 SUYA INDIAN, BRAZIL.

9.1 AN INHABITANT OF THE ISLAND OF NUKAHIVA. COURTESY OF THE AMERICAN MUSEUM OF NATURAL HISTORY, DEPARTMENT OF LIBRARY SERVICES.

formances can still be found. Many believe that these earliest prehistoric dramas were the wellspring of modern theater, but, no matter how we define them, they were surely among our first arts.

The book of Ezekial, a Hebrew prophet of the Old Testament, covers a span of only twenty-two years in Babylon where the Jews were exiled in 793 B.C. According to scriptures, Ezekial "acts out" God's message, explaining that the Lord had made him mute. Of the four visions he enacted, the last presentation prophesied the siege and fall of Jerusalem. Ezekial was instructed to perform symbolic actions that involved a clay tablet around which he drew furrows in the ground and other indications of the siege. He was to appear where all could see him playing the role of God and could understand their fate. With the use of **pantomime**, a soundless performance, he demonstrated God's condemnation of them and their city.

As far as we know, such events do not happen today, but even now, in a remote area of the South Pacific, there are people who put their entire art focus into body adornment. Each color, form, and object in their rituals has a specific meaning that is universally understood and fully appreciated only by them. In a similar way, the Suya peoples of Brazil evolved lip and earlobe distension [9.2] as part of their culture, restricting the opportunity for such practices very narrowly to the upper social classes. Ritual

performances accompanied this body adornment and were observed by National Geographic teams of ethnographers at mid-century. Nineteenth-century African communities also defined rules and traditions for the tribal scarification we learned about earlier [Introduction], but we know nothing of the temporary body decorations that probably preceded those scarification patterns [1.22]; nor do we know the rituals in which they were involved. With the beginning of the twentieth century, Picasso and contemporary artist/philosopher Apollinare rediscovered for the world many of the fine religious objects created by such societies who existed beyond the Western church [1.23].

Street Performances

We have no real concept of how the performances of medieval morality plays looked when they took place in town plazas and traveled from town to town. For that matter, within the brief span of Western European art that followed, we do not know all the religious pageants that incorporated music, poetry, and costume and were performed on mobile street floats. Many believe, however, that these street works were likely to have been the only contact with any form of art enjoyed by the masses, except, perhaps, for a chance view of a distant altarpiece or a sculpture in

9.4 Audrey Flack. *La Macarena Esperanza.* 1971. Oil on canvas. 5′6″ × 3′10″ (1.68 × 1.17 m). Collection Paul and Camille Hoffmann, Naperville, IL.

church. However, it is a testament to street works' integral and continuing importance to the culture of current life that many of today's processions in Europe still feature religious sculptures that have been treasured for centuries [9.3].

It was the author's privilege to observe the *Macareña Madonna* carried down the streets of Seville, Spain, in the early 1980s to celebrate Palm Sunday. The Photo-Realist Audrey Flack (b. 1931) also came upon this life-size Baroque terra-cotta and wood sculpture made in the seventeenth century by Luisa Roldán. Flack was among the hordes of her admirers who followed the procession back to Seville Cathedral. She later painted a portrait of the statue of the Madonna that had been graced with real lace garments and even diamonds that represented her tears [9.4].

Leonardo da Vinci designed many secular court pageants, which surely qualify as art performances, at the request of his royal patrons, while, somewhat later, Giorgio Vasari (1511–1574), also created "triumphs" for the Florentine Cosimo I. An oil sketch still exists for a street procession designed by the Flemish Baroque painter, Peter

9.3 Easter Procession with "Pasos". Seville, Spain.

Paul Rubens (1577–1640). To this strong medieval tradition should be added the presentation of **mystery plays** in plazas and inn-yards, still being performed in some areas of England and elsewhere today. These art offerings have often been combined with the ancient art of pantomime. Mimes exaggerate every gesture and body movement, usually to amuse a crowd who watch time-honored themes that may include social issues of the day. Fundamentals of line, color, mass, and texture are brought into play through pantomime in diverse cultures all over the world, in particular the Far East.

In this connection, among the thousands of decorative objects preserved at the Japanese Shōsō-in at Nara since A.D. 756, described below, are quantities of wooden and lacquer dance masks. While many were used for religious festivals, just as many were involved in street performances such as the **gigaku** [9.5]. The masks are much larger than life-size with facial expressions exaggerated to permit their message to carry over considerable distances. Derived from central Asiatic dramas, their realistic effects were enhanced by the use of actual hair on the skulls, above the lips, and occasionally in the nostrils and ears. The facial expressions range from rage to laughter, from cunning to guileless. Much later, and, much more subtle, are the Japanese *Noh* masks, which also are painted to express visually the role of the wearer [9.6]. Planned for a sophisticated audience, these performances often incorporated elaborate silk brocade robes made for the principal players [9.7] and other accessories, like fans and spears.

9.5 GIGAKU MASK. NARA PERIOD. LACQUERED WOOD, HEIGHT 11-13/16″. SHOSO-IN, NARA, JAPAN.

9.6 NOH MASK, KO-OMOTE. EDO PERIOD, 18TH CENTURY. POLYCHROMED WOOD, HEIGHT 10″. EISEI-BUNKO FOUNDATION, TOKYO.

9.7 KARAORI ROBE FOR NOH PERFORMANCE. EDO PERIOD, 18TH CENTURY. SILK BROCADE. 59-1/4 × 56-7/8″. EISEI-BUNKO FOUNDATION, TOKYO.

Art Talk

The forty-fifth sovereign of Japan (in the traditional count) reigned from 724–749 during a period of considerable political strife, yet, an era rarely equalled in the time, energy, and resources that were devoted to religion. From 741–745, the capital of Japan was moved three times in succession, finally returning to Nara, a site of piety for centuries.

An ardent Buddhist, Shōmu prescribed the establishment of state-maintained shrines (Kokubunji) in every province, and, in the year 747, ordered the casting of the great image of the Buddha, as well as making generous donations of land to other temples, monasteries and convents. His reign was marked by the flowering of the arts under strong Chinese influence. The Late Nara (Tempyō) Period (A.D. 729–749) is generally regarded as the most brilliant in the history of Japanese culture.

The Great Buddha was 53 feet high, using more than 3 million pounds of copper, tin, and lead in its construction, as well as 15,000 pounds of gold. Despite the strain on the economy, the Great Buddha set Japan as the hub of Buddhism in East Asia. And, just as this universal Buddha ruled over the universe, Emperor Shōmu assumed the same control over Japan. [9.8]

In 749, the emperor abdicated in favor of his daughter Empress Kōku. Taking holy orders, he spent the rest of his life in religious devotions. Upon his death, all his personal possessions were donated by the empress to Tōdaiji, in whose treasure house, the Shōsōin, they still remain today. By the safeguarding of these art works, the treasure house may be considered the first to qualify as a repository of art—perhaps, our very first art museum.

More than 6,000 objects, ranging from weapons to musical instruments, have been stored since A.D. 756. Most of the works appear to have been made yesterday since the log construction of the treasure house "breathes" with the seasonal changes in humidity. Arranged in row upon row of chests and cases, many of the works were gifts from abroad and represent rare and exotic items. The **gigaku** mask [9.5], the *Noh* mask [9.6], and the brocaded robe [9.7] are among the thousands of art treasures, which might be described in as many pages.

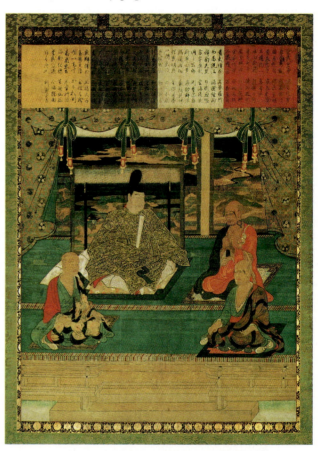

9.8 KANJO. *SHISHO-NO-MIE*. NAMBOKU-PERIOD, 1377 A.D. HANGING SCROLL, SILK, (201.5 × 153 CM). EMPEROR SHOMU PORTRAYED AS LARGER FIGURE. TODAIJI TEMPLE, NARA, JAPAN.

PATRONS OF THE ARTS EMPEROR SHŌMU (701–756) EMPRESS KŌKU (EMPRESS SHOTOKU, RENAMED)

Since the turn of the twentieth century, the artist has again often become the work of art itself. Hence the term Performance Art—an art form depending on the human body but that may also incorporate all the traditional media of the arts, such as painting, sculpture, mime and drama. The Italian Futurists—early twentieth century artists inspired by speed, movement, and the machine—were the first to stage an art *ad absurdam*, intended to flout all the accepted rules governing the arts. Their manifesto was expressed by the poet Filippo Marinetti in 1909, proclaiming a new art of "violence, energy, and boldness." Joined by other futurists, Carrá, Russolo, and Severini, they condemned the stagnation of outdated museum art palaces in favor of energized city arts that might spring from day-to-day living in the real world.

Their improvisational skits ridiculed the formal arts of the academic world and inspired another radical movement shortly thereafter, also made up of poets, writers and painters. Meeting in Zurich, Switzerland, and calling themselves **Dadaists**, they opposed involvement in World

War I. One of the group, Jean Hans Arp, maintained that, " ... while the thunder of guns rolled in the distance, we sang, painted, glued and composed for all our worth. We are seeking an art that would heal mankind from the madness of the age." Some of their Performance Art, documented by the camera, reveals the artists strutting like mechanized dolls, perhaps to symbolize a society that seemed to prefer mindless machines marching off to war to creative, thinking artists.

Carrying these ideas still further during the 1920s, on the stage of the German Bauhaus School of Design, arts Professor Oskar Schlemmer combined painting and sculpture in a formal Bauhaus Dance presentation called *Play With Building Blocks*. The goal in this case was to point to technology as the salvation for a world out of control. The momentum for art performance was established.

At mid-century, American music composer, John Cage began to incorporate elements of chance into presentations. In 1952, one of his compositions *4'33"* consisted of a performer coming from the wings to center stage, sitting down before a piano for four minutes and thirty-three seconds, getting up and retreating to the wings. The "musical" experience was entirely produced by any impromptu sounds from the audience like coughs or even catcalls. Cage's nontraditional concept of music (or theater) has influenced many performance artists.

The social climate was perhaps ripe for inventive, free-form events after the pared-down life-styles experienced during World War II. By 1960, Paris was joining in the staging of wild and bizarre spectacles such as was produced by Yves Klein in front of one hundred guests, formally dressed. An orchestra of twenty presented twenty minutes of sound, followed by twenty minutes of silence during which time three nude females rolled themselves onto wet, blue paint which they then proceeded to transfer, with their bodies, onto white paper spread on the floor. As might be supposed, an invited international press enthusiastically covered the event. The women had served as "brushes," and their body prints then existed as works of art and also as records of the event. Performance Art has become increasingly important since World War II.

Happenings

Performances that depend upon a chance sequence of events are also echoed in the **Happenings** that Allan Kaprow and Claes Oldenburg (b. 1929) were experimenting with in New York during the late 1950s and early 1960s. Kaprow was a student of John Cage at the avant-garde New School of Social Research. As a painter he became enthused, like many other artists at the time, by the **action paintings** of Jackson Pollock and the earlier demonstrations of the Surrealists, the Dadaists and the Futurists. In his view, the "Happening" might very well represent a fusion of advanced painting, the theater, and the real world. His 1961 essay, "Happenings in the New York Art Scene," reprinted by Ellen Johnson in *American Artists on Art*, describes such an event:

9.9 CLAES OLDENBURG. INTERIOR OF *THE STORE*. 107 EAST 2ND ST., DECEMBER 1961–JANUARY 1962.

Everybody is crowded into a downtown loft, milling about, like at an [art show] opening. It's hot. There are lots of big cartons sitting all over the place. One by one they start to move, sliding and careening drunkenly in every direction, lunging into people and one another, accompanied by loud breathing sounds over four loudspeakers ...

All the participants in a Happening were, in a way, trying to mimic Pollock in his desire "to be in the painting." Everyone was to be in the act. There were no bystanders. Stage properties (props) were made available, anything from bottles of catsup to art easels. There was never a script; only a premise. Each event was impermanent and unique.

Claes Oldenburg noted that what he did in his Happenings was often affected by his use of real materials that he had altered, perhaps, in their size or by the materials he used to make them. His events might take place in a grim alley or in his own studio-loft. *Store Days I* was the first presentation he made in *The Store* [9.9] he was renting in any of three adjacent rooms: Room 1, *The Bedroom—Jail*; Room 2, *The Kitchen—ButcherShop*; Room 3, *The Living Room—Funeral Parlor—Whorehouse*. The costumes, properties, and furniture were all made by Oldenburg (or his wife) and were related in some way to the sculptures he was creating at the time.

Painter-printmaker Robert Rauschenberg observed that happenings were creations that developed "in the gap between art and life." Kaprow agreed, also predicting that artists of tomorrow would all be multimedia artists, not restricted to painting, but finding unheard of themes in unexpected places. As we shall see, the following decade confirmed that Kaprow was right.

Born and growing up in a tiny town in a Celtic and Catholic community in north Germany, near the Dutch border, Joseph Beuys demonstrated a unique imagination, even as a child. Before his teenage years, he played the fantasy role of a shepherd, carrying a small staff as he roamed the fields. While he pretended a herd was ambling behind him, he took notes and samples of the flora and fauna he encountered on the way. With the help of young friends, he set up a tent-display of all his finds—a kind of premonition of things to come.

Later, joining the Hitler Youth, he served in World War II. On a German airplane mission, his JU-87 bomber nosedived into the snows of the Crimea, just east of Germany, where he was eventually found by Tartar shepherds. They wrapped him half frozen in layers of animal fat and felt to keep him alive and protect him from the searing cold. After his recovery, he began to include fat and felt items in his works of art as emblems of regeneration and thereby as visual metaphors for the healing and transformation he believed Western society needed after the war was over. From 1947 to 1952, he turned to painting and sculpture as the focus of his life.

The foundation of Joseph Beuys's reputation was established in 1961, after he replaced his professor of sculpture who was retiring from the Düsseldorf Academy of Art. His first major work of performance art was part of the Festival of New Art held at the Aachen School of Technology and sponsored by Fluxus, the international association of radical and Surrealist artists. The program titled *20 July 1944* recalled the day of the failed assassination plot against Hitler and caused an instant riot and national notoriety for Beuys. From that incident forward, no longer politically naive, Beuys transferred the nature of his commitment from the making of art to the staging of art.

No artist in the 1960s and 1970s better understood or achieved the potential of performance art than Joseph Beuys. Many still see him as a larger-than-life teacher-guru who may have been the most influential visionary in the last quarter century. At Düsseldorf's Schmela Gallery, he staged his most poignant performance in *How To Explain Pictures To a Dead Hare*. Alternately sitting, then striding around an empty room (his head coated with honey and gold leaf), he persistently murmured to the dead hare, cradled in his arms. While the audience strained to hear the communication, the sound system was intentionally kept at very low volume. Beuys later explained that he was intent on emphasizing the inherent barriers between art and the viewer.

Beuys toured Europe and finally the United States. Charismatic in his performances, he usually included a blackboard and chalk marker on which he scrawled his enigmatic graffiti and landscape jottings. Generally he introduced fat and felt into his artworks to emphasize that the process of art, like life, is ongoing while the materials are decaying. His presentations stressed that all creation is connected to a single flow of energy. No one who saw him disagreed.

Beuys' desire to cut across the barriers of media in creating environments has made his work virtually impossible to categorize. Adrian Henri, poet, writer, and painter, for whom Beuys may be somewhat of a hero, has characterized the artist, in his book *Total Art*, as something of an enigma, "Beuys certainly possesses an extraordinary charisma, simultaneously shunning the art press while courting it. Equally, his whole life is an artwork, of which the actions and objects are only the islands that show above the surface." Beuys's major piece in the Edinburgh Festival's 1970 exhibition combined some of the elements for which he has become best known. *The Pack, 1969* included a VW van. From the open back of the bus tumbled a series of little wooden sledges, each holding a roll of felt, a lump of fat and a small headlight.

One of his best-known performances in 1974 incorporated the widest range of materials, including live and dead animals, felt, fat, honey, rope and a tape recorder. *Coyote: I Like America, and America Likes Me* **[9.10]** involved the artist's week-long confinement with a coyote in a New York art gallery. He explained his philosophy himself:

I take this form of ancient behavior as the idea of transformation through concrete processes of life, nature, and history ... to stress my belief in other priorities, and the need to come up with a completely different plan for working with substances.

Beuys remains a pivotal figure in Performance Art and was a major influence on world art after World War II.

9.10 JOSEPH BEUYS. *I LIKE AMERICA AND AMERICA LIKES ME*. ACTION, 1974. RENE BLOCK GALLERY, NEW YORK.

ART AS ENVIRONMENT AND INSTALLATION

By mid-century, art was once more invading politics. It was streetwise; freed, to some extent, from academic limitations, art often merged fantasy with reality in its presentations. Further developing the practice of combining real objects with painted backgrounds, such as had been introduced with the two-dimensional Cubist-inspired collages [2.31], a three-dimensional medium called **combine art** emerged. As the name implies, this art form demonstrates the fusion of reality with a painted environment and, in effect, questions the nature of art itself.

In December 1961, Claes Oldenburg opened *The Store* [9.9] on East Second Street in New York City for which he made plaster replicas of food, stockings, shirts, etc., displayed on counters and shelves and available for purchase. Open for two months, Oldenburg maintained inventories and balance sheets. Subsequently, every environment created by Oldenburg has been conceived independently. His materials have changed from cardboard to plaster to vinyl and other assorted surfaces, ranging from soft to floppy to shiny or rough to stuffed or hanging sculptures. His works are important for their formal originality.

The real twentieth-century pioneer in environments and Performance Art remains Joseph Beuys.

Some environmental art may run the gamut of life-size fusions of painting with reality like Rauschenberg's *Rodeo Palace* [3.30] and re-creations of reality through which plaster or polyurethane figures can proceed in space like Carole Feuerman's, to total environments such as Ed Kienholz's *State Hospital* [I.16] and fantasy spaces that originated only in the artist's imagination. With such a mirrored space as *Room 2* [9.11] endlessly repeated, Lucas Samaras seduces the viewer into a boundless world without

seeming dimension. He encourages the human spirit to soar past horizons that could never be seen.

The possibilities of multimedia environments have hardly been tapped. In the 1950s, artists like Nicolas

9.11 LUCAS SAMARAS. MIRRORED ROOM. 1966. MIRRORS ON WOODEN FRAME, 8 × 8 × 10'. ALBRIGHT-KNOX ART GALLERY, BUFFALO, NEW YORK. GIFT OF SEYMOUR H. KNOX, 1966.

Schöffer pushed toward the integration of art and science, constructing what he called "luminodynamic spectacles" in open urban spaces and parks. These were audiovisual towers that responded with light and sound to the passage of people below or to changing weather patterns. European experimentation in the 1950s also led to the establishment of other groups of artists, the most significant of which may have been Group ZERO founded by Otto Piene (b. 1928) and Heinz Mack (b. 1931). Celebrating new beginnings in art, Piene and Mack held a series of *Night Exhibition* performances in their lofts. *Light Ballets* consisted of light projected through moving perforated stencil screens, accompanied by electronic piano sounds.

Eventually established at the Massachusetts Institute of Technology in Cambridge, Piene has stated:

> Elements and technology are the means that permit the revival of large-scale artistic activities. Wind may be considered the new siccative, while fire is the new gel. Technology permits the artist to talk to many, and execute plans for many. It's time now to do more than project: it's time to act.

As dedicated as Piene to the creation of environments and performance is Laurie Anderson, who in the 1980s enveloped spectators in a pandemonium of sound and a bombardment of projected visual images, all activated by electronic equipment. Her works are highly critical of what she sees are the deficiencies of modern society. Her 1990 presentation of *Empty Places* tried to connect the real world with another world of possibility and chance. She explains her work as:

> ... an attempt to describe Dodge City, Coolsville, ... a place where 65% of the people believe in Heaven ... The visual design of *Empty Places* ... includes a series of screens that come and go and are capable of fracturing images as well as creating instant sets—the bottom of a swimming pool, the top of a building.

We who have experienced Anderson's *Performance Art* must suspect she's on target. In pushing past the traditional limits of the picture frame, or art environments, along the way, we reach art as process, that is **Concept** art. In many instances, the goal of the artist is not so much the production of a finished piece of art, but instead the process through which the viewer may be caught up in the act of forming a work of art.

ART AS CONCEPT

When the artist totally loses the boundaries between art and life, artist and work, the artist's act of painting may become the subject of the work. The most radical innovator of them all, Jackson Pollock wrote for *Possibilities* (1947–1948) these oft quoted remarks:

9.13 GEORGES MATHIEU. *FOURTH AVENUE.* 1954. OIL ON CANVAS, 152.4 × 152.4 CM). THE ART INSTITUTE OF CHICAGO. MARY AND LEIGH B. BLOCK FUND, 1961.332.

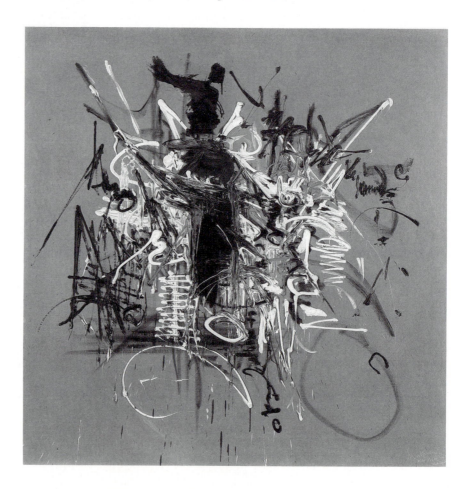

The Artist Sketch

After almost twenty years of exhibitions, concerts, and recordings, Laurie Anderson has moved to the forefront of the "next wave" of Performance Art. She is a writer, composer, inventor, photographer, filmmaker and musician. Until the emergence of Anderson, Performance Art had only appeared in art galleries, but for her special blend of visual images—sometimes films, sometimes seemingly randomly projected still images, electronic rock 'n' roll interspersed with her classical violin playing, thousands of people flock to her every presentation on the formal stage.

Born the second of eight children in Wayne, Illinois, she began studying violin at age five, eventually performing with the Chicago Youth Symphony. Not content with music alone, she moved on to a broader base of art in New York City where she earned a B.A. in art history from Barnard College and an M.F.A. in sculpture from Columbia University. In 1972, interspersing film with still photography, she and Vito Acconci, a poet-sculptor concept artist, presented "Story Shows" that also offered text with the visual images [9.12] at Artists Space in New York City. Her experiments with various media and the influence of avant-garde performers such as composer Philip Glass, writer William Burroughs, and pop musician Captain Beefheart all led her to Performance Art.

Even her early performance pieces fully met the criteria we have applied to the medium. For instance in 1973, at various public sites in New York City and Genoa, Italy, she presented *Duets on Ice*, playing a violin rigged with one of her earlier recordings, while she wore ice skates embedded in a block of ice. As the performance proceeded, Anderson described what she believed were somewhat parallel experiences in skating and playing the violin. *Duets on Ice* ended when

9.12 LAURIE ANDERSON. *EMPTY PLACES.* 1989.

the ice melted. The unexpected success of all these ventures led Anderson to a succession of grants that permitted further experiments, some of which critics wildly praised. In *Art in America* in 1983, Patricia Stewart described Anderson's *Handphone Table*, permitting listeners to "hear" prerecorded music when they closed a circuit by leaning on the table with their elbows, as "psychologically and physically a rapturously absorbing piece."

Her works now concentrate on social issues. She no longer performs directly for her audience but only through an electronic medium. Her work thus enforces the feeling of separation from contact with the performer who uses a mechanical or recording device. The author attended *Empty Places* at BAM (Brooklyn Academy of Music), presented as an almost overwhelming indictment on the role of media in our society and the shallowness of the values that are paraded before us. Anderson does not identify with the technology and its high theatricality. Rather she quotes them and in doing so maintains a distance from her material and herself. As she explains in the playbill:

Because much of what I do involves electronics and the media (locked in an air-conditioned studio, dark, alone) I myself am an extreme example of the effects of electronics on the human being … only part of the story of this work—[yet] it's the control mechanism for the multiple screens, midi instruments, film, video, and animation that make up what this work looks and sounds like … I love electronics because it's fascinating and I hate it because of the enormous potential to isolate people … My current work is an attempt to describe a series of places … that shows the relationship between electronics and human beings … a country armed to the teeth … haunted by the future …

LAURIE ANDERSON (B. 1947)

… On the floor, I am more at ease. I feel nearer, more a part of the painting, since this way, I can work round it, from four sides, and literally be in the painting …

"Be[ing] in the painting" by wielding tubes of paint instead of brushes, with jabs of paint squeezed in an accelerated frenzy, George Mathieu (b. 1921) customarily attacks his canvas in a calligraphic way, having set himself a

time limit to complete the work. In 1950, he produced on stage at Théâtre Sarah Bernhardt in Paris an enormous painting in twenty minutes. Each work bears the imprint of the process which produced it [9.13].

Perhaps the climax to a trend in the evolution of process art, wherein more attention seems to be directed to the creating of art instead of the finished work, may be the concept of art—art as an idea. Many see Marcel DuChamp

as the father of such a movement [2.46], since much of his art aimed at probing the mind with questions only suggested by the works themselves. Sol LeWitt formally defined the terms in 1969 in his *Sentences on Conceptual Art*:

Ideas alone can be works of art, they are in a chain of development that may eventually find some form. All ideas may not be made physical ... If words are used and they proceed from ideas about art, then they are art, and not literature.

RECENT ISSUES BEYOND THE TRADITIONAL BOUNDARIES OF ART

Art In Public Places

A term of recent vintage, **Public Art,** usually referring to sculpture, would seem strange to sculptors of the past. All art created for the great outdoors was expected by most of its designers to be viewed by numbers of people. Increasingly, however, through the 1960s, the Modernist art style, winding down after half a century, took a new slant and focused upon the environment. Many believe that the postwar world has seen our lands and seas overly exploited and earth's mineral resources rapidly depleted. The discards of industry present other hazards that may defy any solution. Objects now designed by environmentally concerned artists are commissioned with public funds to be set within public domain. When Public Art is ordered for a specific site that is subsidized by tax dollars, the artist today frequently finds himself or herself immersed in the very rough realm of art politics.

A successful sculptor who may have been chosen from vast numbers of competing candidates by a panel, expert in the selected art medium, might have believed that his or her responsibilities for sculpture would now range from good design and professional construction to a balanced relationship between sculpture and site. Those challenges may be fun and games compared with the reality a "public" sculptor faces. In the process, twentieth century aesthetics can often be reduced to a lackluster design that suits the lowest level of appreciation in the public at large. Many of the monumental sculptures that have appeared on the American landscape are there because of the U.S. General Services Administration's (GSA) Art-In Architecture program that allows one-half of one percent of the cost of building a new federal construction to be allocated to the installation of art designed to complement structure and site.

For the first time since the Works Progress Administration's Federal Art Project kept alive scores of artists like Jackson Pollock, as we read in his biography (Chapter 2), Willem de Kooning and others, has there been any sort of official patronage of the visual arts. Since 1972, the GSA program has encouraged both local and internationally respected figures to become involved and has been successful in almost every way.

On the other hand, cultural civic tragedies are also called to mind. Commissioned at a cost of $175,000 and chosen by a panel of "civic fathers," Richard Serra designed a 120-foot-long, 12-foot-tall, and 72-ton architectonic cor-ten steel sculpture called *Tilted Arc* [9.14], that plunged through Foley Square, New York City, regally dominating its sliver of space in front of the Federal Plaza Complex. Public complaints regarding its aesthetics, as well as its interference with a straight walk from the subway, and with jazz concerts and other events that once took place in the square, resulted in a petition of thousands of "civil servants" to remove the work.

The professional art community, including both the visual and the performing arts to just about the last man and woman, supported Richard Serra in his contention that to relocate his piece would destroy its site-specific design. There was also the matter of a contract that government officials had given to maintain the sculpture. Nonetheless, bowing in the face of almost universal civil opposition to *Tilted Arc*, the sculpture was dismantled in the dead of night at the cost of $50,000 and warehoused. *New York Times* art critic Michael Brenson repeatedly stated his regard for the sculpture as an inspiring work, flexible and subtle enough to overcome a confused, nonfunctional space. "Did removing the sculpture rescue the public-art program or compromise it?" you may well ask. Public art and the people who make it are certainly now expected to create uncontroversial work. In *The Messy Saga of 'Tilted Arc'*, Brenson put it this way:

Changes are understandable and perhaps inevitable, but they are no panacea. They will lead to art that is generally acceptable to the people who have to live with it, and some of this art is bound to be substantial. But how ambitious and independent art can be that has to make everyone comfortable is another question ... It is also unclear whether our best artists will now seek out site-specific commissions after the Government has removed a work that could only function as intended within the site for which it was made.

While *Titled Arc* was one of the most bitterly contested of all twentieth-century sculptures, it was by no means the only watershed work of public art that created wounds that will not heal. Installation of a Vietnam War memorial proved as controversial as the war itself had been. A fund was established in 1979 to erect a national monument with private, nonpolitical donations to those who had died in the war. Congress voted to provide land that was approved by President Jimmy Carter. The Veterans of Foreign Wars (VFW) set two requirements: 1) the names of all 57,939 Americans lost in Vietnam had to be engraved on the memorial, and 2) the design was to harmonize with the existing Washington and Lincoln monuments. The plan of a young architectural student from Yale University

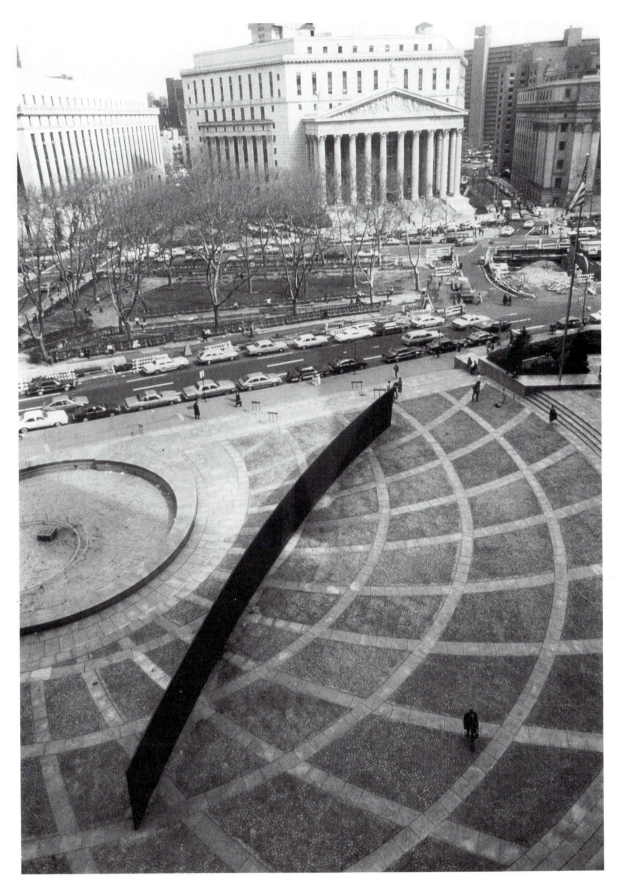

9.14 RICHARD SERRA. *TILTED ARC.* 1981. COR-TEN STEEL. 12′ × 120′ × 2-1/2″. INSTALLED FEDERAL PLAZA, NEW YORK. GENERAL SERVICES ADMINISTRATION, WASHINGTON, D.C. DESTROYED MARCH 15, 1989, BY THE G.S.A. PHOTO COURTESY THE ARTIST.

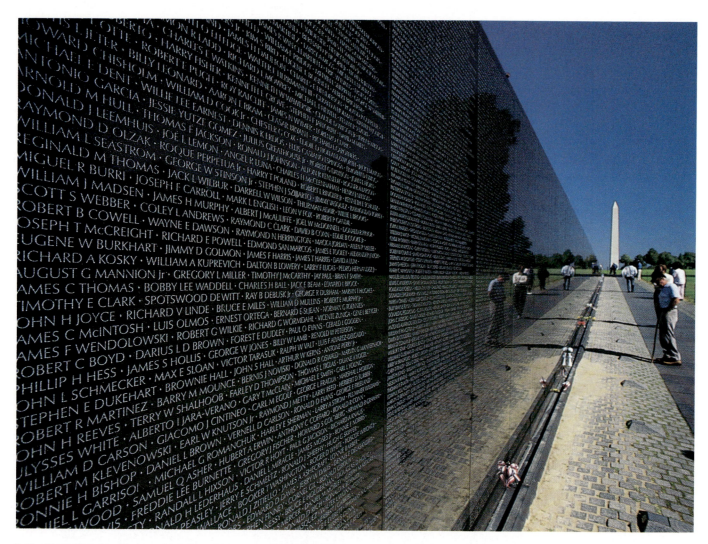

9.15 MAYA YING LIN. VIETNAM VETERAN'S MEMORIAL. 1981–1983. MARBLE EACH WING 246′ LONG. WASHINGTON, D.C.

was chosen over 1400 other anonymous entries by a panel of eight well-known architects, sculptors and landscape architects and was presumably acceptable also to the VFW, which agreed in advance.

The jury's choice was a simple design of two 10-foot-high polished black granite walls, set at an angle into a rise in the lawns. A 21-year-old Chinese-American, Maya Lin, had made the design as a class project and was unprepared for the fury of the sixteen-month veterans' response, fomented by Richard Carhart, a wounded veteran who had helped raise the funds and had even entered the competition. Calling the wall "a degrading ditch," he demanded a white memorial, but the Lin design had been legally accepted. The controversy was so bitter that Maya Lin left Yale before completing her studies and sought anonymity at a job. The veterans demanded nothing less than a realistic sculpture.

Eventually bowing to pressure, an independent agreement was reached with sculptor Frederick Hart, who

had placed third in the competition. Government agencies ruled that his figures could not be visible from the walls, and so they stand today quietly in the distance. Perhaps the most visited site on the Washington Mall, Maya Lin's Vietnam Veteran's Memorial [9.15] has attracted hosts of people, some of whom trace with their fingers the engraved name of a loved one or tearfully lay a flower at the base of the wall. There is even talk of a museum to house the thousands of mementos they leave behind.

The difficulties of satisfying vastly different aesthetics and judgments while still maintaining lasting artistic integrity lead us to the next step.

Governments, Censorship, and the Arts

What goes on between national governments and the arts round the world—outside the United States—may be profoundly different from the American pattern, but many of the underlying issues remain the same. What can the gov-

The Artist Sketch

Trained to be an architect, though not yet licensed, Maya Lin brought her innate sculptor's sensibility to the project that brought her instant fame, if not notoriety. Lin was still an undergraduate student when her design was chosen on May 1, 1981, to commemorate the fallen in the Vietnam War.

Her uncompromising **Modernist** work, established on two acres on the Mall, public ground in West Potomac Park, *The Wall* shares space with this nation's most revered leaders—a paradoxical tribute to the rank-and-file soldiers involved in a war opposed by the largest numbers of people in our history. The Mall is bordered by collections of our most treasured arts, artifacts and documents. Competition for the memorial's design was the largest ever held in America, drawing 2573 registrants and 1421 entries.

Neither sculpture nor architecture, *The Wall* evolves from the whole history of funerary monuments known to Lin through a course she had taken in funerary architecture. One end of the memorial slips into the ground, recalling the protective power associated with Mother Earth. Because the walls form the radii of a circle, inclining toward a rising slope, they recall the *dromos*, stone-lined passageways to Mycenean tombs of royalty. Thousands of common soldiers known only by name partake of the luster usually given only to ancient heroes.

The highly charged message of the Vietnam Memorial and the number of casualties is contained by the sparse design; the top of each slab, cut at an angle, provides jagged angles to balance the symmetry of each panel. Continuing in the austere tradition of the 1970's style of **Minimal** art, Lin utilized the effects of light and reflection upon the fine surface of the granite, quarried in Bangalore, India. The brilliance of the surface, and the gentle cuts of the inscriptions executed by machined engraving, permits fleeting reflections of the landscape. Interrupting the haze, we see ourselves as a part of the larger continuum. This miraculously mirrored surface binds the dead and the living, surrounded within and without by clouds and trees.

And yet, the controversy surrounding Lin's design devastated the young Chinese-American. In 1982, opponents of her design pushed through the addition of a sculpture by Frederick Hart of three combat soldiers and a flag, dedicated on Veteran's Day, November 11, 1984. Commuting each week from Yale, she persuaded officials to place the sculpture at the site entrance, away from view of the wall.

Stung by the negative publicity, she quit Yale in 1983, but returned in 1986 to complete her degree. Vowing never again to deal with a public monument, she relented in 1988 to commemorate a Civil Rights Memorial in Montgomery, Alabama, called *Touchstone*. Her designs succeed in holding a mirror not just to a single visitor but to a nation, not to an unknown soldier, but to named men and women whose deaths record the communal tragedy of war.

MAYA YING LIN (B. 1960)

ernment finance, how can the monies be monitored, and what, if any, role of censorship of art is appropriate are concerns that often distance much of the art world from the general public. The dust has not settled in the wake of controversy over exhibitions of art by Robert Mapplethorpe and Andres Serrano and the vote by the U.S. Senate to eliminate such grants for artists, who, in the words of Sen. Jesse Helms (North Carolina) "promote, disseminate, or produce obscene or indecent materials." Tacked on to the Senate's decree was a prohibition against "material which denegrates the objects or beliefs of the adherants of a particular religion or nonreligion." The question remains as to whether it would be possible to make any political art statement that will not offend someone's "nonreligion," but let us see.

A *New York Times* article on August 13, 1989, covered reports from eight other countries on the arts. Shocking to many, all show far more generous funding than the United States, such as France with its annual subsidy for artists at $1.6 billion, and Germany with support for a total of 500 orchestras, opera houses, music halls and theaters. Italian art funds of $100 billions are scattered among government agencies to maintain the performing arts, the fine arts, and the seemingly limitless number of public monuments. Germany provided millions to the arts but deliberately avoided restrictions on how the money was dispersed, perhaps because of misuse of the arts under Nazi rule when Hitler burned what he considered degenerate art. England, the minimal European art provider, is slowly moving to private support of the arts, allocating only $700 million in public funds (five times the American budget). And, on and on. Why the vast differences between American and foreign support can possibly be explained by the sophistication of cultures. Europeans have valued the arts for centuries longer than Americans, who often seem to see the arts as expendable.

9.16 DEMONSTRATION AGAINST CORCORAN GALLERY ABOUT CANCELLATION OF ROBERT MAPPLETHORPE'S EXHIBITION. JUNE 30, 1989. WASHINGTON, D.C.

The question of censorship is profound. Some American sensibilities have been rubbed raw by a tiny fraction of photographs by Mapplethorpe [9.16] shown briefly in the Corcoran Gallery in Washington, D.C. Yet, in September 1988, the very same show in Paris had scarcely lifted eyebrows, where two small panels had warned that entry to the next room might reveal potentially shocking themes. It was reported that a few families with children went no further, but no one suggested that government was remiss in financing the exhibition, which had originated in Amsterdam. After the Corcoran Gallery canceled its Robert Mapplethorpe show, protesters projected his photographs onto its exterior walls.

A crusader like the Rev. Donald E. Wildmon of Tupelo, Massachusetts, has had varying success opposing "blasphemous" Hollywood films and corporate sponsors of television programs that he believes promote violence and anti-Christian bigotry. An exhibit, partially financed by the National Endowment for the Arts (NEA) included works by Andres Serrano. Inflamed by Seranno's now infamous work showing a 13-inch plastic-and-wood crucifix submerged in yellow liquid (described by Seranno as a protest against the commercialization of sacred imagery), Wildmon set to work. He sent a letter enclosing a reproduction to every member of Congress and mailed more than one million anti-NEA letters all over the country. Before long, he was joined by Helms.

Suddenly, the art agency's reauthorization hearings for its annual, limited $170 million became a circus attended by Congress and the media. Close to one hundred of some of our most esteemed writers, artists, and theater people testified in support of unrestricted Endowment funds. Some of their comments are recorded below:

> The issue may be a radical conservatism that wishes everyone organized in a single mold that conforms to its own "righteous" ways ... Artists are not marginal to society, unnecessary luxuries that society need not support. On the contrary, the work of artists in every medium provides jobs for others ... Putting legislative restrictions on artists' output, whether it be literary or visual, is like printing a dictionary with certain words deleted or setting out a palette with colors struck from the spectrum ...

> If this is a nation that must permit any racist candidate with enough supporters to run for government office or will allow anyone, even a potential maniac, to purchase a semi-automatic weapon without delay in the interests of freedoms supplied by the Bill of Rights, it seems odd, at the very least, that it must bridle its artists to avoid the possibility of offending someone who indirectly supplies tax dollars. Most of us believe that we give up a direct hand in how our taxes are spent when we elect officials for a term of office with the right to "spend our money" without asking for our direct approval for every decision. Until the next election, we can only assume that our representatives in government, acting in our behalf, are guided by more privileged information than is given to us when their views run counter to our own. If we believe in that democratic process, then, we should also accept the decisions of duly se-

lected professionals who monitor art, in preference to partisan, untutored opinions about "public" art.

The real question may remain, after all, not whether any art is, or is not, offensive to some and requires censorship, but whether the arts, when unrestricted, contribute a natural resource as critical to society as our oil supply or our timber.

The Art Market

The enjoyment of works of art is the best reason to collect art, but it is only the beginning. No matter which end of the market we tap—the artist, the collector, the dealer, the museum or gallery director, the scholar, art historian, IRS investigator, accountant, lawyer, art appraiser, art insurer, art restorer, the framer, or just someone who has an interest in art—this may be the best of times to collect art. For all who wish to be involved in art, Andy Warhol had some advice: "Business," he said, "is the step that comes after art, and good business is the best art."

Today's collectors, whether they are millionaires looking for investment opportunities or the person who simply wants to live with artwork, all will develop a passion for what they like and a discerning eye governing their choices. Despite the soaring prices, people are building good collections by looking and listening long and hard. The aesthetic judgments of beginning collectors may shift as their knowledge grows. Every collector believes that he or she buys art for the love of it, but the lure of rapid appreciation—aesthetic and financial—and the prestige that goes with both, no doubt has always attracted collectors from as far back at least as the Roman Emperor Hadrian who bought Greek art and some Egyptian pieces. The fact is that because the art world has drawn so many people to it, prices have always gone steadily up. Financial analysts say that people with large stock portfolios continue to inquire about art as an investment and a hedge against further market turbulence.

At the same time, the art market follows identical patterns as the global economy, pulling away from the soaring pricetags of the 1980s that were given to established artists. Yet there are many more fine works of artists presently unknown that may not be sold at all. New York is no longer the exclusive center. Tokyo has opened its doors to international auctions where, judging by the recent sales, the stakes are still high. Spain has blossomed into a new art center, attracting dealers and collectors. All can plug into the same global marketplace through telephone and fax networks that reproduce almost photographic quality.

The art industry today uses business systems more complex than were imaginable when people were able to uncover art they loved on a voyage of their own discovery. In certain fields, a trusted expert has become essential. *Ars gratia artis*, art for the sake of art, as proposed by James McNeill Whistler a hundred years ago, has given way for many to collect art for profit's sake. When a collection is being formed, large or small, some or all of the following

areas will have to be addressed: 1) art appraisal including authentication 2) art insurance 3) conservation and restoration, the issues we will discuss next.

Authenticity, Conservation and Restoration

Buying art was once a fairly simple procedure, but "I know what I like" is no longer sufficient preparation for an art purchase. Ask any art dealer whether he or she has been ever taken advantage of by an art representative selling a work and you'll find that the best forgers can fool even experienced dealers.

Authentication A forger will provide whatever collectors are looking for. We must question those who sell "family heirlooms" on the street, especially by peddlers in foreign countries, who assume our ignorance of their language extends to our lack of expertise in the art they are selling. No matter where we buy art, flea markets or established galleries, we should know more than what we like in art.

With a painting, perhaps examine the back of the picture as well as the image in the front. Note gallery stickers and any writings. Even a signature can be forged or duplicated, and revealed when compared with others by the same artist. Initials may identify a minor artist rather the artist we think we are buying. Brass nameplates on a frame are no guarantee of authenticity, and official-looking documents may simply be photocopies that have been altered.

Appraisal A professional appraiser may use any of the technological aids below to aid in restoring art masterpieces or to analyze works whose origins may be in question, as well as to conserve existing art. Prints are easier to forge than any other medium of art because only pencil signatures are used. When photographic reproductions of well-known works are marketed as hand-pulled originals, only an authority can verify the work. In the pricey world of art, *caveat emptor*, let the buyer beware!

Art historians are calling more and more on scientific procedures that involve new technological skills. In brief, some techniques:

Cross-Section Analysis: Under the microscope, a paint fragment may reveal a cross section of several paint layers that can identify an artist by the characteristic manner in which the artist applied each layer of paint or varnish.

Pigment Analysis: Chemical, x-ray, and other analyses of paints may pinpoint the area and time of their use.

Infrared Reflectography: Under infrared light, charcoal underdrawings on white ground show up clearly and demonstrate the artist's preliminary sketches in preparation for the final painting.

Raking Light Examination: Side lighting reveals brush strokes, warping, cracks, and paint adherence to the surface.

Radiography: The structure of a painting can be scrutinized by x-ray. Heavy paints, such as lead, absorb more rays and yield lighter images than atomically light paints, revealing how and when each pigment was used in building up the work.

Computer Image Processing: An art image can be encoded (similar to being photographed), enhanced (weak areas strengthened), and meticulously examined by other computer functions, like magnification, color changes, and reversal of details.

Conservation and Restoration Many once-prized works of art seem to have disappeared off the face of this earth. The authenticity of other works in major world museums, some treasured as recently as mid-century, have been called into question. Further, a few paintings are literally flaking off prehistoric cave walls where they had been safe for thousands of years. In all of these cases, it is only the efforts and skills of current technicians that can validate a work in question while determining the best procedures to follow in caring for the art we have inherited.

In the past, many of our archaeological reconstruction efforts were based on inadequate data, such as Sir Arthur Evans's misguided rebuilding of the Palace of Crete. A love for art is not the only factor that may determine the accuracy of a restoration. The disrepair of the Sistine ceiling paintings by Michelangelo sparked the debate of the century (see Chapter 3). The years that have been devoted to the cleaning of the paintings are not universally respected by all art historians, some of whom feel the restoration may have altered the artist's original intent. For many similar reasons, some critics of the massive restoration of film classics (not to speak of the whole colorization process designed to make black and white film classics more palatable to a generation nourished with color) are opposed to film reconstruction (see Chapter 16).

In other cases, it is only modern technology that has permitted authentication of the artist's approach to a work, such as Manet's *The Dead Toreador* [2.23]. Without x-ray analysis, we could not have determined the artist's earliest plans for the larger painting, which he later cut into two works. But what about art of the twentieth century? The preparation demanded of painter-craftspeople in the Renaissance is no longer desired today or even provided.

Beginning perhaps with Marcel Duchamp's *The Bride Stripped Bare by Her Bachelors, Even (The Large Glass)* [9.17], some modern art is not likely to survive long enough ever to be considered old masterpieces. The improperly packed glass work by Duchamp was discovered to be cracked some time after it had been removed from the Brooklyn Museum, where it had been exhibited at the International Exhibition of Modern Art in 1926. Duchamp's reputed reaction, "All the better," hinted at a carelessness about the making and preservation of art that seems to persist to this day.

Gone is the era when artists spent years in apprenticeship to learn all fundamentals of the preparation of painting surfaces, as well as the production of art finished for posterity. The very quality that makes some modern art so exciting to its viewers is its experimental nature—its violation of the traditional rules. Artists like Jackson Pollock shocked the art world by pouring house paint onto canvases that were neither stretched nor prepared for long life. Jean Dubuffet mixed bread crumbs and pieces of grapefruit rinds with his paint. Contemporary German artist Anselm Kiefer has glued bunches of straw onto his paintings. Arthur Page, a Washington conservator, says, "Everyone acknowledges that in painting conservation, the most difficult problem we have is with modern paintings." Certainly, few are designed for eternity.

The *Wall Street Journal* assures us that the modern art market is in no way diminished by conservation concerns. That Willem de Kooning was suspected of mixing mayonnaise into his colors and Mark Rothko combined oils, acrylics, and substances like raw eggs in paint did not prevent collectors from spending almost $2 million each for their works.[1]

The techniques of conserving impermanent arts vary with each problem, but few conservators are able to make enduring art works of those planned, it would seem, for obsolescence. Denise Domergue, president of the Los Angeles-based Conservation of Paintings, Ltd., recalls the replacement of a deteriorated cigarette butt that Pollock had incorporated into one of his paintings. "Somebody had to smoke a Camel down, bend it into the right shape and stick it back," she reported.

Museum temperature and moisture-control technological devices are a help, and Plexiglas boxes (rarely approved of by the original artists) protect some vulnerable surfaces. But who is to safeguard works against physical abuse by a few viewers provoked by Modernism? Even with guards hovering nearby, Ad Reinhardt's black paintings had to be rehung ever higher out of the reach of smudging fingers!

The restoration of sculpture and architecture perhaps present the most difficult problems of all. The torrential rains of 1966, along with four to ten feet of mud deposited by the swollen rivers onto many sections of Florence, also washed off the paints that had been applied by some unknown hand to a work by Donatello in the 1440s. The restoration of *St. Mary Magdalene* [6.10], in this case, returned the figure to its original state (Chapter 6).

One of the most cherished architectural achievements in Western civilization is surely the Parthenon, yet fumes each year from the automobile exhausts rising up to the temple from the city of Athens below are causing the temple to deteriorate faster than one thousand years of wear and tear accomplished. Let's hope current reconstructive efforts, described in detail in Chapter 11, are more efficient than our past restorations have been. And what about the

[1]Tim Carrington, *Wall Street Journal*, January 14, 1985, p. 1.495. Marcel Duchamp.

restoration of a whole city? Is it possible? We know that maintaining the city of Venice under the most trying circumstances is like building a metropolis at the same time that we are living in it—almost impossible, yet this is what is happening to the floating city of Italy (Chapter 7).

The Role of the Museum

Art comes to life in a museum! Catalyst and cornerstone of a community, art museum buildings often illustrate the history of architecture through their structures. During the last decade, an unprecedented number of museums have

expanded, both in the construction of additional buildings, or, more controversial it seems, by designing additions to the existing facilities.

Community Cultural Center For many, the museum has become a center of community life.

Frank Lloyd Wright designed the Solomon R. Guggenheim Museum in New York with flowing curves and human proportions. The interior arrangement of the building, in which elevators carry viewers to the top so that they can walk down a sloping circular ramp to see the paintings, is frankly expressed. The top-heavy shape of the building

9.17 MARCEL DUCHAMP. *THE BRIDE STRIPPED BARE BY HER BACHELORS, EVEN (THE LARGE GLASS)*. C. 1915. OIL AND LEAD WIRE ON GLASS. 109-1/4 × 69-1/8″. PHILADELPHIA MUSEUM OF ART. BEQUEST OF KATHERINE S. DREIER.

9.18 LOUIS I. KAHN. KIMBELL ART MUSEUM, INTERIOR. FORT WORTH, TEXAS.

itself would be disturbing were it not balanced and tied to the ground by the mass of offices and library at one side. The museum was one of the triumphant achievements of genius. Its architectural status after renovation is less clear.

The Museum of Modern Art, New York's major museum of international contemporary art, is a handsome building with a pleasant courtyard and garden where people can wander or sit surrounded by sculpture. It is a haven in the middle of the city, even though the building itself, which invites us inside as we look through the glass front, had to be wedged between existing buildings. Individual projects like this can give some relief from the otherwise deadening effect of the city. In contrast, James Stirling's design of the Neue StaatsGalerie in Stuttgart, Germany, reaches for attention from speeding motorists past its difficult site on a hill. Its Modernist mixture of history is unique in its references to the many periods of inspiration. Its three main wings, accommodating gracious painting galleries, echo the Renaissance Museum nearby, yet suggest the ancients, while offering a collage of the past [7.1]

However, architects for today's museums plan for a wholly new cultural site for the community. Not just a home for art and special exhibitions, the museum is also a place to attend classes, lectures, concerts, and films. There are poetry readings and concerts in the garden; there is dining within a few feet of the museum's art treasures; and, for scholars, there is access to special collections of books. In some respects, the museum has assumed the role filled in medieval times by the church in its indirect focus—a place

for learning and a retreat when the day's labor was past. For these reasons, the 1980s were growth years for museums internationally.

The Pompidou National Center of Art and Culture [7.6], brash and almost cartoonlike in its design, was planned to satisfy many needs; it is described by its director as offering "a creative, changing, multimedia, kinetic, cross-cultural presentation of the arts of our time." Also, the lively plaza flanking it attracts street artists, folk singers, and magicians. In this sense, the magnetism of the museum perhaps echoes the distant past when the church plaza served as the site for miracle plays and other community events.

The National Gallery's East Wing in Washington, D.C., reflects this dual nature of many modern museums in its structural divisions. The art collection is separated from the newly established Center for Advanced Study in the Visual Arts, which provides space for a library and reading room, as well. I.M. Pei's design using pink Tennessee marble for its central atrium enlivened by a vast Calder sculpture, has drawn crowds eclipsing any other work of modern architecture in Washington. Visitors take a kind of joy in its energy, and sense of movement.

However, architects for today's museums, whether they plan for wholly new structures or add to existing structures, are bound to respect the local conditions, without sacrificing the aesthetic integrity of the museum as an active participant in the community. Among the many museums built since World War II, some are major architectural

achievements, but only a minority of these—Louis Kahn's 1972 Kimbell Art Museum in Fort Worth perhaps [9.18]—boast exhibition space appropriate to art. Critics of the most breathtaking museum designs, such as Wright's 1959 Guggenheim, question exhibition spaces that tend to overpower the paintings and sculptures within them. Additional problems challenge architects engaged in expansion projects for major museums who own vast storerooms of art that warrant exhibition. Such new designs must not only satisfy museum officials, but also Landmark Preservation Committees, determined to protect cherished structures, as well as their surroundings. Public interest in traveling exhibitions requires broad spaces, while high attendance demands provision for circulation of large numbers of people. Finally, the need for income-producing facilities, including shops, restaurants, or rental space such as that in the pioneering residential tower of the Museum of Modern Art, forces growing demands on the limited space of an urban museum and its designers.

Changes in recent years in museum programs and, in part, the current role of the museum have expanded audience, staff, and museum holdings to unprecedented levels. Almost all of the current controversial issues we have explored come into focus in today's museum with the possible exception of public art.

The question of censorship of museum shows is a sore issue with curators and museum directors who see their role as a balance between educating their audiences while clarifying the whole, art-historical process. Controversy, of course, builds audiences, but the risks in damaging a museum's credibility far outweigh the temptation to show only that which draws the media. Political art has become more marketable and the issues governing it swirl around both artists and the museum.

Competition between museums for comprehensive and definitive collections is most obvious when a patron of the arts chooses to make his or her bequest. Museum administrations have been known to even promise redesign of their facilities to better showcase a potential benefactor's generosity. The policy of de-aquisition was born only after mid-century and refers to a change of policy following the death of a patron. When a bequest, accepted with appreciation earlier, may make the museum's holdings repetitious at a later date, some museums have chosen to sell those works in the art market, in hopes of a better balance in their collections. Such practices must be tempered by recognizing that such sales may also discourage future donors, all of whom long for a measure of immortality, at least in the museum wing where their collection was to be exhibited.

Integral in the storing and exhibiting of art is the responsibility assumed by the museum for the authenticity, the conservation, and the restoration of the art treasures they hold. The obvious temperature controls and the security guards are only "the tip of the iceberg." Yet, with it all, robberies do occur, and an occasional maniac has damaged work.

While every museum is unique, as a group they illustrate the special problems inherent in all storehouses of art. Whether they be public, private, or university museums, each maintains the highest cultural link between the art, the artist, and the public they serve.

EXERCISES AND ACTIVITIES

Exercises for Research and Class Discussion

1. Contrast the performing arts with performance art.

2. Performance in non-Western cultures seems to be an element of most religious rituals. Can you explain this phenomenon?

3. Are there contemporary street events that qualify as performance art? Can you describe such situations?

4. Do you believe the religious rituals of your denomination can be explained in terms of performance? If so, trace their evolution.

5. Can you explain the connections between performance art and environmental art? Concept art?

6. What are some of the issues involved in art for public places?

7. Should artists be censored? In the gallery or museum? With public funds?

8. What are some of the roles in the art world beyond the artist?

9. Authenticity of art, conservation of art, and restoration—which is the most important?

10. What is the most significant function of the museum?

Studio or Homework Exercises

1. Working with other members of the class, create a performance based on a serious social issue of today.

2. Design a decorative accessory to accompany the above performance.

3. Document a street event that has influenced you, using sketch or camera techniques.

4. Working with other members of the class, design a work of art of the environment.

5. Dealing with a current social issue important to you, consider the design of a conceptual work.

10.1 STONEHENGE. C. 1800–1400 B.C. DIAMETER OF CIRCLE 97′ (29.57 M), HEIGHT OF STONES ABOVE GROUND 13′6″ (4.11 M). SALISBURY PLAIN, WILTSHIRE, ENGLAND.

Part Four
Art In Society

Art began when people first created images to express their responses to the world around them [10.1]. Our ancestors must have known fear and awe at the forces of nature, joy in the warmth of fire and the taste of food, and pleasure in sexual union. Certainly survival occupied most of their time and energy for thousands of years. These primal drives—survival, food, fertility—run as a constant thread in the art of early peoples; the need to express these themes in various ways was apparently common to all.

In the Old Stone Age, artists reflected concern with the unpredictable forces of nature. The art of later peoples expressed other universals—the crises of birth, puberty, marriage, death. In various civilizations, artists have been dedicated to preparing for life after death and glorifying gods and rulers. Later artists turned to depicting the growing middle class, and in the nineteenth century, art also began to demonstrate an awareness of the machine age and its disharmony with nature. The art of our own time echoes our concern with the impact of technology, with social issues and with the environment as well.

Although we may never know exactly what went on in the minds of artists of the past, as we try to reconstruct their societies we can better understand some of their reasons for creating art. At the same time, by examining examples of their artistic expression, we come closer to understanding the life of a people or an age and their ways of dealing with the needs and experiences that are universal.

The following chapters emphasize Western art—that is, European and American art—because it most directly affects us in the late twentieth century. But we also note the abundant artistic expressions of other civilizations beyond the influence of the West. We will find some points in common in the arts of all peoples and enrichment in the interchange of cultures.

Magic and Ritual

PREHISTORY AND THE ANCIENT WORLD

"*[I mhotep]*, master builder who causes people to live . . ."
—*PAPYRUS OF THE KINGS, RAMESSIDE PERIOD (1340–1167* B.C.*)*

• • •

"*[M ycerinus]*, King of Upper and Lower Egypt ... is a god by whose dealings one lives, the father and mother of all men, alone by himself without an equal."
—*REKMIRE, EGYPTIAN MINISTER OF STATE*

• • •

"*C heops succeeded to the throne, and plunged into all manner of wickedness. ... A hundred thousand men laboured constantly, and were relieved every three months by a fresh lot. ... The pyramid itself was twenty years in building ... no stone is less than thirty feet in length.*"

—*HERODOTUS, GREEK HISTORIAN*

40,000 B.C.	20,000	5000	2500	1000	500	100	500 A.D.	1000

THE VISUAL ARTS

c. 40,000 *Paleolithic (Old Stone Age)*
Flaked-stone tools [10.2]

30,000–25,000 *Venus of Willendorf* [1.21]
c. 15,000 *Venus of Lespugue* [10.3]
c. 15,000–10,000 Cave paintings: Lascaux, Altamira [I.2]

c. 8000–6000 *Mesolithic*

3000 *Neolithic (New Stone Age)*

3,500–3000 Ceramic Cup [10.5]
2600–2500 Great Pyramid; Sphinx [2.11]
2100 Ziggurat of Ur [10.7]
2100 Bull's Head Lyre [10.6]
c. 2000–1500 Stonehenge [10.1]
c. 1480 Hatshepsut Sculpture [10.21]
1480 Temple of Hatshepsut [10.20]
c. 1344–1365 Tomb of King Tutankhamen [6.9]
c. 1355 *Queen Nefertiti* [10.24]
1350–1205 Temple of Amun at Karnak [2.34]
c. 1300–1200 Palace of Sargon [10.10]
Winged Lion [10.12]
c. 1150 Ceremonial vessel: Shang [8.1]

1000

c. 1000 The White Lady of Brandberg [10.16]
c. 1000 Tlatilco Figurine [6.13]
c. 1000 Olmec Head [10.26]
c. 600 Tower of Babel [10.8]
c. 575 Ishtar Gate [10.9]
c. 550 Gold Pendant Earring [10.17]
504–496 Double-bull capital; Persepolis [10.14]
c. 400 Rhyton Cup [10.13]
c. 256 Great Wall of China [10.25]
210 Burial of Qin Shihuang's clay army [6.14]
c. 500 A.D. Obelisk, Aksum [10.15]

THE VISUAL ARTS

NORTH CENTRAL EUROPE; THE MIDDLE EAST; AFRICA; ASIA; THE AMERICAS

To understand our early ancestors who first carved or painted images, we assume that most lived in an uneasy and baffling world, with little understanding of the natural forces that affected them. Floods and fires, the migrations of the animals and birds on which they depended for food, and hurricanes and tornadoes were all inexplicable events to them. These natural phenomena must have seemed an expression of frightening forces over which they had no control. Their dwellings may have sheltered them from the wind or rain, but what could they do about other events that so intimately affected their lives? For example, how could they ensure that they would always have food or guarantee that life would go on?

EUROPE

The Old Stone Age

Prehistoric human beings of the Paleolithic period, or Old Stone Age (see the chronology), apparently saw no division between objects of utility [10.2] and beauty, for their world was not as specialized as ours is today. The tools and utensils they made—some lasting, others expendable—to help them hunt, cook, sew, carve, and later build were all a part of their struggle with the powers of nature and were not separated from their everyday lives.

10.2 PALEOLITHIC. STONE TOOLS. (ACHEULIEN). ST. GERMAIN-EN-LAYE, NATIONAL MUSEUM OF ANTIQUITIES.

40,000 B.C.	20,000	5000	2500	1000	500	100	500 A.D.	1000

c. 40,000 *Paleolithic (Old Stone Age)*
Interglacial Period
Emergence of Homo sapiens
　　　c. 18,000 Final Glacial Period
　　　　15,000 Evolution of bow and arrow
　　　　The Great World Floods
　　　　Migration from Asia to America
　　　　c. 8000–6000 *Mesolithic* Domestication of animals, crops and settlements
　　　　　4000–2300 Sumerian Period: Sumer Wheeled vehicles: Sumeria, China
　　　　　3000 *Neolithic (New Stone Age)*
　　　　　c. 3000–2500 Cuneiform script
　　　　　2800 Old Kingdom: Egypt
　　　　　　2000 Middle Kingdom Egypt
　　　　　　1760 Code of Hammurabi
　　　　　　1600 New Kingdom: Egypt
　　　　　　1400–600 Assyrian Period: Ashur
　　　　　　1370 Monotheism introduced by Akhenaton
　　　　　　c. 1100–1000 Phoenician script
　　　　　1000
　　　　　　776 Olympic Games founded in Greece
　　　　　　753 Rome founded
　　　　　　c. 700–c. 1000 A.D. Great Wall of China
　　　　　　551 Confucius born
　　　　　　532–465 Empire of Cyrus, Darius, Xerxes
　　　　　　457–429 Golden Age of Pericles, Athens
　　　　　　332–323 Alexander conquers Persia, Egypt
　　　　　　306–30 Ptolemaic dynasty: Egypt
　　　　　　51–30 Cleopatra queen of Egypt
　　　　　　30 Rome conquers Egypt

HISTORICAL NOTES

NORTH CENTRAL EUROPE; THE MIDDLE EAST; AFRICA; ASIA; THE AMERICAS

Tools Most of their energies were needed to survive, but, even then, they took the time to create art—**prehistoric art**. The oldest hand fashioned objects were simple tools and arrowheads, which were made by flaking stones or by carving bones. Certainly most tools were created for use, but the animals and symbols carved into some of them indicate that the need to create an image was also strong. Although the animals were probably depicted in an attempt to control the outcome of the hunt through symbolic power over the prey, we can surmise that the carver also was expressing a basic artistic need in shaping the forms with such vitality. The later, more complex weapons had barbed tips, which lodged in the body of an animal, becoming more deeply embedded when the creature struggled for freedom. Technical knowledge and artistic creativity slowly advanced as the Ice Age, or Glacial period, disappeared. Humans still roamed as hunters, but their arts extended to sculptures, paintings and engravings and they had to create tools for these activities as well. Artists worked on stone with still harder stones they had shaped by flaking; some were gouges and scrapers, some served as engravers. For drawings, they used chunks of mineral colors. For paintings, they ground the earth-colored minerals into powders that they blew through hollow river reeds onto the walls or mixed with some medium such as animal fat, to apply to their paintings. Animal bristles served as brushes.

Fertility Sculptures Sculptured stone figures, found on the floors of painted caves, apparently date from about the same time as early tools. Although most of the sculptures were female, like the *Venus of Willendorf* [1.21], a few were male, and a very few were bisexual, like an ivory bisexual image [10.3] that looks quite different when seen from the front, side, and rear. Repetitions of bulbous shapes, which link the arms, are surely sexual references. Generally considered to be fertility symbols, such images were likely used with rituals in early attempts to influence the human life cycle.

The New Stone Age

Gradually, over several thousand years, prehistoric peoples ceased to depend solely on hunting for food and turned instead to agriculture and herding animals during the Neolithic period, or New Stone Age. They also acquired the skills of making pottery, weaving, and building. As society became more complex, the caves of the Paleolithc period were apparently abandoned. It is now believed that the paintings and tools of the Old Stone Age were not seen again for millennia, until they were rediscovered in the nineteenth century.

Cave Paintings The huge boulders overlooking the caves in Lascaux, France, must have seemed overwhelming to prehistoric peoples, emphasizing their helplessness in a frightening world. Trying desperately to come to terms with the unknown, they may have believed that magical painted and carved images would help them provide for their most basic needs—food and fertility.

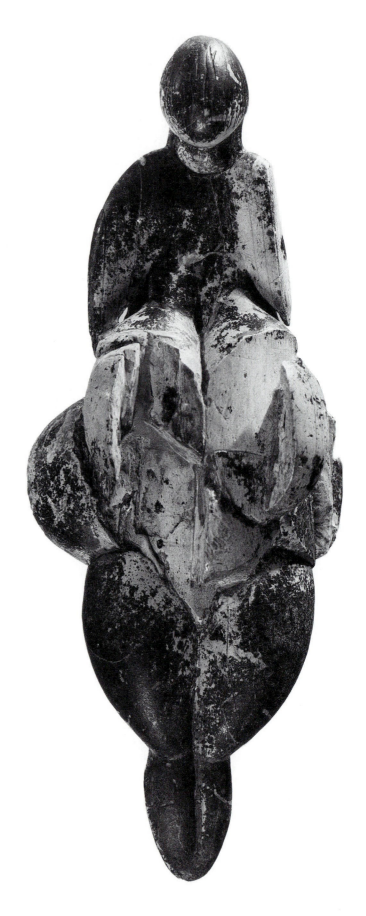

10.3 *VENUS OF LESPUGUE*, HAUTE GARONNE, FRANCE. LATE PALEOLITHIC. MAMMOTH TUSK. MUSÉE DE L'HOMME, PARIS.

For instance, the paintings of animals that cover the walls of caves in Spain, France, and North Africa probably enhanced religious rituals that associated a magic power with a painting. Images of pregnant animals cross cut with spears suggest a belief in the ritual killing of a painted image to ensure a food supply. When these paintings were first discovered in the late nineteenth century, most people believed that they had been recently created, rather than being vivid and accurate impressions of bison, mammoth, and deer made by Paleolithic artists working perhaps twenty thousand years ago. Most early time spans are gauged by a "chemical clock," based on carbon 14. Invented in 1955 as a means of accurate dating, it was noted that all organisms absorb radioactive carbon 14 isotopes that are continuously disintegrating into nonradioactive nitrogen 14. By measuring the amounts of carbon 14 remaining in organic matter, it is possible to determine its antiquity. All will agree that these works were created by early hunters who had an intimate knowledge of the animals they stalked and who used that knowledge to record their essential features with great sensitivity. Working deep in recessed caves, with torches made from animal tallow and perhaps depending on their recollection of living models seen only during the hunt, prehistoric artists must have experienced many difficulties. A visit to these caves, now lit with electricity, remains an awe-inspiring experience, which has had to be mainly restricted to scholars, due to potential damage from masses of visitors.

In the same way that animals were occasionally depicted pierced with arrows or spears, aboriginal tribes in Australia today still make drawings of prey struck by arrows, because they believe that symbolic killings will assure their success in hunting. Scholars still debate the purpose of some prehistoric images. Do they represent early scorecards used after the hunt to record success, or were they actually painted and pierced with arrows earlier? We may never know the answer. Parts of the caves are more fully covered with paintings than others. Possibly this is because new generations felt that the pictures painted by people who preceded them were sacred, and if more paintings were added to these areas, it might assure success for their own rituals. Perhaps that is why in the Lascaux caves, images of horses were painted next to a 40-foot (12-meter) painting of a cow that was already eight thousand years old. But can you guess what the geometric symbol near the animal that many scholars regard as a pregnant mare [I.3] represents? Some scholars suggest these markings may be symbolic of male and female, but we still are not certain.

Monuments in Northern Europe Little remains of the perishable dwellings of the New Stone Age farmers of northern Europe, but many of their impressive monuments still stand. Some of these megalithic structures, made of huge stones (**megaliths**) dragged from distant places, are set in careful arrangements and combinations, which must have served in unknown rituals. Brittany, in northern France, has thousands of **dolmens** (upright boulders with a slab for a roof, sometimes serving as tombs) and

menhirs (single stones) set in rows. In southern England there are circles of stones such as Stonehenge, discussed in Chapter 7, built around 1800 B.C.

The people living in Britain at that time were less sophisticated than their contemporaries in the Middle East, the Far East and, somewhat later, in Middle America, who had developed distinctive civilizations. Nevertheless, Stonehenge is evidence that its builders had precise knowledge of the movements of the sun and the stars, permitting the forecast of seasons and the best time for planting crops; the exact placement of the stones in three concentric circles ensured that at dawn on June 21, the first rays of the sun would pass through the rings of stones to strike the altar in their center. Computer analysis reveals only a tenth of a degree of misjudgment. This impressive event at the summer solstice, the longest day of the year, is enhanced by the height of the stones, more than 12 feet (4 meters), which dwarf human observers. A photograph of Stonehenge by the author [10.1] recreates the religious mood that probably surrounded it when it was in use.

THE MIDDLE EAST

Long before civilization began in Europe, probably the earliest evidences of human culture can be found in the Middle East. Persisting over several thousand years, the first successful attempts to domesticate animals and to plant crops date perhaps 7000 B.C. Fairly recent discoveries through excavations of that early period in Jericho, Jordan, unearthed a group of prehistoric human skulls filled in with plaster by ancient artists. So lifelike are the heads, there is little doubt that they were intended to perpetuate beyond death the venerated spirits of the deceased, whose remains were presumably buried beneath the floor of their homes. The people who so treasured their forebears lived in stone houses with plastered floors in a fortified town protected by the same walls we know today as those "fought" by Joshua in Jericho some thousands of years later.

Early Peoples The advanced state of agriculture in at least three regions—Jordan, Iran, and Turkey—by the eighth millennium suggests long prior development in the Middle East. The cultures fanned out from modern Jordan to the north, through modern Syria and into modern Turkey (known by the Romans as Anatolia), with the exception of Hissarlik, the site we have identified as ancient Troy. Little beyond the remains of architecture has been found. Whenever a culture arose, it was centered in the upland areas of Asia Minor, those parts of the Middle East adjacent to the Mediterranean Sea.

Houses, formed of rough stones or sun-dried bricks on stone foundations within impressive town walls and gates, were carefully laid out and consisted of two to three rooms, one behind the other with central hearths. Their floor plan was the *megaron* prototype that served as inspiration for the palaces of Greek mainland cities such as Mycenae some hundreds of years later. In the second city of

Troy, recovered by the archaeologist Heinrich Schliemann in the late nineteenth century, were hoards of gold jewelry decorated with abstract designs.

Somewhat later, Neolithic farming villages along two river valleys developed into two great civilizations in the Middle East. The **Fertile Ribbon** of Egypt hugs both sides of the Nile River [10.4]. Though it is generally only 16 miles (25.75 kilometers) across, it is nearly 500 miles (804.67 kilometers) long, from ancient Nubia in the south to the wide delta in the north where the river joins the Mediterranean Sea. Quite different in shape is the valley between the Tigris and Euphrates rivers in Mesopotamia, called the **Fertile Crescent**. Both areas had active societies around 4000 B.C. By 3000 B.C. the peoples of these valleys had begun to form larger communities and keep written records and within time became aware of each other. Precise dates are difficult to establish.

Mesopotamia

Like the Fertile Ribbon along Egypt's Nile roughly 600 miles (1000 kilometers) away, the Fertile Crescent, between the Tigris and the Euphrates, was flooded when the rivers overflowed in spring, but in summer was parched by the sun. Here, also, irrigation was necessary to maintain agriculture. Unlike Egypt, however, Mesopotamia had no natural desert barriers to repel invaders and foreign influences. Therefore, over a period of thousands of years, the whole area became the home of many peoples, and its history was in constant flux. The story is confusing, with many shifts of power, especially between the empires of Babylonia and Assyria. However, a protohistory of Mesopotamia is evident, lasting for about 2000 years. Traces of simple dwellings have been found, constructed of clay in the absence of all but minimal stone. In the south of the

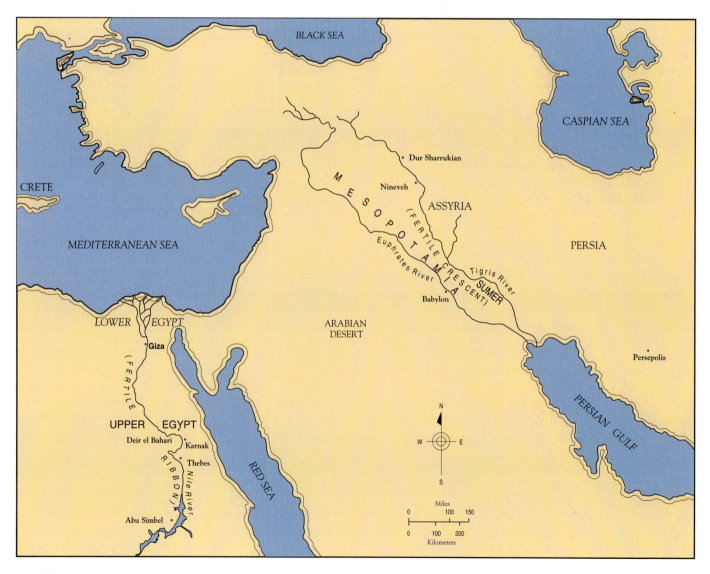

10.4 THE ANCIENT NEAR EAST.

region, ceramics were well developed and consisted of ivory-colored pottery, with abstract and geometric borders edging highly stylized animal or human figures [10.5]. At the end of this prehistoric period, perhaps around 3500 B.C., devastating waters, known to us from the Bible story of the Great Flood, covered everything, leaving in some places a layer of mud some twenty-five feet deep. We shall, however briefly, touch upon the subsequent main societies that dominated this land:

Sumer, c. 4000–2300 B.C.

Neo Sumerian, c. 2100–2000 B.C.

Babylonia, c. 2000–550 B.C.

Assyria, c. 1400–600 B.C.

Persia, c. 550–325 B.C.

Made some 4500 years ago, and buried at the Royal Cemetery at Ur in Mesopotamia, was a remarkable harp, decorated with a bull's head, sheathed in gold, with inlaid shell eyes and a beard of lapis lazuli. Images of the wild bull and the lion are frequent and appear to have

10.6 BULL-HEADED LYRE FROM UR, IRAQ. LAPIS LAZULI AND GOLD. THE UNIVERSITY MUSEUM, UNIVERSITY OF PENNSYLVANIA.

served as symbols of strength [10.6]. Persisting throughout Mesopotamian civilization are the basic achievements of the Sumerians, which later peoples developed or modified.

Sumerian Art The Sumerians were great builders. Living in a land that lacked stone and wood but had plenty of clay, they built large cities, palaces, and temples out of brick. Eventually they learned to fire the bricks and glaze them to make them more weatherproof. In trying to span openings with bricks, they developed the arch (see Chapter 7), a principle known but little used by the Egyptians and the later Greeks.

The characteristic form of Sumerian architecture was the **ziggurat**, an artificial mountain of packed earth surfaced with bricks, crowned by a temple to a god of an aspect of nature such as water, sky, or storm. The temple was believed to be the god's home. All that is left of the ziggurats today are eroded, truncated mounds of sun-dried

10.5 CERAMIC CUP. 4TH MILLENNIUM B.C. LOUVRE MUSEUM, PARIS.

10.7 RECONSTRUCTION DRAWING OF THE ZIGGURAT AT UR. NEO-SUMERIAN, C. 2100–2000 B.C.

clay brick, but an artist's drawing [10.7] shows us how the Ziggurat in Ur may have once looked, with Sumerian-style ramps leading up from terraces on all sides through archways, past gardens and trees. The structure, called the hanging gardens of Babylon, seems likely to have been a ziggurat with trees and flowers planted on its terraces. From a distance the brick ziggurat blended with the dry, surrounding countryside, but the lush greenery seemed suspended in air. Without irrigation, Mesopotamia was dry and poor. When the inhabitants tried to imagine a more desirable existence, or paradise, they thought of it as a garden, such as the Garden of Eden of the Old Testament.

The Sumerians were among the first people to have developed a written language, the cuneiform [8.3]. They also divided the hour into 60 minutes and the circle into 360 degrees, divisions we still use today. Of equal significance may be the Sumerian contribution of the wheel found on chariots in the cemetery at Ur, dating third millennium B.C., and a possible derivation of the potter's wheel even earlier.

Babylonian Art The Babylonians built cities and ziggurats like the Sumerians. Hammurabi, king of Babylon from about 1727 to 1686 B.C., established an empire and

10.8 PIETER BRUEGHEL THE ELDER. *THE TOWER OF BABEL.* 1563. OIL ON CANVAS, 3'8-7/8" × 5'1" (1.24 × 1.55 M). KUNSTHISTORISCHES MUSEUM, VIENNA.

created the first written code of laws, mainly governing property. Lawbreakers were severely punished.

The Old Babylonian Empire founded by Hammurabi was succeeded by the Assyrian Empire, which in turn was replaced by the New Babylonian, or Chaldean, Empire, which emerged about 625 B.C. The palace of Nebuchadnezzar II and the ziggurat of the great god Marduk, called the Tower of Babel, are both gone. Artists throughout history have tried to imagine how the Tower of Babel looked, but without drawings or plans of it no one can be sure. Certainly the painting by Pieter Brueghel the Elder (c. 1525–1569), set in a sixteenth century Flemish landscape peopled with workers in Renaissance dress [10.8], must be far removed from the original palace, but the Mesopotamian ramp shown in the painting remains an authentic feature.

The cultural life, as well as the layout of the city, were centered on the ziggurat and the Temple of Marduk. Glazed brick reliefs of dragons and bulls in brilliant colors lined the Processional Route (Ai-ubur-Shabu) to Marduk, which led to the Ishtar Gate, the only major monument remaining from this period, now restored and located in a Berlin museum. Dedicated to the goddess Ishtar [10.9], she originally represented the earth (and love), but, with

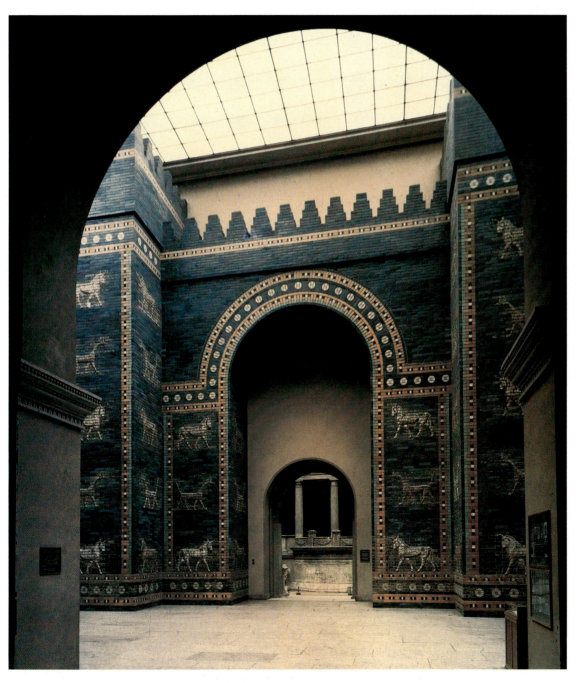

10.9 ISHTAR GATE (RESTORED), BABYLON. C. 575 B.C. ENAMELED, BAKED BRICK, HEIGHT 48′9″ (15 M). VORDERASIATISCHES MUSEUM, STAATLICHE MUSEEN ZU BERLIN, PREUSSISCHER KULTURBESITZ.

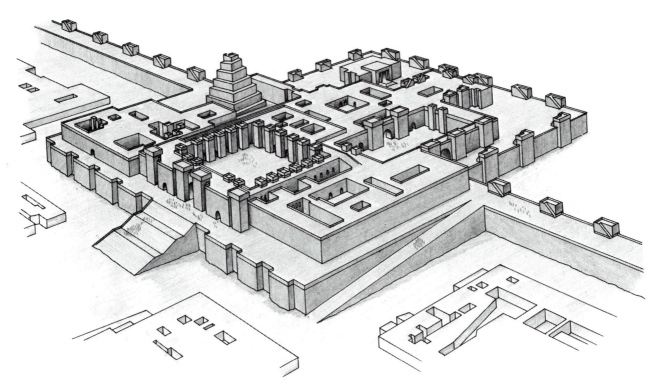

10.10 Reconstruction drawing of the palace of Sargon II, Khorsabad, Iraq. c. 720 B.C.

the Assyrians, soon became identified as the Goddess of War. The gate is faced with glazed brick and decorated with reliefs of animals, some two headed and some 20 feet (6 meters) long.

Assyrian Art The Assyrians, from the upper Tigris River, established an empire between the ninth and seventh centuries B.C. At its height, it stretched from modern western Iran in the east through Mesopotamia to Asia Minor and the Mediterranean in the west. The Assyrians built their palaces at Dur-Sharrukin (modern Khorsabad) and Nineveh (modern Kuyunik), both in Iraq, retaining Babylon in its original importance in the south. The Assyrians adopted much of Babylonian civilization, to which they gave their own distinctive character.

The Assyrians introduced no new construction methods. They built highly elaborate palaces decorated with great stone slabs carved in relief. The 200-room palace-temple complex of Sargon II at Khorsabad [10.10] is known to have enclosed 25 acres (10.11 hectares) and included a ziggurat with a spiral ramp. Unlike the huge Sumerian Ziggurat at Ur, however, the Assyrian mountain to the gods, similar to the ziggurat form, was reduced to a small temple.

The Assyrians were depicted primarily as warriors and hunters; they commissioned their sculptors to show expeditions, hunting scenes, and the lives of kings and the military. The combative Assyrian spirit is reflected in their realistic carvings, such as a relief decorating the palace of

Ashurbanipal at Nineveh [10.11]. The sculptor portrays the death of a wounded lioness, showing a strong sense of action, knowledge of animal anatomy, and even a sensitivity to the animal's pain, a concern rarely directed toward people in Assyrian art.

Many animal sculptures were nonrealistic. For example, each of the pair of stone guardians that stood at one of the entrances to the palace of Sargon II at Dur-Sharrukin has a human head, the headdress of a god, the wings of a bird, and the body of a lion [10.12]. It also was made with five legs, so that when seen from the front, it would appear to have four legs, and as one walked past it into the palace, it would still seem to have four legs. The extra leg represents an effort to make the animal appear as complete as possible. In the same way, the Egyptians drew the human figure from several points of view in an attempt to present a total image.

Persian Art The final period of ancient Near Eastern art, when the area was dominated by Persia (modern Iran), overlaps Greek civilization, and its architecture was stimulated by contact with Greece. In the case of this rhyton [10.13], however, we may note the Middle Eastern focus on the animal form apparent as we began our studies of Mesopotamian art [10.5 and 10.6]. Especially, in Persian metalwork there is clearly the same fondness for the lion and the bull and its adaptation for decorative uses. The exquisite winged lion was discovered only in 1955 and is surely one of the finest examples of Achaemenian skill.

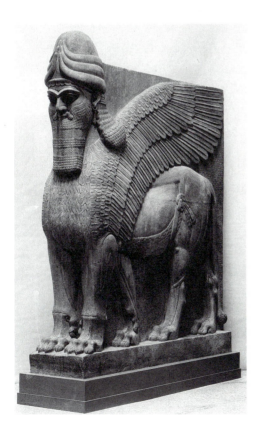

10.13 RHYTON CUP. 5TH CENTURY. GOLD, HEIGHT 6-3/4". THE METROPOLITAN MUSEUM OF ART, NEW YORK. (HARRIS BRISBANE DICK FUND, 1954).

10.12 WINGED LION (GUARDIAN OF THE PALACE GATE), FROM THE PALACE OF ASHUR-NASIR-APAL II. ASSYRIAN, NINTH-CENTURY B.C. LIMESTONE; HEIGHT 10'2-1/2" (3.11 M), LENGTH 9'-3/4" (2.76 M), WIDTH 2'1-1/2" (0.65 M). THE METROPOLITAN MUSEUM OF ART, NEW YORK (GIFT OF JOHN D. ROCKEFELLER, JR., 1932).

EXPANSION OF ANCIENT MIDDLE EASTERN ART

Our survey of the arts of the ancient Middle East would be incomplete without a brief note of outlying cultures dependent on its central traditions. Emigrating across the Red Sea from the area we now know as Southern Arabia, semitic Yemenites encountered the north African state of Aksum in the middle of the first millennium A.D. A culture derived in major part from Egypt and indirectly introduced through the adjacent Nubian Kingdom of Napata, Africa, the early Ethiopian civilization that flourished in the fourth century A.D. is known for its characteristic **obelisks [10.15]**. In form clearly derived from the Egyptian, its unique decoration, a series of stylized doors, points as obviously to South Arabian models. Future

10.14 Double bull capital and column from Persepolis (restored). Achaemenid Period, c. 522–486 B.C. Black limestone, height approximately, 13′ (4 m). Courtesy of The Oriental Institute of The University of Chicago.

10.15 Obelisk from Aksum, Abyssinia. Fourth-century A.D.

Darius, the Achaemenian Persian emperor whose effort to conquer Greece was defeated at the Battle of Marathon in 490 B.C., built a massive stone palace in the city of Persepolis. Its great halls, with roofs supported on slender 60-foot (18.28-meter) pillars, show the influence of Greek architecture. Unlike earlier Mesopotamian palaces, the Persian palace did not look like a fortress; instead, it was open and inviting with many stairways, ramps, and columned waiting rooms. Perhaps this huge capital with two noble bulls' heads placed back to back [10.14] is symbolic of the historical role played by the Persian empire; one head looks back to the civilization of the Fertile Crescent upon which much of the Judeo-Christian tradition is based, while the other head looks toward the Mediterranean and the civilization of Greece, whose philosophy and art have so strongly influenced the West.

archaeologists may yet establish this site as the final flourish of the culture and art of the ancient Middle East and the cradle of major world religions as well. Yet, to date, the earliest human remains were found in Africa, the great continent we shall examine next.

AFRICA

Many paleontologists believe that human life began in Africa, perhaps in southern Rhodesia or Kenya where the Leaky family—Lewis, Mary and Richard—have over the years found many skeletal remains of humanoids that date back 1.75 million years ago, while *pithecanthropus erectus* (modern man) is somewhat more recent. Africa is three times as large as the United States, with nearly a thousand different languages, and has produced almost as many distinctive art styles, some with traditions that persisted for a thousand years. Almost all forms of the visual and performing arts existed in Africa, and among them we might find storytellers with long-standing oral traditions, dancers and

musicians, architects, painters, and sculptors. Rulers thought to be divine governed great empires, while groups of elders directed the affairs of small tribes. We believe that the concept of the extended family, of kinship and communal support, existed long before it was found with the Portuguese invasion of the 1400s.

As African culture developed, the peoples of northern Africa, bordering on the Mediterranean, were influenced by travelers who periodically came by sea. Their racial stock and their art are in many ways more closely related to those of the Middle East than to those of the rest of Africa, south of the Sahara Desert. The art of the sub-Saharan regions, however, is considered to be indigenous to Africa, coming from traditions that were generally independent of outside influences for many millennia, until the 1500s.

Before 3000 B.C. Africans of the Old Stone Age painted animated scenes on rocks in the Tassili region closest to Algeria in the northern Sahara Desert and in the south; they were often of hunters pursuing their game [10.16]. They also depicted their religious beliefs; one

10.16 *THE WHITE LADY OF BRANDBERG. BUSHMAN CAVE PAINTING.* C. 1000 B.C. NAMIBIA, SOUTH WEST AFRICA.

The fame of architect Imhotep, during his lifetime and for a thousand years thereafter, can hardly be overestimated. He served as chief architect of the Pharaoh Zoser (Neterikhet), who was believed to be, like all pharaohs, a descendant of the sun god and the second king of the III Egyptian Dynasty—and of several successors. However, it was Imhotep whose honors and titles read like the attributes of a god, which is how he was regarded a thousand years later in New Kingdom times, when he was deified. One of his relief inscriptions carved on the base of a royal sculpture of Zoser reads: "Ye, who come in peace, [behold] the god of learning, protector of scribes and artisans." In Memphis, Imhotep was also regarded as a physician. In this connection, he was identified with the Greek god Asclepius, perhaps because in one of his representations, Imhotep holds his customary trowel that resembles a surgeon's knife. Some hieroglyphs describe him further: "Seal-bearer of the King of Lower Egypt," "Chamberlain of Seers," "Imhotep, carpenter, sculptor ..." Yet, for all these great titles, we know almost nothing about Imhotep, our only well-identified Egyptian artist. In the Papyrus (Chronicle) of the Kings from the New Kingdom period, he is the only nonroyal personage included in the royal lists. In fact, inscriptions incorporating his name can be followed through twenty-two generations of master builders to the XXVII Dynasty.

Imhotep is regarded most highly for his achievements in architecture, and is the first architect known in history. Certainly the world's first major stone constructions were his; the stepped pyramid and the great tomb complexes that followed were all supervised in part by Imhotep. Egyptians were equipped with metal tools of various kinds; they were probably the first people in the world to master the quarrying of stone and the skills required to cut and dress it into smooth geometric shapes. Perhaps without wheels but with almost unlimited human labor, they evolved ways to transport stone and construct enormous stone structures of precise design. Imhotep was perhaps the first to envision and/or supervise Egyptian construction on a large scale, and that legacy of the world's earliest wondrous stone monuments, forerunners of the Great Pyramids, remains impressive even today.

IMHOTEP (PRE-2635–2595 B.C.)

scene of a creation myth shows the first man mating with the morning and evening stars to produce all the creatures of the earth. Later peoples in West Africa came upon the abundance of gold found in mineral veins in what is now known as Mali and fashioned many gold pieces. Believed to be one of the earliest manufactured objects of gold independent of Indo-European influence, here worn by a *Peul* woman, is the gold pendant earring dating from the first millennium [10.17]. We will find a further brilliant flowering of art coming to focus in a narrow strip of northeast Africa along the river banks of the Nile River in Egypt.

Egypt

It should not surprise us to discover that Egyptian culture was confined, like the Mesopotamian, to the area nourished by the waters of the world's longest river, when we realize that the rest of Egypt, 97 percent of the country, is arid desert. The remaining 3 percent is fertile only because of the annual flooding of the waters of the Nile. For this reason the Greek historian Herodotus called Egypt's civilization "the gift of the Nile." In addition to providing water for agriculture, the Nile also was a means of transportation, communication, and sanitation for the peoples living along its banks. Finally, the wide deserts on both sides of the Nile insulated and protected the Egyptians from foreign intruders, for few invaders could survive the rigors of long desert travel.

In such a favorable environment, Egyptian civilization developed a characteristic continuity over a period of nearly three thousand years. Egyptian history is customarily divided into three main periods:

Old Kingdom, c. 2800–2000 B.C. (Dynasties III–VI)

Middle Kingdom, c. 2000–1600 B.C. (Dynasties XI–XIII)

New Kingdom and later periods, c. 1600–350 B.C. (Dynasties XVIII–XX)

Old Kingdom

Architecture Dynasty followed dynasty with little change in the customs of the Egyptians or the art forms that reflected them. We, who live in a constantly evolving era,

10.17 GOLD PENDANT EARRING WORN BY A PEUL WOMAN. 1ST MILLENNIUM A.D. MALI, AFRICA.

find it difficult to imagine so static a society, but to the Egyptians it seemed natural and desirable.

To cultivate the soil along the Nile, the Egyptians had to develop an irrigation system, which meant many individuals and villages had to work together. From such communal efforts the complex Egyptian civilization arose. Cooperation also made possible the earliest monumental architecture: tombs for the important dead.

Pyramids and Other Tombs The first architectural structure used for burial was the **mastaba**, a low, flat-topped mound with **battered** (sloping) sides. Several mastaba shapes of diminishing size, set one on top of another, form a stepped pyramid, such as that of the ruler Zoser [**10.18**]. Stepped pyramids were solid masses of rubble smoothly faced with brick or stone.

Stepped pyramids were gradually refined into smooth sided pyramids, the three most famous of which were created for three pharaohs, a father, son, and grandson of the Old Kingdom at Giza about 2600 to 2500 B.C. [**2.11**]. The power structure of Egypt centered on the pharaoh, or king, supported by the priests, who could command

10.18 STEPPED PYRAMID, FUNERARY DISTRICT OF KING ZOSER, SAQQARA. C. 2610 B.C.

thousands of men to construct the huge pyramids and the temples that accompanied them. They believed that these structures would safeguard the pharaoh's immortality.

The earliest, largest, and most famous pyramid is that of Pharaoh Khufu (Cheops). Nearby is that of Khafre (Chefren), which has a few limestone blocks at the top, all that remain of the limestone that once covered all three pyramids. The pyramid of Khafre, like the others, was connected by a causeway to a valley temple. Beside the causeway stands the gigantic sculpture of the Sphinx, representing a pharaoh in a royal linen headdress and (before weathering and vandalism) displaying the features of Khafre. A small portrait statue of Khafre from his valley temple is made of diorite, a kind of stone so hard that it would quickly dull a modern steel carving tool [10.19]. We can only assume that the Egyptians carved with tools of a still harder stone, which would be a very slow process indeed.

The architects of the pyramids tried to hide their entrances to prevent the valuables inside from being stolen, but the simplicity of the exterior surface of the pyramid made concealment difficult. No matter what pains the ar-

chitects took, robbers located the entrances, broke in, and stole the pharaoh's belongings. Apparently, even for those who believed that the pharaoh was descended from the sun god, the lust for worldly treasure was stronger than the fear of divine punishment.

Painting and Sculpture Inside the pyramids, which were almost solid mounds of limestone, earth, and rubble, were small rooms full of the rich belongings of the pharaoh, left to provide him with what his subjects believed he would need in his life after death. Another replica of the pharaoh was set up in front of the burial chamber to hold his *Ka*, or spirit, when his body could no longer contain it. The brilliantly colored wall paintings in the burial chambers give us a vivid view of Egyptian life and customs [2.42], as do the many objects found in the tombs. Jewelry, cosmetics, toys, furniture, models of houses, pieces of clothing, figurines depicting such daily events as slaves baking bread—thousands of these have survived to tell us what life was like for a well-to-do Egyptian.

Since the images in the royal tombs were meant to last the pharaoh through eternity, they were carved and painted as clearly as possible, according to strict guidelines. People, scenery, animals, and furnishings were always depicted from an angle or point of view that gave the most characteristic contour. For example, a pond or a lake was painted as if seen from above or from the side. Fish swimming underwater through the reeds and birds and trees were all drawn in profile. A table was shown from one side or from the top.

Human figures usually seem to stand in poses that even the most supple of us could never achieve. The reason for this convention was the Egyptian concept of representing details of the human body as a composite of its typical shapes. They believed that since the head was most easily seen in profile, it should be painted that way. Likewise, the eyes were shown from the front, as were both shoulders; but arms, legs, and feet were presented in profile. Egyptian art is not based on what the artists saw but on what they knew about their subjects. In somewhat the same way a twentieth-century Cubist painter showed many simultaneous views of a human figure in a composite [I.13].

Paintings in these tombs were detailed because pious Egyptians believed that the pharaoh could enjoy in the afterlife only what was provided for him in reality or replica. For example, they thought that the pharaoh would starve if foods were not depicted. Originally, the relatives brought real meals, but it was quickly found that piety is short-lived, while paintings of food are durable. Similarly, birds, plants and animals were painted so accurately that many can be identified as varieties still living in Egypt.

10.19 KHAFRE. GIZA, C. 2530 B.C. DARK GREEN DIORITE, HEIGHT 5'6" (1.68 M). EGYPTIAN MUSEUM, CAIRO.

Middle Kingdom

Egyptians continued to build pyramids as they had in Old Kingdom times, but now they were much smaller since sheer size had not proven to guarantee security for the pharaohs. New burial places were devised to protect the royal dead. During the Middle Kingdom, hidden tombs were constructed out of living rock, such as those at Beni Hasan. New Kingdom tombs, at the Valley of the Kings, for instance, were hewn out of the cliffs west of the Nile, near Thebes. Tomb entrances were concealed, with no monuments to mark the burial spot. Despite these precautions, most tombs were broken into by robbers. This meant more than the loss of the pharaoh's treasures; it also meant that he was deprived of what he needed to exist in his afterlife.

New Kingdom

The inability of the troubled Middle Kingdom to secure peace ended in its downfall, and royal power was passed, first to migrant Asiatics from the area of modern Syria and the Mesopotamian uplands. Asian innovations in weaponry and techniques of war were used to defeat them by clever native Egyptians, and the reign of Ahmose I ushered in the New Kingdom.

Temples The pharaohs of the New Kingdom built magnificent stone temples, using post-and-lintel construction, as noted in Chapter 7. Their immense columns were often shaped like bundles of papyrus stems, which are believed to have been used in place of scarce wood in early Egyptian buildings. Other columns were topped with capitals inspired by the lotus flowers of the Nile such as the Temple of Amun at Karnak [2.34].

The exquisite marble temple at Deir el Bahari that gleams across the Nile at the entrance to the Valley of the Kings was built about 1485 B.C. by Hatshepsut, the only woman to interrupt the male succession of pharaohs and the only one to build a temple [10.20]. The building, dedicated to the sun god Amun, is carved from the living rock of the cliffs and is fronted impressively by three tiers of colonnades connected by ramps. After an unparalleled reign of peace and trade with kingdoms as distant as legendary Punt in the Middle East, Hatshepsut was killed, probably by her stepson and successor Thutmose III.

Royal intrigue was certainly not new, but the coup that had set a woman on the royal throne must have outraged conservative Egyptians. Hatshepsut donned the *nemes* headdress of a king and, at times, even a monarch's false beard. She never occupied any of the three graves she had carefully prepared in the Valley of the Kings, and Thutmose obliterated her inscriptions wherever he could. Her story is told only in wall paintings and hieroglyphs in her temple and on her **obelisks**—tall four sided monuments—which still stand proudly in the Temple of Karnak. Though Thutmose III once walled in these obelisks to conceal Hatshepsut's monuments, their gold caps shone above the wall.

10.20 MORTUARY TEMPLE OF HATSHEPSUT, DEIR EL BAHARI. C. 1485 B.C.

Art Talk

Hatshepsut's story begins in the timeless dust of Thebes. The Great Pyramids of Saqqara were already ancient when she was born. Hatshepsut, daughter of the pharaoh Thothmes I, learned to write as a child with chalk on slate, then ink on papyrus, memorizing all 600 hieroglyphs. A thousand years before Christ, Egyptian religion had already suggested to Hatshepsut that a cosmic unity existed between all living things. The sudden deaths of her older sister and two small brothers seemed only part of a natural order. She was now sole heir to the Kingdom, and she continued to wear boy's kilts, perhaps to please her father. But she also knew that she would have to choose a mate among the half brothers with whom she had once run naked through the palace.

Her life broadened. Her father was proud of his Crown-Prince, as he called Hatshepsut, and he turned his attention to his kingdom. Death was the leading focus of Thebes, and craftsmen worked all their lives for Anubis, the jackel-headed god of death. Mortuary workers were the most respected, fashioning, among many other artifacts, gold and enamel encrusted sarcophagi [6.9]. But Hatshepsut returned to the custom of the third dynasty when she chose her coffin of stone. Rituals were frozen in time, and the living Crown-Prince had to prepare for her own death. At the passing of her mother, Thothmes again flouted custom. He crowned his daughter Hatshepsut as co-regent with him. His words can be read on a pylon at Karnak:

This is my living daughter, Khnemet-Amon [derived from God, Amon] ... I have appointed her my successor ... he who shall speak evil of her majesty shall die ...

For five years, they ruled together, and suddenly at age 70, Thothmes was gone. Hatshepsut chose a husband, Thotmose II, from her many halfbrothers, as was the custom. Although his mother was a commoner, he looked much like his father, but no equal in other respects. No matter, Hatshepsut found the man of her dreams in Sennemut, priest and architect. Together they planned Deir El Bahari, requiring limitless laborers and funds. He used the 400-foot cliff for her temple, as a sculptor might have carved from stone. Hatshepsut was to dominate the temple with 100 sphinxes in her likeness carved in red granite [10.21]. Yet, she was not serene, for her two daughters did not guarantee descent of her line, while the son born to Thotmose II by a harem girl could

claim the throne! The sudden death of her husband forced a scenario hard to believe. Hatshepsut claimed that the god Amon had spoken to her, directing that she be crowned King Hatshepsut I, with all her father's titles but one—Great Bull of Maat, male fertility—and the priests agreed, for without them, nothing was possible.

She launched a building program to rival the later Golden Age of Greece, sending caravans to Nubia, Sinai, and even Asia. She decided to erect to Amon two enormous obelisks sheathed in gold, which remain the tallest monuments in Egypt. All this is recorded in her temple and on her obelisks. Her

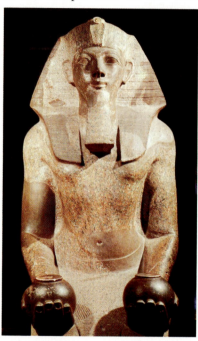

10.21 EGYPT. QUEEN HATSHEPSUT WEARS NEMES HEADDRESS AND KILT OF A KING (FROM DEIR-EL-BAHARI). 18TH DYNASTY. GRANITE. CAIRO MUSEUM.

biography ends in the seventeenth year of her reign, and even the hieroglyphs of her temple are defaced. We find no record of her death. And with Sennemut, the mystery deepens further. His tomb lies empty, with his hieroglyphs defaced. Yet, Hatshepsut's oath to posterity, made at the time of the raising of her obelisks at Karnak, remains a mute testament to her unquenchable ambitions for limitless horizons:

... as I shall be unto Eternity like an "imperishable" ... in order that my name may abide, enduring in this temple forever and ever.

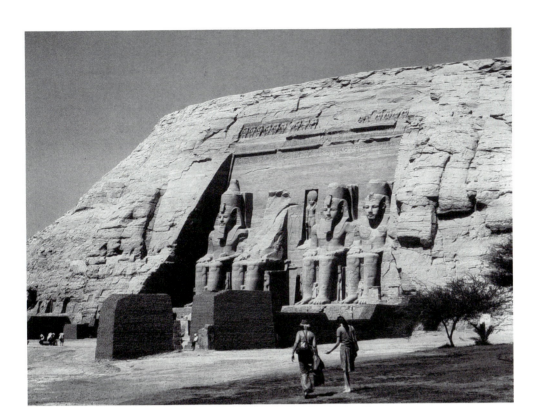

While the Great Temple of Amun at Karnak with its hypostyle halls, discussed in Chapter 7, is characteristic of Egyptian temples, the one built by Ramses II in the cliffs at Abu Simbel on the upper Nile [10.22] is unique. Four colossal statues, intended to inspire awe by their sheer size, guarded the entrance. The building was so designed that twice a year, at the equinoxes, a ray of sunlight would pierce the entrance at dawn, cross the main hall, and penetrate far back to reach the tiny inner shrine containing four statues of the sun god, other gods, and Ramses. The scientific skill of these ancient Egyptian builders, shown in the temple at Abu Simbel, is staggering even when measured against today's engineering skills. When construction of the Aswan Dam was to raise the level of the Nile, the entire temple was moved to the top of the cliffs in 1968 to save it from being flooded. As a result of faulty calculations, however, the sun rays at the equinox now light the inner sanctum one day later, on February 23.

A little more than one hundred years later, the remarkable pharaoh Akhenaton tried to reduce the complex Egyptian religion that involved the worship of many gods (polytheism) to the simple worship of one god, the sun god Aton. He built a new temple to Aton at Amarna, which was later destroyed by his successors and their priests, anxious to restore the old religion. The chief remains from his reign are some reliefs and murals in a realistic style full of movement and individuality. The portrait bust of his queen, Nefertiti, a partner in his reforms, presents her in detail rather than as an abstract symbol [10.23], yet the artist has depicted a commanding presence.

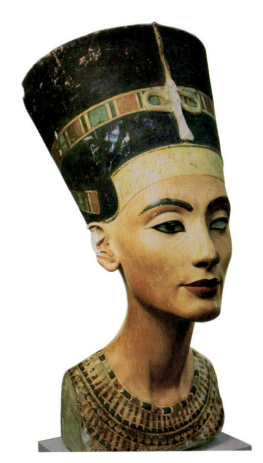

10.23 QUEEN NEFERTITI. C. 1355 B.C. PAINTED LIMESTONE, HEIGHT 20" (51 CM). STATE MUSEUMS, BERLIN.

Art Talk

With "magnetic meters," archaeologists in Egypt are uncovering new passageways, unexpected chambers, and, in some cases, even new tombs that could yield now unknown treasures and new insights into vanished peoples.

Early in 1987, technological devices, including sonar, radar, and magnetometry, were used to locate what may be viewed as the most spectacular finds since 1922, when the almost untouched tomb of the young Tutankhamen was discovered by Howard Carter. A recently discovered 3300-year-old tomb was probably the burial place of several of the many sons of Ramses II, who ruled from 1290 to 1224 B.C. A huge central room, supported by sixteen large pillars and filled almost to the ceiling with rubble, was found; measuring 100 feet (30 meters) on all sides, it is one of the largest in any of the known burial sites in the Valley of the Kings.

In a site only 50 feet from the known tomb of Ramses II, the magnetometer data recorded a change, significant enough for a team of archaeologists, guided by Dr. Kent R. Weeks of the University of California at Berkeley, to start digging. Within ten days they found the entrance to the hidden tomb—a door 5 feet (1.5 meters) high and wide. A rush of hot, moist air bridging centuries greeted the explorers as they crawled through the passageway into the central chamber. Though the tomb has suffered water damage, possibly from the modern irrigation practiced since completion of the Aswan Dam further south, evidence remaining from any of the more than eighty children of Ramses II increases our understanding of the Egyptian empire at its height.

Apparatus that responds to the particles of iron in limestone bedrock, perhaps many feet below, generates a signal that measures the intensity of the magnetic field. A dip in intensity of the signal indicates a break in the rock, such as may be caused by a tomb. While the technology is expensive, it is so accurate that it eliminates wasted digging and speeds discoveries. French, Japanese, and Egyptian authorities are now busily exploring anew the Pyramid of Cheops and the hollows beneath the Sphinx with magnetometry in hopes of locating further treasure.

MAGNETOMETRY IN THE VALLEY OF THE KINGS

Archaeologists have to date discovered only one richly furnished royal tomb, that of the New Kingdom Pharaoh Tutankhamen, who flourished around 1350 B.C. When his tomb was discovered almost intact in the 1920s, the archaeologists found among other treasures a throne [8.29] and a great deal of jewelry inlaid with glass and semiprecious stones. This included golden amulets of the gods, rings, bracelets, necklaces, and even golden guards to protect the mummy's toes. Small sculptures, pottery glazed deep blue, clothing, alabaster boxes and vases, and many ritual objects found in the tomb attested to the delicate and advanced craftsmanship of the ancient Egyptians. The royal mummy was found in a nest of four wood [6.9] and gold coffins, each one smaller than the last, with the innermost one, solid gold, just fitting his body. The delicate throne fashioned for the young king is made of wood, inlaid with gold and enamels. In a scene on the back of the throne, Tutankhamen's fifteen-year-old bride adjusts the lavish jewelry covering his chest by the light of the symbolic sun above. The portraits of the king and queen combine naturalism with the sensitive modeling found in fine portrait sculpture.

The complex arts preserved in the tombs and architectural remains combine to give us a picture of ancient Egypt as an aesthetically sophisticated civilization. Egyptian art, however, required a wealthy ruling class as patron.

When internal power struggles within the structured society led to the collapse of the government, Egyptian art also slowly declined.

ASIA

Asian art in all its variety developed slowly with the emergence of human life in Java and China, perhaps a half million years ago. Gradually evolving from stone choppers to the makers of the honed and polished tools (and beads) of the New Stone Age, the transition from nomadic life to art-producing urban settlements occurred earliest, as far as we know, in the Indus Valley of Northwest India.

India

Civilization flourished in Mohenjo-Daro on the Indus River in the Indian subcontinent as early as 3000 B.C. Indo-Aryans from the northwest invaded the area about 1800 B.C. They brought with them the Vedic religion, based on the *vedas* (hymns to the gods) that are at the root of later Brahmanism and Hinduism. Common to all three religions is the view that men and women are part of nature. Among the concepts introduced were *samsara* and *karma*. Samsara referred to the transformation of the soul on the death of the body, while karma determined the

status of that reborn soul, entirely dependent upon the virtue of the previous life or lives. An austere life of devotion and meditation could be expected to contribute toward *nirvana*, the submersion of individual life in a world soul as with Brahmanism, the highest Hindu caste. Such an outlook permitted enjoyment of the senses, a view that was later reflected in the art of Hindu India (Chapter 11). The *Bhagavad Gita*, a poetic gospel, appeared about the first or second century B.C. and called upon the emotions. Like wildfire, Hinduism, and the art forms it spawned later, overtook most of India.

China

A vast and varied country, almost as large as the United States, China has been a focus of Western interest for centuries, while the country had maintained a pattern of characteristic forms for almost four thousand years. Yet, within those stable traditions, China was also able to absorb new and foreign ideas without in any way losing the stylized native culture. The Neolithic societies of China developed fine painted pottery as early as 2000 B.C., modeling slab worked clay and firing vessels of complex form, establishing early on what would become an unsurpassed art form throughout their history. The Chinese love of jade was as evident in 4000 B.C. as it is today, appearing in small carvings that evolved into fine cut and carved jade disks; these later, perhaps, serving as symbols of the sky.

Rule by dynasties, we believe, first began with the Xia Dynasty and then the Shang Dynasty in the valley of the Yellow River. By the second millennium B.C., more than one hundred Bronze Age (when bronze was evolved) sites had flourished under successive rulers who claimed divine mandate. Well-furnished royal Shang tombs were accompanied by pit burials of numerous men, women, dogs, and horses. The most highly developed preindustrial bronze techniques appeared in Shang ritual vessels made for ancestor worship, some by hammering, most by casting in two piece molds and, much later, by using the lost-wax (*cire perdue*) process (Chapter 6). Shang designs depend for their considerable effect on the linear decoration, often planned to be "read" as two sides of a single form or as the symmetry of two profiles. This distinctive concept of form also can be found in Northwest Coast Indian art two thousand years later—and nowhere else before then or to this day [6.8]. Shang bronze vessels remain unsurpassed technically anywhere in the world [8.1].

The Shang people were defeated by vigorous peoples from Chou (Zhou) in the west, and a new empire endured almost a thousand years (1027–256 B.C.). The late Zhou Period (c. 600–222 B.C.) witnessed a great expansion of Chinese techniques and knowledge of raw materials—glazing of pottery, lacquer refinement of wood, and the likely beginning of painting that was to become so highly developed in China.

As empires were expanding in the West, larger numbers of Chinese became familiar with higher culture

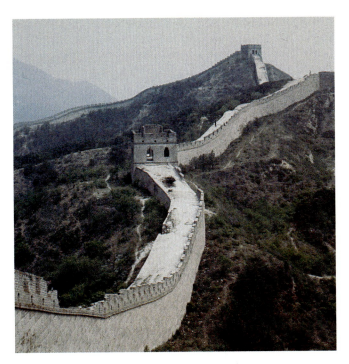

10.24 THE GREAT WALL, CHINA. CH'IN DYNASTY. 256–206 B.C.

and writing. This was the period when the great philosophers Lao-Xi and Confucius and many philosopher-statesmen were born; their writings furthered the rise of the totalitarian Qin Dynasty (221–206 B.C.) in that period of artistic ferment and great intellect. Ch'in Shih Huang Ti (also known as Qin Shi Huang Di), from whom the name China was derived, became the first emperor who consolidated incomplete sections of the Great Wall of China [10.24], as impressive a structure today as it must have been more than two thousand years ago. Buried nearby, in 210 B.C., under a mound close to 150 feet (49 meters) high was the emperor's guardian army of six thousand life-size battle-ready pottery men and horses [6.14]—symbolic substitutes for the ancient practice of live burials that had been discontinued a few hundred years earlier. Ssu-ma Ch'ien, China's great early historian, tells us that 700,000 conscripts worked for thirty-six years on the project, which began the moment Qin (Ch'in) assumed leadership at age thirteen.

Japan

The arts of Japan demonstrate neither the continuity nor the variety of India and China. The origins of the Japanese are shrouded in mystery, but it is clear that the islands of Japan were once connected by land to Asia. Those ties to the mainland persisted in cultural influences at least from 8000–300 B.C. and during much of subsequent Japanese history, affecting almost all Japanese art. Fine stone tools were in use, while pottery vessels and figurines were abundant. They were made by peoples known as Jōmon, a term defined as rope pattern and which probably describes the dominant decoration on their pottery. Dating from as early

as the fourth millennium, a few of the pots incorporated floral decoration. Other clay forms include figurines called Dogū. Most of those discovered represent pregnant women and probably symbolize fertility. Evidences of large pit dwellings also have been found (2 feet deep X 15 feet in diameter), almost coincidental with the emergence of rice paddy agriculture. Not until fourth or fifth century A.D. do we find the indigenous arts that the Western world has come to associate with Japan (Chapter 11). Yet, it was Asians, scholars believe, who emigrated in waves across the Pacific Ocean, establishing as early as the second millennium B.C. civilizations of high art in the Americas.

PRE-COLUMBIAN AMERICAS

Long before Columbus and other explorers arrived on American shores, we believe that adventurous Asians crossed the Pacific Ocean by way of the land mass that more or less connected northeast Asia with North America between 30,000–10,000 B.C. Extending east from Siberia, that land bridge is now covered by waters and is known as the Bering Strait. Some of these wandering peoples remained in Alaska, others stayed on the Northwest Coast, but most of the nomads gradually filtered down through what we call the Western corridor along the Pacific Coast into modern-day Mexico, Central America, and, finally, into South America.

North America

Many of the hunting and foraging peoples left scattered distinctive cultures wherever they traveled; in the north, these were clear-cut, more or less independent units, shaped by local geographic conditions, but little from this early period remains in North America.

Middle America

Middle America was the intellectual and artistic cradle of complex civilization in the American hemisphere, in the same way, as we have seen, that the Nile Valley nourished Egypt in Africa, the Aegean Islands were for Europe, and the Yellow River stimulated eastern Asia. Hundreds of miles to the south, the Central Andes of Peru and Bolivia served as the focus for high civilization in South America. Nevertheless, Middle American native achievements in astronomy and the calendar, mathematics, metallurgy, hieroglyphic writing, and the corbelled Mayan arch, along with architecture, mural painting, and sculpture, were unsurpassed in the Americas. There must have been many contacts and mutual influences throughout because North, Middle, and South American peoples share important features such as maize, cotton, tobacco, irrigation systems, weaponry, metalwork, featherwork, basketry, and textiles.

As in early China, the various nations seem to have contended with both pressures from the nomadic barbarians at their northern frontiers and with periods of warfare with each other.

While the southern half of Central America, from Nicaragua through Panama, is closest to South American cultural traditions, the scholarly term **Mesoamerica** culturally differentiates the area below the contemporary northern boundary of Mexico and includes Guatemala, El Salvador, and Honduras. These regions of Mexico and Central America were occupied in prehistoric times by peoples whose societies were heavily weighted with ceremonial rituals and worship of the plumed serpent divinity Quetzalcoatl, noted earlier. These were societies marked by the development of impressive stone religious architecture [I.21] and an elaboration of the arts and crafts. Over the years with decipherment of hieroglyphic scripts, we have correlated the Mesoamerican chronology with our own and can list names and dates of reigns with precision. Divided into three epochs, the Pre-classic extends from 2000 B.C. to A.D. 300, the Classic from A.D. 200 to 900, and the Postclassic begins in 900 and is terminated with the arrival of the Spanish explorers in the 1500s.

During the Pre-classic period, traces of primitive hunters on a preagricultural, preceramic level in Mexico identify the Tepexpan American, so-called because much of the archaeological finds come from Tepexpan, Mexico. Somewhat later, fine ceramics appeared that included fertility figures from Tlatilco that date from 1000 to 600 B.C. in the Valley of Mexico with eye details that seem Oriental [6.13]. It is tempting to believe that such elements confirm Asian influence, but we cannot be certain. These figurines were buried under a thick cover of lava, fortuitously, perhaps, like the many artifacts preserved when Mount Vesuvius blanketed the city of Pompeii in Italy. In fact, the site called El Pedregal is close to the land made habitable once again by Luis Barragán near Mexico City [7.30].

Peoples of Mesoamerica included the Olmec civilization in eastern Mexico between 1000 and 600 B.C., who carved out of stone sculptured heads like this tremendous work [10.25]; the Toltec in the north; the Maya in the southeast; the Zapotec and Mixtec in the southwest; and the people of Teotihuacán and the Aztec (the last best known because of their dramatic conquest late in the fourteenth century by Spain) in the central Valley of Mexico. All their economies were based on growing maize. Since there are extremes of climate throughout the region, the native Americans probably felt overwhelmed by the forces of nature, personified as gods, on which their crops depended. Their efforts to appease the gods directed their social, political, and artistic lives.

South America

In the Andean region of South America other Indian peoples were raising maize and building ceremonial centers

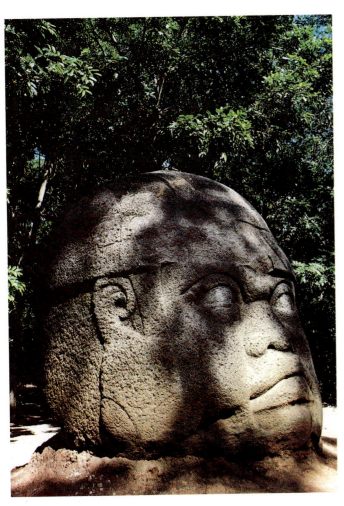

10.25 COLOSSAL OLMECAN HEAD. LA VENTA, TABASCO, MEXICO.

with pyramid temples before 800 B.C. Somewhat later, pottery, weaving, and goldwork reached a highly sophisticated level. The Paracas and Nazca peoples and their descendants on the south Peruvian coast wove and embroidered magnificent garments with colorful, stylized patterns of animals and divinities.

In the first millennium B.C., located in the northern highlands of the Andes, the ceremonial center of Chavín de Huantar consists of a number of stone-faced pyramids, pierced with narrow passageways and tiny rooms that surround a central sunken court. Recent archaeology suggests that planned communities from elsewhere in the Andes, some two thousand years earlier, may have led the way for the Chavín peoples.

EXERCISES AND ACTIVITIES

Exercises for Research and Discussion

1. Where have we found the earliest art forms? What were the materials and functions of that art? Would you consider the art of our earliest ancestors to be simple and childlike? If not, in what way do you think it was skilled and expressive?

2. Locate two examples of modern art that deal with themes similar to those of prehistoric times in the ancient Middle East. In Asia? In Africa? How do the modern works differ from early art, and in what ways are they similar?

3. Describe the construction of Stonehenge. What structural method was used?

4. What is meant by the terms "Fertile Ribbon" and "Fertile Crescent"? How were these areas important? When Herodotus stated that "Egypt is a gift of the Nile," what facts did he have in mind?

5. Contrast the architecture, sculpture, and painting of Egypt and Mesopotamia from the viewpoints of material and style. Explain the reasons for the differences.

Studio Activities

1. Do a simple painting based on a subject from everyday life, using some of the spatial concepts of the Egyptians.

2. From a top view, draw the plans for the three great pyramids, preserving the actual scale of these monuments and their orientations to the cardinal points.

3. Make a small model of King Kafre's pyramid.

4. Carve a model of the Sphinx with whatever material you prefer.

5. Carve onto a piece of slate an incised image relating to any of the five major Mesopotamian periods that seems appropriate to your theme.

Gods and Heroes:

THE CLASSICAL WORLD AND BEYOND: ASIA AND THE AMERICAS

"*Leaving the waters of the splendid East, the Sun leapt up into the firmament to bring light to the immortals and to men who plough the earth and perish.*"

—HOMER, THE ODYSSEY

• • •

"*To the Ancients, the movement of the sun and stars was the image of perfection: to see the celestial harmony was to hear it, and to hear was to understand it.*"

—OCTAVIO PAZ, IN PRAISE OF HANDS

• • •

"*[Augustus Caesar] made so many improvements in Rome, he could rightly boast that he found it brick and left it marble.*"

—GAIUS SUETONUS TRANQUILLIUS

Most of us in the West have been brought up to think of the Greeks and the Romans as the wise ancients who developed within a scant thousand years the sophisticated civilization we call classical. In fact, the Greeks were fortunate in the sense that their world was far smaller and younger than ours. They were unburdened by an accumulated weight of long-established traditions. Nevertheless, the early Greeks chose not to accept even the mythological and religious beliefs with which their neighbors had explained the nature of the world. Instead, they boldly struck out for themselves to evolve new philosophies and governmental systems and different concepts of art. In contrast, perhaps, we in the twentieth century seem to be the ancients, grappling with the inherited problems of a weary world that seems to have made many mistakes. And, with it all, our legacy from the Greek and Roman cultures, termed classical, remains incalculable.

Drama, poetry, architecture, sculpture, experiments in democracy, philosophical concepts, a rational approach to the mysteries of nature—there is hardly a facet of our lives that is not affected by Greek achievements. For instance, 2400 years later, we can still see references to the classical world in today's postmodern architecture. Greek civilization was gradually absorbed by Rome, which added its own contributions, especially in government, architecture, and engineering. Roman law, roads, arches, and its Latin language lasted for centuries after Roman political power came to an end. The combined achievements of both peoples make up the classical heritage of the West. Yet a good deal of what we used to think was original with the Greeks and Romans was in fact derived from others who had come earlier.

PREHISTORY OF GREECE: THE AEGEAN BACKGROUND

The Aegean Sea is full of islands that provided stopping places for sailing ships. During prehistoric and ancient times, the constant trade and exchange of ideas among many peoples bordering the sea stimulated the development of Aegean civilization. At the beginning of this century, archaeologists uncovered within the Cyclades Islands scores of unusual small sculptures. Of all the figures we have seen in other cultures that celebrated fertility, none have been as large or as limited in sexual exaggeration as

2600 B.C.	1000	750	500	250	0	250 A.D.	500	1000	1500

Prehistory
2600–2400 Cycladic Idol [11.1]
1250 Lion Gate, Mycenae [11.3]
1000 Fertility figures, Mexico [6.3]
750 Dipylon vase, Greece [2.3]
600–575 Kouros and kore statues, Greece [11.4, 11.5]
560 Exekias Amphora [11.14]
c. 470 *Charioteer* [11.12]
c. 460 Myron, *Discobolus* [11.13]
448–432 Parthenon, Athens [11.8]
410 Erechtheum, Athens [11.11]
c. 340 Praxiteles, *Hermes with the Infant Dionysus* [11.14]
c. 150 *Laocoön Group* [11.16]
150–100 Aphrodite of Melos [11.19]
c 70–25 Stupa I, 1 Sanchi [11.28]
c 70–25 Yakshi [11.29]
c. 70 House of Vettii, Pompeii [11.23]
c. 50 Pont du Gard, France [7.10]
c. 72–80 Colosseum, Rome [11.17]
c. 100–500 Ajanta cave [11.30]
106–113 Trajan's column [11.26]
118–125 Pantheon, Rome [7.13]
161–180 Marcus Aurelius [11.27]
c. 200–700 Temple of Quetzalcoatl, Mexico [I.21]
310–320 Basilica of Constantine, Rome [11.20]
c. 400–500 Haniwa figures [11.32]
c. 400–600 Pyramid of the Sun, Mexico [11.33]
607 Horyuji Temple [7.17]
c. 800 Tiahuanacan Gateway, Bolivia [11.34]

THE VISUAL ARTS

THE AEGEAN SEA; GREECE; ROME; MIDDLE AND SOUTH AMERICA

this marble idol that appears so modern [11.1]. Varying from a few inches to almost life-size, it is likely that these sculptures may represent highly stylized earth goddesses.

The island of Crete, midway between Greece and Egypt, carried on extensive trade with Asia Minor and Egypt between 2000 B.C. and 1400 B.C. Enriched by these contacts, Crete developed a very sophisticated civilization [11.2]. Egyptian post-and-lintel construction probably influenced the enormous palace at Knossos, which inspired the Greek legend of the Minotaur and the labyrinth. According to the story, the Greek hero Theseus found his way through a complex maze, perhaps representing the many rooms of the palace, to slay the Minotaur, a monster half man and half bull. The Minotaur myth probably developed from the Cretan cult of the bull, so vividly expressed in the palace frescoes of youths and maidens leaping over a running bull [3.13].

By the mid-fifteenth century B.C., Mycenae, in southern Greece, had grown to rival Crete as a center of culture. Gold masks, jewelry, weapons, and cups from the beehive tombs of the Mycenaeans bring to life the lusty days of the ten-year war between the Mycenaean rulers and the Trojans in Asia Minor, described in Homer's epic *The Iliad.* The lion gate stands on the hilltop citadel at Mycenae surrounded by walls of massive stone blocks fitted together without mortar [11.3]. The wall paintings, the metalwork, the architecture, and the sculptures of Mycenae were forerunners of the Greek art that followed.

GREECE

Greek civilization was a blend of many influences. The Dorian Greeks, who invaded the Greek mainland, Crete, and the other Aegean islands from the north about 1000

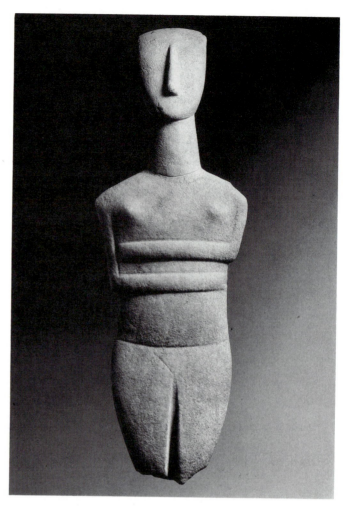

11.1 FROM THE CYCLADES ISLANDS. *FEMALE FIGURE.* C. 2600–2400 B.C. EARLY CYCLADIC II PHASE. MARBLE, HEIGHT 16-1/4". KIMBELL ART MUSEUM, FORT WORTH, TEXAS.

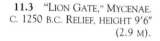

11.3 "LION GATE," MYCENAE. C. 1250 B.C. RELIEF, HEIGHT 9'6" (2.9 M).

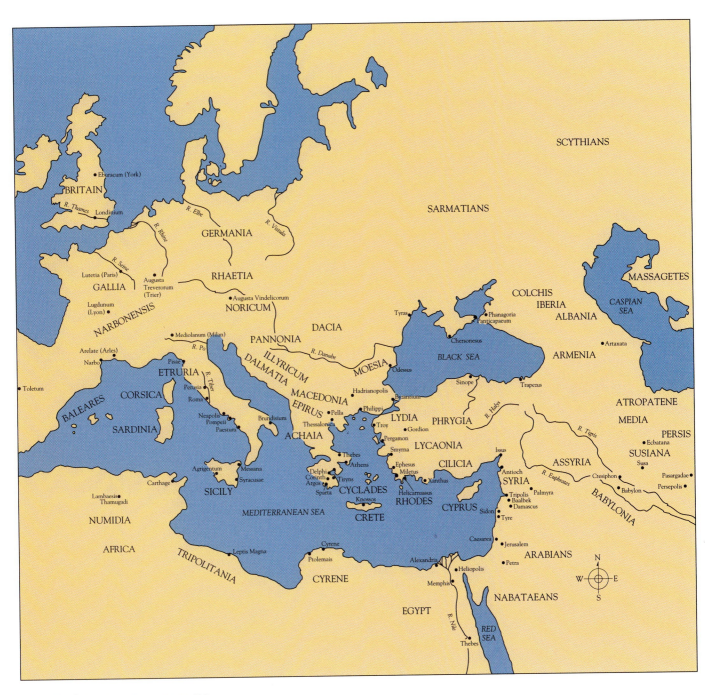

11.2 THE GREEKS AND THEIR NEIGHBORS.

B.C. absorbed the skills of metallurgy, pottery, weaving, and building developed earlier in Mycenae and Crete. The Ionian Greeks, who migrated from southern Greece to Ionia in western Asia Minor in the eleventh and tenth centuries B.C., incorporated into their art and religion ideas from Mesopotamia. These many elements all contributed somewhat to form the distinctive Greek civilization we admire. Greek art may be divided into three periods:

Archaic period, seventh and sixth centuries B.C.

Classical period, fifth century and early fourth century B.C.

Hellenistic period, late fourth, third, and second centuries B.C.

Sculpture of the Archaic Period

By about 700 B.C. the basis of Greek political and economic life was shifting from agricultural villages to cities dependent on trade. Wealthy cities and elite citizens commissioned statues of the gods, legendary heroes, and athletes who took part in the Olympic Games, held to honor the gods since the eighth century B.C. Although the Greeks stood in awe of their immortal gods, they also felt close to

them and imagined them in human form. Greek legends and the epics of Homer presented the gods as superhuman beings entangled in the affairs of mortals. Men and women, although weak and imperfect, were believed to resemble the gods. Therefore, Greek statues of divinities and mortals showed similarities, since athletes served as models for both. Selected features of many athletes were combined in idealized sculpture, which eventually became the standard for human beauty in the West. As a reflection of Greek philosophy, idealized sculptural proportions (Plato believed) could transform an image of the human being to a divine level.

Rigidly posed Egyptian statues must have been the models for the early Greek representation of the nude male figure, known as a **kouros** [11.4]. Unlike the Egyptian artists, who made static figures to serve as eternal replicas of the pharaoh and aristocracy, Greek artists were not content with stiff poses to convey the spirit of their gods and heroes. So, although the kouros is severe, he is also full of vitality, both physical and mental, illustrating the Greek ideal of a healthy mind in a healthy body. Standing with one foot advanced, fists clenched and muscles taut, the figure seems ready to burst from its bonds of stone.

The Greeks also represented a young maiden, or **kore** [11.5]. Her compact figure, always clothed, perhaps because the female figure was not considered the perfect ideal of beauty like the male at that time, she stares at us with an archaic smile that may not have been so much the result of artistic design as of the sculptor's difficulty in carving the mouth. This kore holds a pomegranate, regarded as a symbol of fertility because of its many seeds. Like most Greek sculpture, the kouros and kore statues were colored, and we can still see traces of their original paint.

Even in early figures of gods, heroes, and other mortals, we can perceive that quality of balance among the emotions, sensations, and intellect that became typical of later Greek art in the Classical period, when concept and imagery flowed freely.

Architecture of the Classical Period

The renowned Classical period of Greece refers to a rather short time in the fifth and sometimes the early fourth centuries B.C. when Athens was the center of a rich flowering of art, literature, and philosophy. Classical has since come to refer not only to what might be considered the Greek era at its height, but also to the lasting, significant, best form of any art. This moderately sized city-state produced in three generations such dramatists as Aeschylus, Sophocles, and Euripides; the philosophers Socrates, Plato, and Aristotle; the sculptors Phidias, Myron, and Praxiteles; and the

outstanding political leaders Themistocles and Pericles (461–429 B.C.). During this period, Athens and other city-states built many temples to their patron gods and goddesses. The crowning achievement of Greek architecture of the Classical period was marble temples. They adhered to the same general floor plan—a **cella**, or room housing the statue of the god, entered through a porch with columns. Some temples also sometimes incorporated a porch in back, sometimes a treasure room behind the cella, and a colonnade on all four sides. Temples were approached by three

11.4 *Statue of a Youth (Kouros).* C. 600 B.C. Marble, height with plinth, 6'1/2" (1.84 M). The Metropolitan Museum of Art, New York (Fletcher Fund, 1932).

11.5 *YOUNG MAIDEN (KORE)*. EARLY 6TH CENTURY B.C. ATTIC MARBLE, HEIGHT 6'4" (1.93 M). STATE MUSEUMS, BERLIN.

steps and covered with a gable roof. Every architectural element was subtly related to the whole composition.

Greek marble temples reveal Egyptian influence as well as that of earlier wooden Greek temples. For example, the marble columns were placed at what were originally the meeting points of wooden beams, and an **abacus**, or square form originally interposed between the capital and the beams to strengthen the joining point, was retained. Other decorative details can also be traced to original wood construction.

The Orders of Architecture Variations in temple design are mainly in the elements of the **order** of a temple. A Doric order consists of a column or post (including base, shaft, and capital with abacus and **echinus**) and an **entablature** or lintels above (including a plain **architrave**, a decorated **frieze**, and the **cornice** of the roof) [11.6]. All the elements were refined to create a satisfying and harmonious relationship.

Importance was given to the number three. As the ideal, perfect male body is basically divided into three parts, so also are the components of architecture. There were three kinds or orders, each with its own proportions and decorative scheme. The simple, early Doric order was named for the Dorians, although it may have originated in Crete. It had an unadorned cushionlike echinus, a square abacus for a **capital**, and a sturdy, widely **fluted** (grooved) shaft. The frieze was decorated with **triglyphs**, stone copies of the grooves in the clay tablets that once covered the ends of the wooden beams to protect them from the

11.6 ORDERS OF ARCHITECTURE.

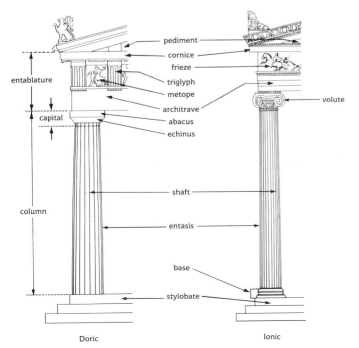

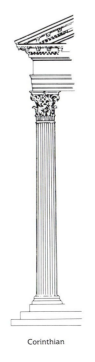

Doric

Ionic

Corinthian

pediment
cornice
frieze
triglyph
metope
architrave
abacus
echinus
volute
entablature
capital
shaft
entasis
column
base
stylobate

weather and probably to drain off rainwater. The square spaces between the triglyphs, called **metopes**, were sometimes filled with sculpture. The Doric order gave an air of massive grandeur to early temples.

The Ionic order, which had **volutes** (spirals) on the capitals and a slender shaft with delicate, narrow fluting to emphasize its height, gave temples a lighter effect that was more open and inviting. The continuous frieze was often ornamented with sculpture. The Ionic order can be traced through Ionia to earlier forms used in Asia Minor, where spiral decoration is believed to be derived from sheaves of rushes native to Mesopotamia but unknown in Greece. Some scholars, however, believe the capital derives from ram's horns.

The later, more ornate Corinthian order had a capital shaped like an inverted bell, usually with overlapping rows of acanthus leaves. It was adopted by the Romans and eventually influenced Romanesque, Gothic, and Renaissance builders.

Since the Renaissance, Western architects have borrowed and adapted all three orders, which still can be seen. Look for them especially on libraries, courthouses, and banks, copied in wood, marble, or even concrete.

The Acropolis Some of the most famous Greek temples were built on the Acropolis overlooking Athens and the Aegean Sea. An **acropolis** is a fortified hill, which originally provided defense in most Greek cities. This artist's reconstruction shows the Athenian Acropolis during the Golden Age of Pericles, when it was at its height as a civic and religious center [11.7]. Temples, a storehouse, and commemorative statues were reached through the **Propylaea**, a ceremonial gateway at the head of a steep, twisting path with steps.

The Parthenon The best known Acropolis temple, although not necessarily the most refined, was the Parthenon. Commissioned by Pericles and designed by the architects Ictinus and Callicrates, it was dedicated to Athena during the Panathenaic Festival of 438 B.C. Its sturdy Doric form reveals the subtle architectural relationships that have influenced so many later architects. The precise proportions, the interplay of vertical and horizontal forms, the contrast of the solid cella against the many columns of the two porches and surrounding colonnade, all combine to create a harmonious design that appears simple but that is actually extremely complex.

The columns were designed to bulge slightly in the center, a distortion called **entasis**, intended to counteract the optical illusion that causes parallel straight lines to appear to curve inward. In addition, the horizontal line of the top step of the porch and the line of the architrave were also curved slightly upward to avoid the appearance of sagging. In the space formed by the columns and architrave at the end of the colonnade, we can see a graceful shape like an inverted vase [11.8]. Was it created by chance or by careful planning, perhaps as a symbol whose meaning is lost?

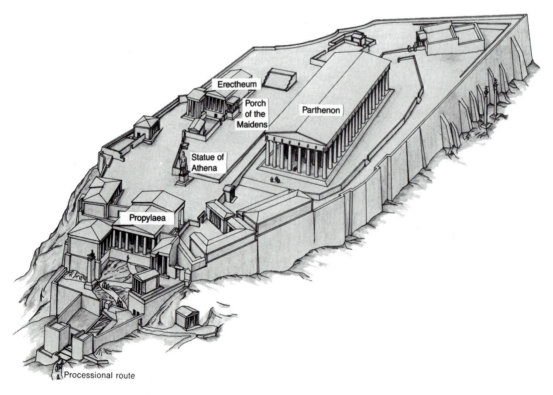

11.7 RECONSTRUCTION DRAWING OF THE ACROPOLIS, ATHENS.

Art Talk

During the 1980s, scientists from many nations have gathered their resources in Athens to salvage a precious monument of the classical world from the ravages of time, tourists, and, worst of all, technology gone awry. The temple sacred to Athena Parthenos, surviving centuries of war and nature's elements, now is attacked by *nefos*, an eye-stinging cloud of sulfur dioxide, a byproduct of petroleum fuel combustion. As rain, dew, and nefos mix, the gleaming marble of the Parthenon turns into crumbling plaster.

ago, have already rusted and caused cracks in the stones with temperature changes.

The present Committee for the Preservation of the Acropolis Monuments, with native-born architect Mangolis Korres, a specialist in restoration, in charge, has nearly completed the seven year project involving the nearby Erechtheum. Its caryatids, which for two millennia stood under roof carvings that acid rain has obliterated, have been replaced with copies. The original sculptures have been taken to the Acropolis Museum to be placed in a nitrogen filled glass chamber

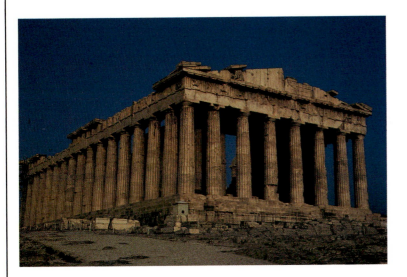

11.8 ICTINUS AND CALLICRATES. THE PARTHENON, ATHENS. 448–432 B.C.

Crowning the Acropolis, the renowned citadel of Athens, the temple to Zeus' daughter Athena the Virgin has outlasted the Romans, who set fire to the colossal gold and ivory statue of Athena by Phidias that was housed in the sacred inner chamber. A thousand years later, the Parthenon still stood after Turkish stored gunpowder blew off fourteen of the outside columns. But the temple's continued existence in the twentieth century is more precarious than ever.

In the past one hundred or so years, bungled restorations have jeopardized some of the 12,500 white marble blocks hewn from Mount Pentelicus to the north that make up the temple. Adding new iron clamps and reinforcing rods to the stone, restorers overlooked the ancient design of sculptor Phidias and architects Ictinus and Callicrates. To eliminate rust-producing moisture, the original rods had been tightly wrapped in a sheath of pliable lead that had also permitted expansion in heat and contraction with cold. The new rods installed, however, only eight decades

where they can be preserved. The Erechtheum walls have been torn down and replaced using today's technology.

Restoration of the eight-times-larger Parthenon has proven more difficult, because the 24,000-square-foot (2230-square-meter) structure is far more devastated. Thousands of the Parthenon's stones have toppled to the ground, presenting a source of danger to the remaining structure as well as to the hordes of visitors, who have therefore been denied access to the temple for decades. Yet, enough of the old marble stones, numbered and cataloged—some weighing as much as 12 tons (10.9 metric tons)—still remain to rebuild much of the Parthenon's inner chamber, or cella. Architect Korres argues against a rebuilding to mint condition. His summation makes it clear: "We are obliged to accept that the perfect lines and surfaces have been lost forever and that the monument has a new character—that of a ruin."

PRESERVING THE CRUMBLING PARTHENON

The Artist Sketch

Anative-born Athenian sculptor, Phidias has had an abiding influence on Greek sculpture, past and present. Chief designer of the sculptures of the Parthenon and of colossal statues throughout the Greek world, his reputation was built as chief sculptor of Athens under Pericles. After training with Hegias of Athens and Argos, his first works were thirteen figures at Delphi, commemorating the Greek victory at Marathon. To this early period is also ascribed the *Athena Promachus*, a bronze colossus set on the Acropolis and visible for miles. Evidence of this figure, of which only the pedestal remains, was discovered in 1845; the statue, dated 460–450 B.C., was probably more than 30 feet (9.14 meters) tall, the largest bronze ever made in Athens.

By 444 B.C. Phidias [11.10] must have been in Athens and closely associated with Pericles, who, during the Greek Golden Age, transformed the city. Most of the great monuments of Athens, including the Parthenon, were erected in this twenty-eight-year interval. The 38-foot (11.5-meter) standing *Athena Parthenos*, finished in chryselephantine (gold and ivory), was consecrated in 438 B.C., paid for with money extracted from allies of Athens. The huge expense of these works brought both Phidias and Pericles into political and financial difficulties. Phidias was accused of sacrilege in that he represented himself and Pericles on the shield held by Athena. The practice of incorporating images of the artist and the patron in religious works was long established in traditions that have persisted to the present time, so the probability remains that the condemnation of Phidias was politically motivated.

The sculptures of the Parthenon—the metopes, frieze, and large pedimental figures—are associated with Phidias and are almost universally regarded as masterpieces of art. They perhaps represent the jewels that crown the Acropolis. In the words of Pliny, "[Phidias] opened up new possibilities in metalwork [and all art]."

PHIDIAS (C. 490–C. 430 B.C.)

The Parthenon, like all Greek temples, was built to be visually satisfying from all sides. Its carefully proportioned form presents an impressive silhouette, which dominates the Acropolis. Let us imagine ourselves part of a procession of Athenians making our way up the rock of the Acropolis through the Propylaea to the Parthenon. Instead of entering the temple at the near, west end, the procession will wind around to approach from the far, east end. We can look up and see struggling figures, such as gods and giants, Greeks and Amazons, and Lapiths and Centaurs carved in high relief in the metopes of the frieze above the colonnade.

Approaching the east end, we may stop to admire the sculptured figures of the three goddesses on the **pediment** [11.9], the triangular space between the frieze and the gable. The quarrel between Athena and the sea god Poseidon for the patronage of Athens occupies the west pediment. The figures in the middle of the pediment have

11.9 *Three Goddesses*, from Parthenon east pediment. c. 438–432 B.C. Marble, over life-size. Reproduced by courtesy of the Trustees of the British Museum.

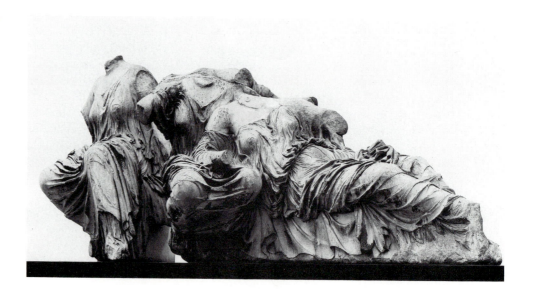

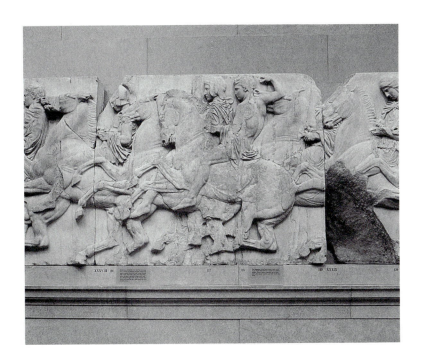

11.10 PHIDIAS. *HORSEMEN OF THE PARTHENON FRIEZE.*
NORTH SIDE. 5TH CENTURY B.C.

enough space to stand erect, but as the roof slopes down, the tapering space dictates figures with crouched and extended poses. These pedimental sculptures, now in the British Museum, were designed by Phidias, who supervised all the architectural projects ordered by Pericles. We must remember, when we think of white marble statues and temples, that many were once brightly painted.

As we pass through the colonnade, we can see above us the low-relief frieze honoring Athena and surrounding the cella, which may depict the Panathenaic procession held every four years. We may look for fellow-citizens represented in the frieze, but the idealized faces have a dignity appropriate to the occasion that makes them difficult to recognize. Perhaps only priests can enter the sanctuary, but if we stand at the door of the cella, we may be able to glimpse the magnificent gold and ivory statue of Athena Parthenos by Phidias.

Now the gold and ivory figure is gone, as well as the pediment marbles of Athens' foremost temple. Only the basic structure and its reliefs remain, and these are in precarious condition.

The Erechtheum On the north side of the Acropolis is the Erechtheum, a temple built on the site of one of the most ancient shrines, sacred to Athena, the early Athenian king and snake god Erechtheus, and Poseidon. This multiple dedication explains the complicated and unusual plan of this early split level temple. Its four levels are marked by three differently proportioned sets of Ionic columns and the **caryatids** (figures of women) that form the Porch of the Maidens [11.11].

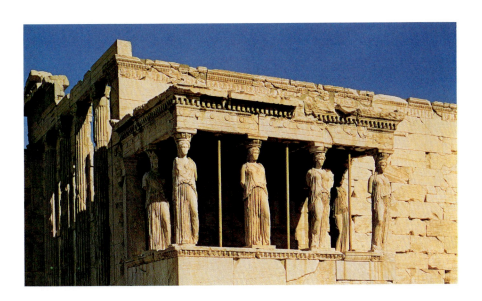

11.11 *THE ERECHTHEUM,* ACROPOLIS, ATHENS; VIEW FROM THE WEST. C. 410 B.C. HEIGHT OF CARYATIDS 7'9" (2.36 M).

Sculpture of the Classical Period

Sculptors of the Classical period learned to distill the essence of beauty from the world around them, idealizing the body but retaining qualities that allow us to identify with the figures. While no particular individual is ever portrayed, enough humanity remains in the figures to express the Greek intent of serenity. Reflecting the ideal of moderation, the body is shown in a state of balance between energy and repose. Greek Classical figures demonstrate the features we still admire: balance, containment, moderation, universality, and idealism.

The bronze *Charioteer* from Delphi, cast about 470 B.C., stands stiffly like a kouros, but there is a lifelike quality in his head with its curly hair held by a headband and its inlaid eyes of semiprecious stone that simulate a piercing gaze [11.12]. Probably the statue was commissioned to celebrate the victory of King Polyzalos of Gela in religious games. Whether it was a portrait or an expression of a healthy mind and healthy body is not known, but we see the beginnings of the idealization, the refined proportions, and the mobile pose that characterize art of the Classical period.

Myron's bronze *Discus Thrower* [11.13], cast about 460 B.C., now existing only in a Roman copy in marble, shows how far sculptors had moved from the rigid positions maintained by the kouros. Myron successfully solved the sculptural problem of rendering movement in space by showing the athlete critically poised. We see him just as he bends down to swing his arm back to throw the discus with all his force. From whatever angle we regard the work, a rhythm develops that draws us into the sculpture and encourages us to examine it from all sides. Our eyes move from the discus to the arm, up to the head, down to the knee, and back to the heavy discus to begin the cycle again. We have come to believe that the most successful sculptures encourage this kind of interaction between viewer and artwork that demands an active appreciation of its aspects from all angles.

Hermes and the Infant Dionysus by Praxiteles is a work of the late classical period, which prefigures Hellenistic trends. When we say that someone has the body of a Greek god, we are probably thinking of such a sculpture as *Hermes* [11.14], noted for the soft, sensuous appearance of the skin and the graceful pose, which contrasts so sharply with the stiff kouros of two hundred years earlier. Hermes, messenger of the gods, stands relaxed, his weight flowing from his torso to the reversed or **contrapposto** direction of his hips in a gentle S curve. On one arm he holds the infant god of wine, and his missing arm probably held a bunch of grapes toward which the baby is reaching. The modeling is smooth and the planes flow so subtly that the contrast with the angular folds of the drapery enhances the figure.

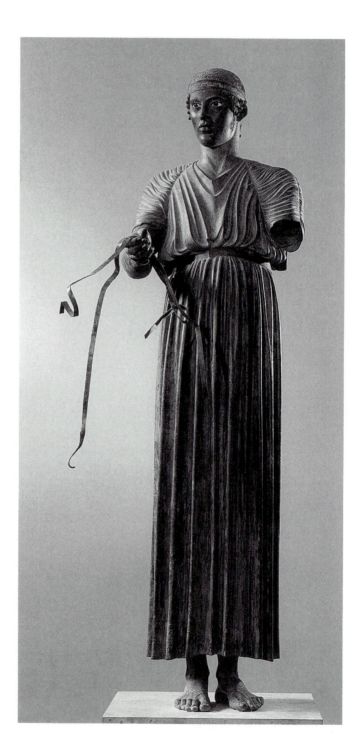

11.12 CHARIOTEER, FROM SANCTUARY OF APOLLO, DELPHI. C. 470 B.C. BRONZE, HEIGHT 6'11" (2.11 M). ARCHAEOLOGICAL MUSEUM, DELPHI.

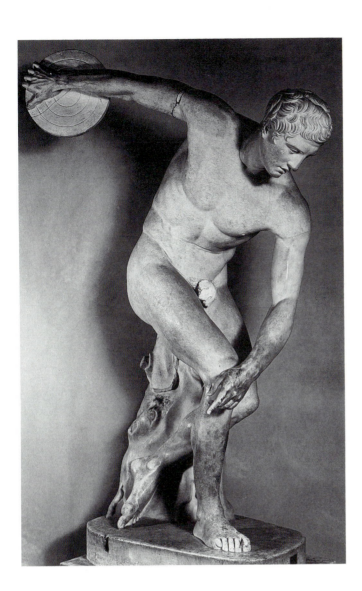

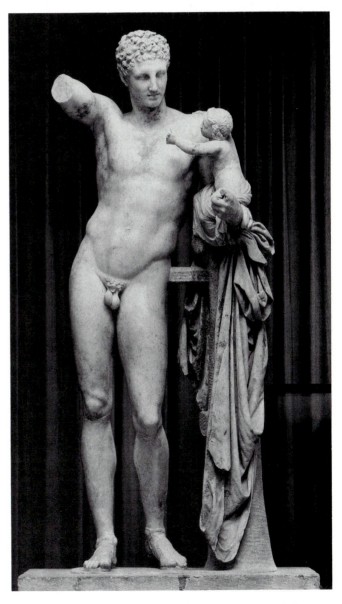

11.14 PRAXITELES. *HERMES WITH THE INFANT DIONYSUS.* C. 340 B.C. MARBLE, HEIGHT 7'1" (2.16 M). ARCHAEOLOGICAL MUSEUM, OLYMPIA.

Painting of the Classical Period

Unfortunately, the great wall paintings that once adorned the temples and civic buildings of the Classical period have disappeared, and we know of them only through literature. But the creativity of Greek painters has been preserved for us in the refined and expressive decorations on pottery.

Greek pottery, famous throughout the ancient world because of its varied shapes and skillful paintings, was a major export item, contributing importantly to the Greek economy. Modern divers have found pieces of Greek pottery on sunken ships as far from Greece as southern France.

Potters and vase painters were highly regarded and often signed their works. Designing specific shapes for specific functions [8.17], painters imaginatively decorated pottery with myths of gods and heroes and activities of daily life. Just as sculpture evolved from the simple forms of the Archaic period to the graceful complexities of the Classical period, so vase painting developed in stages. Early pottery decoration was geometric [2.3]. In the Archaic period, vases had lively black figures painted on red clay with

details scratched through the black. In an amphora by the painter Exekias (late sixth century B.C.) we see the heroes Ajax and Achilles sitting on stools intently bent over a game [11.15]. Note the fine proportions and new use of foreshortening in the shoulders. The design shows a strong sense of order, and the delicately incised lines of the hair and elaborate cloaks testify to the artist's skill.

Vases in the Classical period were in a freer, more sophisticated style in which red figures stand out from a black ground and details are applied with a brush.

Sculpture of the Hellenistic Period

In the late fourth century B.C., Alexander the Great, a Macedonian king, forged an empire that included Greece and the lands of the eastern Mediterranean. As a result of Alexander's enthusiasm for Greek civilization and the military, Greek influence dominated this region and continued even after his death in 323 B.C. Then, his empire was broken into small states ruled by his generals, who competed with one another in commissioning extravagant art. The art of this period, which lasted until the Roman conquest, is called Hellenistic because Greece, which inspired it, was known as the land of the Hellenes.

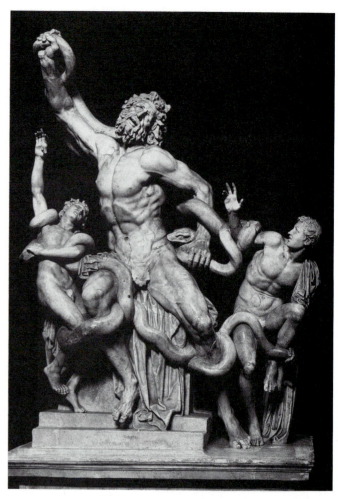

11.16 AGESANDER, ATHENODORUS, AND POLYDORUS OF RHODES. *LAOCÖON GROUP.* C. 150 B.C. MARBLE, HEIGHT 8′ (2.44 M). VATICAN MUSEUMS, ROME.

Sculptors of the Hellenistic period became more interested in portraying in detail specific individuals than in creating serene, idealized figures. The marble group of *Laocoön* and his sons in the agony of their death is typically Hellenistic in its exaggeration of emotion [11.16], tortured pose, stressed muscles, and bulging veins. According to legend, the Trojan priest Laocoön was strangled by sea serpents sent by the gods because he had defied the plans of Apollo. Although Laocoön had in fact revealed to the Trojans that the wooden horse given them by the Greeks was a trick designed to defeat Troy, he was not believed. The horse was admitted through the gates into Troy, leading to the downfall of the city. The sons were grown men, but the sculptor made them smaller to indicate that they were sons.

Influenced by the fourth-century taste for sculpture of nude women was an *Aphrodite* from Melos, better known by its Italian name, the *Venus de Milo* [11.17]. She has captured the imagination of the public ever since being

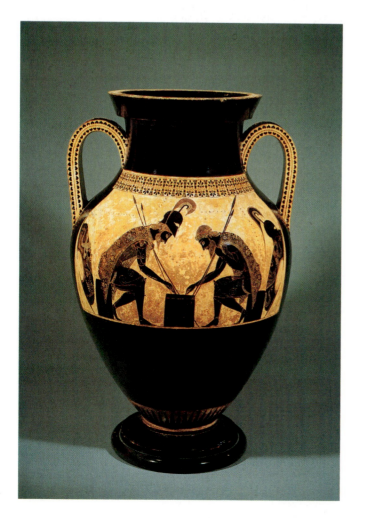

11.15 EXEKIAS. *AJAX AND ACHILLES PLAYING DRAUGHTS,* BLACK FIGURE AMPHORA. 550–525 B.C. TERRA-COTTA, HEIGHT OF AMPHORA 24″ (61 CM). VATICAN MUSEUMS, ROME.

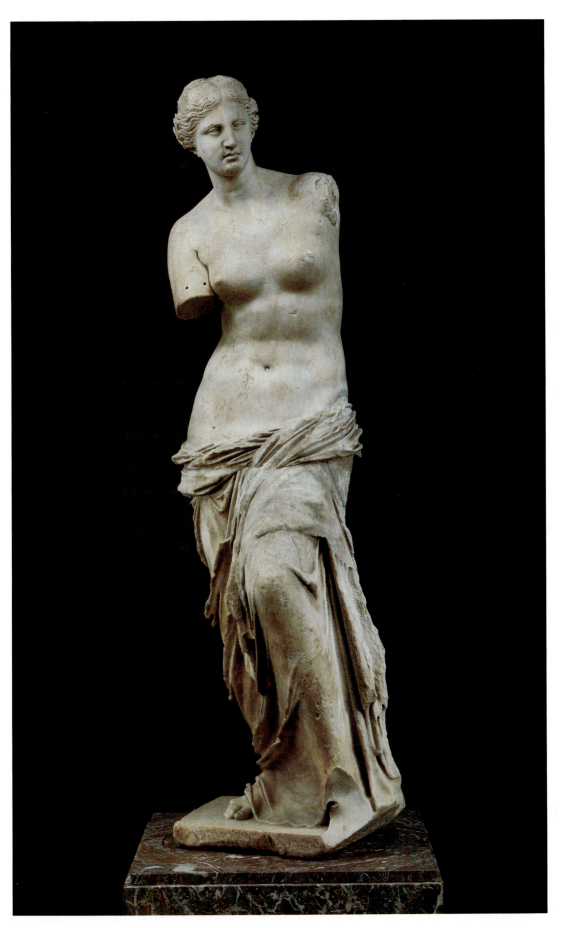

11.17 Aphrodite from Melos. c. 150–100 b.c. Marble, height 6'8" (2.03 m). Louvre, Paris.

discovered in 1820. Some scholars say she was holding a shield in which she was gazing at her reflection. Her **wet drapery**, marble carved to resemble wet cloth, reveals as much as it conceals. It is clear that during this period, the sculptor's goal was to immortalize in cold, hard stone the soft, warm, pulsating human body in the flawless proportions then considered ideal. With brilliant technical skill, the artist has succeeded so well in presenting her form that, as observers, we are scarcely concerned with the subsequent loss of her arms.

ROME

Originally an Italian city-state on the Tiber River, Rome eventually ruled the greatest empire of the ancient world. The expanding Roman culture first overwhelmed the Etruscans, who had developed a civilization in west-central Italy north of the Tiber in the third century B.C. Rome next absorbed the Greek colonies that had been founded in southern Italy and Sicily in the eighth century B.C. and in 146 B.C., the Romans defeated the Greeks at Corinth in their own homeland.

Like the Greeks before them and the rest of us ever since, the Romans borrowed ideas from earlier peoples to incorporate into their civilization. One source of ideas was the Etruscans, who had earlier absorbed elements of Greek, Mesopotamian, and perhaps ancient Italic culture. Many Roman concepts of religion and government began with the Etruscans. The Romans employed Etruscan artists and probably learned from them how to build arches, cast in bronze, and carve in stone. Roman art was also influenced by the vigorous clay portrait figures the Etruscans placed on the lids of their coffins and the lively frescoes of banquets and festivals which they painted on the walls of their tombs [11.18]. Etruscan figures are generally somewhat shorter and more stocky than those of the Egyptians [2.42], Cretans [3.13], and Greeks who preceded them.

The strongest influence on the Romans, however, was surely Greek civilization, first encountered in southern Italy and later as Romans studied with Greek teachers. They also commissioned Greek artists to work for them in Italy and collected Greek works. The Roman town of Pompeii was filled with art objects in the Hellenistic style. Indeed, the art of Italy in the third and second centuries B.C. is called Graeco-Roman.

The Romans, nevertheless, added their own genius in military affairs, government, and engineering to the arts of the Etruscans and Greeks. Roman law and Roman construction was spread over a wider area than that achieved by any prior civilization. Under the *Pax Romanum*, or

11.18 AULOS PLAYER, DETAIL OF FRESCO FROM THE TOMB OF THE TRICLINIUM, ETRUSCAN. TARQUINIA, ITALY. C. 470 B.C.

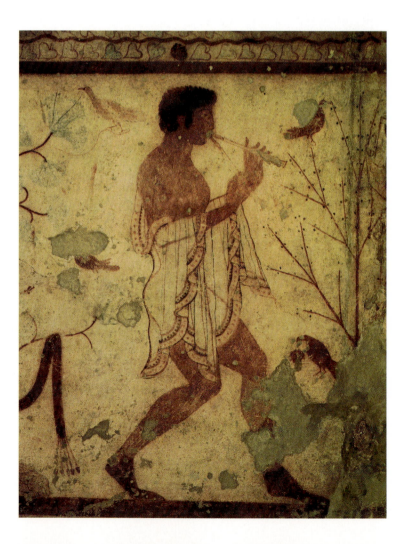

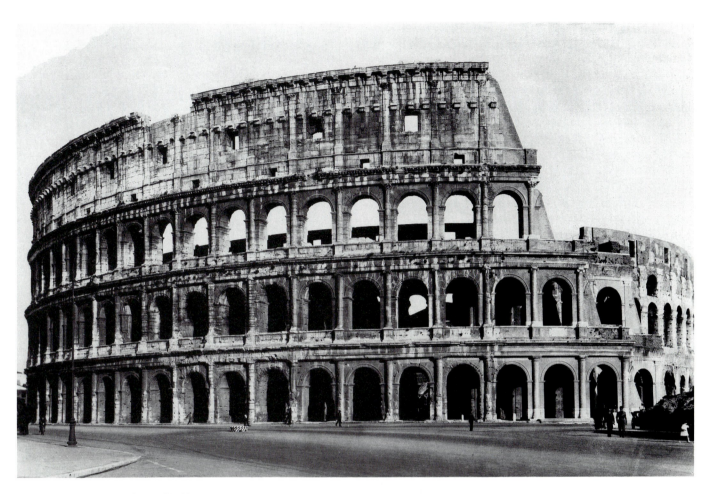

11.19 THE COLOSSEUM, ROME. 72–80 A.D.

Roman Peace, the Roman army maintained law and order and assured conquered peoples of security from other invaders. Roman governors wisely allowed subject peoples to continue to worship local gods as long as they recognized the supremacy of Roman gods. Roman builders, refining the arch and the vault, provided every city under Roman jurisdiction with roads, bridges, aqueducts, temples, basilicas, forums, and baths—enhancements of life that helped unite the empire. Temples in North Africa; the Pont du Gard, which brought water to Nîmes, France [7.10]; and Roman ruins in northern Britain remain as examples of their imperial expansion.

Architecture

The Romans had a taste for large-scale building and lavish decoration. The Roman Colosseum, of concrete faced with stone [11.19], was the largest structure for public assemblies built up to that time. Complex, concrete vaulting on a huge scale permitted steeply rising rows of seating of an auditorium made essentially of two halves of the Greek theater design that had served as its inspiration. Unlike Greek theater, however, which was built as a semicircle into a hillside, an ampitheater was constructed on level ground with a complex substructure of corridors and basements

with barracks for gladiators and cages for animals. There was even machinery for raising and lowering the stage. The Colosseum seated 50,000 spectators, who were protected by canvas awnings from the sun and rain as they watched the bloody battles between men and wild beasts. Like many other Roman buildings, the Colosseum combined columns of all three Greek orders.

Another large, richly decorated building is the Pantheon, the only temple of classical antiquity that has always remained a house of worship [7.13]. Originally designed to hold statues of the seven major planetary Roman gods under one roof, it is now a Christian church. The building, of brick and concrete, was once faced with marble. In its huge dome, the largest of antiquity, with a diameter of nearly 140 feet (42.67 meters), we see the Romans' great skill in engineering. The walls of the building are 20 feet (6.9 meters) thick in some places to support the heavy weight of the dome, symbolically representing the heavens, which had an open central *oculus*, or eye, to admit light. As the sun moved across the sky, it spotlighted in turn every niche holding a statue of a god.

Also large and ornate were the public baths, which included spacious halls and gardens as well as cold and hot rooms, dressing rooms, gymnasiums, open-air swimming pools, and libraries. The baths were heated by furnaces.

Lead pipes, which carried the hot water, can still be seen in the ruins. The vast, cross-vaulted Baths of Caracalla in Rome, resplendent in marble, murals, and carvings, are an outstanding example.

Adopting the **basilicas** of the Hellenistic Greeks, the Romans built long, colonnaded halls throughout the empire as law courts and places of assembly. Most of them had a high central nave flanked by lower aisles. They were entered from the long sides. At one or both ends was a raised semicircular area, or **apse**, where the judges sat behind an altar for the sacrifices that preceded judicial deliberations. Although many had wooden gabled roofs, the Basilica of Constantine [11.20] was vaulted. Even larger than the Pantheon, it rose 114 feet (34.74 meters) and glowed inside with rich marble facing. This basilican plan was used for Christian churches, as we shall see in Chapter 12. Within the walls of the Basilica stood a colossal statue of Constantine, some 30 feet high. Only the massive and impassive head remains, a testament to the belief that the emperor served as God's ruler on earth [11.21]. Any elements of Constantine's personality are completely submerged in a masklike formula of an exalted authority of an absolute despot. It is interesting to compare this image of a ruler with those we have seen earlier, such as the Egyptian Sphinx which represented Khafre.

Typically Roman was the ornate triumphal arch, built by successful generals like Constantine to celebrate

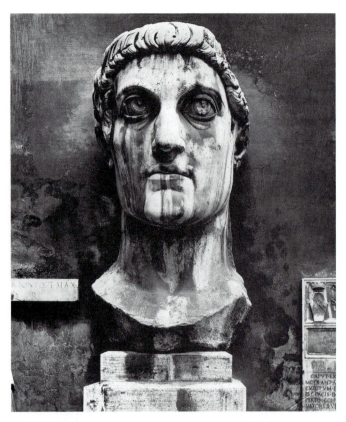

11.21 COLOSSAL HEAD OF CONSTANTINE. MARBLE, 8'6".
CAPITOLINE MUSEUMS, ROME.

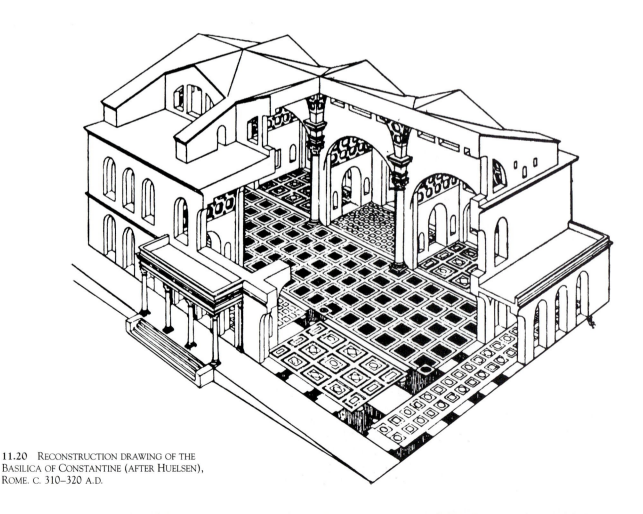

11.20 RECONSTRUCTION DRAWING OF THE
BASILICA OF CONSTANTINE (AFTER HUELSEN),
ROME. C. 310–320 A.D.

11.22 ARCH OF CONSTANTINE, ROME. 312 A.D. HEIGHT 67'7" (20.6 M), WIDTH 82' (25 M).

their victories. Usually set up in areas conquered by Rome, they were constant reminders to the defeated of Roman glory. When we view these monuments today, such as the Basilica, the sculpture and the triple Arch of Constantine [11.22], all in Rome, we begin to understand the power of Roman leaders and how they maintained such status. The triple arch was an important gateway to Rome when the city was still walled for protection. Much later, triumphal Roman arches have been copied in Paris, London, Berlin, and even in Washington Square in New York City. Few question the function they now serve.

Roman emperors, senators, and other rich citizens lived in luxurious palaces and country villas with elaborate fountains and gardens. Well-to-do city dwellers had pleasant town houses built with post-and-lintel construction around a formal court with a pool for rainwater. Many included a colonnaded rear court with a fountain and garden. The House of the Vettii in Pompeii, buried in the volcanic lava and ash that erupted from Mount Vesuvius and now restored, shows how elegant such homes could be [11.23]. Urban citizens often climbed several stories to their rooms in a large apartment house, as noted in Chapter 7.

11.23 HOUSE OF THE VETTII, POMPEII. 63–79 A.D.

Murals

Larger villas and houses were decorated with colorful wall paintings, many of which still can be seen in Pompeii. These murals give us some idea of what ancient Greek painting must have been like, for most of them were done by Greek artists. Landscapes, intimate scenes, ceremonies such as weddings, mythological figures, and still life were favored subjects, sometimes set in panels of flat color. Painted with lively brush strokes and often a sense of architectural perspective, **illusionistic** murals gave the effect of a view beyond a window.

There exists one monumental series of paintings whose grand style and sweeping concept are unique in the history of Roman painting. The great frieze in the Villa of Mysteries just outside the city of Pompeii dates from the latter half of the first century B.C. Placed on a narrow ledge of green against a regular pattern of red panels are twenty-six lifesize figures, many of which are repeated as they appear in what was probably a secret prenuptial ritual celebrated in the murals. Dionysus and Ariadne, with their retinue of satyrs and nymphs, officiate as observers so that the Dionysiac myth, reality, and the viewer are at once all involved [11.24].

Mosaics, made of small pieces of marble set in mortar, were also popular for wall and floor decoration, depicting battle and hunting scenes alive with exotic animals and birds from as far away as Egypt. One example shows the Nile with crocodiles, lotus buds, and a hippopotamus.

Sculpted and Painted Portraits

Perhaps the most typical Roman contribution to art was portraiture. In contrast to the Greek idealization of the face, Roman portraits were **veristic**, duplicating real people with warts, wrinkles, and other disfigurements. Realistic marble busts of stern-looking Roman generals and rulers were placed in local forums to represent Roman authority to the conquered peoples. These, along with faces depicted on Roman coins, spread the imperial image throughout the Roman world. Perhaps this ancient form of mass media contributed to the success of Roman government.

The same Roman taste for realistic portraiture appeared in a group of funerary paintings of Romans who had settled in the Faiyum district in Egypt. When they died, their bodies were wrapped in linen and a colorful portrait of the deceased was inserted over the face, according to Egyptian custom [11.25]. Painted on wood panels in **encaustic**, an exceptionally durable mixture of pigments and hot wax, these informal individualized portraits are so full of life that they seem to have been painted while the subjects were still alive. Such vitality in portraiture was not to be seen again for a thousand years.

Late Roman Sculpture

Constructed in several sections of white marble, a monumental column was erected in the Forum of the Roman Emperor Trajan, commissioned by the Senate and the people of Rome [11.26]. The forum is long since gone, but the 128-foot column remains, its surface entirely covered by a spiral band, reading from left to right the saga of Trajan's exploits defending Rome against the barbarians. More than 2500 human figures appear in the narrative, including ninety of Trajan; its political content, likely designed as state propoganda, was primarily for the masses who could not read but could support the visual images that linked good government with Trajan's victories. Nonetheless, the

11.24 DIONYSIAC CYCLE PAINTING. FRESCO. C. FIRST CENTURY A.D. POMPEII.

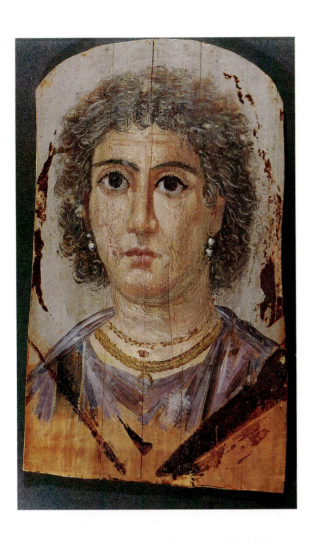

11.25 MUMMY PORTRAIT OF AN ELDERLY WOMAN, FROM THE FAIYUM, EGYPT, 1ST–2ND CENTURY A.D. ENCAUSTIC ON PANEL, 14-7/8 × 9″ (38 × 23 CM). STATE COLLECTION OF EGYPTIAN ART, MUNICH.

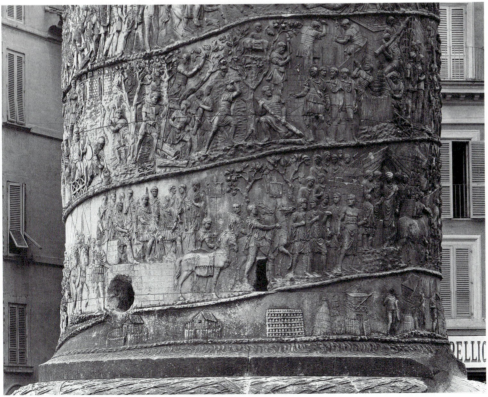

11.26 TRAJAN'S COLUMN (DETAIL OF LOWER PART OF COLUMN). 106–113 A.D.

style is fresh and alive, and, as tradition has it, Trajan chose the column as the site of his burial. His ashes were placed in a chamber beneath.

The imposing, life-size equestrian bronze figure, which unexpectedly became the last sculpted for a thousand years, celebrated the Emperor Marcus Aurelius, highly regarded for his leadership and his philosophical convictions. Having carefully studied the Greek philosopher Stoic, he based his writings on a similar kinship with nature and universal brotherhood. Also implicit was the recognition of the interdependence of all peoples. Aurelius seems perfectly balanced on his splendid mount in an attitude of deep thought, projecting that same patient Stoic philosophy for which his *Meditations* were widely read [11.27].

We began the story of Roman art as a development of many influences from outside sources such as the Greek and the Etruscan, and we must conclude with the waning powers of Rome in the West—the decline of creativity and technical skill, and the coming assimilation of medieval Christianity into Graeco-Roman civilization. Perhaps, most important of all, we will note that Greece and Rome no longer hold center stage in their world, for the seat of power slowly but unfailingly has moved eastward. And only with difficulty will we be able to trace the diffusion of ideas over such vast distances as the West from the East.

ASIA

India

As large as a continent, India continued, as it still does, to reflect the diversity of its peoples, split by millennia-old traditions of caste that go back to the ancient *vedas*. Castes are artificial social divisions, passed on at birth, which limit individual opportunity to the level of the parents. However, during the sixth century B.C., two major religions developed in India that held promise for many. The first, Buddhism, profoundly affected the culture and art of the country for several centuries before spreading eastward. The second, Jainism, still exists as a minor Indian religion, but had little influence on art.

In perhaps 563 B.C., Buddha Sakyumini, the son of a king, was named Prince Siddhartha. After facing Four Encounters—old age, illness, rigid religious devotion, and death—Siddhartha gave up all personal wealth and family to seek the enlightenment that would release him, and all others who pursued the same path, from endless reincarnation and human suffering. Having become known as the Enlightened One, or Buddha, he preached that only through such a course of action could a person win salvation and attain a state of peace (Nirvana). His saintly

teaching inspired an order of monks who wandered with him through India begging in symbolic identification with the Buddha until his death.

Early Buddhists built stupas, domed monuments holding relics, such as Stupa No. 1 at Sanchī [11.28]. Stupas stood on platforms surrounded by walls or railings and large gateways. On top of the domes were finials, like small umbrellas signifying the roof of Heaven. The rails and gates were often carved with reliefs of scenes from the Buddha's life. They never portrayed the Buddha himself but used symbols such as his footprint or the Wheel of Existence. Over the centuries many Buddhists came to believe that Buddha was divine. They built cave temples in his honor and carved freestanding statues, showing him teaching or in meditation [I.4]. His gentle smile and halo suggest

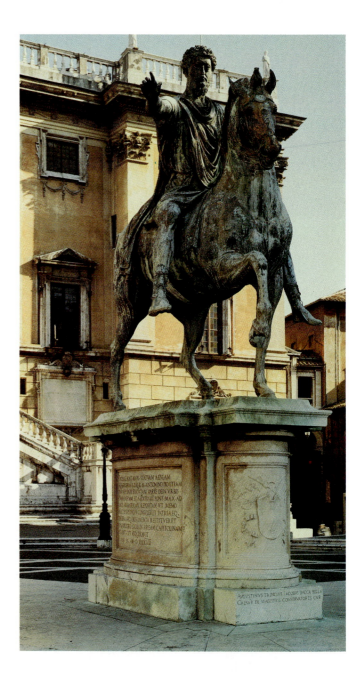

11.27 Equestrian Statue of Marcus Aurelius. Gilt bronze, height 9'10". Capitoline, Rome.

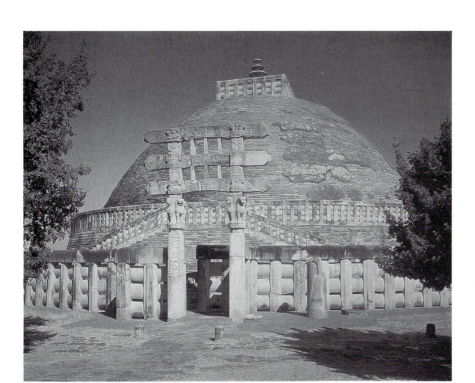

11.29 *YAKSHI (TREE GODDESS)*, FROM THE EAST GATE OF THE GREAT STUPA, SANCHI, INDIA. EARLY ANDHRA PERIOD, 1ST CENTURY B.C.

saintliness. His long ear lobes show how attentively he listens to the secrets of the cosmos and are a symbolic reflection of his pre-Nirvana existence, when he wore the heavy jewelry of a prince. The *ūrnā* in the middle of the forehead of a Buddha image is a tuft of hair, and the *ushnisha* a protuberance of wisdom. The figure is serene, far beyond sensual pleasure and other attachments. In the third century, the Indian monarch Ashoka embraced Buddhism and encouraged its growth beyond India. As Buddhism spread to Southeast Asia and north to Tibet, China, and Japan, painters and sculptors adapted this Indian concept of Buddha with changes that represented local styles.

Hindu Art Although Buddhism became a major world religion, it did not persist in India. Hinduism, which fused with Brahmanism and incorporated some features of Buddhism, had much greater appeal, perhaps because of its delight in the physical world, which dominates Hindu imagery. Because sexual desire was a revered part of life and physical union was believed to be one way to attain unity with the gods and the universe, erotic subjects were frequent. The exaggerated curves of a Hindu tree or earth goddess also express the rhythm that pulses through all of creation [11.29].

The golden age of Indian art came with the rise of the Gupta Dynasty, building a triumph for Hinduism. Large temple complexes appeared, which included a cella, or chamber, for the god surmounted by a tower, assembly halls, ritual baths, and open chambers. These structures were often completely covered with miles of relief sculpture of intertwining human, animal, and floral motifs expressing the rhythm of life. Leaving no surface undecorated, the

sculptors carved a lavish testament to their belief in the unity of all living forms.

There was an intense revival of the pre-Buddha, Hindu gods and temples dedicated throughout the land. Unique were those hewn from solid rock, where the faithful could assemble in the galleries, enriched with a forest of carved pillars and sculptures. The Ajanta caves in Hyderabad achieved an apex with twenty-nine sanctuaries, decorated inside and out [11.30]. Gupta mural painting represents various states of the Buddha, treated in a secular manner with a vitality almost modern in feeling. Despite the fall of the Guptas, some of the most spectacular monuments of India were still to come.

China

The basic characteristic of the Chinese remains the unity of their great civilization. In Chinese hands, nature has taken on an orderly appearance! It has been observed that even when viewed from the air, the effect of the Chinese taming of the environment is perhaps the most moving mark of the culture. The domination of the land can be nowhere more apparent than we have seen in the Great Wall of China [10.25]. Despite the favorable conditions created by the Ch'in dynasty, however, it was not until Han rule that imperial art was produced on a grand scale. While the tombs of the emperors have all but disappeared, inside each remains the *ming-ch'i*, little models of houses whose function seems to have been to comfort the dead with reminders of the life they had enjoyed [11.31]. From the

11.30 *Man Contemplating a Flower.* Fresco. Ajanta Cave. 2nd–6th century A.D.

terra-cotta works we can also visualize the buildings that have since disappeared, with four-sided roofs and interior courtyards.

Towards the end of the Han Dynasty, Buddhism made its appearance, taking hold after still earlier beginnings in India, when the impact of Indian thought was at its height in China. In A.D. 453, the Emperor Wen Ch'eng-ti officially embraced Buddhism, and the characteristic features for the statues of the Buddha were established, including the tuft of hair on the nose, protuberance on top of the head, naturalistic nude body, and hands with open palm. The T'ang Dynasty, which followed, saw an ever-increasing display of art and wealth. The Chinese painted on paper or silk for horizontal scrolls that could be rolled and tied, but unfortunately few works have survived.

11.31 Tomb Model of a House. 1st century A.D. Painted pottery, 52 × 33-1/2 × 27" (132.1 × 85.1 × 68.6 cm). Eastern Han Dynasty, China. The Nelson-Atkins Museum of Art, Kansas City, Missouri (Nelson Fund).

11.32 Haniwa Figures, horse and peasant. 5th–6th centuries. Clay. Left: Horse. Cleveland Museum of Art (gift of the Norweb Collection). Right: Peasant. Cleveland Museum of Art (James Parmelee Fund purchase).

Japan

Japan can claim neither the great age nor the artistic invention of its nearest neighbor, for more than once has Japan turned to China for inspiration. Her prehistoric period of Jō pottery and the Dogū grotesque terra-cotta figures lasted up to the sixth century, followed immediately by the *Yayoi* (300 B.C.–A.D. 300). Ornamental bronzes were introduced, while iron was reserved for utility. Like the Chinese, the custom of burying the important dead in large mound-shaped tombs became common. Large numbers of terracotta *haniwa* [11.32], the Japanese equivalent of the Chinese *ming-ch'i*, have been found and also apparently used to comfort the dead. Tubular sculptures made of fired clay, they were placed around burial mounds to protect the dead and might be human or animal in form. Pottery and the wheel appeared, along with *shinto* shrines of unpainted wood. The native faith of Japan, Shinto celebrates nature, the family and the ruling family of Japan as direct descendents of the gods. A typical shrine, like the Buddhist temple, consists of several buildings within a fenced enclosure. The monastery of Horyuji at Nara demonstrates the characteristics of early Japanese architecture [7.17]. Built on square foundations, the temples were generally single-storied and roofed with tiles. The pagodas, in contrast, were multistoried and crowned with a steep pinnacle.

The Nara period (645–794) witnessed the growth of the capital in the city and establishment of the central edifice, the Hall of the Great Buddha. Constructed, as we learned, by the Emperor Shōmu (Chapter 9), it remains the largest wooden structure in the world. The Treasure House still stands as the earliest "museum," holding thousands of art objects, virtually in as fine condition as when they were first stored. Note the remarkable oversized mask [9.6] and robe [9.7], both more than one thousand years old.

THE AMERICAS

During the first millennium A.D., what remains of the arts of North, Central, and South America can be characterized as primarily abstract and planar, with broad geometric forms. Overwhelmingly religious, there is still considerable diversity in their styles, from community to community, but the rules of convention, which overlaid all religious ritual, could not permit divergence nor experiment in any of the traditional arts. Therefore we find a timeless continuity, resistant even in the face of the destructive influences of colonialism and the changes imported with foreigners. Nonetheless, the native arts of the Americas were firmly suppressed, and only to the extent that colonialism has been largely eroded internationally have we come to appreciate the pre-Columbian arts of these continents.

North America

Pottery, architectural remains, engravings and rock paintings can be found broadly across North America and span great periods of time. The consistency of community styles seems to have persisted up to the arrival of European explorers. Rock arts vary from naturalistic renderings to complex compositions of geometric linear figures used in rituals. Perhaps most significantly, the variety of styles and forms of North American arts document creative, native peoples who were deeply respectful of their environment and reverent toward nature.

Middle America

The influence of Middle America, a somewhat broader term than **Mesoamerica** (Chapter 10) and includes the islands east of Central America, spread far and wide in the Classic period from A.D. 200 to 900—north to the Mississippi Valley and southwestern United States, to the Antilles, and into South America, even briefly through Ecuador and possibly Peru. So advanced was intercommunication between these peoples that, according to native accounts, within a few hours of Columbus' arrival on these shores, on the island called San Salvador, Montezuma, the king of Mexico, had been notified. In the great city of Teotihuacán nearby, pyramids to the sun [11.33] and to the moon still stand on the Avenue to the Dead. Even today's view of what remains of the impressive structures, gives an inkling of why the Spaniard colonizers were so delighted with their discoveries.

South America

The history of the civilizations of South America parallels the pre-Columbian peoples of Mesoamerica. Developing between 200 B.C. and A.D. 600 are the great cultures of the Moche in the north and the Nazca in the south. Perhaps the most famous and unique art objects produced by Peruvians are the ceramic stirrup portrait bottles of the Moche, molded without a potter's wheel and believed to represent a warrior or a priest. Excavated in 1988 on the northwest coast of Peru was an unlooted tomb with a treasury of close to a thousand such ceramic vessels and accessories of gold and silver.

But it is the stone ceremonial architecture in the mountains of southeastern Peru that has probably attracted more attention than the pottery or metal artifacts. Tiahuanaco, an important ceremonial center, was dominated by images of the sun god. Constructed of andesite, sandstone, and diorite, the monolithic Gateway of the Sun [11.34] exerts a commanding presence. Rigidly frontal and symmetrical, the central figure stands on a terraced step, holding a staff in each hand, while from his blocklike head appears a headdress of rays, terminating in puma heads and circles. This same image of a "staff-god" was spread throughout the Tiahuanaco Lake area, always central to a formal composition. Radically abstract with compacted body proportions, the figures have become frozen into symbols that presage the art of the Post-Classic period that greeted Pizarro upon his arrival to Peru.

11.33 PYRAMID OF THE SUN. HEIGHT 216′. TEOTIHUACAN, MEXICO.

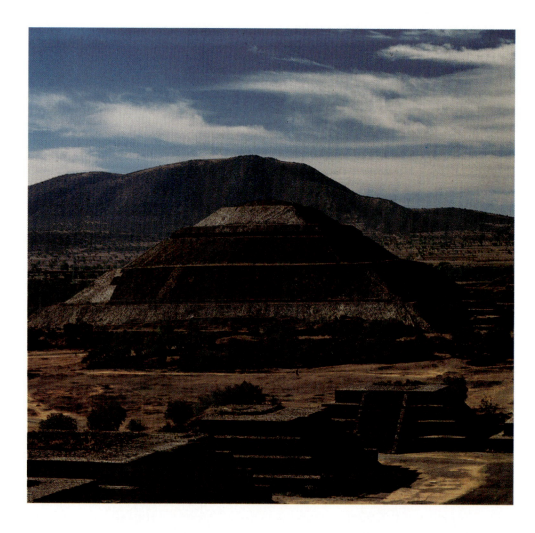

11.34 GATEWAY OF THE SUN (PRE-COLUMBIAN). 9TH CENTURY. TIAHUANACU, BOLIVIA.

EXERCISES AND ACTIVITIES

Exercises for Research and Discussion

1. Consider the Greek architectural principles of unity and proportion that are demonstrated in the design and decoration of the Parthenon. Explain.

2. List and define the different parts of a Greek order. How do the three orders differ?

3. Explain the concept of ideal beauty in relation to Greek art, naming specific works. In what way is that ideal expressed in the sculpture and architecture of the Golden Age of Greece? How did the sculpture of the Hellenistic period differ from that of the Golden Age?

4. What features did Greek and Roman art have in common? What elements from other civilizations did the Romans incorporate into their art? What are some of the Roman engineering innovations?

5. Explain the origins of the arch, its construction, and how it was used in Rome.

Studio Activities

1. Draw a diagram to show construction of the arch.

2. Create in clay, wax, or soap a sculptural work of art inspired by Greek or Roman art.

3. Shape a piece of pottery or clay in the form of a Greek cup (kylix) or a jar (amphora).

4. Carve from soap a sculpture of a head reminiscent of Roman portraits.

5. Form a fertility figure of clay close to the Tlatilco figurine.

Faith

THE MIDDLE AGES

"*B*etween the city in which it is promised that we shall reign and the earthly city there is a wide gulf—as wide as the distance between heaven and earth. Yet ... there is a faint shadowy resemblance between the Roman empire and the heavenly city.*"

—ST. AUGUSTINE, CITY OF GOD

• • •

"*T*o adore images is one thing; to teach with their help what should be adored is another ... what scripture is to the educated, images are to the ignorant. ..."

—POPE GREGORY I

• • •

"*I*n the broad sense anyone is a pilgrim who is outside his fatherland ..."

—DANTE ALIGHIERI, LA VITA NUOVA

As the light of "Eternal Rome" flickered low in the fourth century A.D., in its place throughout the Mediterranean world altar lights glowed softly as the new Christian faith attracted converts. The power of Rome was fading, but images of classical times lingered on through Early Christian religious art and were later perpetuated in Carolingian, Romanesque, and Gothic art during the period we call the Middle Ages.

ART OF SOUTHERN EUROPE

Early Christian Art

For the first three centuries after the birth of Christ, the early Christians worshiped in private homes or, during times of persecution, in the **catacombs**, underground tunnels in and near Rome that honeycombed the soft volcanic rock and were used by Christians and pagans as cemeteries.

Christian fortunes changed markedly in the fourth century. The reigning Roman emperor, Constantine, who himself became a Christian convert in A.D. 303, officially approved of Christianity as one of the accepted religions of the empire in 313. In 330, to strengthen the empire, threatened by barbarians from the north and east, he moved the capital from Rome to Constantinople (Byzantium, or modern Istanbul) in the East. Christians, as inhabitants of the far-flung Roman empire, were already diverse in origin, language, and point of view. Some were Romans, living in the West. Some were Gauls and Goths in the North. Some were Jewish converts, Syrians, and other Middle-Eastern peoples. The shift of the capital, which resulted in a division of the empire into a Latin-speaking West and Greek-speaking East, intensified their differences. Early Christian art reflects this history.

Symbolism in Sculpture and Murals

The language differences between early Christians encouraged them to express their common faith through visual symbols whose meaning was clear to all Christians. Symbols also had the advantage of hiding a religious message so that the Romans would be less likely to persecute believers. For example, the Romans might not recognize the cross as a symbol of the crucifixion of Christ if it were combined with the Greek letters *chi* and *rho*, the first two letters of the word *Christ*. They would not know that the fish stood for Christ and the sacrament of baptism. The early images of Christ that appeared within two hundred years were also developed as symbolic representations.

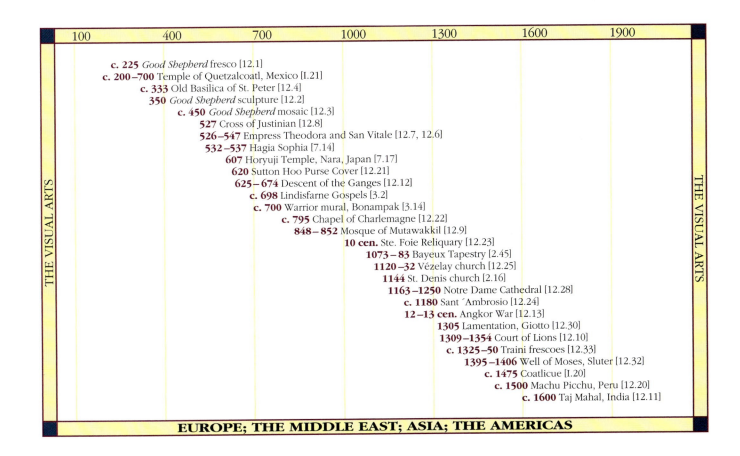

| | | | | | | |
|100|400|700|1000|1300|1600|1900|

THE VISUAL ARTS

c. 225 *Good Shepherd* fresco [12.1]
c. 200–700 Temple of Quetzalcoatl, Mexico [I.21]
c. 333 Old Basilica of St. Peter [12.4]
350 *Good Shepherd* sculpture [12.2]
c. 450 *Good Shepherd* mosaic [12.3]
527 Cross of Justinian [12.8]
526–547 Empress Theodora and San Vitale [12.7, 12.6]
532–537 Hagia Sophia [7.14]
607 Horyuji Temple, Nara, Japan [7.17]
620 Sutton Hoo Purse Cover [12.21]
625–674 Descent of the Ganges [12.12]
c. 698 Lindisfarne Gospels [3.2]
c. 700 Warrior mural, Bonampak [3.14]
c. 795 Chapel of Charlemagne [12.22]
848–852 Mosque of Mutawakkil [12.9]
10 cen. Ste. Foie Reliquary [12.23]
1073–83 Bayeux Tapestry [2.45]
1120–32 Vézelay church [12.25]
1144 St. Denis church [2.16]
1163–1250 Notre Dame Cathedral [12.28]
c. 1180 Sant´Ambrosio [12.24]
12–13 cen. Angkor War [12.13]
1305 Lamentation, Giotto [12.30]
1309–1354 Court of Lions [12.10]
c. 1325–50 Traini frescoes [12.33]
1395–1406 Well of Moses, Sluter [12.32]
c. 1475 Coatlicue [I.20]
c. 1500 Machu Picchu, Peru [12.20]
c. 1600 Taj Mahal, India [12.11]

THE VISUAL ARTS

EUROPE; THE MIDDLE EAST; ASIA; THE AMERICAS

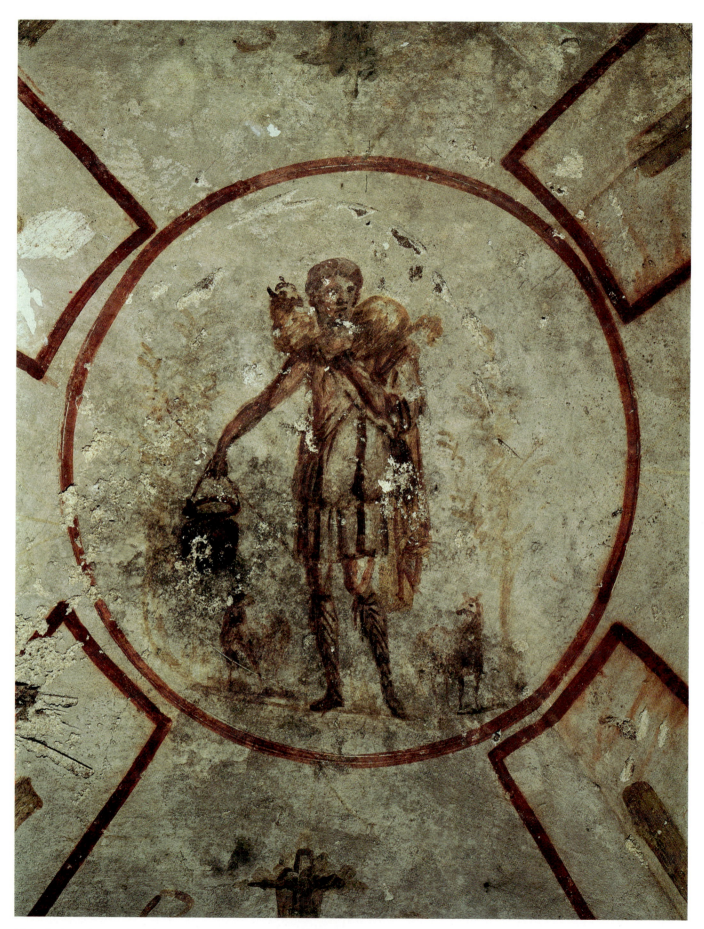

12.1 Crypt of Lucina. *The Good Shepherd.* Early 3rd century a.d. Fresco. Catacomb of St. Callixtus, Rome.

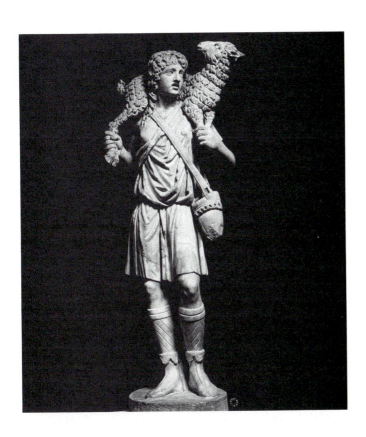

12.2 *THE GOOD SHEPHERD.* C. 350. MARBLE, HEIGHT 39″ (99 CM). LATERAN MUSEUM, ROME.

Early Christian artists, many of whom came from Rome and Greece, used classical images they were familiar with but gave them new religious meaning. No pagan could object to paintings or sculpture of the Good Shepherd, for shepherds were a popular subject in classical art; but in Christian art the shepherd surrounded by his flock symbolized Christ with his disciples or other devout followers. Posed like earlier Greek figures, Christ is beardless and wears a Roman tunic. In a fresco of *The Good Shepherd* from one of the catacombs, Christ is seen as a clean-shaven Roman youth [12.1]. The circle that surrounds the figure signifies eternity. Somewhat later, Christ as a Good Shepherd also appears in sculpture as a typical Roman lad [12.2]. It is interesting to see the changes dictated by the Byzantine influence a hundred years later in the mosaic, where Christ seems older and clothed in more authentic Middle-Eastern dress [12.3].

Just as pagan festivals were reconstituted as Christian holy days, so Early Christian frescoes painted on the

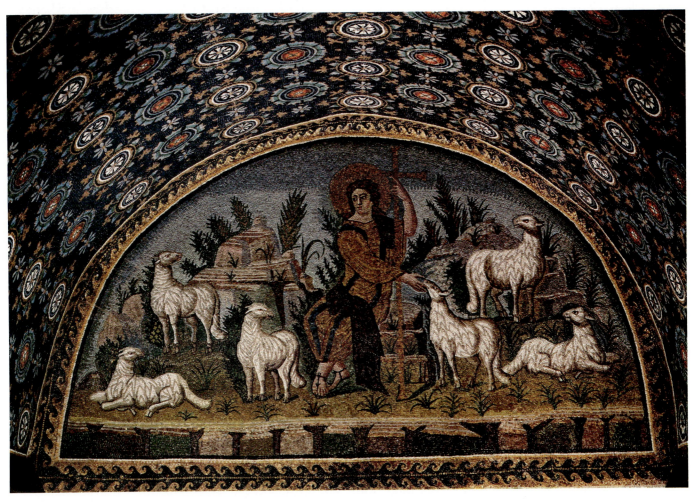

12.3 *THE GOOD SHEPHERD.* 5TH CENTURY. MOSAIC. MAUSOLEUM OF GALLA PLACIDIA, RAVENNA.

walls and ceilings of the catacombs used images of grapes, animals, birds, and fish, borrowed from classical art, to convey new Christian significance. For example, grapes, a pagan symbol of the cult of Bacchus, the Roman god of wine, now represented wine as the sacramental blood of Christ. The peacock, originally meaning wisdom, became a symbol of eternal life because its flesh was believed to be incorruptible.

Frescoes and mosaics on the walls and ceilings of tombs and, later, churches were created to tell the story of Christ's life, death, and resurrection, serving as a pictorial narrative for the illiterate. Artists became progressively less concerned with realistic representations of human forms and more concerned with expressions of religious truths. As a result, images became simplified and spiritualized. Christ appeared as a middle-aged man and acquired a long Middle Eastern robe and beard and a **halo**, a gold circle around his head signifying his holiness.

So he has been depicted ever since. This abstract style and the use of the halo were especially effective in mosaic, a process involving small pieces of glass set into cement and carefully placed to reflect the light that filtered through the small windows and flickered from the altar candles. The walls seemed to lose their solidity in an almost supernatural glow, well suited to express the spiritual messages of early Christianity. The shimmering gold and colored glass pictures suggested heaven, and as the congregation entered the mysteriously lit interior of early houses of worship, they must have felt as if they were already transported there.

Architecture

As Christians increased in numbers, the catacombs were abandoned and new places for worship had to be provided. These could not be modeled on pagan temples, for the ritual of the Christian church differed fundamentally from that of ancient religions. The cella of a pagan temple was reserved for the gods and their priests. The faithful, who processed around the outside of the temple, could only glimpse the sanctuary through the doors. The sacrificial altar was placed outside where they could see it, and the exterior of the building was decorated with sculpture. In contrast, Christian ceremonies took place indoors and the congregation participated. Space was needed to allow people to participate in the Mass and later to move toward the altar to receive communion.

Since Roman basilicas and lavish villas were large secular buildings not associated with pagan religion, their layouts (floor plans) were adapted for the new places of Christian worship. Just as various rooms in a Roman home satisfied different functions, the spaces of the church did also. The apse, placed at the eastern end so that the devout could face the Holy Land and the rising sun, was retained for the altar and clergy, and the main entrance was moved to the west end. This arrangement gave a powerful linear orientation, focusing attention on the altar. Sometimes the builders borrowed columns taken from older pagan structures.

The restoration study of Old St. Peter's Basilica in Rome, an important Early Christian basilica, shows us how the needs of Christian worship were met [12.4]. The

12.4 OLD ST. PETER'S BASILICA, ROME. C. 333. RESTORATION STUDY BY KENNETH J. CONANT.

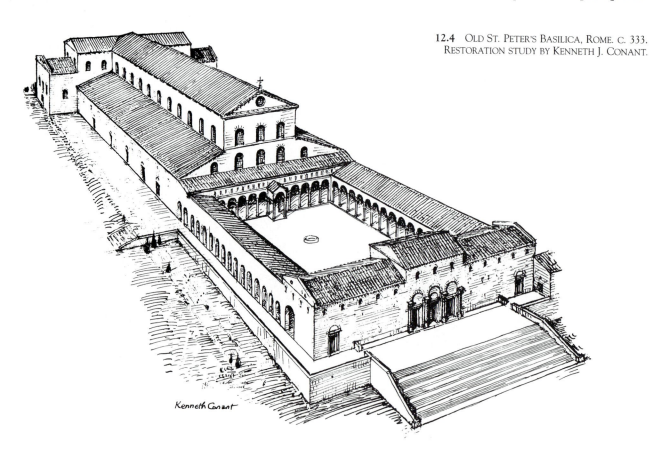

Kenneth Conant

faithful first entered through a gateway into a walled courtyard, like the atrium, with a pool used for baptism, before entering the church, an oblong hall divided by columns into a high nave and four side aisles for the sharing of the scriptures. The low aisles increased the floor space while allowing light to come through the windows of the **clerestory**, the upper part of the walls of the **nave**, which could be seen from the exterior. At the east end was a **crossing** (transept), or horizontal space, that intersected the nave and beyond it the **apse** with an altar for the Eucharist (breaking of the bread).

Christ had preached that riches on earth were less important than salvation. The churches symbolized this belief with plain exteriors and interiors lavishly decorated with richly colored mosaics or paintings representing the spiritual riches of the kingdom of heaven. Such interiors were suitable settings for ornate and gem-studded altar furnishings—chalices, screens [12.5], candle holders, and **reliquaries**, containers that held the relics of martyrs. Many Early Christian churches were constructed over crypts or relics of martyrs because such areas were believed by the faithful to be sacred, and some churches offered a **narthex**, or gateway into the new spiritual city.

BYZANTINE ART AND THE MIDDLE EAST

Before the sixth century, Early Christian art was a blend of its western Roman and eastern Byzantine roots. Roman art was still in its fullness in the third century; Constantine's new capital on the site of ancient Byzantium had not yet been established. Although the city of Constantinople became undisputed arbiter in the arts, it was a slow and gradual process. As the Western Empire weakened, the leadership tended to shift more and more to the East. During the reign of Justinian (527–565), the center was firmly established far to the east in Constantinople. There the emperor launched a building program destined to enrich the Eastern Orthodox Empire.

Architects in the East had been using domes, symbols of heaven, to roof square or cross-shaped churches for many years. In 532, Justinian commissioned the church of Hagia Sophia, or Holy Wisdom, which had a great central dome that seemed to float over the interior space. The Byzantine historian Procopius, who saw it being built, said it hung "as if suspended by a golden chain from heaven." The weight of the dome, carried by four piers at the corners

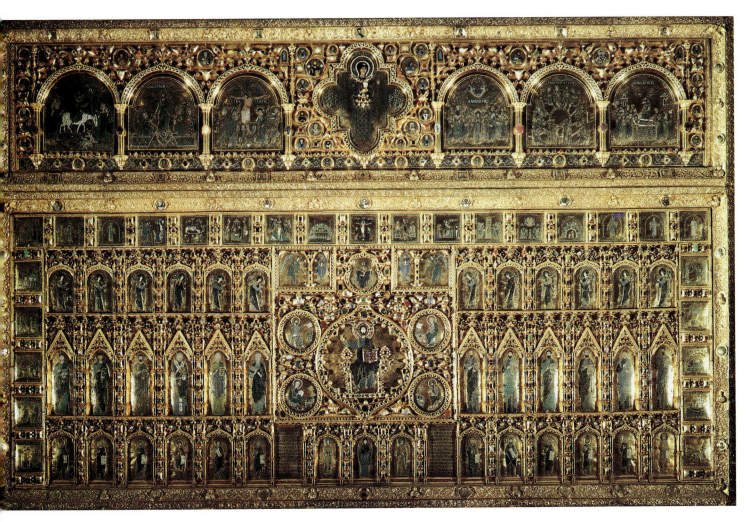

12.5 GOLD REREDOS IN ST. MARK'S BASILICA, VENICE.

of the square space below it, rested on **pendentives**, a brilliant structural innovation, described as spherical triangles, or sections of domes [7.12]. The ribbon of small arched windows around the base of the dome let in a stream of light that must have been dazzling as it played over the original gold and colored mosaics [7.14].

Domes and mosaic decoration were characteristic of Byzantine architecture [12.6], as may be seen in San Vitale, a church built by Justinian in Ravenna, a Byzantine focus of culture in Italy. Octagonal in shape with a central dome, its interior was covered with marble and rich mosaics that echo the imagery of the catacomb paintings while heralding the new Byzantine style, which has remained virtually unchanged for more than 1500 years. The tall, thin, large-eyed figures, high above the heads of the congregation, added to the sense of awe and mystery that would have been felt by the worshippers. Just above the heads of the congregation, in the sanctuary beyond the altar [12.7], mosaic images of Justinian and his bride, the Empress Theodora observe the celebration of the Mass. The message is clear. While God may have created everyone equal, some were surely more equal than others. The Byzantine love of rich decoration may also be seen in the cross of Justinian, an elaborate jeweled reliquary believed to contain a fragment of the true cross on which Christ suffered and died [12.8].

The Byzantine art we have examined primarily concerns the Mediterranean world from the third century perhaps to the eighth—between the ancient world and the medieval. Too important to be considered only transitional, the Byzantine has coexisted, first with Early Christian, and then later with the Islamic, and somewhat with the Romanesque and Gothic. The Islamic world, we will find, is somewhat more unified throughout its media. Whether we are viewing costume, carpets or calligraphy, the outstanding importance of linear elements of decoration such as script will bring together Islamic arts of various regions and eras to hold an outstanding place in the story of all art of the past.

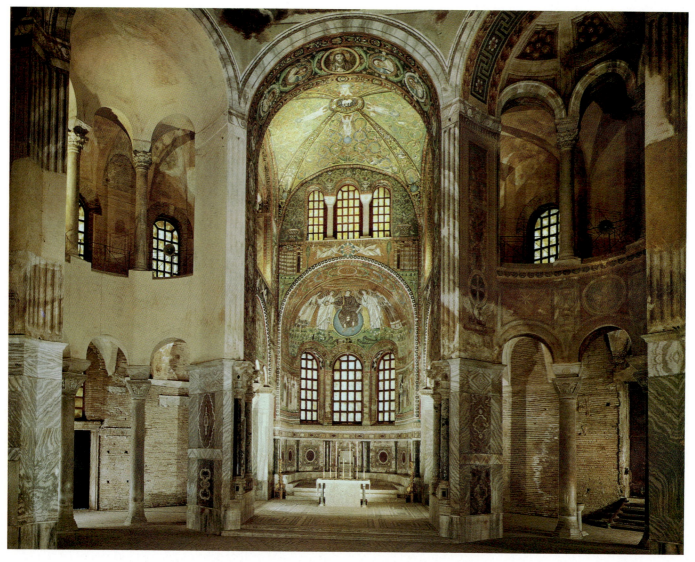

12.6 CHOIR AND SANCTUARY. SAN VITALE, RAVENNA, ITALY. C. 530–548.

12.7 EMPRESS THEODORA. ST. VITALE, RAVENNA, ITALY. C. 530–548.

THE ISLAMIC WORLD AND AFRICA

Almost one-fourth of the world, including the vast area of North Africa and the Middle East, is dominated by Islam, the religion founded by the prophet Muhammed in Arabia in the early seventh century A.D. The Islamic era is counted from the year A.D. 622, the date of Muhammed's migration to Medina. In its first forty years, the new faith spread through the Mediterranean world, drawing more converts than Christianity had won in the previous three centuries. Devout Muslim warriors occupied Spain in the eighth century and in the sixteenth and seventeenth centuries controlled northern India. Medieval Christian crusaders, who drove the Muslims from Spain and fought them in the Holy Land, learned much from their highly civilized adversaries. From Arabic numerals, scholarship, and arabesque ornament to the manufacture of paper, Islamic art, learning, and craftsmanship profoundly affected the European Middle Ages. How can we account for the phenomenal Islamic conquests? Beyond their immediate triumphs by the sword, the new faith must have satisfied the needs of millions of Muslim converts more fully than any of the surrounding older religions.

12.8 CROSS OF JUSTINIAN. 527–565 A.D. TREASURY OF ST. PETER, VATICAN MUSEUMS, ROME.

12.9 MOSQUE OF MUTAWAKKIL, SAMARRA, IRAQ. 848–852 A.D.

Architecture

Throughout the Islamic world the Muslims built **mosques** as houses of worship. A mosque usually consisted of a court-yard and fountain for ritual washing and a spacious col-umned or vaulted hall where men knelt on rugs in prayer. Most mosques had **minarets**, or towers, from which the faithful were called to prayer five times a day. In the great ninth-century mosque built by the caliph Mutawakkil in Samarra (in modern Iraq), the largest ever built, you may recognize the influence of the ancient Mesopotamian zig-gurat [10.7] in the minaret, which is encircled by a steep ramp [12.9].

The Muslims also built religious schools, palaces, and tombs. One of the most magnificent palaces is the four-teenth century Alhambra, or red castle, in the **Moorish** (North African and Spanish) city of Granada in southern Spain. Its lion court [12.10], enlivened by a fountain, is surrounded by brilliantly tiled walls and an arcade of slen-der columns supporting high arches in a lacelike wall. The interior walls are enhanced by an endlessly appearing vari-ety of perforated **arabesque** detail, yet disciplined by the rhythmic design that courses through it all. The Alhambra set a style copied throughout the Islamic world.

Probably the best-known Islamic structure is the Taj Mahal in Agra, India, built in the seventeenth century by the Mughal Emperor Shah Jahan as a memorial to a favorite wife [12.11], who bore fourteen children before her death at 39. The onion-domed, white marble tomb, standing on a square platform with slender minarets at each corner, seems to float above its reflecting pool, appearing a fragile reference to a love that would not die.

12.10 COURT OF THE LIONS, ALHAMBRA, GRANADA, SPAIN. 1309–1354. 115 × 66″ (35.05 × 20.12 M).

12.11 TAJ MAHAL, AGRA, INDIA. 17TH CENTURY. 186' (56.69 M) SQUARE, HEIGHT OF DOME 187' (57 M).

Other Art Forms

Since orthodox Muslim tradition forbade representation of the human figure in religious art, there is little Islamic sculpture. Most figure painting consists of delicate miniature illustrated secular books by Persian court artists. The Muslims excelled, however, in nonrepresentational decoration, which appeared on mosques and other buildings, in copies of the Koran, and in glazed pottery and tile, metalwork, glass, and rugs. Some motifs were geometric; others were flowing abstractions of flowers and plants—arabesques. Inscriptions in Arabic from the Koran [I.9] were especially popular.

ASIA

Hinduism

The medieval world between the third century to as late as the fifteenth, caught up in the fervor of powerful and growing world religions such as Christianity, Islam and Buddhism, expanded far beyond their points of origin to establish pilgrimage centers for the faithful. In scale and complexity, the Hindu site at Mahamallapuram in south India has few rivals. Upon a natural outcropping of granite, a score of sculptors carved immense shrines on the face of a cliff above which is a natural pool. With the rains, the water cascades over a hollow caused by centuries of such erosion and flows near the center through the images, which, in sharp relief, tell the story of creation [12.12]. Deities representing the three sacred rivers of India, along with people and animals, depict the forces of nature creating and destroying through eternity. The most important aspect, perhaps, is the belief in reincarnation, eventually leading to the highest state of being. These traditions and arts were passed along trade routes to Cambodia and Indonesia.

In the southeast, Indian art reached the islands of Indonesia, but in Cambodia, art pursued another course, supported by the aggressive Khmer Dynasty that had followed the Gupta. Of the many temples built between the fifth and fourteenth centuries, none perhaps were more beautiful than Angkor Wat [12.13] with its many terraces and towers. The work of anonymous Khmer craftsmen achieved harmony and power in its design and rhythm in the rendering of its figures.

12.13 ANGKOR WAT, DETAIL. 12–13TH CENTURY.

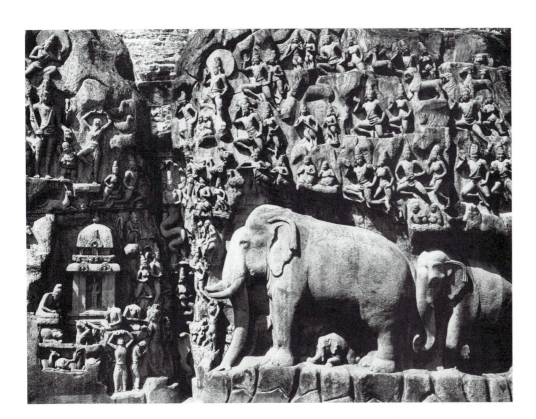

Buddhism

Chinese civilization greatly influenced that of Japan, as we have seen. In both countries, society was structured into rigid classes. Daily life was ruled by the extended family, respect for the ancestors, and custom. With this conservatism, art styles remained much the same for long periods of time.

Architecture Traditional buildings of the Far East used post-and-lintel construction and were made of wood. Conservative architecture changed little over the centuries. Chinese temples, palaces, and houses, as we know from clay models found in tombs of about 200 B.C. [11.32] and from later paintings, consisted of a complex of low buildings built around a series of courts. Each building stood on a masonry platform. Columns topped by brackets, all carved and painted, supported the tiled roof.

Sculpture Early Chinese sculpture was generally religious, with many examples related to tombs. Early Chinese tombs were guarded by large hollow clay figures of people and animals buried in the ground [6.14]. The Chinese carved reliefs on tomb walls and later in the seventh and eighth centuries filled tombs with lifelike glazed pottery figurines of courtiers, camels, and horses [12.14]. The sophistication of culture under the T'ang Dynasty comes alive in the modeling and light glazes of these ceramic sculptures. Although the majority of the terracotta grave gifts were mass-produced from molds, some of the larger pieces were not. In particular, those that reproduce the horses of Ferghana, imported for hunting and polo, were among the most popular images.

12.14 HORSE. T'ANG DYNASTY. 618–906 A.D. GLAZED TERRACOTTA, 30-1/4 × 31-5/8″. THE CLEVELAND MUSEUM OF ART, OHIO (ANONYMOUS GIFT).

Buddhism and its accompanying Indian mythology was a major influence, as we saw in Chapter 10. From the fifth to the eighth centuries, the Chinese carved Buddha figures in the walls of caves, some of them 70 feet (21 meters) tall. Their austere attitudes emphasized the otherworldly qualities of the Buddha. Sculptors made smaller, more graceful images in gilded bronze or wood for temple altars. Some were of **Boddhisattvas** (Buddhas-to-be), also known as deities who represented enlightenment [12.15]. A Boddhisattva figure represents one who is capable of Buddhahood but who renounces it, dedicated to acts of salvation, offering again and again to be sacrificed in some way in order to save humanity. Though Boddhisatt-vas are usually male, one was Guanyin, the Chinese goddess of mercy, known for her gentleness and compassion.

Painting The Chinese considered painting and calligraphy the most important forms of artistic expression. Both arts demanded great skill with the brush, requiring years of training. In calligraphy the quality of the brush strokes and the formation of the characters became as important as the story or poem they conveyed. Most Chinese painters were also poets.

Except for early murals in caves and other temples, most Oriental paintings were on vertical or horizontal scrolls. The latter, held in the hands and unrolled a little at a time, allowed the viewer to "travel" through the painting, moving from scene to scene. Some Oriental paintings depicted the natural world. Others, under the severe influence of Buddhism and Chinese Confucianism and Daoism, were more philosophical. They were less concerned with details of outward reality than with the essence of an object or a scene in order to arouse a response in the viewer.

Chinese scroll painting, which began in the fourth century, included elegant scenes of court life, realistic horses, and the first landscapes. The development of T'ang painting, like every other aspect of its culture, marked the period as the greatest in Chinese political history. The confidence of the age released the artist with the fewest limitations. Li Chao-tao (c. 670–730), perhaps the greatest master of the age, is known to us today only through copies. His narrative paintings of courtly and historical events, in large part military, were primarily decorative and provide us with the beginnings of landscape art [12.16]. The figures are small in scale, even in the foreground, while the mountain dominates the scene, and there is considerable realism in the details. The rocks, the distant trees and the rivers all recede layer on layer into the distance. Despite the seeming complexity of the work, the artist has viewed each of the various sections of the painting from a different **station point**. The unification of space will not be found for several hundred years.

In the Sung dynasty in the twelfth and thirteenth centuries, many gentlemen retired to the country where they painted soft poetic landscapes inspired by the Daoist search for unity in nature. In their ink and watercolor scrolls, tiny human figures seem overwhelmed by the gran-

12.15 SEATED *SHUI-YÜEH (WATER-MOON)*. GUANYIN. LATE YÜAN OR EARLY MING. 14TH CENTURY. GILT BRONZE; HEIGHT 13″ (33 CM), WIDTH 8″ (20 CM). ASIAN ART MUSEUM OF SAN FRANCISCO (AVERY BRUNDAGE COLLECTION).

deur of mountains, forests, and seas. Sung painters worked in gray ink washes and a few spontaneous, brisk brush strokes, reflecting the Chan ideal of flashes of sudden enlightenment after meditation. The oneness of the universe was also a theme of Chan (better known as Japanese Zen) Buddhism. "The branch drooping in the fog, the butterfly on a blossom, the beggar in the filth of the courtyard—they are all Buddha," said the painter Xia Gui (c. 1195–1224).

Woodcuts Papermaking began in China in the second century; it did not begin to spread throughout Europe until the twelfth century. The art of printing from wood blocks developed in China in the sixth century, permitting inexpensive images of the Buddha to be mass-printed for popular distribution. The scholarly elite, who had demonstrated their ability in arduous examinations, were the transmitters of culture and were often artists in their own right, whether painters, poets, or musicians. The liberal arts of calligraphy, painting, and music, practiced for personal enjoyment, were generally exalted above sculpture and architecture. Artists frequently copied past works in homage to their ancestors.

12.16 *The Emperor Ming Huang's Journey to Shu* (after Li Chao-Tao). T'ang Dynasty. 670–730 A.D. Height 21-3/4". Collection of the National Palace Museum. Taipei, Taiwan R.O.C.

Japan

Architecture Japanese art emerged from its pre-historic phase during the Asuka period (538–645), embracing Buddhism as the official religion. Japan accepted Chinese architecture along with Buddhism, imported from China via Korea in the sixth century. Japanese temple complexes such as the Horyuji in Nara, capital of Japan, were laid out on the rectangular Chinese plan and included pillared halls, a pagoda [7.17], and wooden gates. Japanese craftsmen developed wooden architecture to its finest expression. Multistoried pagodas were derived from a combination of elements from the Indian stupa and the Chinese watch tower. The spires on both the stupas and the pagodas were symbols of aspects of the Buddha. The house or palace with its sliding paper screens for walls, opening onto a deep porch and garden, permitted great flexibility in interior design and the integration of indoor and outdoor space. In modern times, through the work of Frank Lloyd Wright who built the Imperial Hotel in Tokyo in the 1920s, con-cepts of Japanese domestic architecture that had its beginnings in the medieval, became widely appreciated. The sliding curtain walls of the Japanese could be easily adjusted to accommodate abrupt climate changes, day or night. This ecological concept was adapted to Western architecture through glass and steel sliding doors such as Mies's German Pavilion [8.35] and Philip Johnson's glass house [8.36].

Sculpture Works of sculpture are perhaps the most numerous of this period. We begin with the *haniwa* [11.33]. Noted for their sprightly expressions, the sculptures have an ingenuous appeal. Almost a mirror of the later Imperial T'ang style, the Asuka and the Nara style, the Japanese Buddhas of wood and bronze, as well as realistic wooden portraits of guardian spirits and priests, were as rigidly formal as a Byzantine icon. The main image at Horyu-ji, by Tori, a descendant of Chinese immigrants, bears the date 632 and is represented with a serene and aloof appearance, larger than life. His elongated ears, mark on his forehead, and his hair reflect his noble birth. The attendants dressed in wordly costumes with crowns and

jewels, like the Buddha's hand gesture, are all prescribed by tradition. The *abhaya mudra* or open palm signifies "fear not" [12.17].

Painting Painting first relied upon Chinese landscape for inspiration but later developed its own richness and refinement. Japanese painting shows strong Chinese Buddhist influence but is infused with a native vitality and decorative quality all its own. Scrolls of the ninth and twelfth centuries, inspired by Chinese art, depict Amida, the Buddha of the Western Paradise, in a delightful but worldly paradise surrounded by lovely Boddhisattvas playing musical instruments and dancing. Other scrolls portray terrifying Buddhist guardian deities. The portrait of Minamoto no Yoritomo, the "Great Barbarian-Subduing General," demonstrates the stiffness of the costume of the day with a new boldness in sharp silhouette [12.18]. Later scrolls present colorful scenes narrating tales from Japanese history or literature or social satires. In the fourteenth to sixteenth centuries, Japanese Zen Buddhist painters, influenced by Chinese Chan art, used a few quickly splashed lines and washes of ink to express their responses to the natural world and their experiences with Zen. Oriental landscapes richly deserve the high place they are accorded in world art; they are noted for strong brush work, brilliantly sparse imagery, and consummate artistry in handling ink on paper. Women, it seems on occasion, were as highly regarded for their artistic and poetic skills as men—as demonstrated by the scroll of Lady Kodai [8.5].

Woodcut By the eighth century, Japan had absorbed the technique somewhat, transforming printmaking into an expression of its own culture. While the influence of Chinese civilization had strongly affected Japan, in time, as we shall see, its own culture developed the art in a unique way that introduced caricature to the country.

Decorative Arts The arts of metalwork, ceramics, and jade carving, developed for ritual use, flowered in the Orient. From earliest times, ceramics was refined into a high art in Japan, where potters adapted Chinese techniques and designs. Statues and accessories of bronze, wood, and lacquer adorn the temples. The Shōsōin at Nara is filled with works of extraordinary Japanese sensitivity and skill. The Noh masks and the great grotesque masks worn by dancers, as we have seen, are remarkable in their unique creativity.

ART OF THE AMERICAS

North America

Eskimos in the North lived by hunting and fishing, moving from one area to another with the seasons and the migra-

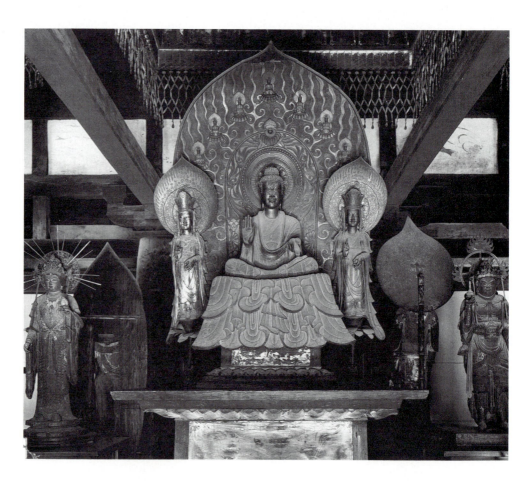

12.17 Tori Busshi. *Shaka Triad.* 632. Bronze with gold. Horyuji Temple, Nara, Japan.

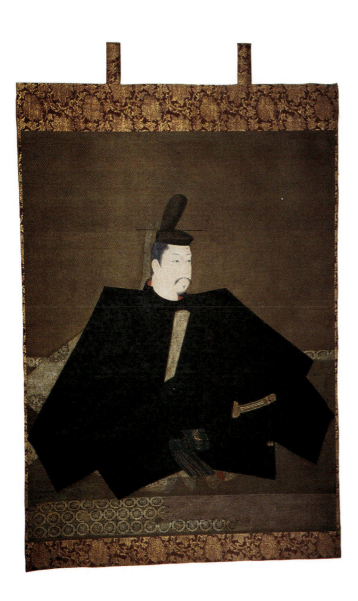

the light of a flickering fire to heighten their effectiveness [6.7].

Northwest Coast peoples also carved utensils used in a community potlatch ceremony. These unique gatherings were ritual occasions for feasting, poetry, and dancing at which a person of rank gained prestige by giving food, drink, blankets, tools, and utensils, sometimes to an entire invited village. While the custom inspired much art, it also ruined village economies. Other native peoples in western America, relying mainly on hunting and gathering, wove delicate baskets in intricate patterns that, like geometricized textiles, reflected the weaving process. The Navajos in the Southwest, who herded sheep brought by the Spanish, wove distinctive blankets.

Southwest native Americans settled in communities called pueblos and irrigated fields of maize. The pueblos were cliff dwellings or freestanding adobe buildings built on mesas or near riverside fields. Each one had a **kiva**, or underground sacred room, symbolizing the underworld, where they believed their ancestors had originated and they themselves would return. Part of the kiva ritual included sand painting, done by pouring different colored sands on the floor in traditional patterns. Such ceremonies reaffirmed the contact of people to the earth and the brevity of the human lifespan. After every ritual, the sand painting was destroyed.

The Anasez cultures flourished from about A.D. 500 to 1200 the Pueblo and later Zuñi cultures followed. The settled communities have all left pottery remains; some **shards** date back to A.D. 500. The arts of native North Americans were largely animal-centered. Much of the pottery, basketry, painted hides, and metalwork found at various sites (different materials at different sites) represent arts that remained consistent for centuries.

Middle America

In the Postclassic period from A.D. 900 until Columbus arrived on these shores, native Americans from Central America and Mexico continued to maintain accurate calendars based on their knowledge of astronomy, written communication in the form of geneological and chronological records in illustrated folios called *codices*, skilled metallurgy, and stone ceremonial architecture lasting to this day.

tions of game. Life was hard, yet artists found time to carve utensils and imaginative masks from driftwood and small figures and harpoon heads from ivory, bone, and stone.

Indians along the Pacific Northwest Coast lived in settled villages. Abundant supplies of fish, wild plants, and berries allowed them some leisure to build large wooden plank houses and carve boats, masks, and furnishings. Each family or clan had a set of songs and myths and a heraldic crest, or **totem**, which was displayed on its possessions.

Dugout canoes, so important to a fishing and whaling economy, were shaped with stone tools and sometimes decorated with carved figures of protective spirits. The complex multiple masks of the Northwest Coast are among the most arresting in the world. Often they illustrated myths enacted by the dancers who wore them. Some were sophisticated masks within masks. During a dance, the wearer could expose several images, one after the other, by pulling the strings that operated the hinges. Other masks had moving parts that made noises. Most of these carved and painted masks were designed to be seen in ritual by

Architecture Native Americans of Middle America were not as concerned with enclosing space as with building impressive stepped pyramids with a temple on top as the focus of religious rituals [I.21]. The pyramids were faced with stone that was often ornately carved or covered with painted stucco. The pyramids stood in the midst of ceremonial centers surrounded by palaces for official functions. An example is Mayan Chichen Itzá, the site of a monumental religious city in which the terraced Pyramid of Kukulkan was a characteristic structure [12.19]. The masses probably occupied simple adobe houses on the outskirts. The late Aztec city of Teotihuacán, however, near present day Mexico City, covered more than 20 acres (8.9 hectares) and supported a large population. Its most imposing structure is the 300-foot (65-meter) Pyramid of the Sun, still standing [11.34]. The city flourished for about six hundred years, attracting sculptors, painters, potters, and other artists.

All these Middle American groups followed a similar calendar based on cycles of fifty-two years instead of cycles of one-hundred-year centuries that we follow. The Mayas kept annals for hundreds of years. Each cycle usually was celebrated by a building, often a temple or pyramid built upon an existing one. Memorial **stelae** were set up in the plazas to mark the time of dedication, as modern cornerstones date Western buildings. The Spanish conquerors, following Indian practice, built their Christian churches on top of native holy places, taking advantage of years of native pious devotion at the same locale. By digging through layers of construction, archaeologists have been able to trace a history of Middle American architecture.

Almost all native communities of size built walled stone courts for highly competitive ritual ball games utilizing the rubber that was first discovered in South America. The rubber ball they bounced from player to player symbolized the sun. To encourage the sun god to make his daily journey across the heavens, Aztec priests made sacrifices of prisoners of war to supply him with human blood. The rain god was also important. Some groups believed that his attention could be attracted by the tears of sacrificed children. The Toltecs and Aztecs worshipped Quetzalcoatl, a symbol of the life force represented by an image that combined the beautiful feathered quetzal bird and the coatl serpent.

Sculpture and Other Arts Much Middle American sculpture was architectural—reliefs of gods and priests and geometric designs on pyramids and temples, as in the

12.19 PYRAMID OF KUKULKAN, CHICHEN ITZA, YUCATAN, MEXICO.

Temple of Quetzalcoatl at Teotihuacán [I.21]. There were also small stone and clay figures of gods, humans, and animals. Filled with vitality, they give us a glimpse of the daily life of the people.

The Mayas and other peoples painted narrative murals of warriors and religious scenes inside palaces and tombs [3.13]. If we closely examine the painting, we may observe how punishment was meted to the vanquished by blinding the victim. Other forms of painting were on pottery and accordion-folded bark paper books. Perhaps a dozen of these codices remain, each in the style distinctive to the region. Finely designed jewelry of gold and jade and ritual objects of inlaid shell, turquoise, and other stones attest to the great skill of Middle American craftsmen. They also wove fabrics and made elaborate feather mosaic headdresses and cloaks for priests and nobles.

South America

Mochiacan potters made clay vessels molded in the shapes of people and animals or painted with animals or scenes. Mochica, Quimbaya, and Chimú craftsmen made fine gold jewelry set with turquoise, and gold cups. The Chimús and the Incas built great cities, such as the fifteenth-century Inca stronghold of Machu Picchu high in the Andes [12.20]. The Incas, who ruled a large empire at the time of the Spanish conquest, constructed large plazas, temples, and palaces of massive stone blocks. So remarkable were their masonry skills that even today a knife can scarcely be fitted into their temple walls.

Although the Spanish disrupted the pre-Columbian civilizations for centuries, many present-day artists work close to the artistic mainstream of their ancestors.

ART OF NORTHERN EUROPE

In contrast to the sophisticated art of the Byzantine Empire and the diverse arts of Islam, the Orient and native Americans, art in northern Europe during the sixth and seventh centuries was an eclectic mixture of Christian and classical elements and pagan influences from central Asia. Celtic peoples occupied central and northwestern Europe. Teutonic peoples from the east had been sweeping across the vast network of Roman roads into Europe ever since the later years of the empire. The highly civilized Romans had called both groups barbarians, but the northerners' art,

12.20 MACHU PICCHU, PERU. C. 1500.

12.21 THE SUTTON HOO PURSE COVER. C. 620.
LENGTH 8″. REPRODUCED BY COURTESY OF THE
TRUSTEES OF THE BRITISH MUSEUM.

though simpler than that of southern Europe, was far from unskilled.

Teutonic craftsmen worked in iron, gold, enamel, and wood, which they ornamented with stylized animals both real and mythological. The **animal style**, as it is called, originated in Asia, where it had developed among nomads of the steppes. The Sutton Hoo Purse Cover [12.21] was found in 1939 in a ship-burial site in England as part of the treasure of a kin. The ship was intended to provide the soul with a vessel to transport the deceased to the next world. The huge ship would have commanded close to forty oarsmen with a rich cargo. The gold lid, decorated with garnets and **cloisonné**, contained gold and ingots. In northern Europe, the style was combined with elaborate patterns of interlaced elements borrowed from Christian art in Italy, Egypt, and the Byzantine Empire.

Celtic craftsmen also worked in metal and enamel and carved monumental stone crosses. They mixed animal forms, geometrics, and spirals, interlacing them into a richly ornamental **Hiberno-Saxon style** that reached its height in the manuscripts of the Gospels and other books. Celtic monks laboriously copied these by hand in monasteries. The Lindisfarne Gospels [3.2] and the Book of Kells, were, in a practice called **horror vacui**, or "fear of emptiness," lavishly decorated over every bit of space with swirling designs of plants, animals, birds, and humans that seem to merge into and out of one another. A beast may dissolve into a snake, which turns into a fish, the whole sequence perhaps forming the letter *T*.

Carolingian Art

In the late eighth century, Charles the Great, or Charlemagne (c. 742–814), a vigorous and wise king of the Franks, tried to revive the Roman Empire in the West and to restore Roman civilization. Choosing Aachen, probably his native city, now in Germany, as his capital, he transformed it into a cultural as well as a governmental center. There he encouraged a blend of Christian and classical

scholarship, Byzantine traditions in art and architecture, and Celtic and Teutonic skills in metalwork, which fused into the **Carolingian style**. As a reward for helping the popes in Rome against their enemies, he was crowned emperor of the Roman Empire in Rome in 800.

As part of his building program, Charlemagne constructed a two-storied Palace Chapel at Aachen [12.22], where he worshipped and was buried. Its massive stone walls were inspired by Roman architecture as well as northern severity, but its octagonal central space, surrounded by an **ambulatory** (passageway) and covered by a dome, was influenced by San Vitale in Ravenna [12.6] and other Byzantine buildings. Roman elements also appeared in the barrel vaulting, the three levels of round arches enclosing the central space, and the marble Corinthian columns that divided the arches of the upper levels into three sections. The columns themselves had come from Ravenna.

The richly decorated surfaces echoed Byzantine influence, and the contrasting colors of the stones in the uppermost arches were typical of Islamic art in Spain. The emperor's throne was in the second-story gallery, where Charlemagne appeared to the congregation below as a representative of Christ on earth. From that position he was close to the Lord, pictured in a mosaic in the dome above. In its energetic combination of these different elements, the Palace Chapel embodied the Carolingian style. This and other churches sponsored by Charlemagne were an important influence on later architecture.

Charlemagne also encouraged the building of monasteries. Each included a church, living quarters for the monks, workshops, guesthouse, hospital, and surrounding farms and was a large, self-sufficient community. Originally founded as quiet retreats in a turbulent world, the monasteries became bustling centers of learning and the arts. In **scriptoria**, or writing rooms, in monasteries or the palace school, copies of Christian and classical manuscripts, which might otherwise have been lost, were made. These manuscripts were illustrated with miniature paintings inspired by Byzantine art and richly ornamented with

covers of gold, gems, and carved ivory. Many demonstrated the continuing Northern influence in the linear qualities of the drawn decorations.

Romanesque Art

During the Romanesque period, about 1050 to 1200, after pagan Viking invaders had settled and been converted and after Christians had recovered Spain from the Muslims, art and architecture flourished. A new Romanesque style emerged, so called because it was inspired by Charlemagne's revival of Roman styles. Romanesque architecture blossomed quite suddenly when a medieval prophecy foretelling the end of the world in 1000 failed to come true. Many Christians emerged from caves where they had hidden and, as one medieval historian put it, showed their gratitude by covering Europe with a "white mantle of churches." Along the route of the Crusades, pilgrimage churches, large enough to accommodate the travelers, sought holy relics to sanctify their crypts. The Ste. Foie reliquary [12.23], enshrining the bones of the saint, was treasured at the monastic church at Conques, France. Dedicated to a third century martyr whose relics were brought there about A.D. 870, the Carolingian church was rebuilt in the Romanesque style c. 1080–1120. Of gold filagree with precious stones over wood, the reliquary was further decorated with inlaid enamelled eyes.

12.23 RELIQUARY OF STE. FOIE. 10TH CENTURY. GOLD WITH FILIGREE OVER WOOD. 33-1/2". CONQUES CATHEDRAL TREASURY, FRANCE.

12.22 INTERIOR OF THE CHAPEL OF CHARLEMAGNE, AACHEN. C. 795.

These churches varied in local detail according to whether they were built in Italy, Spain, Germany, or France, but they all shared a similar floor plan—the central nave and side aisles that originated in the Roman basilica and were adapted by Early Christian churches. Builders used Roman techniques of masonry and adopted the Roman vocabulary of arches and barrel vaults. These stone vaults spanned large areas and lessened the danger of fire, which destroyed so many wooden roofs, but they required heavy walls to support them. As a result, Romanesque churches were often dark because windows were few and small to avoid weakening the walls. Sant' Ambrogio, Milan, is an early example, also incorporating an enclosed courtyard [12.24] modeled after the Roman atrium.

Sometimes walls and vaults were brightened by murals, and columns often were painted. Many columns had elaborately carved capitals, which depicted Bible stories or portrayed the constant battle between Christians and evil demons representing the seven deadly sins. In the **tympanum** (semicircular space) over the entrance doorways, sculpture often depicted the Last Judgment. Perhaps the most beautiful of all Romanesque tympanums is in the church in Vézelay, France, depicting the Mission of the Apostles—exhorting crusaders to spread the Gospel. A large figure of Christ ascending disperses rays of the Holy Spirit on the Apostles, each equipped with copies of the scriptures [12.25]. Eventually the entire church became a sermon in stone.

12.25 Tympanum, abbey church of La Madeleine, Vézelay, France.

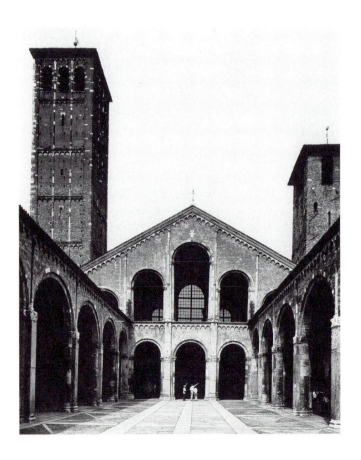

12.24 Sant' Ambrosio, Milan, from west. c. 1181. Length, including atrium, 390' (118.87 m); width 92' (28.04 m).

Gothic Art

As Europe's population grew, many people moved from sparsely populated rural areas dominated by local barons and monasteries into towns. Town dwellers, or burghers, usually organized into guilds, took part in lively commercial exchanges of goods and ideas. Travel became easier, and crusaders, who went to rescue the Holy Land from the Muslims, brought back new ideas from the Middle East. Universities in cities such as Paris, Bologna, and Padua attracted students from all over Europe. Teaching was in Latin, the universal language of educated men and women in the West. Pilgrims moved freely from town to town on their way to visit shrines, while burghers competed for their business. At the same time, ambitious bishops planned impressive cathedrals whose vaults often rose to awesome heights.

The Artist Sketch

Born in Picardy, France, Villard de Honnecourt is mainly remembered for the remarkable sketchbook that he assembled as a traveling master mason in search of work in the great cathedrals of France. The notebook is a compendium of diagrammatic representations of architectural practices of the thirteenth century, supplemented by carefully phrased injunctions on what (and what not) to do in constructing churches.

As we scan the pages, the centuries slip away and we are swept into the medieval world, where itinerant specialists were the rule. News of the outside world came largely by word of travelers such as minstrels, crusaders, and messengers. The written word was prized, so firsthand knowledge gleaned through travels to such places as Rheims, Chartres, Laon, Meaux, and Lausanne was incor-

12.26 VILLARD DE HONNECOURT. ELEVATIONS OF THE INTERIOR AND EXTERIOR OF AN APSE CHAPEL, CATHEDRAL OF RHEIMS. 13TH CENTURY. BIBLIOTHÈQUE NATIONALE, PARIS.

porated into the architect's sketchbook and valued.

Eventually Honnecourt converted his notes into a manual that provided precise instructions for building construction. In his writings, he fused principles derived from ancient geometry with workshop techniques from the Middle Ages. Honnecourt includes sections on technical processes, from mechanical subjects to human and animal figures. Having visited Hungary in 1255, his sketches demonstrate the depth of his understanding of the great churches [12.26] built during his lifetime even outside his native France.

The notebook of Villard de Honnecourt indirectly documents the spread of Gothic architecture in Europe, no mean achievement considering that the architect is believed to have lived a bare twenty-five years or so.

VILLARD DE HONNECOURT (C. 1225–1250)

These new **Gothic** cathedrals expressed not only local ambition but also the pious desire of Christians to strive toward the kingdom of heaven. They were soaring, towered structures whose interiors were filled with an unearthly light filtered through stained glass windows. The term Gothic was originally used by the Romans derisively to describe the "bearded barbarians to the north." Though intended as a slur, the word soon lost its negative associations.

The requirements of this style led builders to experiment with higher vaults and other ways than walls to carry their weight. Groin vaults were strengthened with ribs, which transferred the weight of the vaults to piers at the corners of the bays and thence to the ground, as we saw in Chapter 7 [7.11b, 7.11c, 7.12]. Buttresses against the outside walls, positioned where the ribs met the piers of the wall, provided a counter-thrust against the pressures of the vaults, while pointed arches made it possible to roof spaces that were not squares.

These elements—pointed arch, ribbed vault, and buttress—used independently in Romanesque churches, were combined for the first time in the rebuilt abbey church of St. Denis outside Paris in the mid-twelfth century by the dedicated Abbot Suger. At the head of the nave Suger added a new **choir** behind the apse, surrounded by the col-

umns of a double **ambulatory** from which radiated seven wedge-shaped chapels. Although St. Denis was rebuilt after more than one fire, Suger's design of ribbed vaults, pointed arches, thin interior columns, and exterior buttresses was adopted throughout the church [2.16]. The nonsupporting walls between the buttresses of the choir were filled with glass. They were described by Suger as a "string of chapels, by virtue of which the whole [church] would shine with the wonderful and uninterrupted light of the most luminous windows, pervading the interior beauty."

And so the Gothic style was born. It spread throughout Europe during the next two hundred years and in time became more ornate. The late Gothic style is called flamboyant because the stone **tracery** separating sections of windows was elaborated into curved, flamelike patterns that masked the basic structure. Because cathedrals often took a hundred or more years to build, their plans frequently changed. One section, for example, might be in the early Gothic style and another in the flamboyant style.

Despite local variations in design and detail and stylistic changes over time, all Gothic churches used the same self-supporting system of ribs and buttresses to frame large stained-glass windows. The windows were made of small pieces of glass colored in the molten state, given details with a paint brush, fitted together with lead strips,

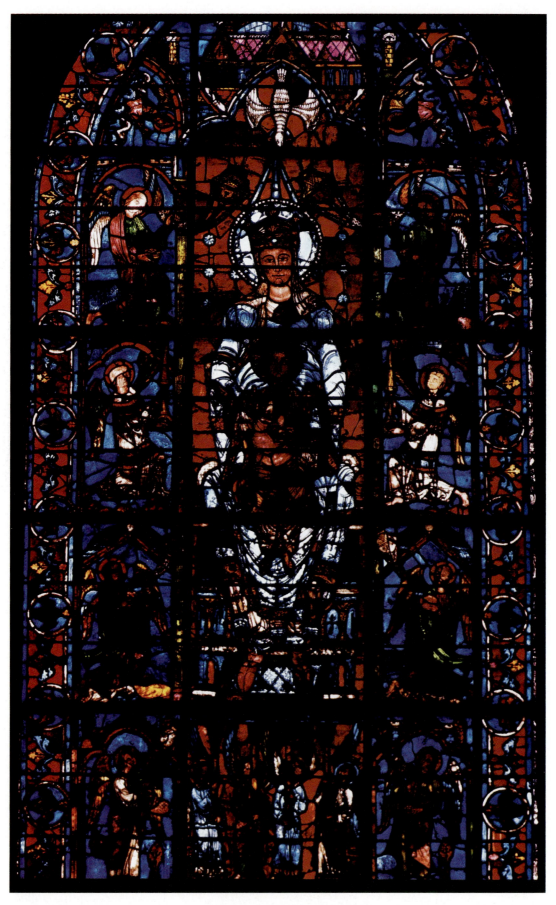

12.27 Notre Dame de Belle Verrière, Chartres Cathedral. Early 13th century.

and placed in an iron frame. Like Romanesque murals, they told biblical and other Christian stories. Particularly fine windows were made for the cathedral at Chartres [12.27].

The exterior of a church was decorated with deeply carved sculpture. The great portals through which the congregation entered were flanked by statues of biblical figures and saints. The tympanum, no longer dominated by Romanesque preoccupation with the Last Judgment, heaven, and hell, showed a broader range of subjects, such as scenes from the life of the Virgin. Greater emphasis on the Virgin led to gentler treatment of figures in general with softer, more graceful poses and drapery.

The Gothic cathedrals were communal efforts in which all the devout participated in whatever way they could—carrying stones, cutting them into shape, hauling them up to the masons working on the high scaffolds, or contributing money. Skilled craftsmen who could carve the stone sculpture and wooden choir stalls and fashion gold and enamel reliquaries were in great demand. Their combined efforts produced magnificent structures towering over the houses and shops huddled at their feet. Auxiliary structures, like the Campo Santo at Pisa, were often decorated with painted murals.

Inside, the vaults soared into a dim blue twilight representing heaven, the windows sparkled like jewels, and on feast days, hundreds of candles glowed on the gold and jewels of altar screens, chalices, and candlesticks and on the gold-embroidered vestments of the priests. The vision of holiness [12.28] enhanced by the singing of the liturgy must have uplifted worshippers from the harsh realities of daily life and transported them to new realms of devotion. Yet it was at this time, when the church dominated almost every phase of life, that the forces which led to a totally different spirit in a new era were already at work.

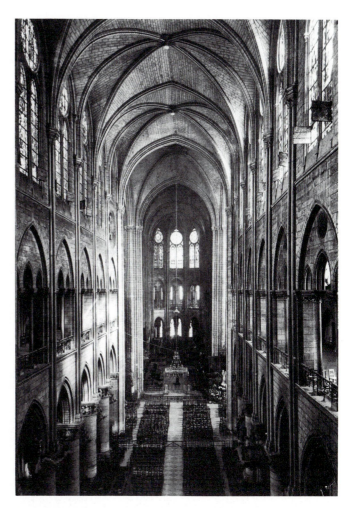

12.28 INTERIOR, CATHEDRAL OF NOTRE DAME, PARIS. C. 1163–1250.

FORERUNNERS OF THE EUROPEAN RENAISSANCE

We can see a new awakening of ideas in the work of three fourteenth-century artists. In Italy the Sienese painter Simone Martini (1284–1344) held fast to the Gothic spirit in his *Annunciation,* with its Byzantine gold background and decorative detail. But the Virgin is depicted for the first time, in hundreds of years, as a real woman, startled by the appearance of the archangel with his fateful message [12.29].

The Florentine painter Giotto (c. 1266–1337) also illustrated religious subjects, but his brush brought the warmth of humanism into these Christian works. In his

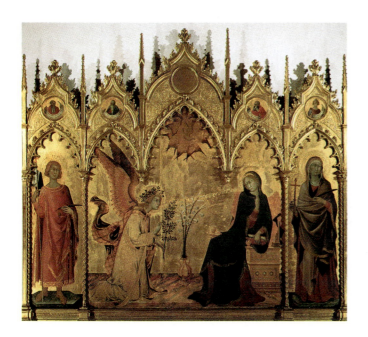

12.29 SIMONE MARTINI. *ANNUNCIATION* (SAINTS IN SIDE PANELS BY LIPPO MEMMI). 1333. TEMPERA ON WOOD, 8′8″ × 10′ (2.64 × 3.05 M). GALLERIA DEGLI UFFIZI, FLORENCE.

frescoes that covered the walls in the Arena Chapel, Padua, illustrating the *Life of Christ* and the *Life of St. Francis* in the church in Assisi, he expressed human emotions in a striking, new way. Again, if we compare the lifelike figures in his *Pietà* [12.30] with those in an altarpiece in the Byzantine style [12.31], we can see how the drapery in Giotto's work suggests the solid shape of the body beneath. The low horizon, the grief stricken mourners, the frantic angels, and the severely descending slope of the hill all direct us to the lifeless figure of Christ and the somber Virgin.

The impact of that drama is heightened by Giotto's daringly original approach. No wonder that, a generation later, the poet Petrarch, accustomed to stylized Byzantine painting, asserted that Giotto depicted nature so faithfully that his paintings could be mistaken for reality. About the same time, the poet Giovanni Boccaccio, famil-

iar with classical art, hailed Giotto as the artist who had "restored to light this art which has been buried for many centuries." Indeed, Giotto is still regarded as the father of a new era in art.

The third artist to foreshadow the change in art style was the Northern sculptor Claus Sluter (1380–1406), who worked at the court of the Duke of Burgundy. In his notable *Well of Moses* [12.32], he portrayed the biblical prophets as real human beings expressing individual personality. Sluter's deep piety belongs to the Middle Ages, but the striking illusion of life that he created points to the Renaissance. Sluter was also the first major sculptor to abandon the tradition of placing sculpture in an architectural setting, such as above the door of a church [12.25]. Instead, he produced freestanding sculptures of monumental size. His innovations and masterful realism influenced later sculptors.

12.30 Giotto. *Pietà (Lamentation of Christ).* 1305–1306. Fresco, 7′7″ × 7′9″ (2.31 × 2.36 m). Scrovegni Chapel, Padua.

12.31 BYZANTINE SCHOOL. *ENTHRONED MADONNA AND CHILD.* 13TH CENTURY. TEMPERA ON WOOD, 32-1/8 × 19-3/8″ (82 × 49 CM). NATIONAL GALLERY OF ART, WASHINGTON. (ANDREW W. MELLON COLLECTION, GIFT OF MRS. OTTO H. KAHN).

12.32 CLAUS SLUTER. *WELL OF MOSES.* 1395–1406. MARBLE, HEIGHT OF FIGURES APPROXIMATELY 6′ (1.83 M). CHARTREUSE DE CHAMPMOL, DIJON, FRANCE.

Art Talk

Constant warfare among the Italian city-states and among factions backing either the Pope or the Holy Roman Emperor, and pestilence on a scale quite equal to our threat of nuclear annihilation—these were facts of life for Italians in the fourteenth century. In 1348 the bubonic plague, or Black Death as it was called, killed almost half the population of Italy, not to mention the rest of Europe. The frescoes attributed to Francesco Traini at the Campo Santo in Pisa are the most striking, dramatic, harrowing depictions of the anxiety and of the ever-present reminders of death Italians were experiencing at the time.

The Campo Santo, or cemetery buildings bearing this *Triumph of Death* fresco cycle, next to the Duomo and near the famous Leaning Tower of Pisa, were themselves victims in 1944. Allied bombings near Pisa reached the Traini frescoes, causing fires which damaged them. In order to prevent complete deterioration, the frescoes were detached from the wall after the war by a technique developed in this century. Once again a disaster called forth at least one unexpected beneficial result: the technology of conservation that facilitated the detachment of the frescoes from the wall brought to light the **sinopie**, or underdrawings, beneath the frescoes. These sinopie were remarkably clear and complete and reveal to us information not only about fourteenth century artists' working methods but also about life at that time beyond what the frescoes tell us. The powerful, forceful sinopie underline the importance of these monumental underdrawings and confirm the belief that the frescoes themselves were probably largely executed by assistants.

There are also figures in the sinopie that did not make their way into the finished painting. For instance in the scene depicting the Last Judgment [12.33], in which Christ damns the sinners who are spirited off to Hell, we can definitely make out a pope, bishop, and a cardinal in the sinopie, whereas these figures disappear and are replaced by two friars in the frescoed version. Whatever animosities against

12.33 FRANCESCO TRAINI. *THE DAMNED,* DETAIL OF *LAST JUDGMENT.* C. 1350. CAMPO SANTO, PISA.

Rome and its hierarchy were freely expressed in the sinopie, for some reason they were toned down for the final version. We don't know the explanation for this change, but it may well be that the artist's superior, the local church, or the community required modifying the potentially inflammatory images. You can compare for yourself the sinopie and the fresco in the museum of the cloisters of the Campo Santo as they appear side by side.

THE *TRIUMPH OF DEATH* FRESCOES IN PISA

EXERCISES AND ACTIVITIES

Exercises for Research and Discussion

1. List the historical reasons why Early Christian art incorporated so many cultural influences. Give examples of images that derived from other cultures and were absorbed into Christian art.

2. Explain how the Romanesque style of architecture originated and whether it varied throughout Europe. What earlier structural systems influenced it?

3. Locate examples of Romanesque and Gothic Revival churches in your community. Describe how they use the elements of these styles.

4. Contrast a floor plan of Romanesque style with the Gothic style. Is it the floor plan or the stained glass that accounts for the differences in impact between the two systems? Explain.

5. The Gothic cathedral provided more than religious experiences for medieval populations. Describe the social, economic, technological, and cultural values that you believe were derived from the church.

Studio Activities

1. Using colored chalks to suggest the effect of a fresco, sketch some Early Christian symbols.

2. Cut out tiny squares from magazine illustrations, searching for varied colors and textures. Paste these small pieces on cardboard to form a mosaic of geometric designs or human figures. Notice how you must simplify forms in order to represent them with mosaic squares. Study an Early Christian mosaic and see how form was developed.

3. Locate old dishes and bottles of different colors. Wrap them in many newspapers and break them into fragments with a hammer. Glue them onto a wooden surface in a satisfying mosaic design.

4. Draw a diagram of the Gothic structural system. Name and explain the function of the parts.

5. Using pieces of colored tissue paper, paste up a design for a stained-glass window. Use this as a guide to make a window from colored glass and leading available in craft shops.

Crossroads

RENAISSANCE, BAROQUE, ROCOCO

"*Thy will is free and whole and upright and now it would be wrong to rein it in. Be thine own Emperor and thine own Pope.*"

—DANTE, THE DIVINE COMEDY, 1321

• • •

"*In his hands I saw a long golden spear and at the end of the iron tip I seemed to see a point of fire. With this he seemed to pierce my heart several times so that it pierced my entrails. When he drew it out, I thought he was drawing them out with it and he left me completely afire with the love of God.*"

—ST. THERESA, VIDA, C. 1550

• • •

"*This goodly frame, the earth; … this most excellent canopy, the air; … What a piece of work is man! How noble in reason! How infinite in faculty! In form and moving how express and admirable! In action how like an angel! In apprehension how like a god!*"

—SHAKESPEARE, HAMLET, 1602

1200	1300	1400	1500	1600	1700	1800

HISTORICAL NOTES

c. 1100–1500 Ife and Benin kingdoms, Africa
1309–20 Dante, *The Divine Comedy*
c. 1430 Portuguese traders invade Africa
1431 Joan of Arc executed
c. 1450 Alberti, *De re aedificatoria*
1456 Gutenberg prints first book
1492 Columbus reaches America
c. 1500 Oil painting replaces tempera
1503 Julius II elected pope
1520 Luther excommunicated
1532 Calvin begins Reformation
1550 Vasari, *Lives of the Artists*
1558 Elizabeth I becomes queen of England
1590–1613 Shakespeare's plays
1605 Cervantes, *Don Quixote*
1632 Galileo Galilei, *On Copernicus*
1643 Louis XIV becomes king of France
1648 Académie Royale founded
1772 Diderot and d'Alembert, *Encyclopédie*

EUROPE; AFRICA; AND ASIA

History does not unfold conveniently in chapters, and the Gothic Age had not dramatically vanished when the Renaissance awakened. The Church still dominated much of medieval life, but urbanization and commerce gave rise to the self-confidence expressed in Dante's epic poem. Similarly, the new Renaissance humanism led to the turbulent, theatrical spirit of the Baroque Age and the intimate Rococo period that followed.

The merchants and bankers from prosperous cities of Italy and Flanders (modern Belgium) formed a well-to-do middle class that threatened the declining authority of the Church. The cities situated on trade routes competed as textile centers. At the same time, intellectuals began to abandon medieval scholastic philosophy. Instead they adopted a humanist view, which emphasized the abilities of the individual and the importance of life in this world.

With these humanist eras, **Renaissance**, **Baroque**, and **Rococo** art turned away from religion to the modern focus of humans who saw themselves as important parts of the universe.

RENAISSANCE IN ITALY

The term Renaissance means rebirth, referring to the renewed interest in classical learning and philosophy, along with the art that developed in Italy in the fourteenth and fifteenth centuries and later spread throughout Europe.

During the Gothic period, France had been the spiritual and intellectual center of Europe. Italy, where classical traditions and monuments still remained, generally resisted the extremes of Northern religion and Gothic

1200	1300	1400	1500	1600	1700	1800

THE VISUAL ARTS

c. 1250 *Enthroned Madonna and Child* [12.31]
13–15 cen. Chinese ceramic [13.47]
1304–13 Giotto's frescoes, Pietà [12.30]
1333 Martini, *Annunciation* [12.29]
1395–1406 Sluter, *Well of Moses* [12.32]
14–15 cen. Coatlique [I.20]
1425 Masaccio, *The Trinity* [13.5]
c. 1426 *Triptych of the Annunciation* [I.19]
1430–32 Donatello, *David* [13.4]
1434 Van Eyck, *Marriage of Arnolfini* [13.18]
c. 1435 Ghiberti, Doors of Baptistery, Florence [13.3]
1446–51 Alberti, Palazzo Rucelli [13.2]
1459–61 Gozzoli, *Journey of the Magi* [13.1]
c. 1478 Botticelli, *Primavera* [13.7]
1490–1500 Mantegna, *Dead Christ* [13.6]
1495–98 Leonardo, *The Last Supper* [2.38]
c. 1500 Bosch, The *Garden of Earthly Delights* [13.21]
1500 Dürer, *Self-Portrait* [4.8]
1501–11 Raphael, *The School of Athens* [13.9]
1502–05 Leonardo, *Mona Lisa* [I.11]
1508–11 Michelangelo, Sistine Chapel ceiling [13.8]
c. 1510 Giorgioni, *Sleeping Venus* [13.10]
1513–15 Michelangelo, *Moses* [6.2]
c. 1535 Parmigianino, *Madonna with Long Neck* [13.12]
1538 Titian, *Venus of Urbino* [13.11]
1547–64 St. Peter's Basilica and Vatican [13.27]
1550 Palladio, Villa Rotonda [13.17]
c. 1500–1600 Ivory Saltcellar [13.43]
c. 1500–1600 Ivory belt mask, Benin, Africa [6.3]
1601–02 Caravaggio, *Conversion of St. Paul* [13.24]
c. 1620 Gentileschi, *Judith Beheading Holofernes* [1.18]
1636–37 Poussin, *Rape of the Sabine Women* [13.30]
1642 Rembrandt, *The Night Watch* [13.33]
1645 Bernini, *Ecstasy of St. Theresa* [13.26]
1669–85 Palace of Versailles [13.29]
1675–1710 Wren, St. Paul's Cathedral [13.34]
1734 Hogarth, *The Rake's Progress* [I.17]

THE VISUAL ARTS

EUROPE; AFRICA; AND ASIA

architecture. The humanistic spirit of the Greeks and Romans never quite faded, and Italian Gothic architecture never lost some sense of classical proportion and balance. In the fourteenth century enthusiastic Italian humanist scholars, joined by artists and princes, "rediscovered" ancient Rome by locating classical manuscripts and digging in ruins to find precious lost statues. These Italians were acutely aware that Rome had once been the center of power in the Western world. The Middle Ages seemed like a barbaric interlude to those who longed for "the glory that was Rome."

Early Renaissance

Italian Renaissance art first flowered in Florence, a city alive with commerce. Rich families built fine palaces and churches and commissioned paintings and sculpture to decorate them. The most prominent was the Medici family, who gained control of the city and the surrounding territory and founded a powerful dynasty of princes to rule it. The Medici were great art patrons, maintaining courts that employed poets, scholars, musicians, and artists.

Clearly, art was no longer the expression of unknown artists dedicated to the Church. Private patronage combined with the individual artist's own sense of accomplishment to open a new era. From the time of Giotto on, we will be able to trace the history of individual artists.

Architecture Italian Renaissance architecture, related to a human scale like Greek and Roman structures before it, was more concerned with the aesthetic questions of proportion, balance, and unity than with developing innovative construction methods.

The young Florentine architect and sculptor Filippo Brunelleschi (1377–1446) and the sculptor Donatello (1386–1466), fascinated by ancient art, traveled to Rome to find buried temples and ancient sculpture or columns. On his return to Florence, Brunelleschi was chosen from many applicants to complete the city's Gothic cathedral. Inspired by the Pantheon of Rome, he awed Florence

with the design and completion of a giant dome over an area so large that no one in the hundred years of the church's construction had dared to undertake the assignment. In the dome and other designs, he incorporated classical columns, pilasters, and arches to achieve balance and symmetry. Also a theorist, Brunelleschi tried to explain the world in a scientific manner, sought laws of mathematical proportion, and discovered the laws of linear perspective (Chapter 2). His work helped bring about the change from Gothic to Renaissance style in both architecture and painting.

After the death of Brunelleschi, Leon Battista Alberti (1404–1472), well educated in classical literature, philosophy, and law, became the foremost architect of Florence. The first man of his time to study Roman buildings in depth, he wrote the famous *De re aedificatoria,* in which he examined the rules of proportion discussed by Brunelleschi. This treatise on architecture became one of the most influential works of the Renaissance. Inspired by the Colosseum in Rome, Alberti designed a façade for the Palazzo Rucellai **[13.2]**, which consisted of three horizontal bands decorated with pilasters freely adapted from the Greek orders. This was perhaps the first time an architect had applied an ornamental classical system to the outside of a nonclassical building, while subordinating the classical elements to the wall itself.

13.2 Leon Battista Alberti. Palazzo Rucellai, Florence. 1446–1451.

Art Talk

The Medici Family, one of the principal families of Florence began in the thirteenth century as merchants and by the sixteenth century dominated intellectual and political life of the region. Although two became popes under the family coat of arms, the design—six red balls on a golden field—has never been explained. The Medici amassed

Cosimo I de Medici (1519–1574) was the Grand Duke of Tuscany and the grandnephew of Cosimo the Elder. In order to strengthen the Florentine State with the support of the aristocracy, he appointed Baccio Bandinelli and Benvenuto Cellini in the design and construction of a series of great fortifications. Although he was not as generous an art pa-

13.1 Benozzo Gozzoli. *Journey of the Magi*, (with a portrait of Lorenzo de Medici). 1459–1461. Fresco, length 12'4-1/4" (3.77 m). Palazzo Medici-Piccardi, Florence.

enormous fortunes through brilliant politics, ruthless ambitions, endless intrigues and successful money-lending policies. Their support of the arts was as lavish as the life-style to which they soon became accustomed.

The origins of the family are obscure, but as the Medici prospered, the record of their holdings several miles north of Florence can be clearly traced through to the eighteenth century. The earliest records date 1216 and show continuing successes until the early fourteenth century. As bankers to the popes, they reaped gigantic profits. At his death, Giovanni Medici was the wealthiest citizen of Florence, while the family totally dominated city life and the arts. By the mid-fifteenth century, Cosimo the Elder, known as "The Great Merchant," was also the great art patron, encouraging scholars to translate Plato. The Medici family commissioned Benozzo Gozzoli to enrich their family chapel with frescoes of *The Journey of the Magi*, in which their own portraits appear [13.1].

Cosimo assembled a major collection of books that formed the core of the famed Laurentian Library. He befriended the sculptor Donatello and underwrote reconstruction of the Church of San Lorenzo, designed by the architect Brunelleschi. Dead at 75, Cosimo was buried in that same church with the inscription determined by government decree on his tomb, *Pater Patriae* (Father of his Country).

tron as his ancestors, he commissioned Vasari (quoted at the start of Chapter 6) and Pontormo to paint a number of fresco cycles in the Palazzo Vecchio. He also founded the Florentine Academy in 1540 and the Academy of Design in 1563.

Born in Florence on January 1, 1449, Lorenzo de Medici, eldest son of another branch of the family, succeeded his father, Piero, when he was not quite twenty, but had no difficulty holding leadership. He had received a superb education, and his intellectual and political interests were sharpened by the great poets and other aristocrats of the city of Florence.

Typical of the constant political intrigues, even to be found today with the Mafia, family-led enterprises, guided by a single patriarch, concocted a plot to assassinate Lorenzo and his brother Giuliano during High Mass on Easter Sunday in 1478. The plotters killed Giuliano but missed their principal target, Lorenzo. Until his death, fourteen years later, Lorenzo directed Florence's political and internal affairs, increasing his grandfather's holdings at the Laurentian Library. His tomb is in San Lorenzo's New Sacristy, which was designed by Michelangelo and houses the portrait sculptures of Lorenzo and Giuliano among others of Michelangelo's most memorable series of Night and Day, Dusk and Dawn. As the influence of the Church declined, so did the Medici.

THE MEDICI FAMILY: ART PATRONS, THIRTEENTH TO EIGHTEENTH CENTURY

Sculpture The Renaissance spirit of individualism flowered in a contest in 1402 to design the bronze doors on the north side of the Baptistery of Florence. Lorenzo Ghiberti (1378–1455) described his victory triumphantly: "To me was the honor conceded universally and without exception. ... I had at that time surpassed the others." For an artist to have expressed this kind of self-congratulation would have been unthinkable when cathedrals were built by humble, unknown artisans. Ghiberti's design consisted of a series of panels depicting biblical scenes in low relief [13.3]. In *The Annunciation* he used **aerial perspective** (Chapter 2), in which forms become fainter the farther away they are from the viewer, to give a greater sense of illusionistic depth than had ever been achieved before in such a shallow space.

13.3 LORENZO GHIBERTI. *THE SACRIFICE OF ISAAC*, DETAIL FROM THE NORTH DOORS OF THE BAPTISTERY, FLORENCE. C. 1435. GILT BRONZE, 31-1/4″ (79 CM).

It was Donatello, however, who made a complete break with medieval traditions by founding a new aesthetic rationale. Following the lead of the Greeks and Romans he admired, he studied the human body carefully and sculpted from models in his studio. In this way, he created the bronze *David*, perhaps his most revolutionary achievement for an aristocratic patron [13.4]. Donatello chose to represent David, the first lifelike, life-size nude statue since antiquity, as a young Italian boy, rather than as a fully developed Greek athlete. Looking at a crucifix sculpted by the more intellectual Brunelleschi, Donatello is said to have remarked, "To you is given to make Christs ... to me peasants." Perhaps this explains why he chose to represent David as a shepherd boy with a peasant's hat instead of the more popular classic (hatless) nude athlete.

Painting Departing from medieval spiritual preoccupations, painters following Giotto were fascinated with the problem of representing three-dimensional objects in flat space and applied Brunelleschi's laws of perspective to painting. And, one of the first was Masaccio (1401–1428). He astonished his fellow Florentines by representing space in *The Trinity* [13.5], a fresco in Sta. Maria Novella, as realistically as if the Crucifixion were taking place in one of Brunelleschi's chapels. Shown kneeling outside the chapel, the wealthy donors are as prominent as the religious figures and so lifelike that we feel we can almost

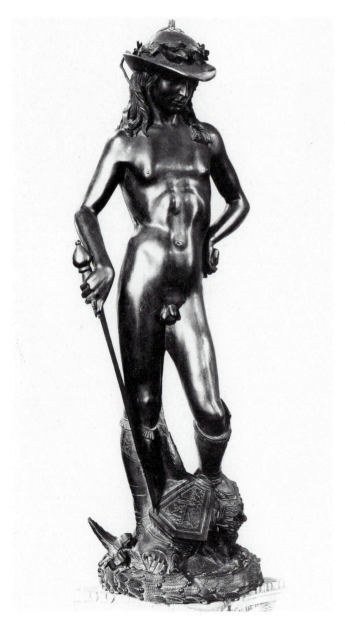

13.4 DONATELLO. *DAVID*. C. 1430–1432. BRONZE, HEIGHT 5′2-1/4″ (1.58 M). BARGELLO, FLORENCE.

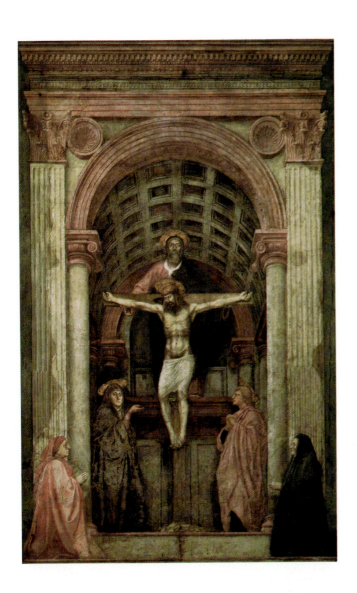

13.5 MASACCIO. *THE TRINITY WITH THE VIRGIN, ST. JOHN, AND DONORS.* 1425. FRESCO, 21'10" × 10'5" (6.68 × 3.18 M). STA. MARIA NOVELLA, FLORENCE.

touch them. The grandeur of scale, the solid masses, and the simple draping of garments on the figures show the influence of Roman architecture and sculpture on Masaccio. His vision was of the new Renaissance man who saw himself as an important part of the universe. The three-dimensional solidity of Masaccio's figures reminds us of both Giotto and early Renaissance sculpture. This relationship between sculpture and painting was important throughout the Renaissance.

As part of their effort to understand and portray the real world, Renaissance painters learned how to show the human body by **foreshortening** or contracting its forms. They also studied anatomy in order to depict figures more naturally. Their paintings of saints and other religious characters show them as real men and women, unlike the stylized and symbolic figures of earlier medieval painting. Frescoes by Andrea Mantegna (c. 1431–1505) for the Ovetari Chapel in Padua illustrating the life of St. James show the influences of Donatello, Masaccio, and classical sculpture. His boldly foreshortened figures, as in *The Dead Christ* [13.6], inspired many later artists to also experiment with perspective.

Italian painters were interested not only in observing and portraying the world around them but also in making formal compositions of almost mathematical precision. Artists such as Piero della Francesca (1420–1492), who worked at Arezzo, found beauty in the Greek Golden Section that we studied (Chapter 2). He predetermined the

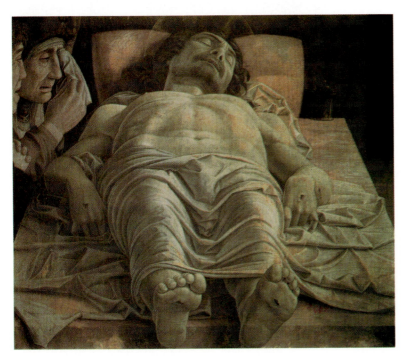

13.6 ANDREA MANTEGNA. *THE DEAD CHRIST.* C. 1490–1500. OIL ON CANVAS, 27 × 32" (69 × 81 CM). BRERA GALLERY, MILAN.

sizes and shapes within his paintings according to those Greek laws of proportions. Some critics, however, maintained that in his use of the formula, he became more of a scientist than a painter.

As Christians and classicists, Italian painters chose both religious and mythological subjects. Sandro Botticelli (1444–1510), who worked for the Medici, painted madonnas and goddesses. He was not, however, so much interested in giving an illusion of reality as in suggesting an unearthly quality. Influenced by Byzantine and Gothic painting, such as that of Simone Martini, he used elongated shapes to suggest the ethereal quality of his figures. The *Primavera* [13.7], for instance, is a symbolic allegory. The classical "Venus" figure he centered but did not use as the focus represents "love," which produces life, as well as unity between the physical and the intellect. She is expressed in a trinity, the triad of graces at the left, who give, receive, and return love. Some scholars also believe that Botticelli is depicting divine love that God gives to humans, who return it as worship to God. Flora on the right, who holds flowers born of passion, represents the flowering spring.

By this time, Italian painters had learned from Flemish painters how to work with oil glazes (Chapter 3).

In addition to working in fresco on plaster walls, they painted in tempera and in oil on wood panels and canvas.

High Renaissance

Most scholars consider the brief High Renaissance to have lasted only twenty years in the early sixteenth century (although some may include the very late fifteenth century). It is characterized, in part, by order, balance, and symmetry and represented, like the Greek Golden Age, the climax, the classic phase, of Renaissance art.

Painting Leonardo da Vinci (1452–1519), who demonstrated vast scope as both artist and scientist, came to symbolize the Renaissance ideal of the universal man. Filling many notebooks with his findings, he investigated scientific subjects, ranging from hydraulics to war machines to botany. He became an accomplished musician and a brilliant engineer. After a career of painting at the court of Milan, he spent his last years on court assignments for Francis I of France.

Beyond his scientific interest, Leonardo was much concerned with humanity. He drew a man at the heart of the universe, represented by a combined square and circle

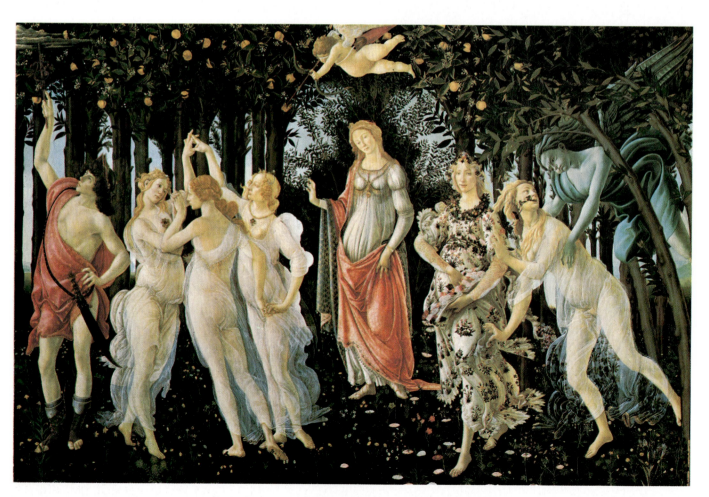

13.7 SANDRO BOTTICELLI. *ALLEGORY OF SPRING (PRIMAVERA).* C. 1478. TEMPERA ON WOOD, 6'8" × 10'4" (2.03 × 3.15 M). GALLERIA DEGLI UFFIZI, FLORENCE.

[2.50], reflecting the humanist view that man is the measure of all things. His largest extant work is the life-size *The Last Supper* on the walls of the monastery of Sta. Maria delle Grazie in Milan [2.38]. It was commissioned by a patron who wished to be in the company of the Lord while joining the monks at dinner. The painting reveals the individual personality of each man as Leonardo deduced it from biblical accounts, achieving the Renaissance ideal of harmony, balance, and beauty through carefully developed intellectual and technical means. The design of the painting (Chapter 2) was mathematically planned, the figures painstakingly researched, and the *fresco secco* technique an exploration into new Renaissance technology. The technique did not hold up, and the painting fell into near ruin. In recent years, however, it has been again extensively restored.

If *The Last Supper* in Milan is Leonardo's best-known religious work, the *Mona Lisa*, or *La Gioconda*, showing the wife of a Florentine banker, is probably the world's most intriguing portrait [I.11]. Here, Leonardo, the intellectual who claimed there was no science that could not be translated into mathematical symbols, produced one of the earliest psychological studies as well. Some say that the soft play of light and shade, called **chiaroscuro**, that models the woman's face accounts for her cryptic smile, while others explain the mood as **sfumato**, a glowing light within the painting. But since Leonardo was a master of his art and a similar smile appears in others of his portraits, it is likely that he intended to paint the mysterious expression just as it appears.

Michelangelo (1475–1564), twenty-three years Leonardo's junior, paved the way through the High Renaissance to the Mannerist and Baroque periods that followed. During his eighty-nine years, he created masterpieces of painting, sculpture, and architecture in Florence and Rome that changed the course of art history. Apprenticed at thirteen, as was the tradition, he learned essential skills from his master, the accomplished mural painter Domenico Ghirlandaio (1449–1494). By the time Michelangelo was thirty, his reputation had attracted the attention of Pope Julius II, a worldly prince of the Church. Julius selected the Florentine to carry out the ambitious plans for marble sculpture for the pope's tomb. When the work was scarcely begun, however, Julius persuaded Michelangelo to undertake an even more exacting commission.

The ceiling of the Sistine Chapel, built earlier by Pope Sixtus IV in the Vatican, was unpainted, although the walls held murals by earlier artists. The pope asked Michelangelo to paint the vault of the ceiling with religious frescoes. Reluctantly agreeing, Michelangelo, who until then had considered himself more sculptor than painter, refused any help and spent the next four years almost in solitude on his back on a scaffold, creating hundreds of figures 60 feet (18.28 meters) above the floor [13.8]. In this huge work, figures of Old Testament prophets alternate with oracles of classical mythology. As a practicing sculptor, Michelangelo believed that the more painting resembled sculpture the better it was. He therefore accentuated the volume of his figures to create the effect of biblical reliefs ranging from the book of Genesis to the Flood. We may note that for the first time, in the spirit of humanism, Michelangelo placed the figures of God and Adam almost facing each other as if on equal terms. As Adam awakens from sleep and gazes directly at God the Father, we sense energy vibrating between their outstretched fingers [I.1].

While Michelangelo was painting the Sistine ceiling, a young rival, Raphael Sanzio (1483–1520), was completing a series of frescoes in the Vatican. Deeply concerned with the universality of human experience, he tried to find a balance between the religious and profane aspects of the High Renaissance. He set on opposite walls of the Stanza della Segnatura theological themes in the

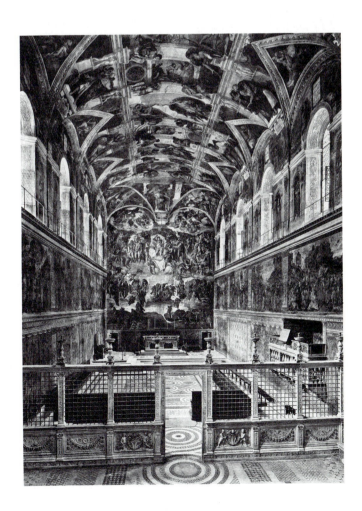

13.8 SISTINE CHAPEL, VIEW TOWARD MICHELANGELO'S *LAST JUDGMENT* OVER THE ALTAR. CEILING PAINTINGS, 1508–1511. HEIGHT OF CEILING 68' (20.73 M). VATICAN, ROME.

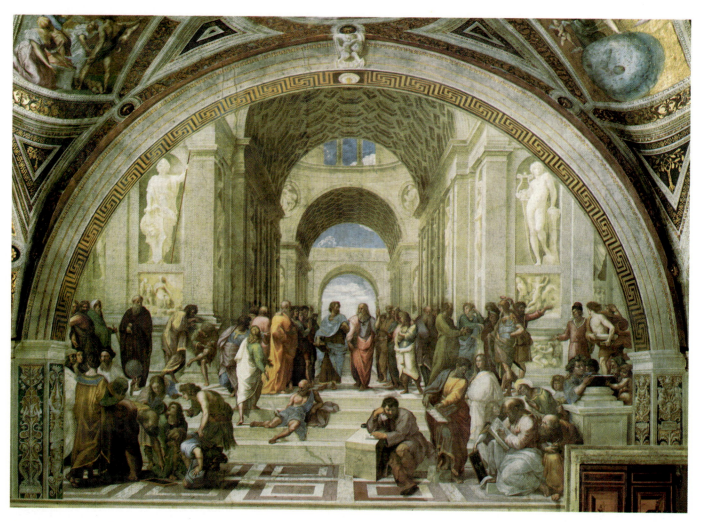

13.9 RAPHAEL. *THE SCHOOL OF ATHENS*. 1501–1511. FRESCO, 26 × 18′ (7.92 × 5.49 M). STANZA DELLA SEGNATURA, VATICAN, ROME.

Disputà and classical subjects in *The School of Athens* [13.9], creating a deep, three-dimensional space as a setting for the figures. Famous classical teachers with their pupils are grouped around symbols by which we can recognize them; Plato and Aristotle are silhouetted against the sky framed by a central arch. The formal, one-point perspective lines lead our eyes to their figures, while the assembly of philosophers and pupils is split into two groups representing the Platonic and Aristotelian schools. In his short lifetime, Raphael became famous for these outstanding large, formal, intellectual paintings, and many consider him the most typical artist of the High Renaissance.

A major center of Italian art, second only to Florence, was Venice, a wealthy maritime power since medieval times. *Sleeping Venus* [13.10] by the Venetian painter Giorgioni helped to reinstate the classic nude, not seen for more than a thousand years, as a standard subject for art. The frankly erotic pose of the languid form enhances the warm flesh tones of the body, which, contrasted with an idyllic landscape, is set off by the shimmering white drapery. Venice, queen of the Adriatic Sea, was probably the most sophisticated city in Europe at the time, famous for the good life it offered and an ideal setting for the important new work. The great plague of 1510 swept through Europe, interrupting the work, later completed, we believe, by Titian after the death of Giorgioni (1475–1510).

Classical ideals of form and proportion had never quite taken hold in the floating city built on canals. Instead, glowing mosaics such as those of the Byzantine cathedral of San Marco, ornate Gothic palaces, and the dazzling colors and sensuous textures of fabrics imported from the Orient dominated Venice. The city produced other fine painters, in particular Titian (1477–1576), a brilliant colorist. Titian reflected the secular spirit of the Renaissance in his *The Venus of Urbino* [13.11], a more worldly version with which to compare the earlier work.

The rhythmically ordered stability of Renaissance painting usually depended on a tri-part division of space—the subject in the foreground against a strongly architectural middle ground, framed by a distant background. Breaking away from such limitations, Titian introduced a new diagonal thrust into many of his works. For example,

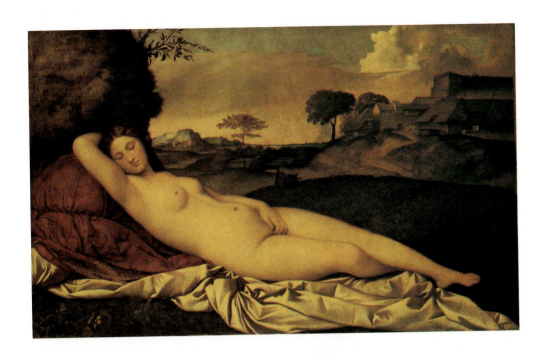

13.10 GIORGIONI (COMPLETED BY TITIAN) *SLEEPING VENUS.* C. 1510. OIL ON CANVAS. 1.08 × 1.75 M. GEMÄLDEGALERIE ALTE MEISTER, DRESDEN.

although our attention lingers on the idealized form of the Duchess of Urbino, our eyes flicker to the maids in the background, positioned not, as was customary, behind the central figure, but diagonally off center. Also, Titian portrayed gods and goddesses as distinctly mortal, such as this languid nude, who awaits the assistance of her maids to dress—and, surprisingly for a Venus figure, if indeed she is, regards us unabashedly in her nakedness.

Sculpture and Architecture After Michelangelo finished the Sistine frescoes, he continued to work on Ju-

lius' tomb, for which he carved the mighty Moses **[6.2]**. He also created tomb figures for the Medici in Florence and for his own tomb. In some works the figures seem to struggle to release their stretched and contorted limbs from the stone. At the same time, the tension between those opposing forces and the larger-than-life scale of the sculptures increases their sense of power and movement. Such remarkable characteristics influenced many later Baroque artists, who then also exaggerated the scale and movement of their own works.

13.11 TITIAN. *THE VENUS OF URBINO.* 1538. OIL ON CANVAS, 3'11" × 5'5" (1.19 × 1.62 M). GALLERIA DEGLI UFFIZI, FLORENCE.

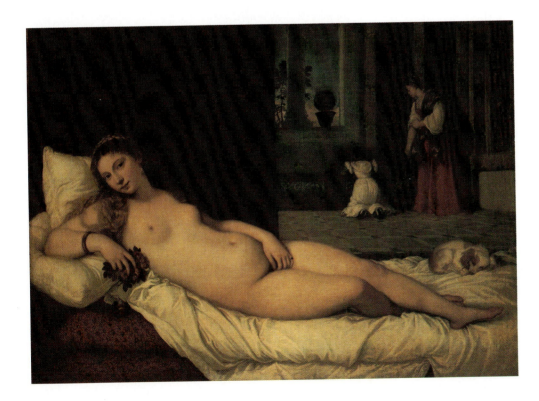

Michelangelo's last great undertaking was the continuation of work on St. Peter's in Rome, notably the dome [7.19]. The overpowering scale, the unity of repeated elements in its design, and the strong contrasts that exist between its diverse architectural elements mark this church as one of the most significant monuments of the High Renaissance and a herald of the Baroque era to come.

Mannerism and Late Renaissance

The sixteenth century was a period of conflict and stress during which Italy was invaded by foreigners. In this changing world the equilibrium of the High Renaissance, like the Classical period in ancient Greece, was difficult to maintain. Even Leonardo and Michelangelo, typical as they were of the High Renaissance, signaled in their work the approaching Mannerist style. For example, Leonardo's preoccupation with light affected the balance of his compositions, and Michelangelo distorted his figures for expressive purposes. By the 1530s the formal boundaries within which Leonardo and Michelangelo had produced their greatest works had broken down. The unrest of the time was reflected in the work of artists who consciously altered the ideals of the High Renaissance, evolving an exaggerated, theatrical **Mannerist** style.

Painting Mannerist painters were not interested in the logic of real space. They experimented with elongated proportions like those of Botticelli's goddesses, the twisting forms preferred by Michelangelo, and asymmetrical compositions often used by Titian. Such effects were probably as startling to sixteenth-century Italians as the works of experimental twentieth-century painters are to the public today.

Parmigianino (1503–1540) shocked his fellow citizens of Parma with the elegance of *The Madonna with the Long Neck* [13.12]. The Madonna, her squirming baby, and attendant angels are crowded on one side, leaving a row of unfinished columns on the other. The contrast between the tightly compressed space and the open, abruptly receding space gives us a sense of instability. These figures are elongated, ivory-smooth, and demonstrate an ideal of beauty not to be measured by the standards of real human beings.

The Venetian painter Tintoretto (1518–1594), influenced by Titian, altogether discarded the laws of classical structure. Tintoretto increased the sense of motion and contrast in his compositions to give the effect of floating masses lit by flickering light. His most famous work is *The Last Supper* [13.13], which provides a striking contrast to Leonardo's mural of the same subject [2.38]. Gone is the classical ideal of balance expressed by Leonardo's one-point perspective and symmetrical composition. Tension and drama now dominate. Judas has been set aside in the shadows, while the remainder of the painting is filled with lights and half lights. This striking interpretation portends the drama of Baroque to come.

One of the most important Mannerists was Domenico Theotocopulos, known as El Greco (c. 1548–1614). Born on the Greek island of Crete, he was familiar with **icons** (panel paintings of holy subjects) in the Byzantine style. Traveling to Venice, he studied the achievements of Titian and Tintoretto in using light, shade, and rich color. But he retained the elongated figures of Byzantine art and developed his own strong colors to create an unreal world unlike that of other Venetian painters. After a period in Rome, he settled in Spain, where his richly expressive style was in keeping with Spanish piety. His tall figures of saints in swirling drapery of violent rose, blue, and yellow maintain a link with the Byzantine style. Rejecting the formal balance of the Renaissance, he painted the city of Toledo [1.17] charged with emotion as dramatic clouds contrast with jagged hills and deep river valleys.

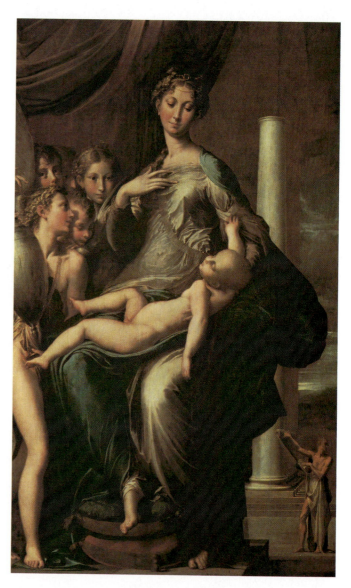

13.12 FRANCESCO MAZZOLA (PARMIGIANINO). *THE MADONNA WITH THE LONG NECK.* C. 1535. OIL ON CANVAS, 7'1" × 4'4" (2.16 × 1.32 M). GALLERIA DEGLI UFFIZI, FLORENCE.

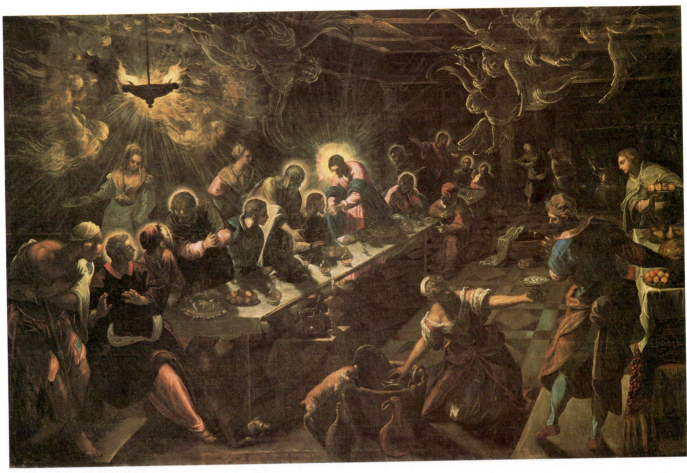

13.13 TINTORETTO. *THE LAST SUPPER.* 1594. OIL ON CANVAS, 12′ × 18′8″ (3.66 × 6.69 M). SAN GIORGIO MAGGIORE, VENICE.

By the late sixteenth century a few women, usually born into families of painters, also became artists. Among the first to attract attention was Sofonisba Anguissola (c. 1528–1625), one of six sisters all trained in art. Sofonisba is noted by the sixteenth-century historian Giorgio Vasari for her skill in portraiture, much in demand in the Renaissance. Despite the simplicity of the composition, the psychological rapport between *Husband and Wife* **[13.14]** is remarkable for this period. Perhaps this quality and her conservative, sensitive observations account for Sofonisba's favored position at the court of Phillip II of Spain. Another well-known portraitist, Lavinia Fontana (1552–?) from the university town of Bologna was also trained in art, as a daughter of painter and teacher Prospero Fontana. Despite her considerable skill, she chose not to resist male dominance of the arts and signed her husband's name to her work, while she and her husband remained for 25 years in her father's home. She accepted as many church commissions as she could handle until her father's death, when she

13.14 SOFONISBA ANGUISSCIOLA. *HUSBAND AND WIFE.* OIL ON CANVAS, 28-1/4 × 15-1/2″ (72 × 65 CM). GALLERIA DORIA, ROME.

moved on papal appointment to Rome. *The Visit of the Queen of Sheba* [13.15] is typical of the demands put upon her to incorporate portraiture into a fairly rigid, religious format. Such an eclectic approach to art was a requirement for artistic survival in Bologna.

Sculpture and Architecture Mannerism's concern with effect rather than content or intellect was typical of the work of the Florentine goldsmith and sculptor Benvenuto Cellini (1500–1571). His lively autobiography reveals expert craftsmanship and extreme egotism. Cellini was clearly delighted with his own virtuosity, displayed in the gold and enamel saltcellar he made for Francis I [13.16]. He wrote of this feat: "The Sea, fashioned as a man, held a finely wrought ship which could hold enough salt, beneath I had put four sea horses, and I had given the figure a trident. The Earth I fashioned as a fair woman. ...

Beside her I placed a richly decorated temple to hold the pepper." The boldness of this design is no less apparent if we compare this work with contemporary salt and pepper mills. Yet, such rich novelty appealed to princes and other wealthy patrons.

Similarly, architects such as Andrea Palladio (1518–1580) were determined to display inventive skill as well as classical knowledge. His Villa Rotonda, near Vicenza, was intended to duplicate ancient Roman styles, but there is no classical counterpart to this square mansion distinguished by four identical porches grouped around a central hall [13.17]. The low dome is reminiscent of the Pantheon. Details of other Palladian buildings—columns, pediments, and three-window groupings—influenced later architecture in Italy and eighteenth-century Georgian style in England. Even wood derivatives in far-off New England were often graced with Palladian windows.

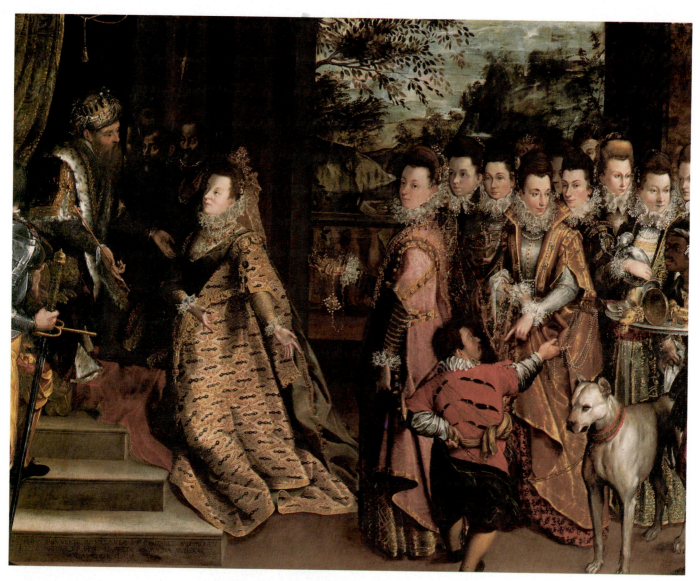

13.15 Lavinia Fontana. *The Visit of the Queen of Sheeba.* The National Gallery of Ireland.

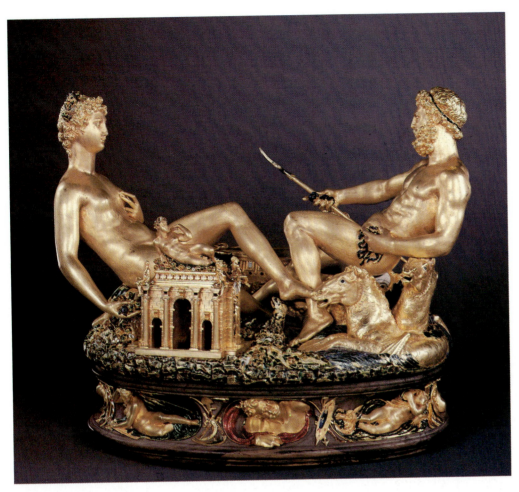

13.16 BENVENUTO CELLINI. *SALTCELLAR OF FRANCIS I.* 1540–1543. GOLD, CHASED AND PARTIALLY ENAMELED; BASE MADE OF EBONY; 10-1/4 × 13″ (26 × 33 CM). KUNSTHISTORISCHES MUSEUM, VIENNA.

13.17 ANDREA PALLADIO. VILLA ROTONDA, VICENZA. BEGUN 1550. 80′ (24.38 M) SQUARE, HEIGHT OF DOME 70′ (21.34 M).

13.18 JAN VAN EYCK. MARRIAGE OF GIOVANNI (?) ARNOLFINI AND GIOVANNA CENAMI (?). 1434. OIL ON WOOD, 32-1/4 × 23-1/2″ (81.8 × 59.7 CM). REPRODUCED BY COURTESY OF THE TRUSTEES, THE NATIONAL GALLERY, LONDON.

RENAISSANCE IN THE NORTH

By the fifteenth century, the cities of Flanders, part of the duchy of Burgundy, were developing a wealthy middle class. Bankers and merchants made fortunes, guilds of tapestry weavers and other skilled craftspeople prospered. Women appeared in numbers on guild lists. Gradually, through increased trade and travel between North and South and the development of printing (Chapter 4), the Flemish absorbed some of the artistic heritage of Rome and humanism.

Fifteenth Century

Flemish painters made revolutionary technical discoveries in oil painting (Chapter 3). By underpainting in black or brown and white tempera, drawing details in white, and overlaying thin oil glazes in color, they evolved a new technique that combined the precision of tempera with the depth of oil. It was ideally suited for rendering the rich fabrics in glowing colors, shining brass furnishings of the comfortable houses of Flemish burghers and the soft blue depth of Flemish landscapes used as background.

Such painters as the Master of Flémalle (believed to be Robert Campin, 1406–1444) [I.19] and Jan van Eyck (c. 1390–c. 1441), who worked for the Duke of Burgundy, depicted supernatural religious (and secular subjects) in the new oil technique, often as though the events were taking place in their own fifteenth century homes. In this way, both painters are breaking out of tradition. Further, most of the room furnishings carry extra symbolic messages as we learned in the case of the *Merode Altarpiece*. In Van Eyck's *Arnolfini Wedding*, the Italian silk merchant and his shy bride are surrounded by symbols of the religious aspects of marriage [13.18], as analyzed by scholars well versed in the period. The solitary lighted candle in the chandelier represents the presence of God, placed to remind the couple that their vows were made before Him. They stand on hallowed ground, their shoes discarded. The fruit on the windowsill represents the delights of lost paradise, while the dog symbolizes fidelity and possibly fertility. This Flemish room, therefore, had a deep meaning to those who understood its symbolism. The artist himself can be seen in the mirror, which repeats the uncompromising reality of the scene. He also inscribed in Latin above the mirror, "Jan van Eyck was here," a witness to the marriage!

Sixteenth Century

By the early sixteenth century, the states of Germany were in transition from medieval piety to Renaissance humanism and the new Reformation teachings of Martin Luther and other Protestant leaders. The basic spiritual conflicts produced an intensity of emotion, typified in Matthias Grünewald (1470–1528). His monumental masterpiece, *The Isenheim Altarpiece* was Gothic in spirit and, like most medieval religious art, preached a visual sermon. When the wings are closed on the central panel, we see the *Crucifixion* [13.19], a stark scene of suffering. Christ's dying body, painted in heroic scale, is distorted by his wounds, and his pain is reflected in his mother's face. In contrast to this

13.19 MATTHIAS GRÜNEWALD. *CRUCIFIXION,* CENTER PANEL EXTERIOR OF *ISENHEIM ALTARPIECE.* COMPLETED 1515. OIL ON WOOD, 8'9-7/8" × 10'7/8" (2.69 × 3.07 M). MUSÉE D'UNTERLINDEN, COLMAR.

The Artist Sketch

In Germany, the birthplace of the Reformation, Grünewald may be second only to Dürer as the greatest German artist of the sixteenth century. Unlike Dürer, who quickly became internationally famous, Grünewald's life is a mystery. In fact, he remained so little known that not till this century did we learn that his real name is Mathis Neithardt Gothardt. We know nothing of his early years when he set up an active workshop in Seligenstadt. Tax records list Grünewald's profession as an architect, although he had painted at least two of his best-known works during that period.

Even his extraordinary major work, The Isenheim Altarpiece, painted between 1509–1515, was long attributed to Dürer. Commissioned for the monastery church of the order of St. Anthony at Isenheim, the paintings are now housed in the museum of the nearby town of Colmar. Made up of two sets of movable wings, intended to be shown in three different arrangements, the altarpiece is a carved shrine. The primary and outermost, visible only when all the wings are closed, shows the Crucifixion that many consider the most impressive ever painted. Grünewald's concept has never been equalled. A faithful adherant of the late Gothic spirit, he was in many respects the most brilliant German colorist of all. In spite of evidence of a new flow of ideas rushing through Europe in the sixteenth century, many countries could not break out of medieval traditions. The altarpiece brings an originality of vision and boldness that springs from more modern inspirations.

We wonder how much Grünewald was indebted to the Renaissance era. Although the answer may be not at all, his use of perspective and the vitality of his figures surely are not medieval. He is known to have been in accord with Martin Luther's views that condemned religious images as idolatrous, but as a painter or architect, his very livelihood depended on his Catholic patrons. We know little about his career except that he did not pursue the settled life of a painter-craftsman. He worked for many different patrons. For example, a notation in 1511 describes him as "Master Mathes, painter and stonecutter of the castle of Aschaffenburg." There can be little doubt that he was involved in the religious and social conflicts of his time. His estate inventory lists a sealed box with Lutheran works and a booklet, drawn up in Swabia, calling for free choice of pastors, abolition of slavery and of small tithes, such as the right to fish, hunt, or cut wood. There is some evidence that he was part of the defeated Peasants' War of 1525.

13.20 Portrait of Matthias Grünewald.

Torn between the need for a free form of Christianity independent of the control of the pope in Rome and the formal Platonic ideals, Grünewald embodied late Gothic mysticism with the awakening spirit of individualism. The need to go beyond the limits of tradition was recognized by every artist anxious to assert his own personality. No one better succeeded in doing this in his time and place than Grünewald.

MATTHIAS GRÜNEWALD (C. 1470–1528)

scene of suffering, in an expression of hope for the world, the opened panels reveal the *Annunciation*, the *Virgin and Child with Angels*, and the *Resurrection*. These works are filled with mystical beauty and radiant light. Here, Grünewald stepped beyond his medieval traditions, and through his use of solid forms and dramatic expression of personal emotions, influenced many later painters.

Albrecht Dürer (1471–1528), in his portraits and landscapes, showed Northern painters how to adapt Italian Renaissance ideas without losing their own traditions. As an apprentice to a painter and an engraver, he developed the meticulous draftsmanship that characterizes all his work and makes memorable even the simple subject of prayer that we noted earlier [3.10]. Already familiar with the paintings of Van Eyck, Dürer traveled to Italy, where he saw works by Mantegna and Michelangelo. He brought back to Germany the Renaissance concern for science and wrote treatises on perspective and anatomy.

In printmaking, however, Dürer truly excelled. The development of printing in the previous century had increased the demand for woodcuts and copper engravings, as we saw in Chapter 4. In these media he showed his mastery of light and shade and his devotion to the traditional faith. The classical architectural detail of the enormous *Triumphal Arch of Maximilian* also reveals a strong Renaissance interest in ancient Rome even in Germany [4.7]. The emperor Maximilian, convinced of the value of art as propaganda in service to the crown, cleverly entrusted Dürer with celebrating his royal deeds in a woodcut on paper rather than commissioning an architect to produce such a work in costly stone.

While sixteenth-century Italians were delighting in light, color, texture, and experiments in perspective and composition, Northern Europeans were undergoing the Reformation, which rejected the visual arts. Because the Protestant churches were opposed to religious paintings

as idolatrous and the mercantile class had little interest in classical myths, Northern artists searched for other subjects. Many painted on small panels, "in-hand" paintings, which could be hung on the walls of a patron's home. Landscape made its appearance as an important subject at this time. Another theme was portraiture. However, for the strictest Calvinists, all decorative objects were considered dispensible luxury. Only portraits, small panels, and book illustration provided means by which most artists could make a living.

A unique example of religious panel painting [13.21] is the work of the early Renaissance painter Hieronymous Bosch (1450–1516), who drew on his imagination to point out a moral lesson in *The Garden of Earthly Delights*. On the left panel, fantastic creatures inhabit the Garden of Eden. On the right panel, fearsome demons—half animal, half machine—punish sinners in hell. In the center, nude figures innocently enjoy sexual pleasures in a garden that may represent earth or paradise. While questions continue regarding the intent of this work, few can compete with the impact of its myriad figures and startling concept.

One of the foremost Northern portraitists was Hans Holbein the Younger. Born in Augsburg, Germany, he went to England, where he became court painter to Henry VIII. There he completed many portraits of the English nobility and was among the first to combine the Northern interest in the precision of tempera and oil glaze with the Italian interest in perspective and rich color. In his glowing portrait *Sir Brian Tuke* [13.22] every detail of shape and texture has been painstakingly recorded.

13.22 HANS HOLBEIN THE YOUNGER. *SIR BRIAN TUKE.* C. 1527. OIL ON WOOD PANEL, 19-3/8″ × 15-1/4″ (49 × 39 CM). NATIONAL GALLERY OF ART, WASHINGTON. (ANDREW W. MELLON COLLECTION, 1937).

13.21 HIERONYMUS BOSCH. *THE GARDEN OF EARTHLY DELIGHTS.* C. 1500. OIL ON PANEL; CENTER PANEL, 7′2-5/8″ × 6′4-3/4″ (2.2 × 1.95 M), EACH WING 7′2-5/8″ × 3′2-1/4″ (2.2 × 0.97 M). MUSEO DEL PRADO, MADRID.

Scenes of the everyday world of kitchen or tavern and still-life themes consisting of tables stocked with food and flowers were much favored by painters. Pieter Brueghel (c. 1525–1569) set even biblical stories, such as the *Tower of Babel* [10.8], in the local countryside populated with peasants going about their daily activities. For all his apparent taste for country-bumpkin humor, Brueghel was really a sophisticate who had traveled to Italy. In his landscapes, humans are depicted as tiny figures, conveying the lesson of human insignificance in the scheme of the universe. While many of his paintings are religious allegories, they also reveal his personal joy in nature—in the hot sun on hay fields and in frozen, snow-covered fields at dusk.

BAROQUE IN ITALY

The extraordinary achievements of the Renaissance were, perhaps, possible only at a time when traditional religious beliefs still had meaning and artists in a new spirit of inquiry and observation found fresh means to express them. During the Age of the Baroque, the seventeenth and early eighteenth centuries, the religious unity of Europe was destroyed, and the growing scientific spirit of the new age encouraged a secular outlook. It was a period of confusion and longing for a more perfect world that beckoned out of reach. Artists of the Baroque period went beyond the limits set by the Renaissance. Sometimes their individualism spilled out of strict stylistic categories, but their innovations foretold similar developments in later times.

By the seventeenth century the exodus of converts from Catholicism to Protestantism had been halted, while the Roman Catholic Church sustained a period of renewal called the Catholic or Counter Reformation. Many Church reforms were instituted, and in Italy an intensive program of renovation and rebuilding was launched to make Rome once again the center of the world. This program continued in the Baroque period. The papacy spared no expense to proclaim the authority of Rome and authorized architects to design churches, piazzas, fountains, and gardens on a grand scale. Paintings and sculptures were commissioned to decorate the architecture. Much of this art was intended for the aristocracy, but some, such as the piazza of St. Peter's, added a new dimension to the life of the ordinary citizen.

The word Baroque originated from an insulting Portuguese term used to mean "absurd" or "grotesque" because many considered Baroque art a degeneration from the restraint of the High Renaissance. In Baroque painting and sculpture emphasis was placed on light and dark contrasts, turbulent compositions, and exaggerated emotion. In Baroque architecture classical elements were freely handled to create the effects of painting and sculpture. Dramatic and mysterious effects were preferred.

Painting One of the first to work in this new style was Annibale Carracci (1560–1609), a member of a family of painters from Bologna, who had begun their training in the **bottega** of Prospero Fontana, alongside Lavinia Fontana. Distrustful of Mannerist distortion and in the spirit of variety for which the city was known, in his frescoes for the ceiling of the Farnese Palace in Rome he combined a sense of classical anatomy and Renaissance foreshortening with late Renaissance use of light and energy [13.23]. The Carracci family founded an academy of art in Bologna, the very first art school. Later, as other academies appeared, aspiring artists no longer were apprenticed to a master painter but could enroll for schooled instruction in art—a pioneering change in the art world.

Also opposed to Mannerism but preferring high drama to the conservative solutions of the Carracci was Michelangelo Merisi da Caravaggio. To explain a miracle to ordinary viewers, he presented starkly lit biblical themes as they might have happened in their own time. In *The Conversion of St. Paul*, traditional images are gone. St. Paul is shown as an armored man flat on his back, almost trampled beneath his horse. The striking perspective and extreme contrasts of dark and light draw us into the event. It is obvious why many of Caravaggio's conservative contemporaries were appalled by setting sacred figures into such unconventional poses. Do you believe this remarkable work would be better received by the Church today, 400 years later [13.24]?

13.23 Annibale Carracci. *Triumph of Bacchus and Ariadne.* 1597–1601. Ceiling fresco. Galleria Palazzo Farnese, Rome.

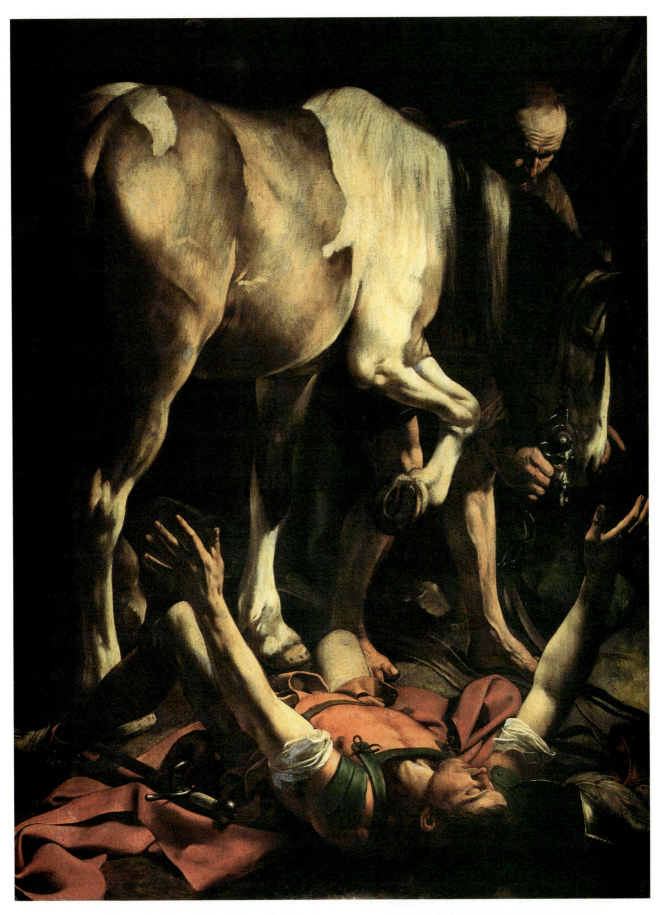

13.24 CARAVAGGIO. *THE CONVERSION OF ST. PAUL.* 1601–1602. OIL ON CANVAS, 7′6-1/2″ × 5′9″ (2.3 × 1.75 M). CERASI CHAPEL, STA. MARIA DEL POPOLO, ROME.

The Artist Sketch

Well known as Caravaggio from the name of the Italian town where he was born, Michelangelo Merisi was the son of a local architect. Revolutionary in his approach to art in his relatively short and quite troubled life, he is best regarded for his shadow-painting technique called **tenebroso**.

After an apprenticeship of five or so years to a popular Milanese painter, by 1592 Caravaggio was in Rome, turning out works for established artists. This period was brief because he preferred to eke out a precarious art existence independently. The works of this period, light in tone, predominantly composed with earth colors, demonstrated early a direct approach to the subject, eschewing all idealization. Using models from the street, he painted his subjects realistically, as if to convince the observer that his themes had occurred just as they were described in myths and in biblical records. The works he turned out in this period show astonishing pictorial creativity, with a craftsmanship in strong contrast to his own disorderly and dissipated life-style. Through the efforts of Cardinal Del Monte, a prelate of great importance in the papal court, Caravaggio obtained a commission to render an imposing three-painting cycle of the life of St. Matthew. This work established him, at twenty-four, as a "pictor celeberrimus," a "renowned painter." The dramatic realism of the works astonished the public, accustomed to idealized rendering of sacred narratives. Light itself became the medium of Caravaggio's revolution. A twentieth-century Italian scholar, Roberto Longhi, explains Caravaggio's illumination of form out of deep shadow "as a magical light from above, at the onlooker's shoulder, that, unlike natural light, modifies the color scheme and eliminates subtleties in its path, much like theatrical spotlights."

Despite his inventive solutions to common art concerns, however, Caravaggio was not universally appreciated. He was quick to take offense at criticism and was involved in a stream of conflicts until, in 1606, he killed a man in a brawl. Fleeing from town to town to avoid arrest, he contracted a fatal case of malaria in 1610. Thus did an unfortunately common end come to a most uncommon man, who left us his self-portrait in the form of the features of the decapitated head of Goliath. His earthy realism and *tenebroso* herald a new phase of the era of Baroque, so important that Longhi likens Caravaggio's unique use of light to that of the Renaissance discovery of perspective [13.25]!

MICHELANGELO MERISI DA CARAVAGGIO (1573–1610)

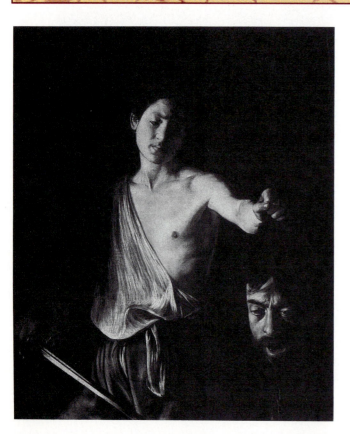

We will remember the leading woman painter of the Baroque period, Artemisia Gentileschi (c. 1597–c. 1651), the daughter of a painter. Influenced by Caravaggio, a friend of her father, she painted biblical scenes, portraits, and nudes. Her first major work, *Judith Beheading Holofernes*, powerfully portrays a heroic woman performing a horrendous act with resolve [1.18]. The strong diagonals all lead to the sword blade and drops of blood, which brilliantly contrast with the snow-white bosom of Judith. Gentileschi chose to outdo all her predecessors by showing the ferocity with which Judith destroyed the general who was attacking her beloved city.

Sculpture and Architecture The most outstanding sculptor-architect of the Baroque period was Giovanni Lorenzo Bernini (1598–1680), who is probably best known for his extraordinary *The Ecstasy of Ste. Theresa* [13.26], influenced by emotional Hellenistic works. This sculpture of religious mysticism epitomized the spirit of the Baroque.

13.25 CARAVAGGIO. *DAVID WITH THE HEAD OF GOLIATH.* C. 1609–1610. OIL ON CANVAS, 49-1/4 × 39-3/4" (125 × 101 CM). GALLERIA BORGHESE, ROME.

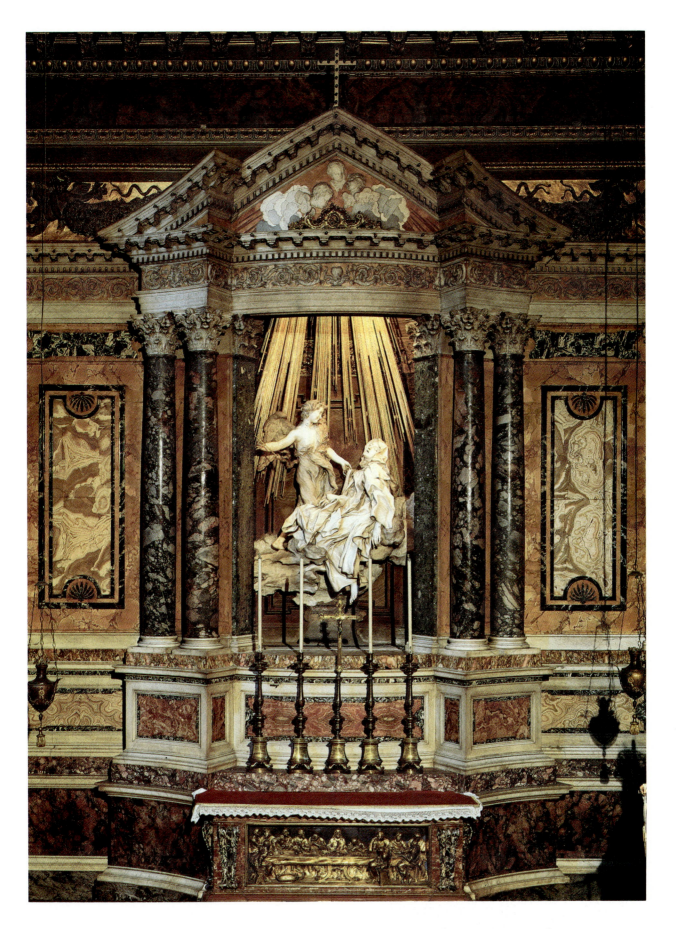

13.26 GIOVANNI LORENZO BERNINI. *THE ECSTASY OF ST. TERESA.* 1645–1652. MARBLE AND GILT BRONZE, LIFE SIZE. CORNARO CHAPEL, STA. MARIA DELLA VITTORIA, ROME.

In the saint's own words, at the moment of ecstasy she felt such a great love of God that "the pain was so great that I cried out, but at the same time, the sweetness which the violent pain gave me was so excessive that I could not wish to be rid of it." The drapery falling in a cascade of agitated folds rejects the solidity of the marble from which it was carved, revealing Bernini's technical skill and preoccupation with detail.

Bernini's religious intensity led him also to create a spectacular design for the piazza of St. Peter's Basilica in Rome. Designed to hold crowds of worshippers at Easter and Christmastime, the piazza is said to accommodate half a million people. Bernini intended the two curving colonnades to represent the arms of the Church, which "embrace Catholics to reinforce their belief, heretics to reunite them with the Church, and agnostics to enlighten them with the true faith." [13.27].

BAROQUE IN SPAIN AND THE NORTH

Born in Italy, the showy Baroque style soon spread to Spain, France, Germany, the Low Countries, and England. In each country, Catholic or Protestant, it was modified by local circumstances. Princes and nobles competed to build magnificent palaces and gardens, redesign cities, and amass works of art. Even functional objects soon acquired Baroque curves and elaborate decoration.

Spain

With the immense wealth derived from their colonies in the Americas, the kings of Spain maintained an impressive court in keeping with the role in which they saw themselves, as divinely appointed rulers of their people and supporters of the Church in Spain. Continuing the sixteenth-century practice of commissioning works from foreign painters, such as El Greco and Titian, they also favored Spaniards.

The most illustrious Spanish court painter was Diego Velázquez (1599–1660), who excelled in portraiture and grandiose historical scenes. Although influenced by Caravaggio's lighting and by Titian and the Flemish Baroque painter Peter Paul Rubens, Velázquez evolved his own personal style. His canvases are Baroque in color, depth of space, and light and dark contrasts, but he applied his paints in separate brushstrokes that presaged nineteenth-century Impressionism. With this technique, Velázquez could recreate the play of light over the rich garments of his royal subjects and the luxury of their palaces. In *Las Meniñas,* he painted his own portrait standing at the canvas near the small Infanta surrounded by her maids of honor [13.28]. Tiny portraits of the king and queen, who came to watch the artist at work, appear in the mirror behind him. He must indeed have felt secure as court artist to record himself more prominently than his royal employers.

France

The most outstanding example of French Baroque art was the Palace of Versailles, built by Louis XIV outside Paris to reflect France's position as the major power in Europe. The king assembled a team originally consisting of the architect Louis Le Vau (1612–1670), the landscape architect André Le Nôtre (1613–1700), and the painter and decorator Charles Lebrun (1619–1690) to integrate all aspects of the design. Although a new wing for the old Louvre Palace in

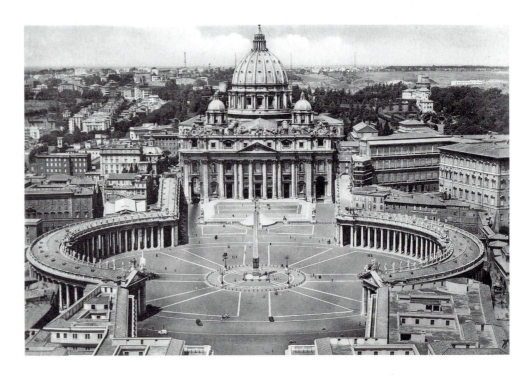

13.27 St. Peter's Basilica and the Vatican, Rome. Apse and dome by Michelangelo, 1547–1564; dome completed by Giacomo della Porta, 1588–1592; nave and facade by Carlo Maderno, 1601–1626; colonnades by Giovanni Lorenzo Bernini, 1656–1663.

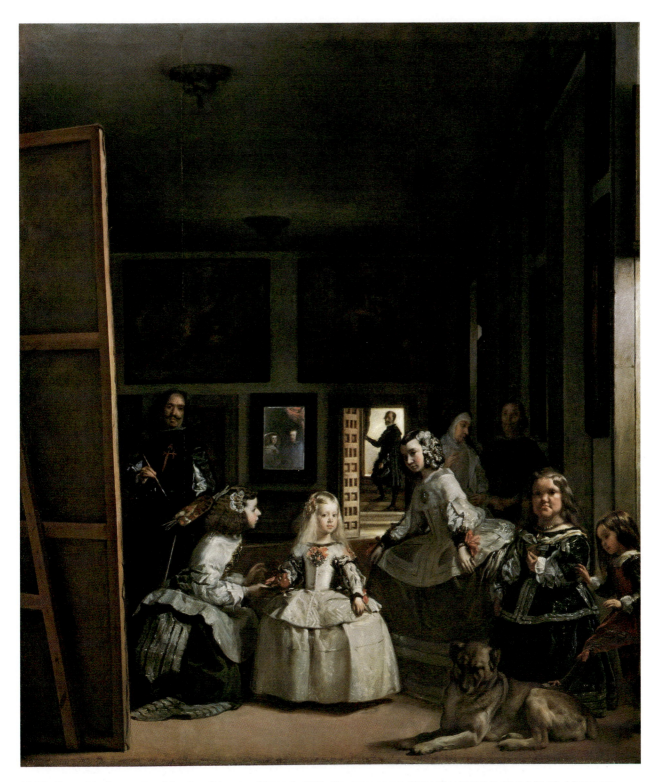

13.28 DIEGO VELÁZQUEZ. LAS MENIÑAS (MAIDS OF HONOR). 1656. OIL ON CANVAS, 10′5-1/4″ × 9′3/4″ (3.18 × 2.76 M). MUSEO DEL PRADO, MADRID.

Paris had been a collaborative effort, Versailles was the first design and construction of such tremendous scope to be a group effort [13.29].

In its magnificent scale, Versailles resembled Bernini's piazza in Rome, but its restrained, intellectual style defined characteristic qualities of French Baroque. Unlike most Italian Renaissance palaces, which looked inward on central courtyards, Versailles' long, windowed galleries overlooked broad terraces and formal gardens full of pools, splashing fountains, and marble statuary in the classical style. The palace with its gardens and park covered about 20 acres (8.9 hectares). A small city in itself, it held a thousand brilliantly dressed courtiers and the servants needed to maintain the palace.

Louis XIV, who believed French culture was centered in him, "L'Etat c'est moi" (I am the state), was responsible for the founding of royal academies of literature, science, and the arts. Other rulers followed his lead, establishing similar institutions. These powerful, conservative state academies set official standards and dispensed honors upon only those who followed their dictates. Artists who opposed their rigid rulings usually had a difficult time finding work. Perhaps the greatest French painter of the century, with international renown, was Nicolas Poussin (1593/4–1665), leader of the Neoclassic style established by the Royal Academy of Painting. Poussin stoutly maintained that "the highest aim of painting is to represent noble and serious actions!—not as they really happened, but as they would have happened if nature were perfect." We will encounter the same philosophy a century later with Diderot, who defined art criticism for us (Chapter 1). *Rape of the Sabine Women* [13.30] is so carefully composed, with evenly distributed colors and directional forces, that the emotion and turmoil of the event seem frozen in action, but the rational clarity of Poussin's work served to reinforce Neoclassic views for later generations of painters.

The Low Countries

Peter Paul Rubens (1577–1640), a prolific painter trained in Flanders and Italy and a worldly, well-traveled ambassador at home in many European courts, also helped spread the Baroque style. During his years in Italy he learned to make full use of color and light. His huge, impressive, movement-filled canvases reflect his delight in painting rich drapery, the sheen of armor and jewels and the glowing skin tones. His work, such as the *Garden of Love* [13.31], was tremendously popular, bringing him great wealth and a studio in Antwerp with many assistants. He kept such tight control over the art, however, that when a painting was almost completed by his helpers, he had only to take a brush to a detail here or there to make the work his own.

Meanwhile, Dutch painters were producing for a Calvinist merchant class unassuming works that emphasized middle-class daily life. Frans Hals (1580–1666), a Protestant from Haarlem, was a popular portraitist of Dutch burghers, whom he often depicted in official group paintings. He was innovative in his method of finishing his paintings in loose, distinct brush strokes. In *The Bohemian Girl* [3.22] we viewed earlier, he catches a momentary expression to give the impression of quick work, which was in fact the product of long, calculated effort. Hals' rough naturalism is, however, quite different from the smooth realism of Caravaggio's *The Conversion of St. Paul.*

13.29 PERELLE. ENGRAVING OF A GENERAL VIEW OF THE *PALACE OF VERSAILLES.* 1669–1685. PALACE WIDTH 1935′ (589.79 M). PALAIS DES BEAUX ARTS, PARIS.

13.30 NICOLAS POUSSIN. *RAPE OF THE SABINE WOMEN.* C. 1636–1637. OIL ON CANVAS, 5'7/8" × 6'10-5/8"
(1.55 × 2.1 M). THE METROPOLITAN MUSEUM OF ART (HARRIS BRISBANE DICK FUND, 1946).

13.31 PETER PAUL RUBENS. *GARDEN OF LOVE.* C. 1632–1634. OIL ON CANVAS, 6'6" × 9'3-1/2" (1.98 × 2.83 M).
MUSEO DEL PRADO, MADRID.

Hals greatly influenced his fellow citizen Judith Leyster (1609–1660), whose substantial body of work is somewhat similar in style. Several of her paintings, such as *The Jolly Companions* [13.32] and *The Jolly Toper,* which has her monogram, were sold as the work of Hals. Although the themes of the two artists are similar, there are differences in their work. Leyster's compositions are generally more intricate, the brush work perhaps more sensitive, and the mood less exuberant.

While Hals and Leyster painted their subjects as if caught in a passing moment, Rembrandt van Rijn (1606–1669), working in Amsterdam, studied his subjects with psychological penetration, searching for the "soul" of each one. His portraits reveal such depths that at times we turn from the embarrassing intimacy of his insights. To find authentic models for the biblical themes of his works, he frequented the Jewish quarter of Amsterdam.

Rembrandt used strong contrasts of light and shade like Italian Baroque painters, but with more restraint. His unconventional approach to group portraits is evident in *The Night Watch,* in which he strengthened the overall composition with light and shadow at the expense of detailed likenesses. So titled because darkened layers of varnish made it look like a night scene until it was cleaned in the 1940s, *The Sortie of Captain Frans Banning Cocq's Company of the Civic Guard,* as it is properly called, actually represents a volunteer military company called together to honor visiting royalty [13.33].

Rembrandt was also a master at graphics. He preferred etching to engraving because etching gave him more freedom to change a plate in preliminary states (Chapter 4). With only a few lines he could express the essence of a scene, a gesture, or a pose.

In contrast to Rembrandt's uncluttered, deep shadowed works, paintings by Jan Vermeer (1632–1675) of Delft appear clearly detailed. He portrayed the interiors of Dutch households with loving concern for meticulous accuracy, using mellow colors that reflect Dutch Baroque taste. The strong compositions brought attention to the sensuous colors and textures of everyday objects [1.3], as

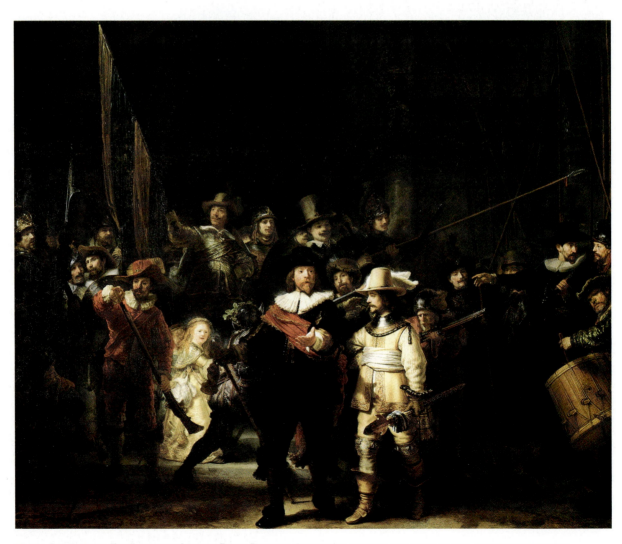

13.33 REMBRANDT. *THE SORTIE OF CAPTAIN FRANS BANNING COCQ'S COMPANY OF THE CIVIC GUARD (THE NIGHT WATCH).* 1642. OIL ON CANVAS, 12'2" × 14'7" (3.71 × 4.45 M). RIJKSMUSEUM, AMSTERDAM.

13.32 JUDITH LEYSTER. *THE JOLLY COMPANIONS*. 1630. OIL ON WOOD, 26-3/4 × 21-3/4" (68 × 55 CM). LOUVRE, PARIS.

Their pillared porches, classical pediments, and single, slender steeples, imaginatively combined to give an effect of dignity and strength, influenced eighteenth-century churches in the English colonies in North America.

AGE OF REASON

The restless Baroque period passed quietly into the Age of Reason. Sir Isaac Newton had discovered laws of physics that led to a Scientific Revolution in the eighteenth century. Later, writers such as Voltaire in France expressed questions about the gap between the brilliant court life of the aristocracy and the poverty of the masses. Reflecting the times, art also underwent changes. Whereas the Baroque taste had favored theatrical arts of sensuous color and huge scale, French designers now created an intimate Rococo style, smaller in scale and characterized by subtle colors and a profusion of curved ornament. Palaces and country estates were soon filled with paintings, tapestry, porcelain, and silver, intricately decorated.

you may remember. If the paintings were reduced to abstract shapes and flat colors in the twentieth-century style of Mondrian, we could see the careful plan of the composition. Vermeer's skill in framing his scenes with draperies, combined with his innovative device of cutting off figures at unusual levels, presaged a different way of depicting the world.

England

Separated from the mainland of Europe by the English Channel and conservative tradition, England was slow to accept Renaissance and Baroque art. English Baroque, exemplified by St. Paul's Cathedral by Sir Christopher Wren (1632–1723), is not so ornate or luxurious as Italian Baroque. Wren's restrained forms link St. Paul's more closely to Italian and French Renaissance styles than to exuberant Italian Baroque [13.34]. The dome and façade were probably influenced by the late Renaissance St. Peter's in Rome [7.19], and the double rows of paired columns are reminiscent of the classical Louvre in Paris.

St. Paul's was the largest of many churches that Wren designed after the Great Fire of London in 1666.

13.34 CHRISTOPHER WREN. ST. PAUL'S CATHEDRAL, LONDON. 1675–1710.

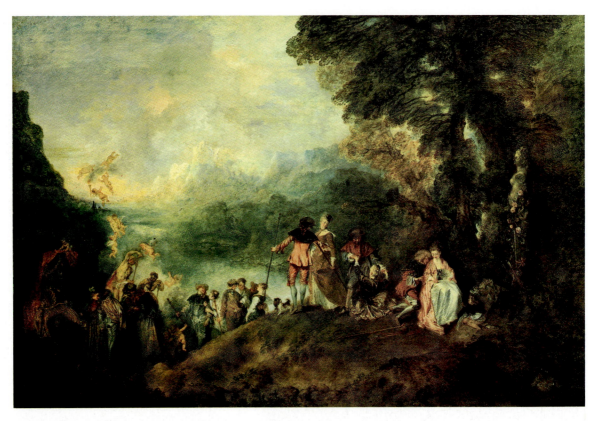

13.35 JEAN ANTOINE WATTEAU. *THE EMBARKATION FOR CYTHERA.* 1717. OIL ON CANVAS, 4'3" × 6'4-1/2" (1.3 × 1.94 M). LOUVRE, PARIS.

Rococo Painting

Painters in the new style chose as subjects classical divinities and the aristocracy, in classical or rich court dress. Their palette was light—white, gold, pink, blue, and other clear hues. The work of Jean Antoine Watteau (1684–1721) [13.35], who, like most court painters, was also an interior designer, shows us the Rococo style at its best. He was especially successful at recording the open-air entertainments so popular at court, making quick sketches at the scene and then painting the event in silvery tones in his studio. *The Embarkation for Cythera*, a dreamy landscape peopled by courtiers leaving (in spite of the title) the mythological island of love, may have been inspired by a court fête. Adapting painting techniques from Rubens' more robust works, Watteau also borrowed ideas from the theater. His subjects, who included actors, seemed to act out their parts like tableaux in a stage setting as artificial as their lives. By focusing on the departure of the young couples from the island of love, he perhaps wistfully foreshadowed the coming changes that ended in revolution.

Portraiture

One of the most popular subjects of Rococo painters was portraiture. Rosalba Carriera (1675–1757) gained a reputation for life-size and miniature portraits in her native Venice. Many were in pastel, a new medium, which she introduced to Paris on a trip there in 1720. Her pastels,

which range from simple studies to complex group compositions, illuminate the character as well as features of her subjects. They were so popular with Paris society that she was elected to the French Royal Academy of Painting and Sculpture. Her self-portrait [13.36] is a typical example.

Also elected to the French Royal Academy was Elisabeth Vigée-Le Brun (1755–1842), the daughter of a painter. Of the more than twenty portraits to her credit, the best known, a self-portrait with her daughter Julie, is a typical rhythmic composition well suited to aristocratic demands [13.37]. In fact, she pleased royal tastes so well that Queen Marie Antoinette sponsored her election to the Royal Academy.

The art of portraiture flourished especially in England. One of the foremost portraitists of his day was Sir Joshua Reynolds (1723–1792), who had studied in Italy. As co-founder and first president of the Royal Academy in London, he laid down rules governing the creation of art in accordance with Italian and French academic principles. Although his writings on art were somewhat pompous, his portraits have grace and dignity. Flattering to their subjects, they appealed to aristocrats and set a style in fashionable portraiture [13.38].

Genre and Still Life

The middle classes, like the aristocracy, also enriched their surroundings with art. Some chose allegories by François Boucher, Jean Honoré Fragonard (1732–1806), and

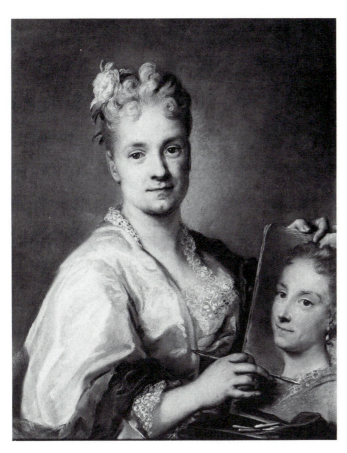

13.36 ROSALBA CARRIERA. *SELF-PORTRAIT, HOLDING PORTRAIT OF HER SISTER.* 1715. PASTEL, 28 × 22-1/2" (71 × 57 CM). GALLERIA DEGLI UFFIZI, FLORENCE.

13.38 JOSHUA REYNOLDS. *ANNE, VISCOUNTESS, AFTERWARDS MARCHIONESS OF TOWNSEND.* C. 1780. OIL ON CANVAS, 7'11" × 4'10" (2.41 × 1.47 M). FINE ARTS MUSEUM OF SAN FRANCISCO (GIFT, ROSCOE AND MARGARET OAKES FOUNDATION).

others, but many preferred subjects that reflected their own world—comfortable household scenes and boisterous drinking parties or tables laden with food and flowers. In short, their tastes were much like those of seventeenth-century Dutch burghers.

Of the many women practicing flower painting in the Lowlands, Rachel Ruysch (1664–1750) was particularly successful. Married to a portrait painter, she also became a member of the guild and later a court painter in Düsseldorf. The sixty years of her professional life, however, witnessed the huge success of floral subjects; then an

13.37 ELISABETH VIGÉE-LE BRUN. *SELF-PORTRAIT WITH HER DAUGHTER.* OIL ON WOOD, 51-1/8 × 37" (130 × 94 CM). LOUVRE, PARIS.

Internationally known, Angelica Kauffman (1741–1807) studied the human figure from plaster life casts of famous works, assembling her sketches to form the finished artworks. While this practice was not born with Kauffman, it is still used today [13.41].

One of the great still-life painters of the time was Anne Vallayer-Coster (1744–1818), the daughter of a goldsmith. She reveals a delight in her subject, even in such early work as *The White Tureen*. The composition, setting directional forces with the napkin, the ladle, and the tureen lid, is masterful. For instance, from whatever point in the composition our eyes begin the journey of inspection, they are led to the focus of the painting. But it is likely that her skill in portraying texture determines the lasting appeal of the work [13.42].

Life in the eighteenth century had its problems, then, as today, even among the privileged. The unpleasant side was told by William Hogarth in bitingly satirical works such as *The Harlot's Progress* and *The Rake's Progress* [I.17], a moralizing series of engravings narrating the downfall of a young man and woman. The rake comes to a pathetic end as a raving maniac in Bedlam, London's insane asylum,

inevitable decline. The grace of her compositions and delicate floral arrangements maintained Ruysch's leadership in the field [13.39].

The foremost French painter of **genre** and **still life** was Jean Baptiste Chardin (1699–1779). His refined arrangements of food and cooking implements [13.40] reveal subtle color harmonies and textures, and, despite the simplicity of the subjects, they satisfied even the most conservative patrons. Through his ability to infuse a quiet dignity in domestic scenes, he reminds us of Vermeer. Chardin's paintings were even enjoyed by the aristocracy, who liked to play at living a simple life.

Still-life painting, called *nature morte* ("dead nature") by the French, did not, however, rank high by the standards of the academies, which insisted that narrative content was a painting's major justification. Since few women were encouraged to try their hands at "noble narratives" or were admitted to the academies for the requisite anatomical training, still-life subjects, especially flower painting as we have just seen, had obvious appeal for them.

13.41 ANGELICA KAUFFMAN. ENTRANCE HALL CEILING, WEST END NORTH SOMERSET HOUSE. 1778. OIL ON CANVAS. 52 × 59″. ROYAL ACADEMY OF ARTS, LONDON.

13.42 ANNE VALLAYER-COSTER. THE WHITE TUREEN. 1771. OIL ON CANVAS, 19-5/8 × 24-1/2″ (50 × 62 CM). PRIVATE COLLECTION, PARIS.

where his demented companions include a grimacing fiddler and a schizophrenic wearing an impromptu crown. Engravings had become a popular and inexpensive form of art, and a series like this reached large audiences. With Hogarth, the graphic arts had become an important propaganda tool for arousing indignation against social injustices, the vices of the rich, and the uneducated tastes of the new patrons. As the century progressed, the rising tide of democratic ideals presaged a new age.

AFRICAN CULTURES AND ART

Since Graeco-Roman times, Africa had been known to Europeans through travel and also through the Muslim expansion of the seventh century. During the late Middle Ages, European trade with Africa and the East continued to increase. But not until the fourteenth century, with a newly expanded mercantilism, did Europeans arrive in significant numbers upon African shores. The first to come were the Portuguese, followed in the 1450s by the Spanish, and near the end of the century by the English and French. The Dutch were next, and by the end of the sixteenth century they had challenged the lead of the Portuguese.

 The reasons for this surge of interest were partly political, but largely economic. In the beginning, trade between Europeans and Africans took the form of barter. The Portuguese and later invaders found highly developed arts of gold and ivory [13.43], as well as profitable slave trade. By the end of the fifteenth century, gold and slaves had superseded all other exports. Travelers from north to central Africa found a continent criss-crossed with caravan routes and cart trails. Their chronicles tell of the glories of busy cities such as Songhai and the legendary Timbuktu and of African empires that rose and fell. By the late fifteenth century, Timbuktu had developed into the central educational and commercial metropolis of western Africa—a sophisticated city that included doctors, judges, priests, and scholars maintained by the king and assisted by a council of ministers.

 In rural areas, however, traditional animistic beliefs, cults, and rituals were perpetuated, as was a social structure that can still be found in some African communities today. People are grouped in extended families consisting of several generations and many cousins, on whom they depend for support. Important in Africa and other traditional societies, these extended families are parts of clans united by blood ties in devotion to their ancestors. The clans in turn form groups that share a common language and culture.

 African sculpture was highly developed. Although most of it is made of wood, Africans also used other materials. The earliest sculptures are small clay heads from Nok in Nigeria, made about two thousand years ago. Metalworking was known by about 500 B.C. From the twelfth century A.D. rulers in the kingdom of Ife and from the sixteenth

13.43 IVORY SALTCELLAR, SIERRA LEONE. HEIGHT 43 CM. MUSEO PREHISTORICO ETNOGRAFICO, ROME.

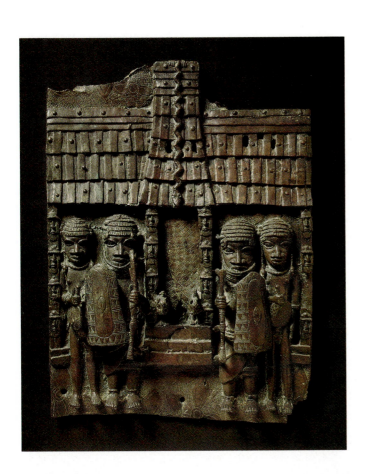

13.44 BRONZE PLACQUE. BENIN, NIGERIA. EARLY 17TH CENTURY. 40 × 52 CM. MUSEUM FÜR VÖLKERKUNDER. BERLIN.

century the Benin kingdom in Nigeria commissioned cast bronze and brass relief plaques and portrait heads, which were realistic representations of rulers [13.44]. The Benin people also worked in ivory. One of the masterpieces of Benin art, this impressive saltcellar is carved with extraordinary precision and invention. The slender rods that separate the figures also support the bowl, itself resting on a flat disk [13.45]. The complex scene depicts an executioner, who was probably an important chief, his victim and six severed heads. The skill required to undercut the sculptural elements from the original monolithic ivory piece demands a caliber rarely equalled anywhere in the world.

If we closely study the ivory pendant mask made for a belt [6.3] that we noted represented a king, we may see tiny heads of Portuguese soldiers in the scalloped beard and pierced headdress. Thus, with typical wit and inventiveness, the African artist created a work of art expressing deep feelings about the Portuguese invasion of the African homeland. European accounts describe the skill shown in goldwork and the precise accuracy of the Africans in measuring gold. Note is made of the *çire perdue* gold weights

13.45 DETAIL OF 13.43.

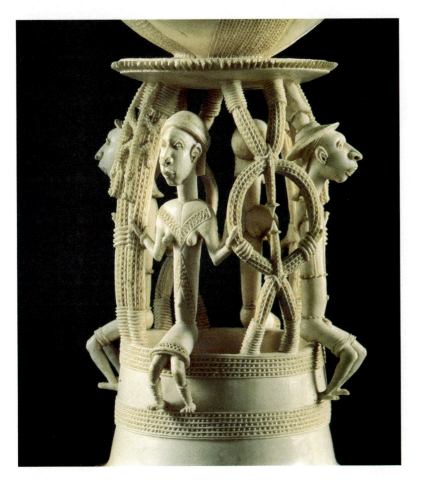

produced by African artists at the time of the early Renaissance. The gold fields of Ghana, West Africa, major sources of gold, were discovered early and worked from about the fourteenth century. Some of the finest gold castings were produced in the royal workshops of Kumasi. This later piece [13.46], acquired by Sir Cecil Armitage at Kumasi in 1896, and designed traditionally, was a chief's bracelet of hollow-cast gold made in two identical halves. The surface is decorated with modeled designs, the most prominent being the ram's horn symbols of royal power.

ASIA

China

The period of European Renaissance was echoed in the East by a gradual refinement of media that had emerged during the Middle Ages. And of all the arts examined earlier, Chinese potters gained worldwide recognition for masterful porcelain with colorful underglazes and subtle nuances of shades. The beauty of these pieces in turn brought attention to elaborate, sophisticated details of form, such as appeared on sculpture or functional pottery [13.47]. During the Ming Dynasty, pottery reached the heights reserved for the best a culture has to offer. The flower pot stand of *Jun* ware was thrown on the wheel for the imperial court, then carefully worked into a scalloped rim. Different glazes decorated inner and outer sides. Highly educated amateur painters concentrated on refining works of past masters whom they studied, while professionals continued to produce works of great skill.

13.47 FLOWER POT STAND. JUN WARE. YUAN-MING DYNASTY, CHINA. 13TH–15TH CENTURY. STONEWARE, DIAMETER, 9-1/4". THE CLEVELAND MUSEUM OF ART, OHIO (JOHN L. SEVERANCE FUND, 57.33).

Japan

Buddhism, which had reached Japan from China by the sixth century, coexisted with native *Shinto* beliefs. The Zen Buddhist sect emphasized the simplicity that spurned luxury, favoring in its place basic principles of Japanese aesthetics—irregularity, `simplicity, and perishability. Growing like a plant in its setting, the *Flying-Cloud Pavilion* was built in 1594 by the ruler, or *shogun*, Hideyoshi in Kyoto as one of his palaces [13.48]. With its irregular plan, unfinished wood, and thatched roof, the building rises in Chinese style to three stories in the center. The interior shares *sukiya* "artless" simplicity—elegance in understatement.

A great impetus to painting developed from the need for ornamentation in the calm interiors of the palaces. Encouraged by the spirit of Zen, landscape painting appeared on screens and sliding paper doors. Architects began to design homes for the aristocracy, the upper middle class, for villas and for tea houses.

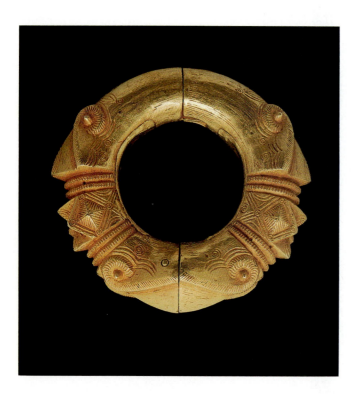

13.46 BRACELET. GOLD, 10 × 8 CM.; WEIGHT, 220 GRAMS. CHARTREUSE DE CHAMPMOL, DIJON, FRANCE.

13.48 FLYING CLOUD PAVILION. 1594. (HIUNKAKU), KYOTO, JAPAN.

EXERCISES AND ACTIVITIES

Activities for Research and Discussion

1. What factors were responsible for the development of the Renaissance attitude? How was it reflected in art? Describe one example of Renaissance sculpture, painting, or architecture and contrast it with one work of art from the Middle Ages.

2. How did the Renaissance discovery of the mathematical laws of perspective change the character of Western art? Using examples from this book, discuss the effect of this discovery of perspective on painting and on relief sculpture. How did the Italian concern with perspective and idealized form affect the art of northern Europe?

3. Study of *The Last Supper* [2.38] by Leonardo reveals that he viewed this event in terms of both the everyday world and divine harmony. Explain how the painting depicts the unity of both concepts.

4. In *The Night Watch* [13.33], Rembrandt includes a few formal portraits but many were painted in a process of action. Was this a typical group portrait? Explain.

5. What is meant by the statement "Michelangelo was born with one foot in the Renaissance and the other in the Baroque era"? Cite examples of his work that support this statement.

Studio Activities

1. Renaissance architecture was influenced by Greek art. Find a building in your community and sketch some of its Renaissance details.

2. Analyze the use of perspective in Renaissance paintings or prints, one each from Northern and Southern Europe. Trace each work and make a diagram of its perspective, using paper wide enough to incorporate both right and left vanishing points. Can you see the differences in the way Southern and Northern Europeans used perspective?

3. Select a Renaissance work such as Raphael's *School of Athens* [13.9]. Using colored chalk or pens, create a new composition from it in which Renaissance colors are changed and the subject is reorganized in the Baroque style.

14.1 ROBERT DELAUNAY. *THE EIFFEL TOWER.* 1910–11. OIL ON CANVAS, 78-3/4 × 50-3/4″.
KUNSTMUSEUM, BASEL.

Part Five
The Modern Age

The **Age of Reason** had promised that all problems could be resolved through the application of science. But instead the impatient revolutionary spirit in Europe and America soon overwhelmed the *reasonable* approach. From this ferment of emotion, the modern world was born.

Confidence in science and progress ran high. Many believed that the advances brought with the Industrial Revolution and the machine, especially the wondrous new horse-less carriage, and the airplane as well, would enrich the world in a glorious burst of speed [14.1]. Industrialists and the growing middle class lived comfortably side by side. The United States survived a Civil War. For the lower classes, however, industrialization often meant low wages, uncertain employment, and disagreeable living conditions in crowded, dirty factory towns.

As the twentieth century replaced the nineteenth, world war, economic exploitation, and dehumanizing labor enveloped many who crowded into smoky towns. The rate of change has accelerated enormously over the last fifty years. Advances in technology reflected in our art—mass communication, cinema, television, and computers—follow so quickly that we reel from the shock of rapid change. Our slow biological rhythms are upset by the speed of modern transport and communication. The mass media help to create a society to which millions are persuaded to conform, while their survival is threatened by its pace. Much of the world continues to face famine. Wealthy countries find that they can no longer deny entire nations or races an equal share in the profits of their labor.

At the same time, the safety net of welfare can no longer contain the growing hoards of our impoverished. The homeless roam our streets, abandoning hope, while inner city youth lashes out at authority, unwilling, or unable, to provide the help they need. Our industry despoils our natural resources, and even remote areas are affected by our abuse of this earth.

How can the arts help us to marshal our strengths and restore the balance between our needs and what we are willing to offer in return? Against this background of change we will view the art of modern times.

Revolution and the Modern World:
1776–1900

"Revolution is the larva of civilization."

—VICTOR HUGO

• • •

"It is not easy to retain the imagination's immediate, transitory intention and the harmony of the first execution."

—FRANCISCO GOYA, c. 1785

1770	1800	1830	1860	1890	1920

THE VISUAL ARTS

1770–84 Jefferson, Monticello [14.2]
1787 David, *Death of Socrates* [14.3]
19 cen. Bamboo fan [14.29]
19 cen. Loro Blonyo; Java [14.30]
19 cen. Akua´ba fertility [14.35]
19 cen. Chi Wara Mask [14.32]
1800 Benoist, *Portrait of a Negress* [I.13]
1814 Goya, *Third of May* [2.9]
1818 Géricault, *The Raft of the "Medusa"* [14.7]
1821 Constable, *The Hay Wain* [14.5]
1823–29 Hokusai, *Great Wave* [4.5]
1830 Delacroix, *Liberty Leading the People* [14.8]
1855 Courbet, *The Studio* [14.10]
1857 Hiroshige, *Maple Leaves* [4.6]
1863 Manet, *Luncheon on the Grass* [14.11]
1863 Manet, *Olympia* [14.12]
1867 Manet, *Execution of Emperor Maximilian* [2.22]
1871 Whistler, *Arrangement in Gray and Black* [14.17]
1872 Monet, *Impression: Sunrise* [14.13]
1884–86 Seurat, *Sunday on La Grande Jatte* [2.28]
1889 Van Gogh, *The Starry Night* [1.16]
1891 Sullivan, *Wainwright Building* [7.21]
1891 Cassatt, *Woman Bathing* [4.10]
1892 Gauguin, *Spirit of the Dead Watching* [14.22]
1892–95 Toulouse-Lautrec, *At the Moulin Rouge* [14.25]
1893 Munch, The *Cry* [4.12]

THE VISUAL ARTS

1770	1800	1830	1860	1890	1920

HISTORICAL NOTES

1772 Diderot and d'Alembert, *Encyclopédie*
1773 Boston Tea Party
1776 American Declaration of Independence
1776–79 James Cook voyage to the New World and Hawaii
1789 Fall of Bastille, Paris
1789–97 George Washington first U.S. president
1791 Thomas Paine, *Rights of Man*
1793 Execution of Louis XVI
1804 Napoleon crowned emperor
1815 Napoleon defeated at Waterloo
1829 Invention of photographic Daguerrotype
1837 Victoria becomes queen
1847 Karl Marx, *Communist Manifesto*
1851 Crystal Palace, London
1852 Harriet Beecher Stowe, *Uncle Tom's Cabin*
1853 Matthew Perry opens Japan
1861–65 American Civil War
1860 on American expansion to Pacific
1865 Lincoln assassinated
1884–1957 European colonization of Africa
1889 Eiffel Tower, Paris
1901 Queen Victoria dies

HISTORICAL NOTES

EUROPE, AMERICA, ASIA, AND AFRICA

By the mid-eighteenth century, absolute monarchies ruled almost everywhere. Aristocrats were insulated from the real world where most people lived in abject poverty. But the farther the wealthy retreated to their country estates, the stronger the revolutionary spirit that grew through Europe and the New World. The modern age began with revolution—political, social, and artistic.

AGE OF REVOLUTION

As the eighteenth century drew to a close, the French ruling classes chose to ignore signs that the monarchy was shaky and isolated themselves futher from the needs of their subjects. Despite the example of the American Revolution against British rule in 1776, most were unprepared for the violence of the French Revolution in 1789, which cost the king and scores of nobles their lives. A new spirit of democracy and reform was sweeping the land, to which many artists were sympathetic.

Neoclassicism

Long before the Revolution, Rococo art was slowly displaced by another style. Rediscovery of the buried cities of Pompeii and Herculaneum in the 1730s and 1740s and

their study through archaeology led to renewed interest in classical Greece and Rome. The earlier **Neoclassical** movement led by Nicholas Poussin [13.30] grew stronger and, combined with the new scientific approach, appealed to intellectuals, who believed in the power of reason to uplift society. The style eventually became associated with the republican ideals of the French Revolution and the early career of Napoleon Bonaparte and merged with the Romanticism that followed.

The Neoclassical style stressed straight lines and classical ornament in architecture and decorative arts. Neoclassical paintings emphasized balanced formalism, precise linear drawing, and often classical subjects. In England, Neoclassicism appeared in Georgian architecture and in the interior decoration of great houses by Robert Adam (1728–1792), who made his own interpretation of classical motifs. Neoclassicism also affected American architecture, for example, Monticello, Thomas Jefferson's home that he designed himself near Charlottesville, Virginia [14.2], and most government buildings in Washington.

The most prominent Neoclassical painter was Jacques Louis David (1748–1825), who celebrated in his work the French Revolution and the rise of Napoleon. David portrayed classical themes as dictated by the Royal Academy while expressing republican ideals and the moral strengths of Greece and Rome. In *The Death of Socrates*

14.2 THOMAS JEFFERSON. MONTICELLO, CHARLOTTESVILLE, VIRGINIA. 1770–1784; 1796–1809.

[14.3] he retold the self-sacrifice of the ancient Greek philosopher who preferred to die rather than to give up the freedom to teach what he believed. In a formal composition he shows Socrates addressing his followers in prison. Vertical and horizontal shapes dominate the rigidly composed painting, giving it a structured quality of shallow space, quite revolutionary at the time. David, however, felt that these classical forms were the best way to express the ideals of liberty, equality, and fraternity that were the watchwords of the Revolution. His emphasis on two-dimensionality became increasingly important in later nineteenth-century painting.

Belonging both to the Age of Reason and the Age of Revolution, Francisco Goya (1746–1828) was one of the foremost painters of the modern age. He was a skillful portraitist in the tradition of Velázquez, adept at depicting both the personality and fine costumes of the Spanish aristocracy and the court. He was most popular with his subjects, who apparently did not realize that beneath the elegance of his paintings he was commenting on court vanity and corruption.

Goya witnessed Napoleon's invasion of Spain in 1808. The artist depicted the violence and human capacity for evil in a series of etchings, *The Disasters of War*, which presented an uncompromising view of slaughter, rape, and destruction. Some of his paintings delved into the same themes, such as *Execution of the Madrileños on May 3, 1808* [2.9], which marks an incident of the war. This work, we will find, strongly influenced Edouard Manet in France a half century later. Disillusioned in his last years, Goya lived in seclusion and produced dark Romantic images of horror and despair. They might be taken as indications of the greed of the court feeding on its children, the masses [14.4]; or possibly, as works of the artist's old age, they were an allegorical reference to time, which consumes all.

Romanticism

Reacting against early eighteenth-century confidence in reason and the artificiality of court life was the **Romantic** movement, which began in the eighteenth century and continued into the nineteenth century. It was characterized

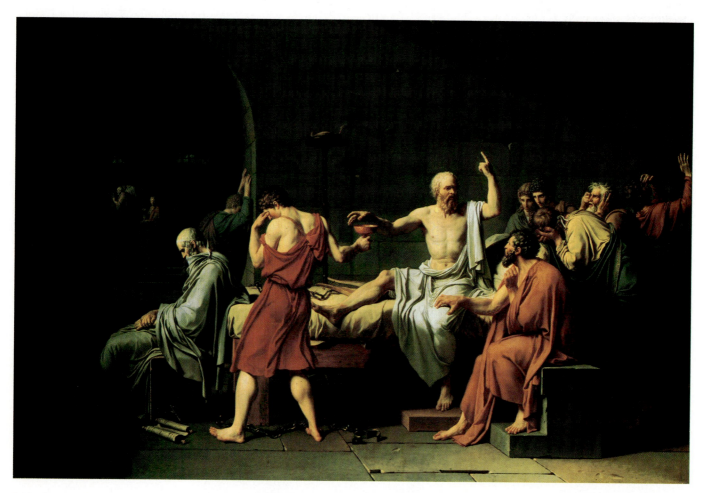

14.3 JACQUES LOUIS DAVID. *THE DEATH OF SOCRATES*. 1787. OIL ON CANVAS, 4′3″ × 6′5-1/4″ (1.3 × 1.96 M). THE METROPOLITAN MUSEUM OF ART, (WOLFE FUND, 1931; CATHARINE LORILLARD WOLFE COLLECTION).

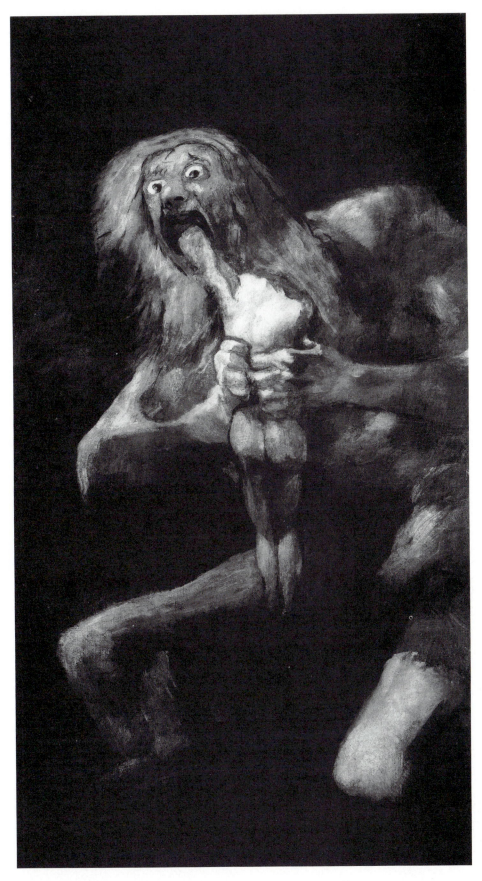

14.4 FRANCISCO GOYA. *SATURN DEVOURING ONE OF HIS SONS.* C. 1821. FRESCO DETACHED ON CANVAS, 4′9-1/2″ × 2′8-1/2″ (1.46 × .83 M). MUSEO DEL PRADO, MADRID.

by the great value placed on strong emotion believed to be instinctive, on the sublime, and on a fascination with untamed nature, country folk in natural settings, and the picturesque or exotic.

English Landscape Romanticism flourished in England, which was not torn by revolution and had little need for an art of propaganda. John Constable (1776–1837) devoted himself to the study of nature. His picturesque English landscapes, painted in rich earth tones, shocked people accustomed to pretentious academic art. Constable said he wanted to capture the "light—dews—breezes—bloom—and freshness" of the English countryside. He sketched outdoors, and his quick studies are bolder than the paintings that he later composed in his studio. Nevertheless, he tried to keep the freshness of nature in his work and to portray what he saw, without contriving compositions to fit academic rules. *The Hay Wain* [14.5], typical of Constable's rural subject matter, was painted with a real love of the countryside and an ability to show atmo-

spheric effects with a free brushstroke. The idea of landscape without allegorical or religious references attracted other artists, and the technique paved the way for the Impressionists, at mid-century.

Another landscape painter, J.M.W. Turner (1775–1851), had visions of painting the "unpaintable" and was possessed with a determination to record the changes of nature's atmosphere. In many ways, Turner was ahead of his age, reducing air, water, and even fire to undetailed color arrangements. When Turner watched the fire that destroyed the Houses of Parliament in 1834, he was inspired to paint a series of remarkable pictures of the disaster. Images of flames, smoke, reflections in the river, and crowds of people watching all dissolve into one another [14.6]. Occasionally applying paint with a palette knife, Turner suggests turbulence with spontaneous, bold streaks and dabs.

Turner was a forerunner of the Impressionists and was rediscovered by two of them, Pissarro and Monet, after his death. But Turner was affected by the poetic quality of

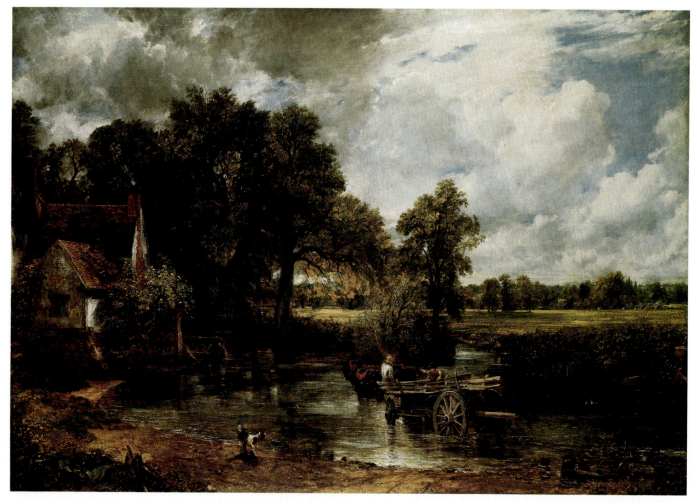

14.5 JOHN CONSTABLE. *THE HAY WAIN.* 1821. OIL ON CANVAS, 4′2-1/2″ × 6′1″ (1.28 × 1.85 M). REPRODUCED BY COURTESY OF THE TRUSTEES, NATIONAL GALLERY, LONDON.

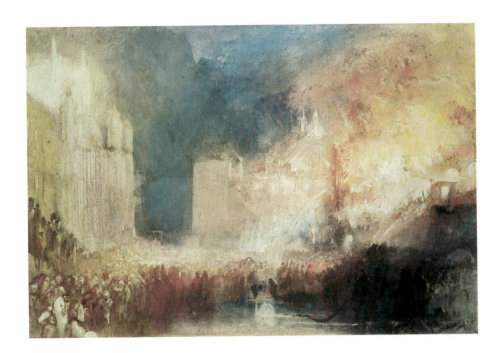

14.6 J.M.W. TURNER. *BURNING OF THE HOUSES OF PARLIAMENT.* 1843. WATERCOLOR. CLORE COLLECTION OF THE TATE GALLERY, LONDON.

light; he had more interest in abstract patterns than the Impressionists, who were mainly concerned with the effects of light on objects. A poem by Turner about Switzerland, where it was fashionable for English artists and lords and ladies to go to contemplate the grandeur of the Alps, tells us a good deal about his attitude toward nature:

… its pine clad forests
And towering glaciers fall,
the work of ages
Crashing through all …

French Romanticism In the spirit of Romanticism, the French painters Théodore Géricault (1791–1824) and Eugène Delacroix chose far-away and exotic subjects. Géricault's *The Raft of the "Medusa"* [14.7] was also an indictment of mismanagement and corruption in the French government, which had sent a shipload of emigrants to North Africa without life-saving equipment. Géricault depicts in realistic detail the makeshift raft crowded with desperate, starving, shipwrecked passengers and crew. But the protest went unheeded. Instead, the public was outraged by the artist who used naked figures in

14.7 THÉODORE GÉRICAULT. *THE RAFT OF THE "MEDUSA".* 1818. OIL ON CANVAS, 16'1-1/4" × 23'6" (4.91 × 7.16 M). LOUVRE, PARIS.

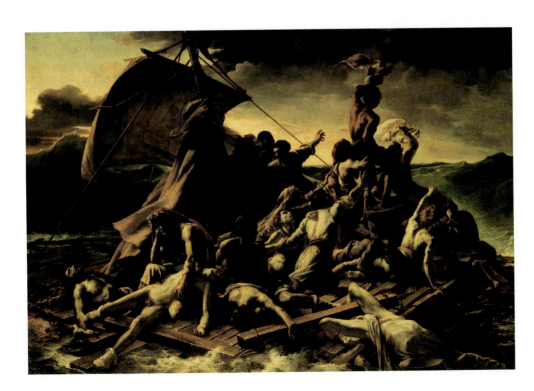

unclassical poses to convey his message. This was a revolutionary painting in its dramatic championing of a current political cause and in the use of colors and composition to intensify emotion. Compare its complex arrangement of turbulent forms with David's Neoclassical painting [14.3] to see how strongly Géricault was rebelling against academic constrictions.

Described as a Romantic and a Neoclassicist, while straddling both camps, was the fiery Eugène Delacroix (1798–1863). Romantic extremes of emotion and a brilliant palette, fused to the purity of form and nobility of subject typical of Neoclassicism, were both present in *Liberty Leading the People* [14.8]. High drama can be found in the radical linking of rich and poor, male and female, young and old in a communal cause. Turbulent though the content was, the traditional triangular composition with liberty at the apex produced stability, reinforced by the huddled masses at her feet.

Also rebelling against tradition was Rosa Bonheur (1822–1899), daughter of a painter, who studied at the École des Beaux Arts. From her childhood, Rosa had adopted masculine dress, which freed her to travel (and paint) in public places. Her reputation as a painter was established by *The Horse Fair* [I.23], which won her the rank of Chevalier de la Légion d'Honneur. Although animals and flowers were considered suitable subjects for women, Bonheur's work was outstanding for its power and scope, and its themes we might consider "macho" today.

Realism and Social Protest

During the nineteenth century the Industrial Revolution encouraged a capitalist economy in which hard-driving entrepreneurs used the productivity of workers for personal gain. Peasant families crowded into industrial towns to find work and settled in cheap housing near factories, which quickly became slums. Even children were forced to work long hours in factories and mines. Although the British abolished the slave trade early in the nineteenth century and slavery was ended in the United States by the Civil War, the exploitation of industrial workers continued.

Newly rich industrialists and bankers, if they bought art at all, chose academic, Neoclassical paintings such as those of David, whose portraits and exotic scenes show his mastery of line and classical composition. Few were interested in the social criticism of Géricault or the political commentary of satirist Honoré Daumier (1808–1879), who earned his living as a cartoonist and illustrator. His lithographs were sympathetic to the poor and disadvantaged while presenting brutal caricatures of the ruling classes. Critical of the French political, judicial, and police systems, these prints appeared in newspapers, where they influenced political cartooning for years to come. In addition to his graphic work, Daumier painted the slum dwellers of Paris in their squalid surroundings. His *The Third Class Carriage* [14.9] and its companion *The First Class Carriage* make strong statements about the gulf between the

14.8 Eugène Delacroix. *Liberty Leading the People.* 1830. Oil on canvas, 8'6″ × 10'10″ (2.59 × 3.3 m). Louvre, Paris.

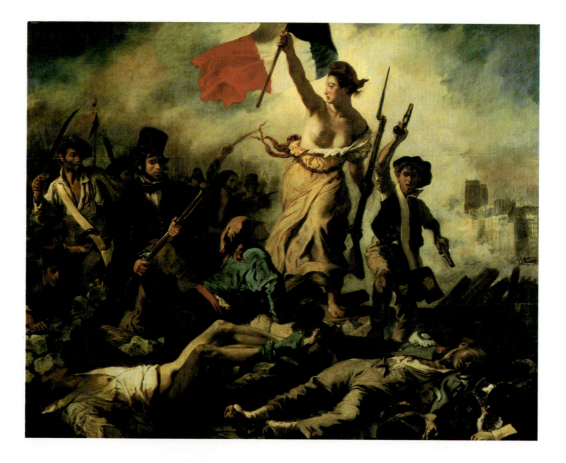

14.9 HONORÉ DAUMIER. *THE THIRD-CLASS CARRIAGE*. C. 1862. OIL ON CANVAS, 25-3/4 × 35-1/2" (65 × 90 CM). THE METROPOLITAN MUSEUM OF ART (THE H.O. HAVEMEYER COLLECTION. BEQUEST OF MRS. H.O. HAVEMEYER, 1929).

rich and the poor. At the same time, the three generations represented in the third-class coach, all trapped in the economic system, reflect Daumier's view of the power of the proletariat.

Another French painter who rejected the standards of the Academy was the independent Gustave Courbet (1819–1877). His paintings did not depict graceful poses or rich textures, but, like those of Caravaggio two centuries earlier, were realistic portrayals of daily life. He gathered students to him and even brought a bull into the studio for them to draw.

Refused entry to the Paris Exposition of 1855, Courbet set up in a nearby wooden shed his own exhibit entitled "Réalisme, G. Courbet." His most ambitious painting, *The Studio: A Real Allegory of the Last Seven Years of My Life* [14.10], was featured. Among the figures were a

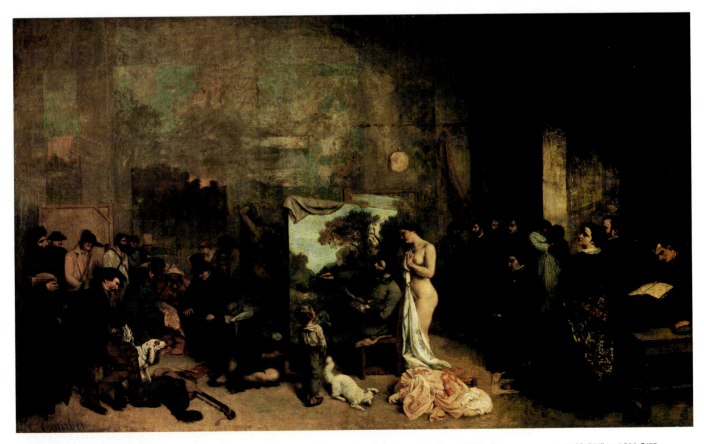

14.10 GUSTAVE COURBET. *THE STUDIO: A REAL ALLEGORY OF THE LAST SEVEN YEARS OF MY LIFE.* 1855. OIL ON CANVAS, 11'9-3/4" × 19'6-5/8" (3.6 × 5.96 M). LOUVRE, PARIS.

nude, Courbet himself at the easel, a small boy, famous critics, and a cadaver. Courbet issued a "Manifesto of Realism" supporting this work. Thus he addressed an issue central to avant-garde artists as they struggled against the rigid control of the Academy. Accused of socialist political activities, Courbet was exiled in 1873, but his independent spirit continued to influence young artists.

OTHER VIEWS OF REALITY

In the mid-nineteenth century, fresh views of reality expanded European artists' traditional depictions of nature. Exposure to the world outside the West, to Oriental, African, and Oceanic art, opened new possibilities in the two-dimensional rendering of three-dimensional space, possibilities that were not based on the Renaissance "window view" of reality.

The Reality of the Camera and Protoimpressionism

As a result of the invention of the camera, nineteenth-century painters in the West, trained to believe that the purpose of art was an imitation of nature, faced a new dilemma. Because the camera could capture a sitter, an event, or a scene more quickly and more realistically than the painter could, no artist was needed to transcribe reality. Relieved of having to transpose solid forms onto a flat surface, many painters were forced to find new outlets for artistic expression.

Edouard Manet (1832–1883) faced this dilemma creatively; instinctively combining many influences, he transformed them into a new style sometimes called **Protoimpressionism**. Schooled academically, he was, however, a Romantic in his choice of exotic subjects and use of rich color and texture. He often chose Spanish themes in paintings that show his admiration for Velázquez [13.28] and Goya [2.9] [14.4], and he was fascinated by the flat areas of color in Japanese art. His broad areas of paint, reminiscent of early photographic effects, and his occasional spots of brilliant color shocked a public accustomed to academic painting. In addition, Manet was attacked as a heretic because he did not follow the traditional method of modeling forms, going back to the time of Giotto, by painting dark values, middle values, and then building up lights and reinforcing darks. Instead, he adopted a radical approach of trying to duplicate sunlight by preserving the natural brilliance of the primed canvas and gradually adding darker tones.

Manet's large painting, originally titled *The Bath* and dubbed by critics *Luncheon on the Grass*, presented a nude woman picnicking with two fully clothed men in a woodland glen [14.11]. The painting was a reworking of

14.11 EDOUARD MANET. *LUNCHEON ON THE GRASS (LE DÉJEUNER SUR L'HERBE)*. 1863. OIL ON CANVAS, 7'3/4" × 8'10-3/8" (2.1 × 2.7 M). MUSEE D'ORSAY, PARIS.

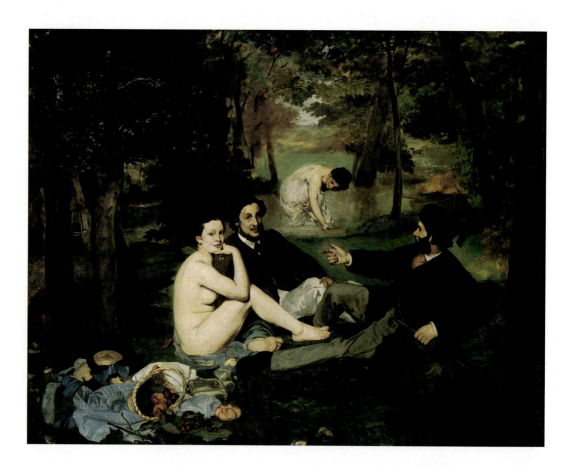

14.12 Edouard Manet. Olympia. 1863. Oil on canvas, 4'3-1/4" × 6'2-3/4" (1.3 × 1.9 m). Musée d'Orsay, Paris.

the Renaissance painting by Giorgione, *Sacred and Profane Love,* an allegory referring to the Muse, who must be present to inspire art. Manet included a figure bathing in a pool in the background to justify his posing nudes outdoors and used a well-known courtesan as a model, presenting her as a naked picnicker gazing boldly at the viewer. The public was scandalized. Moreover, his painting of skin tones under strong natural light was not considered sound academic practice. The Academy refused to exhibit his painting in the official Salon of 1863. The protests of Manet and other rejected painters led to the government's forming a separate *Salon des Refusés,* which eventually broke the hold of the Academy on artists.

In 1865, Manet's masterpiece, *Olympia* [14.12], today a favorite in the Musée d'Orsay, created an even greater scandal than *Luncheon*; in fact, it was considered pornographic by some of the artist's contemporaries! Actually, Manet based *Olympia* on Titian's classical *The Venus of Urbino* [13.11], a work commissioned by the Duke of Urbino to feature his wife as Venus. But Manet's figure scarcely resembles a goddess. Obviously a courtesan of the Paris demimonde (a world of questionable morals), she lies on her rumpled bed, with no signs of modesty when her maid brings an admirer's flowers. Although figures of goddesses were traditional subjects, Manet's suggestion in *Olympia* that Venus was an ordinary woman in the business of love was badly received by the public. The flat silhouette of her body further shocked traditionalists. Manet never hesitated to paint as he believed, but he disliked the criticism that came his way, and he rejected for himself the term Impressionist, which his followers were beginning to apply to him.

14.13 CLAUDE MONET. *IMPRESSION: SUNRISE*. 1872. OIL ON CANVAS, 19-1/2 × 24-1/2″ (60 × 62 CM). MUSEE MARMOTTAN, PARIS.

IMPRESSIONISM

Several young artists were influenced by Manet's attempts to capture the immediacy of a moment, his use of flat areas of color, and his efforts to depict natural light. Rejected by the official Salon of 1874, these rebellious painters organized their own exhibit in the studio of the photographer Nadar [2.20]. They considered the location appropriate because they believed that photography was a vital new art medium, just as they hoped their own work marked a new direction in painting. The name **Impressionism** was provided by a journalist who laughed at a painting exhibited by Claude Monet (1840–1926) entitled *Impression: Sunrise* [14.13]. The critic's statement that "these are not artists, they are Impressionists" seemed to describe the common trait in their work. Although it was meant as an insult, the painters adopted the label for their new style.

Theory and Technique

The Impressionists were more interested in the fleeting light and color reflected from an object than in form or content, and they had little interest in storytelling. To capture the effects of movement and atmospheric vibration over landscape and figures, Monet and other Impressionists such as Camille Pissarro (1830–1903) and Auguste Renoir

(1841–1919) painted *en pleine air* ("in the open air"). This practice, begun by painters who took to the Barbizon forest near Paris in the 1830s, was a radical departure from the academic custom of making only sketches outdoors and developing them traditionally into paintings in north-lighted studios. Another departure was the Impressionists' determination to paint directly on primed canvas without the traditional underpainting in an umber (brown) tone. Also revolutionary was the Impressionists' use of the **broken-color** technique, in which they painted with pure colors taken directly from the tube. Instead of, for example, mixing blue-green and yellow on their palettes to make green, or yellow and red to make orange, they placed small brushstrokes of analogous colors, those next to each other on the color wheel, intending the eye to mix them. They sometimes juxtaposed strokes of complementary colors to intensify their effect. When viewed from a distance, these areas of color became images of trees, flowers, figures, and buildings. Such techniques enabled many Impressionists and some Postimpressionists, such as Georges Seurat, to produce works that seemed to vibrate with color.

Broken colors, emphasis on visual sensation, flat shapes, and unusual perspective, the last two borrowed from the Japanese, were common traits of Impressionism, but individual painters varied considerably in their styles. Some, such as Monet and Pissarro, remained dedicated Impressionists all of their lives. Others, Cézanne, Gauguin,

and Van Gogh, for example, briefly practiced Impressionism but developed different approaches soon afterwards.

Painters

Most typical of the Impressionists, perhaps, was Monet, who was chiefly concerned with the appearance of objects in changing light. Intrigued by the dancing patterns of sunlight through mist on the water at dawn, he created the controversial *Impression: Sunrise* [14.13]. Influenced by Hokusai's *Thirty-six Views of Mt. Fuji* [4.5], he explored the effects of light at different times of day in twenty-six canvases of Rouen Cathedral. As Monet continued to refine the broken-color technique, he became more and more absorbed in light. Saying that he wished he had been born blind so that he could regain his sight and paint objects without knowing what they were, he painted solid forms that dissolved into mists of color. Monet produced hundreds of studies of the shimmering surface of water and light on the shiny leaves and delicate blossoms of the water lilies of the Japanese-style pool in his garden at Giverny. In his last, large paintings done just before his death, the water lilies are almost completely abstract. These loose, much-admired paintings, like his Japanese garden, have become aesthetic environments that were forerunners of the large field paintings of Jackson Pollock and other **Abstract Expressionists** in the 1950s.

Academic tradition was also questioned by Pissarro in such works as the *Boulevard des Italiens, Morning, Sunlight* [1.26], when he captured a busy Paris street scene on canvas. According to the Academy, beauty was achieved through the careful, rational rearrangement of nature and the elimination of the accidental. But Pissarro, influenced by the unusual perspectives of Japanese prints, chose the reality of a bird's-eye view of a boulevard from his room under the roof. The critics condemned *Boulevard des Italiens* as having no center of interest; no foreground, middle ground, or background; no ordered path through which the eye could travel. They also criticized Pissarro's technique because one could see the strokes of color. Today, we find it difficult to imagine that people once found it shocking, but we must remember that we have become used to the Impressionist way of looking at the world.

Auguste Renoir (1841–1919), who was first apprenticed to a painter of Rococo ornament and flowers on porcelain cups and plates, loved color, flowers, beautiful women, and charming children. He sincerely wished to please himself and his viewers. Because Renoir would not undertake commissions from those he found unappealing, all his works show similar delight in their aesthetic subject.

The traits we identify with Impressionism can be seen in Renoir's *Le Moulin de la Galette*, a painting of a Parisian outdoor dance hall [14.14]. The scene is informal. Color is broken. The vertical and horizontal shapes, such as the pavilion in the background, are emphasized so our eyes stay on the surface of the painting, for depth in space was not important to Impressionists. We may compare this shallow Impressionist space with the deep space in a Ren-

14.14 AUGUSTE RENOIR. *LE MOULIN DE LA GALETTE*. 1876. OIL ON CANVAS, 4'3-1/2" × 5'9" (1.31 × 1.75 M). MUSÉE D'ORSAY, PARIS.

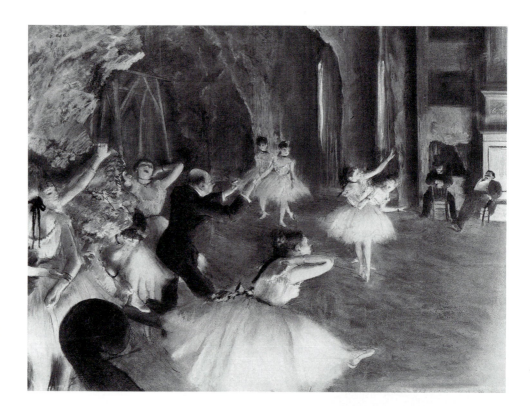

14.15 EDGAR DEGAS. *THE REHEARSAL OF THE BALLET ON THE STAGE.* 1878-1879. OIL COLORS FREELY MIXED WITH TURPENTINE ON PAPER MOUNTED ON CANVAS; 21-3/8 × 28-3/4″ (54 × 73 CM). THE METROPOLITAN MUSEUM OF ART (GIFT OF HORACE HAVEMEYER, 1929. THE H.O. HAVEMEYER COLLECTION).

aissance painting such as Leonardo's *The Last Supper.* In spite of his early dedication to Impressionism, Renoir, as much as Degas, was concerned with composition in his paintings, and his later canvases, especially those of bathers, were influenced by Titian and other Venetian painters.

Degas carried the idea of painting figures in momentary poses even further than Manet. Like most Impressionists, he was intrigued by movement, and horses and dancers were among his favorite subjects. He liked to catch ballet dancers in unusual positions or moments of action on stage, lit by bright footlights [14.15]. His paintings appear to capture movement like candid shots with a camera, with which he experimented. Inspired by Japanese prints, he also depicted his subjects from unusual views.

Degas, however, was deeply concerned with composition and worked out his paintings carefully in sketches and studies. While he exhibited with the Impressionists, he never considered himself one of them because of his formal interest in composition. He supported Impressionist efforts to change the rules of the Academy primarily because he believed in the right to question restrictive attitudes. He could afford to give them his support, for he was a wealthy aristocrat by birth, had been trained in the tradition of the Academy, and had been accepted to exhibit in the Salon. Set apart from the Impressionists also because of his concern for faithful draftsmanship, Degas might have become one of the greatest portraitists of his day. But he would paint only friends with whom he felt empathy.

An important figure in the Impressionist group was Berthe Morisot (1841–1895). She began early to experiment with the technique of capturing fleeting impressions. Her portrait of a young woman with its sketchy brush

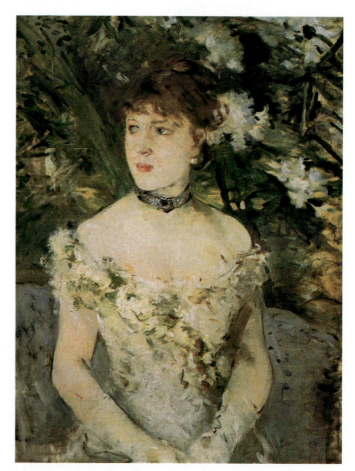

14.16 BERTHE MORISOT. *YOUNG WOMAN IN A BALL DRESS.* 1879. OIL ON CANVAS, 28 × 21-1/4″ (71 × 54 CM). MUSEE D'ORSAY, PARIS.

strokes [14.16] shows characteristics similar to Monet's later work. Dedicated to Impressionism, Morisot tried to keep the early group functioning while continuing to employ the style after most had abandoned it.

American Expatriates Also responding to the influence of Japanese art, James Abbott McNeill Whistler (1834–1903) was particularly impressed by the apparent simplification of planes and colors that he identified in Oriental woodcuts and paintings. As an expatriate American who from an early age lived in Europe and was exposed directly to European art, he managed somehow to detach himself, like Degas, from the Impressionist movement around him. Rejecting the brilliant colors of his Impressionist friends, Whistler used muted grays and subtle harmonies with only touches of gold and red. He called his paintings "nocturnes," "symphonies," and "arrangements" to emphasize his belief in the importance of the abstract qualities of painting, which he compared to music. Unlike artists such as Pissarro and Monet, who painted the momentary light effects they saw before them, Whistler believed that "Nature contains the elements, in colour and form, of all pictures, as the keyboard contains the notes of all music." Form and color, rather than subject matter, were elements he considered important. He called his famous portrait of his mother *Arrangement in Gray and Black No. 1* [14.17] because he saw no reason why the public should be interested in the identity of the sitter. Whistler's concept of a painting as an arrangement of color, value, and shape had an important influence on later painters and on the development of abstract painting in the twentieth century.

We have seen the number of women in the art world gradually increase since the Renaissance. Although they were often denied entrance to the academies for instruction, some of them traveled to distant lands to paint the exotic scenes popular during the Romantic period.

One of the youngest associated with the Impressionists was Mary Cassatt. After a comfortable childhood in a rich Philadelphia family and training at the Pennsylvania Academy of Fine Art, she studied in Europe. Although she is best known for her sensitive paintings of women and children [4.10], it is in her etchings and aquatints that she is most original and free. They show the influence of Degas, whom she greatly admired, and an unusual point of view likely inspired by the perspective of Japanese prints.

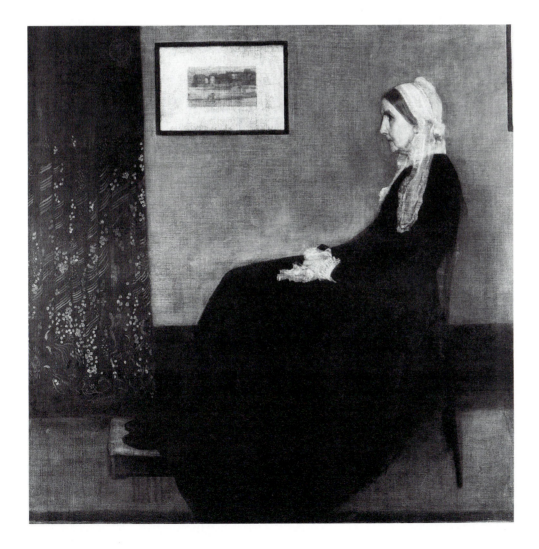

14.17 JAMES ABBOTT MCNEILL WHISTLER. *ARRANGEMENT IN GRAY AND BLACK NO. 1 (THE ARTIST'S MOTHER)*. 1871. OIL ON CANVAS, 4′9″ × 5′4-1/2″ (1.45 × 1.64). LOUVRE, PARIS.

ENGLISH ARTS AND CRAFTS; ART NOUVEAU

As a result of the Industrial Revolution, with its cheap, over-decorated factory-made goods, people such as the critic John Ruskin and the painter and designer William Morris (1834–1896) campaigned for a new attitude toward art and crafts. Attempting to reinstate the traditional skills of the medieval guilds, they turned toward stained glass, decorative wall paintings, and handcrafts. They were associated with a group of painters who called themselves Pre-Raphaelites because they were inspired by the forms of art created just before the High Renaissance of Raphael. Morris, who was also a writer and social reformer, was a Romantic in his desire to return to the Middle Ages, but with his competent technical knowledge he inspired a revival of interest in the crafts that led to such designs as Louis Comfort Tiffany's **Art Nouveau** lamp [8.32] and handmade ceramics, jewelry, weaving, and book printing. Genuinely appalled at the ugliness of the pompous furniture and household implements exhibited at the Crystal Palace in 1851, he designed the Morris chair in an attempt to simplify furniture and make it more functional. Believing that design, whether it be fabrics, wallpaper, glassware or the space in which they were housed, should reflect form and function, Morris was progressive in his beliefs. His interiors such as *The Green Dining Room* provide a serene environment in which no flat surface was decorated with motifs that had evolved from the past [14.19]. His decorative style was derived from plants and applied to jewelry, furnishings, and architecture. His English Arts and Crafts Movement was one of several that led to Art Nouveau, which evolved from about 1895 to 1905.

ARCHITECTURE AND SCULPTURE

Architecture of the nineteenth century at first continued the Neoclassical style exemplified by Jefferson's Monticello [14.2]. Soon a nostalgia for all things past produced an eclectic mixture from Assyrian to Gothic. Revivalists built banks, stock exchanges, and government buildings patterned on Greek and Roman temples. Engineers, however, were using their new prefabrication skills, introduced in Joseph Paxton's Crystal Palace [7.20], to build bridges, railway stations, and monuments such as the Eiffel Tower. By the end of the century, some architects were following their lead. The pioneer American architect Louis Sullivan, despite his traditional training, turned to the new structural systems in his designs. His ideas led the way to the skyscrapers of the twentieth century, in keeping with an aesthetic interpretation of the new technology (Chapter 7).

In contrast to the static academic sculpture at this time, Auguste Rodin (1840–1917) restored sculpture to a major art form while creating a style that would lead to **Expressionism**. Born in a working-class quarter of Paris, Rodin first earned his living as a goldsmith and a maker of

14.19 WILLIAM MORRIS. *GREEN DINING ROOM*. 1867. COURTESY OF THE BOARD OF TRUSTEES OF THE VICTORIA & ALBERT MUSEUM, LONDON.

The Artist Sketch

In the post-Civil War years when Mary Cassatt grew up, Philadelphia (where she was born) was second only to New York as a cultural center. While still a child, Cassatt recalled pressing her nose against a shop window where Degas's paintings were displayed. At that point on, she knew she wanted to be an artist like him, and that is almost what happened.

Following graduation at twenty-one from the Pennsylvania Academy, one of the earliest art schools in the nation, Cassatt headed for independent study in Paris, and, in 1872, exhibited her first painting at the Paris Salon. Already an admirer of Impressionism, the style she had adopted, she persuaded Louisine Elder of Philadelphia to purchase a Degas work, the first Impressionist painting to come to America. In 1874, an April exhibition of the Impressionists at which their style was first given its name took place at Durand-Reul, and a second and third, 1876 and 1877, at which Cassatt participated. Her career began to blossom. By 1892, she was commissioned to paint a mural for the Woman's Building in the 1893 Chicago World's Fair, the year of her first solo show at Durand-Reul, Paris, to be followed the next year at Durand-Reul in New York.

14.18 MARY CASSATT. *PORTRAIT OF THE ARTIST*. GOUACHE, 23-1/2 × 27-1/2″. THE METROPOLITAN MUSEUM OF ART.

In Cassatt's declining years, the onset of diabetes played havoc with her eyesight, which several cataract operations failed to cure. The fact that she spent most of her life abroad can be explained in part by her recognition of the resistance of the American public to female artists, in particular, the cultural world of Philadelphia with which she maintained her strongest link. No doubt because of her abiding affection for Impressionism and her lifelong admiration for Edgar Degas, Cassatt moved to Europe returning only three times to the United States: in 1875, 1899, and 1908. She died and was buried in France, although her will listed Philadelphia as her permanent residence.

Her legacy may be threefold. First, her determination to study abroad was a course of action rarely indulged by women, who were not encouraged to travel alone. Secondly, Mary Cassatt devoted her life to her art; neither aligning herself with a man as was expected, nor with another woman in a life-style almost never accepted. Third, her dedication to supporting the Impressionists by encouraging her Philadelphia friends to purchase their art was the backbone of the American support for the movement—altogether unique accomplishments.

MARY CASSATT (1844—1926)

plaster decorations for buildings. Fascinated by the human body in action, he made quick drawings and clay sketches of dancers to catch their momentary poses. In this way he became familiar with the natural movements of the nude human body instead of repeating the stiff stances approved by the Academy. The influence of Impressionism can be seen in the way the light plays over the textured surfaces so that they seem to vibrate [6.5]. He himself called sculpture "quite simply the art of depression and protuberance."

POSTIMPRESSIONISM

By the mid-1880s, the Impressionists were accepted as serious artists by critics and a large portion of the public. But many of their colleagues and younger followers came to feel that in the search for momentary sensations of light and color, traditional elements of picture making had been neglected. The **Postimpressionists**, as they came to be

known, all worked for more solid structure in art, which each, in his or her own way, found by a method essentially personal.

One of the most important of these artists was Paul Cézanne (1839–1906), who exhibited in early Impressionist shows, although he disagreed with their aesthetic theories. He thought that Impressionistic works were brilliant renderings of natural light and color, but lacked clarity and order. He determined "to make of Impressionism something solid and durable like the art of the museums." By emphasizing horizontal and vertical shapes and other classic devices of composition, he brought formal order and sculptural grandeur to his paintings. To further his knowledge, he studied great paintings of the past, stating that a museum is "the book in which we learn to read." Cézanne very early discarded the idea of capturing transient light effects. His paintings, although colorful, are made up of forms that exist in a timeless light rather than in the glancing sunlight seen by Monet or Renoir.

In order to develop solidity, Cézanne modeled his masses in a series of planes of color. This approach made him one of the most innovative painters of the nineteenth century and led directly to the art of the twentieth-century Cubists. "Treat Nature by the cylinder, the sphere, the cone," he wrote, applying this rule to his painting by breaking down the most complex objects into geometriclike forms. In his later paintings, Cézanne treated masses in small planes of color, using warm yellows and oranges to bring planes forward and cool blues, violets, and greens to push them away from the viewer. He also distorted perspective and shapes to achieve the composition he wanted, disregarding realistic appearances. Deliberate and careful, he painted Mont Sainte-Victoire near his home in the South of France over and over again, gradually abstracting the familiar view [14.20]. The mountain, valley, trees, and houses in his later paintings of the mountain are no longer treated as recognizable themes but become simply planes of color. In essence, he diminished the subject's importance to stress the objective character of his art and the totality of his painting.

Thus Cézanne, although he lived most of his life in the nineteenth century, was one of the strongest painters of the modern period, and from him we can move easily into the daring art of the early twentieth century. We have only to compare *Mont Sainte-Victoire* with a loose, Romantic landscape such as Constable's *The Hay Wain* [14.5] and with later geometric, Cubist paintings by Picasso to see how important Cézanne was as a bridge between the old and new ways of looking at the world. Without the influence of Cézanne's experiments, the radical twentieth century view that art need not imitate nature could never have developed.

While Cézanne searched for new ways of depicting form, Georges Seurat (1851–1891) was also trying to develop more ordered compositions than those of the Impressionists. Seurat extended earlier ideas of broken color into a scientific process called **Divisionism**, or **Pointillism [2.28]**. He studied scientific theories of light and color in order to separate colors, trying to analyze the exact amounts of each color complement. Then he meticulously placed dots of different colors side by side on the canvas, letting the eye blend them. Seurat was also concerned with the silhouettes of objects, simplifying them into simple shapes. He assembled his figures into large compositions, which, despite the vibrations of the color, appear stable because of the quiet shapes and poses. This reduction of form and strong composition, even more than his use of broken color, makes Seurat historically important and an influence on the twentieth century.

A young, enthusiastic Dutchman, painting in the blazing sunlight of Southern France, also searched for new color techniques. But, unlike Cézanne and Seurat, who had used color to define planes in space, Vincent van Gogh (1853–1890) used hot color to express his very personal, emotional response to the world. Van Gogh was deeply

14.20 PAUL CÉZANNE. *MONT SAINTE-VICTOIRE.* 1902–1904. OIL ON CANVAS, 27-1/2 × 35-1/4". PHILADELPHIA MUSEUM OF ART (THE GEORGE W. ELKINS COLLECTION).

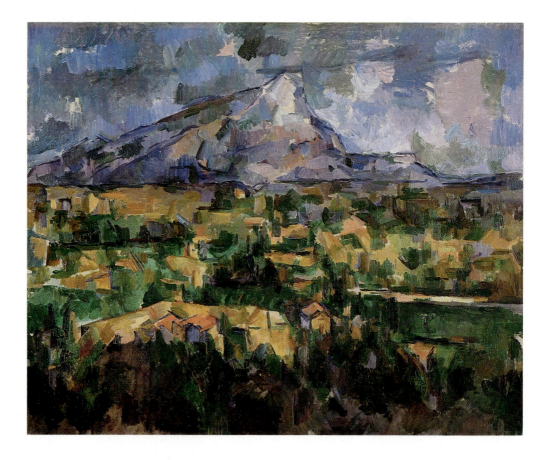

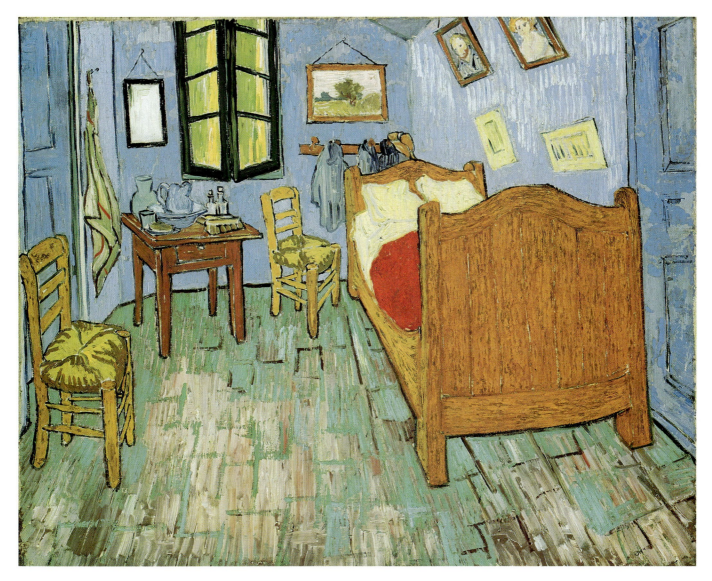

14.21 VINCENT VAN GOGH. *THE BEDROOM.* 1888. OIL ON CANVAS, 73.6 × 92.3 CM). THE ART INSTITUTE OF CHICAGO (HELEN BIRCH BARTLETT MEMORIAL COLLECTION, 1926). © 1991 THE ART INSTITUTE OF CHICAGO. ALL RIGHTS RESERVED.

religious, concerned about all of humanity. Indeed, at the start of his painting career he had lived with coal miners and had painted their poverty in dark, depressing colors. He had also hoped, with the help of his brother Theo, to establish a community of artists dedicated to spiritual values, in rebellion against the commercialism produced by the Industrial Revolution.

In a frenzy of creation, Van Gogh painted the grandeur of nature [1.16] and the simple objects of his daily surroundings. Primarily concerned with a fresh response to familiar objects, he used bright colors to intensify the mood of joy and somber colors for pain. A painting of his bedroom [14.21] shows how strongly color can affect us. He wrote about this bedroom: "I had a new idea in my head and here is the sketch to it—this time it's just simply my bedroom, only here colour is everything."

Along with many nineteenth-century painters influenced by Japanese prints, Van Gogh, like Cézanne, was unconcerned with linear perspective. However, his interest was not in portraying the structure of objects as was Cézanne's. Van Gogh saw the outer world in emotional terms, which he expressed with strong, slashing brush strokes and brilliant color. In this approach he was a forerunner of twentieth-century Expressionism.

Distrustful of conventions in art and impatient with academic emphasis on technical skills, Paul Gauguin was as idealistic as Van Gogh. To escape the harsh realities of an industrial society, he retreated to the island of Tahiti in the South Seas. There Gauguin sought the simplification of reality that he believed could exist only where life was stripped to its essentials. Many were attracted to such remote cultures, believing they could lose themselves and

The Artist Sketch

The story of Paul Gauguin's life reads like a best-selling novel, and the novel about him by W. Somerset Maugham that appeared in 1919 was indeed a best-seller. Titled *The Moon and Sixpence*, it was followed in 1943 by a film that also was successful. We can begin to piece together the reasons for the continued popularity of both book and film.

This French painter and woodcut artist, born in Paris, was the son of a journalist and a French-Peruvian mother. Gauguin went to sea at an early age, but soon gave up the maritime life for marriage and a settled career in banking. Neither held him very long; by 1883 Gauguin had left his wife and five children and the bank to take up the uncertain life of a painter.

Aligning himself with the Impressionists, by 1886 he had exhibited with them in four shows. The next year, he sold all his possessions and left for the tropics as a protest against the demands of civilization. Convinced of the purity of simple cultures, he settled in Martinique in the West Indies. Illness forced him to return the next year to France, where he had a brief but tragic interlude in Arles with Vincent van Gogh. Instead of establishing the artists' colony they had intended, Gauguin and Van Gogh quarreled violently, and Gauguin's visit to Arles was aborted.

In 1888 Gauguin and Emile Bernard, an artist in enamel and stained glass, proposed a bold **Synthetist** theory of art, emphasizing the use of flat planes and bright, unrealistic color to render religious and non-Western themes. This style, which had many adherents, characterized most of Gauguin's works for the rest of his life. His autobiographical novel *Noa Noa* appeared in 1895 (English translation, 1947), while he lived in Tahiti in the South Seas, producing some of his finest work. Although in despair and in considerable physical suffering from tropical maladies contracted in the islands, he painted until the very end.

As the nineteenth century came to its close, clearly, painting had become less of a dependable livelihood and more of a lifetime commitment for him. Gauguin noted: "The painter's art calls for too great a body of knowledge. It requires of the artist a higher, dedicated life, especially when instead of going along with the general run he rises above it and becomes an Individual, having to take account of the peculiar nature of the creative artist, and to take account too of the surroundings in which he lives and his education." The painter is alone: "In front of his easel, he is the slave neither of past or present, neither of nature or his neighbour. He contends with himself, only himself." To make the painter's art express something, "it has got to be searched into unremittingly by searching into oneself" [14.23].

PAUL GAUGUIN (1848–1903)

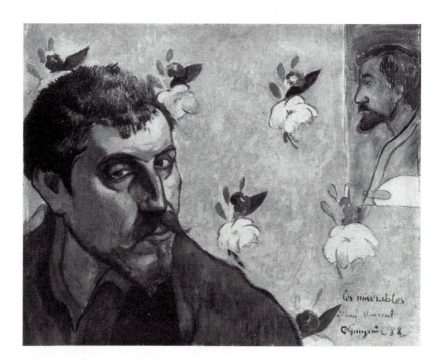

14.23 Paul Gauguin. *Self-portrait with the Portrait of Emile Bernard (Les Miserables).* 1888. Oil on cloth, 17-3/4 × 22" (45 × 56 cm). Vincent van Gogh Foundation/National Museum Vincent van Gogh, Amsterdam.

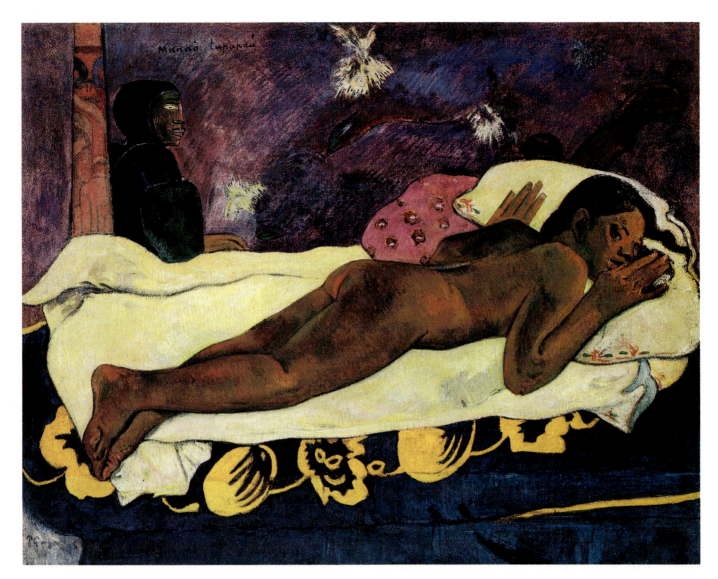

14.22 PAUL GAUGUIN. *SPIRIT OF THE DEAD WATCHING.* 1892. OIL ON BURLAP MOUNTED ON CANVAS, 28-1/2 × 36-3/8″. ALBRIGHT-KNOX ART GALLERY, BUFFALO, NEW YORK (A. CONGER GOODYEAR COLLECTION, 1965).

avoid worldly problems. We, as viewers of their exotic works, are also momentarily diverted from our daily pressures. In *The Spirit of the Dead Watching* [14.22] we can vicariously experience a simple lifestyle in a romantic setting. The drama is heightened for us by a juxtaposition of tropical flowers with the dark figure from the spirit world.

Gauguin was influenced by Japanese prints, and he also studied the art of Polynesian craftspeople in the village where he lived. He developed a decorative style of painting, making use of flat areas of pure, often unrealistic, color. Gauguin believed that the Impressionists used color without freedom, constrained by the needs of reality and probability. He simplified the outlines of figures and objects until they often appeared unrealistic or symbolic. He believed that a painter should study the silhouette of every object—as he saw it—for distinctness of outline comes from sure knowledge. Aside from their own beauty, Gau-

guin's paintings are important also for their influence upon later Expressionists.

Another noteworthy Postimpressionist was Suzanne Valadon (1865–1938), a former artist's model and mother of the **Fauvist** painter Maurice Utrillo (1883–1955). She had no formal art training but great skill in drawing [14.24]. She worked in the spirit of the Impressionists, especially Degas, although she painted at the beginning of the twentieth century. The heavily defined contours, simplification of form, and nonrepresentational colors of her vigorous paintings link her also to Gauguin and the Expressionists.

The dissatisfaction of Van Gogh and Gauguin with Western society was a point of view shared by others at the end of the nineteenth century. Henri de Toulouse-Lautrec, an artist of great talent, led a dissolute life on the fringes of society, illuminating the café scene in the flat, patterned

14.24 SUZANNE VALADON. *RECLINING NUDE*. 1928. OIL ON CANVAS, 23-5/8 × 31-11/16" (60 × 80.5 CM). THE METROPOLITAN MUSEUM OF ART (ROBERT LEHMAN COLLECTION, 1975).

Japanese style he so much admired. *At the Moulin Rouge* is a fine example of his work **[14.25]**.

The turn of the century found many European artists preoccupied with decadence and despair. For example, Edvard Munch (1863–1944), a Norwegian with a tragic sense of human isolation, expressed alienation, anxiety, and despair in both paintings and prints. His remark, "I hear the scream in nature," is vividly illustrated in *The Cry* **[4.12]**. The open mouth of the central figure suggests howls of fear or pain, while the anonymous silhouettes on the bridge portray the coldness and indifference of the world. The torment of the lonely figure fills the atmosphere with expanding waves of terror, which are repeated in the water and sky. Munch's figures, isolated from one another and caged in their separate terrors, are ageless, sexless, classless symbols of late nineteenth-century humanity.

EIGHTEENTH- AND NINETEENTH-CENTURY AMERICA

Across the Atlantic Ocean, in the Americas, art was for the most part a distant and late echo of European models. The rambunctious spirit of the New World was missing in the realm of art. Patrons of art, like their British and Dutch counterparts, looked for traditional portraits, or for painted shop signs—even an occasional painter to repaint a house wall or a barn. Most itinerant artists were anonymous craftspeople who made their way from house to house and plantation to plantation. Remarkably few were known by name—black or white. Still fewer African Americans became established portrait painters, but Scipio Morehead

(eighteenth century) and Joshua Johnston were indeed successful. Though Johnston's commissions during the period we know most about, from 1796 to 1824, were mainly from middle-class whites, the somber *Portrait of a Cleric* is an exception, and, accounts state, "a fine likeness," typical of Early American portraiture **[14.26]**.

14.26 JOSHUA JOHNSTON. *PORTRAIT OF A CLERIC*. 1805–1810. OIL ON CANVAS, 28 × 22" (71.1 × 55.9 CM). BOWDOIN COLLEGE MUSEUM OF ART, BRUNSWICK, MAINE (HAMLIN FUND).

Art Talk

The life of Henri de Toulouse-Lautrec was the material out of which legends are customarily made. A wealthy French aristocrat, as a child he injured his legs so severely in a fall that his growth was permanently stunted. He rejected the social circle of his birth in favor of the bohemian nightclubs and cafés of Montmartre in Paris in the 1880s and 1890s, recording this demimonde in his paintings, prints, and posters. His untimely death in 1901 of a stroke related to his alcoholism left a legacy of more than three hundred lithographs and posters.

One of Lautrec's most celebrated paintings, *At the Moulin Rouge*, has served for years as an icon of the world that the painter immortalized, and just as myth has attached itself to Lautrec's life, so, too, with the painting [14.25]. In *At the Moulin Rouge* we see five

vas segment was the original and that the L-shaped canvas with the head of the woman had been added later. Not until the fall of 1985 was the painting painstakingly examined by the conservator at the Art Institute of Chicago, where the painting has been exhibited since 1928. The conservator's x-ray examinations provide us with information causing us to draw completely different conclusions from what was formerly believed. The original painting indeed was comprised of both fragments, which were later cut up. The rectangular portion was exhibited as a painting in its own right, and the L-shaped part of the canvas was probably rolled up and stored until the two were reunited. We can only conjecture why the canvas was cut apart and when, but it may well have had to do with combating the outrage which some of the public

14.25 HENRI DE TOULOUSE-LAUTREC. *AT THE MOULIN ROUGE*. 1892–1895. OIL ON CANVAS, 4'3/8" × 4'7-1/2" (1.23 × 1.41 M). THE ART INSTITUTE OF CHICAGO (HELEN BIRCH BARTLETT MEMORIAL COLLECTION, 1928). © 1992 THE ART INSTITUTE OF CHICAGO. ALL RIGHTS RESERVED.

figures, including the artist himself and his cousin, seated around a table in the middle ground, four standing figures in the background, repeating Lautrec and his cousin, and a woman lit as if by footlights in the foreground at the far right, part of whose electric blue face is cut off at the edge of the painting. It is apparent to the naked eye that the picture is composed of two joined canvas segments, a rectangle comprising the figures seated at the table and the figures in the background, and a backward-L-shaped segment of canvas consisting of the right and lower borders with the foreground figure on the right.

For years it was believed that the rectangular can-

expressed about the lack of convention surrounding the artist's life. Soon after Lautrec's death the remarkable face on the right, depicted in shocking complementary colors, may have seemed to lend fuel to the tales of the excesses of the artist's existence. Later, when his artistic stature was more widely recognized and public indignation had subsided, the two segments could have been reunited. When they were, the greatness of the work was able to speak for itself and for the genius of the artist, who displayed therein a bold use of space, inventive composition, and expressive color unique in his time.

HENRI DE TOULOUSE-LAUTREC (1864–1901) AND *AT THE MOULIN ROUGE*

Hudson River School

American patrons became increasingly more sophisticated as the nineteenth century drew to a close. Portraits remained popular, but there was a growing interest in genre and landscape subjects that expressed a patriotic enthusiasm for the natural beauty of a growing America. The traditions of what came to be called the **Hudson River School** began when Thomas Cole (1801–1848) and Asher Durand (1796–1886) set out easels in the Catskills near the Hudson. Soon landscape enthusiasts found other vistas. As it had for the French who had taken to Barbizon woods forty years earlier, a romantic nostalgia developed in America for grand landscape and seascape painting, of which *The Fog Warning* **[14.27]** by Winslow Homer (1836–1910) is a fine example. The colors are somber. The boat is set at a diagonal, thrust upward by the power of natural forces, showing the influences of Japanese woodcuts. As a young man, Homer worked as an illustrator for *Harper's Weekly* before his trip to Paris when he began to concentrate upon the fine arts. Living in isolation along the Maine coastline in his later years, his paintings often reflected the turbulence of the sea.

After the Civil War, slowly gained opportunities for African Americans made study in Europe a possibility for Henry O. Tanner (1859–1937). Having learned what he could at the Pennsylvania Academy, a leading center of the arts for minority artists, Tanner moved permanently to Paris in 1891 where he completed *The Banjo Lesson* **[14.28]**. The soft light and visible brush strokes reveal the influence of the new Impressionist style. He received both an honorable mention and later a gold medal at the Paris Salon, and was the first American black artist to achieve such distinction.

ASIA

Japan

Japan had been isolated from the outside world for more than two hundred years, while its arts, as before, continued to prosper **[4.5]** under the Daimyo feudal lords, who had controlled the provinces of Japan from 1185 to 1868. The art and culture of the Daimyo was created by and for a class whose existence depended upon military power, but whose society became increasingly based upon the arts of peace. The reign of Hideyoshi had unified Japan and permitted him to transform the social structure of the country, albeit he became involved in a life-and-death struggle in an attempt (unsuccessful) to vanquish his neighbor, China, launching an invading army into the Korean peninsula in 1592.

14.27 WINSLOW HOMER. *THE FOG WARNING.* 1885. OIL ON CANVAS, 30 × 48" (76.2 × 121.9 CM). OTIS NORCROSS FUND. COURTESY, MUSEUM OF FINE ARTS, BOSTON.

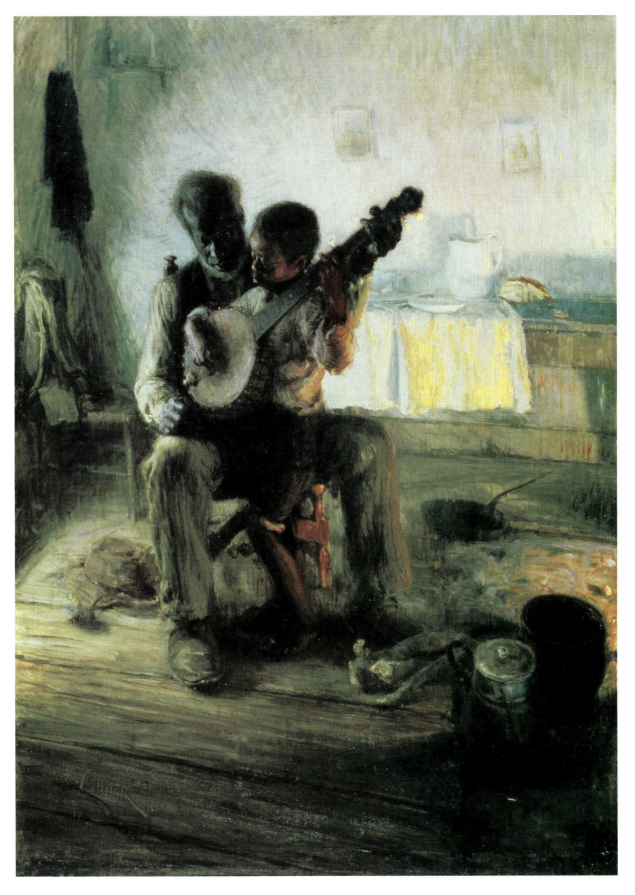

14.28 HENRY O. TANNER. *THE BANJO LESSON.* 1893. OIL ON CANVAS, 48 × 35″. HAMPTON UNIVERSITY MUSEUM, HAMPTON,
VIRGINIA.

Decorative Arts But he shared a passion for the Zen tea ceremony and for the courtly arts, reviving the *Nō* formalized dance-dramas, primarily products of Zen. We have been introduced to Zen, which was based on a foundation of extreme simplicity and pure intuition, through **raku** ware [8.18]. Hideyoshi himself, inaugurating a ten-day festival of tea, served tea to more than eight hundred people on the first day. He sponsored *Nō* plays and even gave gifts to their actors. We have already seen and admired the masks [9.6] and the brocaded robes from the Edo period [9.7]. The *Koomote* mask pictured is one of the earliest *Nō* to be developed, representing a calm young woman, whose neatly arranged hair is parted in the middle. Reflecting the standards of beauty, the oval face is full; the eyebrows shaven and repainted high on the forehead. The teeth are blackened to indicate the woman has come of age. The *Chūkei* folding fan [14.29] was an important accessory in the dramas. We would do well to remember that male actors took the parts of the women they represented.

As the clamor of battle receded, *Nō* and its comic counterpart *Kyōgen* remained the official dramatic form patronized by the Daimyo. Every Daimyo household was required to maintain a full set of robes, masks, fans and musical instruments for the performance of *Nō*.

In 1857, actions of the United States Navy supporting an "open door" doctrine opened more than Oriental ports to trade with the West. Europeans excitedly brought back the newly discovered arts of Japan as well. In addition, even the packing used to protect products for shipping showed new ways of representing form, for it often consisted of discarded woodcuts used as wrappings.

Woodcuts From the seventeenth century on, woodblock printing was a mass medium that all Japanese could afford. Illustrations of folktales appeared in wide-spread, inexpensive editions, along with topical images of the day in the nineteenth century, when prints of courtesans and actors were banned.

The popularity of these **woodcuts** depended on the styles of the moment; a new hairstyle could suddenly outdate a whole edition of prints. When the woodcuts reached Europe in the mid-nineteenth century, their flat shapes with little depth and diagonal composition profoundly affected French Impressionist painters. The refreshing variety of themes expressed in a new way proved inspiring. For example, in the woodcut showing an unusual view of Mount Fuji, Hokusai created a bold composition in which a huge wave curls up and breaks in the foreground, dwarfing the distant mountain [4.5]. A traditional Western landscape artist would probably have emphasized the mountain, not the off-center wave, and would have shown Fuji in realistic perspective. In addition, the Japanese approach to portraiture, which also reduced form to flat images, appeared strange, though fascinating, to Western eyes.

Pottery Oriental porcelains were imitated by Western potters from the seventeenth century on. The Japanese also developed a rough, simpler pottery, influenced by Zen Buddhism, as we saw in Chapter 8. Its spontaneous shapes, variety, earth-colored glazes, and quickly brushed-on decoration have appealed greatly to twentieth-century potters in the West.

Because Zen Buddhists considered everyday living to be as important as the spiritual, many took delight in the process of making pots, stressing that uniformity and repetition were fatal to imagination. The Zen tea ceremony, a religious ritual, traditionally takes place in a simple teahouse designed to recreate the peace and purity one might feel alone by a mountain waterfall. Everything used in the ceremony is intended to induce serenity. The subtle

14.29 HAMPTO CHOKEI FAN. EDO PERIOD. 19TH CENTURY. INK, GOLD-LEAF ON PAPER, BAMBOO, LACQUER. EISEI-BUNKO FOUNDATION, TOKYO.

response of the tea drinker to the shape of a bowl, the sound of the bamboo whisk stirring the tea, or the color of a flower in a vase characterizes for us the essential difference between the art of the Far East and the art of the West.

Indonesia

Indonesia, a country where nearly three hundred languages and myriad cultures, 13,000 islands, and a recorded history reaching 2000 years in the past, became an independent nation in 1945. The cultures were noted by Chinese historians and by the European Marco Polo in the thirteenth century, in particular, for their textiles, among the greatest creations of the archipelago. Their variety and weaving techniques, representing the female contribution in Indonesian clan symbols, is related to fabric of the cosmos. The colors also are symbolic: the brown of the earth and the blue of heaven set upon the white of air. Secret rites accompany tie and batik dying, usually done by men where outsiders are forbidden [8.21].

The flowering of a traditional art achieved its highest expression in the *wayang kulit*, the shadow play in which intricately carved, painted and gilded puppets [8.30] perform behind a white cotton screen. The art of shadow puppetry may have had beginnings in China or even India, where a first century Buddhist text describes what may have been a shadow play. Some believe the shadows represent the souls of the ancestors in an intermediate state of visibility. The *dalang* or puppeteer manipulates the arms of the puppets, adding sound with his feet and other accessories. In a constant cycle of scenes, he also recites the Javanese poetry. The intricacy of the puppets and their variety can only be suggested by the still camera [8.31].

Indonesian celebrations of the rites of passage include birth, puberty, and, of course, marriage. Images of the fertility goddess *Dewri Sri* pervade all layers of society. In harvest time in central Java, offerings of rice, or rice paste, are made to her. The courtly *loro blonyo* figures [14.30], placed before the ritual marriage bed in Central Java, are specifically named *Dewri Sri* and *Dewa Sadana*. The bed may be a curtained alcove, a screen, or even a completely enclosed shrine. These wooden figures are painted with gold leaf, and set with diamonds and semiprecious stones.

14.30 SURAKARTA, JAVA. LORO BLONYO FIGURES. 19TH CENTURY. WOOD, PIGMENT, FISH GLUE MEDIUM, IRON, GOLD, DIAMONDS, SEMI-PRECIOUS GEMS. K.R.T. HARDJONAGORO.

Oceania

The islands of the south Pacific Ocean are grouped into three cultural areas: Micronesia (including the Caroline and Marshall islands), Melanesia (including New Guinea), and Polynesia (including Hawaii, New Zealand, and Easter Island). Sometimes Australia is considered part of Oceania. Although each area and island had a distinctive culture, many elements were common to all.

Most Oceanic people came originally from the Asian mainland and traditionally belonged to extended families and clans. They farmed and fished for a living and worshipped their ancestors and other spirits. Since wood was plentiful, it was the most common material for building tools and war implements, often fitted with blades of shell or stone. Each island had its particular form of war club, all of them lethal. Wood was also used for carved stools, house posts, and figures of the gods.

Oceanic art objects, such as carved and painted shells, reflect the constant warfare between the islands. Many were part of elaborate religious ceremonies. Most art was made to be seen in action—masks moving with the rhythms of ceremonial dancers, weapons wielded in battle, the carved paddles and prows of Maori canoes moving over water.

The statues on Easter Island in Polynesia, made from volcanic tufa, are an exception to the liveliness of most Oceanic art [14.31]. These large, brooding sculptures,

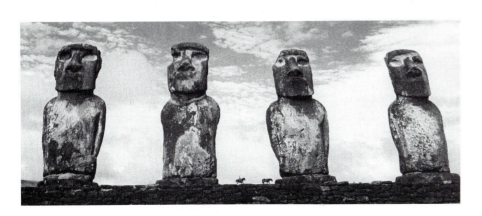

14.31 FOUR OF THE SEVEN STATUES OF AHU-AKIVI, EASTER ISLAND.

originally set on ceremonial stone platforms, were discovered on Easter Sunday by nineteenth-century missionaries. The islanders had then lost all recollection of the origins of the sculptures, and archaeologists are still uncertain of the religion they served.

Africa

By the nineteenth century, after two thousand years of Greek and Roman inspiration, many Western artists began to question their goals. The spiritual essence of much Oriental art profoundly affected Western concepts, while from Africa came part of the Cubist impulse for Picasso and others. Beyond the Church and our classical heritage existed a whole world we knew little about. The art of our twentieth century took part of its legacy from that other world.

Africans of the nineteenth century continued to live much as they had for centuries, grouped in extended families. Africans who continued in this traditional way of life lived in villages of a few families, raised crops for the community, and believed in an animistic religion. They thought of the world around them and the forces of nature—sun, rain, fertility of crops and humans, and death—as determined by powerful spirits or divinities. African art expresses human responses to those forces with great emotion and vitality.

The Western division between fine and functional art never existed in traditional African (or any other preindustrial) society. Some art objects, such as masks and headpieces [14.32], were created for religious ceremonies held by secret organizations, so our knowledge of their use is scanty. Houses and furnishings were decorated with carving and color. Africans also enhanced their own bodies with paint, tattoos, and scars [1.22], both as decoration and as symbolism. For the Africans, as for the ancient Greeks and many other peoples, art was an important part of life.

Expressing an emotional response to the world was vital to African artists, who usually considered realism in art an infringement on the powers of the divine. Therefore, they emphasized and exaggerated the characteristic shapes of humans, animals, or imagined spirits, sometimes so strongly as to startle Western eyes. Perhaps that is why many artists looking for new approaches have found African art so appealing.

Wood Sculpture In Africa as in the West, the human figure has been a constant source of inspiration. Sculptured forms, usually carved from wood, range in height from 3 inches to 6 feet (7.6 to 183 centimeters). Most figures were left uncolored or painted solid red or black. Some present-day Yoruban art from Nigeria and sculpture from East Africa is multicolored. Male and female figures were carved from tree trunks for ancestor rites as commemorative statues or as mendicant figures holding bowls for contributions [1.23]. Many of these figures were status symbols made for the well-to-do community.

Like Christian sculptures of religious figures, African images evoke ancestors and gods. Some of the sculptures are fetishes, which were designed both to make contact with the gods for help and to ward off evil spirits. For example, in this fetish from Zaire [14.33], each nail represents an attempt to reach a divinity. If there had been no rain for weeks, a priest might drive a nail into the figure to attract the power of the rain god. Or if someone were ill, a fetish would be used to reach a spirit for help in effecting a cure. An unsuccessful fetish would soon be discarded. Such rituals might be distantly compared with Christians lighting a candle before an image of a saint in a plea for help.

14.32 CHI WARA MASK. WOOD. 19TH CENTURY. COLLECTION OF ALLEN WARDELL. COURTESY OF THE CENTER FOR AFRICAN ART, FROM THE EXHIBITION CATALOGUE, *AFRICA EXPLORES: 20TH CENTURY AFRICAN ART.*

14.33 NAIL FETISH, FROM ZAIRE. 19TH CENTURY. WOOD, HEIGHT 32-1/4″ (82 CM). WHEREABOUTS UNKNOWN.

Besides figures, African sculpture includes ceremonial thrones (stools), neck rests, masks, and other furnishings. Most were ornamented with carving, paint, or materials such as feathers, shells, hair, and stones. Typically, a wooden throne from Cameroon was completely covered with a geometric design of beads and cowrie shells [14.34]. Thrones were important to Africans. In some regions people believed that a person's soul occupied the throne that he cherished during his lifetime. In other regions, certain stools were reserved for important personages. The Ashanti people of Ghana preserved a myth about a golden throne that fell miraculously from heaven and brought good fortune. Royal Ashanti thrones were often

14.34 BEADED THRONE. BAMUM SULTAN, NJOYA, CAMEROON GRASSLANDS. 19TH CENTURY. WOOD, GLASS, COWRIE SHELL BEADS, HEIGHT 32/34″. ETHNOLOGICAL MUSEUM, BERLIN.

covered with gold, which was once so abundant that Europeans called Ghana the Gold Coast. Neck rests were used to support the head of a sleeping person without disturbing an elaborate hairstyle. Most decorations on these rests were geometric, but designs differed from place to place.

Sculptural styles and decorative patterns varied widely. Often certain objects were unique to an area. An example from Ghana is the disc-headed Akua'ba figure similar to those worn by young Ashanti girls as fertility charms, belted in support at the waist, to ensure a good marriage and children [14.35].

Masks African ritual masks played an important role in community life. Elaborate masks were worn in ceremonial dances to heighten the emotional effect on the spectator as well as to draw power from the spirits. Masks also emphasized the strong emotional ties that exist among humans, animals, and nature. Some masks were made to fit on top of the head, others to cover the face, and still others to fit over the head and shoulders. In order to help dancers keep their masks on, they were often fitted with a bar inside for the wearer to grip with his teeth [14.36].

In addition, the body of the masked dancer was usually decorated with paint or costumed in feathers, skins, cloth, or vegetable fibers. Representing a particular god or spirit, masked ritual dancers often felt themselves to be psychologically identified with the power of the spirit. And, in turn, they were identified as that spirit by the community. Similarly, masks for identification and emotional effect were used in ritual dances in Oceania and pre-Columbian North America and in Chinese and Japanese theater.

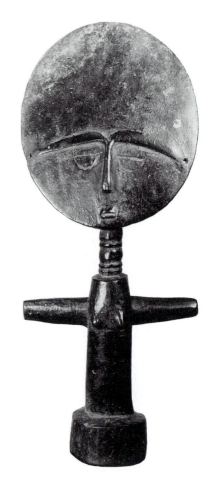

14.35 AKUA'BA STATUE, FROM GHANA. ASHANTI. WOOD, HEIGHT 11″ (28 CM). SEGY GALLERY OF AFRICAN ART, NEW YORK.

14.36 BAYAKA MASK (FRONT AND BACK VIEW), FROM LOWER CONGO. 19TH CENTURY. PAINTED WOOD, 13 × 12 × 9″ (33 × 30 × 23 CM). COLLECTION THE AUTHOR.

Many African dance masks were designed to celebrate the rites of passage through life—particularly birth, puberty, marriage, and death. Since ancestor worship was strong in African cultures, death was a constant preoccupation, and masks reflected its importance. Thus, a white mask might be worn to attract the power of ancestral spirits, because white symbolized dead flesh. In this Bayaka puberty mask from the Congo, the color white signifies the death of the child and the initiation of the young adult into community life.

African Influences on Nineteenth- and Twentieth-Century Art In the nineteenth century, European traders began to return home with large numbers of African sculptures. Artists in Paris soon discovered these exotic objects. Searching for new ways to depict the world and express their emotions, they were impressed by the uncanny ability of African sculptors to emphasize the essentials of a subject while simplifying and distorting it. Picasso and Braque, influenced by African sculpture, developed **Cubism**.

Technological developments of the nineteenth century had succeeded in focusing artists the world over on their new role in an age that no longer required large numbers of realistic portraits. The Age of Revolution had signaled the growing movement toward freedom for personal expression in the subject matter, technique, and style of art. The styles of Postimpressionism, with which the century closed, anticipate the bold individuality of art in the twentieth century.

EXERCISES AND ACTIVITIES

Exercises for Research and Discussion

1. Select a passage from the *Discourses* by Sir Joshua Reynolds that seems particularly relevant to today's world. Explain your reasons for choosing that passage.

2. Locate some buildings or photographs of buildings that show Palladio's influence on architecture.

3. How were such artists as Goya and Turner influenced by the earlier works of Velásquez and Rembrandt? How were they affected by the new spirit of the age?

4. Discuss some art movements of the nineteenth century that expressed the influence of Africa or the conflict between industrialization and nostalgia for the past. Analyze two artworks.

5. The Impressionist painters of the nineteenth century developed a technique that created the illusion of light, color, and atmosphere. How did it differ from earlier painting techniques? Give examples.

Studio Activities

1. Draw a still life in outline. Using poster paints, create an illusion of light on the objects, applying dabs of pure color next to each other. See if your eye mixes the dots to form an area of color. If it does not, alter the proportions of the colors until you achieve the effect you wish.

2. Sketch a view of part of a room. Paint it, using dabs of poster, oil or acrylic paint to simulate either an Impressionist or Postimpressionist technique.

3. In the spirit of Whistler, organize a cityscape in charcoal based on a division of space, respecting the Golden Section. Does this principle apply to a composition of houses and sidewalks?

4. On a simple loom made from a picture frame with yarn stretched between nails, interlace yarns, using native American motifs as a guide.

5. Create in clay or soap a three-dimensional figure reminiscent of the art of the Orient.

Tradition and Innovation: 1900–1935

"*If you bring a mirror near to a real picture, it ought to become covered with steam, with living breath, because it is alive.*"

—PABLO PICASSO

• • •

"*Every work of art is the child of its time; often it is the mother of our emotions*"

—WASSILY KANDINSKY

• • •

"*To become truly immortal a work of art must escape all human limits; logic and common sense will only interfere.*"

—GIORGIO DE CHIRICO

• • •

"*The clown is not I, but rather our monstrously cynical and so naively unconscious society that plays at the game of being serious, the better to hide its own madness.*"

—SALVADOR DALI

1900	1905	1910	1915	1920	1925	1930	1935	1940

THE VISUAL ARTS

1897 Rousseau, *The Sleeping Gypsy* [15.24]
1905 Matisse, *Madame Matisse* [15.10]
1907 Modersohn-Becker, *Mother and Child* [15.14]
1907 Picasso, *Les Demoiselles d'Avignon* [15.1]
1909 Wright, Robie House [15.45]
1910 Delaunay, *Eiffel Tower* [14.1]
1911–12 Picasso, *Ma Jolie* [I.12]
1912 Duchamp, *Nude Descending Staircase (No. 2)* [2.46]
1913 Boccioni, *Unique Forms of Continuity* [15.32]
1914 De Chirico, *The Melancholy of Departure* [15.25]
1917 Van Doesburg, *The Cow* [15.7]
1922 Klee, *Twittering Machine* [15.26]
1925 Eisenstein, *Potemkin* [5.23]
1925–26 Gropius, Bauhaus [15.42]
1928 Brancusi, *Bird in Space* [15.34]
1929–30 Le Corbusier, Villa Savoye [15.46]
1931 Dalí, *The Persistence of Memory* [15.28]
1932 Picasso, *Girl Before a Mirror* [15.2]
1934 Kollwitz, *Death and the Mother* [15.16]
1936–37 Wright, Kaufman House [7.16]
1937 Picasso, *Guernica* [I.15]

EUROPE AND AMERICA

As we approach the art of our own time, the pace quickens and diversity becomes the rule. Changes occur so rapidly that despite the perspective of almost a hundred years, we are shaken by the explosion of styles.

The 1920s and 1930s were a period of broad disillusionment and unrest. Nineteenth-century promises of peace and prosperity had dissolved in World War I and the Great Depression of the 1930s. Numerous writers and artists saw this era as one of mass exploitation, dehumanization, and irrational political leadership. Social confusion led to considerable artistic experiment. It was a period when modern art flourished, and some critical artists even produced works that were anti-art, an unexpected current, which began early in this century and which has gathered volume at its close.

The spirit of artistic freedom that had developed in the nineteenth century with the efforts of Courbet and Whistler to choose their own styles, subjects, and titles of works increased in the twentieth century. By the second and third decades, a half-dozen or so manifestos had been issued, and artists, who generally resisted grouping, had developed several art currents. By the early 1930s, however, the many confusing styles or "-isms" could be sorted out into the following general trends, which have persisted to the present time: formalism, Expressionism, fantasy, and realism.

Formalism refers to an intellectual approach popular in the modern period that is more concerned with form—the spatial arrangement of such elements as line, shape, and texture—than with content from the real world.

Expressionism refers to a concern with the intensity of the artist's emotions as opposed to his or her representation of external reality, an approach that often results in distortions of color and shape. The term was perhaps first applied to the art of Vincent van Gogh.

Fantasy refers to art derived from the artistic imagination. It may be expressed either realistically or with abstract symbols.

Realism refers to the artist's use of light, shade, color, and perspective to reproduce as closely as possible the appearance of objects in nature. As proposed by Courbet in the nineteenth century, the trend never took hold in most of the European world, but it never quite disappeared in America.

If we remember that the many styles and "-isms" discussed in Chapters 15 to 18 are loosely grouped within these general currents, perhaps the twentieth century will be easier to follow.

FORMALIST PAINTING

For centuries artists tried to paint the illusion of three-dimensional objects in deep space on a flat, two-dimensional surface. The Greeks and Romans used a limited form of linear perspective, which Renaissance painters developed into a science, as if they held up a mirror to nature and then surrounded that view with a frame. The painting became a window on reality. This concept prevailed until the mid-nineteenth century, when the invention of the camera released Western artists from the need to reproduce nature. Cézanne and Gauguin began to take advantage of this freedom, as we saw in Chapter 14.

The public is always slow to accept change. Few people in 1910 understood the new views of the world, and many artists continued to cling to tradition, comfortable as skillful recorders of society. But in the early twentieth century, avant-garde artists plunged ahead to explore new horizons, especially in styles of formalist painting. Their work

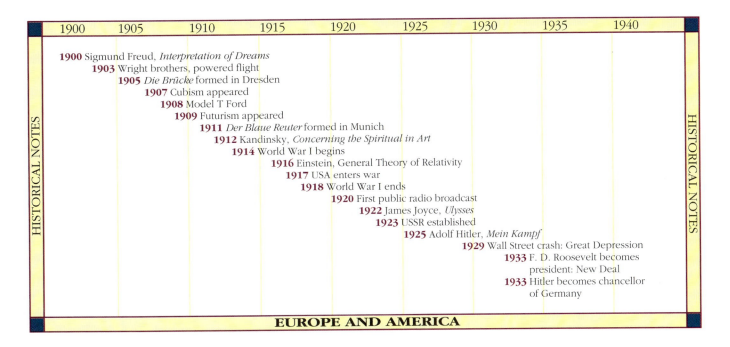

| 1900 | 1905 | 1910 | 1915 | 1920 | 1925 | 1930 | 1935 | 1940 |

HISTORICAL NOTES

1900 Sigmund Freud, *Interpretation of Dreams*
1903 Wright brothers, powered flight
1905 *Die Brücke* formed in Dresden
1907 Cubism appeared
1908 Model T Ford
1909 Futurism appeared
1911 *Der Blaue Reuter* formed in Munich
1912 Kandinsky, *Concerning the Spiritual in Art*
1914 World War I begins
1916 Einstein, General Theory of Relativity
1917 USA enters war
1918 World War I ends
1920 First public radio broadcast
1922 James Joyce, *Ulysses*
1923 USSR established
1925 Adolf Hitler, *Mein Kampf*
1929 Wall Street crash: Great Depression
1933 F. D. Roosevelt becomes president: New Deal
1933 Hitler becomes chancellor of Germany

HISTORICAL NOTES

EUROPE AND AMERICA

in **Cubism**, **Futurism**, **Nonobjectivism**, **De Stijl**, and **Suprematism**, all of which we shall now examine, has come to be recognized for its outstanding creative achievement.

Cubism

The young painters and sculptors who gathered in Paris from all over Europe from the 1880s on discussed Cézanne's efforts to reduce volume and space to simple cones, cylinders, and planes as if objects were seen from several vantage points. Many of these rebels also looked to the arts of Africa, with their exaggerations and simplifications of forms, as an escape from the binding rules of the Academy and from the Impressionists' preoccupation with fleeting light. Under these major influences two young artists, Georges Braque and Pablo Picasso, "roped together like mountaineers" as Braque put it, formed the collaboration of the century, developing a new kind of pictorial space in which objects were represented from several angles. Some observers believe that they also added a temporal dimension to space by representing objects in sequential moments of time. A startled critic gave the name **Cubism** to this new style. Braque and Picasso later said, "We had no intention of creating Cubism but simply of expressing what we felt inside."

Leaving Cézanne behind, in 1907 Picasso explored the essential elements of Cubism in a major experimental work, *Les Demoiselles d'Avignon*, or *The Young Ladies of Avignon* [15.1]. In this painting, artistic rebellion became outright revolution. First planned as an allegory of vice and virtue, the painting became intense and stark. The figures and faces of the women are distorted in angular, jagged forms. The girl on the left is depicted in a series of overlapping planes; the central figure has eyes that look directly at us, but the nose is in profile; and the faces of the figures on the right look like African masks. *Demoiselles* attacked long-held Renaissance concepts of space and the idealized nude. That Picasso may also have been representing women from the brothel district of Avignon, as many believe, had a tremendous effect on the course of twentieth-century Western art.

Both Picasso and Braque recorded the world in a startling way, as if they echoed the weakening in social patterns and the uncertainty of the new age. Just as the political radicals tried to find a new order to restructure an unjust society, so too did the Cubists search for a new way to rearrange visual images. Familiar objects—tables, wine bottles, violins, sheet music, and the human figure—were reduced to geometric abstractions, simplified, and then restructured. Picasso said, "We have kept our eyes open to

15.1 PABLO PICASSO. *LES DEMOISELLES D' AVIGNON*. 1907. OIL ON CANVAS, 8′ × 7′8″ (2.44 × 2.36 M). COLLECTION, THE MUSEUM OF MODERN ART, NEW YORK. (ACQUIRED THROUGH THE LILLIE P. BLISS BEQUEST).

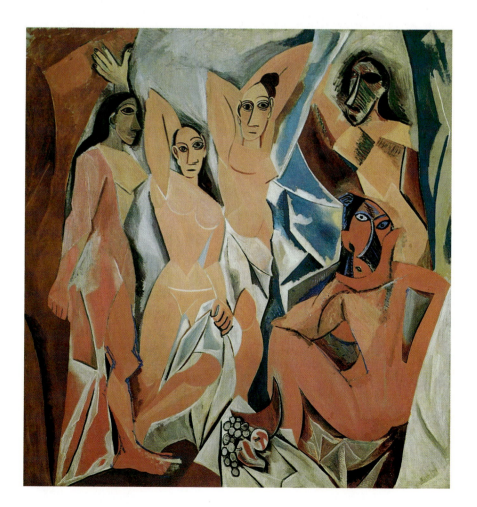

our surroundings, and also our brains." The Cubists abandoned conventional linear perspective, replacing it with a new surface perspective that does not create a sense of depth in the canvas but rather seems to advance from the frame. A comparison of *Ma Jolie* **[I.12]** with Leonardo's *The Last Supper* demonstrates the revolutionary manner in which these young painters handled perspective.

The Cubists painted not only what they saw but also what they knew was there. For instance, a wine bottle might be painted as if seen from the side, back, and top; all these views organized into a single, complex, intellectually analyzed composition in muted colors. Because of the intellectual and disciplined nature of these paintings, the early stages of the style are described as **Analytical Cubism**, a collage. Gradually, however, the object itself was lost, and the Cubists became more interested in the design formed by bright-colored, overlapping shapes in a shallow space. This mingling of the decorative aspects of an object by taking its various parts and combining them into compositions that may only remotely resemble their origins is described as

Synthetic Cubism. Picasso's *Girl Before a Mirror* **[15.2]** is a remarkably direct Synthetic Cubist work. It presents a psychological study of a young girl considering her impending sexual maturity with apparent fear and anticipation. Her arm, stretched into the mirror, forms a bridge from the present time to what will be.

Along with Cubist paintings, Picasso, Braque, and others made collages **[2.31]** and, then, paintings that looked like collages **[2.41]**. The colors, shapes, and volumes of the language of Cubism were used more inventively and expressively, often with humor. The rules of academic art were totally shattered. Even painters who used the academic devices of perspective and light and shade to create the illusion of three dimensions used them more freely. Art would never again be the same.

In 1908 the American inventor Wilbur Wright flew across the English Channel at about the same time that Ettore Bugatti was designing racing automobiles in Italy. Many artists were intrigued by concepts of motion, and a group of young painters eager to escape tradition

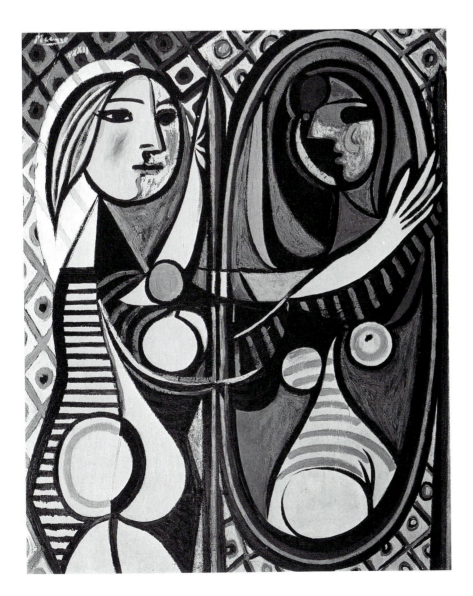

15.2 Pablo Picasso. *Girl Before a Mirror.* 1932. Oil on canvas, 5'4" × 4'3-1/4" (1.62 × 1.31 m). Collection, The Museum of Modern Art, New York. (Gift of Mrs. Simon Guggenheim).

The Artist Sketch

Although Picasso was one of the founders of Cubism, he also worked in a number of different styles. Cubist, Expressionist, Neoclassical, Surrealist—any of these labels suit some of his work, but none could describe it all.

Born in Malaga, Spain, Picasso produced his first oil painting at age eight. By 1894, as the story goes, the artist father of Pablo, so overwhelmed by his son's painting, handed over to Pablo, from the cabinet housing their art materials, his own palette and brushes and never painted again. At sixteen, Pablo was on his own studying at the Royal Academy of Art in Madrid, and by 1904, was living in Paris. Of the many phases of his art, his preference in color was known, first, as the blue series, and then, the rose.

For Picasso, artistic success came easily—as easily, perhaps as the women who paraded through his life—two marriages, and many long relationships, some overlapping. The last in 1961, a marriage with Jacqueline Rogue, his model, lasted to his death. He was an artist of vitality and inventiveness. In his long life he produced thousands of paintings, drawings, etchings, lithographs, sculptures, and ceramics in a rich and varied outpouring of artistic expression. In his work, lush colors alternate with muted soft tones; sketchy images of bullfights contrast with amusing ceramics or play with light. He met with Gertrude Stein, the art patron, and painted her portrait [15.3]. When she complained of the eighty to ninety sittings and lack of resemblance the portrait bore to her, he responded, "Never mind, you will [look like it.]." Yet, it is probably for his large painting *Guernica* [I.15] that he will be best remembered.

Guernica was painted during a few weeks in the spring of 1937 after German planes supporting Gen. Francisco Franco attacked the village of Guernica in a test run of saturation bombing. The village was totally destroyed. Picasso's 26-foot (7.92 meter) black, white, and gray mural was his memorial to those who had perished—his agonized protest against senseless destruction of human lives. The many studies that Picasso made for the painting [I.14] show the gradual evolution of the images—from three-dimensional drawings of distorted, screaming mouths and fragmented bodies to the flat, abstracted shapes of the final painting. In the finished work, a mother clutches a dead child, a woman falls from a flaming house, and a horse dies from the thrust of a spear. The bull, sometimes a symbol of evil and sometimes of resurgent Spain in many of Picasso's etchings, stands triumphantly over the dead and dying villagers, while a single glaring light bulb stares down like a cold eye on the scene of death. It is difficult to judge from reproductions the full impact of one of the strongest antiwar statements of our century. Universal in its images, this painting could represent a village in Vietnam, the Middle East, or Northern Ireland — anywhere the horror of war destroys the innocent.

Picasso summed up the confused reactions to Cubism (and to much of his art) by saying, "Everyone wants to understand art. Why not try to understand the song of a bird?" Spontaneously creative, he could paint a charming young girl in a lyrical Neoclassical style, capture the pathos of starving beggars with a few lines, and then assemble a bicycle seat and handlebars into a humorous bull [1.4]. With such works, Picasso introduced playfulness and humor into art that was a refreshing change from the intensity of academic painting and the intellectualism of Analytical Cubism. But the impact of Cubism on painting was so powerful that it affected sculpture and architecture as well, as we shall discover shortly.

In 1949, he played with light, a final new medium for him, having begun somewhat earlier a five-year venture into Madoura pottery at Vallauris, where his presence served as a magnet for visitors, the author among them. For sheer volume of art, variety of styles and media, and long, continuously productive life, he is not likely to be matched in the history of art, nor equaled in brilliance of output.

PABLO PICASSO (1881–1973)

founded the **Futurist** movement. In their painting and sculpture they tried to reconcile the human being with the new machines and to express euphoria with the boundless speed of steam engines, automobiles, and airplanes. Influenced by the Cubists, some of these artists reduced forms to planes and painted almost abstract canvases with titles such as *Dynamism of the Automobile*. Robert Delaunay (1885–1941) and his wife Sonia Terk-Delaunay (1895–1979) experimented with the mechanics of light, merging Pointillist techniques with Cubist and Futurist forms in a short-lived variant of the style that became known as **Orphism**. *The Eiffel Tower* represents confidence in an age of technology and an explosion of optimism for the future it might bring [14.1].

Others, such as Gino Severini (1883–1966), who painted multiple images to show movement, may have been influenced by the new art of the motion picture. In

Art Talk

At the turn of the last century in Paris, artists and writers beat a path to the doors of the American Gertrude Stein [15.3], a collector of art along with the people who make it. It would be fair to say that wherever she set up residence soon became the center of the cultural life of that community. Her informal gatherings, known as "Salons," included such well-known leaders of the arts as painters Pablo Picasso, Henri Matisse, Paul Cézanne, and Auguste Renoir and the writers and poets Jean Cocteau, Ernest Hemingway, and F. Scott Fitzgerald, to name a few.

volvement in the conflict, Stein and Toklas contributed their efforts by taking to the countryside in a battered Model T Ford, cheerfully delivering supplies to the French wounded. When the war was resolved in 1918, the two women returned to their major goal, getting Stein's writings published. Often quoted for her most obscure statement, "A rose is a rose, is a rose," many believe she was referring to our association of things by their names instead of by what the names represent, forgetting that nametags are meant only to be aids to communication. But her writings

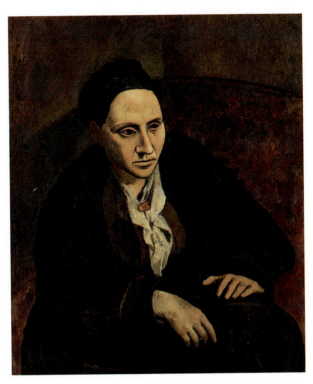

15.3 PABLO PICASSO. GERTRUDE STEIN. 1906. OIL ON CANVAS, 39-1/4 × 32". THE METROPOLITAN MUSEUM OF ART (BEQUEST OF GERTRUDE STEIN, 1946).

Born in Alleghany, Pennsylvania, and raised in California, Stein pulled up roots to join her brother Leo in Paris in 1903 at age twenty-seven, at rue de Fleurus on the Left bank of the Seine River. They formed a happy partnership acquiring a collection of art that made their Saturday evening gatherings a mecca for artists eager for financial support. After four years, their association began to unravel with the introduction of another American. Leo moved from the apartment with half the art collection when Alice B. Toklas moved in. She was destined to become Stein's lifelong companion, typist and quasi-housekeeper, and, probably most valuable of all, she deciphered Stein's writings, incomprehensible for most even when legible.

With the onset of World War I and France's in-

with their repetitious style were not easily understood, much less marketable.

The success of her *The Autobiography of Alice B. Toklas* in 1934, in reality a story of her own life, raised the status of both women to world renown, and clearly delighted Stein. They came back to America and enjoyed a whirlwind tour of their homeland for the first time in three decades. Returning in triumph to Paris, the women continued to entertain world notables. When Stein died of cancer, she was recognized as a major literary figure whose reputation has continued to strengthen. She left her art collection to Toklas, whose death in 1967 returned the works to the family. A testament to the appreciation of well-chosen art, that which had been purchased for hundreds of dollars was sold for millions.

ART PATRON AND WRITER GERTRUDE STEIN (1874–1946)

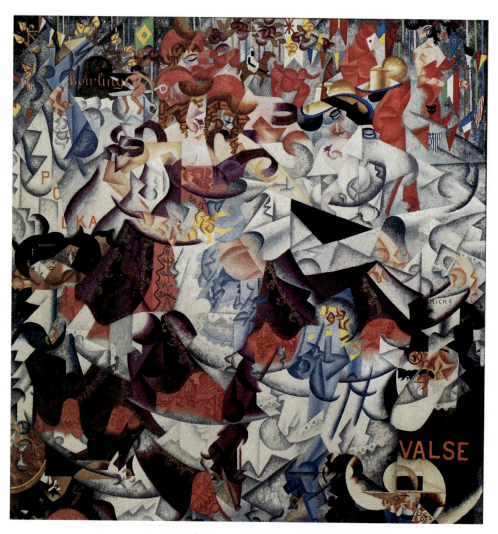

15.4 GINO SEVERINI. *DYNAMIC HIEROGLYPHIC OF THE BAL TABARIN.* 1912. OIL ON CANVAS WITH SEQUINS, 5′3-5/8″ × 5′1-1/2″ (1.62 × 1.56 M). COLLECTION, THE MUSEUM OF MODERN ART, NEW YORK. (ACQUIRED THROUGH THE LILLIE P. BLISS BEQUEST).

Dynamic Hieroglyphic of the Bal Tabarin [15.4], Severini expressed the swirling movements of cancan dancers in a brilliantly colored painting whose forms have been broken down into Cubist planes. Only the dancers' ringlets and red lips remain recognizable; added touches of painted lace and real sequins suggest their costumes. The Futurist movement broke up under the stress of World War I, but Futurist influence continued in works by Fernand Léger (1881–1955), Marcel Duchamp [2.46], and later machine-oriented painters. Duchamp's Cubistic, machinelike walking nude parodies the idealized Venus figure of Renaissance art.

First aligned with the Cubists, Léger moved slowly toward a style that related human beings to machines. In his paintings he turned city buildings, smoking factories, machine parts, and human bodies into simplified cylinders, rectangles, circles, and cubes, painted in brilliant blue, yellow, and red against stark white and black. His figures are static robots surrounded by machine parts. The colors and forms of Léger's painting directly influenced furniture

design and advertising art in the United States in the 1940s, for his simplified forms were suited to graphic art [15.5].

De Stijl and Other Nonobjective Art

During the years of World War I, the neutral Netherlands remained one of the few countries where creative design and construction could continue uninterrupted. As a consequence, this country became a center of innovation. The architect Gerrit Rietveld (1888–1964) and the painters Theo van Doesburg (1883–1931) and Piet Mondrian (1877–1944) worked closely together and in 1917 evolved a movement they called **De Stijl** ("The Style"). Convinced that realistic or even semiabstract images had no place in the machine age, the painters of De Stijl reduced their images to simple horizontal and vertical shapes. Later, Van Doesburg's studies of a cow reveal clearly the process of abstraction [15.6]. In most canvases by Mondrian and Van

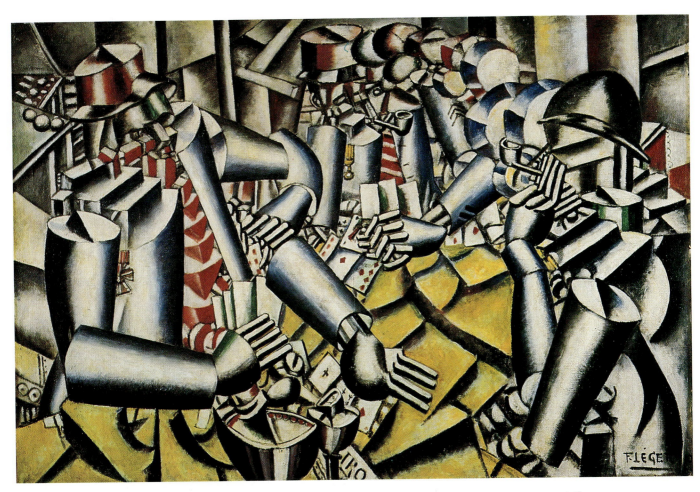

15.5 FERNAND LÉGER. *SOLDIERS PLAYING CARDS*. 1917. OIL ON CANVAS, 46 × 32″. COLLECTION: STATE MUSEUM, KRÖLLER-MÜLLER. OTTERLO, THE NETHERLANDS.

15.6 THEO VAN DOESBURG. *THE COW* (SERIES OF 8 PENCIL DRAWINGS). C. 1917. NOS. 1, 2, 4, 5, 6, 7: 4-5/8″ × 6-1/4″ (12 × 16 CM); NOS. 8, 9: 6-1/4″ × 4-5/8″ (16 × 12 CM). COLLECTION, THE MUSEUM OF MODERN ART, NEW YORK. (PURCHASE).

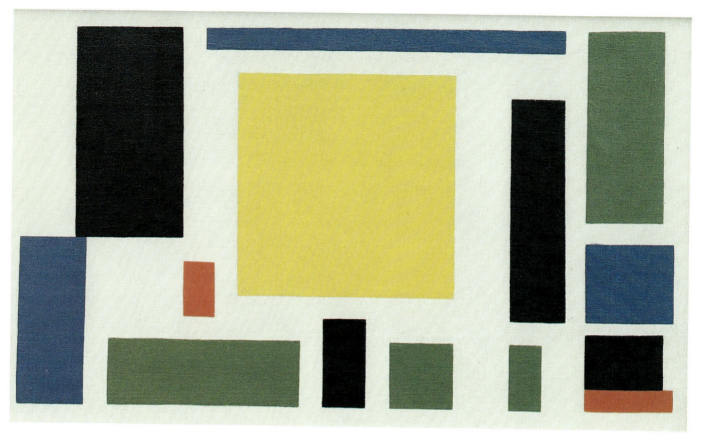

15.7 THEO VAN DOESBURG. COMPOSITION (*THE COW*). C. 1917. OIL ON CANVAS, 14-3/4″ × 25″. COLLECTION, THE MUSEUM OF MODERN ART, NEW YORK (PURCHASE).

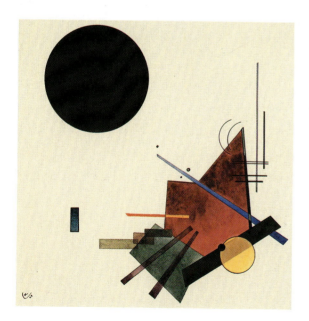

15.8 VASILY KANDINSKY. *BLACK RELATIONSHIP.* 1924. WATERCOLOR AND PEN AND INK ON PAPER, 14-1/2″ × 14-1/4″. COLLECTION, THE MUSEUM OF MODERN ART, NEW YORK (ACQUIRED THROUGH THE LILLIE P. BLISS BEQUEST).

Doesburg [15.7], the object that may have originally inspired the works has all but disappeared, leaving only flat rectangles of color and strong dark lines placed in harmonious compositions. Applied to painting, architecture, and all areas of design, De Stijl affected creative expression in many countries for decades, as shown by Rietveld's straight-lined chair [8.26]. While many see De Stijl art as "pure" and tranquil, others find the style harsh and rigid.

Another painter who helped develop nonobjective art (see the Introduction) was the Russian Wassily Kandinsky (1866–1944). Studying in Munich and visiting Paris, he was exposed to various kinds of avant-garde art. He painted his first nonobjective work, a watercolor of pure color and line, in 1910, about the time he also became a leading figure in Expressionism. He claimed that what is most important in art is what the viewer feels while under the effect of the combinations of form and color in a painting. Like Whistler before him, he wanted painting to approach pure music. He called his compositions "improvisations" to emphasize their lack of literal subject matter. His later works in the 1920s and 1930s, when he was teaching at the Bauhaus, became entirely geometric [15.8].

Nonobjective art was also evolving in Russia about the time of World War I by such artists as Kasimir Malevich (1878–1935). In 1913 he exhibited a painting of a black square on a white background. Describing this work

15.9 KASIMIR MALEVICH. *SUPREMATIST COMPOSITION: WHITE ON WHITE.* 1918. OIL ON CANVAS, 31-1/4″ (79 CM) SQUARE. COLLECTION, THE MUSEUM OF MODERN ART, NEW YORK.

Malevich stated, "It was not just a square I had exhibited but rather the expression of nonobjectivity." Malevich spent years exploring squares and their relationships to each other. In 1918 he painted *Suprematist Composition: White on White* [15.9] in which he believed he had attained the ultimate in purity of art. Many agreed. Despite its apparent simplicity, this work was a milestone of modern art because it reduced art to its essentials, and was echoed in many later works.

In Russia at this time nonobjective painting and other experimental art were encouraged by the Communist Party, which came to power in 1918. By 1920, there were more museums of abstract art and more artists working in a nonobjective manner in Russia than anywhere else in the world. As with Courbet in France, political radicalism was again linked with artistic radicalism. Soon, however, the new regime outlawed experiment and insisted on realistic works that glorified the state. Avant-garde artists chose either to stay in an environment that was hostile to growth or to leave the country. Kandinsky, for example, who had taught in Russia during World War I, left in 1921 and joined the faculty of the Bauhaus, an innovative school of design we shall soon examine.

EXPRESSIONIST PAINTING

Also innovative but very different in their approach to art were the Expressionists who worked in France and Ger-

many. Of course, emotional expression has existed as long as art. Certainly Romanesque sculptors expressed religious emotion. In the nineteenth century, Goya expressed his horror at the cold-blooded murder of hostages by Napoleon's troops. Later, Géricault, in *The Raft of the "Medusa,"* protested against the heartless disregard for human life by the authorities. Van Gogh poured his emotions into his vigorously brushed, vibrantly colored paintings. Munch expressed his personal distress in woodcuts and lithographs.

Troubled by the dehumanized and materialistic world they saw around them, many early twentieth-century painters worked in a variety of styles that are loosely classified as Expressionist. Those in France are known as the **Fauves**. Those in Germany are called **German Expressionists**.

Fauvism

In 1905 a new movement burst on the Paris scene with an astonishing exhibit by Henri Matisse (1869–1954) and eleven other artists. Among the rooms filled with brilliantly colored canvases a bewildered critic noticed a small bronze sculpture in Renaissance style, which, he remarked, was like "Donatello among the wild beasts." Consequently, the term *les Fauves* ("the wild beasts") was applied to artists of this movement, called Fauvism. It lasted only three years or so, but had far-reaching effects.

Matisse's innovative use of color and strong, simplified forms was startling. For example, in his *Madame*

15.10 Henri Matisse. *Madame Matisse (The Green Line).* 1905. Oil on canvas, 16 × 12-3/4″ (41 × 33 cm). Staten Museum for Kunst, Copenhagen.

Matisse (The Green Line) [15.10] he arbitrarily painted one of his wife's cheeks a warm yellow-ochre, the other a cold pink, and then separated them with a line of green down her face and a background of color complements. Here he used color with minimal reference to reality, and, like other Fauves, in its fullest intensity. The features were simplified into a mask.

Throughout his long life, Matisse showed an impressive ability to put colors together successfully in unusual ways. As an accomplished pictorial designer, he could define space by overlapping planes of flat color. As a fine draftsman, through extreme simplification and elimination of detail, he, unlike many other Expressionists, represented a serene world where line, color, and shape could be enjoyed independently of subject matter.

The Fauve painter Georges Rouault (1871–1958) was haunted by the poverty and misery of his day. His paintings depicted the degradation of prostitutes and tragic circus clowns [15.11] as symbols of the cruelty of people toward each other. Deeply religious, Rouault also painted many biblical characters and Crucifixions. His youthful apprenticeship to a maker of stained glass is reflected in the glowing colors and black outlines of his paintings. As an experimental printmaker, commenting on the horror of war, Rouault developed daring graphic techniques. For instance, he combined etching and engraving in one print and worked on the plate with files, sandpaper, and anything else that would mark it. This free approach helped expand the limits of twentieth-century printmaking.

An Expressionist painter and sculptor who lived in Paris but was not a Fauve was the Italian-born Amedeo Modigliani (1884–1920). He used the distortions of African art as well as strong, often somber colors to express the restlessness of his life. While *Head* [15.12] appears quite

African in style, comparison with the *Gabun* mask **[15.13]** reveals the connections as well as the differences, which are considerable. Handsome, poor, dissipated, and dying of tuberculosis, he nevertheless carved fine abstract figures and painted portraits and nudes that echoed the work of Botticelli in their graceful elongation of the female form.

German Expressionism

Before World War I, Dresden, Munich, and cities in northern Germany were centers of artistic innovation, where avant-garde artists formed groups to promote their Expressionist ideas. They used harsh, brutally simplified forms and strong, clashing colors to express the intensity of their inner sense of conflict, violence, and tragedy.

Paula Modersohn-Becker, a gifted and intense artist, was torn after marriage between her artistic aspirations

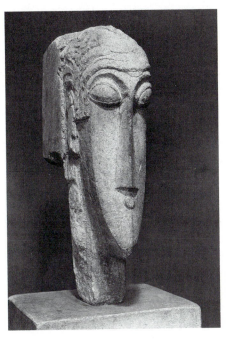

15.12 AMEDEO MODIGLIANI. *HEAD.* C. 1915. LIMESTONE, 22-1/4 × 5 × 14-3/4" (57 × 18 × 37 CM). COLLECTION, THE MUSEUM OF MODERN ART, NEW YORK. (GIFT OF ABBY ALDRICH ROCKEFELLER IN MEMORY OF MRS. CORNELIUS J. SULLIVAN).

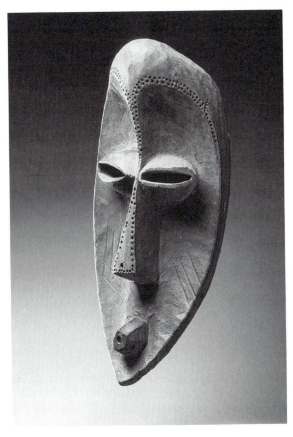

15.13 GABON MASK, ITUMBA, ZAIRE. (BRAZZAVILLE) C. 1775. WOOD, HEIGHT 14" (35.5 CM). MUSÉE BARBIER-MUELLER, GENÈVE.

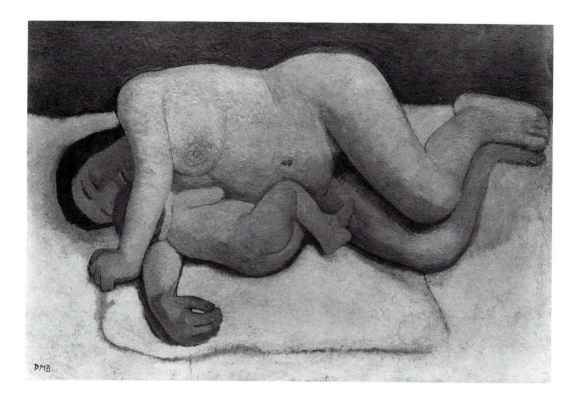

15.14 PAULA MODERSOHN-BECKER. *MOTHER AND CHILD.* 1907. OIL ON CANVAS, 32-1/4 × 49″ (82 × 124.7 CM). PRIVATE COLLECTION.

and her maternal responsibilities. Of all her 259 paintings, many of them intense reworkings of images of motherhood, she sold only one. The maternal bond of protection in *Mother and Child* **[15.14]** is emphasized by the mother's arms, strong forces of tenderness cradling the small baby.

The German Expressionists used distortion and exaggerated color not only to convey their own feelings but also as symbols of emotion. Emil Nolde (1867–1956) in his violent religious and moral works distorted the physical features of his figures to the point where they resemble animals, driven by greed, anger, or grief **[15.15]**. Some of these artists may have reached their greatest heights in their prints. Inspired by Japanese prints and perhaps drawing on their own medieval graphic tradition, they began to experiment with woodcuts, often using color in conjunction with strong black and white. They distorted figures to bring intense emotion to printmaking. Käthe Kollwitz (1867–1945) chiefly made black and white drawings and

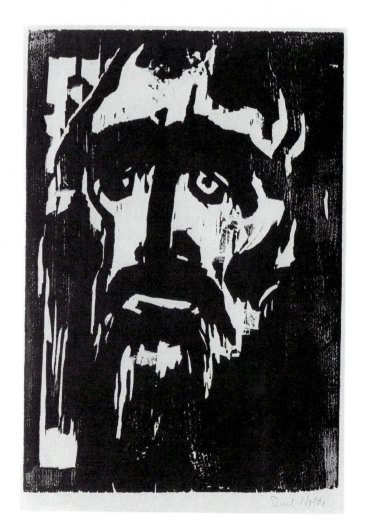

15.15 EMIL NOLDE. *PROPHET.* 1912. WOODCUT, 12-3/4 × 9″ (32 × 23 CM). NATIONAL GALLERY OF ART, WASHINGTON (ROSENWALD COLLECTION).

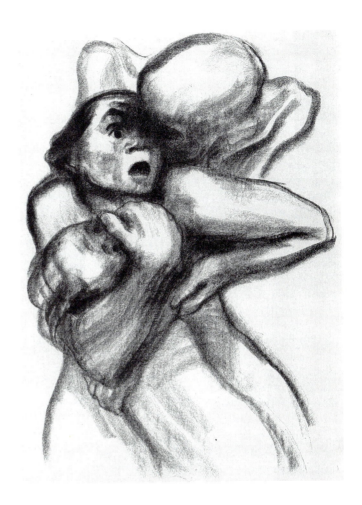

lithographs [15.16]. A champion of the poor and exploited, she poignantly depicted agonized mothers clutching starving children and peasants revolting against rapacious landlords. Other German Expressionists tempered in the crucible of war such as George Grosz (1893–1959) screamed their hatred of social apathy, militarism, and corruption in their works [15.17]. Thus the Expressionists continued the tradition of social protest introduced by Goya and Daumier a century earlier.

FANTASY IN ART

During World War I and the uneasy years that followed, when Europe was gripped by political tension, anxiety, and fear of revolution, many intellectuals and artists became disillusioned by traditional values. While Cubists, Futurists, and Expressionists sought different ways to represent the world and their feelings, others reached nihilistic conclusions. Their rejection of the world took the form of **Dada**, **Surrealism**, or other expressions of fantasy.

Dada

The movement known as Dada began with European poets, experimental writers, and artists arriving in neutral Zurich in 1915. To express their rebellion at the uselessness of war and the meaninglessness in what they saw in past art, they called their movement Dada, meaning nonsense like the babble of babies. The word was supposedly found by opening a dictionary at random, but probably it was carefully chosen. The founders were laughing at the pompousness of traditional artists and at the society that supported them. Unlike artists of the past, who presented viewers with images from their own culture, which they were expected to understand, Dadaists did not care to be understood. They felt they were living in an incomprehensible world bound for destruction. Nevertheless, they began to publish the journal *Dada* in 1917. Dada also flourished in New York, where European artists had settled during the war, and later in Paris. The movement ended in the 1920s, but its influence continued in Surrealism.

The Artist Sketch

Born in Dresden, Germany, Paula Becker became interested in art when whe was given art lessons at age sixteen, as part of her finishing school education. Overcoming her parents' resistance, she enrolled at twenty in the same art school for women attended nine years earlier by Käthe Kollwitz.

After two years of traditional instruction, Becker, like many other artists seeking a more natural way of living outside of civilization's weaknesses, joined an Expressionist artists' colony at Worpeswede in Northern Germany. On New Year's Eve, 1900, and also on other occasions over the next seven years, she went to Paris, the acknowledged center of the art world (perhaps since Louis XIV in 1666 had founded the Académie Royale). She joined other women working at the Académie Colarossi and later at the École des Beaux-Arts, once restricted to male artists.

With renewed confidence in herself, Becker returned to Worpeswede, to the school founded by Fritz Mackensen and Otto Modersohn. Amidst pressure from her

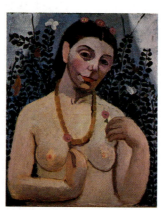

15.18 PAULA MODERSOHN-BECKER. *SELF PORTRAIT (HALF-LENGTH WITH AMBER NECKLACE)*. 1906. OIL ON BOARD, 24-1/2 × 18-7/8″ (62.2 × 48 CM). PRIVATE COLLECTION.

parents to abandon art and giving in to the recently widowed Modersohn's needs for a wife and mother to his children, in 1901 she was married. The marriage was not particularly fulfilling for her, and in 1903, she returned to Paris. Still under the spell of Cézanne, as can be seen by her own still-life paintings of this period,

she also discovered the arts of Japan, India, and Persia. When she saw the work of Van Gogh and Gauguin, she recognized a kinship with their interest in workers and people of the earth. She is probably the first German artist to incorporate Postimpressionist ideas into her work. During her third visit to Paris, she encountered the works of the Nabis, a radical group of artists and writers, attracted to Gauguin's primitivist-synthetist theories, and made plans to visit their studios, a step quite bold for a single, unescorted woman at that time.

Letters from Modersohn, whom she loved, brought her back briefly to Worpeswede and a group exhibition in which she was moderately praised by the local critic and by the poet Rainer Maria Rilke, also a resident of the small village. Becker's use of simplified shapes, heavily outlined contours, and modified color reveals her Postimpressionist style, but her strong feeling for maternity is unique.

Perhaps this self-fulfilling entry in her 1901 journal foretold her untimely death with the birth of her only child, at thirty-one: "I know I shall not live very long. But why should this be sad? Is a festival more beautiful for lasting longer? For my life is a festival. My sensual perceptions grow sharper, as though I were supposed to take in everything with the few years that will be offered me … " [15.18].

PAULA MODERSOHN-BECKER (1876–1907)

One of the founders of Dada in Zurich, who later became a Surrealist, was the painter and sculptor Hans (later Jean) Arp (1887–1966). He created some artworks by tearing or cutting paper and gluing the pieces as they fell onto a sheet of paper. He also favored paintings and then wood reliefs of amoebalike forms with curving contours, mushroom-shaped heads, and round-dot eyes or simplified egg or navel shapes. He abhorred contrived art. To him, art was "a fruit which grows out of a man like a fruit out of a plant or like a child out of a mother." In *Collage with Squares Arranged According to the Laws of Chance* he used flat, organic shapes of paper to make a small collage [15.19]. His love of nature is perhaps best expressed in his later stone sculpture, influenced by Surrealism, with its sensuous and organic forms as smooth and simple as waterworn rocks. Arp's free-form shapes have inspired contem-

porary industrial design such as that of cocktail tabletops, but they have been so much modified by poor imitations that much of their early impact has been lost.

Working with similar motifs in her paintings, Sophie Taeuber-Arp (1889–1934), wife of Hans Arp, also created a prodigious range of works, including weaving, embroidery, stained glass, collage, and wood reliefs. She and her husband shared a creative relationship that inspired productivity in both.

One of the pioneers in Dada who worked both in New York and in Paris was Marcel Duchamp (1887–1968). According to him, "Dada was a way to get away from clichés—to get free." He had left behind his Cubist- and Futurist-inspired paintings such as *Nude Descending a Staircase (No. 2)* [2.46] to comment on the results of the machine age. Like Picasso and Braque, he also worked in collage. In

1913 he had glued string onto a canvas and combined it with paint and varnish to recreate the childhood memory of a chocolate-grinding machine repeated as part of *The Bride Stripped Bare by Her Bachelors, Even* [9.17]. This *Large Glass*, as it is also known, is in reality a mixed-media narrative about six bachelors courting the same pretty young woman—the eternal chase of male/female—and the lure of the bride who is not what she purports to be. Duchamp's art statements were there to be consulted and deciphered rather than glanced at. Out of such experiments he combined ordinary mass-produced objects into constructions, which he called ready-mades. His first construction consisted of a bicycle wheel fastened to a kitchen stool so that the wheel could be spun easily—a spoof on activity (possibly referring to the government) that gets nowhere, ending where it starts [15.20].

15.19 JEAN ARP. COLLAGE ARRANGED ACCORDING TO THE LAWS OF CHANCE. 1916–1917. TORN AND PASTED PAPER, 19-1/8 × 13-5/8″ (48.6 × 34.6 CM). COLLECTION, THE MUSEUM OF MODERN ART, NEW YORK. (PURCHASE).

With this new method of absorbing actual objects into compositions, painters had moved away from the mere representation of reality. The question became, "Where does reality end and art begin?" Dadaists believed that art begins with the artist's first choices. Duchamp's ready-mades emphasized his belief that there is no boundary between life and art, and his constructions expressed his disgust with the assembly-line production of material goods. In bringing together everyday experiences and common objects in new combinations, Duchamp was reflecting on the absurdity of human attachments to the mundane. He considered the creating of art the only worthy act.

15.20 MARCEL DUCHAMP. BICYCLE WHEEL. 1951. THIRD VERSION, AFTER LOST ORIGINAL OF 1913. ASSEMBLAGE: METAL WHEEL MOUNTED ON PAINTED WOOD STOOL, 50-1/2 × 25-1/2 × 16-5/8″. COLLECTION, THE MUSEUM OF MODERN ART, NEW YORK. (THE SIDNEY AND HARRIETT JANIS COLLECTION).

Mocking human attempts to find salvation through materialism, the New York Dadaist Man Ray (1890–1976) transformed manufactured objects, disturbing their accepted functions while delighting the viewer. He made a flatiron into a work of art by gluing a row of tacks to it. The success of this *Gift* led him to the next project. By adding to the pendulum of a metronome the photograph of an eye, the pendulum swayed rhythmically from side to side, keeping time with or without music [15.21]. Both of these objects echoed Duchamp's ready-mades, pleasing us by their unexpected contexts. The original title of the metronome with its vacillating eye was *Object To Be Destroyed*. With his encouragement, there have been numerous copies assembled in accord with Ray's instructions:

> Cut out the eye from a photograph of one who has been loved but is not seen any more. Attach the eye to the pendulum of a metronome and regulate the weight to suit the tempo desired. Keep going to the limit of endurance. With a hammer well aimed, try to destroy the whole with a single blow.

A useful object in the hands of a Dadaist becomes nonfunctional, leading us to consider whether people today may also become nonfunctional because of dependency on machines. Dadaist objects like these also posed another question—whether a culture that produces masses of material goods, frequently preferring the disposable item to the recyclable, has provided disposal space for that mountain of discarded junk. Meret Oppenheim (1913–1985) emphasized the Dadaists' sense of the absurd. In the spirit of Man Ray's *Object To Be Destroyed*, her *Object*, a fur-covered cup and saucer, mocked a pretentious society whose products could no longer function [15.22].

An outstanding German Dadaist was Kurt Schwitters (1887–1948), who deliberately threw out traditional notions of beauty as a gesture against artistic authoritarianism. He collected crumpled trash to make collages that hint at the disintegration of our civilization and perhaps of our personal values. In his home in Hanover about 1925, he built the first of three *Merzbau*. It was a spatial environment of little grottoes, assembled from refuse, which filled a whole room and the one above. Titled a "cathedral of erotic misery" and dedicated to his friends, it even incorporated bits of their discarded clothing cast in plaster [15.23].

Surrealism

In Paris in the 1920s a few Dadaists such as Francis Picabia (1879–1953) and Max Ernst (1891–1976), whose work we will study, and avant-garde writers such as André Breton brought their ideas together in a new literary and artistic movement called Surrealism. According to Breton's *Manifesto of Surrealism* (1924), the movement was based on the conviction that dreams and other nonrational mental processes were the most effective way to deal with life.

15.21 MAN RAY. *INDESTRUCTIBLE OBJECT (OR OBJECT TO BE DESTROYED)*. 1964. REPLICA OF 1923 ORIGINAL. METRONOME WITH CUTOUT PHOTOGRAPH OF EYE ON PENDULUM, 8-7/8 × 4-3/8 × 4-5/8" (22.5 × 11 × 11.6 CM). COLLECTION, THE MUSEUM OF MODERN ART, NEW YORK (JAMES THRALL SOBY FUND).

Influenced by the Austrian psychologist Sigmund Freud and the Swiss psychologist Carl Jung, Surrealist poets and painters tried to strip away the façades that often conceal our unconscious desires. They advocated spontaneous or automatic scribbles, doodles, or drips as a means of bringing such desires to light, and they gloried in the unexpected, the contrary, and the element of shock for shock's sake. In 1925 the Surrealists held their first group exhibition, including works by Jean Arp, Man Ray, Picasso, Giorgio de Chirico, Paul Klee, and Joan Miró. Not all these men continued to paint in the Surrealist manner, and others such as Dalí joined Surrealism later, but these painters formed the core of the movement.

Long before the appearance of Surrealism as a recognized style, people were interested in art inspired by dreams and the subconscious, as depicted in the early Renaissance *Garden of Earthly Delights* [13.21]. Later in the

15.22 MERET OPPENHEIM. *OBJECT (LE DEJEUNER EN FOURRURE)*. 1936. FUR-COVERED CUP, 4-3/8″ DIAMETER; SAUCER, 9-3/8″ DIAMETER; SPOON 8″; OVERALL HEIGHT 2-7/8″. COLLECTION, THE MUSEUM OF MODERN ART, NEW YORK (PURCHASE).

15.23 KURT SCHWITTERS. *MERZBAU*. C. 1923–1936. (PHOTOGRAPH C. 1933). HEIGHT 13′ (3.93 M). DESTROYED. SPRENGEL MUSEUM, HANNOVER.

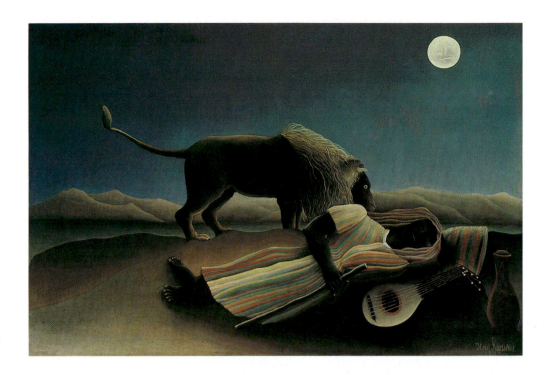

15.24 HENRI ROUSSEAU. *THE SLEEPING GYPSY*. 1897. OIL ON CANVAS, 4'3" × 6'7" (1.46 × 2 M). COLLECTION, THE MUSEUM OF MODERN ART, NEW YORK. (GIFT OF MRS. SIMON GUGGENHEIM).

nineteenth century the self-taught artist Henri Rousseau (1844–1910) painted an enchanted dream world. A customs inspector, unspoiled by exposure to traditional artistic conventions, Rousseau painted exotic canvases, such as *The Sleeping Gypsy*, which anticipated the limitless space of Surrealist paintings **[15.24]**. We delight in the paradoxical relationship of the woman and the lion, brightly illumined by the moon's face in the deep azure sky.

An early twentieth-century forerunner of Surrealism was the Italian poet, novelist, and Metaphysical painter Giorgio de Chirico (1888–1978). He wrote,

"Everything has two aspects: the current aspect we see and the ghostly which only rare individuals see in moments of clairvoyance and metaphysical abstraction." Strongly affected by the classical architecture of his homeland, De Chirico believed that an understanding of architecture was vital to the painter and that a landscape enclosed in an arch acquired "a greater metaphysical value, because it is solidified and isolated from the surrounding space." He frequently used arches in his urban scenes to suggest timelessness and a sense of menacing loneliness. In *Gare Montparnasse*, distorted linear perspective creates an eerie

15.25 GIORGIO DE CHIRICO. *GARE MONTPARNASSE (THE MELANCHOLY OF DEPARTURE)*. 1914. OIL ON CANVAS, 4'7-1/8" × 6'5-8" (1.4 × 1.84 M). COLLECTION, THE MUSEUM OF MODERN ART, NEW YORK (GIFT OF JAMES THRALL SOBY).

15.26 PAUL KLEE. *TWITTERING MACHINE. (ZWITSCHER-MASCHINE).* 1922. WATERCOLOR AND PEN AND INK ON OIL TRANSFER DRAWING ON PAPER, MOUNTED ON CARDBOARD, 25-1/4 × 19″. COLLECTION, THE MUSEUM OF MODERN ART, NEW YORK. (PURCHASE).

15.27 MARC CHAGALL. *THE THREE CANDLES.* 1939. OIL ON CANVAS, 4′3-1/4″ × 3′2″ (1.3 × .96 M). CORPORATE ART COLLECTION, THE READER'S DIGEST ASSOCIATION, INC.

space, broken only by shadows cast by empty buildings, with tiny figures, a train, and a clock ticking off the minutes before departure [15.25]. These same images are repeated in other works where a distant horizon and empty city express the infinite time and space of the subconscious mind.

The Swiss artist Paul Klee (1879–1940), who taught at the Bauhaus, combined aspects of the nonobjective, Expressionistic color, and elements of fantasy and humor that link him with Dada and Surrealism. He believed there is a kind of laughter that "can be put on the same dignified level as higher lyrical emotions." Certainly his watercolor *Twittering Machine* [15.26] and his many etchings make us smile with a sense of delighted discovery. As a Surrealist, Klee believed in the importance of intuition as opposed to analysis. He tried to avoid the burden of historical styles by dipping into the art of children and "primitives," that is, people without art training. He wrote, "Everything vanishes around me and good works rise

from me of their own accord. … It is not my head that functions but something … more remote." To keep in touch with his subconscious, Klee left himself open to new associations throughout the painting process. He rarely knew at the start of a work what might emerge, but developed in a splash of color or a line images as they suggested themselves. He titled the work after he had finished it.

Instead of expressing Surrealist anxiety and pessimism, Marc Chagall (1889–1985) painted his feelings of joy, festivity, and love with a sensuous delight in color and texture. His works, based on memories of his childhood in a Russian Jewish family, are steeped in folklore and the mystical Hasidic tradition. He filled his canvases with fiddlers, Talmudic scholars, peasant women, and floating cows and roosters. In his fantasies, Chagall is close to Henri Rousseau, and his works are richly personal. His portrait of himself with his wife recreates for us all the irresistible euphoria of love [15.27].

15.28 SALVADOR DALÍ. *THE PERSISTENCE OF MEMORY.* 1931. OIL ON
CANVAS, 9-1/2 × 13" (24 × 33 CM). COLLECTION, THE MUSEUM OF
MODERN ART, NEW YORK (GIVEN ANONYMOUSLY).

15.29 MAX ERNST. *ATTIREMENT OF THE BRIDE.* 1940. OIL ON
CANVAS, 51 × 37-7/8" (129.6 × 96.3 CM). PEGGY GUGGENHEIM
COLLECTION, VENICE.

The Spanish painter Salvador Dalí (b. 1904–
1989), whose explanations of his paintings are purposely
enigmatic, declared, "All men are equal in their madness."
His paintings reflect this view. Brilliant and arrogant, Dalí
has been a master at publicizing himself and is, probably,
the best known of the Surrealists. He joined the movement
late, and many consider him too theatrical to be taken
seriously. Technically skilled, he created precisely deline-
ated, dreamlike landscapes filled with unexpected images.
In *The Persistence of Memory* **[15.28]**, time wilts in a limit-
less desert; ants cavort in an empty watch case; and a
warped headlike image in the foreground, said to be a self-
portrait, suggests the last remnant of a vanishing humanity.

Spaniard Joan Miró (1893–1983) used abstracted
images in his inventive, poetic paintings, which Surrealis-
tically combine humor and horror. Some of the images are
recognizable, while others are strange forms, which he said
he saw in hallucinations as a starving young artist. About
Carnival of Harlequin **[2.47]** he wrote, in flamboyant Surre-
alist prose:

> The ball of yarn unraveled by the cats dressed as Harle-
> quins of smoke … throbbing like the throat of a bird at
> the contact of a woman … at this period I plucked a
> knob from a safety passage which I put in my eye like a
> monocle … which dives into the phosphorescent ocean
> after describing a luminous circle.

Miró was trained in Spain in the academic tradition, and
there is nothing undisciplined about his seemingly childlike
paintings. Although he was anti-intellectual, passionately
fond of color, and hostile to tradition, he produced paint-
ings, sculpture, lithographs, and ceramics that are subtle
and brilliantly structured. He was also active in theater and
ballet, designing sets and costumes for the famous ballet
company of Serge Diaghilev, and it is from this period that
Carnival of Harlequin dates. Of all the Surrealists, Miró per-
haps had the strongest influence on painters of the later
abstract expressionist movement.

Perhaps the most creative artist in early Dada and
later Surrealism was Max Ernst (1891–1976). By combin-
ing media such as collage with **frottage**, the process of
transferring rubbings by pressure from one surface onto an-
other, he produced a unique work in oil on canvas that is
surely not to be believed. The richness of his images lie in
his uncanny ability to assemble from disparate sources a
situation that intrigues and might indeed be a dream born
of a romantic imagination **[15.29]**.

The Belgian Surrealist René Magritte (1898–
1967) also used unexpected and disturbing images in his
paintings. Heavy rocks float lightly through soft blue skies;
or a room as perfect in scale and detail as a Van Eyck inte-
rior **[13.18]** may contain a huge apple, which almost
reaches the ceiling. A closet full of discarded clothes may
bulge with invisible human forms, becoming a chronicle of
past events. Painted in a meticulous, realistic style, most of
Magritte's works present the incredible as an accomplished

15.30. RENÉ MAGRITTE. *THE CASTLE OF THE PYRÉNÉES.* 1959. OIL ON CANVAS, 6′6-3/4″ × 4′9-1/8″ (2.0 × 1.45 M). ISRAEL MUSEUM, JERUSALEM (GIFT OF HARRY TORCZYNER, NEW YORK, TO THE AMERICAN FRIENDS OF THE ISRAEL MUSEUM, 1985).

fact. Alternating truth with illusion, Magritte makes us suspicious of both the painted and the real world. He presents us with a world in which we see his dreams become real objects and his objects become dreams [15.30].

The Surrealist current may be said to continue in the paintings of the Irish-born Francis Bacon (1910–1992), who uses the past as a basis for his works but transforms

them through his own inward vision of personal torment. As part of a series of works on the Crucifixion, one of his characteristic themes, he painted *The Butcher.* The figure's solid form recalls Giotto. Under an umbrella, the gaping mouth howls in grief, surrounded by nightmarish carcasses, stretched and pinioned. This work reveals Bacon's superb skills as a painter, his foundation in realist tradition, and an

15.31 FRANCIS BACON. *PAINTING.* 1946. OIL AND PASTEL ON LINEN, 6'5-7/8" × 4'4" (197.8 × 132.1 CM). COLLECTION, THE MUSEUM OF MODERN ART, NEW YORK (PURCHASE).

acute sense of the horrors of the painful world he experienced [15.31].

Sculpture

Until the twentieth century, sculptors had carved or cast figures that relied on visually solid volumes surrounded by space. At the beginning of the century, many sculptors continued that tradition, exemplified by Rodin. In the new age, however, the changing concepts of space and motion that affected painting also affected sculpture. Avant-garde sculptors reached for different images, techniques, and materials, as we saw in Chapter 6.

Futurism

One of the first sculptors to break with the past was Umberto Boccioni (1882–1916), whose *Manifesto* of 1912 announced Futurism. His *Unique Forms of Continuity in Space* [15.32] depicts a figure rushing forward in violent motion. Expressive as it is, with very strong, forward-thrusting diagonals, the cubistic figure is impersonal. Boccioni was inter-

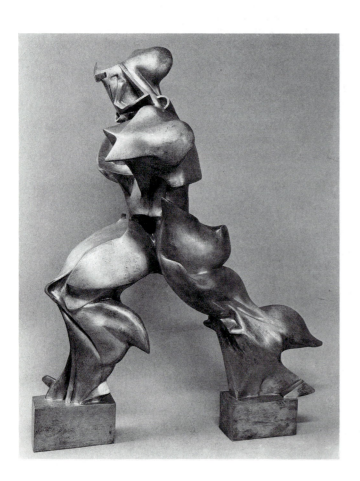

ested in movement in the abstract and arranged the shapes to convey the impression of action. The Futurists set out to make of Italy, where the style was born, a Utopia of tension and transformation whose god was machine-created movement (and speed).

Cubism

The Cubist movement freed many sculptors from traditional imagery. Jacques Lipchitz (1891–1973) at first created flat forms that seemed to be almost literal translations of Cubist paintings into sculpture. Later he developed a personal style in which he combined Cubist simplification with his own ideas about birth, growth, and death. Also affected by African art, he searched for a way to reconcile

15.32 UMBERTO BOCCIONI. *UNIQUE FORMS OF CONTINUITY IN SPACE.* 1913. BRONZE (CAST 1931). 43-7/8 × 34-7/8 × 15-3/4" (101 × 88 × 40 CM). COLLECTION, THE MUSEUM OF MODERN ART, NEW YORK (ACQUIRED THROUGH THE LILLIE P. BLISS BEQUEST).

human forms with the new geometry of the machine. His bronze, robotlike *Figure* [15.33] is composed of biomorphic (organic) shapes, yet in its stark simplicity suggests an ominous, machinelike force.

An academically trained Rumanian, Constantin Brancusi (1876–1957), joined the radical young artists working in Paris. Although he was concerned with the machine age, African art, and Cubism, he never gave up his deep involvement in the natural world. His renowned *Bird in Space* [15.34] explores forms in movement in quite a remarkable way, expressed with Cubist simplification of masses. Also related to the Cubist simplification of form and to the elongation of features seen in Sudanese masks, Amedeo Modigliani's work, seen earlier [15.12], demonstrates the influence of African art while expressing its own sensuous qualities.

Constructivism

An even more radical break with tradition was Constructivist sculpture. No longer dependent on carving, model-ing, or casting but moving into a new technical area, these sculptures consisted of constructions, or assemblages of pieces of wood, metal, plastic, or other materials. Constructivist space between solid forms and seen through transparent planes was composed as carefully as the forms themselves.

Constructivism began in Russia, where two brothers, Naum Gabo (1890–1977) and Antoine Pevsner (1886–1962), were attracted to the analytical approach of Cubism and to new arenas of technology. In 1920 they wrote *Realistic Manifesto*, in which they declared that sculpture need no longer describe reality but must be in harmony with engineering technology. When the Soviet government insisted on a return to traditional, conservative arts, they, like Kandinsky, left for the West, where their ideas were well received by avant-garde artists. Pevsner's *Torso* [15.35] used Cubist-inspired planes to recreate the concave and convex forms of the human body out of sheets of copper and plastic. The transparency of the plastic denied the solid aspects of traditional sculpture. Even more revolutionary was Gabo's *Linear Construction No. 1*

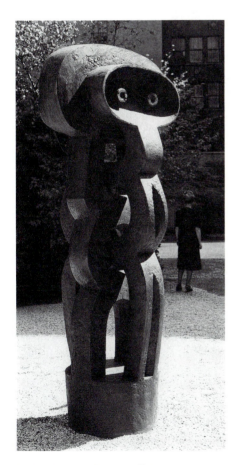

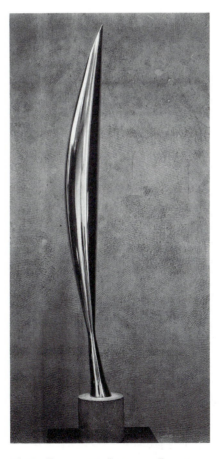

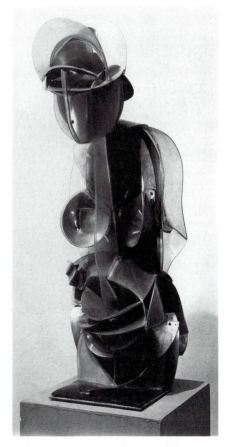

15.33 JACQUES LIPCHITZ. *FIGURE.* 1926–1930. BRONZE (CAST 1937), 7'1-1/4" × 3'2-5/8" (2.17 × .99 M). COLLECTION, THE MUSEUM OF MODERN ART, NEW YORK (VAN GOGH PURCHASE FUND).

15.34 CONSTANTIN BRANCUSI. *BIRD IN SPACE.* 1928. BRONZE (UNIQUE CAST), 54 × 8-1/2 × 6-1/2". COLLECTION, THE MUSEUM OF MODERN ART, NEW YORK (GIVEN ANONYMOUSLY).

15.35 ANTOINE PEVSNER. *TORSO.* 1924–1926. CONSTRUCTION IN PLASTIC AND COPPER, 29-1/2 × 11-5/8 × 15-1/4". COLLECTION, THE MUSEUM OF MODERN ART, NEW YORK (KATHERINE S. DREIER BEQUEST).

[15.36], which consisted of a plastic frame threaded with nylon. Like Cubist painters, both sculptors were concerned with overlapping and combining multiple views of the same, usually geometric, subject as well as with the relation of mass and interior and exterior space.

Both Cubism and Constructivism influenced the work of the outstanding British sculptor Barbara Hepworth (1903–1975). Using highly polished marble, wood, and bronze, she sculpted abstract geometric forms, which were usually pierced or hollowed out in order to incorporate space within their design. Her *Single Form* (Dag Hammarskjöld memorial) [15.37] may be her most highly regarded sculpture. She wrote of it:

> I had to work to the scale of twenty-one feet and bring into my mind everything … taught me about stress and strain and gravity and wind force. Finally all the many parts were got out of St. Ives safely, and when assembled, … they stood in perfect balance. This was a magic moment.

Realism

The human body has been the main subject of figurative sculpture since ancient times. It has been treated in a variety of ways. Egyptian sculptors carved massive stone stat-

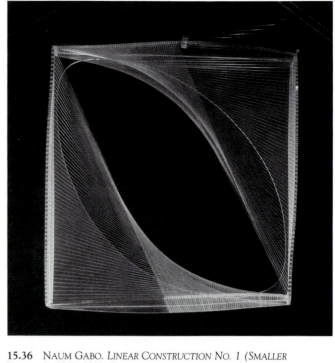

15.36 Naum Gabo. *Linear Construction No. 1 (Smaller Version)*. 1942–1943. Plexiglass and nylon thread on Plexiglas base, 12-1/4 × 12-1/4 × 2-3/4″ (31 × 31 × 6 cm). Hirshhorn Museum and Sculpture Garden, Smithsonian Institution, Washington (Gift of Joseph H. Hirshhorn, 1966).

ues, abstracted in form and exaggerated in scale, to glorify their rulers and gods. Classical Greek statues of gods and heroes, subtly elegant exemplars of moderation, show the body in a state of balance between energy and repose. Medieval sculpture, chiefly for the Church, portrays the human figure symbolically in conflict between yearning for heaven and earthly temptation. The open sexuality of an Indian goddess was intended to remind the viewer of his or her oneness with the universe. In nineteenth-century Europe, Rodin's sculpture expressed his interest in psychology and movement.

In the twentieth century, we have seen the concept of the figure changed radically. Reflecting the machine age, the body was abstracted and almost dehumanized by Cubist sculptors and ignored by Constructivists. Other sculptors, however, remained closer to the figurative tradition. The fertility symbol first seen in the prehistoric *Venus of Willendorf* [1.21] reappears in the work of Gaston Lachaise (1882–1935). Throughout most of his career he was obsessed by the image of the female nude, always modeled by his wife. He saw her as a gross maternal figure with mountainous breasts and thighs, but her delicately tapered arms and legs give her an almost

15.37 Barbara Hepworth. *Single Form*. 1964. Bronze, height 21′. United Nations Plaza, New York.

15.38 GASTON LACHAISE. *STANDING WOMAN.* 1932. BRONZE, HEIGHT 7′4″ × 3′5-1/8″ × 1′7-1/8″ (2.24 × 1.04 × 0.48 M). COLLECTION, THE MUSEUM OF MODERN ART, NEW YORK (MRS. SIMON GUGGENHEIM FUND).

classical elegance. She sits in a chair, floats on a high pedestal [2.18], or stands [15.38].

One of the most creative of the figurative sculptors was Henry Moore (1898–1981), the son of an English coal miner. Unlike the work of his friend and colleague Barbara Hepworth, Moore's work is highly organic. He was interested in the biological structure of the body and the connections between its forms and the natural world. He explored these relationships in wood, stone, and bronze, handling each with a deep sensitivity to its innate characteristics.

Moore developed his style to express an association of the body with the universal mystery of life and to separate it from the emotions of the individual. Often he reduced the head, concentrating instead on the shafts and terminals of the body structure, which is mainly shown

15.39 HENRY MOORE. *RECLINING FIGURE.* 1935. ELM WOOD, 19 × 35 × 15″ (48 × 89 × 38 CM). ALBRIGHT-KNOX ART GALLERY, BUFFALO (ROOM OF CONTEMPORARY ART FUND, 1939).

reclining [15.39]. Like the Constructivists, he brought space into sculpture. He created great hollows in the middle of his figures, sculpting strong rhythmic volumes and spaces that suggest the openings of the living body and emphasize sexual associations but may also recall caves and holes in rocks and trees. One of the most pervasive influences in Moore's work was the *Chac Mool* [15.40], a massive pre-Columbian stone figure of a rain god from Mexico that lies on its back and has a hollowed-out abdomen. Echoed in the simplified forms of his figures, their groupings suggest timeless mountains as well as the solidity of the bony structure under the flesh.

Two influential Continental sculptors, Marino Marini (1901–1980) and Alberto Giacometti (1901–1966), used the human figure expressively to comment on human isolation and fear. In the tradition of Rodin, both emphasize surface textures. Having absorbed Surrealist attitudes as well as influences from early Italian figure sculpture, their styles are nonetheless quite personal.

Although Marini's subjects included female figures and portraits, he is best known for his bronzes of men on horses—forms that seem linked to the Etruscan sculpture of his native Tuscany. The sense of isolation and fear projected by these anonymous riders is not accidental. Marini

15.40 CHAC MOOL (RAIN GOD) FROM CHICHÉN-ITZÁ, MEXICO. MAYAN-TOLTEC, 900–1300 A.D. LIMESTONE, HEIGHT 42-1/8″ (107 CM). COURTESY OF THE AMERICAN MUSEUM OF NATURAL HISTORY, NEW YORK.

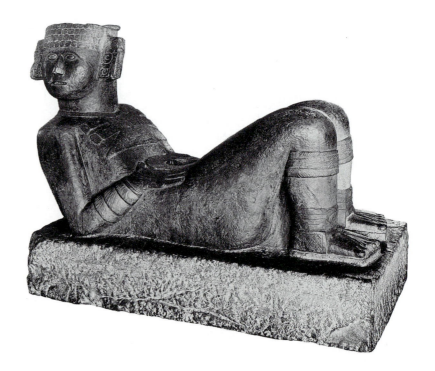

watched Italians fleeing from wartime air raids; the frightened way they looked upward to watch the sky for bombers became an important gesture in his sculpture—expressing human helplessness [15.41]. In his later years his images became increasingly violent. The stumplike vestiges of feet and hands suggest mutilation of bodies by war and make his figures appear even more isolated and mute.

Giacometti, the son of a Swiss painter, created a new human image in his emaciated bronze figures that stand so stiffly and face us so directly. The attenuated forms in *City Square* [2.19] appear almost like shadows that float across the flat plane of the street. The five figures, captured in a momentary encounter, seem unable to experience any real interchange. Large or small, in groups or by themselves, Giacometti's forms seem lonely and alienated. He has exaggerated the distance between subject and viewer by erasing the nonessential details of the body, thereby increasing its sense of isolation.

ARCHITECTURE

We saw in Chapter 7 how consideration of structure, function, and space was related to the development of new building materials and engineering methods in the nineteenth century. Louis Sullivan, who used new techniques in his tall steel-frame buildings [7.21], made a statement that widely influenced twentieth-century architecture: "Form follows function." That is, an architect should consider the function of a building and then design a form to suit the function rather than deciding on a Neoclassical temple design, for example, and forcing a modern bank to fit into it.

As early as the 1900s in France, Auguste Perret (1874–1954) was using reinforced concrete frames and nonsupporting, or curtain, walls, to leave building interiors free to be divided into a combination of rooms. In Germany, Peter Behrens (1868–1940) and Walter Gropius (1883–1969) were using the same technique to construct functional buildings with clean, almost mechanical lines. Gropius, in collaboration with Adolf Meyer (1881–1929), carried a curtain wall of glass windows out to the corners of the Fagus Shoe Factory in Alfeld-an-der-Leine. This device made possible simultaneous views of the interior and exterior, as in the shifting planes of a Cubist painting, and at the same time achieved an appearance of lightness. In the United States, Frank Lloyd Wright was experimenting with functional buildings, Cubist planes, and cantilevering [7.15]. This ferment of new ideas influenced artists, who in turn influenced architects. In fact, architects, artists, and designers often knew each other and were familiar with one another's published works.

The Bauhaus and the International Style

Many of these ideas flourished in the **Bauhaus**, a school of design founded by Gropius in Weimar, Germany, in 1919

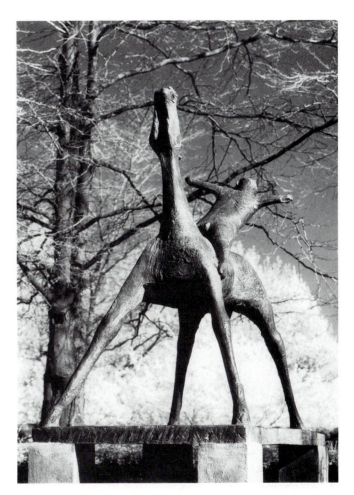

15.41 MARINO MARINI. *HORSE AND RIDER.* 1952–1953. BRONZE, 6′10″ × 6′9″ × 3′10-1/2 (2.8 × 2.06 × 1.18 M). THE HIRSHHORN MUSEUM AND SCULPTURE GARDEN, SMITHSONIAN INSTITUTION, WASHINGTON.

from two earlier schools of arts and crafts. Here art, technology, and business were brought together in an attempt to apply principles of good design to industrial production. Artists from Germany, Russia, the Netherlands, and Switzerland joined the faculty to develop an **International Style** of architecture and design, which gradually spread throughout the industrialized world.

Fundamental to Bauhaus teaching was Sullivan's principle that form follows function and William Morris' belief that utility and aesthetics could be integrated. Rather than returning to old craft-guild concepts that Morris had promoted, however, the school looked forward, embracing modern technology and materials. It explored new approaches to printing, metalwork, weaving, pottery, and stagecraft, as well as architecture. The faculty included such prominent figures as the painters Kandinsky and Klee and the designers and architects Ludwig Mies van der Rohe and Marcel Breuer. Gropius declared:

We want to create a clear, organic architecture whose inner logic will be radiant and naked, unencumbered by

lying façades and trickiness; we want an architecture adapted to our world of machines, radios, and fast motor cars, an architecture whose function is clearly recognizable in the relation of its form.

Basic to the new style was the use of a weight-bearing cage, or frame, on which the outer, non-weight-bearing walls could be hung. These **curtain walls** could be made of any material that would serve to enclose space. As a result, windows and doors could be enlarged almost indefinitely, while the reduction of interior supports allowed the inside of the building to be rearranged at need. The new International Style avoided applied decoration. Gropius believed that aesthetic satisfaction in a building could be achieved through a balance of solids and spaces. Nothing more was needed to make a building beautiful.

When the Bauhaus was moved to Dessau in 1925, new administrative offices, classrooms, studios, workshops, a library, and living quarters for faculty and students were needed. Instead of attempting to fit these varied areas into a group of Gothic or Neoclassical buildings, Gropius designed a new building, using new engineering methods, that honestly served its varied functions and reflected them in its design [15.42]. Beginning with an open box as the basic unit, Gropius varied its volume according to its potential use and then grouped the boxes into a pleasing three-dimensional composition that suggested the crisp rectangles of a Mondrian painting.

Impressed with Mondrian and the style of Cubism he had studied, a young Dutch architect, Gerrit Rietveld (1888–1964), demonstrated both influences in his work. Among his most important commissions was Schröder House, which looks in some ways like a Mondrian painting

translated into three dimensions. The rhythmically balanced façade is based on Mondrian's principles of dynamic equilibrium. Painted in bright colors to accent the breakup of space, the parts appear capable of adjustment, but the truth of the matter is that the composition would require total renovation should any element be adjusted [15.43]. On the other hand, the interior space can be configured in many ways to suit the artist-owner's needs. The flexibility makes possible an open floor plan that shares spaces.

Ludwig Mies van der Rohe (1886–1969), who became director of the Bauhaus after Gropius, refined the International Style, bringing to it an elegance through use of light-reflecting materials and subtle detail. His German Pavilion at the International Exhibition in Barcelona in 1929 (since destroyed) was the archetype of the International Style [8.35]. The long, low, open building conveyed a quality of serenity through its clean lines, refined details, and sensitive use of materials. Its interior spaces were defined, without being isolated, by chrome-plated steel supports, glass walls, and marble panels. These surfaces contrasted with one another and with the open expanse of the pool in the court. Mies's famous Barcelona chair [8.33], designed for this pavilion, can be seen through the glass wall, expressing the Bauhaus ideal of carrying good design throughout a work.

Because of its progressive ideas and its many Jewish faculty, Hitler closed the Bauhaus in 1933. Many of its faculty came to the United States, where they taught Bauhaus principles and continued to work in the International Style. In his buildings for the Illinois Institute of Technology in Chicago, his Lake Shore Apartments in Chicago, and the Seagram Building in New York, Mies integrated concrete, steel, and glass into refined, rational composi-

15.42 WALTER GROPIUS. BAUHAUS, WORKSHOP WING. DESSAU, GERMANY. 1925–1926. PHOTOGRAPH COURTESY THE MUSEUM OF MODERN ART, NEW YORK.

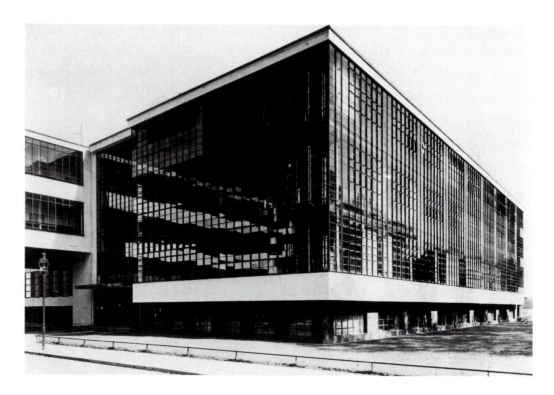

tions. Gropius and Marcel Breuer (1902–1981) designed low, cubistic houses. Breuer's tubular metal chair **[15.44]**, first made in Germany, and Mies's Barcelona chair were mass produced, as were lamps and other objects that showed Bauhaus influence. Herbert Bayer (1900–1985), also from the Bauhaus faculty, influenced typography and advertising design.

Frank Lloyd Wright and the Organic Style

An American pioneer in early twentieth-century architecture was Frank Lloyd Wright (1869–1959). Although he affected the International Style, he despised it and developed a personal style that never fit into any category. Brilliant, rebellious, and innovative, he was influenced by Sullivan, with whom he studied. Like Sullivan he believed that buildings should openly reflect the functions they are intended to perform but deplored the ferroconcrete boxes produced by the International Style. Wright designed the Imperial Hotel in Tokyo around an open court, adapting Oriental decorative details; he also built it according to a structural system that enabled it to withstand the devastating earthquake of 1923. (It was razed in 1968 only to make way for a larger hotel.) Wright also believed that a building should reveal the materials with which it is constructed. For example, stone should look like stone and be used as a means of support rather than to conceal modern structural systems. In the same way, he believed that ferroconcrete building blocks should not pretend to be anything else.

In addition, Wright always respected nature and people's spiritual needs. Rejecting the European idea that buildings should function like machines, he believed that a

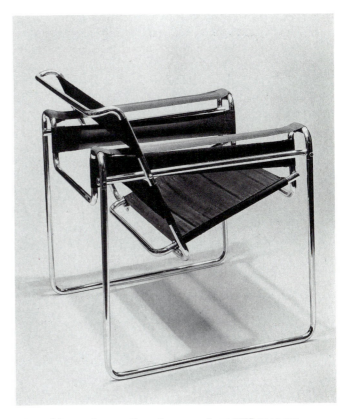

15.44 MARCEL BREUER. *CLUB ARMCHAIR.* LATE 1927 OR EARLY 1928. CHROME-PLATED TUBULAR STEEL WITH CANVAS SLINGS, 28-1/2 × 30-1/4 × 27-3/4". COLLECTION, THE MUSEUM OF MODERN ART, NEW YORK (GIFT OF HERBERT BAYER).

15.43 GERRIT RIETVELD. SCHROEDER HOUSE.

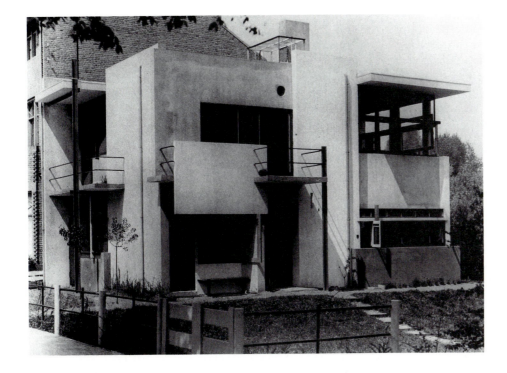

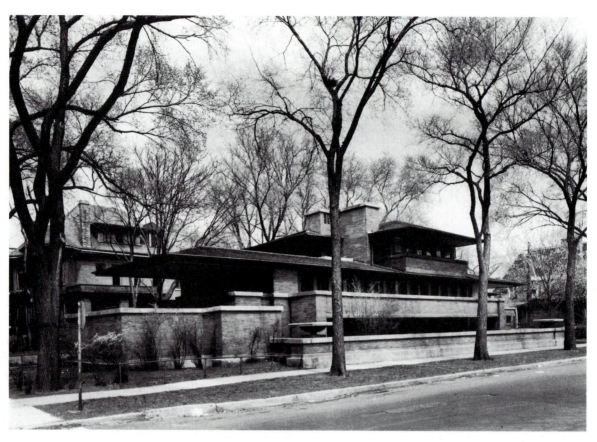

15.45 Frank Lloyd Wright. Robie House, Chicago. 1909. Photograph courtesy The Museum of Modern Art, New York.

house should provide for the spirit as well as the body. Strongly influenced by Japanese architecture, he was convinced that people must keep alive their relation to the natural world. Therefore he gave his houses an organic, growing quality by often using wood and stone and designing them to fit naturally into their surroundings while accommodating the special needs of the occupants. The long, low lines of the early ranch-style Robie House in Chicago [15.45] are integrated with the flat site, and the later Kaufman House in Bear Run, Pennsylvania, is cantilevered over a waterfall [7.16].

Wright's designs evolved over the years. In the 1920s, for example, his buildings were massive rectangular forms as a result of his experimenting with poured concrete and patterned concrete blocks. Decorative elements were provided by the texture of the materials and the interplay of blocklike masses and open space. The glass and cantilever construction of the Kaufman House suggests the machine-oriented International Style. Nevertheless, his basic philosophy was maintained.

Wright was once asked by a student how to develop an original personal style. He responded briefly, "You can't. I invented the new architecture at the turn of the century. All you can do is learn its principles and work them." Arrogant though the statement was, there was

truth to it; Wright's buildings radically altered the course of architecture in the twentieth century.

Le Corbusier and the International Style

In France, Le Corbusier (1887–1965), who had worked with Behrens, was also designing innovative, functional buildings in the International Style. He used his knowledge of modern engineering techniques to open up his buildings and introduce light, air, and sun. He saw a house as "a machine for living in," believing it should function no less than a machine. In his influential book *Towards a New Architecture* (published in French in 1923), he urged architects to move away from an architecture stifled by custom and to study ocean liners, airplanes, and automobiles instead. His Villa Savoye in Poissy, France [15.46], one of the outstanding examples of the International Style, illustrates these beliefs.

The concrete and glass structure is close to the purist ideals of Mondrian, and the combination of its curved forms and rectangles suggests Le Corbusier's interest in ocean liners. The Villa Savoye has none of Wright's respect for site; instead, raised on posts, it seems to float above the earth, suggesting the rootless, transient quality of modern life. Many of its features, such as the posts and the windows

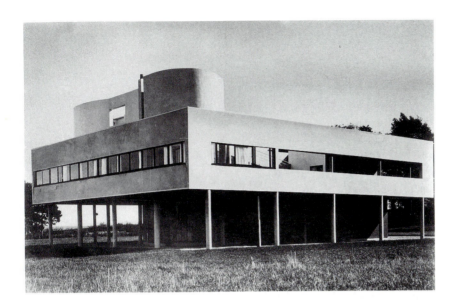

15.46 LE CORBUSIER. VILLA SAVOYE, POISSY-SUR-SEINE, FRANCE. 1929–1930.

in horizontal strips, were adapted by later architects. Wright derisively referred to Le Corbusier's buildings as "boxes on stilts," but they may have influenced his Kaufman House [7.16].

Le Corbusier's influence on architecture was immense, but perhaps in the long run he will be remembered best for his social philosophy. He believed that not only the rich, who could afford houses like the Villa Savoye, but *all* human beings are entitled to live in buildings that will surround them with space and beauty. Dedicated to this ideal, he planned groups of inexpensive, mass-produced houses made of reinforced concrete. These houses were designed to provide comfortable living in units, which could be divided inside according to the needs of each family. As the movement of population to cities progressed and space became scarce, he gave up his early row-house concept and built vertical apartment towers surrounded by open space. These structures are discussed in Chapter 7.

The work of these internationally active architects, and others who adopted their philosophies, has profoundly affected our lives. Thousands of useful objects and buildings in the last several decades have been influenced by them. Out of the chaos of changing needs, changing materials, and changing art of the twentieth century, these creative minds brought a measure of logical order, through architecture, into our world.

EXERCISES AND ACTIVITIES

Exercises for Research and Discussion

1. Trace the growth of one new style of art that emerged during the first two decades of the twentieth century. Discuss in detail two artists who worked in that style.

2. Explain in what way exposure to African art was an important force in the development of twentieth-century art; give examples. Explain what aspects of Oriental art influenced twentieth-century artists.

3. Search for and quote passages of poetry or fiction that deal with the same themes as those that appear in Surrealism and Dadaism.

4. What is the International Style? How did the style start, and how did it influence painting, architecture, sculpture, and the industrial arts?

5. What was the Bauhaus? How did it influence twentieth-century art? Cite examples.

Studio Activities

1. Draw a composition in the style of Cubism, superimposing in one drawing at least three views of an object. Include interior and exterior aspects and top, side, and front views, presenting a familiar object in a new way.

2. Create a construction of objects emphasizing nonart values.

3. The creation of the illusion of deep space has appeared throughout art history. What Surrealist painters used this technique? Create a composition in color or in black and white using perspective, changing hues, and values to create an illusion of deep space, but using images from the world of dreams and fantasy.

4. Using poster paints, create a simple still life in at least two of the styles that developed in the first quarter of the twentieth century.

5. Draw a floor plan of the Bauhaus in Dessau, Germany.

16

America Ascending: 1900–1945

"*B*orn into a place and an age in which space and time are our principal companions-in-concern, I find it inevitable to love them more than the solid materials with which my ancestors were involved."

—RICHARD LIPPOLD, 1973

• • •

"*T*he four large systems of commerce, museums, education and great bureaucracy exist, requiring art and artists. The integration of art into bureaucratic society … may destroy art."

—DONALD JUDD, 1984

1900	1925	1930	1935	1940	1945	1950	1955	1960	1970

THE VISUAL ARTS

1899 Eakins, *Mrs. Thomas Eakins* [16.1]
1926 O'Keeffe, *Yellow Calla* [16.3]
1930 Hopper, *Early Sunday Morning* [16.5]
1930 Wood, *American Gothic* [16.7]
1931–32 Shahn, *The Passion of Sacco and Vanzetti* [16.6]
1934 Douglas, *Aspects of the Negro Life* [16.9]
1936 Chaplin, *Modern Times* [16.26]
1936 Lange, *Migrant Mother* [5.11]
1937 Siqueiros, *Echo of a Scream* [16.13]
1937 Picasso, *Guernica* [I.15]
1942 Matta, *Disasters of Mysticism* [16.22]
1944 Gorky, *The Liver is the Cock's Comb* [16.16]
1946 Lawrence, *Going Home* [16.11]
1946 C. and R. Eames, plywood chair [8.27]
1948 Wyeth, *Christina's World* [3.18]
1948 Pollock, *Number 1 1948* [1.13]
1949 Kahlo, *Diego y yo* [16.14]
1950 Rivera, *History of Mexico* [I.3]
1950–52 De Kooning, *Woman, I* [16.19]
1952 White, *Preacher* [3.9]
1953 Albers, *Homage to the Square* [16.18]
1964 Bearden, *Prevalence of Ritual* [I.24]

HISTORICAL NOTES

1914 World War I begins
1917 USA enters war
1918 World War I ends
1925 Scott Fitzgerald, *The Great Gatsby*
1927 Al Jolson, *The Jazz Singer*
1929 Wall Street crash: Great Depression
1933 F. D. Roosevelt becomes president: New Deal
1936 Spanish Civil War begins
1939 World War II begins
1941 Japanese bomb Pearl Harbor; USA enters war
1943 Penicillin developed
1945 Germany surrenders
1945 USA drops atom bomb on Hiroshima
1945 Japan surrenders

AMERICA IN THE WORLD

After a brief euphoria following World War I, the world slowly slid into the Great Depression of the 1930s. Paris, where the arts had continued during the international conflict, resumed its position as the art capital, but, an ocean away, America's growing isolation had led our artists to develop their own art forms. As bankruptcy and unemployment gripped much of the country, social problems multiplied. In response, the arts in the United States became more socially conscious, increasingly realistic, and often nationalistic. The diversity of European art did not exist in this country. We can identify for the most part, however, the same basic trends that we have seen in European art—realism, derived from what already existed in America; Expressionism, with strong emotional overtones comparable to the European currents; formalism, with a concentration on design and color; and fantasy.

REALIST PAINTING

The *Réalisme* of Gustave Courbet (Chapter 14) found few European enthusiasts, but American tastes were more conservative. Even before the turn of the century, Thomas Eakins (1844–1916), trained in America but much influenced by historical painters of Europe, was established as an uncompromising realist. His fascination with photography had led to many experiments; he used some of his camera studies to prepare his paintings and others—like the series by Eadweard Muybridge [2.44]—to investigate movement. Eakins' style of precision and realistic details, shown in his portraits, were no doubt inspired by photography and influenced many American realist artists of the early twentieth century. In brilliant, raking light from the left, Susan Eakins [16.1] confronts the viewer with firmness and strength. Eakin's admiration for his wife at forty-seven appears as uncompromising as are the details he rendered of her dress, the open coat with the light on it and the scarf pinned in place.

During the first decades of the twentieth century, conservative American artists continued to follow the American academic rules, like those established by their counterparts in Europe where many Americans studied.

The Ash Can School and Modernism

The high caliber of late nineteenth-century realist painting developed by such artists as Thomas Eakins was coupled with growing interest in the camera—leading to an early twentieth-century movement (dubbed **Ash Can** by critics) that carried realism much further. Many, possibly drawing on their experiences as journalists, found themes for art in backyards, city streets, and bars. One of the most noted, John Sloan (1871–1951), produced paintings and etchings showing New Yorkers at work and play [16.2].

The year 1908 witnessed a group show of "Eight Independent Painters," including Sloan, that could be

16.1 THOMAS EAKINS. MRS. THOMAS EAKINS. C. 1899. OIL ON CANVAS, 20-1/8 × 16-1/8″ (51 × 40.8 CM). HIRSHHORN MUSEUM AND SCULPTURE GARDEN, SMITHSONIAN INSTITUTION. GIFT OF JOSEPH H. HIRSHHORN, 1966.

termed the twentieth century's first band of rebel realists committed to painting what they saw, not what society proclaimed to be aesthetic. With the Armory Show of 1913, which included the more radical European and American artists such as the Parisian Duchamp's nonconformist painting, *Nude Descending a Staircase* [2.46], America was faced with growing misgivings about academic teachings. The photographer and art pioneer Alfred Stieglitz's ground-breaking art magazine *Camera Work* quoted no less an authority than the conservative Metropolitan Museum of Art! Museum director, Sir Purdon Clark, went on record to address the mounting unrest of the art world by offering some support for modern art. From these beginnings, the American tradition of **Modernism** was born between 1908 and World War I. Predictably, perhaps, it was a group of young artists, newly exposed to radical European art, who were bold and uninhibited in testing those modernist idioms.

While many of us have grown accustomed to thinking about the highly publicized and world-accepted art of the late Georgia O'Keeffe, she was indeed an early Modernist, pioneering in her art and her life style as well.

16.2 JOHN SLOAN. *HAIRDRESSER'S WINDOW*. 1907. OIL ON CANVAS.
31-7/8 × 26″ WADSWORTH ATHENEUM, HARTFORD, CONNECTICUT.
THE ELLA GALLUP SUMNER AND MARY CATLIN SUMNER COLLECTION.

Georgia O'Keeffe, who began her career by teaching in West Texas, eventually settled in New Mexico, painting the barns, mountains, and bleached bones characteristic of the harsh, barren landscape of the Southwest. As she matured, other subjects concerned her such as flowers, New York skyscrapers, and even clouds seen from a jet plane. Well acquainted with European art currents, she presented all these objects, man-made and natural, from a distinctive point of view and in a precise personal style that gave them fresh meaning [16.3]. The natural smoothness of her technique and the extreme perspective and enlarged scale of the objects tend to convert most of her work into almost abstract images, in their starkness and intensity, which were often shocking to early viewers.

Closer to the mainstream of twentieth-century American realist art, Edward Hopper (1882–1967), perhaps influenced by the earlier Ash Can school, adhered to American realistic traditions, commenting on human isolation with paintings of empty city streets and lonely houses. Hopper, who supported himself for years as a commercial artist, insisted that his aim in painting was always "the most exact transcription possible of my most intimate impression of nature." While that may have been true, his sensitive eye carefully selected and reorganized colors, forms, and light patterns in order to convey a sense of poignancy. His point of view is that of a traveler who stands in the street watching the lives of other people through the windows of all-night cafés and empty-looking, flatly lit rows of apartments. In *Early Sunday Morning*

16.3 GEORGIA O'KEEFFE. *YELLOW CALLA*. 1926. OIL ON FIBERBOARD. 9-3/8 × 12-3/4″ (22.9 × 32.4 CM). NATIONAL MUSEUM OF AMERICAN ART, SMITHSONIAN INSTITUTION. GIFT OF THE WOODWARD FOUNDATION.

The Artist Sketch

Georgia O'Keeffe was always a very private person. From her first meeting in 1914 with Alfred Stieglitz, who would later become her husband, she found him very exciting, yet watched her friends asking him personal questions and backed away, thinking, "That isn't for me. Let them talk if they want to." Early on, however, she found she "could say things" with art that she could express in no other way.

With this realization, in 1917 she sent a bundle of her drawings to a Columbia University school friend, Anita Pollitzer, with instructions to show them to no one else. Thrilled with the work, Pollitzer took them instead to photographer Stieglitz at his 291 Gallery, a showplace for avant-garde art. He included the large, sensuous organic forms that O'Keeffe had called "Lines and Spaces in Charcoal" in his next group show. Despite her anger at what O'Keeffe saw as a betrayal of her trust, her relationship with Stieglitz ripened into marriage within seven years. From that point on—for almost thirty years—he was her chief advocate and photographer [16.4].

Born in Sun Prairie, Wisconsin, O'Keeffe retained all her life the spirit that burned best in vast empty space—like the six hundred acres of farmland where she grew up. In her youth and in her maturity at the Ghost Ranch in New Mexico where she spent most

16.4 ALFRED STIEGLITZ. *GEORGIA O'KEEFFE.* 1918. PHOTOGRAPH. THE METROPOLITAN MUSEUM OF ART. GIFT OF DAVID A. SCHULTE, 1928.

of her later life, she nurtured that need for individualism. She had once remarked, after studies at the Art Students League, that "a lot of people have done this painting before I came along." She destroyed all her work at that point and quit the League.

In the 1920s, O'Keeffe began painting blown-up images of dark-tissued iris and bone-white jimson weeds. With the flower paintings for which the artist is best known—images so large they crowd the picture plane— she found the idiom she was to retain through the years. Her work over the seventy or so years of her productivity indeed shows amazing consistency. Although she varied her interests from nature to "ideas in her head," those first abstract "Lines and Spaces in Charcoal" can be identified even by those familiar only with her last works.

As a girl, Georgia "was already known in her family for wild notions." She retained to the end an isolation and fierce disinterest in worldly involvement. Two years before her death, a Long Island exhibition of work of the two great matriarchs of twentieth-century art, O'Keeffe and Louise Nevelson, was planned. When asked for works that might be shown, O'Keeffe is said to have responded, "You can expect absolutely no help from me." Called a new woman of the twentieth century, she was known as an independent spirit to the very end.

GEORGIA O'KEEFFE (1887–1986)

[16.5], without seeing a single person, we sense the silent world of individuals caught in their own cycles of life and death. Each area of the painting is reduced to the essentials, and the bare windows and empty shops are organized into a quiet, almost formal vertical and horizontal composition that implies, rather than depicts, the loneliness behind drawn shades.

Social Protest

With the Great Depression, Americans turned inward, frightened and disillusioned by the failure of the economy. The stock market crash of 1929 meant that people could no longer depend on limitless material progress to provide security. Businesses failed and unemployment spread. Artists stood in bread lines with factory workers. To give some

artists employment the Works Progress Administration (WPA) commissioned them to paint murals in public buildings. This was the first broad governmental program of support for the arts in U.S. history.

Many artists turned to social issues for their subject matter. Before the 1930s, most artistic expressions of political and social criticism in the United States had been limited to cartoons. But the Depression inspired the first American movement that combined serious art with social protest in the tradition of Goya and Daumier. One artist involved in this movement was Ben Shahn (1898–1969), whose work powerfully expressed the tragedy of human degradation and social injustice. Experienced as a mural painter and illustrator, he depicted isolated city dwellers, victims of official inequity, and the starving wives and children of coal miners. Shahn, like other American artists,

16.5 EDWARD HOPPER.
EARLY SUNDAY MORNING. 1930.
OIL ON CANVAS,
35 × 60″ (88.9 × 152.4 CM).
COLLECTION OF WHITNEY MUSEUM
OF AMERICAN ART, NEW YORK.
PURCHASE, WITH FUNDS FROM
GLORIA VANDERBILT WHITNEY.

incorporated the influences of Cubism and Expressionism into his protest paintings. In *The Passion of Sacco and Vanzetti* [16.6] he condemned the execution of two Italian immigrants who he, and many other Americans, believed were victims of personal and political prejudice.

Isolationism, sometimes seen as conservative American patriotism, was generally strong in the Midwest, where a combination of erosion, caused by years of poor farming practices, and prolonged drought created dust-bowl conditions in many areas. At first, Midwestern artists depicted the world around them with a satirical eye. As the Depression wore on, they became more nationalistic, turning their anger toward foreign influences rather than toward the mistakes of their own government or their own poor farming. Many rural and small-town Americans viewed European culture with distrust, even though their own ancestors had come from Europe. Fearful that what they had worked so long to achieve might be lost in the Depression, they clung to their possessions and their beliefs. Grant Wood (1892–1942) in *American Gothic* [16.7] combined humor with a respect for the hardships of farm life. He depicted a farmer and his wife as solemn, suspicious provincials; their barn representing their cathedral of hope.

From a strongly personal viewpoint, Ivan Le Lorraine Albright (1897–1983) used an almost microscopic form of realism to express his response to the disintegration of the individual in a hostile world. Of *Poor Room* [16.8], which shows a clutter of Victorian decadence seen through a broken basement window, Albright gave as a title, *Poor*

16.6 BEN SHAHN. *THE PASSION OF SACCO AND VANZETTI.* 1931–1932. TEMPERA ON CANVAS, 7′1/2″ × 4′ COLLECTION OF THE WHITNEY MUSEUM OF AMERICAN ART, NEW YORK. GIFT OF EDITH AND MILTON LOWENTHAL IN MEMORY OF JULIANA FORCE.

16.7 GRANT WOOD. *AMERICAN GOTHIC.* 1930. OIL ON BEAVER BOARD, 29-7/8 × 24-7/8″. ART INSTITUTE OF CHICAGO. (FRIENDS OF AMERICAN ART COLLECTION, 1930). © 1988 THE ART INSTITUTE OF CHICAGO. ALL RIGHTS RESERVED.

Room—There is No time, No end, No Today, No Yesterday, No Tomorrow. Only the forever and forever and forever without end. The sense of gray-green decay and rotting flesh that pervades Albright's still lifes and figure paintings turns them into intense statements about the impermanence of material possessions and of life itself.

THE HARLEM RENAISSANCE

The spirit of the new twentieth century produced some optimism for all, with a hint of new opportunity for blacks, at least for Northern blacks, that culminated in the **Harlem Renaissance**. This cultural movement flourished in the Harlem section of New York City and included writers, jazz musicians, and entertainers, as well as painters. Not until then, during the 1920s and 1930s, did black artists develop an art based on appreciation of their own unique heritage. Black artists of the Harlem Renaissance took pride in their roots and expressed that pride in their work. For example, Archibald Motley (1891–1981), Lois Mailou Jones (b. 1905), who painted in France and Haiti, and Hughie Lee-Smith (b. 1914) all dealt with African themes. Aaron Douglas (1899–1979) combined African simplification of

forms with a personal symbolic style in his murals for a Harlem branch of the New York Public Library. His paintings were emotional stylizations, employing extreme elongation, distortions, and circles of mystical light to honor his racial heritage [16.9]. In 1925 Douglas collaborated with the author Alain Deroy Lock to produce *The New Negro*, an illustrated anthology of writings by black sociologists and political scientists. That book encouraged the African orientation of American blacks.

The rediscovery of African culture inspired many black American artists, who cultivated a close kinship with it. Douglas was soon followed by Charles White (1918–1979) [3.9] and others. These artists, sponsored by the Works Progress Administration, contributed significantly to the development of American art of the 1930s. Hale Woodruff (1900–1980) evolved a highly personal style, which resulted from many influences—his studies of

16.8 IVAN LE LORRAINE ALBRIGHT. *POOR ROOM.* 1931–43. OIL ON CANVAS. (121.9 × 94 CM). THE ART INSTITUTE OF CHICAGO (GIFT OF IVAN ALBRIGHT, 1977). © 1992 THE ART INSTITUTE OF CHICAGO. ALL RIGHTS RESERVED.

16.9 AARON DOUGLAS. *ASPECTS OF NEGRO LIFE: FROM SLAVERY THROUGH RECONSTRUCTION.* 1934. OIL ON CANVAS, 60 × 139". SCHOMBERG CENTER FOR RESEARCH IN BLACK CULTURE, ART & ARTIFACTS DIVISION. NEW YORK PUBLIC LIBRARY, ASTOR LENOX AND TILDEN FOUNDATIONS.

Cézanne in Paris, his work in Mexico with Diego Rivera, and, of course, African art. By the 1940s and 1950s, Woodruff's work had achieved a lyrical abstraction [16.10]. His *Amistad* murals, in particular, celebrated African themes that served as a source of black pride. Other artists, such as Romare Bearden (1914–1988) [I.24], were inspired by what they knew best—their own experiences and dreams.

By 1941, Jacob Lawrence (b. 1917) had emerged as a vigorous artist who drew material from the historical background of his race as well as from everyday life. His subject matter, his flat, vividly colored shapes, and his originality established him as an exceptional painter. In his witty summary of day's end on a train, his gouache painting *Going Home* [16.11], the drooping shapes of the fatigued train travelers contrast with strong horizontal and vertical lines. The only active figure is the man reaching hurriedly for his suitcase as the train nears the station. The rhythmic repetition of seats and passengers reinforces the message of returning home, after a day's work, utterly exhausted.

Only since the 1960s have blacks (like other minorities) achieved fuller access to the art world. Many remain concerned with aiding other blacks in their struggle for justice. However, most black artists, in company with women, Asian-Americans, and Hispanic-Americans, are part of the mainstream of American art, all exploring personal creative avenues. Each of these groupings will be studied in the concluding chapters.

16.10 HALE WOODRUFF. *SHRINE.* 1967. OIL ON CANVAS WITH GOLD LEAF. 20 × 40" (51 × 102 CM). PRIVATE COLLECTION.

MEXICAN PROTEST ART

The Spanish conquistadors brought with them to the Americas the typical colonizer's attitude that the only worthwhile culture came from their homeland. Consequently, Mexican colonial art after the sixteenth century was generally modeled on that of Baroque Spain. The vitality of the native American tradition, however, contributed to the rich decoration of Mexican churches. The culture of the Mexican people was influenced by pre-Columbian traditions. Such artists as José Guadalupe Posada (1852–1913) were passionate in their support of working-class Mexicans against an oppressive dictatorship, combining fantasy, humor, religion, and protest. Their art formed a direct link between native cultures and the painting of the three great Mexican protest muralists, who flourished in the late 1920s and 1930s—José Clemente Orozco, David Alfaro Siqueiros and Diego Rivera.

The works of José Clemente Orozco (1883–1949) are more powerful, brutal, and political than those of Diego Rivera. Trained in architecture as well as painting, Orozco created huge murals in which surging masses of peasants and workers struggle against tremendous odds symbolized by steel bayonets in their unceasing striving to reach their revolutionary goals. His figures echo the violence and cruelty of ancient Aztec religious practices and the conquering Spaniards, which were perpetuated in Mexican folk tradition. There is also an element of folk fantasy, for Orozco's skeletons and the tortured forms of the oppressed relate to the candy figures traditionally sold in Mexico for the Day of the Dead.

Orozco covered the walls of government buildings in Mexico with his dramatic works. Those in Guadalajara are so exaggerated in scale, so violent and twisted in form, and so savage in their masses of figures that they seem to burst from the walls. His murals at Dartmouth College in Hanover, New Hampshire, create a panorama of the history of Mexico in brilliant colors and striking symbols. The overpowering figures tell stories of the feathered-serpent god, Quetzalcoatl, and of the coming of the Spaniards. The murals also protest the destructive forces of war and the

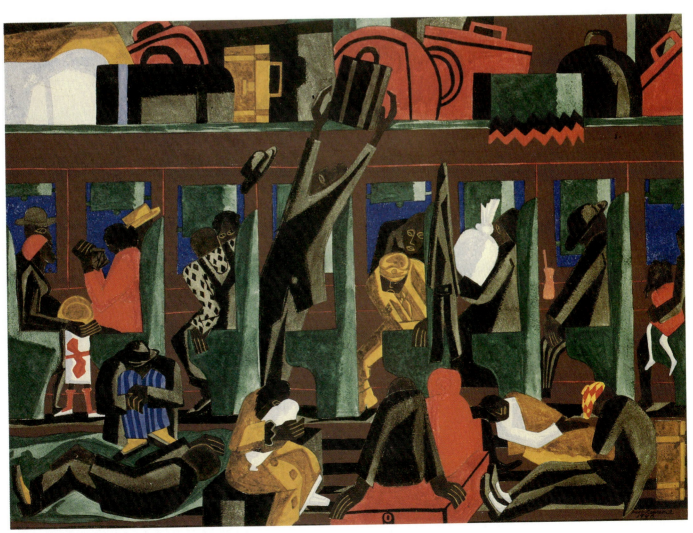

16.11 JACOB LAWRENCE. *GOING HOME.* 1946. GOUACHE ON PAPER MOUNTED ON BOARD. 22 × 30-1/4″. COLLECTION IBM CORPORATION, ARMONK, NEW YORK.

The Artist Sketch

"There is something monolithic about Jacob Lawrence and his work; a hard core of undeviating seriousness and commitment to both social and Black consciousness. He has projected the Black experience more consistently and effectively than any other Negro artist of his generation," wrote Milton Brown in the catalog to Lawrence's retrospective exhibition at the Whitney Museum of American Art in 1974. For half a century, Jacob Lawrence has been considered America's foremost African-American artist. He has given us powerful images that chronicle the period from the Civil War to the Civil Rights movement and beyond.

Born in 1917 in Atlantic City, New Jersey, Lawrence spent his early years with his mother and his brother in settlement houses in Pennsylvania while his mother struggled to hold the family on her own. By 1930, they put down roots in Harlem, where society was upbeat with the pride fostered by the Harlem Renaissance. Lawrence studied art at the Harlem Art Workshop between 1934 and 1935, with the guidance of Charles Alston from whom he rented studio space at a site destined for fame, 306 West 141 Street, until 1940. Alston was the Harlem director of the Works Progress Administration's Mural Project, and artists checked in at "306" to sign up for work.

16.12 PORTRAIT OF JACOB LAWRENCE. PETER A. JULEY & SON COLLECTION. NATIONAL MUSEUM OF AMERICAN ART. SMITHSONIAN INSTITUTION.

The community became an extended family to Lawrence and the "306" a nurturing force. In the mid-1930s, he came to know Romare Bearden who was studying with George Grosz at the Art Students League on 57th Street in New York, where it still remains. In 1937, he received a two-year scholarship to the American Artists School, where Lawrence began to produce significant paintings of Harlem everyday life. At this point, he was using poster tempera paints because they were cheap and dried quickly. By age 20, his works were exhibited at the Harlem Artists Guild Show, alongside those of his teachers, Charles Alston and others.

In the 1930s, Africanism and African art became powerful forces in the Harlem community. The 135th Street Library continuously displayed pieces from its impressive collection of African sculpture. Hale Woodruff's epic *Amistad* series of murals in Alabama, coupled with the strong influence of Augusta Savage, a black artist concerned with feminist issues long before Feminism became popular, increased Lawrence's awareness of his heritage. Equally influential to his work were the Mexican Social Protest painters. But, it is clear from the very beginning that Lawrence developed an original style in no way derivative of any other. What did have monumental influence in his artistic life was his participation in the WPA Federal Art Program.

Introduced by Augusta Savage and accepted to the program in 1938, Lawrence joined an illustrious generation of artists supported by the Federal Art Program, many of whose works we have already seen, such as Ben Shahn, Louise Nevelson, and Jackson Pollock. While with the WPA, Lawrence initiated his historical series, and, at the same time, established his techniques. The narrative and stylistic aspects of his paintings were set while he worked for the WPA. And he had found the theme that would become his life's work—the black struggle for survival. In 1940, he received the first of three Rosenwald Fellowships with which he began his *Migration Series*, an account of the massive movement of blacks from the rural South to the urban North. A sociological epic, the work captures people in flux, the force of history driving people onward like dust in the wind! Two museums shared in the purchase of the *Migration*.

Lawrence's career never wavered. With his marriage to painter Gwendolyn Knight, Jacob Lawrence epitomized the exemplar artist in tune with his origins, masterfully continuing to express, as he put it, the human struggle for survival [16.12].

JACOB LAWRENCE (B. 1917)

machine age. Their climax is reached in an overwhelming figure of a militant, flayed Christ, who destroys his cross, calling on oppressed peoples everywhere to arise.

David Alfaro Siqueiros (1898–1974), like Courbet a half-century earlier in France, was as involved in political activities as he was in painting and was later imprisoned for

his Communist beliefs. He led the organization of the Syndicate of Technical Workers, Painters, and Sculptors, which contributed much to the development of art in Mexico. Siqueiros' murals, more visionary than those of Rivera and Orozco, use Surrealist images to protest social injustices. Compare his *Echo of a Scream* [16.13] with Picasso's

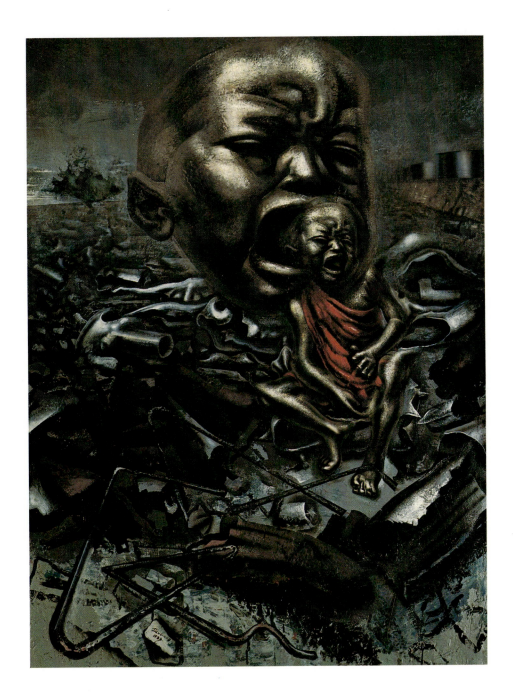

16.13 DAVID ALFARO SIQUEIROS. *ECHO OF A SCREAM*. 1937. DUCO ON WOOD, 48 × 36″ (121.8 × 91.4 CM). COLLECTION, THE MUSEUM OF MODERN ART, NEW YORK. GIFT OF EDWARD M.M. WARBURG.

Guernica [I.15] and Munch's *The Cry* [4.12] to see how the three artists employed strident images in different ways to express inhumanity and horror. Siqueiros, like Jackson Pollock [1.13], also experimented with materials, using industrial enamels for his outdoor murals, which he hoped would expose his ideas to the largest possible number of people.

Diego Rivera (1886–1957) was an enthusiastic student in France, when he encountered the then fledgling style of Cubism. Later traveling in Italy, he was deeply affected by the frescoes in the churches. In fact, he was mainly responsible for the rebirth of the fresco technique in North America, where his frescoes show the influence of Renaissance art in their formal composition.

Rivera's murals for Mexican public buildings—the National Palace, the Secretariat of Public Education, and the University of Mexico, all in Mexico City—took art from galleries and museums to places where it could be seen by large numbers of people. Convinced that his countrymen needed to develop a pride in their past, he painted scenes that chronicled the life of the peasant and drew on Mexican legend and folk custom as well as on revolutionary social and political themes [I.3]. Thus he used murals to teach Mexican heritage in the same way that the medieval church used art to make the Bible a familiar part of everyday life. Although his murals were decorative and at times rigid in composition, they brought a sense of community to the Mexican people.

Frida Kahlo, who would later become the wife of Diego Rivera, was as dedicated to illuminating women's issues as her husband was determined to develop Mexican

The Artist Sketch

Frida Kahlo has become *La Patrona* (patron saint) to multitudes of women struggling to express a personal vision of honesty and heroism. She was as flamboyant as the paintings she created. No wonder that in recent years, Frida Kahlo may be the most famous Mexican artist of all. In fact, pop singer Madonna, who collects Kahlo's artwork, has expressed an interest in the movie rights to Hayden Herrera's definitive 1983 biography *Frida*. Through his pages parade a series of sometimes shocking, sometimes piteous incidents with Frida projecting an aura almost not to be believed.

Nearly paralyzed as a teenager from a streetcar accident, she was literally impaled on a metal bar; her spine fractured, her pelvis crushed, and her foot broken. Until her death twenty-nine years later, she lived with pain and hovering illness, but maintained an indomitable *alegría*, a lightheartedness in the face of suffering. In 1929, she became Diego Rivera's third wife, but became incensed at his womanizing. She had her revenge, however. With her small figure and good looks, she attracted men and took many of them as lovers. As for her involvement with women, there is evidence of these relationships as well.

She dressed flamboyantly, preferring Mexican costume to high fashion. Her uncommon choices of dress attracted attention wherever she passed, no doubt pleasing her. According to Herrera, she and Diego knew everyone; Leon Trotsky and Isamu Noguchi were her friends, and perhaps lovers. Their home in Mexico City was a cultural center for such guests as Andre Breton, Sergei Eisenstein, Henry Ford, and Nelson Rockefeller.

Because of Rivera's obsession with publicity, the couple's adventures and battles were chronicled in detail in the press. "I hold the record for operations," she said, but she also yearned for the child she seemed unable to maintain in pregnancy. European Surrealists claimed her as a member, but she rejected the notion. "I never painted dreams," she insisted, "I painted my own reality." She was in fact one of the creators of her own legend, "The only thing I know is that I paint because I need to, and I paint always whatever passes through my head, without any other consideration." What passed into her art were images of herself, cracked open and bleeding. Her autobiography in paint is gripping but painful to view and impossible to forget.

In April 1953, a few months before her death, preparations were made for her first retrospective show in Mexico, a display from the beginning to the end. Held at the *Galería de Arte Contemporáne*, Frida arrived by ambulance in her canopied bed, set up in the center of the lobby where she greeted each of her guests. Her small paintings seemingly lost in the vastness of the hall, instead, appeared like sparkling jewels. Her energies faded fast after the show as though she had willed herself to survive until it was over. The last entry in her diary is a sketch of a black angel with the words, "Espero alegre la salida—y espero no volver jamás. Frida" (I hope for a happy exit and I hope never to come back). Her ashes rest in her Casa Azul—the blue house, now a museum. She lives on through her paintings and her haunting story [16.14].

Women everywhere have identified with the struggle of her life, and, like most legends, the facts and fantasies surrounding Kahlo are fused.

FRIDA KAHLO (1907,11–1954)

pride in the heritage of its peoples. While most of Kahlo's art was directed toward exploring her own personal problems, there were also many universals in her painting from which many men and women could find inspiration. Her life story may explain the devotion of her followers.

Artists in the United States became interested in fresco painting in the 1930s through exposure to the works of Rivera and Orozco. Supported by the WPA, many, such as the Dutch-born Willem de Kooning, traveled around the United States, painting murals in post offices and other government buildings. Most of the paintings were conservative, and few could approach the impact of their Mexican counterparts as expressions of social protest.

ABSTRACT EXPRESSIONISM; NEW YORK SCHOOL

During the Great Depression and World War II, New York became a center for the kind of discussion and stimulating exchange that had formerly made Paris so attractive to creative people. Artists came to New York from all over the country, from Mexico (Orozco and Rivera) and from Europe (Mondrian, Chagall, Ernst, Dalí, and Léger). Whether they settled in New York or only visited, some are loosely classified as the **New York School** because they shared a common center of artistic concern. Their work

showed no uniform style. They issued no manifestos. A few of these artists were realists, such as Hopper [16.5], but most explored highly personalized nonobjective painting. Many developed a free-flowing style that was described by critics as **Abstract Expressionism**.

Abstract Expressionist paintings are generally nonobjective, without obvious reference to reality. Many have a raw, tough strength that is remote from the grace and finesse of the early nonobjective formalist paintings of Kandinsky [15.8], Malevich [15.9], and Mondrian [I.28]. Abstract Expressionist works may be grouped in two broad divisions. In **Action painting**, the physical traces of the artist's actual gestures are explicit and emphatic. In the other, known as **Color-Field painting**, the emphasis is on large planes of color. Action painting dominated the 1950s. The formalist painting of color areas developed more gradually until it emerged as one of the significant movements in the 1960s, as we will see in Chapter 17.

When we look at Action paintings, our own muscles respond with awareness of the movements of the artist's body. The canvases are very large because traditional easel-size paintings seemed too small to contain the artist's energies. The artist had to reach beyond restrictive borders to enormous areas in which to work out his or her drives. To feel this physically expressed energy we must see the paintings themselves, for their huge scale intensifies the impact, forcing us to become involved in the work. The term Action painting was coined by a New York critic, Clement Greenberg, in a review of Jackson Pollock's work, for whom he later became a powerful advocate.

European influences on Abstract Expressionism were the powerful transitions of color developed by such nineteenth-century painters as Turner [14.6] and Monet [14.13] and the various forms of Expressionism of the early twentieth century, such as that of Emil Nolde [15.15]. Abstract Expressionism drew also on Oriental sources,

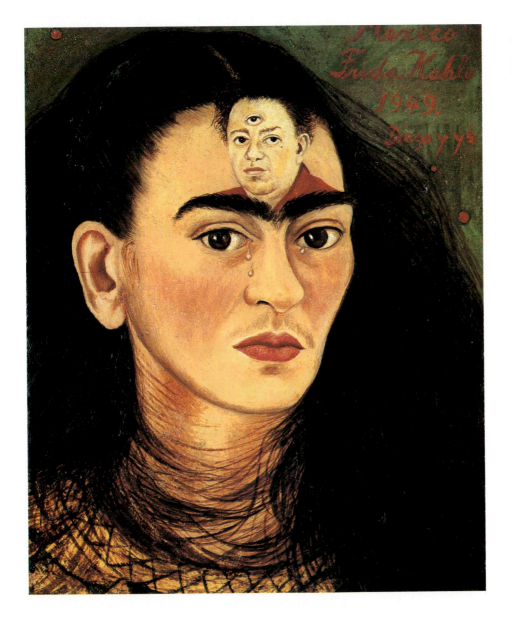

16.14 FRIDA KAHLO. *DIEGO Y YO.* 1949. OIL ON MASONITE. 11-5/8 × 8-13/16" (29.8 × 22.4 CM). PRIVATE COLLECTION, MEXICO. PHOTO COURTESY MARY-ANNE MARTIN/FINE ART, NY.

Art Talk

Deeply bound to the Abstract Expressionist movement, Clement Greenberg remains its most vigorous spokesman. Equally at ease as editor of *Partisan Review*, as a staff writer for the *New York Times*, or as an author of such critical studies as *Joan Miró, Matisse*, and *Hans Hoffmann*, Greenberg is perhaps America's most distinguished art critic. For fifty years, he served as the spokesman of Modernism. Since his views were the most controversial, he can also be seen as the most influential critic as well. As a columnist writing for *The Nation, Arts Magazine International*, as early as 1939, Greenberg made definite, permanent, and elitist distinctions between "popular art" and "true genuine culture."

As he saw it, pure art presents form and content as one and the same, namely an arrangement of design elements, while he terms the art for mass culture "kitsch" or superficial diversion. Using the techniques of high culture, kitsch turns out formulas of art and spectacle with which government (in particular, fascist regimes) can manipulate the public for political gain. From this viewpoint at mid-century, consumer goods came to be seen as the gifts of democracy. Greenberg's benchmark article *The Avant Garde and Kitsch*, 1939, served as a manifesto, announcing the shift from art as social realism to abstraction. As one of the most important documents supporting Abstract Expressionism, Greenberg may have written the single most quoted, most discussed article on art criticism in America. Prepared for *Partisan Review*, the leading publication devoted to social concerns, Greenberg contrasts the aims and achievements of painting with the values and pretensions of its viewers.

The destiny of Modernism, he maintained, was to purify art. In the hands of the avant-garde, diversionary influences could be eliminated, reducing art to its essential properties. Anything else was considered kitsch—popular commercial art in all its forms including advertising and the comics. Greenberg argued that even when talent could create superficial distractions, such an approach eliminated the public's need

to think—to reach below the surface for the formal values possible only in an aesthetic limited to organization, textural differentiation, and the glory of color.

Greenberg, however, has recently done an about-face. Interviewed for *Art News* in September 1987, he said, "I think the best painter alive is Jules Olitsky ... (Kenneth) Noland is still a great painter ... I think

16.15 CLEMENT GREENBERG.

(Andrew) Wyeth is way better than most of the avant-garde stars of this time." Contradictory, indeed, to much of what he has been telling us for half a century.

Exploiting Greenberg-like notions of "quality" and aesthetic "purity," the federal government is censoring much work that would trouble the human mind and challenge public order. Greenberg's pronouncements, then, of avant-garde vs. kitsch remain as critical an issue as when they were first expressed [16.15], half a century ago.

THE CRITICAL CONTRIBUTION OF CLEMENT GREENBERG (B. 1909)

notably calligraphy and Zen Buddhism. According to Zen belief, when the mind and body are in accord, or centered, the hand becomes free to serve a deeper purpose, allowing inner vitality to be released. This attitude, which inspired much of Chinese and Japanese painting for centuries [3.8], proved congenial to many Abstract Expressionists.

From these currents, Abstract Expressionism evolved in the late 1940s. It had a vitality that was typical

of much American painting of the twentieth century no matter what its style. It seems that American artists tackled art frontiers with the same fresh excitement with which their ancestors had tackled the physical frontiers of Western America.

We may consider Arshile Gorky (1904–1948), who painted abstract expressive works that recalled his childhood in Armenia, as an early Abstract Expressionist.

16.16 ARSHILE GORKY. *THE LIVER IS THE COCK'S COMB*. 1944. OIL ON CANVAS, 73-1/4 × 98″. ALBRIGHT-KNOX ART GALLERY, BUFFALO, NEW YORK. (GIFT OF SEYMOUR H. KNOX, 1956).

He evolved his paintings in the automatic manner of the Surrealists, who used doodles to suggest images, drawing and painting according to impulse. In their random brush marks, the Surrealists would see suggestions of a figure, which they would then encourage to emerge into a more definite image. Gorky's organic forms and erotic fantasies were influenced by the works of Kandinsky, Miró, and Picasso. He brought to his painting a love of texture and especially of richness of paint. Compare, for example, Gorky's lively, free brush strokes [16.16] with the tight, smooth surface of American Realistic painting as in Grant Wood [16.7].

The free-flowing style of Gorky and other abstract organic painters was also characteristic of Hans Hofmann (1880–1966), a German-born artist whose art classes in New York became a center of Expressionism and abstraction. The apparent spontaneity of his brush strokes was based on an unusual combination of painterliness and abstraction. In *The Golden Wall* [16.17], rectangles of rich color are contrasted with areas of thick, loosely brushed paint. Hofmann's glowing color expresses his joyful attitude toward life. He considered the actual process of looking at a painting to be an important part of the act of art. He felt that if this process is successful, the painting and the viewer will establish a relationship based on spontaneous feeling.

Two painters became the focal point for the new style—Willem de Kooning (b. 1904) and Jackson Pollock [1.14]. In direct opposition to the carefully composed geometric painting of Josef Albers (1888–1976) [16.18] and Mondrian [I.28], they brought to their work an immediacy of emotion that made the process of painting an important

16.17 HANS HOFMANN. *THE GOLDEN WALL*. 1961. OIL ON CANVAS, 151 × 182 CM. THE ART INSTITUTE OF CHICAGO. (MR. & MRS. FRANK G. LOGAN PURCHASE PRIZE FUND, 1962). © 1987 THE ART INSTITUTE OF CHICAGO. ALL RGHTS RESERVED.

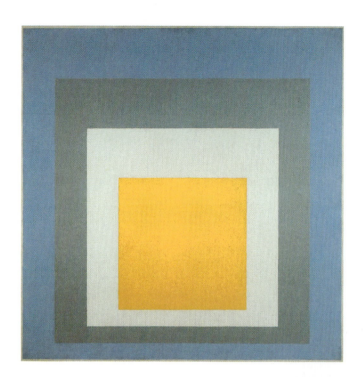

16.18 JOSEF ALBERS. *HOMAGE TO THE SQUARE: "ASCENDING."* 1953. OIL ON COMPOSITION BOARD, 43-1/2 × 43-1/2". (110.5 × 110.5 CM). COLLECTION OF WHITNEY MUSEUM OF AMERICAN ART, NEW YORK. PURCHASE.

part of the artwork itself. For several years De Kooning painted in a broadly Abstract Expressionist style, angrily slashing wide, violent strokes onto his canvas. Later, in the 1950s, he became almost obsessed with the image of a female [16.19]. If we study his first painting of a woman carefully, it is possible to find a young blonde seated in profile view on the far left of the work. Still closer examination clearly reveals sandals usually accepted as footgear for *Woman I*, but more appropriate to her genesis, the girl. Some interpret the horrendous woman image to represent what De Kooning sees as the ultimate fate for the young girl and, likely, women in general. With each successive image he has painted of the theme "woman," the artist was increasingly biting in the renderings. The 1950s seem to have

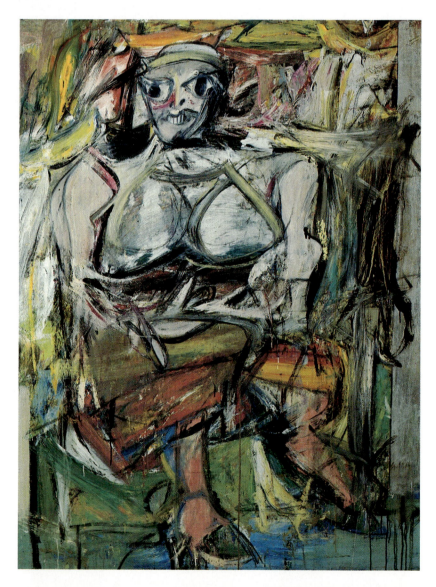

16.19 WILLEM DE KOONING. *WOMAN, I.* 1950–1952. OIL ON CANVAS, 6'3-7/8" × 4'10" (1.93 × 1.47 M). THE MUSEUM OF MODERN ART, NEW YORK (PURCHASE).

16.20 JACKSON POLLOCK. *MALE AND FEMALE.* C. 1942. OIL ON CANVAS, 73 × 49″. PHILADELPHIA MUSEUM OF ART. GIFT OF MR. H. GATES LLOYD.

represented a period when his point of view was shared by a few writers; notably, Philip Wylie. De Kooning's paintings appear conceived in horror and depict a sense of desperate rage that was physically expressed in the brush strokes. This use of the larger muscles of the body, typical of Abstract Expressionism, brought great energy to his paintings.

There have been various explanations for the critical focus upon women of both Wylie and De Kooning. Probably the clearest rationale originates with Wylie himself. In his *Generation of Vipers*, he addresses "Momism," which he sees as a false elevation of women, perhaps because of their role as childbearers through which, he believes, they dominate males. De Kooning, on the other hand, in his *Woman Series*, may be pursuing the Venus figure to a sexual conclusion consistent with Picasso's view [15.1], that the ultimate Venus may be a prostitute. For all three men, woman exists primarily as a sex object without whom they cannot survive.

Jackson Pollock approached his art, even in the early periods while he was studying with Thomas Hart Benton at the Art Students League (as we noted, Chapter 1), in terms of automatism introduced earlier by Hans (Jean) Arp [15.19]. Years later he wrote, "My work with Benton was important as something against which to react very strongly." While in Jungian psychoanalysis, he experimented with primitive myths and symbols to be pulled from his subconscious. Towards the end of 1943, the Solomon R. Guggenheim Museum, then called the Museum of Non-Objective Painting, held his first one-man show, where *Male and Female* [16.20] was exhibited, prompting Clement Greenberg to write of the "surprise and fulfillment in Jackson Pollock's not so abstract abstractions."

Benton had been a member of Alfred Stieglitz's circle, and as a muralist, introduced Pollock to the Mexican masters, Rivera, Orozco and Siqueiros. Pollock responded, "I believe the easel picture to be a dying form and the tendency of modern feeling is toward the wall picture or mural." Because he felt the public was not ready for murals, he painted on large canvases, which he considered to be a transitional step toward wall painting. Pollock's drips, splashes, and spills appear to have been painted in an intense and undisciplined fury of action. His paintings, however, actually are carefully textured and organized. Each of his active strokes appears balanced by an opposing one. His color combinations are subtle, and the structure of each painting develops through the rhythm of his movements. Pollock, who often used industrial enamels and metallic paints, spread his canvases on the floor and dripped his paints from buckets, using sticks and large brushes. The concentration of paint on the canvas from the path of his hand forces us to note the importance of the artist's association with his materials [1.13]. His unfortunate use of industrial materials instead of art pigments has dramatically limited the life span of each work.

Pollock's passages of color lead our eyes into the painting to wander through the canvas, finding refreshment by following the myriad paths of the paint as they build up a weblike surface. Through the involvement of our eye movements, his paintings become environments that surround us. Perhaps subconsciously expressing the fears and hopes of the mid-century, Pollock extended his painting to limitless horizons, bringing together the near and the far, the important and the trivial, to merge into a broad cosmos. Through his work we may sense the tensions of all

people trapped by the twentieth century, as well as Pollock's own expressive personal frustrations as an artist living in a world he viewed as hostile.

Lee Krasner (b. 1908), who studied and worked with Hofmann and married Pollock, assimilated Surrealism, Fauvism, Cubism, Oriental Zen, and Action painting. Her images suggest movement, flux, and growth, reflecting energies essential to life. The rhythmic flow of her paint and the density and transparency of her surfaces identify her as an Action painter, but it is the monumental concept of even her small-scale work that marks her contribution as significant [16.21].

A solo show at a New York City gallery in 1940 introduced to the art world exciting work that can be seen as transitional, or a fusion, between Surrealism and the new Abstraction. The artist was Chilean and relatively little known despite his successes in Paris. Sabastian Antonio Matta Echaurren (b. 1912), better known simply as Matta, suggests in his work an excursion into fantasy. *The Disasters of Mysticism* [16.22] alludes to an unworldly level of consciousness, more likely residing in the artist's mind than the world most of us know. Ambiguous shadows and brilliant flamelike lights may represent outer space, a state that fascinated Matta increasingly with time.

From Cubism, James Brooks (1906–1992) evolved a free-form curvilinear style that can be better accommodated within the abstract expressionistic categories of painting than any other. Like Pollock, Brooks often worked large before he extracted, and later framed, core sections of the works lyrically expressed. He confided to the

16.21 LEE KRASNER. *THE GUARDIAN*. OIL, 53 × 58″. COLLECTION OF THE WHITNEY MUSEUM OF AMERICAN ART (GIFT OF URIS BROTHERS FOUNDATION, INC.).

16.22 MATTA. *DISASTERS OF MYSTICISM*. 1942. OIL ON CANVAS, 38-1/4 × 51-3/4″. PRIVATE COLLECTION. COURTESY OF SOTHEBY'S, INC., NEW YORK.

author in the late 1970s that he could not afford canvas when he began to paint, using cardboard as a poor man's substitute. The color is brilliant, and although the application of form and paint seem to be intuitive, the paintings are strong, unique and totally unified structure systems [16.23].

The Oriental calligraphic element is particularly strong in the work of Franz Kline (1910–1962). Kline painted enormous black shapes, somewhat like enlarged Chinese characters. His large strokes of black drawn across the white surface of the canvas create tensions to which we respond physically—a pull we can feel [16.24]. Kline was concerned with tensions and balances of positive and negative space like the art he studied in China.

The youngest of the original Abstract Expressionists, Robert Motherwell (b. 1915), wrote in *The New Decade*: "I happen to think primarily in paint. ... If a painting does not make a human contact, it is nothing." The act of applying paint to canvas itself was what dominated the Action painters. They did not represent their emotions but enacted them in their works.

PHOTOGRAPHIC ARTS

The same spirit of freedom that inspired painters to break away from academic and realistic representation led artists and others to experiment with still photography and film in both Europe and America. Film became a big business in America as well as a major art form, often fulfilling the role of fantasy, as it still achieves for many today.

16.23 JAMES BROOKS. *TONDO*. 1951. OIL ON CANVAS, DIAMETER 82″. PRIVATE COLLECTION, NEW YORK.

16.24 FRANZ KLINE. *TWO HORIZONTALS*. 1954. OIL ON CANVAS, 31-1/8 × 39-1/4″. COLLECTION, THE MUSEUM OF MODERN ART, NEW YORK (THE SIDNEY AND HARRIET JANIS COLLECTION, GIFT).

Still Photography

Classical American photographers such as Edward Weston and Ansel Adams explored form and light in their still lifes and landscapes (Chapter 5). The artist Alvin Langdon Coburn (1882–1966) experimented with mirror-multiplied photographic images he called vortographs. Skilled also in rotogravure (Chapter 8), he made the plates used to print four of his books. László Moholy-Nagy, who founded the New Bauhaus in Chicago after the closing of the original in 1933 in Berlin, was convinced that photography is an indispensable tool of this century. He created photographic shadow prints and micrographs of rare scientific beauty and educational value [5.13].

During the 1930s, photographic technology improved greatly. New lighting methods, more sophisticated lenses, and smaller cameras made for greater flexibility. *Life* magazine, which featured the new art of photojournalism, first appeared in 1936 and soon became so popular, it was rapidly followed by imitations. The Farm Security Administration of the federal government used skilled photographers to record the life of rural America during the Depression years. These sensitive and perceptive photographers produced prints that are unquestionably fine art. Dorothea Lange, in particular, commented on the tragic plight of the farmers who were driven from their homes in Oklahoma by dust storms. Her photographs of women and children from this period are classics. Realistic and objective, she never used unusual angles or lighting to increase the expressiveness of her work. *Migrant Mother* [5.11] is much more than a mere recording; the faces and poses speak eloquently of hopelessness and despair.

Film

In the early twentieth century, avant-garde painters and writers alike were fascinated by the potentials of filmmaking. In Paris, Marcel Duchamp made a natural progression from the painting of a technological *Nude Descending a Staircase (No. 2)* [2.46] to using ready-made objects (such as the wheel) that moved [15.20] to his moving picture *Anaemic Cinema* (1926). Fernand Léger developed his interest in machines into moving images in his film *Ballet mécanique* (1924), and Salvador Dalí expressed his theatrical and Surrealist viewpoint in films. French filmmakers created art films in an Impressionist style that brought cinema into the stream of modern art. René Clair's (1898–1981) stylized, fanciful films commented on the absurdities of our machine-dominated lives. During the 1920s filmmakers in Sweden and Germany introduced innovations in visual design that made possible new intensity of emotion, unity of mood, and fuller expression of character. The Soviets refined a new system of editing by montage [5.23], which allowed unprecedented evolution of ideas.

Despite these achievements in Europe, the "movies" are more closely identified with the United States than with any other country. While Europe was involved with World War I and America was still neutral, Americans gained several years' lead in filmmaking. In contrast to European "art films" for elite audiences, Hollywood produced films for the mass market, ranging from the epic pageants of D. W. Griffith (1875–1948), culminating in *Birth of a Nation* (1915), to the disciplined lunacy of comedies by Mack Sennett (1884–1960) and British-born Charlie Chaplin (1889–1977) [16.26], to the classic romances starring

16.26 FILM STILL FROM CHARLIE CHAPLIN'S *MODERN TIMES*. 1936. THE MUSEUM OF MODERN ART/FILM STILLS ARCHIVE.

16.25 ROBERT GITT AND RICHARD DAYTON. *"RESTORING BECKY SHARP."* BEFORE AND AFTER RESTORATION.

Greta Garbo, Gloria Swanson, and others. The classic Western film such as *Stagecoach*, introduced by John Ford in 1939, presents a historic image of America by which much of the world still identifies this nation. The ability to appeal to a wide variety of tastes, plus American business skills of mass production and distribution, established the American motion picture as a great commercial success and an influential art form. *Birth of a Nation* grossed an estimated $50 million, making it the top money-maker until recent years.

Greater performances in silent films than Lillian Gish's in D. W. Griffith's 1920 film *Way Down East* may not exist, nor finer early color films than Rouben Mamoulian's three-strip Technicolor *Becky Sharp* (1935); yet few film historians or film critics—not to speak of us, the general public—have ever had an opportunity to view these works. And they are just two of the extensive list of fading classics.

Critics and scholars have had to rely on inferior, two-color prints that have drastically altered original color schemes; in the case of black-and-white films, many prints have missing or damaged frames. For example, Becky's costume that Mamoulian described as "demure pink" now appears as brilliant yellow. The restoration of disintegrating films is a painstaking process. The problems are at least twofold. Not only are the surviving prints exceedingly fragile, perhaps from imperfect processing originally or the very nature of the film itself, but early directors' editing cuts often permitted various film versions to be circulated.

The recent restoration of Griffith's film by the Museum of Modern Art (MoMA) in New York has raised questions certain to disturb film historians for decades. Since many established film classics are available in a variety of versions, which is to be considered authentic? The shortest, the longest, or the earliest? In the case of *Way Down East*, only a year after the film was released, it had

already lost footage. In the early 1930s, when a sound track was added, *Way Down East* was down approximately three reels, or thirty minutes.

When MoMA began its efforts with two silent 35mm nitrite prints with the original tinting from the mid-1920s, the tangled web of Griffith's versions came to light. Neither print conformed to the example of the negative (with sound) already in the museum's archives. From a complete list of shots and intertitles deposited by Griffith with the Library of Congress at the time of copyrighting the film, and by comparison with the musical score, an exact correspondence of film version and script was finally found. Perhaps the most tantalizing sequences, however, remain those carefully described in the shot list, which even MoMA cannot locate!

After more than four years of technical work, including approximately $70,000 spent on chemical preservation and hand restoration, MoMA has presented a version of *Way Down East* as close as possible to that of its premiere in 1920. In the case of *Becky Sharp*, extraordinary and costly technological processes of color filtration and photocopying have produced a landmark film restored to its historic colors and clarity of detail. And the restorations of other film classics continue [16.25].

The major breakthrough in cinema was signaled on October 6, 1927, when Warner Brothers presented *The Jazz Singer* with Al Jolson, the first feature film with synchronized music, speech, and other sounds. Their Vitaphone system used disc recordings, which were mechanically synchronized with the projector. At the end of the 1920s there was no doubt that synchronized sound films would be the film form of the future.

In commercial cinema, the need for mass escapism during the Great Depression led to slick, sophisticated comedies and elaborately staged singing and dancing shows. Charlie Chaplin, however, continued to produce

satirical comedies. He commented on the world of machinery [16.26] or on the rising European dictatorships in such films as *Modern Times* (1936) and *The Great Dictator* (1940). These films describe the loneliness and isolation of those who refuse to conform to the dictates of the world around them—whether it be a factory or an oppressive political regime.

Chaplin's creativity was echoed in the remarkable American phenomenon of the animated cartoon. The need for food for the spirit and escape in fantasy from daily reality perhaps explains the desire of millions to return to an adolescent state through the art of Walt Disney (1901–1966) and other animators. Mickey Mouse, imaginary subject of many short Disney cartoons, became for many people a symbol of America. The importance of music to Disney led him to create *Fantasia* (1940) [16.27], a feature-length film composed of seven episodes of animated ballet set to classical music. In visual style, *Fantasia* ranges from total abstraction as a background for music by J. S. Bach to romantic cartoons for most of the film. Mickey Mouse himself appears as the hapless servant in the *Sorcerer's Apprentice* by Paul Dukas.

Disney's art was determined, perhaps most significantly, by his creative organization of skilled technicians, whom some consider pioneering artists. In their hands, color is used expressively rather than illusionistically. It is bright and flat. All the best Disney films use line rather than modeling to present an image. One can recognize in them the influence of Picasso, Matisse, and even Modigliani. The Disney films effectively convince us that art can also be entertainment and storytelling can be art.

Yet, the credit we attribute to Walt Disney cannot be restricted to the one individual. Were we to evaluate films, as with any other form of art, any list of the world's most successful judged on almost any criterion would be likely to include *Citizen Kane* (1941). This film [16.28] dramatically points out the base factor of team participation, no less in its way than the group effort of artist-designers who produced the Palace of Versailles, Lincoln Center [7.32], or for that matter, the Parthenon in ancient Greece. Rated, then, as a film of major significance, who should get the credit for *Citizen Kane*? The producer-director-actor Orson Welles who put it together?

16.27 Still from *Fantasia*. 1940. Mickey Mouse as the Sorcerer's Apprentice. © The Walt Disney Company.

16.28 STILL FROM ORSON WELLES' FILM *CITIZEN KANE*. © RKO PICTURES, INC. ALL RIGHTS RESERVED. IN COOPERATION WITH TURNER ENTERTAINMENT COMPANY.

Or, would it be the screenwriter Hermann J. Mankiewwicz who shaped the story line? Or, the special-effects cinematographer Gregg Toland who tried out expressionistic techniques that can only be compared with today's avant-garde video technology a half-century earlier? Or, would it be the editor who simulated newsreel footage and lightning *mixes*, the merging of imagery that proved a valuable metaphor for the passage of time? Or, would it be the music? Or, perhaps the palatial sets for *Xanadu*, home to *Citizen Kane*? The key, of course, is collaboration and a single director. Such is the case with every film that has become or will one day achieve the status of a classic.

Film seems to have given us a universal language. While cartoons can amuse people, documentaries can influence public opinion. Such films as *Nanook of the North* (1922) made audiences feel close to people struggling for existence in two difficult natural environments. Techniques developed in these films were used in army films during World War II and have continued to influence documentaries.

The American contribution to film—in comedy, fantasy, drama, or documentary—is obvious. We will consider recent developments in cinema and the effect of video and television in Chapters 17 and 18.

EXERCISES AND ACTIVITIES

Activities for Research and Discussion

1. Abstract Expressionism was an important force in art in the 1950s. Compare and contrast the work of Jackson Pollock and Willem de Kooning. Analyze how their works are similar and how they differ.

2. The traditional fresco technique was revived by Mexican painters to serve a particular purpose. Why was the technique particularly appropriate to their work? How did they use it? How did their art influence painting in the United States?

3. Describe your reaction to a work of Orozco and to Picasso's Guernica [I.15]

4. How did a changing approach to the human body affect sculpture of the twentieth century? Give examples.

5. Read a novel of protest that describes the social conditions existing between World War I and World War II. Discuss the art of the period in relation to the book. Does the art mirror in visual form the conditions described in the book? If so, how?

Studio Activities

1. Create in oils, acrylics, or enamels a painting in the style of Jackson Pollock. To get the full impact of the muscular involvement in his work, you will need a large area of paper or canvas.

2. Using images from magazines involving blacks, create a photo montage that concerns a theme of black interests. You may use Romare Bearden's work [I.24] as a reference.

3. Create a photographic essay that expresses the Depression era into which Franklin D. Roosevelt introduced his New Deal programs, using magazine cutouts or snapshots of your own.

4. Express the changing approach to the human body in sculpture of the twentieth century, using clay or any other medium of your choice.

5. Create an artwork of your own that responds to technology in the 1930s.

The Mid-Century World: 1945–1970

"The future of art no longer seems to lie with the creation of enduring masterpieces, but with defining alternative cultural strategies."

—JOHN MCHALE, ART CRITIC

• • •

"Swift social change coupled with unconscious technological habits of mind ... offer the critic countless obstacles to the measured development of his thoughts, and this situation he shares with the contemporary artist."

—DORE ASHTON, A READING OF MODERN ART

1950	1955	1960	1965	1970	1975

THE VISUAL ARTS

1948 Pollock, *Number 1* [1.13]
1950 Dubuffet, *Corps de dame piece de boucherie* [17.1]
1950–51 Newman, *Vir Heroicus Sublimis* [2.30]
1952 Le Corbusier, Unité d'Habitation [17.35]
1952 Reinhardt, *Abstract Painting, Blue* [17.11]
1953 Albers, *Homage to the Square* [16.18]
1954 Johns, *Flag* [I.22]
1956 Hamilton, *Just what is it . . .* [17.25]
1956 Rothko, *Orange and Yellow* [17.2]
1957 Gottlieb, *Blast II* [17.3]
1959 Krasner, *The Bull* [17.4]
1960 Tinguely, *Homage to New York* [17.21]
1961 Bontecou, *Untitled* [3.29]
1962 Warhol, *Marilyn Diptych* [1.24]
1963 Frankenthaler, *Formation* [2.32]
1963 Lichtenstein, *Drowning Girl* [17.25]
1964 Bearden, *Prevalence of Ritual* [I.26]
1964 Smith, *Cubi Series* [17.16]
1964 Agam, *Double Metamorphosis II* [17.14]
1966 Kienholz, *State Hospital* [I.16]
1966 Oldenburg, *Giant Soft Fan* [6.23]
1968 Indiana, *Love* [17.28]
1968 Nevelson, *Royal Tide II* [6.11]
1970 Smithson, *Spiral Jetty* [1.15]
1972 Judd, *Untitled* [17.18]

1950	1955	1960	1965	1970	1975

HISTORICAL NOTES

1949 George Orwell, *1984*
1950 Korean War begins
1957 USSR launches Sputnik I
1957 Boris Pasternak, *Dr. Zhivago*
1959 USA: first transistorized computer
1961 USSR: first man in space
1963 Betty Friedan, *The Feminine Mystique*
1963 President John F. Kennedy assassinated
1965 USA in Vietnam
1965 Selma, Alabama, Civil Rights demonstrations
1968 Martin Luther King, Jr., assassinated
1969 USA: first man on moon
1970 Kent State campus killings
1970 Germaine Greer, *The Female Eunuch*

EUROPE AND AMERICA

World War II marked the end of European art leadership. The flow of art directed for hundreds of years by European tastes was now firmly centered in America. The shift in power surprised very few. The United States dominated so many aspects of living overseas—from American fast-food hamburgers, Coca-Cola, and blue jeans to the heavy industries we had set up all over the world. Other factors contributed to centering the art world in America. Several major artists had spent the war years here—Mondrian, Chagall, Ernst, Dalí, and Léger—joining Duchamp, De Kooning, and other artists, writers, and critics already on the East Coast.

It seems that few areas could compete with the stimulation of New York. Poetry, aesthetics, and the philosophies of Zen, Jung, Jean Paul Sartre, and Kirkegaard provoked heated discussions among artists, while exhibitions at the Museum of Modern Art and the Solomon R. Guggenheim Museum provided on-the-spot stimulation. The pioneering New York School of Abstract Expressionism had established a strong medium for individualism and, in so doing, was rejecting most traditional art conventions that might inhibit "modern art." Many postwar artists became engrossed in highly personalized interpretations, such as De Kooning's preoccupation with the female figure

[16.19]. On the other side of the ocean, just as De Kooning had begun working with the Venus-fertility symbol, Jean Dubuffet (1901–1985) independently came upon the same theme.

After completing college studies, Dubuffet attended art school in Paris for several years, but eventually despaired of making a worthy contribution to the art world. After a lapse of some time, he returned to art, formulating a dazzling anticultural philosophy that was to serve him well for the rest of his life. Rejecting all Western academic and societal conventions, he evolved an art form he termed *art brut*—spontaneous works foreign to the professional artist:

> … painting can conjure things—not in isolation—but linked to all that surrounds them; a great many things simultaneously. Painting is a more immediate and direct vehicle than verbal language, much closer to the cry, or to the dance …

Eliminating composition and perspective, he flattened his images and added nonart materials like gravel, glass, and even mud. As early as 1946, he shocked the world with his *corps de dames* series [17.1], scratching and scraping the monstrous forms until the "classical nude" with which he

17.1 Jean Dubuffet. *Corps de Dame Piece de Boucherie.* 1950. Oil on canvas, 45-1/2 × 35″. Courtesy Sidney Janis Gallery, New York.

began rather resembled a graffitied public wall than a Venus figure.

Against this background, antibiotics, computerization, electronic transistors, and nuclear power, all portended a dynamic world. Yet, it is still possible to view 1945 through 1970 within much of the framework we have seen before—formalism, modified realism, Expressionism, and fantasy.

FORMALISM

As we noted, America took the lead in avant-garde art all over the world at mid-century. While the more emotional side of Abstract Expressionism, called Action painting, had dominated the art world in the 1960s, many artists turned to cooler, more intellectual, nonobjective art whose formal aesthetic depended mainly on color, shape, and texture.

Color-Field Painting

Some Abstract Expressionist painters in the 1950s had been more interested in planes of color than in gestural brush strokes. Their interest developed into a form they called **Postpainterly Abstraction, Field painting,** or **Color-Field painting,** a dominant style of the 1960s. Color-Field painting avoids subject matter in order to concentrate on color relationships (see Chapter 2 on color). A painted canvas may consist of large, nonobjective areas of color on a flat-colored or white ground, with one brush stroke as large as a conventional easel painting or even as large as the viewer. Although a large area of color may have smaller shapes that float on it, few ever disturb that initial impact of color.

Color-Field painters usually created oversized works so large that they are not meant to be seen all at once. Widths of 10, 12, or even 40 feet (3.04, 3.65, or 12.19 meters) are not unusual. Such paintings are designed to overwhelm us. To appreciate them as the artist intended, the viewer must stand close enough to the canvas to be surrounded by the field of paint and be visually led into it.

Many Color-Field painters used acrylic paints (Chapter 3), which came into general use in the 1950s. Although they have not replaced oils, they are applied in new ways, giving painters an opportunity to create new effects. Acrylics can be used to fill in flat areas by creating a smooth surface that is glossy or matte according to the vehicle used. Since acrylics flow easily onto the canvas and dry quickly, they are more suitable than oils for painting sharp edges on forms next to each other. Also, acrylics can be thinned to give a transparent, watery look; and if used on absorbent, unsized canvas, they will sink into the fabric and produce soft edges.

A Color-Field painter who used acrylics in this way is Morris Louis (1912–1962) **[3.25].** His pigments interacted with the canvas, becoming part of it, rather than remaining on the surface. This technique gives depth to the color, reducing the reflective quality of the painting and producing a very different effect from that of oils. Difficult to evaluate in reproductions, Louis's paintings express a tension and a flow that physically involve the viewer. Like Louis, Helen Frankenthaler (b. 1928) **[2.32]** often allows her colors to soak into the canvas. Like Pollock, she lays her huge canvases on the floor, pouring and pushing her paints into the fabric until the color arrangements satisfy her, enveloping an observer in the joy of pure color. A summer at Hans Hoffman's school in Provincetown, Massachusetts, in 1950 exposed her to color for the first time. Now, the brilliance of her pigments create powerful and satisfying visual effects, some achieved by chance and spontaneity, but all with deft gesture. Works such as *Orange and Yellow* by Mark Rothko (1903–1970) have great impact based on color sensation and large size **[17.2].** Rothko placed vaporous, rectangular patches in front of one another, and his color, unrestrained by drawn lines or hard edges, spreads from one shape to the next. Often the color areas are extremely close to each other in value. Sometimes Rothko soaked and stained the canvas with transparent paint, and sometimes he brushed on opaque pigment. Color provides both the form and the content; it is the sole carrier of his ideas, capable of endless variations. By reducing shape to minimal variation, Rothko compels the observer to revel in subtle colors alone.

In a series of large paintings, Adolph Gottlieb (1903–1974) produced images that remind us of explosions **[17.3].** In *Blast II* the two main forms are separate, placed

17.3 Adolph Gottlieb. *Blast II.* 1957. Oil on canvas, 7′5″ × 3′9″ (2.26 × 1.14 m). Collection Joseph E. Seagram and Sons, Inc., New York.

17.2 MARK ROTHKO. *ORANGE AND YELLOW.* 1956. OIL ON CANVAS. 91 × 71″. ALBRIGHT-KNOX ART GALLERY, BUFFALO, NEW YORK (GIFT OF SEYMOUR H. KNOX, 1956).

one above the other. The brilliant color and the rounded form of the upper shape may represent the sun or a nuclear explosion, while the somber colors below remind us of the earth. No matter what these forms may suggest to us, however, their opposition creates a visual tension in the viewer. All these artists whose major focus may be the impact of color have produced individual styles of art very different from one another, as with Lee Krasner.

Beginning earlier than her famous husband, Jackson Pollock, and coming to fullest realization of her powers after his death, Lee Krasner (Pollock) was an abstract expressionist of the first order. By 1939, Krasner had already evolved her own style distantly echoing influences of the fractured planes of cubism and the Moroccan colors of Matisse. *The Bull* [17.4] maintains the bold areas of color, strong use of negative and positive shapes, and rhythmic gestures. Few of her works are large by abstract expressionist standards, yet the power of her strokes energize the viewer.

Many of the artists whose work we have discussed, and a few still to come, met informally as a group now and then, calling themselves The Irascibles. On January 15, 1951, *LIFE* magazine published a photograph of them by Nina Leen [17.6]: Willem de Kooning; Adolph Gottlieb; Ad Reinhardt; Hedda Sterne; Richard Pousette-Dart; William Baziotes; Jackson Pollock; Clyfford Still; Robert Motherwell; Bradley Tomlin; Theodoros Stamos; Jimmy Ernst; Barnett Newman; James Brooks; Mark Rothko.

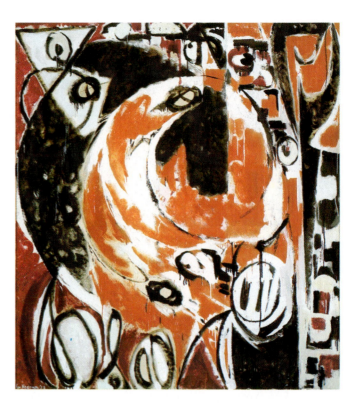

17.4 Lee Krasner. *The Bull.* 1959. Oil on cotton duck, 76-1/2 × 70-1/2″. Private Collection, Courtesy Robert Miller Gallery. New York.

17.6 *The Irascibles* (Major members of Abstract Expressionist artists). 1950. Photograph by Nina Leen. Accompanied article in *Life*, January 15, 1951.

17.5 Lee Krasner. *Self-Portrait.* 1930. Oil on canvas, 30-1/8″ × 25-1/8″. Courtesy Robert Miller Gallery, New York.

The Artist Sketch

The founders of the New York School include Lee Krasner, along with the better-known Jackson Pollock, Willem de Kooning, Arshile Gorky, and others. She was a master of line and color in her energy-filled canvases that suggested the rhythms of nature. A significant painter before husband-to-be Jackson Pollock hit his stride, Lee Krasner's art skills were submerged after marriage by her husband's need for support during his constant battle with alcohol.

Born in Brooklyn, New York, to Russian immigrants, Krasner was accepted at the Cooper Union for the Advancement of Science and Art, where entry to the school is still based upon competitive demonstration of art and scholarship. With the completed degree, like other artists, she went on to the Art Students League for more specialized instruction. The only member of the New York School to also study with the German master Hans Hoffmann, Krasner [17.5] retained his influence all of her life. Although Hoffmann rarely used his own work to bolster his teachings, reluctant to overwhelm his students, the value of his instruction was such that art critic Clement Greenberg (Art Talk, Chapter 16) later wrote, "You could learn more about Matisse's color from Hoffmann than from Matisse himself."

Such was the case with Krasner's work, through which many learned about Hoffmann. She actively promoted the principles that she had absorbed at the Hans Hoffmann School of Arts, structuring her canvases cubistically into "complexes." Her paintings maintained the "flatness" of abstraction, while, at the same time, the colors she chose to interweave with the bulbous shapes she formed generated a sensation of pulsating life. The extent of her influence on others in the New York School may in part be attributed to her participation in shows sponsored by the American Abstract Artists Association (AAA). In fact, as action painters, only she and Ad Reinhardt were willing to undertake a lifetime commitment to the doctrine of limiting art to nonobjectivity as achieved with flat colors.

From 1934 to 1943, the Federal Art Project made it possible for Krasner to devote herself fully to art, supplementing her income with an assistantship to Max Spivak, a muralist. She became a spokesperson for the project when Congress threatened to undercut it and was twice fired from employment because of her outspoken views. In 1942, she was invited to participate in the French and American Painting show at the McMillan Galleries in New York City. Curious about the other artist scheduled in the same room with her, she visited Jackson Pollock's studio in Greenwich Village and was bowled over. Soon the two were living together and were married in 1945, moving into a home near De Kooning in The Springs, on the east end of Long Island, financed by Peggy Guggenheim.

As Pollock's fame grew internationally, Krasner was relegated to the background. Gradually, she became identified only as Pollock's wife. When she was passed over by The Irascibles, an Abstract Expressionist Protest Group, formed to oppose art museum policies, she was deeply crushed; in particular, because it seemed all her creative energies were going to hold up Pollock with whom she was absorbed. After his death in 1956, she painted a whole group of stormy canvases, working through the anguish of her loss.

Not until thirty years later did Krasner experience her first retrospective solo show, opening in Houston, Texas. The exhibition later toured the United States, finally reaching New York City, the hub of the New York School she had helped found. But at that point, Krasner was dead. Like many a woman torn between a marriage and a career, the art often bows to family needs. Krasner's stoic acceptance of this fact was expressed in an interview by Gaby Rodgers in 1977 for *Women's Art Newsletter*, but her words may ring hollow:

> Even as a kid, I knew I was an artist. I have stayed with that conviction.
> I have worked all my life—before and during my marriage. I can't imagine staying with a man who wouldn't let me do my own work.

Despite her claims of independence, she wasn't capable of focusing her energies on her art instead of on the man she loved. Nor did their bond permit her to leave him.

LEE KRASNER (1908–1984)

The early wave of this second generation of Abstract Expressionists tended to exhibit in the Greenwich Village area in New York City, where newcomers in growing numbers joined them as the 1950s progressed. Having grown up in the South Bronx as the only son of Russian Jewish immigrants, Larry Rivers was caught up in the family focus on music that remains a lifetime passion for him. In reviewing these years, Rivers shared insights with

The Artist Sketch

Born in Rotterdam, De Kooning experienced the early divorce of his parents and by age twelve was already working at a commercial art company. His evening studies were unique in Holland because they provided him an art education that blended fine and functional arts (the guild system) with intellectual philosophies (the academy). De Kooning recalls that guild and academy ideas were often fused into a single project. There was no stress on originality, which was present in the artist—or not. As part of the curriculum, the brilliant "De Stijl" group under Mondrian and Van Doesburg introduced concepts of the modern artist as a revolutionary social engineer, a viewpoint De Kooning has continued to maintain.

At twenty-one, De Kooning was in the United States, where he had finally arrived after several illegal and unsuccessful attempts to slip in through Holland-America Line ships. By 1935, he was able to commit all his energies to painting and had spent a valuable year on the Federal Arts Project. De Kooning and Arshile Gorky had become friends and with other New York artists created a social milieu that in part led to the great flowering of postwar American art with the New York School. Few were financially successful during these years, but collegiality and mutual respect promoted serious creative growth. About the time of his

17.9 WILLEM DE KOONING. PHOTO © 1992 TIMOTHY GREENFIELD-SANDERS.

marriage to Elaine Fried, an art student [2.6], he launched—by coincidence—his series called *Women*, a theme continued for several years.

In the late 1930s and the 1940s, both De Kooning and Gorky became underground leaders in the art world, counter to the mainstream of realistic art. Like many of their friends, they reacted strongly against the aesthetics of the then dominant school of Paris. Particularly abhorrent to them was the "finish" so critical to academic practice. Their pictures instead revealed the obstacles they encountered, along with their solutions—functional parts of the image inextricably fused with the content itself. The process introduced contradictions and ambiguities that often led to unfinished work. His house in The Springs on eastern Long Island is a major undertaking he is not likely to ever finish. With the same devotion to ambiguity, he has concurrently maintained identification with abstraction that pushes and pulls, held to the surface by bright colors, so close in value that, in the artist Fairfield Porter's words, they "make your eyes rock." In his figural abstractions there are neither foregrounds nor backgrounds; surfaces are continuous.

De Kooning's work cannot be divided into neat periods. He has always remained open to any possibilities and therefore to apparent inconsistencies.

WILLEM DE KOONING (B. 1904)

poet Frank O'Hara:

> I was energetic and egomaniacal, and what is even more important, cocky and angry enough to want to do something … I thought of a picture as a surface the eye travels over in order to find delicacies to munch on …

As we have seen in Chapter 4, O'Hara and Rivers collaborated on a series called *Stones* [17.7]. *Melancholy Breakfast* may have been the joint effort on which they were working when they were photographed [4.21].

17.7 LARRY RIVERS. MELANCHOLY BREAKFAST. 1958, FOLIO 8 FROM STONES, BY FRANK O'HARA, WEST ISLIP, UNIVERSAL LIMITED ART EDITIONS. 1960. LITHOGRAPH, PRINTED IN BLACK, COMP.: 15 × 19-1/8″. COLLECTION, THE MUSEUM OF MODERN ART, NEW YORK. GIFT OF MR. AND MRS. E. POWIS JONES.

17.8 WILLEM DE KOONING. *ROSY-FINGERED DAWN AT LOUSE POINT.* 1963. OIL ON CANVAS, 80-1/8 × 70-3/8″ (203.6 × 178.8 CM). STEDELIJK MUSEUM, AMSTERDAM.

While tension and fury often appeared in the early Abstract Expressionist work of Willem de Kooning [16.19], he continued to think of himself as a colorist steeped in Renaissance traditions. Moving away from his *Women* series by 1960, he had developed a new personal style, with a delicate pastel palette of flowing color shapes [17.8].

Hard-Edge Painting

Other artists who came to maturity in the 1950s turned away from Action painting in favor of a form of Postpainterly Abstraction known as **Hard-Edge painting**. Their works are comprised of flat areas of color, confined within precisely delineated boundaries. In formal investigations of color and design, many approached painting methodically, using masking tape, triangles, and rulers to make straight edges. Within this climate of technical precision, the contribution of Josef Albers is prominent.

After leaving the Bauhaus, Albers continued his preoccupation with color in the United States. For more than fifteen years he worked on a series of one hundred paintings called *Homage to the Square* [16.18]. Of approximately the same outer dimensions, each consists of squares that vary in size, color, and relationship to each other. Albers experimented with innumerable combinations of

warm and cool, muted and intense color. The simplicity of the square shapes intensifies the visual relationships of the colors, exploiting their optical effects fully. Albers recognized that in visual perception a color is rarely seen alone but usually in relation to the colors around it. As a simple demonstration of this, look at the corner of a plainly painted room. The slight variation in the intensity of the light that hits the two walls will show some difference in the color of the two surfaces. One wall may appear nearer, while the other looks distant. If a warm light hits one wall and the other is in cool shadow, the tension between them will be further increased.

The variety in Albers' series of squares depends not only on the combinations of colors but also on how the colors change in relationship to each other, the amount of each color used, and the number of squares. Albers also made use of the physical phenomenon of afterimages to cause vibrations in our eyes. For him, color experiments enriched the visual experience, and because he believed that the eye is an important part of the mind, he also believed that his paintings had intellectual as well as visual content.

Two other Hard-Edge painters who were color purists were Alice Trumbull Mason (1904–1971), descendant of the American historical painter John Trumbull, and Ad

Reinhardt (1913–1967), who claimed to be following her lead. Mason was a charter member of the American Abstract Artists Association and first exhibited with the group in 1937. Both worked mainly in a geometric style after the 1930s. Mason's canvases have a haunting, poetic lyricism, which she sometimes produced with a few colors [17.10]. She studied with Gorky and the graphic artist Stanley Hayter at his Atelier 17 and produced a large body of significant works that are even more highly regarded today than in her lifetime.

Like Mason, Reinhardt gradually reduced his paintings to areas of muted tones, close in intensity and value. By the late 1960s, he worked only in dark monochromes, creating areas of paint on canvases as large as 5 by 5 feet (1.5 by 1.5 meters). His goal was the refinement of painting to a single, all-consuming experience. A small reproduction cannot convey the aesthetic response that a large painting elicits [17.11]. Experiencing such a work, we feel drawn into its depth and may have a physical sensation of floating in a lightless, soundless void. As in many Color-Field paintings, Reinhardt's canvas surfaces cease to exist, leaving a mysterious infinity of visual and spatial effects created by color. Paintings such as these are closely related to **Minimal** or **Primary** painting.

Other Color-Field painters, such as Kenneth Noland (b. 1924) and Frank Stella (b. 1936), also depend on large scale and color to offer a visual experience of total immersion. The concept of expanding and contracting intervals of color arranged in hard- or soft-edge stripes is dominant in their work. As in his graphics, Stella painted complex patterns of stripes separated by light lines [17.12]. He also used unconventional shapes for his paintings [3.31], fitting the pattern of the stripes into the shape of the canvas or contrasting them to set up an opposing tension. Avoiding the individualization of Action painting,

17.10 ALICE TRUMBULL MASON. *SHAFTS OF SPRING.* 1955. OIL ON GESSO BOARD, 27 × 29″ (69 × 74 CM). COLLECTION THE AUTHOR.

the clean-cut outlines and flat surfaces of these large, bright Minimalist paintings often suggest the anonymity of mass-produced industrial products. Other Hard-Edge paintings are created by repeating hundreds of small shapes.

Mathematical rigor underlies the large gridded canvases of Agnes Martin (b. 1912), grande dame of **Minimalism** that reigned supreme through to the early 1970s.

17.11 AD REINHARDT. *ABSTRACT PAINTING, BLUE.* 1952. OIL AND ACRYLIC ON CANVAS, 75 × 28″ (190.5 × 71.1 CM). THE CARNEGIE MUSEUM OF ART, PITTSBURGH (MUSEUM PURCHASE, GIFT OF THE WOMEN'S COMMITTEE OF THE MUSEUM OF ART, 65.26).

17.14 AGAM (YAACOV GIPSTEIN). *DOUBLE METAMORPHOSIS II*.
1964. OIL ON CORRUGATED ALUMINUM IN ELEVEN PARTS, 8'10"
× 13'2-1/4" (2.70 × 4.02 M). COLLECTION, THE MUSEUM OF
MODERN ART, NEW YORK (GIFT OF MR. AND MRS. GEORGE M.
JAFFIN).

The effect is of poetry and great serenity. Inspired by the sense of light and open air of New Mexico, from where Martin moved to New York, her grids seem almost to float. In their tendency to induce contemplation in the viewer, Martin's paintings [17.13] invoke comparisons with Buddhist philosophy, as is the case with some Optical Art, to be considered next.

17.13 AGNES MARTIN. *THE TREE*. 1964. OIL AND PENCIL ON
CANVAS. 6 × 6' (1.83 × 1.83 M). COLLECTION, THE MUSEUM OF
MODERN ART, NEW YORK. (LARRY ALDRICH FOUNDATION FUND).

Optical Art

Art has used optical illusions since the Old Stone Age. Without illusion, we would not accept foreshortening and we could not use linear perspective to create a three-dimensional representation of a two-dimensional surface. The **Optical** artists of the 1960s and 1970s made such illusions the basis of their work (often called Op art). The Israeli-born artist Agam (Yaacov Gipstein, b. 1928) devised works that appear to change as we view them. Possibly inspired by moving billboards, which change their images by means of mechanically turning louvers, Agam incorporates similar, though fixed, projecting louvers in some of his paintings [17.14]. Looking at an Agam creation from one side of a room, we see what appears to be a flat painting with simple, nonobjective shapes. But if we observe the same painting from another point in the room, it looks like a different work.

Bridget Riley (b. 1931) also depends on optical illusions for the impact of her linear black-and-white paintings [2.12]. These illusions suggest movement where none exists and produce an intense, sometimes uncomfortable but seductive sensation as we view the works.

The tensions produced by Stella's *Bijoux indiscrets* [17.12] draw the nest of squares toward optical experiences. In this painting, named perhaps after an indiscreet eighteenth-century novelette by Denis Diderot with the same title, Stella presents twenty-three concentric squares and the compositional effect of a regularly stepped pyramid seen from above. By setting hot colors in the outermost and innermost zones, the painting appears to dilate, almost erotically. The regulated geometry of the squares strives toward the flat plane, but the colors struggle to give the painting a thrust toward the third dimension.

Direct-Metal and Primary Sculpture

A logical progression from the work of early twentieth-century Constructivist sculptors was the **direct-metal** and **Primary sculpture** of the 1950s and 1960s. Rejecting the traditional representation of the human figure, sculpture became an ex-

tension of physics rather than a direct reflection of humanity. Architectural space became an arena for exploration by means of welded metal sheets, rods, and wires.

John Chamberlain (b. 1927) welded discarded automobile parts to form strong spatial constructions and to highlight our growing stockpile of debris [17.15]. Destruction is the dominating theme of his work. In such pieces as *Essex*, he builds bent and welded remnants of dead automobiles from junkyards into sculptures that provoke aesthetic responses from us with their colors and textures, while their battered parts form tensions that intrigue.

David Smith (1906–1965), one of the more inventive sculptors of his generation, began his studies as a painter at the Art Students League, but turned his attention to constructed sculpture when he became absorbed with Picasso's sheet-metal constructions and the work of other Europeans. Having learned to weld in an automobile factory, he found himself welding tanks during World War

17.15 JOHN CHAMBERLAIN. *ESSEX*. 1960. AUTOMOBILE BODY PARTS AND OTHER METAL, RELIEF; 9′ × 6′8″ × 3′7″ (2.74 × 2.03 × 1.09 M). COLLECTION, THE MUSEUM OF MODERN ART, NEW YORK (GIFT OF MR. AND MRS. ROBERT C. SCULL AND PURCHASE).

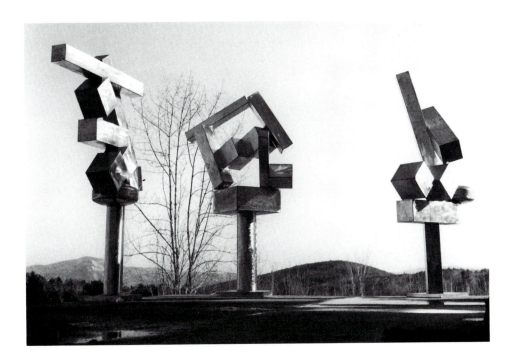

17.16 DAVID SMITH. *CUBI* SERIES. POLISHED STAINLESS STEEL. LEFT: *CUBI XVIII*. 1964. HEIGHT 9'8" (2.95 M); BASE 21-3/4" (55.2 CM) SQUARE. MUSEUM OF FINE ARTS, BOSTON (GIFT OF SUSAN W. AND STEPHEN D. PAINE). CENTER: *CUBI XVII*. 1963. 8'11-3/4" × 5'4-3/8" × 3'2-1/8" (2.7 × 1.64 × .97 M). DALLAS MUSEUM OF ART (THE EUGENE AND MARGARET McDERMOTT FUND). RIGHT: *CUBI XIX*. 1964. HEIGHT 9'4-3/4" (2.84 M). TATE GALLERY, LONDON.

II; skills that led him to experiment with complex linear steel constructions that he developed in a fanciful vein. In later work, using painted steel plates, he explored the human figure in Cubist terms [17.16]. Unlike most metal sculptors who send their drawings or maquettes (small models of a sculpture) onto a foundry or shop, Smith was personally dedicated to every step in the production of his sculptures, cutting, welding, and abrading the surfaces himself. Just before he died, he created his *Cubi* series that stand like sentinels on permanent guard. Considered Primary sculptures only in the stark simplicity of their forms and in the economy of their flat surfaces, the works demonstrate endless variety and are executed with great technical skill and precision.

The new inquiry into space led to a gradual reduction of nonessential details until sculptors reached a vocabulary, or system, of simple, basic geometric volumes. Their works are called **Primary, Minimal, ABC,** or **Systemic sculpture.** The shapes are usually so depersonalized that the artists can turn over their drawings to a workshop to do the actual construction. As a reflection of materialistic, anonymous society, the surfaces of the shapes are mechanically finished, and they are assembled in multiples.

Primary sculpture may be placed on the floor or against the wall, suspended from the ceiling, or placed outdoors on a lawn or sidewalk. Such work enjoys the same freedom in three dimensions that nonobjective painting occupies in two. Although the physical presence of the viewer is not part of the design, his or her perceptions and responses to spatial openings, volumes, and enclosures concern the artist. Most significantly, the spectator is often invited to become part of the scene, to wander under, around, and through the sculpture.

Primary sculptors range from engineers who design by equation and computer to sculptors who create intuitively. Isamu Noguchi's (b. 1904) bold red *Cube* is a Minimal sculpture that engages our attention and creates tension by the questions it raises about balance [17.17]. Its apparently precarious position, poised on one corner, startles and disturbs us, while its huge geometric mass forces us to see it in relation to the surrounding architecture. An approach to his sculpture streetside is a startling and provocative experience.

By placing modular repeats in a straight line, Donald Judd (b. 1928), another Minimalist sculptor, eliminates variables, or human qualities. The predictability of his

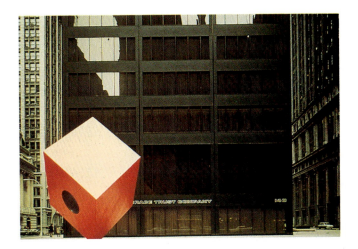

17.17 ISAMU NOGUCHI. *RED CUBE*. 1968. PAINTED WELDED STEEL AND ALUMINUM, HEIGHT 28' (8.54 M). PHOTO BY ELIOT ELISOFON, COURTESY OF THE ISAMU NOGUCHI FOUNDATION, INC., NEW YORK.

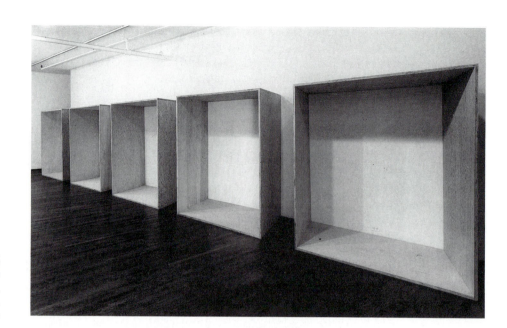

17.18 DONALD JUDD. *UNTITLED.* 1972.
PLYWOOD; FIVE BOXES, EACH 3′5″ × 6′ × 6′
(1.4 × 1.83 × 1.83 M), SPACED 1′7″
(0.48 M) APART. PRIVATE COLLECTION.
COURTESY LEO CASTELLI GALLERY,
NEW YORK.

sculptures make no reference to past traditions, reducing emotional overtones to zero. What remains is only a real sculpture in real space [17.18]. If we find such sculptures disturbing, it may be that they remind us of manufactured environments that cannot fulfill human needs.

Before we close this section dealing with sculpture, we should note the work of Vladimir Tatlin, leader of the early Russian Constructivist movement. Commissioned to design a *Monument to the Third Communist International* back in 1920, construction costs for the projected 1300-foot construction prohibited more than a small model of the work. Replicated in recent years, we will remember that the design was to have symbolized the current technology, reflective of the revolutionary state of the Soviet Union. The variously shaped glass units were to have housed rooms, intended to revolve at different speeds [17.19].

Motion in Sculpture

Like all animals, we are fascinated by motion. The driving rain, waving branches in the wind, the crash of waves onto a beach intrigue us as they did our ancestors. Motion is essential to life, even if it is the slow, almost imperceptible motion of a germinating seed thrusting a shoot through the earth. Today, however, we live in an age of motion unlike any the world has ever known. The speed with which our space vehicles rush toward other planets is almost beyond comprehension, while here on earth jets travel at velocities never dreamed possible. It is no wonder, then, that twentieth-century artists have been fascinated with motion and have attempted to respond to it in their art.

The concept of combining sculptured figures with mechanical motion is not new. Turkish sultans had elaborate mechanical figures built for their amusement, probably

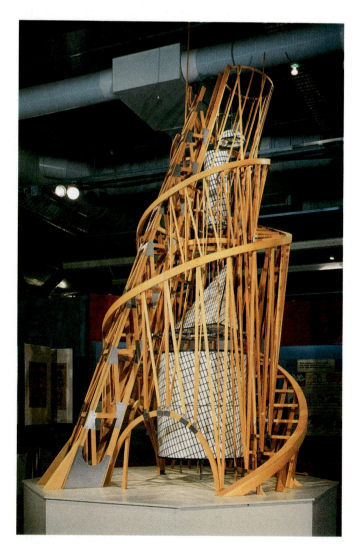

17.19 VLADIMIR TATLIN. REPLICA, *MONUMENT TO THE THIRD COMMUNIST INTERNATIONAL.* ORIGINAL 1920.

inspired by Oriental creations. In medieval Europe, the bells in many clock towers were struck by mechanical figures, and during the Renaissance, Leonardo designed figures for royal festivals which were moved mechanically.

The machine-oriented Futurist Umberto Boccioni expressed motion in his sculpture as early as 1913 [15.32]. Constantin Brancusi's *Bird in Space* of 1928 [15.34] minimized the material limitations of solid mass by its soaring form. But it was the Constructivist sculptor Naum Gabo who, in 1920, designed the first motorized sculpture, a tall shape that vibrated. Works of this kind, often moved by a motor, are called **kinetic sculptures**. At the Bauhaus, László Moholy-Nagy (1895–1946) built the first light-and-motion sculptures, which were activated by the sun and called light modulators [17.20].

In the 1930s and later, Alexander Calder (1898–1979) constructed moving sculptures from industrial materials such as sheet metal and wire. Although he added motors to some constructions to make them move, he preferred to leave their motion to the unpredictability of air currents. The result was a totally new sculptural form called a **mobile** by his friend Duchamp [2.46]. The cheerful elements of his mobiles remind us not of machines but of fish, animals, plants, and sometimes planets. Arranged in carefully balanced systems, they are set in motion by a passing breeze, the hot air of a furnace, or even the movement of someone walking past. Each element moves independently but within a prescribed orbit. Some strike each other like gongs and bells, adding an element of noise to the sculpture. Many of Calder's largest pieces are balanced on bases anchored to the ground, and movements of their heavy forms are slow and stately. He also built some pieces of sculpture, called **stabiles,** that do not move.

Thus, over the last fifty years, motion has become an important feature of some works of art. Kinetic sculp-

17.20 LÁSZLÓ MOHOLY-NAGY. *LIGHT-SPACE MODULATOR.* 1923–1930. MOBILE CONSTRUCTION OF STEEL, PLASTIC, WOOD, OTHER MATERIALS, WITH AN ELECTRIC MOTOR. HEIGHT 4'11-1/2" (1.51 M). COURTESY BUSCH-REISINGER MUSEUM (GIFT OF SIBYL MOHOLY-NAGY). HARVARD UNIVERSITY, CAMBRIDGE, MASSACHUSETTS.

tures sometimes consist of nonfunctional machines, their movement existing only to provide a visual experience. Some of these machines perform complex operations perfectly, but at the same time they amuse us with their somewhat ridiculous uselessness. In our mechanistic society, a machine that can do nothing but move seems laughable.

Erratic movement is expressed uniquely by the Swiss sculptor Jean Tinguely (b. 1925), who creates machine-powered kinetic sculptures that perform a series of actions. *Homage to New York* [17.21] was constructed of assorted discards found in dumps or second-hand stores. It made music with a battered piano, issued reports from an

17.21 JEAN TINGUELY. FRAGMENT FROM *HOMAGE TO NEW YORK.* 1960. PAINTED METAL, 6'8-1/4" × 2'5-5/8" × 7'3-7/8" (2.04 × 0.75 × 2.23 M). COLLECTION, THE MUSEUM OF MODERN ART, NEW YORK (GIFT OF THE ARTIST).

old typewriter, and gave birth to machine offspring. Finally one memorable evening in the garden of the Museum of Modern Art in New York, under the baleful eye of a New York City fireman and before an enthralled audience, *Homage to New York,* with some frantic help from its inventor, committed suicide in a flurry of movement, sound, and smoke. Its demise echoed the absurdity of Dada as it parodied modern self-destructing society.

EXPRESSIONISM AND REALISM

The emotional trend in art, identified with Abstract Expressionism in the 1940s and 1950s, all but disappeared from the scene during the 1960s and 1970s, only to reappear in new form later. For a brief time the Feminist movement became a passionate cause for some, combining personal feelings with a response to the real world that the public often found disturbing.

Feminism

The Feminist movement that gathered strength in the 1960s led to a reexamination of women's achievements in the visual arts. In the past, as we have seen, few women not born within a family of artists had any opportunity for art training or patronage. In the 1960s and 1970s, however, women's cooperative galleries mushroomed, and a few

17.23 Judy Chicago. *Hatshepsut Place Setting from the Dinner Party (detail).* Multimedia. © Judy Chicago 1979.

17.22 Judy Chicago. *The Dinner Party.* 1979. Mixed media, 4′ × 4′ × 4′ installed. Photo courtesy of the artist.

commercial dealers in art of women appeared and have continued. These galleries and dealers succeeded in informing women themselves about their ground-breaking role as artists. Much Feminist work attacked sexism, often in erotic ways that shocked many.

Judy Chicago (b. 1939), an ardent Feminist, uses hard-edge imagery to communicate her intuitions about the nature of womanhood. While she taught at the California Institute of the Arts in Los Angeles, she initiated a Feminist art program that was highly successful in politicizing the female art community. Together with Miriam Schapiro (b. 1923) [18.1] and her codirector of the art institute's Feminist Art Program, Chicago worked on projects such as *Womanspace*. As the first cooperative women's art gallery on the West Coast, the Woman's Building, as it is now known, still functions as a busy art center in Los Angeles. Her best-known work is *The Dinner Party* [17.22], the archetypal Feminist work. Five years in the making, it was assembled by the collective skills of four hundred women who executed Chicago's design. The format of the work is a huge triangular table with thirteen place settings on each side, referring to Christ and his disciples at the Last Supper. All thirty-nine place settings, named in honor of famous women [17.23], consist of plates, goblets, and flatware, with each one decorated with explicit female sexual symbols that affronted many anti-Feminists, as well as other women and men with moderate views. They repose on hand-worked place mats. The triangular ceramic floor bears the names of 999 other cultural heroines. *The Dinner Party* was exhibited to packed crowds and, like many frankly sexual works, has received mixed evaluations.

As we review the works of various women artists, it appears that women's experiences, although different from men's, do not make women's artworks similar to one another in style. Most women artists, in fact, seem to find affinity with other artists of their own **milieu** (environment) and period and work within the general mainstream of art.

Fantasy

Fantasy, like formalism, was partly a reaction to the emotional aspects of Abstract Expressionism. It pervades Pop Art, assemblage, and the improvisational art experiences known as "happenings." Two important transitional figures who began as Abstract Expressionists, but were forerunners of Pop Art, were Robert Rauschenberg (b. 1925) and Jasper Johns (b. 1930).

Rauschenberg, as we saw in Chapter 3, in his desire to work in the gap between art and life, combines collage, the commercial silk-screen process, Action painting technique, and ready-made objects such as a real door to create **combine art**. The prevailing theme is often non-meaning or, like Dada, art of the absurd expressed in the mass-media idiom.

Johns painted familiar objects such as American flags [I.22] and beer cans. In *Studio I* [17.24] he is inspired by the theme that began in the Renaissance with Vermeer—the artist painting in his own studio—and was later repeated by the Romantic Courbet's painting of his studio [14.10]. Courbet's important work has since been considered a manifesto for freedom of artistic expression. Building upon this tradition, Jasper Johns adds the actual tools of the

17.24 Jasper Johns. *Studio I*. 1964. Oil on canvas with objects, 6'1-1/2" × 12'1" (1.87 × 3.68 M). Collection of Whitney Museum of American Art, New York.

artist's trade to his piece, consisting of several canvases nailed together to which a string of his paint cans is attached. *Studio 1* is another early example of combine art: adding objects that already exist in the real world to art.

Pop Art

A movement of the 1960s that combined both fantasy and realism was Pop Art. It began in London in 1956 when the Independent Group, a small group of artists, architects, sculptors, and art historians who were studying the symbolism and imagery of the art of mass society, staged the exhibition "This Is Tomorrow." It included a provocative work by one of the members, Richard Hamilton (b. 1922), entitled *Just What Is It That Makes Today's Home So Different, So Appealing?* [17.25]. It was unclear whether the public was expected to consider as art this montage of ready-made motifs culled from many nonart sources and explicitly connected to Dada.

However, the content of Hamilton's work could also be compared with a seventeenth-century Dutch painting whose genre theme is brought up to date—a couple at home, served by an upstairs maid standing before a window

view of an urban scene beyond. The name for the new style may be expressed in the oversize Tootsie Pop held by the head of the house. It any event, this work ridiculed the banalities of daily life and the fantasy world depicted by advertising. The popular culture represented at this exhibition was identified as Pop Art by the British critic Lawrence Alloway, a member of the group.

Pop Art focuses on movies, billboards, machines, comic books, and advertising. Pop artists examine our everyday world and report it directly, with neither satire nor antagonism, but with such intensity that the spectator frequently becomes conscious for the first time of what he or she sees every day. Pop Art may depend on large scale to increase its impact, thrusting forward in monumental size aspects of our culture we have chosen to ignore. Another characteristic of Pop Art is the repetition of images in patterns reminiscent of the rows of mass-produced packages seen in the supermarket.

In the United States, Andy Warhol (1930–1987) was a pioneer in using multiple images and in packaging art as well, making use of his commercial training and early career in advertising in his paintings. After 1961, his subjects included soup cans, Marilyn Monroe [1.24], and a

17.25 RICHARD HAMILTON. *JUST WHAT IS IT THAT MAKES TODAY'S HOME SO DIFFERENT, SO APPEALING?* 1956. COLLAGE ON PAPER, 10-1/8 × 9-3/4″ (26 × 25 CM). KUNSTHALLE, TÜBINGEN, SAMMLUNG (COLLECTION OF PROFESSOR GEORG ZUNDEL).

bottle of Coca-Cola. Some of his pieces are paintings on two-dimensional surfaces, but many are sculptures executed in mixed media such as commercial lithography and silk-screening. In this way Warhol removed the artist's touch from the art, not scientifically like Seurat but by the techniques of industry. He believed that "painting is essentially the same as what it has always been. ... All painting is fact, and that is enough; the paintings are charged with their very presence."

The work of James Rosenquist (b. 1933) [I.10], who initially was an outdoor-sign painter, performs the same function as the work of Warhol—magnifying images and forcing us to look at the photocopy quality of our lives and at the endless assembly-line products of which we have become a part. In F-111 he covers all four walls of a room with blown-up images of food, automobile tires, spaghetti, an atomic mushroom cloud, and a little girl being initiated into the rites of grown-up artificiality. Roy Lichtenstein (b. 1923), however, may best represent Pop. He has seized standardized imagery of sentiment and violence in our popular comic strips and greatly enlarged its impact while faithfully transcribing every detail [17.26]. It is perhaps ironic that Lichtenstein's satirized review of popular culture has in thirty years become a million dollar icon itself.

Jim Dine's (b. 1935) art, like that of Rauschenberg and Johns, draws on abstract expressionism. Retaining the stock accessories of theater—stage-set colors and actual props—Dine uses paint and modeling materials to remind the spectator of commonplace objects. His work combines anti-art objects with the immediacy of Action painting. For instance, in one of his assemblages, Dine set a lawnmower against a canvas painted green and permitted the paint to drip off the canvas onto the mower as if art must include not only paint and canvas but also anything in contact with the canvas [3.6].

17.26 ROY LICHTENSTEIN. *DROWNING GIRL.* 1963. OIL AND SYNTHETIC POLYMER PAINT ON CANVAS, 5'7-5/8" × 5'6-3/4" (1.71 × 1.70 M). COLLECTION, THE MUSEUM OF MODERN ART, NEW YORK (PHILIP JOHNSON FUND AND GIFT OF MRS. BAGLEY WRIGHT).

Pop artist Ed Ruscha anticipated **Conceptualism**, discussed in Chapter 9, when he began to introduce individual words and phrases into his paintings as if they were objects in a still life work of art. Yet by his employing non-traditional art materials in these works, such as painting on a textured surface, the viewer is forced into recognition of an utterly new subject matter for art [17.27]. Also, Ruscha's choice of impersonal theme further links the art with the mass production of popular culture.

Anonymity is a particular feature of Pop Art. Robert Indiana (Robert Clark, b. 1928) exhibits paintings of stenciled signs that reveal nothing about the artist except what can be read into his choice of subjects. Indiana is absorbed by word images that suggest the stark simplicity of flashing neon signs. The words *eat*, *love*, and *die* are rendered in clashing, precise, hard-edged colors. His *Love* [17.28] has become so much a part of the popular American scene that few are aware of its source. Many other Indiana word images are bitter indictments of modern life. Thus Pop Art echoes the bland character of our commercial surroundings as contrasted with the highly individualized creations of traditional art.

17.27 EDWARD RUSCHA. *VIRTUE.* 1973. OIL ON CANVAS. 4' 6-1/8" × 5'. PHOTO COURTESY OF EDWARD RUSCHA AND LEO CASTELLI GALLERY; © EDWARD RUSCHA.

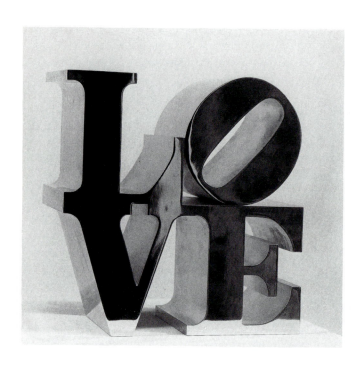

17.28 ROBERT INDIANA. *LOVE.* 1968. ALUMINUM, 12 × 12 × 6″. COLLECTION OF THE WHITNEY MUSEUM OF AMERICAN ART, NEW YORK (PURCHASE, WITH FUNDS FROM THE HOWARD AND JEAN LIPMAN FOUNDATION, INC.).

The most impressive sculptor associated with Pop Art may be George Segal (b. 1924), who, like Edward Kienholz [I.16], will be discussed later as an environmental sculptor. After working on happenings with Allen Kaprow (b. 1927), Segal turned to building real environments into which he placed sculptured people [17.29]. These works, often assembled from junkyard materials, are filled with machines, oil cans, and other Pop images. But the figures are always taken directly from life. Replicas of nondescript people, they are cast from the live model into plaster as if they could be produced in multiples, like beer cans or soap boxes.

Marisol (b. 1930) has created her own style, which uses wood, plaster, paint, photographs, and accessories. Her works are studies of modern personalities, mocking the

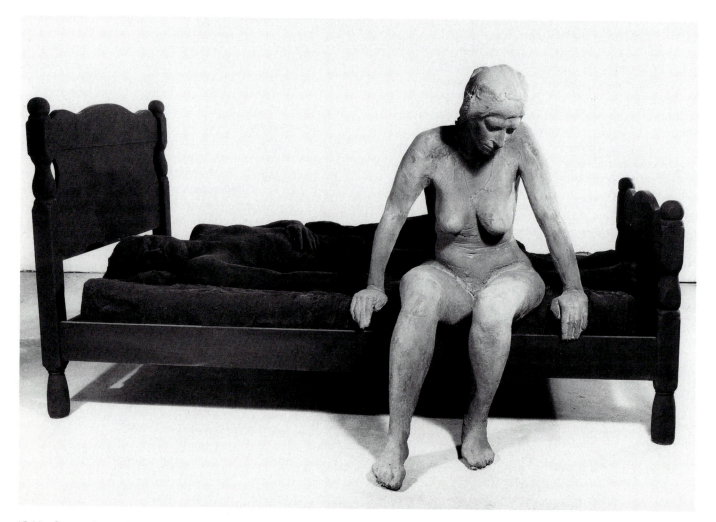

17.29 GEORGE SEGAL. *COUPLE ON BLACK BED.* 1976. PAINTED PLASTER AND WOOD, 44 × 82 × 60″. COURTESY SIDNEY JANIS GALLERY, N.Y.

The Artist Sketch

First viewed by the critics of the 1960s as an ingenious Pop artist, Oldenburg clarifies our obsessive focus on food, sex, and the human comforts we seek right off the assembly line.

Born in Stockholm, Sweden, the son of a singer and a consular official, Claes had the good fortune to travel through Europe and the United States during his childhood. It was his Swedish aunt, however, who introduced him to advertising with gift scrapbooks of advertised products that she had clipped from magazines.

Writing was his first love. Armed with a B.A. from Yale, he was hired as a reporter for *City News Bureau* in Chicago, but much of what he experienced on assignment appeared in his later Happenings. Next, in attendance at the Art Institute of Chicago, he supported himself as art editor and illustrator for *Chicago Magazine*. By 1956, he had gone East to an apartment on Manhattan's Lower East Side. The piles of discarded street debris and the lavish displays in store windows seemed to emphasize for him the short life of material purchases. Responsive to Jean Dubuffet's use of garbage [17.1], Duchamp's found objects [15.20], and Arp's insistence on the laws of chance in life and art [15.19], Oldenburg's first solo show in 1959 consisted of bundlelike sculptures that were made of paper, wood and string.

17.30 CLAES OLDENBURG. PHOTO © 1992 TIMOTHY GREENFIELD-SANDERS.

Joining Jim Dine the following year in a Judson Gallery show, both explored street themes. From street subjects, Oldenburg moved to *The Store*, a series of watercolors depicting actual merchandise. A summer job as a dishwasher in "arty" Provincetown, Rhode Island, inspired him to return to New York and rent an actual store [9.9] where he staged ten Happenings—events of sound and movement that always involved the audience. Some of the fabric and vinyl "props" used in the Happenings were made by his wife and led to his later "soft scuptures."

Among his many proposed monuments to materialism included a giant vacuum cleaner to be set up in New York City's Battery Park and an ironing board for the Lower East Side. All of Oldenburg's works are rich in satire, such as *Giant Lipstick Ascending*, a reference to the cosmetic industry, devoted toward helping women provide a visual illusion often quite different from reality. The sculpture was first set up at Yale University in 1969 as a donation from the artist to his alma mater. His giant *Clothes Pin* stands as a traffic control in downtown Philadelphia, Pennsylvania. His proposed monument to himself is a three-way electric plug to be carved of stone! As he has stated, his goal through all his art has been the making of connections.

CLAES OLDENBURG (B. 1929)

stuffed-animal figure of the hero, an empty image of leadership, which the public demands. Her portrait of Louise Nevelson [6.13] rounds out her series devoted to well-known twentieth-century artists, whom she has addressed with respectful satire.

In his sculpture, Claes Oldenburg (b. 1929) calls attention to the character of ordinary objects by taking them out of context and changing their scale. His *Hamburger*, the symbol of American fast food, made of painted plaster of paris and enlarged to four times normal size for his *Store* (Chapter 9), had a wide influence on the art of the 1960s. Explaining his role as storekeeper, Oldenburg said of his pieces that galleries are "not the place for them. A store would be better." Everything he sees becomes saturated with meaning, and he has turned things inside out or upside down or changed their substance. For example, he reproduced an electric fan in soft, stuffed vinyl as a satire on

our dependency on material objects [6.23]. Art critic Max Kozloff observes:

> With Claes Oldenburg, the spectator's nose is practically rubbed into the whole pointless cajolery of our hard-sell, sign-dominated culture. Oldenburg may even be commenting on the visual indigestibility of our environment by his inedible plaster and enamel cakes and pies.

Assemblages

The refuse of our industrial culture possesses great variety and appeals to many artists as a substitute for conventional materials. They combine debris—the rind of an orange, bits of advertisements, and found objects such as pieces of old cars—with paint to create collages and assemblages. Early examples are Cubist collages and assemblages such as

the *Merzbau* of Kurt Schwitters [15.23]. Jean Dubuffet's (1901–1985) statement that "anything can come from anything" explains the attitude of artists who create assemblages. Neither painted nor sculpted in the traditional sense, and not expected to last, they are made of whatever appeals to the artist.

Joseph Cornell (1903–1972) made memorable contributions to assembled sculpture. Perhaps inspired by penny arcade fortune-telling machines, he concentrated on boxes, creating glass-fronted containers crammed with odds and ends rich with personal associations. Occasionally they included Cubist forms and multiple images. Often containing mirrors, his assemblages suggested intimate, magical dream worlds [17.31].

Sometimes, assemblages that are made of rusted, crushed, or fragmented forms have a macabre fascination for us. Images that symbolize destruction such as *Essex*

[17.15] may allow us vicariously to experience deterioration without submitting ourselves to danger. Tinguely's self-destruction machine [17.21] had a similar appeal. In many of us there seems to be an element that enjoys seeing buildings torn down, cars crashing in a movie, or a piano being torn apart, as the comedian Jimmy Durante used to do on stage nightly. We may conclude that destruction must be attractive to many people or there would not be so much of it on stage or in events reported by media.

Happenings

When the distinctions that separate art from reality blur, the art object may concern us less than the *making* of art. The staged happenings of the 1960s might have occurred anywhere, on the street or in the supermarket. Allen Kaprow, an assemblage sculptor who was one of the first to

17.31 JOSEPH CORNELL. *UNTITLED.* C. 1952–1954. BOX CONSTRUCTION, 17-1/4 × 11-3/4 × 4-1/4″. PHOTOGRAPH COURTESY OF THE PACE GALLERY.

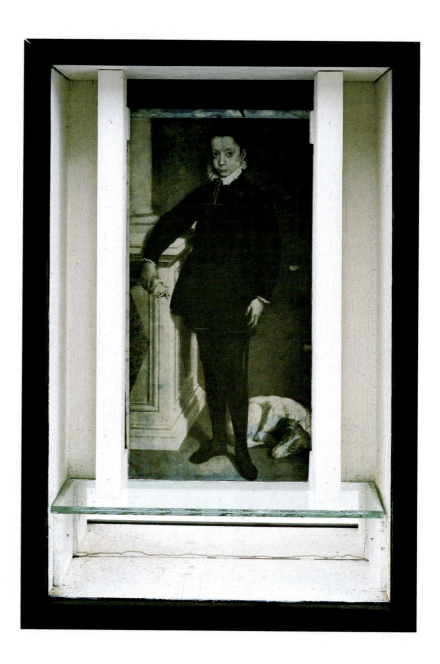

stage such events, believes that "the gallery has given way as a place for staging happenings to a craggy canyon, an old abandoned factory, a railroad, or the oceanside."

Happenings were performed without a real script or even a rehearsal. Participants were selected for their suitability to the plan, and props and costumes were gathered. Happenings were an art, sometimes closer to life than to theater. They were briefly a part of the American art world, perhaps because they reflected the sense of chaos many of us still observe in society.

ENVIRONMENTAL ART

The term **Environmental Art** refers to art that may combine painting and/or sculpture in architectural settings. Built on a large scale, many surround the viewer with visual sensations, totally immersing him or her in the art experience. As such, they may be called **Experiential Art**. By extension, the term may include art that reworks the natural environment.

Robert Smithson, a major innovator of earthworks, was interested in spirals, which he saw as moving from a path as close to us as our own cells out to the vastness of a spiraling nebula in space. In *Spiral Jetty* [1.15] he fused the concept of the spiral with his dedication to nature:

My works have been based on a dialogue between the outdoors and the indoors. ... I'm not interested in reducing art to a set of ideas. I prefer making something physical, and the world is a part of the process. ... Art will become less isolated and deal more in relationships with the outside world, out of the white room of the gallery into spaces that are natural.

In the late 1960s, while accompanying her husband Robert Smithson, Nancy Holt (b. 1938) began to design sculptures to integrate with the landscapes for which they were intended. Often planned to correlate with ancient celestial maps, these projects carry mystical associations. Keyed to the local terrain of mist-shrouded hills and the jagged coastline of the Pacific Northwest, *Stone Enclosure: Rock Rings* [17.32] consists of two concentric circles of stone walls, 10 feet (3 meters) high and 40 and 20 feet (12.2 and 6.1 meters) in diameter, hand-carved from 230-million-year-old rock. These site sculptures, like Smithson's, are always documented by drawings and photographs and suggest in their shifting patterns of light and dark ideas of sculptural stability amidst nature's fluctuations.

Departing from the early concept of "earthworks" that are characteristic of Environmental Art, new aspects of content emerged in the 1960s and 1970s. Alice Aycock (b. 1946) builds complex constructions such as *A Simple*

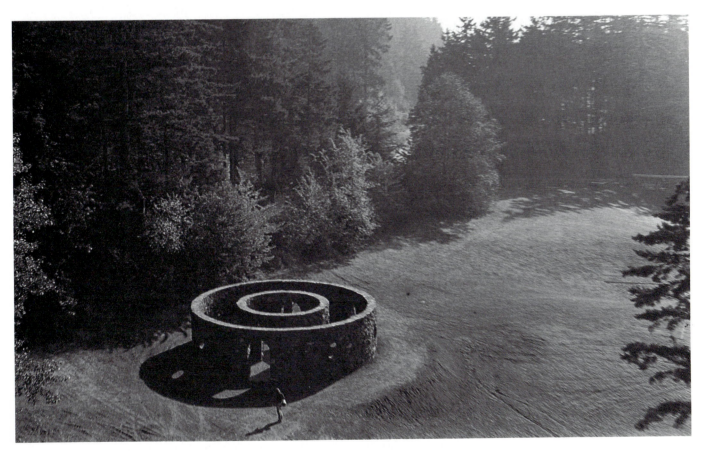

17.32 NANCY HOLT. *STONE ENCLOSURE: ROCK RINGS*, DETAIL 1977–1978. HAND-QUARRIED SCHISM; OUTER DIAMETER 40′ (12.2 M); INNER RING DIAMETER 20′ (6.1 M). HEIGHT OF RING WALLS 10′ (3.05 M). COURTESY JOHN WEBER GALLERY, NY.

Network of Underground Wells and Tunnels that require a spectator to enter her sculpture to pursue its maze forms. The earth is drastically altered and enriched with archaeological associations that intrigue the participants in their pursuit of an experience laid out by Aycock and accompanied by her philosophical notes [17.33].

Aycock, Holt, and others have all produced site sculptures that share salient connections of form with changing environment. In fact, as Michael Brenson, *New York Times* art critic, has said, "The flourishing of contemporary sculpture is related to the *sense of possibility* women have brought to it."

Architectural Environments

To create an architectural environment requires multiple skills. Its combination of assemblage and other techniques is another indication of the merging of the arts after centuries of separation. Most of them permit the viewer to walk inside them, and many are rooted in the artist's response to social concerns.

In their commentaries on contemporary culture, Pop artists Edward Kienholz (b. 1927) and George Segal seem to inherit themes of the social-protest paintings of the 1930s. Kienholz's tableaux [I.16] place us in the role of Peeping Toms, and our own macabre fascination with what we see provides an added element of discomfort. Like Kienholz, Segal also creates groupings of people in environments [17.29], but instead of presenting dramatic scenes, he reveals their banality. Segal may be reporting the nondescript aspects of our lives so that we may either more fully enjoy daily living or find a way to transcend its psychological castration. One of his most bleak works is a dream of despair, with the intensity of a tragedy. The body of a blackened man, asleep, almost has been absorbed by the bed—the echo of a coffin. The woman, on the other hand, is alive and deep blue. She is unable to rise although she is pushing. The lowered head holds her immobilized.

Alexander Calder created an architectural environment in the form of a 60-foot-high (18.3 meters) direct-metal sculpture, through which automobile traffic was channeled in Spoleto, Italy. He also designed an acoustical ceiling for an auditorium in Caracas, Venezuela, in which tremendous, free-form shapes seem to float above the seats.

17.33 ALICE AYCOCK. *SIMPLE NETWORK FOR UNDERGROUND WELLS AND TUNNELS.* 1975. CONCRETE-BLOCK WELLS AND TUNNELS UNDERGROUND, DEMARCATED BY A WALL, 28 × 50′ (8.54 × 15.25 M); AREA 20 × 40′ (6.1 × 12.2 M). TEMPORARY INSTALLATION FOR THE EXHIBITION *PROJECTS IN NATURE,* MERRIEWORLD WEST, FAR HILLS, NEW JERSEY. COURTESY JOHN WEBER GALLERY, NY.

Art Talk

Born in another era under the flag of the old Hapsburg Empire in Trieste, Italy, the extraordinary art dealer, Leo Kraus Castelli, fourth son of a wealthy banker, was certain from the start that he wanted to know it all. "I read helter-skelter … I read Freud … I wanted to be the Renaissance man," Castelli said during an interview with Alan Jones for the 1989 issue of *Berliner Kunstblatt*. What seems to please him most today, after a lifetime of involvement with the arts, is that he has succeeded quite well with at least part of that goal. He does know all about contemporary art. The roster of the artists who choose to sell their work through him includes none we could afford to overlook in our study of significant art since the 1950s, when he launched his career.

His native language was Hungarian, but before he was fifteen, he could also speak Greek, German, French, and Italian. With a law degree from the University of Milan, he joined the world of business and was sent on assignment to Bucharest, Romania, where he fell in love with Ileana Schapiro, daughter of one of the country's wealthiest industrialists. On their honeymoon in Vienna, they acquired their first work of art (a watercolor by Matisse) and that is where their passion for collecting art took hold, leading them eventually to New York.

By 1957, their collection had outgrown their apartment, and they became professionally involved as dealers. With a great sense of timing, the Pop artists they had chosen led the Castellis to the top of the market, followed by similar successes in Minimal, Concept, and Neo-Expressionist art. Attendance at a Castelli Gallery reception was a not-to-be-missed social ritual for collectors, critics, and museum professionals. When the marriage of Leo and Ileana broke up, both remarried, and Ileana opened her own gallery with the Sonnabend name of her current husband, while preserving contacts with Leo in a Castelli-Sonnabend Videotape and Film venture.

The Castelli successes may be allied to his generous support of his artists long before their works become marketable. But more likely, it is his continental elegance and charm that contributes to his effective salesmanship. Money never seems to enter discussion. Responding to Alan Jones's questions, Leo Castelli put it this way:

17.34 LEO CASTELLI. NEW YORK. MID 1980S. PHOTOGRAPH BY ROBERT MAPPLETHORPE.

Galleries in our time have fulfilled a function of great importance, one which could not and was not done by museums … Our main function is to show new work and to discover new artists, to show new work in every combination … No museum did any of these … Not the other way around.

ART DEALER - LEO CASTELLI (B. 1907)

Before Calder, architectural sculpture had been obviously attached to the building; in this work, it appeared to be a suspended element of the environment.

Working with wooden found objects and other materials, the assemblage sculptor Louise Nevelson (1899–1988) [6.11] is most often identified with the large environmental works discussed in Chapter 9. The art critic Cindy Nemser has said of them, "All the rubbish of Man-

hattan is transformed by this artist into phantom architecture." Similarly, an Italian-born tile setter named Simon Rodia designed the Watts Towers of Los Angeles. Emerging from Rodia's tiny backyard like the towers of a medieval city, the steel, mesh, and mortar spires are lovingly covered with broken tiles and other discards [1.9]. Rodia's environment became a living echo of himself. Here again, the line between art and reality is difficult to find.

ARCHITECTURE

The essence of the International Style (1930–1950) was its conviction that architecture could produce the millennium—a perfect society instituted by architects. The famous dicta followed in profusion: "Form follows function," "The house is a machine for living in," "Less is more," and so forth. By mid-century, Le Corbusier and others had persuaded us that there could be no civilization without cities. Mies van der Rohe [8.35] claimed that the essence of modern buildings was "skin and bones"—the skin of glass, the bones of steel or concrete. And Walter Gropius [15.42] convinced us that the "building team" was the only effective way to create modern construction.

If any one building sums up mid-century philosophy, it is Le Corbusier's *Unité d'Habitation* [17.35] in Marseilles. *Unité* is one of the most famous structures of the postwar world. It was to be the model for a series of complexes that Le Corbusier planned to build across France to house, without resorting to urban sprawl, the four million French families made homeless by the war. In its design, he evolved unusual combinations of past traditions and new ideas—the pillars on which it stands taper toward the bottom, the gardens are on the roof, the streets are inside and in the air, the shopping center is on the seventh floor instead of connected to the commercial center of Marseilles.

Critics were numerous. Jane Jacobs condemned the shopping center for being too far from the center of the city. Lewis Mumford criticized the long apartment units as being too much like halls. Siegfried Giedion complained that the internal streets were all dark corridors, and journalists attacked the notion of one thousand people holed up in a vast, anonymous beehive. Nevertheless, *Unité*, efficiently constructed of precast concrete, achieved a balance of positive goals: (1) twenty-three different types of apartments for all family sizes, (2) absolute privacy, (3) isolation from traffic fumes and noise, and (4) twenty-six communal facilities. Because of such work in urban architecture, Le Corbusier was asked to apply his ideas on urban design to Chandigarh, the new capital of the Punjab in India. His beliefs are still an inspiration to city planners.

Despite Le Corbusier's far-reaching goals in *Unité*, this gargantuan design has not proved to be Utopia for its inhabitants. Can it be the loss of personal identity in an autonomous living center? Or, isn't it likely that the human animal depends to some degree on natural environments for survival? Certainly we may recall that Moshe Safdie *was* able to achieve in *Habitat* [7.32], a large communal facility, apparently so desirable that even now the supply of available apartments never equals the demand for them. And Buckminster Fuller [7.7] *was* able to provide efficient climate control in the U.S. Pavilion at Expo '67 and elsewhere, unlike *Unité*, which was designed before universal awareness of the eco-environmental balances required to accommodate efficient energy consumption.

The world of the 1990s will demand a different set of architectural priorities, as we shall conclude, and our designers will have to develop solutions to meet these needs effectively.

17.35 Le Corbusier. L'Unité d'Habitation, Marseilles, France. 1947–1952. Length 550' (167.64 m), width 79' (24.08 m), height 184' (56.08 m).

EXERCISES AND ACTIVITIES

Exercises for Research and Discussion

1. What are some of the major mid-century movements, grouped as to formalism, Expressionism, realism, and fantasy?

2. Explain how the approach of many women to art changed in the 1960s.

3. How does the art of assemblage reflect our growing concern with the wastes of our society?

4. Environmental art can be found in painting, sculpture, and architectural design. What are the common features in all three media? What are the differences?

5. Consider a large open space in your town and try to visualize (or conceptualize) a monumental sculpture for it. What material, form, and design would express your recommendations for that space?

Studio Activities

1. Can you think of other popular slogans as significant as the *Love* theme of Robert Indiana? Create a work of art in paint, sculpture, or any combination that uses Pop images or slogans.

2. Create a work of art in which motion—either natural or mechanical—is an important element.

3. Modifications of earlier geometric abstraction and nonobjective art can be seen in Op Art. Using graph paper or your own ruled squares, experiment with small units of color. Create an illusion of three dimensions by varying the sizes and colors of the units. Superimpose three-dimensional louvers made of paper or cardboard to create more exciting visual effects.

4. Create a work that recycles some materials from industry.

5. Create an artwork that deals with Feminist issues. Try to incorporate found objects in your design.

Our Own Time:

THE 1970s AND BEYOND

"There are more artists creating more works of art than ever before in our history."
—HILTON KRAMER, EDITOR,
THE NEW CRITERION

• • •

"As I see it, the struggle is between those who believe art is essentially dead and make dead art to prove it, and those who don't. Either art will survive the test of time or it won't."
—ERIC FISCHL, ARTIST

• • •

"I look for works in which I feel there are issues and feelings that need to be communicated to a larger public ... If you write about art, you create a dialogue with artists."
—MICHAEL BRENSON, CRITIC, NEW YORK TIMES

• • •

"For the young artist, it's indispensable to live in New York ... in order to succeed ... My advice to the young artist is to "become a genius."
—LEO CASTELLI, DEALER, NEW YORK

1965	1970	1975	1980	1985	1990	1995

THE VISUAL ARTS

1967–71 Aalto, Finlandia Hall [18.38]
1968 Hesse, *Aught* [18.9]
1970 Neel, *Andy Warhol* [18.14]
1970 Smithson, *Spiral Jetty* [1.15]
1971 Graves, *Variability* . . . [18.36]
1971–72 Christo, *Valley Curtain* [18.33]
1972 Kahn, Kimbell Art Museum [9.18]
1972 Shapiro, *The American Dreams* [18.1]
1973 Paik, *Charlotte Moorman* [5.27]
1973 Pearlstein, *Female Model* . . . [18.13]
1975 Aycock, *A Simple Network* . . . [17.33]
1975 Bartlett, *Rhapsody* [18.6]
1977–78 Holt, *Stone Enclosure: Rock Rings* [17.32]
1978–82 Johnson & Bergee, AT&T Building [18.40]
1979 Palyka, *Picasso 2* [18.22]
1979 Chicago, *The Dinner Party* [17.22]
1980 Close, *Self-Portrait/Composite* [18.17]
1980 Clemente, *Two Painters* [18.24]
1980 Schnabel, *Some Peaches* [18.25]
1980–82 Graves, Portland Public Services Building [18.41]
1981 Pfaff, *Dragon* [18.37]
1982 Brown, *Wildflower* [18.20]
1982 Cohen, AARON drawing [18.21]
1982 Holzer, *Abuse of Power* [18.31]
1982–84 Steir, *The Brueghel Series* [18.8]
1983–85 Acconci, *Building Blocks* . . . [18.18]
1984 Salle, *Midday* [18.26]
1985 Puryear, Sculptures [18.12]
1985–86 Starns, *Stretched Christ* [5.21]
1985–87 Keifer, *Osiris and Iris* [18.23]

AMERICA AND THE WORLD BEYOND

The arts of the 1960s were fairly easy to follow. There was Pop, and then, Op: Claes Oldenburg's *Giant Soft Fan*, Andy Warhol's multiple images, Ad Reinhardt's monochromatic paintings. The 1970s showed little homogeneity. Art responds to the mood of the times and even to specific events. Our time line notes show much dissonance, and many of the arts were ephemeral. Several kinds of art found room to coexist, even while contradictions abounded.

The accelerating rate of change that pervades our lives today is reflected in the art of the 1970s, the 1980s, and the first half of the 1990s. Many artists feel liberated from traditional rules and free to follow any line of exploration. Art styles constantly shift, while artists develop their styles into new forms. Categories of art become blurred. Painting, for example, often merges with sculpture in assemblage. The line between art and craft is soft as sculptors crochet, quilt, blow glass, or weave environments and some painters use the dye techniques of crafts, combining fabric with paint [18.1]. New categories emerge that use light, the natural environment, or pure ideas and, an intensity not seen since Goya, burns in the art of social conscience—a strong force in the 1990s.

As we have traced the history of art through the centuries, we have often been rewarded with many kinds of

18.1 MIRIAM SCHAPIRO. *THE AMERICAN DREAMS.* 1977–1980. ACRYLIC AND COLLAGE ON CANVAS, 77 × 80″. PRIVATE COLLECTION. COURTESY BERNICE STEINBAUM, GALLERY, NEW YORK.

1965	1970	1975	1980	1985	1990	1995

HISTORICAL NOTES

1964 *Fiddler on the Roof* opens on Broadway
1968 *Hair* opens
1969 Woodstock concert, N.Y.
1971 *Jesus Christ Superstar* opens
1971 *Grease* opens
1971 Attica prison uprising, N.Y.
1973 USA out of Vietnam
1973 *All in the Family,* television show
1973 *American Graffiti*
1973 Supreme Court permits abortion
1974 Energy crisis: gas lines
1974 President Nixon resigns (Watergate)
1975 *Rocky Horror Picture Show,* cult classic
1976 Death of Mao Tse-tung
1977 *Saturday Night Fever* and disco craze
1977 *Star Wars;* special effects
1978 Jim Jones: People's Temple mass suicide
1979 USA: Three-Mile Island nuclear accident
1981 Assassination attempts: Pope John, President Reagan
1985 USSR: Gorbachev institutes Perestroika
1986 USA: *Challenger* and crew explode
1986 USSR: Chernobyl nuclear disaster
1989 Berlin Wall torn down
1991 USA: Persian War/Desert Storm
1991 Dissolution/USSR

AMERICA AND THE WORLD BEYOND

Art Talk

Author and editor of numerous catalogs of art exhibitions, Lucy Lippard has been described by Barbara Braun in the *Village Voice* on May 31, 1983, "like a bee in the garden of contemporary art, buzzing industriously, dazzling onlookers by her transformative capacity and tireless flight." A *New York Times* book reviewer, Suzi Gablik, on March 20, 1977, encapsulates Lippard's output, "as the art world's most outspoken feminist/social critic, Lucy R. Lippard has always gone against the tide, insisting emphatically on art with a message. She is deeply troubled by the fact that we live in an era that produces increasing numbers of artists who are without any sense of purpose beyond their own professional aims and that as a culture, we seem to have lost any notion of what our art is for."

Lippard was born in New York City, the daughter of Vernon William, dean of Yale University Medical School, and Margaret Lippard. Having received many awards and honors for her works, she remains an authority on Ad Reinhardt, following her 1981 critical study of the artist, for which she was awarded a Fulbright Scholarship. As a well-known and highly respected art critic and historian, she has written or edited close to twenty books that examine many artists and art monuments.

Married to artist Robert T. Ryman, whom she later divorced, Lippard was educated at Smith College and New York University. Awarded many honors for art criticism, her major preoccupation (past motherhood) has been her writings through which we can probably understand Lucy Lippard best. Of her many books that received almost universal praise was her study of the sculptor Eva Hesse. In the March 20, 1977, *New York Times Book Review*, Hilton Kramer remarked that "Lippard writes with sympathy and precision ... and is an enlightening guide to the difficult terrain of this artist's work ..." In 1983, she wrote *Overlay: Contemporary Art and the Art of Prehistory* in which she notes

the changes in the function of art today as contrasted with its early role when art was part and parcel of the everyday world; an observation we made in our Introduction. Lippard explains her position further:

18.2 LUCY LIPPARD. PHOTO © 1992 TIMOTHY GREENFIELD-SANDERS.

[My book is about] what we have forgotten about art ... It is an attempt to recall the function of art by looking back to times and places when art was inseparable from life.

Lucy Lippard's contribution to our time as art historian and critic is evident at first reading of her penetrating studies of artists and culture.

ART HISTORIAN AND CRITIC—LUCY LIPPARD (B. 1937)

art that affect us today as strongly as they moved observers at the time they were created. No less significant is what we may learn from history. We might even have anticipated a total fulfillment of art in our time based upon the evolution of all that we have studied. But art does not imitate life in this way. That would be so only if art, like science, were to evolve from past discoveries toward a glorious new age.

For many, it is tempting to think that as Western society has moved in cycles in the past, today it moves faster and in wider circles. And yet we cannot be sure that

either of these views is accurate. Without the distance that time provides, it is difficult to sift through the rich variety of today's art to distinguish the significant from the merely novel. However, beneath the surface variety of present-day art, we may observe a general continuation of the four tendencies that we have already noted.

The formalist trend is found in abstract paintings and sculptures. In some works an impulse toward expressiveness has been added and in others a harking back to the geometric abstraction of earlier in the century. We will

shortly note a **Pattern and Decoration** trend, that may be a reaction to computers. Realism remains a strong force in artists who can produce a verisimilitude perhaps comparable to the verism of late Roman sculpture (Chapter 11). Expressionism can be found mainly in European art and young American artists for whom the real world remains an opportunity for emotional interpretation. Art as escape from this imperfect world through fantasy also continues, chiefly in the form of television and film. These photographic art forms, which dominate our world as never before, sometimes provide us experiences in alternate life-styles and forbidden modes of conduct. The multiple image, whether film, video, or graphics, predominates, relating mechanical duplication to the repetitious electronic aspects of our world. The intellectual planning process also dominates in conceptual art and some environmental art, which is planned to disappear after it is made.

FORMALISM

Although a large body of writing exists about mass culture and the avant-garde, much of it ignores how art is made or the individual people who make it. And so, a view of the world of art in the closing years of our century becomes a richer experience through the eyes of an art historian, Lucy Lippard [18.2], schooled and gifted in contemporary art and criticism.

Painting

In the early 1970s, Minimalism still reigned supreme. By the middle of the 1970s, Minimalism in painting was exhausted and gave way to a reaction that embraced what the now passé movement had rejected: decoration, content, and the presence of the artist's hand.

Pattern and Decoration Among these early reactions to Minimalism was the movement known as Pattern and Decoration, sometimes called P&D, a highly formal, decorative style involving the regular repetition of motifs intended to cover a surface. A leader in the Feminist art movement, Miriam Schapiro, drew upon women's historical connections with decorative materials and patterns such as patchwork and laces. *The American Dreams* [18.1] combines acrylic paints with a selective choice of patterned fabrics instead of the tempting riot of configurations that many less sensitive artists often found irresistible. Her highly personal collages that she calls *femmages* may include sequins, lace edgings and even buttons in tightly organized compositions of rich color.

Also working through Minimalism and thence to P&D was Robert Kushner (b. 1949), who exploited thrift-shop purchases of fabrics, tacking them together in loose arrangements [18.3]. Kushner also made wall pieces using fabrics layered with figurative contour drawings and paintings. His works reveal the Islamic influence that he picked up in a 1971 tour of Iran, Turkey, and Afghanistan. His choices for wallpaperlike patterns of arabesques, all mosaics, overpainted with human and bestial imagery reflect Moslem inspiration. In seeming determination to combine most all current approaches to art, he occasionally introduced painted, flattened nudes that are almost lost in the myriad patterns they inhabit. Yet, the figures emerge as surprisingly sensual. The bravado of his presentations, we suspect, also links Kushner with the Conceptualists.

On the whole, however, abstraction during these years, until about the mid-1980s, declined in favor. Abstractionists, such as Elizabeth Murray (b. 1940), learned to buck current trends and find their artistic identities off center stage. Murray's work is perhaps best set within the formalist painting idiom. Brilliantly inventive, her grouped

18.3 ROBERT KUSHNER. *SUNLIGHT.* 1983. MIXED FABRIC AND ACRYLIC ON COTTON. 8'5" × 13'7". COURTESY HOLLY SOLOMON GALLERY, NEW YORK.

18.4 ELIZABETH MURRAY. *ART PART.* 1981. OIL ON 22 CANVASES, 9'7" × 10'4" (2.96 × 3.17 M). COLLECTION OF THE ARTIST. COURTESY PAULA COOPER GALLERY, NEW YORK.

canvases are shaped sometimes with curvilinear organic parts but as often rather like sharp notes in a tone poem. Each element may function independently, yet in concert creates pulsating rhythms with strong directional force [18.4]. *Art Part* is essentially the work of a giant hand with brush, palette, and cups for paint. Murray says: "I want the panels to look as if they had been thrown against the wall and that's how they stuck there." Her billowing cut-out shapes, with origins in household and other common forms, often threaten to devour one another. She brings the melodrama of daily life into a dialogue with modern art.

New Image Art The Whitney Museum of American Art in New York presented an exhibition in 1978 called New Image Painting—a style prompted by Philip Guston (1913–1980) when he abandoned his beloved Abstract Expressionism in favor of new figural work in the 1970s [18.5]. Maintaining a bit of his former expressionistic brush strokes, he and a group of young artists of the 1970s, including Susan Rothenberg (b. 1945) [4.11] and Jennifer Bartlett, developed styles with some reference to the figure, along with the formal systems they had inherited from Minimal art of the 1960s.

Philip Guston, an original member of the New York School, found himself drawn more and more to the real world that forms the earliest inspiration of most artists. He began to introduce humanist imagery. It was reported that he told Harold Rosenberg, art historian/critic, in 1966, "I imagine wanting to paint as a caveman would, when nothing existed before." Closest to Guston with his sooty palette and gestural strokes of paint, Rothenberg cov-

ers her canvas with a mass of silvery, painterly brushwork. Her first images were horses partly because they were "a way of not doing people, yet it was a symbol of people ..." and therefore perhaps unique. In the 1980s, Rothenberg switched from acrylics to oils, introducing human images to her increasingly agitated surfaces. The new images seem even more mystic and ephemeral than the horses, exploring an art of transformation with fresh emotional energy.

18.5 PHILIP GUSTON. *CITY LIMITS.* 1969. OIL ON CANVAS, 6'5" × 8'7-1/4". COLLECTION, THE MUSEUM OF MODERN ART, NEW YORK (GIFT OF MUSA GUSTON).

The Artist Sketch

From kindergarten days in California, Jennifer Bartlett [18.7] always knew she wanted to be an artist. Even then, she worked with serial images. Her first viewing of Disney's *Cinderella* inspired her to complete about five hundred drawings, each one a different version of the dress Cinderalla wore. Her reworking of other people's art was a premonition of art in the 1980s!

At Mills College, Bartlett discovered Abstract Expressionism, but not until she was at the Yale School of Art and Architecture, under Jack Tworkov's guidance, were her creative energies fully tapped. In 1966, as Abstract Expressionism was fading for her, she produced a 9-by-18-foot (2.7-by-5.5-meter) painting with 250 12-by-3-inch (30-by-7.6-centimeter) rectangles, each a different color. Her need both for control in her plan and for impulse as she painted launched Bartlett into the new idiom so enthusiastically acclaimed at her first major exhibition. By 1975, when *Rhapsody* was completed, however, she was $10,000 in debt for analytical therapy, paints, and the plates so integral to her art. Each plate was

18.7 JENNIFER BARTLETT. 1985–86. COURTESY PAULA COOPER GALLERY, NEW YORK.

painted by formula. As she states, "Freehand has to be painted standing up. By now the painting has become method."

Bartlett's ambitions were growing. She began to write more and paint less. The linear-program idea was applied to the plates, cards, and paint cups. Using a thesaurus, she wrote out all the words she could find beginning with A, then B, and so on. These dictionary words of early essays gave way to narration of packets of her experience. Her autobiographical *History of the Universe* grew into a thousand pages. *Universe* reveals less of a reaching for a transcendental universality (like *Rhapsody*) than a mind headed for self-destruction. Her voracious appetite for public exposure and her creative energies have produced a stunning array of unified complexity in which she has embraced it all—works that have "everything in it." Bartlett perhaps has led the narrative revival in painting. She sums it up, "I want to move people. Yes, I'd like to be a strong, heart-breaking artist." That seems to have happened.

JENNIFER BARTLETT (B. 1941)

Among New Image's originators, Jennifer Bartlett had evolved from Action Painting and Conceptual art. In addition, Bartlett incorporated mathematics into her first major (987-unit) work, entitled *Rhapsody*, that filled the Paula Cooper Gallery with but 6 feet (1.8 meters) to spare. She painted on 1-foot-square (30.5 centimeter) steel plates, each printed with a silkscreen grid, using a basic set of six colored enamels; the result was color-dot painting in a dazzling display of decorative abstract patterns [18.6]. Her desire to recognize reality was satisfied by including the forms of a house, tree, mountain, and ocean, reduced to their essentials. The painting overwhelmed the first viewers; it was regarded by *New York Times* art critic John Russell as "the most ambitious single work" he had ever seen.

18.6 JENNIFER BARTLETT. *RHAPSODY (DETAIL)*. 1975–1976. ENAMEL AND BAKED ENAMEL, SILK-SCREEN GRID ON STEEL PLATES; 988 PLATES, 12 × 12″ EACH (30.5 × 30.5 CM); OVERALL 7′6″ × 153′9″ (2.29 × 46.89 M). COURTESY PAULA COOPER GALLERY, NEW YORK.

With close to the impact of Bartlett in the 1970s, Pat Steir (b. 1940) introduced the *Brueghel Series* in 1984 [18.8]. Also based on the Minimalist grid, the vast work is a 64-panel assemblage. Laying a grid over a Brueghel still life of a blue vase bursting with flowers, Steir painted each section (28 1/2 by 22 1/2 inches) in the style of a different historically familiar artist, progressing through a myriad of eras. According to Michael Brenson, *New York Times* art critic, "Steir has made it seem as if all the artistic voices that began speaking when she took the lid off Brueghel's still life were both shooting her down and giving her the energy and will to persevere." A poet as well as an artist, Steir explained her work:

> I feel there's very little difference between the stylistic modes of art historical periods … The difference is in the scale, in the use of space … Scale up Van Gogh's color and mark it's De kooning. All art making is research …

Sculpture

Some Minimalist sculpture concepts were difficult to execute in the late 1960s because of their large scale. Since that time a new appreciation for large-scale public art has helped make commissions possible. One of the more controversial works of public art has been *Tilted Arc* by Richard Serra (b. 1939) [9.14]. Another sculptor who retained some of Minimalism's clear, gridlike structure was German-born Eva Hesse (1936–1970) [18.9]. Commenting on the synthetic quality and similarity of many lives, she arranged plastics and other synthetics in endless repeat patterns, per-

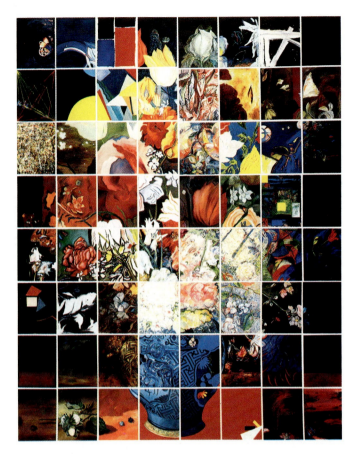

18.8 PAT STEIR. *THE BREUGHEL SERIES.* (A VANITAS OF STYLE). OIL ON CANVAS. 64 PANELS, EACH, 28-1/2 × 22-1/2". COLLECTION OF THE ARTIST. ROBERT MILLER GALLERY, NEW YORK.

18.9 EVA HESSE. *AUGHT.* C. 1968. DOUBLE SHEET LATEX, POLYETHYLENE INSIDE, FOUR UNITS, 78 × 40" (198.1 × 101.6 CM) EACH. UNIVERSITY ART MUSEUM, UNIVERSITY OF CALIFORNIA AT BERKELEY; GIFT OF MRS. HELEN CHARASH.

mitting form to evolve from the predictability of change, such as gravitational pull, implicit in the materials she used.

When Joel Shapiro (b. 1941) came in contact with Minimalism, his experiences in India as a Peace Corps volunteer had guided him to a more personal, expressive approach. Although he renders in miniature dimensions [18.10], his work has the clarity of Minimal form. Whether made of iron, lead, or bronze, the emotional factors they introduce despite their clean lines demonstrate the Modernist belief that "less is more," bringing an uncanny expressiveness to human form. Every change of plane speaks of aesthetic decision and a craftsmanship that is almost fanatical. Yet, pathos underlies his figures—symbols for men.

Born in Tehran, Iran, in 1939, and later settling in Minnesota, Siah Armajani embodies the polarities of Asian and American cultures in the complexities of his art. *Dictionary for Building: Closet under the Stairs* [18.11] invites us to enter the work, but the space allotted does not permit it, nor can the structure's second level be accessed. The sculpture is no less contradictory in its sculptural metaphor than the postmodern tenets we will soon encounter with architects Vincent Scully and Robert Venturi. Similarly, Scott Burton's *Rock Chairs* [6.24], made of the most resistant material on earth—granite—invites the viewer by its compact shape yet puts off participation on its hard seat.

18.10 JOEL SHAPIRO. *UNTITLED.* 1980–81. CAST BRONZE, 53 × 64 × 45-1/2″. PHOTOGRAPH COURTESY OF THE PACE GALLERY, NEW YORK.

18.11 SIAH ARMAJANI. *DICTIONARY FOR BUILDING: CLOSET UNDER STAIRS.* 1985. CONSTRUCTION OF PAINTED, STAINED WOOD AND ROPE, 9′2-1/2″ × 7′2-3/8″ × 3′8-1/8″ (280.6 × 219.4 × 112.0 CM). HIRSHHORN MUSEUM AND SCULPTURE GARDEN, SMITHSONIAN INSTITUTION. (THE JOSEPH H. HIRSHHORN PURCHASE FUND, 1986).

Martin Puryear's (b. 1941) sculptures of rings, arcs, and guardianlike shapes seem to pulsate and lock in soft rhythms. His feeling for public art is largely a response to his need to make art that people he grew up with can understand. His work, founded on Minimalism's economy of shape, form, and depersonalized surfaces, but unlike Minimal art, demands a relationship with the environment and firm connections with the artist. Puryear makes a clear distinction between his large-scale public work—the "amenities" he has designed, for instance, a fountain, benches, and pavilions for a garden plaza in Maryland— and sculptures made for the individual. Regarded by many as a key figure in contemporary sculpture, Puryear may be a significant bridge between the 1960s and 1990s, combining the traditions of handwork with natural materials and collaboration in site sculptures. His art is grounded in respect for craft, fierce pride in himself, and a commitment to the expressive potential of the sculptural language [18.12]. Perhaps the first black American to represent the United States (and win awards) at the Saõ Paolo Bienal, Puryear has also designed stunning sets and costumes for "Griot New York," an African-inspired jazz-dance with music by Wynton Marsalis, presented at the Brooklyn Academy of Music's Next Wave Festival, 1991.

Light Art

Obviously, light is involved in all art. But in recent years artists have become aware of the potential of light itself as a theme, and light artists use their material with the same skill that other artists apply to color and paint.

Thomas Wilfred (1889–1965) was one of the first artists to conceive of light as an independent aesthetic experience in the early part of this century, leading to the *Clavilux Lumia*, an instrument on which he performed as early as 1922. From the spectator's viewpoint, a continuously changing pattern of fading and regenerating colored light produces a hypnotic effect similar to that of some Color-Field and Optical paintings.

One of the most innovative light artists is German-born Otto Piene (b. 1928), who first created a light ballet that toured Europe in 1961, made of thousands of individual bulbs programmed to coordinate with activity onstage. Many light artists combine light and motion, and some have used light along with water to create moving compositions that delight the eye with artificially lighted waterfalls and fountains and gratify the ear with the sound of rushing water. All these experiences defy photographic transcription. Larry Bell, whose work we have viewed, creates light environments in a world bounded by glass. Greek light artist (Varda) Chryssa (b. 1933) combines theatrical skill with technical precision in blinking neon sculpture enclosed in simple shapes. Her inventive work comments on today's industrialization, while at the same time it suggests the ever-expanding frontiers of science and technology. Like many of today's experimental artists, Chryssa has explored some aspects of environmental art by combining theatrical and technical elements in an aesthetically excit-

18.12 PHOTOGRAPH OF MARTIN PURYEAR WITH TWO OF HIS SCULPTURES.

ing spectacle. Her work is reminiscent of the glaringly lighted environment of Times Square in New York City [6.21] or the Strip in Las Vegas. For example, under the sponsorship of Intermedia 68 and the Museum of Modern Art, she created an electromagnetic environment in which vibrating color and light was designed to envelop the participants.

REALISM

Realism has been a strong current in American art since the eighteenth century. Even during the great enthusiasm for Abstract Expressionism, when it was almost impossible for realistic painters to find galleries in which to exhibit their work, painters such as Andrew Wyeth (b. 1917) continued to paint recognizable people and objects, as he and others have kept on doing ever since.

Painting

Wyeth's approach to realism can be seen in *Christina's World* [3.18], a painting in which he illuminates the hardships and isolation of the physically challenged. His precise tempera technique establishes a matter-of-fact world, yet he imbues his subject, a disabled girl, with pathos. However realistic the painting appears to be, Wyeth uses exaggerated perspective in the high horizon and the wide vista of the sky to increase the sense of distance between Christina and the house, and her problems in getting there.

Magic Realism, or **Superrealism**, is a hyper-realistic style in which the painter exploits our camera-oriented responses but takes us beyond them. At first glance, an oil painting by Philip Pearlstein (b. 1924) may strike us as a mere copy of a photograph (an aid he never uses). His painting demonstrates in its light and shadow the harsh quality of a snapshot. But on deeper scrutiny we see that with this kind of lighting, Pearlstein achieves a sharper, heightened reality, which emphasizes certain features of the model, usually a rather heavy, melancholy mood, heightened by the downward glance of the eyes and the drooping hand [18.13].

Also working with traditional materials and techniques was the unconventional Alice Neel (1900–1984), an outspoken Feminist who was probably best known for her portraits. Her paintings on the theme of mother and child are incisive, sometimes shocking, transcriptions of her subjects, devoid of any sentimentality. Neel's self-portrait shows her in a rocking chair, naked but for her glasses, but her portrait of Andy Warhol [18.14] is even more revealing.

18.13 PHILIP PEARLSTEIN. *FEMALE MODEL IN ROBE SEATED ON PLATFORM ROCKER.* 1973. OIL ON CANVAS, 6 × 5' (1.83 × 1.52 M). SAN ANTONIO MUSEUM ASSOCIATION (PURCHASE). COURTESY HIRSCHL AND ADLER MODERN.

18.14 ALICE NEEL. *ANDY WARHOL.* 1970. OIL ON CANVAS, 60 × 40" (152.4 × 101.6 CM). WHITNEY MUSEUM OF AMERICAN ART, NEW YORK (GIFT OF TIMOTHY COLLINS, 1980).

Photography, especially the Polaroid camera, has become the realist artist's ultimate research tool. Photographic "sketches" are translated into **Photo-Realist** paintings, often with the aid of the airbrush, originally a tool for commercial illustration, that reinstate a focus on inanimate objects. Richard A. Estes' (b. 1936) camera provides detailed images of urban environments, which he then painstakingly reproduces with oils on masonite. Like Edward Hopper, he is more concerned with physical evidences of our society than with the people who created it. His particular interest in recent years has been scenes of storefronts, in which he carefully lays complex street reflections over detailed, meticulously rendered shop-window displays [18.15]. His focus is always the evidences of our society's materialism.

In the hands of an expert such as Audrey Flack (b. 1931), the airbrush can simulate fine (photographic) detail, making a painting almost indistinguishable from camera art. We have already seen Flack's oil painting of the

Roldán *Macareña* is a tribute to the unrecognized genius of the Baroque sculptor as well as to her own skill [9.4]. As a pioneer of Photo-Realism, and an ardent Feminist, she revived the *vanitas* theme of Late Renaissance by heaping her compositions with items of feminine vanity, using a palette of maximum brilliance [18.16]. Vanitas, some of us may recall, is one of the seven deadly sins, a transgression of the divine law. Flack, like many other Photo-Realists, believes that the advertising of cosmetics and other imagery of "the good life" accounts for our endless preoccupation with youth and wealth.

Another pioneer among artists using photographs as a source of imagery, Chuck Close (b. 1940) is noted for huge, photographically precise portraits. From a distance, they seem monumentally scaled blowups of the original photographs he has used as references. At closer range, they assume alter-identities as fields of dots, brush marks, or fingerprints. Confronting his portraits is a direct experience. Of vast scale and sober countenance, they have

18.15 RICHARD ESTES. *MIAMI RUG COMPANY.* 1974. OIL ON CANVAS. 40 × 54″. PRIVATE COLLECTION. COURTESY ALLAN STONE GALLERY, NEW YORK.

18.16 AUDREY FLACK. *LEONARDO'S LADY*. OIL OVER ACRYLIC SYNTHETIC POLYMER PAINT ON CANVAS, 6'2" × 6'8" (188 × 203.2 CM). COLLECTION, THE MUSEUM OF MODERN ART, NEW YORK. (PURCHASED WITH THE AID OF FUNDS FROM THE NATIONAL ENDOWMENT FOR THE ARTS AND AN ANONYMOUS DONOR).

fixed, hypnotic stares that are riveting. He later turned to six-panel photographic montages produced only from Polaroid prints [18.17]. Recent health problems have forced Close to adapt his techniques, resulting in hypnotic images that seem to blur while you watch them.

Sculpture

A certain amount of American sculpture, like painting, is an effort to imitate reality. Somewhat conventional forms are created with unconventional materials, such as polyester reinforced with fiberglass and wood. Surfaces are dense and opaque, and the figures are often painted and slick. Occasionally, they are placed on real props, creating a juxtaposition of art objects within real environments. Examples are George Segal's early white plaster figures of ordinary people seated in real settings. Others of his sculptures are painted brilliant primary colors with powerful results, as we have seen [17.29]. We may also recall the realist fiberglass sculptures of Carole Jeane Feuerman, successfully used as advertising gimmicks [I.7].

 By contrast, Duane Hanson (b. 1925), a sculptor who often feigns reality with painted polyresins and synthetics, cultivates the banal. His groupings are so lifelike that visitors who see them in museums are uncertain which figures in the crowd are Hanson's and which are alive. Avoiding most stereotypes of beauty, Hanson's overweight, middle-class subjects are placed in situations such as a bus

18.17 CHUCK CLOSE. *SELF-PORTRAIT/COMPOSITE*. 1980. COLOR POLAROID PHOTOGRAPHS; EACH 7'7" × 3'8" (2.16 × 1.13 M), ASSEMBLED 14'2" × 11'2-1/2" (4.32 × 3.42 M). PHOTOGRAPH COURTESY OF THE PACE GALLERY, NEW YORK.

stop or a fast-food restaurant [6.1]. Using age-old ceramic processes, such sculptors as Robert Arneson (b. 1930) reaches to the past for inspiration, but shows stronger affinity with Marisol [6.13] than with the classic commemorative sculpture he parodies. Investing his subjects with humor, as would have been unthinkable for the Greeks, at the same time Arneson scorns tradition in pinpointing the feet of clay of our heroes or—in this case—the itchy clay shoulder of Picasso [6.15].

GRAPHICS

Throughout the 1970s, the thrust of printmaking was somewhat conservative. The return to expressionism in paint was accompanied by a more personal, autographic mark in printmaking. In recent years, artists have been increasingly experimental in their approaches to printmaking, trying new methods and materials. The most notable example is the growing popularity of the monotype—a unique image that utilizes a blending of inks and other effects unobtainable through direct work. Such works have an authority and presence as strong as a painting.

Recent developments must be seen in the light of the great changes in the graphic arts of the last few decades.

The unprecedented vitality in the production of prints can be accounted for, in part, by the growing numbers of painters (and sculptors) enthusiastically joining the ranks of printmakers in all branches of the medium. The infatuation with advertising images, first perceived by Pop artists such as Richard Hamilton [17.25], who carefully chose and composed the materials of his montages, persisted through the 1970s.

The return of large sheets of handmade paper was simultaneous with increasing concern for the quality of paper. As the craft grew, artists became a part of the papermaking process, such as Coco Gordon [4.18], Robert Rauschenberg, and Michael Ponce de Leon.

Some of the major printmakers have succeeded in producing wall prints that are not unlike architectonic paintings. Vito Acconci's (b. 1940) *Building-Blocks for a Doorway*, which is almost 8 feet (2.4 meters) square, is the ultimate in the public print, a print in a public site accessible to all. One of Acconci's major concerns in all his work—concept, sculpture, and now graphics—is the interaction of people with art. It is almost impossible to consider this print without physically reacting to at least the concept of passing through it. The arch connotes a passage to a new space, and so the print becomes architectonic, the most public evidence of the plastic arts [18.18].

18.18 Vito Acconci. *Building-Blocks for a Doorway*. 1983–1985. Photo-etching, hard-ground etching, soft-ground etching, aquatint, edition of 8; 7'9-7/8″ × 7'10-1/2″ (2.38 × 2.40 m). Published by Graphicstudio, University of South Florida, Tampa, Florida.

In addition to those noted elsewhere, the list of artists whose works we have included, who are making their work more accessible through the print medium, reads like a Who's Who of a substantial part of the art world: Julian Schnabel, Robert Kushner, Jennifer Bartlett, Chuck Close, Jim Dine, Nancy Graves, David Hockney, Jasper Johns, Philip Pearlstein, Judy Pfaff, Susan Rothenberg, Richard Serra, Joel Shapiro, James Turrell, and Frank Stella. Stella has progressed from single-color lithographs to giant-scale mixed media prints of dazzling complexity that have, as is the case with other artists, like Eric Fischl, fed back into his paintings. In the print *Year of the Drowned Dog*, just as in his paintings, Fischl disturbingly illumines the hidden life of suburbia by escorting us through twin vistas of loneliness and pleasure so that we become witnesses and perhaps even stimulated participants. In public, we look away. In private, we stare. These prints consist of a layering that forces the viewer, at his or her own will, to connect the segments in order to interpret them. The first is a beach panorama. The second is made of three separate smaller sheets that may be affixed to the center to overlap the panorama. No matter how the viewer arranges the layers, none of the figurative groups can relate to any of the others. When assembled as shown [18.19], *Year of the Drowned Dog* presents an arrangement of ambivalent ideas, as may characterize all of Fischl's art. "One reason why they've become more fragmented," Fischl explains, "is that I no longer believe in the rectangular canvas, because it presents the world as holistic." The choice of segmented imagery is very much a feature of printmaking (and for that matter, painting and photography, as well) today.

Xerography While it seems a long way from the hand techniques of making fine prints to the industrial techniques of commercial reproduction, artists successfully use both. The fascination that photocopying holds for so many artists, perhaps beginning with Rauschenberg [4.20], has led them to investigate light-activated processes for multiplying their images. Ozalid, Cyanotype (blueprint), 3M, and the ultracomplex technology of Xerography are all being explored. Uncommonly handsome works in black

18.20 CHARLOTTE BROWN. *WILDFLOWER*. 1982. XEROGRAPHY; CHINE COLLÉ 3M PROCESS ON HANDMADE PAPER AND WOOD, 42 × 45 × 5" (107 × 114 × 13 CM). COLLECTION OF THE ARTIST.

and white and in color are being produced by **Xerography**, a medium that also permits the translation of solid objects into printed images. A pioneer in machine-involved art, Charlotte Brown uses a 3M color copier. Through an electrostatic technique she has developed, Brown transfers images chosen from textiles and printed papers onto handmade paper, fabric, and clay, creating tapestrylike patterns. In her three-dimensional *Wildflower*, suspended from fabric-covered wood, she has combined floral prints onto squares, embellished with delicate clay blossoms [18.20]. Xerography offers implications for the future.

18.19 ERIC FISCHL. *YEAR OF THE DROWNED DOG*. 1983. ETCHING WITH AQUATINT AND DRYPOINT, SIX SHEETS OF VARIOUS SIZES; OVERALL 25 × 70" (63.5 × 177.8 CM). BROOKLYN MUSEUM, NEW YORK. (FRANK L. BABBOTT FUND).

Computer Graphics The computer, which has revolutionized so many spheres of activity, has formed a bond with art in the field of graphics. With a keyboard or electronic tablet, an artist can form a pattern on a screen, enlarging or contracting the whole design or sections of it as desired. The effect is described as drawing with electronic light on a display terminal [5.30], a possibility barely suggested by Picasso's early experiments with light.

Another way of displaying computer graphics is through a plotter on paper. By suitable programming techniques, an artist can produce any effects imagined. Artistic forms can also be developed by high-speed, computer-programmed printing and spacing of characters. Whatever method is used, the performance of the computer depends solely on the instructions of the artist. With AARON, a computer designed and programmed by Harold Cohen (b. 1928), a stylus moves up, down, and across a 22-by-30-inch (56-by-76-centimeter) sheet. Shapes appear that suggest spatial inhabitants of a future world [18.21].

Touching base with science, creative art, and Eastern philosophy is Duane Michael Palyka, computer scientist and former senior artist at the Computer Graphic Laboratory of New York Institute of Technology. Palyka has explored the differences in thought processes of "the artistic state of mind" vs. "the computer state of mind," while creating computer art that can truly be considered fine art. With his own software program, requiring complex mathematics, he was able to generate female forms that with their richly colored and textured surfaces suggest a brilliant future world. The "stretched" form of the figures, a feature only possible to achieve with computers, fully utilizes (and reveals) its computer origins, qualifying *Picasso 2*, with its dynamic movement, color, line, and futuristic human forms, as a contemporary statement likely to stand the test of time [18.22].

EXPRESSIONISM

Neo-Expressionism

Neo-Expressionism, or the New Figuration of the 1980s, is little more than a decade old, yet seems to have achieved mature status, perhaps because the prices commanded by many of its young practitioners are immense. These artists rebelled against the prevailing nonfigurative, Minimalist art, assuming a new intensity in gesture, color palette, and scale that the critics dubbed Neo-Expressionism—a movement that has become worldwide.

In 1973, the German-born Anselm Kiefer (b. 1945), then in his late twenties and a student of Joseph Beuys at Düsseldorf Academy [9.10], had already produced Expressionistic paintings that were astonishing to an art world in tune with Minimalism. The thunderous beauty of Kiefer's current works, in the opinion of many critics, marks him as one of the most remarkable artists to have emerged in Europe in the last quarter century. Apart from paint, his materials may include paper, staples, canvas, straw, oil, tar, feathers, and even lead. And, like many artists of his generation, he has conjoined ancient myths to modern metaphors of good and evil. The tumultuous, cratered works, more than 10 feet (3 meters) high by 18 feet (5.5 meters) wide, absorb us. The viewer travels through them, exploring all the layers of meaning. Of *Osiris and Isis* [18.23] Kiefer states, "I see myths living, like the parts of Osiris gathered to make a new energy. The same process lives in nuclear fusion. I want to show something that was lost but is still here, transformed, today." He also makes books, which are marked by textured and blackened pages, soaked in oil and shellac, incorporating detailed charts painted over with acrylic and oil. The results are disturbing and haunting.

18.21 LEFT: A DRAWING PRODUCED BY AARON, A COMPUTER BUILT BY THE ARTIST HAROLD COHEN. 1982. RIGHT: HAROLD COHEN AND A COMPUTER-DRIVEN MACHINE OF HIS OWN DESIGN PRODUCING A DRAWING GENERATED BY HIS PROGRAM. 1982.

18.22 Duane Palyka. *Picasso 2*. 1979.
Computer painting. New York
Institute of Technology.

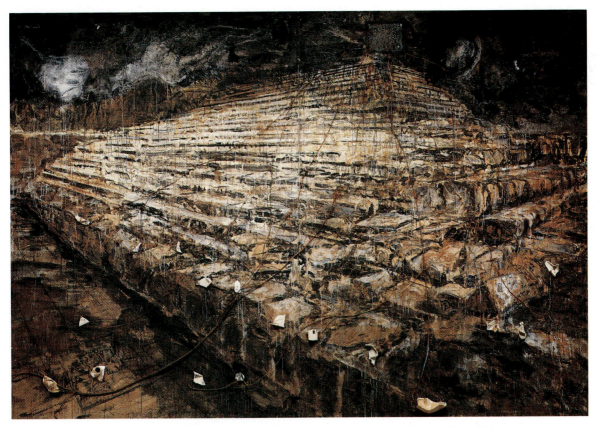

18.23 Anselm Kiefer. *Osiris and Isis*. 1985–1987. Diptych, mixed media on canvas, 12′6″ × 18′4-1/2″ × 6-1/2″
(3.8 × 5.6 × .16 m). San Francisco Museum of Modern Art. Courtesy Marian Goodman Gallery, New York.

Characteristic of some of the new breed of artists, the Italian Francesco Clemente (b. 1952) taught himself oil painting and likes to feel independent of any prescribed style. Unusually imaginative, he tends to explore erotic themes with ironic twists. In *Two Painters*, he responds to the kind of enigma we saw in De Chirico's works [15.25]. This composite work [18.24], made on nine papers, addresses the ambivalence of exchanging cultures between the East and West, shown by gestural reference to body openings. Immensely prolific, he has produced paintings, drawings, frescoes, and prints in numbers that reveal an encyclopedic range of fantasies.

Brooklyn-born, Texas-trained, Julian Schnabel (b. 1951) perhaps typifies much of the reigning art scene. At age thirty, with only six years experience in the art world, he enjoyed a retrospective exhibition in a world-renowned museum in Amsterdam. Perhaps his large-scaled literary

themes, adroitly marketed by his dealer, Mary Boone, hit a responsive nerve in the viewer [18.25]. Working on velvet, a fabric once associated with royalty but currently at the heart of tawdry sleeze, offered Schnabel a connection with Pop media. Yet, the image, tightly controlled by composition, as oil sinks in the fabric, hovers in a brilliant theatrical depth. There is often a ferocious mockery of the purely aesthetic and a sense of rage in much of the work of these artists. Some of those feelings erupt in art of social conscience and others in sudden vulgarities, free reuse of historic works, contradictions, and pseudo contradictions. Among the American Neo-Expressionists, the controversial David Salle (b. 1952) embraces all the above, often expressing his feelings in the segmented format we have seen in contemporary art. Using a projector to trace his forms loosely onto the canvas, he thereby appropriates images from the past. He may also add nonart materials, such

18.24 FRANCESCO CLEMENTE. *TWO PAINTERS*. 1980. GOUACHE ON 9 SHEETS OF HANDMADE PAPER WITH CLOTH BACKING, 68 × 94-1/8″ (172.7 × 239 CM). COLLECTION FRANCESCO PALLIZZI. COURTESY SPERONE WESTWATER, NEW YORK.

18.25 JULIAN SCHNABEL. *SOME PEACHES (SEBASTIAN'S SUMMER POEM)*. 1984. OIL AND MODELING PASTE ON VELVET, 10 × 9′. PHOTOGRAPH COURTESY OF THE PACE GALLERY, NEW YORK.

The Artist Sketch

Perhaps more than other artists of his generation, David Salle is a product of Postmodern life. A former student of John Baldessari at Cal Arts (California Institute of the Arts), Salle arrived in New York, participating in various exhibitions. The critics responded favorably to his works and apparently also to his foundation philosophy. Salle is convinced that originality of concept in art is not possible today or even desirable, and so, he lifts excerpts from such well-known master painters as Caravaggio [13.24] while interposing provocative images appropriated from the media. Salle believes that we are engrossed in media simulations of reality that we watch primarily on television. In the same way, Salle aims to inform us through words and images of the real and the imaginary that cohabit what he calls "the single plane of electronic flow."

Born in Oklahoma and brought up in Kansas, he attended the newly founded California Institute of the Arts. His B.F.A. in 1973 and his M.F.A. in 1975 left him with little support for the traditional art beliefs generally presented in the academic world. Early in the evolution of his career in New York, he began to teach drawing at Ocean County Community College in New Jersey, then lectured for Robert Longo (Chapter 1) at the State University of New York, Buffalo. In the summer of 1976, he worked in the art department of a pulp magazine publisher, presumably where he collected provocative photographs from their archives.

That year, his first solo exhibition was held at Artists Space in Soho, New York, and in the Netherlands as well, where his photo-text works were displayed.

18.27 DAVID SALLE. PHOTO © 1992 TIMOTHY GREENFIELD-SANDERS.

Only three years out of college, with international acclaim behind him, Salle expanded his art media for another show in Amsterdam with music, flashing lights, some large photographs that he had found of a race car, and live performances by female African dancers. The exhibition was a resounding success and was repeated at The Kitchen in Soho. That summer, he created his first "performance" piece *A Man Is Like a Tree* back at Fondation de Appel, Amsterdam, where he added electronic lights, images of a car crash, a fire, and a dog fight. These presentations led to an appointment at the Hartford School in Connecticut, where he again taught drawing.

In the last decade and a half, his paintings have been exhibited in museums worldwide. By the mid-1980s, he was commissioned to design sets for Mikhail Baryshnikov's American Ballet Theater. His record is phenomenal by almost any historical standard, yet his art defies conventional criteria. His use of appropriated imagery is neither universally understood nor appreciated. No doubt Salle intends literary and historical allusions that may trigger connections in the viewer. These connections are not simply absent like "the emperor's clothes," as a few nonadmirers claim, because his images are decipherable. To many viewers, the images pulsate, expand and separate. Salle's major achievement may be the concept of an art opposed to Modernism while forcing viewers to recognize and confront ambiguities of an uncertain world, where he believes mass media replication undermines the distinctions between an original and a copy—much as television's docudramas often blur historical facts.

DAVID SALLE (B. 1952)

as a bra suspended from a dowel affixed to the canvas. Salle's Venus figures are clearly achieved from models posing for the artist, assuming unnatural and arduous poses, staged in quasi-pornographic setups designed to affront the viewer [18.26]. Unlike this clear reference to Caravaggio [13.24], many of his clues are oblique. Salle comments, "Connections that exist between things in the world, and ... images in my pictures ... are not random. ... Not to perceive the difference I think could be very frustrating." Indeed, frustration is the response of many of Salle's critics.

Protest art also exists in a humorous vein. A recent poster series was produced by the Guerrilla Girls [18.28], who claim to represent the "Conscience of the Art World." Since their formation in 1985, their black-and-white, eye-catching posters have been targeted at galleries they see as run by pricey dealers who rarely include women in their rosters. Anonymous, the women don gorilla masks in their midnight expeditions, plastering posters throughout New York City, especially lower Manhattan. Extending social awareness on the West Coast, Corita Kent's intense

18.26 DAVID SALLE. *MIDDAY*. 1984. ACRYLIC AND OIL ON WOOD, 9′6″ × 12′6″ (2.9 × 3.8 M). PRIVATE COLLECTION. PHOTO COURTESY OF GAGOSIAN GALLERY.

twenty-year crusade against war culminated in huge highway signs that exploited the media that she believed were exploiting us [I.5].

Emerging Countries—Emerging Arts

The world is changing. With every passing day, we become more conscious of our need to live with nature as well as each other. But, in one respect at least, art goes beyond nature to spring from ashes (death) like the mythical Phoenix (bird). People everywhere who are enjoying new freedoms also are producing art from the tradition they are leaving that expresses the human spirit, unique to their new time and place. If any unity exists worldwide in the arts of Africa, Israel, Latin America, and the former Soviet Union, it may be in an emotional Neo-Expressionism, somewhat related to the styles we have just examined [18.29].

18.28 GUERRILLA GIRLS. 1992. SAN FRANCISCO, CALIFORNIA.

18.29 TRIGO PIULA. *TA TELE*. 1988. OIL ON CANVAS, 100 × 100 CM. COURTESY OF THE ARTIST AND THE CENTER FOR AFRICAN ART, NEW YORK.

Africa Contemporary African artists in modern cities are creating artworks that are distinctly African, while in rural areas the traditional arts linger in altered forms. African societies are as various and changing as are the cultures and subcultures almost anywhere in the world today. And, just as African arts have exerted global influence on twentieth-century art, African artists have been much influenced by the West.

Since the late 1950s when African nations began to achieve independence, political, economic, and social changes have profoundly affected the arts. Some African artists, like those who lived centuries ago, seek to revive age-old forms especially those in rurual areas. Other artists paraphrase ancient styles adding neo-expressionist overtones found internationally today. Still others, largely untrained, are producing an urban art, rooted in the present and as close to the graffiti and street art as any we have seen in the West, such as the Athens, Georgia Community Mural [3.27]. This large body of urban art, primarily produced for the tourist trade, is also popular with masses of Africans who display it prominently in their homes.

With the surge of nationalism, most Africans now expect art to play a political, social and moral role. This art thrust, termed international, is produced by academically trained artists who work in a variety of styles, nearly always figurative. Much of this art, supported by the government, is exhibited in the few existing African galleries, government buildings, and corporate spaces. Works are sold to foreigners, international businesses and the African elite. In general, African artists form part of a deep network that is purely local and independent of Europe. In Senegal, the work of the *Laboratoire AGIT-Art* is among the most innovative and includes painters, writers, filmmakers and musicians. These artists work outside governmental galleries and museums.

A typical cultural amalgam of art influences appears in the work of Congolese artist Trigo Piula (b. 1953). *Ta Tele* compares the nineteenth-century power figure [14.13] with an *Nganga* (traditional healer). A television set has replaced the ancient mirror that once enriched many power figures and was intended to capture distant images (spirits) for the benefit of a patient. Featured in a pioneering 1991 traveling exhibition set up by Susan Vogel, director of the Center for African Art in New York, Piula explained in the catalog *Africa Explores* that accompanied the show:

> The dreams and escapist fantasies that TV satisfies are depicted in the images that appear on the rear screens, while each patient's personal dream appears inside his or her own head… The Word *ta* in the title corresponds to the Kikongo word for father. The word *Tele* means television in French, the national language of Zaire. In Kikongo "tele" means "said." Thus, in French the title means "Your television" and in Kikongo it means "Father said."

Both meanings are important to understanding the painting [18.29].

Art in Africa, past and present, Vogel tells us, has been made for a function: to celebrate, to mourn, to preach, to worship, and to sell . . . the very opposite of our (fine) art, which by definition is supposed to transcend utility.

Israel The land of Israel has a long history but a short past. Beginning in 1906, the first Academy of Arts and Crafts was established in Jerusalem. Neither art traditions nor institutional patterns existed to transmit an art heritage, since the arts were specifically frowned upon by extreme Orthodox Jewry which forbade anything to do with art based on the Second Commandment that prohibits graven images. The Academy fostered art objects for ritual after 2000 years of exile from the homeland and so Israel began to develop an art tradition.

If Israel has found a place on the map of contemporary art, it is due to the talents of a few artists, organized to collectively arrange exhibitions. The Tel Aviv Museum has provided an outlet for some new and experimental trends. At least two of the artists we know: Moishe Safdie, architect of *Habitat* [7.32], and Agam, the Op Artist [17.14] who has also explored computer graphics and holography. Israeli painters for the most part work within the Abstract Expressionist idiom.

Latin America South of our borders lies a vast culture, fragmented by its native traditions, harshly repressed by the Conquistadores, who imposed their Eurocentrist Colonial arts, and a slowly emerging Hispanic

art. When Surrealist Andre Breton made friends with Diego Rivera [I.3] and Frida Kahlo [16.15], the voodoo arts of Haiti became respectable and such art as Rufino Tamayo's surrealism joined European Modernism, Marxism and a nostalgia for the frescos of antiquity that could be seen in the Mexican Protest painters (Chapter 16). If within this diversity we may find a unified current, it resides with the international movement of Neo-Expressionism, as clear here as anywhere in the world.

The Former Soviet Union Plagued and oppressed by restrictions, numbers of Soviet artists fled or were expelled from their country in the 1970s and 1980s. Most of the art shows characteristics of the adopted land, but in a few cases, exile has reinforced previously held ideas. These include artists trained under strict Soviet academies, some who have a socioeconomic fervor to use as content, some who echo Western art, and others clearly affected by culture shock. There is little thematic interest in landscape, but considerable in a fantasy world, where comments on the human condition seem particularly irrational. There are always reminders of the geometric abstract forms pioneered by the Russian Constructivists in the 1920s. They also seem to enjoy themes of irony, and we can become absorbed in translating their visual conundrums. Soviet art perhaps reflects the tension of the journey.

PHOTOGRAPHIC ARTS

Like other arts, photography has been perceived as an arena for experiment, attracting painters like David Hockney [5.19] and sculptors like Lucas Samaras [9.11], as well as many newcomers to art.

Still Photography

Photography is now accorded the stature of the other fine arts by leading museums, critics, and collectors. As painters become fascinated with photography and some try to create imitation photographs in their paintings, they cause an identity crisis for photographers. In reaction, some photographers tend more toward unusual effects than toward the classicism of Edward Weston or Ansel Adams [5.10]. Many are interested in handwork on photographs. Others, however, make new use of ideas and techniques taken from the photographic past. After a quarter century of dependence on the 35-mm camera, many are returning to the large-format, tripod-mounted camera used by the early twentieth century photographers. Such developments may lead photography back to an era of careful preplanning, creativity, and control of scientific photographic techniques.

We have already observed Cindy Sherman's capacity for self-exploitation in images that seem to be taken from films of the 1950s but which actually express our fears today [5.20]. We have seen the fragmentation of David Hockney's (b. 1937) vision, made whole in his photo mo-

saics [5.19]. The Starn brothers, like Hockney, split and stretch their images to increase their impact [5.21], while others montage several views to form the segmented image we see in much art of the 1980s.

The controversial Robert Mapplethorpe (1946–1986), like many current photographers, was always more concerned with making a work of art—as he put it, as "an object"—than by using photography to record a scene. His works evolved from segmented presentations, made up of several photographic strips to those that objectified the human body. Coupled with his awareness of the dominant social and sexual issues of the 1980s was a sincere delight in the beauty of the human body. The platinum print on linen works were especially important for they fused characteristics of painting and photography, such as his view of *Thomas* [9.16].

Many minority artists continue to grapple with inherited social roles, ripping at racial stereotypes in works [18.30] as controversial as "rap" that provide insights we might otherwise avoid about interracial American life. Carrie Mae Weems, born in Portland, Oregon, often supplements her photographs with displayed commentary, such as conversation of the people whom she has photographed, that adds information to broaden our perspectives further. This procedure seems to be growing in the 1990s.

Like Ed Rushka [17.27], Jenny Holzer (b. 1952) uses words of texts as the subject of her work. She follows Laurie Anderson (Chapter 9) in a search for means of commenting on mass media by using it herself. Responding to the graffiti environment of New York's Soho to Times

18.30 CARRIE MAE WEEMS. UNTITLED. 1980. SILVER PRINT, EDITION OF 5, 28-1/4 × 28-1/4″. COURTESY OF P.P.O.W., NEW YORK.

Square, she installed the famous moving-message Moto-gram by forcing public awareness of the "Truisms" we seem to have ignored in our current culture [18.31]. With her sense of spectacle, Holzer, perhaps beyond other Conceptual artists, has addressed our "loaded" language with a surreal command of the spaces she selects. Winner of the 1990 Venice Biennale for her installation, in an interview with Lilly Wei, she stated, "I was very aware I was the first woman to represent the United States ... Although I am an American and a woman, I want my work to be ... more universal."

Film and Television

America dominates the cinema. Perhaps most important is the element of the unreal that films provide. Audiences can escape the everyday world through the fantasy of classic romance or of science fiction, as in Stanley Kubrick's (b. 1928) ground-breaking *2001: A Space Odyssey* (1968). Anticipation builds from the start of the title sequences, linked by designers to the film that follows. The brilliant sequences designed by Saul Bass for *The Quest* [8.2] are a case in point. Bass, in his own 1970s film *Why Man Creates*, illumines the process of creativity, fundamental to all the arts and indeed to life itself. Designers like Bass and Steven Spielberg (b. 1947), with their technical wizardry, are changing the face of the films we see.

Most American films continue to provide escape through action and violent adventure. Although our cinema is not yet governmentally controlled, because we spend vast sums in production, the sky-rocketing costs of filmmaking allow less opportunity for experiment and risk today than in the film industry's infancy. The effect of television on cinema has already been felt. What changes cable television and cassette and disk recordings of motion pictures will make remain to be seen.

American film directors, however, have worked with originality and distinction. Alfred Hitchcock (1899–1980), creator of suspense films, earned increasing respect for achieving deeper intensity and increased control. Francis Ford Coppola (b. 1939) in *The Godfather* (1972) and its successors may be pointing out the all-too-frequent gulf between what we say and what we do in our sometime moral society. Other directors of the 1970s, such as Michael Cimino (b. 1943) of *The Deer Hunter*, have made important statements. The future of film, despite fewer pictures and smaller audiences, may lie with present-day directors who can survive the uncertainties of the art to create

serious works that may make us angry but force us to think with fresh minds, such as Oliver Stone's *JFK*.

Television continues to play a large part in many people's lives. Over-the-air television generally serves a mass market, while the increasing popularity of cable television makes possible a wider variety of programs and greater specialization.

Video

The incorporation of video into many other arts, such as sculpture, performance—to be discussed shortly—and earth installation projects, has been an important part of video art's history. Nam June Paik's extensive contribution to that history is a matter of record [5.28]. The connections and interface of video with computer art are logical in that both are electronic media and share in the manipulation of content and the formal joining of images through image processing and electronic editing. The relationship is even stronger with regard to animation, both two- and three-dimensional arts that will surely expand as the century closes.

Many artists have both implicitly and explicitly rejected commercial television in videotapes that express a sociocultural ideology. Martha Rosler's *If It's Too Bad to Be True, It Could Be DISINFORMATION* (1985) [18.32] uses the strategy of interfering electronically with network news reports recorded directly from television. Rosler's breakup of the images is her metaphor for the disinformation she sees often intruding through telecasts that are presented as objective reporting. Her videotape is a vivid testament to the impact and influence of the mass media, as Marshall McLuhan forewarned twenty years ago (Chapter 5).

Other video artists embrace the techniques of commercial television. Noting the impact of choreographed multimillion-dollar Pepsi-Cola commercials made by Michael Jackson, it comes as no surprise that music video has become one of the strongest emerging art forms, embodying surrealistic effects along with a variety of other special effects inherent only in the electronic media.

It is scarcely possible to conclude the segment on video without noting, at the very least, the crashing impact made upon our current culture by the *Material Girl* herself, Madonna Louise Veronica Ciccone (b.1958), who has been able to indict our time, while maximizing her own financial benefits, as few earlier phemonena have been able to achieve. Utilizing the best our technology has to offer, her own incisive lyrics tell it all in her videos, "cause we're living in a material world, and I am a material girl." Her grasp of audience response permits her to behave like Robert Kushner. He wore and then stripped off his body the very fabrics of which his art was made [18.3]; Madonna hits us in the face with her armored brassieres. It seems that what we want is what we have gotten, and we have paid her well to market it.

Holography

Holography, the most convincing method yet invented for creating three-dimensional photographic imagery, is little more than twenty years old, yet already scores of artists have produced a significant body of works. The principles underlying the art depend on the laser beam, a highly controllable source of coherent light. The holographic image, or hologram, is a three-dimensional picture that can be stored on glass plates, awaiting the proper light source to bring it out. The resulting image captures not only frontal views but several others, producing a volumetric result that is uncanny. While the technology dominates this art in which scale and coloration are unreal, holography forces the viewer to rethink reality and perception. Op artist Agam, well known for relief constructions that reconfigure as the viewer passes by [17.14], is already producing holograms that work within his pre-established art aesthetic.

CONCEPTUAL AND PERFORMANCE ART

Conceptual Art

Over the last hundred years, struggling Western artists have gradually won release from many restraints society imposed on creativity. Impressionism in the nineteenth century and nonobjective art in the early twentieth century were steps in this struggle. In the 1960s, **Conceptual Art**, based on the premise that art may exist as ideas rather than as objects to be permanently displayed and evaluated, took a further step toward freeing the artist from any restrictions. Similar to a theatrical or musical performance, which leaves no art object after it is over, Conceptual Art may involve a process, but it rarely leaves material art objects. The idea itself or the process is sufficient reason for its being.

Vito Acconci, whose public print [18.18] relates to Conceptual Art by emphasizing the process, in this case, of passing through *Building Blocks for a Doorway*, was inspired early in his career by a documentary television series on an American family. Creating a three-week series called *Following Pieces*, he chose a figure in the art world at random and followed the artist for a day. His written report of his findings, which he mailed to art critics, was the only record of his activity. His goal through the years seems to have remained an interaction between subject and observer that focuses most often on the process of making art.

Always endowed with a sense of the theatrical, the Bulgarian-born artist Christo (b. 1935) selected as one of his first projects an arena where art could happen within a specific time period of his own choosing. After twenty-eight months of planning and obtaining approvals and actual construction, on August 10, 1972, in Rifle, Colorado, at 11 a.m., a 200,000-square-foot (18,587-square-meter)

18.32 MARTHA ROSLER. *IF IT'S TOO BAD TO BE TRUE, IT COULD BE DISINFORMATION. 1985.* VIDEOTAPE. COURTESY OF VIDEO DATE BANK, CHICAGO.

curtain of woven nylon fabric was suspended across a 1250-foot (381-meter) valley between two mountains. This giant *Valley Curtain* [18.33] was hung from steel cables supported from concrete foundations deep within the mountains. The work confronts us with a paradox, as do so many Conceptual works and earthworks. It seemed to be functional but in fact served no practical purpose because it was translucent, allowing light to come through, and was hung to allow space for traffic to pass. More important, instead of acting like a theatrical curtain that unveiled or concealed a spectacle, Christo's curtain *was* the spectacle. In the same spirit, he surrounded eleven islands of Florida with 6.5 million square feet (604,089 square meters) of floating pink fabric, as well as constructing a 24.5-mile (39-kilometer) cloth fence in California. Instead of making containers for works of art, he has made the packaging become art, while bringing attention to the site and the very process of making art.

The evolution of Conceptualism today can be seen in the art of Mark Tansey (b. 1949) [18.34], whose paintings involve what he defines as *bricolage* or "reverse collage." By photocopying images, he reassembles them in new, seamless configurations. Lifting elements from Cézanne's *Large Bathers*, he has reversed the sex of his images in the reflections that appear in the forest stream, pinpointing Cézanne's own discomfit in working from the nude model. Eliminating color in the copy process, he links past and present in a single metaphorical relationship, while unifying his image.

Proceeding still further in this unchartered realm of appropriation, Sherrie Levine (b. 1947) rephotographed reproductions by famous male photographers and exhibited the works as her own. When confronted with the laws of copyright, she retorted that while appearing to plagiarize Edward Weston, she had only interrupted the male line of succession to link herself to it. Weston appears to

18.33 CHRISTO. *VALLEY CURTAIN, RIFLE, COLORADO.* 1970–72. 142,000 SQUARE FEET; 110,000 POUNDS OF CABLES; 1250 × 365′ (375 × 111 M). © CHRISTO 1972.

18.34 MARK TANSEY. *MONT SAINTE-VICTOIRE*. 1987. OIL ON CANVAS, 8′4″ × 12′1″. COLLECTION THOMAS AMMANN, ZURICH; COURTESY CURT MARCUS GALLERY, NEW YORK.

have imitated ancient Greek sculptures in the poses he used while photographing his young son's torso. She commented in an interview with Mazorati:

> I never thought I wasn't making art ... I believed I was distilling things ... And I was getting tired of being represented by men.

Other forms of Conceptual Art are thinkworks and nihilworks. **Thinkworks** yield only information: The medium thus becomes the message. Joseph Kossuth (b. 1945), for example, shares ideas by transferring a negative photostat of words such as *water* or *nothing* to canvas. He has said, "what is seen is the presentation of the information. The idea exists only as an invisible ethereal entity."

Nihilworks destroy themselves, like Tinguely's self-destructing machine [17.21]. At Alfred University, Robert Smithson [1.15] studied accounts of the legendary lost continent of Atlantis and roughly determined its imagined silhouette. He had students collect large, smooth, round rocks, which were positioned on a quicksand bed in the approximate shape of the continent. Slowly they sank

out of sight. This type of art raises questions about permanence. Was the event still authentic art after the stones were no longer visible? Can a work of art be justified if someone only remembers it?

Performance Art

Many artists have even found the written word as documentation of Conceptual art too confining and have broken free from all static forms, creating pieces in the temporal medium of Performance Art, with the artist himself or herself as subject. No one was more effective in this new process than Joseph Beuys (1921–1986). His concerns were the continuity between art and life and the ever-changing nature of things. He never appeared in public without hat, ammunition jacket, jeans, and hunter's boots; he once lived in a tableau [9.10] in the René Block Gallery in New York for three days with a live coyote and daily deliveries of the *Wall Street Journal*. That show was commemorated at the Hirshhorn Museum in Washington, including a yellowing stack of *Journals* and the artist's overcoat. There is no record of the coyote in the recreated event in Washington.

Laurie Anderson, who continues to overwhelm her audiences with excursions into sound, visuals, and performance [9.12], has added video to her stock in trade, both as a backdrop for her presentations, and as a productive way to encapsulate her art for the market.

ENVIRONMENTS

Earthworks

Art forms that involve some significant, often enduring, change in the natural environment are called **earthworks**, a term that may refer to alterations to the sea and sky as well. They are related to Conceptual Art.

Throughout history, artists have interacted with their environment; today the interest in large-scale art has reached a climax in earthworks. Artists such as Michael Heizer (b. 1944) and Robert Smithson have used the natural world itself as a medium. Like engineers, architects, or farmers, they want to change the face of the earth. They may dig trenches in a dry lake, redirect streams of water, pile up embankments of earth, or merely photograph natural geological sites. They seem to be protesting against artistic traditions and also human tampering with fragile ecosystems. Like happenings, many earthworks are too vast or too transient to be experienced permanently by many people, and they are limited by the economic resources needed to support them.

An example of a more transient earthwork, and thus one closer to Conceptual Art, is *Annual Rings*, executed by Dennis Oppenheim (b. 1938). It consisted of concentric rings the width of a snow shovel cleared on a section of the frozen St. John River at Fort Kent, Maine. Of course, this drawing in the snow could last only until the spring thaw.

Sculpture/Environments

In the 1970s and 1980s, many artists struggled to create alternate environments to the world produced by our mechanized civilization; in some ways, they succeeded.

Nancy Holt's *Stone Enclosure* [17.32], is a permanent outdoor installation that evokes Stonehenge [7.18]. The work appears to have always been there, poetically addressing the ephemeral: its lights and shadows gradually change with the movement of the earth in relationship to the sun. We are affected in a similar way by the work of James Turrell [6.26] and Alice Aycock [17.33].

Sculptor Charles Simonds (b. 1945) has constructed hundreds of tiny clay "dwellings" on such unexpected sites as an urban street corner or a vacant lot. Perhaps, in crafting these small clay structures that loosely resemble native Pueblo architecture [18.35], Simonds evolves in his mind a mythical story of civilization on which we can focus, which we can contrast with the beginnings of today's society. Though his primal earthwork structures are very personal, Simonds reflects a style of primitivism common to many artists today.

In a related way, Nancy Graves (b. 1940) evokes early non-Western cultures with the sculptures and environments she creates [18.36], most of which embody natural and synthetic elements. As she mates organic shapes with a painter's vision in a trial-and-error approach, dominated by wit and sophistication, her work seems to compare the anxiety of modern times with primeval fears of the unknown.

Following a different road toward environments is Judy Pfaff (b. 1946), who creates on-site installations that democratically combine art and nonart, junkyard and hardware store materials. London-born and American-trained, Pfaff works from a base of Abstract Expressionism, related

18.35 CHARLES SIMONDS. *DETAIL OF DWELLING, CHICAGO*. CLAY, ENTIRE WORK 8 × 44′ (2.44 × 13.41 M). MUSEUM OF CONTEMPORARY ART, CHICAGO (GIFT OF DOUGLAS AND CAROL COHEN).

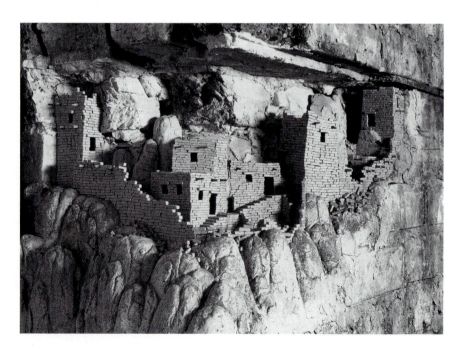

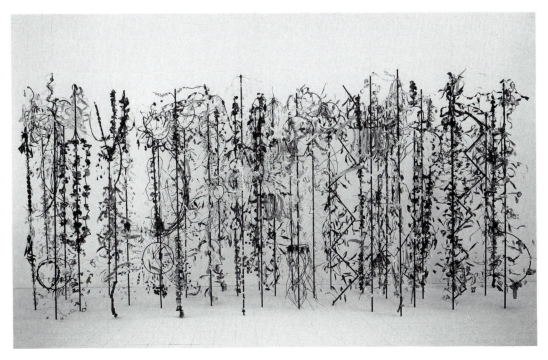

18.36 NANCY GRAVES. *VARIABILITY AND REPETITION OF VARIABLE FORMS.* 1971. STEEL, WAX, LATEX, GAUZE, PLASTER, ACRYLIC, OIL PAINT, 38 UNITS; INSTALLED APPROXIMATELY (3.05 × 7.93 × 4.27). NATIONAL GALLERY OF CANADA, OTTAWA.

to the work of her teacher, Al Held, at Yale. Entering a Pfaff installation is like entering a giant, gestural painting. Day-Glo-painted constructions appear to leap off the walls. In this controlled chaos, the effect is exuberant and even sensual [18.37].

Red Grooms (b. 1937), whose print of Gertrude Stein [4.19] we have seen, fills entire rooms with brilliantly, dissonantly colored cut-out figures and objects through which the visitor must pass. These "cities of the mind," as they have been described, are fun to play with. His energetic visions of Chicago or New York are of teeming places, alive with people, buildings, bridges, and even subways—all the razzmatazz of 42nd Street. His art is endearing and yet a pointed comment on urban architecture.

ARCHITECTURE

Central to the International Style that dominated the architecture of the middle twentieth century was the belief that the architect could bring us Utopia, that properly designed buildings could influence social change. This principle pervaded the art of the Russian Revolution and of the Bauhaus designers both in Europe and later in the United States. It was fundamental to the city planning done by Le Corbusier in Paris in 1920 and in Chandigarh in the 1950s.

The principle has not, however, worked out as planned. The unadorned grid structure with curtain walls, first advanced in its newness and purity by Mies van der Rohe [8.35], was repeated all over the world during the building boom of the 1950s and 1960s. In the process it was

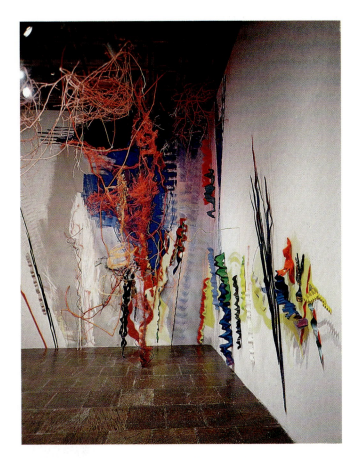

18.37 JUDY PFAFF. *DRAGON.* 1981. MIXED MEDIA. INSTALLATION AT THE 1981 BIENNIAL OF THE WHITNEY MUSEUM OF AMERICAN ART, NEW YORK. COURTESY HOLLY SOLOMON GALLERY.

debased into rubber-stamp construction, impersonal and lifeless. As Wright once said, "Doctors bury their mistakes, but architects can't." The architect Peter Blake (b. 1920) described the American scene in his book *Form Follows Fiasco* (1977):

> All around, the environment we have built over the past century or so, with supreme confidence, is literally collapsing ... literally; the finest public housing projects to be found anywhere in the world, ... are turning into enclaves of murder, rape, mugging, and dope addiction ... literally. Something or somebody isn't quite up to snuff somewhere ...

Certainly the master builders of the twentieth century whom we have studied so far—Gropius, Mies, Le Corbusier, Wright, Fuller, Saarinen, and Breuer—have made great contributions to their field. Others have also created outstanding works—Philip Johnson (b. 1906), mentioned in Chapter 7, I. M. Pei (b. 1917), Alvar Aalto (1898–1976) **[18.38]**, and Louis Kahn (1901–1974).

Alvar Aalto, a Finnish architect, has been particularly esteemed because he evolved a rich, expressive style of understated humanism as opposed to the prevailing extremes of sterile, glass-box rationalism and curvilinear flamboyance. Each of his designs appears new, yet all share a spatial flow, are warmed by textural modifications, especially through the use of wood and brick, and are scaled to their human occupants. The concert hall of a cultural center in Helsinki, his last major work (1967–1971), is an irregularly shaped structure of white marble. The classically simple form of Finlandia Hall is an appropriate climax for a revolutionary architect who was dedicated to humanizing

the architecture of the twentieth century. Pei, formerly a partner of Johnson, built such varied structures as the towering John Hancock Building in Boston **[18.39]** and the triangular East Wing of the National Gallery of Art in Washington. He has also designed a controversial addition to the Louvre museum in Paris—a pyramid-shaped, glass entrance structure located in the central courtyard.

Both the monuments of classical antiquity and the buildings of Le Corbusier were influences on Louis Kahn, who created some of the most fresh, most imaginative, yet timeless buildings of his era. The complex problems involved in designing an art museum—circulation, lighting, work and storage space, rooms for other events—were solved in a most effective way in Kahn's Kimbell Art Museum in Fort Worth, Texas **[9.18]**. In this celebrated building Kahn turned his attention to integrating the exterior with the environment and to creating a light-filled interior, at once monumental yet sensitive to the art it was built to house.

Postmodernism

Architecture Postmodernism refers primarily to post-Bauhaus architecture, although the term has sometimes been broadened to include painting and sculpture also. Its major exponent is Robert Venturi (b. 1925), whose *Complexities and Contradictions in Architecture* of 1966, a witty but scholarly tract, attacked mainstream Modernism for the weaknesses we have cited. To Mies van der Rohe's comment, "less is more," Venturi retorted, "less is a bore."

Venturi's reactions to the 1950s "glass box" put the accent on decoration—much of it. With his wife Denise

18.38 ALVAR AALTO. FINLANDIA HALL, HELSINKI, FINLAND. 1967–1971.

Philip Johnson, long considered the dean of American architects, praised Venturi, however, as a new voice and "leading theoretician of this country, if not the world." Johnson's own immense prestige persuaded conservative AT&T to invest more than 200 million dollars in a Postmodern design that has become a symbol of revolt against mainstream Modernism, the company's headquarters in New York [18.40]. The dazzling compositional effects that Johnson and John Burgee planned were made possible by an internal structural "bridge" between the 80-foot-tall (24 meter) entry arch and the 647-foot-tall (197 meter) tower,

18.40 PHILIP JOHNSON AND JOHN BERGEE. AT&T HEADQUARTERS, NEW YORK. 1983–1984.

Scott Brown, a specialist in popular culture, Venturi wrote a second, even more critical book entitled *Learning from Las Vegas*. The architect critic of the *New York Times*, Ada Louise Huxtable, joined others of the Modernist school in almost wholesale condemnation of Venturi, whom she termed the "guru of chaos," perhaps because of his free use of classical motifs in unclassical structures.

using architectural engineering principles that have become common in the last half-century. The colonnade of the entrance plaza, intended by Johnson to recall the epic grandeur of the Hypostyle Hall at Karnak, is considerably less successful because the site is very confined. No doubt the controversy over the unusual pedimented roof configuration will subside as New York is refurbished with other structures, especially later Johnson and Burgee designs. Though its major critics have described the AT&T building as a "Chippendale highboy," it has also been praised for its pink granite surfaces and the three "oculi," or circular openings, that pierce the lateral walls of the plazas. Its design may portend the future.

In the opinion of Charles Jencks, Michael Graves's Public Services Building in Portland, Oregon [18.41] is the first pure monument of Postmodernism on a grand scale built with art and ornament that the public understands. Somewhat resembling a child's block constructions, Graves has retorted that he designs as if he were a child, free to pick and choose without inhibitions of design issued from centuries long past. Despite the many challenges and changes through which Graves' designs often pass, the *Portland* is a boldly assertive civic structure.

Deconstructivism, the most recent trend in architecture is a reaction to Russian Constructivism. Existing today primarily as a theoretical approach [7.27], the models that have been designed may yet offer a direction for tomorrow's architecture.

Sculpture Postmodernism as it appears in media other than architecture often goes by the name of **Post-Structuralism**. Derived from Ferdinand de Saussure, the

18.41 MICHAEL GRAVES. PORTLAND PUBLIC SERVICES BUILDING, OREGON. 1980–82.

father of modern linguistics, the term has been applied to objects other than verbal language, while meaning seems to have migrated from the producer to the product. This and other terms have been applied to Jeff Koons (b. 1955), a former commodities trader. Objectifying *vanitas* and "kitsch," descriptive of mass-produced items of little taste and cheap design, Koons recontextualizes the products we seem to keep buying. His products gain further allure by the costly materials he uses, overlaid with metaphors for the "Midas touch." Wall Street's strategies seem to have worked astonishingly well in the art marketplace at least for him [18.42].

Mixed Media Categorized as a Conceptualist, a Minimalist, or a multi-media artist, John Baldesarri (b. 1931) is as comfortable, or as disquieted by, any medium he selects. Rarely satisfied with the traditional direction of any medium he taps, his extraordinary creativity has been most recently applied to photography. In *Blasted Allegories* [18.43], words collide with images in a rich confusion that seduces the viewer into a search for his message. Over the years, Baldesarri has collected a treasury of images pirated from his television set. Inspired by a formula bequeathed from an anthropologist, Charles Levi-Strauss, both believe all myths can be reduced to that single formula "Fx(a):Fy(b) = Fx(b):Fa-1(y)." Neither has offered further explanation.

18.42 JEFF KOONS. *PINK PANTHER*. 1988. PORCELAIN, 19 × 20-1/2 × 41″. COURTESY OF THE ARTIST.

18.43 JOHN BALDESSARI. *BLASTED ALLEGORIES. (COLORFUL SENTENCES AND PURPLE PATCH): STARTING WITH RED FATHER.* 1978. THIRTY-SIX TYPE-C PRINTS ON BOARD WITH COLORED PENCIL AND TAPE, 30-5/8 × 36-5/8″ (77.8 × 93 CM). THE MORTON G. NEUMANN FAMILY COLLECTION, CHICAGO. COURTESY SONNABEND GALLERY, NEW YORK.

LOOKING TO 2000 AND BEYOND

Today it is more than ever apparent that avant-garde artists have lost their traditional power to shock even die-hard conservative critics. In the last few decades such new trends as Optical Art, combine paintings, kinetic and light sculpture, Environmental Art, and Conceptual Art have exploded accepted ideas of what art should be. It is the very nature of the current scene that no single style or point of view predominates. If the categories of art, styles, and artists we have just surveyed seem overwhelming, perhaps it is because we live in a world of multiplicity, which the world of art often illumines.

We may observe certain trends. The popular taste for photographic verisimilitude is unparalleled in the modern period. Museums, galleries, and critics have begun to accept minority artists as professionals. In the 1990s, however, most artists are creating as individuals, rather than as members of groups. And, there is no question but that considerable controversy continues to exist and many issues remain to be resolved.

In summation, we have come to find that the artist is a creative being, with more than a small element of inspiration. We would wish the artist to be a model of free action, yet we often question those freedoms when the artist makes works that go beyond our comprehension. Perhaps, as Picasso once urged us, we need to accept art as it is and appreciate it "like the song of a bird." Art springs from the human mind and spirit. It inevitably will be the human mind and its basic consciousness of high values that will offer the final, most promising solutions to our problems. The art in our world must stem from our basic human spirit.

There was once a time when art was an important element of everyone's life, not just the artist's personal preoccupation. Today we realize that art can again become a part of everyday life, enhancing the buildings in which we live and work and even the highways on which we drive. To bring art into our daily lives involves choice, commitment, and support—not only from the dedicated artists but also from citizens who care—those of us who appreciate the art in our world.

EXERCISES AND ACTIVITIES

Exercises for Research and Discussion

1. Some artists use their art as the vehicle of social protest, while others are concerned only with form and style. Select examples of these two approaches from the artists discussed in this book, giving reasons for your choices. Is one approach more valid than the other?

2. Today the pace of change in every area of life has accelerated. How does art reflect that acceleration?

3. Light art, Conceptual Art, earthworks—all have their followings. Realistic painting also exists in the style of Magic Realism. Discuss two of these movements. What were their predecessors in earlier styles, if any? List prominent artists and their works.

4. The public usually has resisted the most pioneering artistic efforts. How do you account for the public mistrust and lack of interest in the works of experimental artists? In view of the general resistance to innovative art, how do you account for the popularity and acceptance of other new media, such as cinema, radio, and television?

5. The major architectural achievements of every civilization identify its primary concerns. Evaluate today's world on the basis of its major structures. How does our architecture suggest the directions in which we might continue to grow?

Studio Activities

1. Plan and outline a Conceptual artwork.

2. Many individual and regional styles exist in art today. No one style is dominant. Create an artwork in any medium, either based on a familiar style or in your own personal style. How does this work relate to other art of the 1990s?

3. Working within a segmented format, create a work that expresses an aspect of social concern that interests you. You may use a series of photographs, sketches, or magazine reproductions.

4. Plan a configuration that echoes Jennifer Bartlett's *Rhapsody*, while dealing with a theme you favor, perhaps an illustrated calendar of your school's sports events.

5. Create a work that embodies written communication along with the visual imagery.

Glossary

abacus The slab that forms the upper part of the *capital* of a column.

ABC sculpture See *Minimal art*.

abstract art Art not mainly concerned with representation of nature; the artist selects and distorts certain aspects of reality reducing the subject to its essential qualities by means of *line, color, form, etc.*

Abstract Expressionism A painting style, also called the *New York School*, developed after World War II, combining spontaneous personal expression with abstracted or nonobjective shapes painted on large areas of canvas. The action of the artist in flinging, brushing, and dribbling the paint, using the large muscles of the body, led to the term *Action painting*. Jackson Pollock was an early Action painter.

Academy From the Greek *Akademeia*, a grove where Plato lectured. The official school of art in France in the eighteenth century, which set forth rules dictating the style in which artists should work, controlling art by refusing to exhibit any work that did not follow these rules. The term "academic art" now describes conservative art, adhering to traditional rules.

acropolis From the Greek *akros*, meaning "hill town" or "fortified hill," applied to the upper section of a Greek city that usually contained the temples. The Acropolis at Athens is the best-known example.

acrylic paint A synthetic resin paint which, along with *polymer* paint, is often used by artists today in place of traditional *oil paint*. Quick-drying and durable, it can be used on a great variety of surfaces. Helen Frankenthaler and Morris Louis are painters who use acrylic paints.

Action painting See *Abstract Expressionism*.

additive primary colors Red (magenta), blue (cyan), and green—combined colors that produce white when projected onto a single area.

additive process Building up objects from plaster, clay, wood, or metal fragments, joined mechanically or by adhesives. See also *assemblage*.

adobe The clay used to make a kind of sun-dried brick of the same name; a building made of such brick.

aerial perspective See *atmospheric perspective*.

aesthetic Having to do with beauty or heightened sensory perception as opposed to utility or moral or emotional content.

afterimage The illusion of an *image* persisting after the original visual stimulus is removed.

airbrush A small precision spray gun, used to produce soft lines and fine graduations of paint.

aisle The portion of a church flanking the *nave*, separated from it by a row of columns or piers.

altarpiece A screen, a series of painted panels, or a sculpture placed on or behind the altar in a church. Usually decorated with religious subjects.

ambulatory The *apse* aisle of a church, such as the gallery aisle behind the altar.

analogous colors *Hues* that are close to each other on the *color wheel*, such as blue-violet, blue, and blue-green.

Analytical Cubism See *Cubism*.

aperture In photography, the opening that admits light into the camera. The size of the aperture, measured in f-stops, controls the amount of light that reaches the film.

appraisal Determination of authenticity and market value of an artwork.

apse The semicircular or polygonal area at the end of a building. First used in Roman *basilicas*, continued by Christian church builders. The apse of a Gothic cathedral was roofed with complex *vaults*; often with small chapels opening off it.

aquatint A *print*, or an area in a print, which is textured by coating the metal plate, from which the print is made, with rosin dust. The plate is then heated and etched with acid, producing an allover textured tone. See *mezzotint*.

arabesque "Arabian-like." A flowing intricate pattern derived from stylized organic motifs, usually floral, often arranged in symmetrical designs; generally an Islamic decorative motif.

arcade A series of arches supported by *columns*, standing free or attached to a wall for decoration. First used by the Romans, later incorporated into Christian churches and *Renaissance* buildings.

arch A curved structural member that spans an opening; generally composed of wedge-shaped blocks (*voussoirs*) that transmit the downward pressures laterally. See *arcade, barrel vault*.

Archaic The earliest period of Greek art from the eighth to the sixth centuries B.C. Also used to describe the beginning stages of art in any civilization.

architecture The art of building with solid materials, enclosing space in a useful and pleasing way.

architrave The lowest division of an *entablature*.

armature An internal metal or wood support for clay, plaster, or wax to be modeled into sculpture.

artist's proof The first *print* to be *pulled* that satisfies the artist's criteria.

Art Deco Art style of the 1920s and 1930s, based on contemporary materials and curvilinear geometric patterns.

Art Nouveau A style with decorative linear qualities that evolved from a nineteenth-century craft movement yet rejected all historical art connections in favor of new materials and technologies in building and decoration.

Arts and Crafts Nineteenth century movement originating with William Morris to promote handcrafted, functional products.

Ash Can school Early twentieth century American artists who produced realistic art concerned with unpretentious subject content.

assemblage A work of art composed of materials, objects, or parts originally intended for other purposes. See also *additive process*.

atelier Artist's workshop or studio.

atmospheric perspective Also called *aerial perspective*. A method of creating an illusion of three-dimensional depth on a two-dimensional surface, using *color*, light, and *shade*. Objects painted in intense, warm colors with strong contrasts of dark and light appear close to the viewer. Light, cool colors with less contrast make objects appear farther away.

atrium The court of a Roman house, past the entrance and partly open to the sky.

avant-garde From the French meaning "advance guard"; artists whose works incorporate the latest art trends, or may, indeed, inspire changes in the prevailing art styles. In opposition to traditional art of the Royal French Academy, mid-nineteenth century

artists such as Courbet and Manet were the first to openly challenge the "status quo."

balance The visual balancing of *colors*, shapes, or masses to create a sense of equilibrium.

baldacchino A canopy on columns frequently built over an altar.

balloon framing A lightweight wooden frame of milled lumber nailed together to support the walls, floors, and roof of a building. Developed during the nineteenth century and still used today.

baptistery A building used for baptism in the Christian church, usually circular or polygonal in shape. The baptistery in Florence, Italy, is a famous example.

Baroque A style of art in Europe originating in the seventeenth century known for its dramatic light and shade, violent composition, and exaggerated emotion. Caravaggio was a Baroque painter.

barrel vault A roof over a square or rectangular area consisting of a continuous round arch of stone or brick that spans the space between the walls. Widely used in Romanesque churches.

base In architecture, the lowest part of a *column*. Made of stone in ancient temples, it protected the wood from the moist ground.

basilica A rectangular Roman assembly hall containing rows of *columns* that divided it into aisles, usually with a raised platform and semicircular area at one end. Early Christian churches were based on the basilica.

bas relevé See *relief sculpture*.

batik A method of producing a design or image on cloth. Wax is painted on the cloth, and the material is immersed in dye. When the wax is removed, the areas that had been covered by it retain the original color of the material.

battered Sloped, as in *battered* walls.

Bauhaus School of Design Founded in Germany by Walter Gropius, fostering learning by working with professional artisans, painters, designers, and architects (1919–1933).

bay A subdivision of interior space.

bearing wall The wall that supports a superstructure, such as a roof or an *entablature*.

beehive tomb A beehive-shaped type of underground tomb, constructed as a *corbelled vault*.

binder The material used in paint that causes *pigment* to adhere to the surface.

bisque Ceramics that have been fired at a low temperature, prior to *glazing*.

Boddhisattva In Buddhism, a being who is a potential *Buddha*.

bon à tirer The first print *pulled* that suits the artist for use as the standard for the rest of the *edition*.

bottega The Renaissance studio shop of an Italian artist or craftsperson.

broken-color Application of pure tube colors onto a painting surface, intending the eye to mix the colors. See *Impressionism*.

Buddha Supreme enlightened being of Buddhism, an embodiment of divine wisdom and virtue.

buon fresco See *fresco*.

burin A pointed steel tool for engraving or incising.

buttress A solid *masonry* support, usually square, built against a wall to counteract the outward thrust of the wall and roof. Used extensively in *Romanesque* and *Gothic* churches. See *flying buttress*.

Byzantine art Styles of painting, *design*, and *architecture* evolving from Byzantium, now Istanbul, involving round arches, massive *domes*, *mosaics*, stylized elongated figures, and rich use of color, especially gold.

cage construction Self-supporting steel frame used for skyscrapers and other many-storied structures. A system used by pioneer architect Louis Sullivan. See *steel cage*.

calligraphy The art of writing, or controlled, flowing *line* used in a decorative manner. Oriental characters that are written with a brush.

camera obscura A device developed during the *Renaissance* to project an image through a small hole onto a surface from which it could be traced. Forerunner of the modern camera.

campanile A bell tower, usually free-standing.

cancellation proof The proof of a *print* that is *pulled* after the block has been intentionally defaced by the artist, to verify the end of the *edition*.

cantilever A structural method in which beams or sections of a structure project beyond their support and are held in place by weight on the attached end.

capital The top part of a *column*, usually wider than the upright section, often carved. Different civilizations used a variety of decoration on capitals. See also *Greek orders*.

Carolingian style The era of Charlemagne, eighth to tenth centuries. Devoted to restoration of Classical culture.

cartoon A drawing that is used as a guide for a major artwork, usually drawn the same size as the finished work. Also a humorous or satirical drawing.

carving Subtractive, sculptural method in which the image is formed by removing material from a block, using sharpened tools.

caryatids Whole female sculptured figures supporting the roof of a building. The most famous are in the porch of the Erechtheum in Athens.

casting The process of pouring a liquid material into a *mold*, causing it to take the shape of the mold when it hardens. Used for metals, clay, and synthetic materials.

catacombs A series of subterranean tunnels used for burial. Those in and around Rome were used by the early Christians for worship; they contain many paintings.

cella The main room in an ancient Greek temple, containing the ritual image of a god or goddess.

centering The method of supporting an arch in construction. Once the *keystone* is in place and the arch becomes self-supporting, the centering is removed.

ceramics Any object (sculpture, pottery, or tiles) formed of clay, then, built up by hand, formed on a *potter's wheel*, or in *molds*, and hardened by baking.

chalk An ancient material found in prehistoric cave paintings, chalk occurs in natural deposits of richly pigmented earths, providing black, iron oxides, reds, ochres, dull yellows, brown, and, with talc, white. Used as found, or ground into fine powders, mixed with adhesives and shaped into round or rectangular sticks.

champlevé A style of *enamel* decoration in which areas to contain colors are dug away and bounded by ridges.

charcoal A drawing material made from charred wood. Used since prehistoric times for drawing on a variety of surfaces.

chasing A technique for decorating metal by engraving or gouging it.

chiaroscuro (kee-a-roh-skoo-roh) An Italian word meaning "light and dark." In painting and drawing, the use of gradations of light and dark areas to create the illusion of light and shade.

chine collé Printmaker's technique that includes collage elements upon which the etching is printed.

chinoiserie Chinese motifs used as decoration for furnishing, mainly during eighteenth-century Rococo.

choir That part of the church separated from the *nave* and altar, often designated for the singers and/or musicians during a religious service.

cinematography The art of expressing emotion or communicating meaning through moving images made with a motion-picture camera.

cinquecento The 1500s (sixteenth century) of Italian art.

cire perdue See *lost wax* process.

classic From the Latin, the highest class of Roman citizen; first rank, a work, period, or system of the highest order, the standard of excellence.

Classical In general, the art of ancient Greece and Rome. In particular, the art of Greece of the fifth century B.C. It can also mean any art that is based on a carefully organized arrangement of parts, with special emphasis on balance and proportion. See *Neoclassicism*.

clerestory That part of a building that rises clear of adjoining roofs, and whose walls contain windows to light the central area below.

cloisonné An enameling technique in which color or design areas are separated by wire strands fused to the metal base.

cloister A court, usually with covered walks.

close-up Camera shot of subject at close range (C.U.), framed tightly; (E.C.U.) extreme close-up; (M.C.U.) medium close-up.

coffer A sunken panel in a ceiling, often ornamented.

collage Generally two-dimensional works made of pasted paper pieces, cloth, or other materials.

collography A method of printing from a flat surface onto which a variety of materials has been attached. When damp paper is pressed against the surface, a print with indented areas is produced.

colonnade A row of columns that supports a beam, or *entablature*.

color What we perceive when our eyes sense the waves of visible light reflected from a surface. As the light hits the object, certain colored rays are absorbed, while others are reflected. Our eyes see the hue of these reflected waves as red, yellow, or blue. Color is also formed by coating a surface with a *pigment* that reflects certain rays. See also *spectrum, hue, value,* and *intensity*.

Color-Field painting A style of painting of the 1960s and 1970s using large areas, or fields, of color to surround the viewer with a visual experience of color, such as in the work of Frankenthaler or Rothko.

color wheel An arrangement of the *hues* of the *spectrum*, usually twelve. They are placed in a circular pattern, with *complementary colors*, such as yellow and violet, opposite each other.

column An upright, usually cylindrical, support for a roof or upper portion of a building. In *Classical* architecture it was made up of a *base*, a *shaft*, and a *capital*, and generally was made of stone. Today a column may be made of wood-reinforced concrete or metal.

combine art A combination of media, usually painting and diverse objects, such as the doorway in *Rodeo Palace* by Robert Rauschenberg. See also *assemblage*.

complementary colors The *hues* that appear opposite each other on the *color wheel*, such as orange and blue, red and green, yellow and violet. When mixed in equal amounts, these hues form neutral grays or browns.

composition The ordered grouping of *line, color, shape,* or *mass* in the visual arts. Composition implies an effort on the part of the artist to organize the parts into a whole, whether the result appears carefully organized or free and spontaneous.

computer graphics *Images* produced with computer assistance.

Concept (Conceptual) Art Art or an event conceived in the mind of the artist, sometimes produced in visible form, but often merely presented as a concept.

Constructivism An art movement, overlapping *Cubism* and *De Stijl*, based on the use of nonobjective, often technological, shapes and new materials. In sculpture the artwork was constructed rather than being cast or modeled. Naum Gabo and Antoine Pevsner were the best known of the constructivist group.

content The theme, meaning, or story of a work of art communicated by its form.

contextualism Understanding art through its relationship with the rest of the cultural life that surrounds it.

contour The edge of a form or group of forms in painting or sculpture.

contrapposto Italian for "counterpoise," the counter position of the upper and lower parts of the body, as when the weight is unevenly distributed in an active pose. The hips and shoulders are counterbalanced in nonparallel directions.

corbelled arch A method of spanning an opening by placing each stone or brick so that it projects slightly beyond the one below it.

Corinthian One of the Greek orders of temple architecture, which used slender columns topped by elaborate *capitals* decorated with carved leaves. Copied extensively in Roman and *Renaissance* times.

cornice The horizontal section crowning a *façade* or a roof.

crayon Waxy stick of white or colored chalk impregnated with a *binder*.

cross-hatching A system of lines drawn in close parallel order, crossed at an angle by other lines, which produce changes in tonality. Shading or volumes so indicated can be reproduced as *line art*, or a *linecut*.

cross vault See *groined vault*.

crossing The point of intersection where one passage crosses another, as when the *transept* crosses the *nave* of a church.

crypt A vaulted space, in *medieval* churches under the floor of an *apse*.

Cubism A style of painting developed by Picasso and Braque, who built up *still lifes* and figures with cubelike shapes. From 1907 to 1911, Analytical Cubism presented multiple views, neutral colors in flattened, ambiguous space. Joined by other artists, by 1912 Synthetic (collaged) Cubism appeared with fewer forms, interwoven surfaces, richer colors, and textures.

cuneiform A form of writing with wedge-shaped characters carved in stone or pressed into clay tablets. Used in ancient Assyria, Babylonia, and Persia.

curtain wall A non-load-bearing wall, also called a *screen* or *skin* wall.

cut-away Exterior view with one or more outside section(s) removed to expose internal structure.

Dada World War I anti-art movement, introduced by Duchamp, Ray, and others, ridiculing contemporary culture and conventional art. Many of its adherents later became *Surrealist* artists.

daguerreotype An early photograph in which the photographic image is fixed on a base (plate) of metal.

deconstructivism Arising from Russian *Constructivism*, an architectural style that does not necessarily accept conventional form and space; exists primarily in models and plans.

decorative arts See *functional art*.

design The organization, structure, or *composition* of a work of art or object of use. Commercial or *industrial design* refers to the activity of planning and designing objects for factory production and commercial or individual use; *graphic design* applies to design for printing. Also used to describe the decoration applied to objects.

De Stijl From the Dutch "The Style"; an art movement introduced

by Mondrian and van Doesburg in Holland during World War I, using nonobjective geometric shapes.

diptych A double-paneled altarpiece.

direct-metal sculpture Art constructed in metal, as contrasted with sculpture cast in metal or modeled in stone.

direct painting A painting method in which undiluted paint is applied directly to the canvas instead of being built up in layers of transparent *glazes*.

direct process In sculpture, the creation of the final work by removing wood or stone from the original block. See also *subtractive process*.

dissolve Cinematographic and television transition that permits one scene to be gradually replaced by another.

Divisionism See *Pointillism*.

dolmen An upright boulder.

dome A hemispherical roof supported on *columns* or walls. The Pantheon in Rome and the Church of Santa Sophia in Constantinople are famous domes.

Doric The oldest Greek order of temple building, in which the column has no *base*, is heavy, and is topped with a simple flat *capital*. The Parthenon in Athens is the best-known Doric temple.

drypoint A type of *printmaking* in which a sharp needle is used to cut a groove into the metal plate. The rough edge of the groove catches the ink, giving the printed line a soft edge.

dugento (duecento) The 1200s (thirteenth century) of Italian art.

earth colors Paint *colors* derived from colored earth. Usually browns, reds, and yellows.

earthenware A type of rough *ceramic*, used for pottery and some sculpture, fired at a low temperature.

earthwork Sculpture involving the moving of earth in large amounts to shape it into an image or *composition*.

easel painting Any painting that is small enough to be painted on an artist's easel, as opposed to a large wall painting.

echinus In architecture, the convex element of a *capital* directly below the *abacus*.

eclectic A style of art in which parts of a work echo earlier styles that are combined into a new whole.

edition In *printmaking*, the number of prints taken from one block or plate, usually numbered consecutively.

elevation In drawing and architecture, a geometric projection of a building on a plane perpendicular to the horizon: a vertical projection.

embossing See *repoussé*.

emulsion A suspension, usually in a viscous vehicle—such as photographic silver salts in gelatin—coating plates, films, and so on.

enamel The method of applying ground glass to metal, fusing it with heat into a shiny, colored surface.

encaustic A method of painting with *pigments* in hot wax. Used by the Romans for funeral portraits in Fayum, Egypt, in the second century A.D.

engaged column A column-like form, projecting from a wall and articulating it visually.

engraving The process of making grooves in a material either to decorate it or to create an image from which prints can be made. Also the *print* that is made by pressing paper onto an inked wood or metal engraving.

entablature In *Classical* architecture, the horizontal section between the *columns* and the roof.

entasis In Greek architecture, the slight swelling of a column *shaft* to counteract the optical illusion that makes a series of vertical columns appear to curve inward.

Environmental Art Art that forms or represents a total visual environment, usually large, and frequently combining light and sound with paint, sculpture, and often landscape.

ergometrics The engineering of consumer products for home, office, public facility, or aeronautical space to ensure a good fit between a human's measurements and his/her environment.

etching An *intaglio* printmaking process. An *image* (or area) applied to a metal plate that has been coated with a resist, thus removing the resist from those sections, allowing them to be exposed to acid. The resultant grooves can be inked and printed. The finished print is also called an *etching*.

Experiential Art Works that require audience participation.

Expressionism A style of art that developed at the beginning of the twentieth century, dominated by German artists and emphasizing an artist's expression of personal emotion. Also applied to art of any period that is particularly concerned with the expression of group or individual emotion.

façade The front exterior of a building, usually containing the main entrance.

fade in, fade out Cinematographic and television procedure that defines the beginning and end of a screen event by gradually illuminating the scene from empty black screen up to full image and then back down to black screen.

fantasy Art that is irrational, mystic, or "make-believe."

Fauvism A style of painting in the early twentieth century characterized by the use of large areas of brilliant, strong color, often with violent, distorted shapes. The name comes from the French word for "wild beasts." Henri Matisse and Georges Rouault were well-known Fauvist painters.

ferroconcrete A building material consisting of concrete with metal rods or mesh embedded in it. Also known as *reinforced concrete*.

fetish A power figure believed to have magical powers.

Field painting See *Color-Field painting*.

fin de siècle Characteristic of the ideas and customs of the last years of the nineteenth century.

fine arts Arts whose primary concern is *aesthetic*.

fisheye lens A lens used in photography to achieve a distorted image in which the central portion of a circular image is magnified.

flamboyant Flame-like, as applied to aspects of Late Gothic Style, especially architectural tracery.

fluting Grooving, as in the shaft of a *column*.

flying buttress A *masonry* arch, or segment of an arch, used on *Gothic* churches to counteract the outward thrust of the *vault* of the *nave* by carrying the force to a vertical support away from the building, down to the ground.

focus A point of convergence or center of attention. In photography, the degree of sharpness of an image.

folk art Ethnic art perpetuated by artists (frequently untrained) who are steeped in that tradition, such as Ukrainian egg-painting, or Amish decorative motifs.

foreshortening A method of representing an object on a two-dimensional surface so that it appears to be projecting toward the viewer. Developed by *Renaissance* painters.

form In two-dimensional art, any defined area on a picture surface, flat or creating the illusion of solid, three-dimensional mass. In three-dimensional art, any solid part of the composition, or the overall shape of the composition.

formalism Art prescribed by rules of color, design, or other specific intent.

forum In the Roman world, the marketplace or public place of a city, the center of judicial business.

frame construction *Cage construction* in which all parts of a design support one another, as in a *skeleton* or *balloon frame*.

fresco A painting technique in which *pigments* are brushed onto wet plaster, drying to become part of the surface of the wall. Also called *buon fresco*.

fresco secco Fresco painting in which *pigments* mixed with a *binder* are applied to dried plaster. The result is less durable and brilliant than *buon fresco*.

frieze In *Classical* art, that portion of the *entablature* between the *architrave* and the *cornice*, usually decorated. Any horizontal area of decoration.

frottage From the French, rubbing techniques transferring a relief image to paper.

full round Sculpture in full and completely rounded form (not in *relief*).

functional art Any art that fills a utilitarian need and is aesthetically satisfying. Often called *decorative* and *minor arts*.

Futurism A style of painting and sculpture in the early twentieth century that represented and interpreted modern machines, particularly those that moved. An attempt to represent movement and speed with nonmoving materials.

gable See *pediment*.

Gabun East central African art tradition.

gallery The second story of an *ambulatory* or *aisle*.

gargoyle In architecture, a waterspout (usually carved), often in the form of a grotesque animal.

gates Vents or channels allowing air to escape in metal casting.

genre art The casual representation of everyday life and surroundings.

geodesic A structural system based on tetrahedrons; developed by Buckminster Fuller as an alternative to, and improvement on, cube structure. Used to create *domes*.

gesso A mixture of glue and *chalk* painted on panels or canvas as a base for *tempera* and other paints. It may be pure white or tinted.

gigaku Comic, often vulgar, larger-than-life Japanese masks used for religious and secular festivals.

glaze In painting, a thin, transparent coat of pigment. Traditionally used in *oil painting* since the 1500s; now possible with synthetic paints. In *ceramics*, a mixture of minerals painted onto clay that fuses into a glasslike substance when fired in a kiln.

Golden Section (Golden Mean) A ratio for determining pleasing proportions in art; the size of the smaller part relates to the size of the larger part as the larger part relates to the whole (a:b = b:a + b). Introduced by the Greeks, it was employed by *Renaissance* and later artists.

Gothic A style of architecture that spread throughout most of Europe between the twelfth and sixteenth centuries. Characterized by an interlocking system of stone *arches, vaults,* and *buttresses* that carried the weight and thrust of the building, enabling buildings to reach great heights. Gothic cathedrals were constructed by communal efforts and expressed the religious faith of the time.

gouache (goo-ahsh) Painting medium in which watercolor *pigments* are made opaque by binding with gum or glue, and white opaque in contrast to pure *watercolor* paint, which is transparent.

graffiti Decoration produced by fine lines over a surface. Also, painted or drawn markings illegally applied to surfaces of public places. See also *sgraffito*.

graphic Descriptive of art involving line or flat tones. "Graphic design" usually refers to the arrangement of printed advertising, packaging, and editorial art.

graver A cutting tool used by engravers and sculptors.

gravure A form of commercial printing from an *etched* plate. The ink is transferred to the paper from the depressed areas of the plate, as opposed to *letterpress* printing, in which the raised areas of a plate transfer the ink to the paper.

Greek cross A cross in which all four arms are the same length.

Greek orders Three types of architectural structures developed by the Greeks: the Doric, Ionic, and Corinthian. Although the orders varied in proportion and decoration, they all consisted of a vertical *column, capitals,* and a horizontal *entablature* between the columns and the roof. Copied and changed by later architects, they have been used in various forms throughout Western *architecture*. See *Doric, Ionic,* and *Corinthian*.

greenware Clay objects that have been air dried and are ready for the first, low-temperature firing in a *kiln*.

grisaille A monochrome painting done mainly in neutral grays to simulate stone sculpture.

groin(ed) vault A structural method of roofing a square area. Two *barrel vaults* of the same dimensions intersect at right angles, producing edges called "groins." Introduced by the Romans and used by *Romanesque* church builders.

ground A preliminary base applied to a support in preparation for drawing or painting. *Gesso* is the usual prime coat. Also the preliminary coating—a waxy, acid-resistant substance—applied to a plate before *etching*.

halftone A metal plate used for reproducing illustrations in commercial printing. The image is photographed through a grid that breaks down the areas of tone into various-sized dots. The plate is *etched*, leaving the dots raised. When inked and run through a press, the plate transfers the *image* to paper with all the gradations of tone of the original image. Also refers to a reproduction printed from such a plate.

halo From the circular light (aureola) around the sun or moon; an aura sometimes shown behind the head of religious or chivalric figures.

Haniwa Pre-Buddhist Japanese period known for sculpture made of tubular, or ribbonlike, or slabs of clay.

happening An event, generally unrehearsed and without predetermined script, produced by artists. It may include light, sound, props, and costumes and may involve audience participation.

Hard-Edge painting A mid-twentieth-century art style depicting sharp-edged geometric form, precisely rendered.

Harlem Renaissance Black movement involving jazz, literature, and art which flourished in Harlem in New York City around 1930, and featured the black cultural heritage.

hatching A technique used in drawing, engraving, etc., in which almost parallel lines are drawn closer or further apart to achieve an effect of shading from dark to light.

haunch The part of an *arch* between the *springing* and the crown at which the lateral thrust is strongest.

haute couture Unique or limited editions of highly styled fashions designed for the trend-setters of society.

Hellenistic In Greek art, the style of the third and second century B.C. known for its exaggerated emotion, movement, and pose.

Hiberno-Saxon style Medieval style in which profuse geometric and animal forms are decoratively interlaced.

hieroglyphic System of writing using non-phonetic symbols or pictures, such as Egyptian written communication.

high key Subject consisting primarily of pale or light *values*.

highlight The lightest area of an artwork. Usually refers to the spot where the brightest light is reflected from an object or figure.

holography The production of images using laser beams to record on a photographic plate a diffraction pattern from which a three-dimensional image can be seen or projected.

horizon line In *linear perspective*, the imaginary level toward which all the parallel lines receding into the picture seem to converge. Along the horizon line there may be several *vanishing points*.

horror vacui Fear of empty space; crowded design.

Hudson River School Romantic art movement initiated by Thomas Cole and others that concentrated its theme on regional landscape painting, often in the Hudson River area north of New York City.

hue An identifiable color on the *color wheel* or *spectrum*. Also, the element of a particular color that separates it from others.

humanities Branches of culture, especially the classics, as contrasted with science or religion.

icon An *image* of symbolic significance, often sacred.

iconography Visual *images*, conventions, and *symbols* used by a culture or religion.

idealization The representation in art of objects or figures in a simplified, perfected style, particularly characteristic of Greek sculpture of the fifth century.

illuminated manuscript Any decorated manuscript, particularly those of the *medieval* period, in which religious scenes, daily life, animals, flowers, and humans were favorite subjects.

illusionistic An art style that recreates a convincing reality.

image A visual representation of an object, figure, or event in painting, sculpture, photography, or any visual art.

impasto Thickly applied paint.

impost Top section of a wall, serving as support for an *arch*.

Impressionism A style of painting developed in France in the last half of the nineteenth century that tried to capture the quality of light as it plays across landscapes and figures. Its followers used small strokes of contrasting color placed next to each other to create the illusion of vibrating light.

incising Cutting into a surface with a sharp instrument, especially on metal and pottery.

industrial design See *design*.

inlay Any material set into another material, particularly wood or metal set into the surface of an object to decorate it.

in situ In place, in original position.

installation Originating in the 1970s, an art style encompassing a total environment; often involving a wide range of media.

intaglio A printmaking technique in which lines and areas to be printed are recessed below the plate surface. See *etching*.

intensity The degree of purity or brilliance of a *hue*. Also called *saturation*.

International Style Geometric architectural style, developed in Europe between 1910 and 1925 and relating to *De Stijl*; structural system emphasizing massive horizontals, based on functional design, devoid of ornament.

investiture The outer, fire-resistant *mold* used in the process of metal casting in sculpture.

Ionic One of the Greek styles of temple architecture; characterized by slender, fluted column shafts and capitals decorated with carved spiral shapes.

isometric perspective Drawing system that depicts three-dimensional volumes on a flat surface without converging lines or vanishing points; used in Eastern art as well as in mechanical shop drawings.

justify Spacing a line of type exactly the intended length.

keystone The central wedge-shaped stone in an *arch*, the last one to be put in place. When the keystone is inserted, the temporary supports holding up the arch may be removed, and the pressure of the wedge-shaped stones against each other will hold the arch in place.

kiln An oven in which clay objects are baked to harden them. Simple outdoor kilns are fired with wood, while complex gas and electric kilns are capable of reaching extremely high temperatures under closely controlled conditions. Some large and complex Japanese kilns have traditionally been fired with wood.

kinetic Art that incorporates movement, usually motor-driven, but occasionally powered by air currents or even human muscles.

kiva A ceremonial Native American Indian, mainly subterranean.

koomote One of the earliest Japanese *Nō (Noh)* masks, representing the standard of female beauty.

kore Greek for "maiden." An archaic sculpture of a standing female, usually clothed.

kouros Greek for "youth." An archaic sculpture of a standing nude male.

krater (crater) Greek wide-mouthed bowl for mixing wine and water.

kylex (cylix) Greek drinking cup, shallow and having two handles and a stem.

lacquer A clear, hard-finish resin used to coat wood or metal. May also be mixed with *pigment* to give brilliant colors. Oriental artists used coats of lacquer over wood in furniture and sculpture as well as iron dishes.

laid paper Distinctly patterned paper made on a mold composed of intersecting wires of different weight. See also *wove paper*.

lantern In *architecture*, a small, often decorative structure, with openings to admit light, that crowns a *dome* or roof.

Latin cross A cross in which the vertical member is longer than the horizontal member.

lens The part of the camera that gathers and concentrates the light to produce an inverted image on light-sensitive film.

letterpress A method of *printing* in which the ink is transferred to the paper from raised type or from a raised image etched on a plate, as opposed to *gravure*, which uses grooves to hold and transfer the ink.

line A mark made by a moving point, pencil, brush, or pen. Also, the edge between two forms, or the silhouette edge of a form.

line art *Images* created by lines or dots.

linear perspective A method of determining or representing the size of objects as they recede in space. Imaginary parallel lines drawn at right angles to the viewer appear to converge at a *vanishing point* on the *horizon line*. Widely used by painters during and after the *Renaissance* to create the illusion of space on a two-dimensional surface. Eastern art and much contemporary art may not be concerned with linear perspective. See *isometric perspective*.

linecut In printing, a metal plate used to reproduce images that consist only of lines or flat areas such as drawings, woodcuts, or architectural plans.

lino (linoleum) cut Relief printmaking technique in which a linoleum block is carved to leave raised image areas that may be easily inked like a rubber stamp.

Linotype A machine that casts type for printing in the form of slugs of one-piece lines, already spaced for printing.

lintel A structure member that spans a rectangular opening between two posts, *columns*, or walls.

lithography A method of *printmaking* based on the antipathy of grease toward water. The image is drawn with a greasy crayon on a grainy plate or stone, which then is chemically treated so that it will accept the printing ink only where the crayon has been used. The image is transferred under pressure from the stone to damp paper.

local color The natural color of the subject of an *image*.

logo (logotype) A design of two or more letters symbolizing a product, company, or an institution.

long shot (L.S.) *Camera* shot of distant subject, framed loosely; extreme long shot (E.L.S.) if very distant.

loom A device for producing cloth by interweaving weft and warp fibers. See *weft* and *warp*.

lost wax A method of *casting* in which wax is used to form the sculpture. Heat-resistant material is built up around the wax to form a *mold*. When this mold is baked, the wax runs out, leaving a hollow space that may be filled with molten metal to reproduce the original. Also called *cire perdue*.

low key Subject consisting primarily of dark values, as occurs in a night scene.

macramé A fiber technique, achieving form by knotting strands into patterns.

Magic Realism See *Photo Realism*.

magnetometry Technology that aids archaeologists in determining the extent of buried art or artifacts prior to possible excavation of an area, based upon the magnetic response to subterranean areas.

Mannerist A style of art in Western Europe in the sixteenth century that rejected the classic balance and moderation of *Renaissance* art and was characterized by exaggerated, distorted, and highly emotional images.

marquetry Complex designs of contrasting woods in furniture and floors. See also *parquetry*.

masonry Stone or brickwork used in building.

mass A three-dimensional form that has actual physical bulk. Also, the illusion of weight and bulk created on a two-dimensional surface.

mastaba Arabic term for "bench"; applied to earliest Egyptian burial monuments, from which the design of the great pyramids evolved.

matte (mat) In painting, pottery, photography, and other arts, dull finish.

mausoleum A large and elaborate tomb, usually for a person of great importance.

mechanical A pasted-down assembly of the parts of an advertisement or other pieces of graphic art (camera ready) for photographing to make a printing plate.

medieval Characteristic of the Middle Ages in Europe, between the fourth and late fifteenth centuries A.D.

medium The material, method, or techniques used by an artist to create a work of art. Also, the material used to dilute paint, such as water or turpentine.

medium shot The medium-range equivalent of a cinematographic *long shot*.

megalith A huge stone.

menhir A single large stone, usually set with others in formation.

Mesoamerica *Pre-Columbian* cultural region of Middle America, south of northern border of Mexico through Central America.

metope Square slab, often decorated with carving, alternating with triglyphs in a Doric *frieze*.

mezzotint A variant of *etching* and *engraving* in which large areas of the *image* are roughened to produce flat tones.

mihrab In the wall of a *mosque*, the niche that indicates the direction of Mecca.

minaret A tower outside a *mosque* from which Moslems are called to prayer.

Minimal Art Painting and sculpture of the simplest contours, surfaces, and colors. The precision of machining may dominate. *Primary*, ABC, *Systemic*, or *Minimal* sculptures are largely comprised of depersonalized geometric forms.

mixed media The use of several different materials, methods, or techniques in one work of art.

mobile A sculptural construction incorporating motion. The parts of the construction are moved by currents of air or by motors. See also *stabile*.

modeling In painting or drawing, the apparent shaping of a three-dimensional form by means of the gradations of light and shade reflected from its surface.

Modernism Early twentieth-century American movement that rejected traditional art values in favor of radical new European styles.

module A unit that is standard in size and can be fitted into another, similar unit to form a larger composition. Used in building and in furniture.

mold The hollow form or cavity in which a liquid or pliable material is shaped or cast to create sculpture, jewelry, or *ceramics*. Also, the sieve through which the mash of fibers is poured in papermaking.

monochromatic A color scheme that uses only one hue in varying degrees of light and dark.

monotype A printmaking method in which only one impression is made.

montage An arrangement of pictures, or parts of pictures, previously drawn, painted, or photographed. In *cinematography*, the splicing of several segments of film to expand or dramatize a single event.

Moorish Style of the Moors derived from Morocco, North Africa that was expanded to Spain after the seventh century A.D. Moslem invasion.

mosaic A surface decoration made of small pieces of glass, tile, or stone set in plaster or mortar. Used widely throughout history for decorative floors and as wall decoration.

mosque A Moslem religious building, usually incorporating towers, pools, and fountains, as well as a central hall.

motif A decorative element of a composition.

MTV Music Television

mural A wall painting, usually large, which may be painted with any kind of paint. Often confused with *fresco*, which refers only to a painting done on a wet plaster ground.

narthex Porch or vestibule of a church, generally *colonnaded* or *arcaded* and preceding the *nave*.

nave The central hall of a church. In *Gothic* cathedrals, the nave was much higher than the side *aisles*. Amiens cathedral has a well-known example of a Gothic nave.

negative space The background in a work of art; the space surrounding the main defined areas or *shapes*.

Neoclassical A style of art in the eighteenth century that revived much of the approach of *Classical* art of Greece and Rome in painting, sculpture, and *architecture*. Many government buildings in Washington, such as the Lincoln Memorial, are Neoclassical.

Neo-Expressionism Post-World War II art style that originated in Germany, Italy, and the U.S.; distorted natural *form*, space, *color*, and conventional media. Emotionally related to early German *Expressionism*; Kiefer was a pioneer of the art style.

New Image Art First introduced in 1978 in an exhibit at the Whitney Museum of American Art, New York, entitled New Image Painting, varied untraditional works of emerging artists who were rooted in *Conceptual* and *Performance Art*, also demonstrated *Postmodern* simplification and produced through a system each defined.

New York School Artists in the New York area who shared a common center of artistic concern during the 1940s and 1950s.

niche A recess in a wall, usually containing a piece of sculpture.

Nō (Noh) Japanese religious and secular presentations that began in medieval times.

nonobjectivism A style of art in which no object is represented. Originating in the early twentieth century, the art force continues today. Piet Mondrian, Jackson Pollock, and Ad Reinhardt represent different types of nonobjective painters.

nonrepresentational art See *nonobjectivism*.

obelisk A tall, four-sided monument, sometimes covered with carved inscriptions.

objet d'art Object of aesthetic art; that is, a figurine, vase, etc.

oculus Round central opening (eye) in a dome such as the Pantheon.

oeuvre (ur-vra) The whole of an artist's output, the artist's work.

offset A method of printing in *lithography*. The image is transferred from a printing plate curved around a roller to another roller and then offset to paper. The printing plate is usually made by a photographic-chemical process.

oil painting A method of painting developed in the *Renaissance* in which *pigment* is combined with one of a number of oil mixtures. Applied to a surface, it dries to form a continuous film. Oil paint is still widely used today.

one-point perspective Viewed from directly in front of a subject. Only one *vanishing point* is apparent.

Optical art Also called *Op art*. A style of art in the late 1960s and 1970s characterized by flat shapes of contrasting *colors* or *values*, placed next to each other to cause the illusion of vibrations in the eye.

order See *Greek orders*.

Organic Architecture Building system developed by Frank Lloyd Wright, which satisfies in design the needs of the occupants in relationship to the site. Such constructions "grow" like living organisms.

Orphism (Orphic Cubism) Pioneered by Robert and Sonia (Terk) Delaunay, the art style recreated fractured light rays, combining aspects of *Pointillism* and *Cubism*.

pagoda Buddhist tower with many winged eaves, derived from Indian stupas and Chinese watch towers.

painterly Painting style dependent on *shapes* and *color* areas rather than *contours*, outlines, or edges.

palette A range of *colors*; the surface on which an artist mixes paint.

palette knife Knife with a small, flexible, wedge-shaped blade, used to mix colors on the *palette*; sometimes used to apply paint to an art work.

panning Moving the cinematographic camera horizontally to capture sequential views. See also *tilting*.

papyrus Plant native to Egypt used to make a paper-like writing surface.

parquetry Geometric designs of contrasting woods in furniture and floors. See also *marquetry*.

pastels Sticks of pure *pigment* with a minimum of gum *binder*. A favorite *medium* of the *Impressionists*, because of its freshness and brilliance.

paste-up See *mechanical*.

patina The finish applied to a metal sculpture. Also the finish applied to wood sculpture and furniture.

Pattern and Decoration (P&D) 1970s formalist style of painting, produced by systematically repeating pictorial motifs. Works thus formed from decorative designs, materials, and techniques that were once related only to the crafts, *folk art*, and "women's work" achieve a new significance.

pediment The triangular space forming a gable of a double-pitched roof.

pendentive A triangular construction serving to transfer weight from a *dome* to a *pier*.

Performance Art Dramatic production of some aspect of the making of visual art by an artist before an audience; may also include music or recitation, often exploring a social theme such as in the works presented by Laurie Anderson.

perspective See *linear perspective* and *atmospheric perspective*.

photogram A photographic technique in which an object is placed on light-sensitive material and exposed.

photo montage Composite image made by assembling parts of two or more photographs.

Photo Realism An art style of the mid-twentieth century in which objects or people are depicted with hyper-photographic precision that invites comparison and contrast with reality.

pictograph Picture, usually stylized, that represents an idea.

picture plane Flat picture surface of an artwork, usually associated with the foreground.

pier A heavy *masonry* support, usually square.

Pietà Work of art depicting the Virgin Mary mourning over the body of Christ.

pigment A dry coloring material, made from a variety of organic or chemical substances, which is mixed with some form of liquid and a binding material to form paint, ink, *crayons*, or *pastels*.

pilaster A decorative, usually flat, non-weight-bearing *column* attached to a wall.

pile weave A form of *weaving* in which loops are left on the surface and are cut to form a soft texture. Often used in rugs and velvets.

pillar Weight-bearing member.

pilotis Exposed weight-bearing posts or *columns* supporting multistories above.

pixel Picture element, the building block of computer *images*.

plain weave The simplest form of *weaving*, in which the *weft* passes over one *warp* thread and under the next. Broadcloth and burlap are examples.

plan In *architecture*, a view of the layout of space in a building, drawn as if looking down on it.

plane Any flat or level surface.

plastic Synthetic materials with varying qualities that are used in the *functional arts* as well as in painting and sculpture. Also used as a general term to describe any of the visual arts. Also, any material that has the characteristic of being easily formed or manipulated, such as clay.

Pointillism A technique of applying tiny dots of *color* to painting; especially referring to the work of Georges Seurat.

polymer See *acrylic paint*.

polyptych A multipaneled altar painting usually employing *tempera* on wood.

Pop Art A style of painting and sculpture in the 1950s and 1960s that used popular and commercial *symbols* and *images* as subject matter.

porcelain A form of thin, delicate *ceramic*, created from fine clays and baked at an extremely high temperature. The potters of the Orient have produced porcelain for centuries.

portico Entrance porch with roof supported by *columns*.

post and beam See *post and lintel*.

post and lintel A type of *frame construction* using two upright posts and one horizontal beam to span a space. Also called post and beam.

Post-Impressionists A group of artists active in the late 1800s who painted in varying personal styles that were outgrowths of *Impressionism*. Some, such as van Gogh and Gauguin, were most interested in personal expression, whereas others, such as Cézanne, were more concerned with *composition* and structure.

Postmodernism 1970s and 1980s movement that rejected values of *Modernism*; instead it varied elements of *styles*, subjects and *symbols* of the past.

Postpainterly Abstraction Art *style*, developed in the mid-twentieth century as reaction against *Abstract Expressionism*, in which forms are meticulously depicted and separated; also known as *Hard-Edge painting*. See also *Color-Field painting*.

Poststructuralism See *Postmodernism*.

potsherds (shards) Fragments of broken pottery that settle into geological strata, providing archaeological chronologies.

potter's wheel A circular metal, wood, or stone disk that revolves by foot or motor action on which a potter shapes wet clay into a vessel.

pottery The art of making utensils and vessels of clay. See *ceramics*.

Pre-Columbian art Art produced in North and South America before the European invasions of the sixteenth century.

prehistoric art Art created before written history: the only record of many early cultures. Cave paintings and rock paintings in Europe and Africa, carved implements, and statuettes are examples of prehistoric art.

primary colors The *hues* that can be mixed to produce all other hues. In painting, the primary colors are red, yellow, and blue.

Primary sculpture See *Minimal art*.

print A multiple impression made from a wood block, a *lithographic* stone, or by *etching* a plate, screen, or other type of plate. Usually signed by the artist or under his or her direction.

printer's proofs The sample *prints* that guide the printing of a finished *edition*.

printing A method of producing *images*—verbal or pictorial—by transferring the ink on a master surface to another surface.

printmaking The process of making *prints*, generally done by the artist or under his or her careful supervision. Also called "graphics."

proportion The relationship of one part of a work of art to another and of each part to the whole. See *Golden Section*.

propylaea Greek gateway leading to an open court.

psalter Book containing psalms.

Public Art Sculptural or *architectural* works set into public places to redeem an urban or rural landscape, often brutalized earlier by human disruption of its natural order. Receipt of public funding may require a flexible balance between the art's internal coherence and the immediate surroundings, both human and natural.

pull To remove a *print* from the printing plate.

pylon Monumental *pier*, or entrance to an Egyptian temple.

raku ware Rough, low-fired, dark *glazed* ware.

raising Hammering a flat shape of metal into a hollow vessel.

Rap Sugar Hill Gang's *Rappers' Delight* in 1979 marked the emergence of rap; black underground music, a vibrant amalgam of fast-talking catch phrases and rhymes, spoken over a stripped-down rhythm track.

rayograph See *photogram*.

ready-made *Dada* works that combined several manufactured objects into one construction. A method of working developed by Marcel Duchamp.

realism Mid-nineteenth-century art style, developed by Gustave Courbet in opposition to contrived *Academic art*. Art style depicting subject matter, true to its appearance.

registration In hand or machine color printing, the process of aligning the impressions of multiple colors on a single image.

reinforced concrete See *ferroconcrete*.

relief sculpture Sculpture in which the three-dimensional *forms* are raised from a flat background, as contrasted to free-standing sculpture. The relief may be low, called bas-relevé, or high (haut-relevé), in which the forms are raised far above the background.

reliquary A small box, casket, or sculptural object that contains a religious relic.

Renaissance The period in Europe between the fourteenth and the sixteenth centuries; characterized by a rebirth of interest in *Classical* art and philosophy. A scientific attitude dominated, and art expressed balance, harmony, and the importance of individual humans.

repoussé A process, raising a *relief image*, usually metal, by pushing out areas from the back surface to the front. Also called *embossing*.

representational art Art that reproduces reality with little or no change or distortion.

rhythm Developing from the repetition, either regular or varied, of visual elements, such as *lines*, *shapes*, or *colors*. As in music, visual rhythm is an expressive tool, important in the creation of an aesthetically pleasing work of art. The repeated *pilasters* on the Colosseum in Rome are an example of rhythm in *architecture*, while the figures in Michelangelo's *Creation of Adam* show the use of a more subtle rhythm in painting.

rib vault A *groin* construction that follows the line of the *arches* and joints of the *vault*.

Rococo A style of art, popular during the eighteenth century, in which delicate *colors*, curving *shapes*, and sinuous *lines* created ornate decoration on interior surfaces, silverware, and furnishings. Paintings of the period were elegant and pleasant, reflecting the life of the aristocracy.

Romanesque A style of *architecture* and its art prevalent in Europe between the Roman and *Gothic* periods. Characterized by the round *arch*, heavy walls, and small windows, such as in Sant'Ambrogio.

Romantic movement A style of art lasting from the mid-1700s into the nineteenth century, emphasizing individual emotions expressed in a dramatic manner. Exotic subject matter and scenes of distant places were common. The movement rebelled against the established *Neoclassical* art of the times.

rose or wheel window Large, circular window decorated with tracery that holds stained glass used in *Gothic façades*.

sacra conversazione Holy conversation, a group of holy figures seemingly engaged in conversation.

Salon Government-sponsored exhibition of artworks, held biennially, later annually, in Paris.

sans serif A letter, especially in printing, that has no *serifs*, or cross strokes, at top or bottom.

satin weave Weave in which the *weft* passes over several *warp* threads at a time, producing a lustrous surface.

saturation See *intensity*.

scale The size, or apparent size, of an object relative to other objects, people, or its environment. In architectural drawings, the ratio of the dimensions to the full-size building: for example, "one inch equals one foot."

scriptoria The rooms in *medieval* monasteries where manuscripts were copied and decorated.

secondary colors Three *hues* on the *color wheel* formed by mixing the *primary colors* to produce green, violet, and orange.

serif A fine line or cross stroke at the top or bottom of a letter.

serigraphy See *silkscreen.*

sfumato The hazy blending of light and dark tones in a painting, creating soft and indefinite edges.

sgraffito Decoration produced by scratching a surface of metal or plaster, often revealing a different colored ground.

shade A color that is low on the *value* scale; a dark color.

shaft In *architecture,* the upright portion of a *column,* usually cylindrical.

shape Any area defined by *line, color,* tones, or the edges of *forms.*

shards See *potsherds.*

Shinto Pre-Buddhist cult and religion of Japan consisting of reverence for the imperial ancestors and nature deities. Interwoven with Buddhism until separated by law in 1871.

silkscreen Also called *serigraphy.* A process of *printmaking* in which *stencils* are applied to silk that is firmly stretched across a frame. Paint is forced through the unblocked portions of the screen onto the paper or cloth beneath.

silverpoint A drawing technique in which a fine-pointed silver tool inscribes lines on paper coated with white or tinted *pigment.*

simultaneous contrast The contrast formed when *complementary colors* are placed side by side.

sinopia or sinopie Reddish-brown earth color; also the *cartoon* or underpainting for a *fresco.*

Siva (Shiva) Hindu god of creation and destruction.

skeleton frame See *frame construction.*

slip A creamlike mixture of clay and water, mainly used in *mold casting.*

social realism Art that depicts the life of the working person, primarily in the twentieth century, as shown in paintings, sculptures, graphics, and photography during the Great Depression.

soft sculpture Sculpture made with fabric forms or woven freestanding or hanging shapes. A technique used by *Pop artists* such as Claes Oldenburg.

solarization The reversal of gradations in a photographic image by intense or continued exposure to light.

spectrum A continuous sequence or range of *colors,* from the shortest (red) to the longest (violet) wavelengths.

springing The point at which the curve of an *arch* or a *vault* leaves the upright.

stabile Sculpture of flat (painted) construction, attached to the ground. Technique developed by Alexander Calder. See also *mobile.*

state Each reworking of a printing plate constitutes a new state or stage of development of a particular *print.*

station point The viewer's position from which a subject is perceived and drawn in *linear perspective.*

steel cage Also called steel frame. A structural method in which steel supports, placed in a *post-and-lintel* system, are connected to produce a strong self-supporting framework. Nonsupporting walls, floors, and roof are attached to the frame. Used extensively in contemporary construction. See *cage construction.*

stele A free-standing upright stone or *pillar,* usually bearing an inscription or relief decoration.

stencil An *image* or design cut out of a stiff material. Paint is forced through the holes in the stencil to reproduce the cut image. Used for hand *printing* on cloth, paper, or walls, and in *silkscreen* printing.

still life A painting of ordinary objects such as bottles, flowers, or fruit. Also, the arrangement from which such a painting or drawing is made.

stoneware A type of coarse *ceramics* fired at a low temperature.

storyboard A series of sketches (or photographs) of the key visualization points of an event that also include audio cues of sound, voice, and music, along with video cues of camera actions.

stupa The earliest type of Buddhist religious building, probably derived from the Indian funeral mound. Erected in places made sacred by a visit from the Buddha.

style The characteristic approach an artist takes to his or her theme. Also, those characteristics that identify a period, movement, or society.

subtractive primary colors Cyan (blue), magenta (red), and yellow, colors that produce black when white light is projected through them.

subtractive process Process through which *form* is created by removing, cutting away, or carving out unwanted materials. See also *direct process.*

successive contrast The appearance of a *complementary color* in neutral gray when the gray is placed next to a *primary color.*

Superrealism See *Photo Realism.*

support The surface on which a two-dimensional work is made, such as canvas, paper, or wood.

Suprematism Geometric, *nonrepresentational art* style derived from *Cubism* by Kasimir Malevich in 1913 and defined by him as "the supremacy of pure feeling in creative art."

Surrealism A style of painting that developed in the early twentieth century; based on subject matter from dreams, fantasy, and the subconscious. Its images often appear unrelated and startling. Max Ernst was a Surrealist painter. Many artists incorporate some Surrealist qualities into other styles.

symbol An *image* or sign that stands for something else, or the visible sign of something invisible.

symmetry Aesthetic balance achieved by distributing *forms, shapes, colors, textures,* etc., equally on both sides of a configuration.

Synthetic Cubism See *Cubism.*

Synthetism Gauguin's theory of art that involves broad areas of strident *color* and symbolic or primitive subject matter.

Systemic art Art based on a mathematical system of unit repeats that might be infinitely expanded. See *Minimal art.*

tapestry Tightly woven hangings, carrying patterns and *images.*

tapestry weave A weave in which the *weft* makes patterns only in specific design areas.

taroc (tarot) (tarocchi) From the Italian, an old card game popular in central Europe and North Africa, used for fortune telling in *medieval* times; playing cards decorated pictorially.

tempera A *medium,* binding *pigments* with egg yolk, gum, or casein. Egg tempera is usually applied to wood first coated with a *ground* of gesso.

terra cotta Hard-baked clay.

texture The tactile quality of a surface.

three-point perspective An extension of *linear perspective* in which three different *vanishing points,* widely separated, provide the effect of great depth.

thrust Outward force.

tie dye Process of hand-dyeing fabrics with ties and knots to create resist areas that will not absorb dyes.

tilting Moving the cinematographic camera vertically. See also *panning*.

Ting ware (*Ding* in Pinyin) Delicate creamy white *porcelain* from northern China. The *glaze* is transparent and almost colorless.

tint A light *hue*, or a *color* with a large amount of white mixed in it.

totem A symbolic *image*, often thought to represent blood lineage.

tracery Decorative stone openwork in the head of a *Gothic* window.

Traditionalist Modern Eclectic fusion of traditional and modern architecture, such as in the Chrysler Building in New York in 1930.

transept The space (axis) of a building that crosses another (usually the main axis) at right angles. Generally refers to areas within a church or cathedral.

trecento The 1300s (fourteenth century) of Italian art.

triglyph See *metope*.

trompe l'oeil The illusion of *form*, light, space, and *texture*, contrived so that the observer confuses the *image* for reality.

truss A framework of beams, bars, or rods arranged in triangles. Used to span the space between posts or walls, supporting floors, or roofs. Triangular construction is more rigid than that using only right angles.

tusche A greasy black liquid used to paint *images* on a *lithographic* stone or plate in preparation for *printing*.

twill weave Weave in which *warp* and *weft* yarns are interlaced in broken diagonal patterns, as in gabardine and denim.

two-point perspective *Perspective* viewed when an object is observed from an angle. There are two *vanishing points*.

tympanum A recessed space, arched or triangular, spanning an *arch* or above a *lintel*, often decorated with sculpture.

typography The art of composing printed characters; a variety of typefaces of wood or metal have been designed since early Roman times.

ubiquitous computing Technology that maintains mid-room data banks that automatically and continuously update names of room occupants, and their involvements on the site.

unity The arrangement of a work in which all parts seem interrelated.

vacuum forming A method of shaping sheet *plastic* into sculpture. The plastic is heated and softened, then pulled against a *mold* by a vacuum machine, which causes the plastic to take the shape of the mold as it cools. An industrial technique adapted to art.

value The measure of lightness or darkness of a *color* or of tones.

vanishing point The point on the *horizon line* at which parallel lines appear to converge.

vantage point See *station point*.

vault An arched covering spanning two walls, constructed of a series of continuous *arches*.

vehicle A liquid or emulsion used as a carrier of *pigments* in a paint; used interchangeably with the term *medium*.

verism Art style that includes the displeasing truth as well as the beauty of a subject.

video The visual aspect of the television medium; *videotape*, a prerecorded television presentation.

video synthesizer Panel of controls that regulates and integrates various aspects of sound and visual arts.

vignette Decorative elements that have no definite boundaries or frame.

virtual reality Imaginary world created and manipulated by means of a technology controlled by the artist with a technologically driven helmet and a glove.

visual arts Arts appealing to the optical sense—painting, drawing, *printmaking*, photography, sculpture, *architecture*.

volute Spiral or scroll-like form, as in an *Ionic capital*.

votive statue A statue dedicated to a god or goddess in fulfillment of a vow or promise. Many Greek statues were originally votive statues.

voussoir Wedge-shape block used in construction of a true *arch*.

warp The lengthwise threads in a loom—a machine for *weaving*. See also *weft*.

wash A thin, transparent layer of paint or ink. Wash drawings combine wash and *line*.

watercolor Any paint that uses water as a vehicle. Generally applied to paint formed of *pigments* mixed with a gum *binder* and diluted with water to form a transparent film, as opposed to *gouache*, which is opaque.

weaving The forming of fabrics by interlacing lengthwise threads (the *warp*) with crosswise threads (the *weft*).

weft The crosswise threads in a loom—a machine for *weaving*. Also called *woof* or *filling*. See also *warp*.

wet drapery The technique of modeling a stone-carved sculpture as though the subject were clad in wet fabric.

woodcut A *print* made from an *image* cut into a block of wood. The ink is transferred from the raised surfaces onto the paper.

woof See *weft*.

wove paper Smooth, virtually patternless paper made on a mold composed of fine, smoothly woven wires of even weight.

Xerography Late twentieth-century art medium, utilizing a photocopy technique, in black, white, and color, derived from a process developed by the Xerox Corporation.

yakshi Female earth deity in Hindu and Buddhist pantheon.

zen Buddhist sect emphasizing enlightenment.

ziggurat Mesopotamian mountain dedicated to a god. Brick-surfaced pyramidal-shaped mound of rubble.

BIBLIOGRAPHY AND SUGGESTED READINGS

General References

CUMMINGS, PAUL. *Artists In Their Own Words.* New York: St. Martin's, 1982. An intellectual treat to read about the philosophical base of artists while enjoying their art.

DE LA CROIX, HORST, AND RICHARD G. TANSEY. *Gardner's Art Through the Ages,* 8th ed. New York: Harcourt, Brace Jovonavich, 1986. Updated edition of a timeless text.

ELSEN, ALBERT. *Purposes of Art,* 4th ed. New York: Holt, Rinehart and Winston, 1981. An engaging, personalized viewpoint, introducing art history in terms of the universal themes of the artist.

FLEMING, WILLIAM. *Arts and Ideas.* 8th ed. New York: Holt, Rinehart and Winston, 1991. Broad survey of the contextual base of the visual arts and music.

GOMBRICH, E. H. *The Story of Art,* 15th ed. Englewood Cliffs, N.J.: Prentice-Hall, 1989. Still the favorite introduction to art before mid-twentieth century. Although minimally illustrated, the charm of the text overrides any limitations.

JANSON, H.W. *History of Art.* 4th ed. Englewood Cliffs, N.J.: Prentice-Hall, 1991. Popular, comprehensive text into art history, modernized by son, Anthony Janson.

LEE, SHERMAN. *A History of Far Eastern Art,* 4th ed. Englewood Cliffs, N.J.: Prentice-Hall, 1982. New York: Abrams, 1982. Perennial choice for an introduction to Eastern art; well organized and illustrated.

Introduction: The World of Art

EHRENZWEIG, ANTON. *The Hidden Order of Art.* Berkeley and Los Angeles: University of California Press, 1976. Interesting insights into the creative process and the psychology of the artist.

CANADAY, JOHN. *What Is Art? An Introduction to Painting, Sculpture & Architecture.* New York: Knopf, 1980. Easy to read survey, full of insights.

GOMBRICH, E. H. *Art and Illusion,* 12th ed. London: Phaidon, 1972. Fascinating configurations that illustrate ambiguities in human perception.

HAUSER, ARNOLD. *The Social History of Art.* 4 vols. New York: Vintage, 1957—1958. The definitive sociological approach to art history.

NELSON, GEORGE. *How To See.* Boston, Little, Brown, 1977.

Chapter 1: Creation and Response

BERENSON, BERNARD. *Aesthetics and History in the Visual Arts.* St. Clair Shores, MI: Scholarly Press, 1979.

EDWARDS, BETTY. *Drawing On the Right Side of the Brain.* Los Angeles: Tarcher, 1979. Early, unique approach to creativity.

_____ *Drawing on the Artist Within: A Guide to Innovation. Invention, and Creativity.* New York: Simon and Schuster, 1986. Extended perspectives on the creative process.

FLACK, AUDREY. *Art and Soul: Notes On Creating.* New York: Dutton, 1986. Significant artist shares insights on creativity.

FULLER, BUCKMINSTER. *Ideas and Integrities.* Englewood Cliffs, NJ: Prentice-Hall, 1963. A leading and innovative architect of the last quarter-century shares his philosophy in easy-to-read terms.

LOWENFELD, VIKTOR. *Creative and Mental Growth.* 8th ed. New York: Macmillan, 1987. Classic text introducing art education.

MAY, ROLLO. *The Courage To Create.* New York: W.W. Norton, 1975. Important text.

SAMUELS, MIKE, AND NANCY SAMUELS. *Seeing with the Mind's Eye: The History, Techniques and Uses of Visualization.* New York and Berkeley: Random House, Inc., and The Bookworks, 1975. Contemporary approach to age-old beliefs.

Chapter 2: Exploring the Artist's Language

ALBERS, JOSEF. *Interaction of Color.* New Haven, CT: Yale University Press, 1975. A lifetime of devotion to color experiments discussed by the Bauhaus authority on color.

BEVLIN, MARJORIE ELLIOT. *Design Through Discovery,* 4th ed. New York: Holt, Rinehart and Winston, 1984. Excellent survey of design, with many fresh perspectives.

BIRREN, FABER. *Color and Human Response.* New York: Reinhold, 1974.

ITTEN, JOHANNES. *The Art of Color.* Trans. by Ernest Van Haagen. New York: Reinhold, 1973.

_____ *Design and Form.* New York: Reinhold, 1975. The foundation course of the Bauhaus school.

JUDD, DEANNE B., AND GUNER WYSCEWSKI. *Color in Business, Science, and Industry,* 2d ed. New York: Wiley, 1975.

KEPES, GYORGY. *Light Graphics.* New York: International Center of Photography, 1984. Pioneer Bauhaus artist presents his view of design.

LAUER, DAVID. A. *Design Basics.* 2nd ed. New York: Holt, Rinehart and Winston, 1985. Clear introduction to design with many choices for student projects.

PILE, JOHN F. *Design: Purpose, Form and Meaning.* New York: Norton, 1982.

Chapter 3: Drawing, Painting, and Mixed Media

Periodicals
Art in America
ARTnews
Arts Magazine

CHAET, BERNARD. *An Artist's Notebook.* New York: Holt, Rinehart and Winston, 1979. Survey of drawing and painting techniques—traditional to contemporary.

GOLDSTEIN, NATHAN. *Painting: Visual and Technical Fundamentals.* Englewood Cliffs, NJ: Prentice-Hall, 1979. Emphasis on traditional materials and techniques.

MAYER, RALPH. *The Artist's Handbook of Materials and Techniques,* 3d ed. New York: Viking, 1981. Exhaustive survey of materials and techniques.

MENDELOWITZ, DANIEL M. *A Guide to Drawing,* 4th ed. New York: Holt, Rinehart and Winston, 1988. Comprehensive yet compact drawing analyses with excellent illustrations—traditional to contemporary.

NICOLAIDES, KIMON. *The Natural Way To Draw.* Boston: Houghton Mifflin, 1975. Unique, tri-part approach to drawing; particularly successful in drawing the human figure.

READ, HERBERT. *A Concise History of Modern Painting.* New York: Praeger, 1985. Selective survey through mid-twentieth century.

Chapter 4: Printmaking

Artist's Proof: The Annual of Prints and Printmaking. New York: Pratt Graphics Center and Barre Publishers. Annual review.

The Complete Woodcuts of Albrecht Dürer. New York: Dover, 1963. Works by one of the greatest printmakers of all time.

HOFFMAN, DETLEF. *The Playing Card.* Greenwich, Conn.: New York Graphics, 1973. Fascinating account of a surprisingly ancient form of printed art.

HELLER, JULES. *Papermaking.* New York: Watson-Guptill, 1978.

MAYER, A. HYATT. *Prints and People.* New York: Metropolitan Museum of Art (Dist. New York Graphic), 1980. Excellent analysis and survey.

NARAZAKE, MUNISHIGE. *Japanese Printmaker: Essence and Evolution.* Palo Alto, CA: California Kodansha International, 1969. Works by major Oriental artists influencing the East.

PETERDI, GABOR. *Printing Methods Old and New.* New York: Macmillan, 1980. A pivotal 20th-century printmaker defines the art of prints.

ROSS, JOHN, AND CLARE ROMANO. *The Complete Printmaker.* New York: Free Press (Macmillan), 1972. Remains an up-to-date text, incorporating most printmaking processes.

Chapter 5: Art of the Lens

FEININGER, ANDREAS. *The Complete Photographer.* Englewood Cliffs, NJ: Prentice-Hall, 1984. Successful teacher-photographer's text on know-how for the student.

GERNSHEIM, HELMUT. *A Concise History of Photography.* New York: Dover, 1986. Full account of photographic history to the mid-20th century.

HALAS, JOHN. *Masters of Animation.* New York: Salem Press, 1987. Clear and well-organized text.

KARSH, YOUSUF. *Karsh Portraits.* Toronto: University of Toronto Press, 1976. Gallery of famous subjects by the well-known photographer; biographical summary with each portrait.

LYONS, NATHAN. *Photographers on Photography.* Englewood Cliffs, NJ: Prentice-Hall, 1966. Many of the major 20th-century photographers share their views.

MacDONNELL, KEVIN. *Eadweard Muybridge.* Boston: Little, Brown, 1972. Still views and multiple photographs.

McKOWEN, CLARK, AND MEL BYARS. *It's Only a Movie.* Englewood Cliffs, NJ: Prentice-Hall, 1970.

ROSS, R. J. *Television Film Engineering.* New York: Wiley, 1966. Lucid and well-organized text.

SOUTO, H. M. R. *Technique of the Motion Picture Camera.* New York: Hastings, 1967. Like the others of the series, this text is clear and complete.

STEICHEN, EDWARD. *A Life in Photography.* Garden City, NY: Doubleday, 1963. Magnificent illustrations include portraits of famous personalities, with Steichen's notes on each.

SWEDLUND, CHARLES. *Photography: A Handbook of History, Materials, and Processes,* 2nd ed. New York: Holt, Rinehart and Winston, 1981. Comprehensive text covering all aspects of photography, including 35 mm and other formats, developing, printing, special processes.

WOOLEY, A. E. *Photographic Lighting,* 2d ed. New York: Amphoto, 1971.

Chapter 6: The Sculptural Arts

BEARDSLEY, JOHN. *A Landscape for Modern Sculpture: Storm King Art Center.* New York: Abbeville Press, 1985. Good survey of modern sculpture.

———— *Earthworks and Beyond.* New York, Abbeville Press, 1989. Up to date account of contemporary trends in sculpture.

KAPROW, ALLAN. *Assemblage, Environments and Happenings.* New York: Abrams, 1966. Pioneer in these related art expressions traces their evolution as they were occurring.

KEPES, GYORGY, ED. *The Nature and Art of Motion.* New York: Braziller, 1965.

LIPMAN, JEAN. *Calder's Universe.* Philadelphia: Running Press, 1989. The contribution of a genuinely unique sculptor is respectfully reviewed.

READ, HERBERT. *A Concise History of Modern Sculpture.* New York: Praeger, 1964. A selected presentation in readable style.

ROTTGER, ERNEST. *Creative Wood Design.* New York: Reinhold, 1961.

SEITZ, WILLIAM C. *The Art of Assemblage.* New York: Museum of Modern Art, 1961. The museum curator defines a popular medium at mid-twentieth century.

WITTKOWER, RUDOLPH. *Sculpture: Processes and Principles.* London: Allen Lane, 1977.

Chapter 7: Architecture and Environmental Design

Periodicals
Arts and Architecture
Architectural Record
Progressive Architecture

BLAKE, PETER. *The Master Builders.* New York: Norton, 1976.

———— *Form Follows Fiasco: Why Modern Architecture Hasn't Worked.* Iconoclastic viewpoints about The International Style and its anticipated demise.

CONRADS, ULRICH, ED. *Programs and Manifestoes on 20th-Century Architecture.* Cambridge, MA: M.I.T. Press, 1971.

FULLER, R. BUCKMINSTER, AND ROBERT W. MARKS. *The Dymaxion World of R. Buckminster Fuller.* New York: Reinhold, 1960. Controversial findings by a remarkable architect.

GIEDION, SIEGFRIED. *Space, Time and Architecture,* 5th ed. Cambridge, MA: Harvard University Press, 1967.

GROPIUS, WALTER. *The New Architecture and the Bauhaus.* Boston: Branford, 1965. Classic study by the founder of the Bauhaus.

HAMLIN, TALBOT. *Architecture Through the Ages.* New York: Putnam, 1953. Classic survey of architecture.

HALPRIN, LAWRENCE. *Citites.* New York: Reinhold, 1972.

JACOBS, JANE. *The Death and Life of American Cities.* New York: Random House, 1961. A controversial view of city planning.

LE CORBUSIER. *Towards a New Architecture.* New York: Dover, 1986. Leading 20th-century architect explores his philosophy.

———— *The Modular and Modulor.* Cambridge, MA: M.I.T. Press, 1980. An approach to architecture, based on a universal human scale.

MUMFORD, LEWIS. *The City in History.* New York: Harcourt, 1968. Comprehensive survey of cities throughout history.

NEUTRA, RICHARD. *Survival Through Design.* New York: Oxford University Press, 1969.

RUDOFSKY, BERNARD. *Prodigious Builders.* New York: Harcourt, 1979.

WRIGHT, FRANK LLOYD. *The Natural House.* New York: Horizon, 1958. Pioneer architect defines the organic system.

Chapter 8: Design for Living

Periodicals
Advertising Age. Weekly newspaper for the trade.
Design Quarterly. Highlights of fine design.
Craft Horizons. Monthly periodical dealing with craft design.
Design Quarterly. Highlights of fine design.
Interiors. Furniture and interior design.
Vogue. Fashion magazine leader for decades.
Women's Wear Daily. A must for the fashion trade.
Art Directors' Annual. New York: Watson-Guptill. The annual of advertising, editorial, television art and design, chosen by the Art Directors' Club of New York as the best work of the year.

BAKER, STEPHEN. *Systematic Approaches to Creativity.* New York: McGraw-Hill, 1983. Excellent survey of the advertising art field.

BACKUS, WILLIAM. *Advertising Graphics.* New York: Collier-Macmillan, 1986.

BEVLIN, MARJORIE. *Design Through Discovery,* 4th ed. New York: Holt, Rinehart and Winston, 1984.

CARDAMONE, TOM. *Advertising Agency and Studio Skills,* 3rd ed. rev. and updated. New York: Watson-Guptill, 1981. Guide to the preparation of art and mechanicals for reproduction by well-known illustrator.

FAULKNER, RAY, LUANN NISSEN, AND SARAH FAULKNER. *Inside Today's Home,* 5th ed. New York: Holt, Rinehart and Winston, 1986.

FAULKNER, RAY, HOWARD SMAGULA, AND EDWIN ZIEGFELD. *Art Today,* 6th ed. New York: Holt, Rinehart and Winston, 1987.

FRINGS, VIRGINIA. *Fashion: From Concept to Consumer.* Englewood Cliffs, NJ: Prentice-Hall, 1982.

HELD, SHIRLEY E. *Weaving: A Handbook for Fiber Craftsmen,* 2nd ed. New York: Holt, Rinehart and Winston, 1978.

JACKMAN, DIANNE R., AND MARY K. DIXON. *The Guide to Textiles for Interior Designers.* Winnipeg: Pequis Publications, 1984.

JOSEPH, MARJORY L. *Essentials of Textiles,* 3rd ed. New York: Holt, Rinehart and Winston, 1984.

KENNY, JOHN B. *Complete Book of Pottery Making.* New York: Chilton, 1.

KLEPPNER, OTTO. *Advertising Procedure.* Englewood Cliffs, NJ: Garland, 1985. Leading reference for many years; voluminous survey of advertising. 976. Clear, comprehensive; leading text for decades.

MEILACH, DONNA Z. *Contemporary Batik and Tie-Dye.* New York: Crown, 1973.

MURPHY, DENNIS GRANT. *The Materials of Interior Design.* Burbank, CA: Stratford House Publishing Company, 1978.

NELSON, GLENN C. *Ceramics: A Potter's Handbook,* 5th ed. New York: Holt, Rinehart and Winston, 1984.

PAYNE, BLANCHE. *History of Costume.* New York: Harper & Row, 1965. A complete history from ancient times to the 20th century.

QUANT, MARY. *Color by Quant.* New York: McGraw-Hill, 1985. Readable book by the British designer.

ROTTGER, ERNEST. *Creative Wood Design.* New York: Reinhold, 1961.

SCHIAPARELLI, ELSA. *Schiaparelli.* New York: Dutton, 1954. Autobiography by the grande dame of the fashion world.

VON NEUMAN, ROBERT. *Design and Creation of Jewelry.* Philadelphia: Chilton, 1962.

ZELANSKI, PAUL, AND MARY PAT FISHER. *Shaping Space.* New York: Holt, Rinehart and Winston, 1986. Fine text dealing with dynamics of three-dimensional design.

Chapter 9: Expanding the Boundaries of Art

AMERICAN ASSOCIATION OF MUSEUMS, *The Official Museum Directory*. Washington, D.C., 1982.

ARMSTRONG, RICHARD, *Mind Over Matter: Concept and Object*. Whitney Museum of American Art, N.Y., 1990. Clarification and elucidation of terms.

HESS, THOMAS B., AND JOHN ASHBERRY, eds. *Avant-Garde Art*. London, 1968.

HUGHES, ROBERT, *Shock of the New*. Knopf, N.Y., 1981. Provocative survey of the last decades of modern art.

LEVIN, KIM, *Beyond Modernism*. Harper & Row, N.Y., 1988. Postmodernism defined.

LIPPARD, LUCY, *Six Years: The Dematerialization of the Art Object from 1966–1972*. London, 1973. Scholarly study of the 1960s.

LOVEJOY, MARGOT, *Postmodern Currents*. Michigan: University of Michigan Press, 1969. Fine analysis of current art directions.

MOFFITT, JOHN, *Occultism in Avant-Garde Art; The Case of Joseph Beuys*.

OLDENBURG, CLAES, *Works In Edition*. Margo Levin Gallery, Los Angeles, 1971.

ROSENBERG, HAROLD, *The De-Definition of Art: Action Art to Pop to Earthworks*, London, 1972.

VRIES, GERD DE, *On Art: Artists Writing On the Changed Notion of Art After 1965*. Cologne, 1974. Artists explaining themselves always offer fresh insights to the observer.

Chapter 10: Magic and Ritual: Prehistory and the Ancient World

ALDRED, CYRIL. *Egyptian Art*. New York: Thames & Hudson, 1985.

CHILDE, V. GORDON. *New Light on the Most Ancient East*, 4th ed. New York: Norton, 1969.

COE, RALPH T. *Lost and Found Traditions: Native American Art 1965–1985*. New York: American Federation of the Arts, 1986.

FRANKFORT, HENRI. *Art and Architecture of the Ancient Orient*. Baltimore: Pelican-Penguin, 1977.

GUINDONI, E. *Primitive Architecture*. New York: Abrams, 1978.

LAUDE, JEAN. *The Arts of Black Africa*. Berkeley: University of California Press, 1971.

LEE, SHERMAN E. *A History of Far Eastern Art*. New York: Abrams, 1982. Comprehensive introductory survey of the scope of Eastern art.

LEROI-GOURHAN, ANDRÉ. *Treasures of Prehistoric Art*. New York: Abrams, 1980.

LEUZINGER, ELSY. *The Art of Black Africa*. New York: Rizzoli, 1979. Slim, easy to read early survey of African art.

MENDELSSOHN, KURT. *The Riddle of the Pyramids*. New York: Pyramid, 1974.

ROWLAND, BENJAMIN. *Art and Architecture of India*. Baltimore: Pelican-Penguin, 1971.

SICKMAN, LAURENCE, AND ALEXANDER SOPER. *Art and Architecture of China*. Baltimore: Pelican-Penguin, 1971.

Chapter 11: Gods and Heroes: The Classical World; Asia and The Americas

ANDREAS, G. *The Art of Rome*. New York: Abrams, 1978.

BEAZLEY, J. D. *Attic Red-Figured Vase Painters*. New York: Hacker, 1985.

DINSMOOR, W. B. *Architecture of Ancient Greece*. London: Batsford, 1973. The standard work on the subject brought up to date.

LAWRENCE, ARNOLD. *Greek Architecture*. Baltimore: Pelican-Penguin, 1954. A basic text.

RICHTER, GISELA. *Archaic Greek Art*. New York: Oxford University Press, 1949. Lucid, well-organized, and illustrated. These texts and all others by Richter have remained valuable aids since publication of the first in 1929.

_____ *A Handbook of Greek Art*, rev. ed. London: Phaidon, 1960.

_____ *Sculpture and Sculptors of the Greeks*. New Haven, CT: Yale Universtiy Press, 1970.

ROBERTSON, D. S. *A Handbook of Greek and Roman Architecture*. New York: Cambridge University Press, 1954.

Chapter 12: Faith: The Middle Ages

BECKWITH, JOHN. *Early Medieval Art*. New York: Thames & Hudson, 1985.

BOAS, FRANZ. *Primitive Art*. New York: Peter Smith, 1962. Classic study of non-Western art; reissued and translated into English.

DOCKSTADER, FREDERICK H. *Indian Art of the Americas*. New York: Museum of the American Indian, 1973. Comprehensive approach to Native American art.

GRABER, ANDRÉ. *Christian Iconography*. Princeton, NJ: Princeton University Press, 1980.

PANOFSKY, ERWIN. *Abbot Suger on the Abbey Church of St. Denis and Its Art Treasures*. Princeton, NJ: Princeton University Press, 1946.

_____ *Gothic Architecture and Scholasticism*. New York: Meridian, 1957.

RICE, DAVID TALBOT. *Art of the Byzantine Era*. New York: Praeger, 1963.

STOCKSTAD, MARILYN. *Medieval Art*. New York: Harper & Row, 1986.

SWIFT, EMERSON. *Hagia Sophia*. New York: Columbia University Press, 1940.

WINGERT, PAUL S. *Primitive Art*. New York: Oxford University Press, 1965. Pioneer scholar in African art surveys the field of African, Native American, and Oceanic art.

ZARNEKI, GEORGE. *Art of the Medieval World*. New York: Abrams, 1976.

Chapter 13: Crossroads: Renaissance, Baroque, Rococo

BAZIN, GERMAIN. *Baroque and Rococo Art*. New York: Thames & Hudson, 1985. Good general text.

BERENSON, BERNARD. *Italian Painters of the Renaissance*. 2 vols. London: Phaidon, 1982. The long-established text on Italian painting (first published in 1952).

KITSON, MICHAEL. *Rembrandt*. New York: Salem House, 1983.

LEONARDO DA VINCI. *Notebooks*. ed. E. MacCurdy, New York: Braziller, 1985.

MARLE, RAIMOND VAN. *The Development of the Italian Schools of Painting*. 19 vols. New York: Hacker, 1971. Comprehensive treatment of the subject.

MILTON, HENRY. *Baroque and Rococo Architecture*. New York: Braziller, 1961. Clear introduction to the period.

POPE-HENNESSY, JOHN. *The Study and Criticism of Italian Sculpture*. New York: Metropolitan Museum of Art, 1984. Good complete survey of sculpture of the Renaissance.

PORTOGHESI, PAOLO. *The Rome of the Renaissance*. London: Phaidon, 1972. Brilliant study.

ROSENBERG, JAKOB, SEYMOUR SILVE, AND E. H. KUILE. *Dutch Art and Architecture*. Baltimore: Penguin, 1972. Excellent regional study.

RYKWERT, JOSEPH, ED. *Alberti's "De re Aedificatoris."* Ten Books on Architecture. London: Tiranti, 1955. Invaluable source book of the time.

THOMPSON, DANIEL. *Cennino Cennini*. New York: Dover, 1954. Translation of Cennini's handbook for the craftsman-artist. Original document of the period.

VASARI, GIORGIO. *The Lives of the Painters, Sculptors, and Architects*. New York: Biblio. Dist., 1980. Fascinating chronicle and source book.

WITTKOWER, RUDOLPH. *Architectural Principles in the Age of Humanism*. New York: Norton, 1971. Intriguing, scholarly exploration of harmonic ratios in music and architecture.

_____ *Art and Architecture in Italy*. Baltimore: Penguin, 1958.

_____ *Gian Lorenzo Bernini*. London: Phaidon, 1955. Penetrating specialized study of the exponent of Baroque sculpture and his age.

WOLFFLIN, HEINRICH. *Principles of Art History*. 1932. Reprint. New York: Dover, n.d. Classic comparison of the Renaissance and the Baroque.

Chapter 14: Revolution and the Modern World: 1776–1900

BOIME, A. *The Academy and French Painting in the 19th Century*. New York: Phaidon, 1970.

CANADAY, JOHN. *Mainstreams of Modern Art*, 2nd ed. New York: Holt, Rinehart and Winston, 1981. Personalized chronicle of the Romantic period through the 1920s.

DAVAL, J. L. *Photography: History of Art*. New York: Skira/Rizzoli, 1982.

DOUGLAS, FREDERICK H., AND RENÉ D'HARNONCOURT. *Indian Art of the United States*. New York: Museum of Modern Art, 1970. Introduction to Indian Art.

DRUCKER, PHILIP. *Cultures of the North Pacific Coast*. New York: Harper & Row, 1965. Interesting presentation of Native American art with historical background.

LINTON, RALPH, AND PAUL S. WINGERT. *Arts of the South Seas*. 1946. Reprint. New York: Museum of Modern Art, 1972.

REWALD, JOHN. *The History of Impressionism*. New York: Graphic Society, 1980.

———. *Post-Impressionism*. New York: Museum of Modern Art, 1977. Fundamental survey.

REYNOLDS, SIR JOSHUA. *Discourses on Art*. Ed. by Robert Wark. San Marino, CA: Huntington Library, 1959. Founder of the British Academy discusses his philosophy of art in 15 addresses as delivered between November 2, 1769, and December 10, 1790.

Chapter 15: Tradition and Innovation 1900–1935

ARNASON, H. H. *History of Modern Art*. Englewood Cliffs, NJ: Prentice-Hall, 1986. Comprehensive survey to the present.

BARR, ALFRED, JR. *Fantastic Art*. New York: Museum of Modern Art, 1970. Museum of Modern Art curator covers the art of dreams and the irrational world.

BAYER, HERBERT, WALTER GROPIUS AND I. GROPIUS. *Bauhaus, 1919–1928*. New York: Avert Company, 1972. Written by founders of the Bauhaus; based on the Museum of Modern Art exhibition in 1938.

CANADAY, JOHN. *Mainstreams of Modern Art*, 2nd ed. New York: Holt, Rinehart and Winston, 1981. The *New York Times* art critic presents an absorbing account of art from the late 18th century through the early 19th century.

HAMILTON, GEORGE H. *Painting and Sculpture in Europe, 1880–1940*. Baltimore: Penguin, 1981. Covers Western modern art to World War II.

INVERARITY, ROBERT B. *Art of the Northwest Coast Indians*, 2nd ed. Berkeley and Los Angeles: University of California Press, 1967. Thorough treatment of the subject.

KANDINSKY, WASSILY. *Concerning the Spiritual in Art*. New York: Dover, 1977. Pioneer abstractionist explores his philosophy.

MOTHERWELL, ROBERT. *The Dada Painters and Poets*. New York: Wittenborn, 1951. Insights into the non-art movement and philosophy; essays and poetry.

RAYMOND, MARCEL. *From Baudelaire to Surrealism*. London: Methuen, 1970. Commentary on the literature of the period.

RICKEY, GEORGE. *Constructivism: Origins and Evolution*. New York: Braziller, 1967. Innovator in kinetic art traces the development of the style.

RUBIN, WILLIAM. *Dada, Surrealism and Their Heritage*. New York: Museum of Modern Art, 1968.

SELZ, PETER. *German Expressionist Painting*. Berkeley and Los Angeles: University of California Press, 1959.

SELZ, PETER, AND M. CONSTANTINE. *Art Nouveau and Design at the Turn of the Century*. New York: Museum of Modern Art, 1987. Surveys of the movements.

Chapter 16: America Ascending: 1900–1945

ALLOWAY, LAWRENCE. *Roy Lichtenstein*. New York: Abbeville, 1983.

ARNASON, H. H. *American Abstract Expressionists and Imagists*. New York: Solomon Guggenheim Museum. 1961.

BROWN, MILTON. *American Painting from the Armory Show to the Depression*. Princeton, NJ: Princeton University Press, 1970. Survey of realistic art.

FINE, ELSA HONIG. *The Afro-American Artist: A Search for Identity*. New York: Hacker, 1982.

GELDZAHLER, HENRY. *American Painting in the Twentieth Century*. New York: Museum of Modern Art, 1965. Interesting survey of American painting.

GREENBERG, CLEMENT. *Post-Painterly Abstractions*. Los Angeles: Los Angeles County Museum, 1964. A definitive text.

HOBBS, ROBERT C., AND GAIL LEVIN. *Abstract Expressionism: The Formative Years*. Ithaca, NY: Cornell University Press, 1981.

JANIS, SIDNEY. *Abstract and Surrealist Art in America*. New York: Arno Press, 1944. Traces the abstract movement in the United States. Reprint Ayer & Co.

———. *They Taught Themselves*. Reprint. New York. Discusses black self-taught artists. Well illustrated.

LOCKE, ALAIN. *The New Negro*. New York: Arno Press, 1968. The original anthology of the Harlem Renaissance with illustrations by Aaron Douglas.

ROSE, BARBARA. *American Art Since 1900*. New York: Praeger, 1967.

SANDLER, IRVING. *The Triumph of American Painting*. New York: Harper & Row, 1976. Good accounts of individual movements.

Chapter 17: The Mid-Century World: 1945–1970

ASHTON, DORE. *The New York School: A Cultural Reckoning*. New York: Penguin, 1980.

CHICAGO, JUDY. *The Dinner Party: A Symbol of Our Heritage*. Garden City, NY: Doubleday, 1979.

GREER, GERMAINE. *The Obstacle Race*. New York: Farrar Straus Giroux, 1979. Subjective survey of women painters and their work.

JANSON, HORST W. *History of Art*, 3rd ed. New York: Abrams, 1986. The definitive text for art history students and an excellent foundation for the beginning student in art.

KNOBLER, NATHAN. *The Visual Dialogue*, 3rd ed. New York: Holt, Rinehart and Winston, 1980.

KOZLOFF, MAX. *Renderings: Critical Essays on a Century of Modern Art*. New York: Simon & Schuster, Clarion, 1969. Inclusive essays on art and artists.

MUNRO, ELEANOR. *Women Artists, Originals*. New York: Petersen and Wilson, 1976. Succinct summary of achievements of women in art.

SCULLY, VINCENT. *Modern Architecture*, rev. ed. New York: Braziller, 1974.

WITHERS, J. *Julio Gonzalez: Sculpture in Iron*. New York: New York University Press, 1978.

Chapter 18: Our Own Time: The 1970s and Beyond

AMERICAN ASSOCIATION OF MUSEUMS, *The Official Museum Directory*. Washington, D.C., 1982.

ADES, DAWN. *Photo-Montage*. New York: Thames & Hudson, 1986.

ANDERSON, LAURIE. *United States*. New York: Harper & Row, 1984.

ARMSTRONG, RICHARD, *Mind Over Matter: Concept and Object*. Whitney Museum of American Art, N.Y., 1990. Stimulating tract.

ARNASON, H. H. *History of Modern Art, Painting, Sculpture, Architecture*, 3rd ed. New York: Abrams, 1986. Most inclusive text on the subject.

BEARDSLEY, JOHN. *Earthworks and Beyond: Contemporary Art in the Landscape*. New York. 1984.

BRANZI, ANDRÉ. *The Hot House: Italian New Wave Design*. Cambridge, MA: M.I.T. Press, 1984.

COLE, DORIS. *From Tipi to Skyscraper: A History of Women in Architecture*. Cambridge, MA: M.I.T. Press, 1978.

ELLIS, JACK C. *A History of Film*. Englewood Cliffs, NJ: Prentice-Hall, 1985. Early film discoveries, good treatment of regional European and Hollywood productions, third-world cinema, re-emergence of American films.

GREENBERG, CLEMENT. *Art and Culture: Critical Essays*. Boston: Beacon, 1961. Fascinating philosophy of a leading art critic of the 1950s and beyond.

HESS, THOMAS B., AND JOHN ASHBERRY, EDS. *Avant-Garde Art*. London, 1968.

HUGHES, ROBERT. *Shock of the New*. Knopf, N.Y., 1981.

JENCKS, CHARLES. *Modern Movements in Architecture*. New York: Penguin, 1987. Compact analyses.

LANGER, SUSANNE K. *Problems of Art*. New York: Scribners, 1977. Fine subjective work.

LEVIN, KIM, *Beyond Modernism*. Harper & Row, N.Y., 1988.

LIPPARD, LUCY R., ED. *Six Years: The Dematerialization of the Art Object from 1966–1972*. New York: 1975.

LOVEJOY, MARGOT, *Postmodern Currents*. Michigan: University of Michigan Press, 1969.

LUCIE-SMITH, EDWARD. *Art in the Seventies*. Ithaca, NY: Phaidon, Cornell University Press, 1980. Non-chronological analysis of modern movements.

LYNTON, NORBERT. *The Story of Modern Art*. New York: Dover, 1980.

MOFFITT, JOHN, *Occultism in Avant-Garde Art: The Case of Joseph Beuys.*

OLDENBURG, CLAES, *Works In Edition.* Margo Levin Gallery, Los Angeles, 1971.

READ, HERBERT. *Art and Alienation.* New York: Viking, 1969. The role of the artist in society.

ROSE, BERNICE. *Drawing Now.* New York: Museum of Modern Art, 1976. Illuminating unexpected works.

ROSENBERG, HAROLD. *Art on the Edge: Creators and Situations.* Chicago: University of Chicago Press, 1983. Critical essays by authority on mid-20th-century art.

ROSENBERG, HAROLD, *The De-Definition of Art: Action Art to Pop to Earthworks.* London, 1972.

RUBIN, WILLIAM. *Primitivism in Twentieth Century Art.* New York: Museum of Modern Art, 1984.

RUSSELL, JOHN. *The Meanings of Modern Art.* New York: Harper & Row, 1981. Engaging account explaining modern art.

SMAGULA, H. *Currents: Contemporary Directions in the Visual Arts.* Englewood Cliffs, NJ: Prentice-Hall, 1983.

VRIES, GERD DE, *On Art: Artists Writing on the Changed Notion of Art After 1965.* Cologne, 1974.

WALLIS, B., ED. *Art After Modernism: Rethinking Representation.* New York. 1984.

WILSON, STEPHEN. *Using Computers to Create Art.* Englewood Cliffs, NJ: Prentice-Hall, 1986. Clear text that blends science with aesthetic considerations.

INDEX

References are to page numbers. **Boldface type** identifies pages on which illustrations appear. Works of art are listed under the names of their creators, when known; otherwise under their titles. Many technical terms are included in the index, with references to their text definitions. For a more complete list of terms, consult the Glossary.

COPYRIGHTS AND ACKNOWLEDGEMENTS